THE LOCATION
PHOTOGRAPHER'S HANDBOOK

THE LOCATION PHOTOGRAPHER'S HANDBOOK

The Complete Guide for the Out-of-Studio Shoot

Ken Haas

 VAN NOSTRAND REINHOLD
New York

We welcome readers' comments about this book. Please send your comments to the following address: Ken Haas, c/o Van Nostrand Reinhold, 115 Fifth Avenue, New York, N.Y. 10003.

Copyright © 1990 by Ken Haas, Inc.

Library of Congress Catalog Card Number 89-9084
ISBN 0-442-31948-7

Text design: Monika Grejniec

Cover design: Henry Steiner/Graphic Communication Ltd., Hong Kong

Printed in the United States of America

Van Nostrand Reinhold
115 Fifth Avenue
New York, New York 10003

Van Nostrand Reinhold International Company Limited
11 New Fetter Lane
London EC4P 4EE, England

Van Nostrand Reinhold
480 La Trobe Street
Melbourne, Victoria 3000, Australia

Nelson Canada
1120 Birchmount Road
Scarborough, Ontario M1K 5G4, Canada

16 15 14 13 12 11 10 9 8 7 6 5 4 3 2 1

Library of Congress Cataloging-in-Publication Data
Haas, Ken.
 The location photographer's handbook : the complete guide for the out-of-studio shoot / by Ken Haas.
 p. cm.
 Includes index.
 ISBN 0-442-31948-7
 1. Photography, Commercial. I. Title.
TR690.H27 1989
770'.68—dc20
 89-9084
 CIP

For my wife, Jacqueline Costello,
who makes coming home an adventure as well.

Contents

Health and Physical Fitness / 122
Health Suggestions for Plane Trips / 122; Jet Lag / 122; Dealing with Stress / 123; Your Eyes / 125; Your Back / 125; Your Feet / 126; Exercise / 126; Health Hints for the International Traveler / 126; Health Emergencies / 134; Death of a Member of Your Team Abroad / 134

Relationships on the Road / 135

Some Final Thoughts / 137

Country Files / 139

Appendixes / 351

About the Author / 415
Index / 417

Preface

Life is like a peacock. One can choose to look at its
feet or its feathers.

—Persian proverb

A lifetime spent as a location photographer can be a paranoid's delight. Real and imagined threats to your work and safety seem to vault, like mechanical fun-house ghosts, from every corner. But it is also a passionate existence, often glamorous, always intriguing. I have spent the night in a tree house in Malaysia and in a suite in Claridges of London, dodged fireworks on Chinese New Year in Hong Kong, held candles in the solemn processions of Holy Week in Seville. My recollections of people and events are as precious as the images I sell, for few people experience as much enrichment in a lifetime of vacations as the successful location photographer does in a busy year.

The purpose of this book, then, is not to discourage or complain. "Vigilance" is my watchword not because of a negative strain in my thinking but because it encourages the security and efficiency that frees me to enjoy my work and travels. An assignment plagued by problems that might have been avoided by a more meticulous approach will produce weaker photographs, poorer relationships, and perhaps worst of all, bitter memories.

Clearly, the methodical, even compulsive procedures recommended in this book reflect my personality. You will need to modify this approach to suit your individual style and creative needs. Yet I know of no successful location photographers who are careless in their work habits. There is a world of difference between a liberated spirit behind the viewfinder, open to the magnificent accidents and coincidences that yield the finest images, and a haphazard approach to the business of the assign-

ment itself. The photographer who prefers to leave all to chance will find little of value in what follows.

The fundamental concern of this book is the *safe and successful* return of you and your crew from a location shoot, whether it be across a foreign border or on the other side of town. The two key themes around which the first two sections of this book are organized are the mainstays of my philosophy.

The first is *preparedness*. Every unanticipated contingency creates a geometrically increasing risk of catastrophe on the road. The more obsessively you organize procedures and logistics in advance, the more you ensure against disaster.

The second is *crisis management*. No matter how well you do your homework, unexpected contingencies of all kinds will arise on the road. Understand that the art of location photography *is* the art of crisis management. Section 2 will alert you to a host of potential problems and their solutions. You will also find suggestions on how to deal with these problems effectively without losing the positive attitude that enriches your life and work.

In preparing this book, I realized that my basic rules of the road are the common-sense ones I first learned from my grandmother: be polite, wear comfortable shoes, don't take candy from strangers. One bit of her advice has been ignored, however—I do run, not walk, to catch a bus. . . .

Acknowledgments

Hundreds of individuals in industry and government were consulted in preparing this book. I am grateful to them all, for they were almost without exception gracious and resourceful. I would like to express my special thanks to the following:

Alan Ampolsk; Paul Armato, Armato Photo Service; APA, Marilyn Wallen, Director; ASMP Executive Board; G. Babin, Center for Safety in the Arts; Ron Berlin; Peter Carey; Jerry Cheske and Richard White, Automobile Association of America; Alvaro DeSousa, Assembly of National Tourist Representatives in New York; Rosamond R. Dewart, Centers for Disease Control; Donald Dougherty; Tom Dufficy, National Association of Photographic Manufacturers; Larry Farrell, Flash Clinic; Debbie Filibert, Burnham & Company; Roger Freed and Jeffrey Eisenberg, New York Foreign Exchange Inc.; William Garrett, MCI International; Hugh Gillespie, International Road Federation; Burt Glinn; David Gregory, Dialectics; Stephan P. Haas; Grace Herget, Japan National Tourist Office; Zaloum Ittah, International Civil Aviation Organization; Stephen C. Kahan; Jacques Kaufman, Imaging Management and Consulting International; Michel LaRose, International Air Transport Association; Bruce Mathews; Ann Middlebrook, American Showcase; Bruce Mitchell, Fuji Photo; William Moss and Mathew Stover, American Express; Stacy Newman, Photo District News; Department of State's Bureau of Consular Affairs; Jim Pickerell; Michael Reynolds, Falcon Locks; Will Rhyins and Dorothy McNeill, Professional Photo Source; Minona Rossol, Arts, Crafts, and Theatre Safety; Peter Roth; Wolfgang Schneckenberg, Swissair; Jack Sherin; Stephanie Studios NY; Glo-

ria Tanzini, Association of Film Commissioners; Ray Taylor, Taylor & Taylor; Steven Trombetti, The American Hotel and Motel Association; Glenda Walfish, U.S. Customs; Rich Wallerstein, AT&T; Bruce Wilson, U.S. Council for International Business; Pat Woodson, Photonet; Bob Weinreb, Tenba; Herb Zimmerman and Rick Rankin, Professional Camera Service.

Marty Forscher and my travel agent, Agnes Warburton of Travel People, New York, honored me with hours of their time in preparing key sections. I am enormously grateful to them for their generosity.

My readers, John Echave and Maggie Steber, were thoughtful, illuminating, and greatly encouraging in an unenviable task.

Photographer Gregg Martin has traveled with me on many assignments throughout the world. I want to acknowledge his suggestions for the text, and more important, his numerous contributions to the style of working that formed the basis of so much of this book. He has been a superb companion in both the pleasures and crises of the road.

My warmest thanks to Tom Goss of RC Publications for writing an article about my location procedures in the March/April 1987 issue of *How* magazine. It underscored the need for this book and provided the opportunity to begin organizing my thoughts on the subject.

This offspring had a godfather. My old friend Henry Steiner needled and nagged until I finally committed to the project. I'm sure many colleagues have thought about systematically exploring the problems of the road in print, but no doubt just then a PC cord failed or their flight was called, and they certainly didn't have Henry's displeasure to contend with. But it was devilishly shrewd to put myself in his debt once again—I already owe him more than I can ever repay.

And, if all this was not lucky enough, I had the good fortune to work with as fine a publishing team as I can imagine. Judith Joseph (Vice President, Editorial Director), Cynthia Zigmund (Associate Editor), Amanda Miller (Editorial Assistant), Maud Keisman (Editorial Supervisor), Linda Venator (Copyeditor), Phil Goldberg (Production Manager), and my magnificent Sponsoring Editor, Lilly Kaufman, accorded me endless patience, expertise, and encouragement.

1

PREPARING FOR THE ASSIGNMENT

The readiness is all.
—*Hamlet*

NEGOTIATING THE ASSIGNMENT

You have been called in by a designer, agency, magazine, or corporate client to talk about a location shoot. What are some of the issues you will have to discuss, or at least keep in mind? Remember, on many location shoots you will be traveling unaccompanied, so it is particularly important that you understand these issues completely before you leave. Contacting your client to clarify matters while on the road will not always be convenient or possible.

Why Send One Photographer to Shoot in Different Locations?

Before your travels are considered, the above question may arise. Clients on a budget often want to economize by hiring you to shoot in your community and contracting with local photographers elsewhere to complete the assignment in the more distant settings. You might want to remind them diplomatically of the advantages of using only one photographer:

- The style of the photos will be consistent.
- All negotiating and planning are with only one individual.
- Hiring a distant, unknown photographer can be a gamble.

- Emulsions and other technical elements will not vary.
- Original transparencies will not have to be transported back to the client from an out-of-town photographer.

The Major Issues

The major photographers' organizations have done a splendid job in clarifying photographer concerns and codifying business practices, from day rates to copyright. These are complicated issues that cannot be adequately reviewed here. Certainly every professional photographer should have a copy of either ASMP's *Professional Business Practices in Photography*, fourth edition, 1986 (212–889–9144); or APA's *Assigning Advertising Photography: A Buyer's Guide* (212–807–0399).

Keep a list of both the standard industry issues and your personal concerns in front of you for the meeting, and make the list available to the client. Take notes on how these issues are resolved—rely on memory as little as possible.

First, just sit back and listen. Ask the client to tell you as much as possible about the job, and be sure to elicit a full discussion of approach, style, theme, and key selling points of the photographs you have been hired to make. Listen very carefully and ask for clarification when necessary, since these instructions can sometimes be contradictory. In this discussion you will also get considerable subtextual information about the client's culture, ways of thinking, prejudices, anxieties, and past bad experiences. Bear in mind too that, although you are not necessarily dealing with visual professionals, your clients are often sophisticated individuals with a keen understanding of the goals of the organization and the tastes of the audience for their messages.

This should be followed by a discussion of the major issues enumerated in the ASMP/APA business practices guides (although it is sometimes advisable to discuss exact fees at the end of your talk, when all the facts are known).

The following matters should also be reviewed. With experience and a receptive negotiating partner, all the issues below can be resolved in an hour—or less when there is a complete meeting of the minds.

Deadline: The date for delivering the final print or transparency.

Specialists: Assistants you may need on the shoot, such as photographic assistants, stylists, models, location scouts, or electricians.

Unusual expenses: Extra costs you might incur, such as those for specialized rental equipment, cherry pickers, gyros, vans, or airplanes.

Special insurance: Additional coverage, such as extra liability and property damage for locations you have chosen or an extra floater policy for expensive merchandise to be photographed. Have available a printed summary of the coverage provided by your standard insurance, particularly if you charge some premiums for production insurance back to the client (see "Insurance," later in this section).

Model releases: As a rule, having a release is always preferable. What form of release will be used and to whose name will it be assigned? The forms recom-

mended by ASMP and APA are reproduced in appendix 7. I prefer the short release form pioneered by photographer Burt Glinn. This simple permission statement is less likely to be resisted or misunderstood than the more comprehensive form, which some subjects find intimidating. Printed on letterhead, my short form reads:

```
I hereby for good consideration grant Ken Haas and [CLI-
ENT] permission to publish the photographs taken of me
on _____, 199_, in _____, for editorial,
advertising, or commercial purposes.
```

 Your Signature

For convenience, the translations of this release into Spanish, French, German, Italian, Russian, Chinese, Japanese, and Arabic appear in appendix 8.

A decision must also be made regarding situations where releases will be impractical, if not impossible, to secure. Is the client aware of the risks of reproducing images without model releases? Is the client willing to indemnify the photographer against all claims should a lawsuit result? Is using an unreleased photograph worth the risk for anyone or should an alternative photographic solution be explored?

Shipment of footage: I most strongly recommend that you do not ship unprocessed footage to your client unless absolutely necessary. If shipping is required because of tight deadlines, however, it is extremely important that procedures be discussed thoroughly in advance. The client should be aware that shipping footage is not without risks and that all resources should be brought to bear to reduce those risks (see "Couriers" in section 2).

Delay contingencies: Try to anticipate possible delays, and determine who will be financially responsible when delays occur.

Communications: Ask for your client's home phone number and permission to use it in emergencies. Most have no objections to a call in their private time if it is important. Clearly, developing good judgment concerning which situations warrant a call at home is politic. Do you have the client's fax, cable, or telex numbers? With whom should you communicate (or avoid communicating) when your usual contacts are unavailable?

Travel arrangements: Decide who will make them. I prefer to have my own travel agent involved (see "Travel Agents," later in this section). If different individuals are arranging travel, how will they communicate to ensure everyone's plans are coordinated? What class of air fare and level of accommodations are expected? Often the choice of accommodations is left to your discretion. Ask for some guidance from well-traveled clients in this regard. Their suggestions may reveal the level they normally use (be sure they are not just recommending the hotel that

the chairman of the board prefers!) and may provide information that your travel agent might not have, such as the closest hotel to your shooting location.

Promotional copies of the finished piece: Since the main thrust of my self-promotion is direct mailing of completed samples, I always discuss the possibility of using the piece in my own promotion. Who will pay for the printing and shipping of the hundreds of extra samples ordered? (I never rely on printer overruns, which may be insufficient.) Some organizations may be sensitive about uncontrolled circulation of their material. How should the client or designer be credited in the literature accompanying your mailings?

Review some technical questions in your discussion as well:

Will the organization's facilities have proper electrical output for your gear (see "AC-dependent Strobes," later in this section).

What are the ambient lighting conditions of the locale? Can existing lights be turned off or controlled if necessary?

Are there plant or office shifts that have to be accommodated in planning your schedule?

Are there public holidays that have to be considered in the locales you will be visiting (see the Country Files for dates of holidays in specific countries)?

What is the appropriate dress code for you and your crew?

What should the subjects be wearing?

Who will accompany you on the shoot?

What sort of identification or documentation will you need? In addition to internal clearance documents, request the following general letter of introduction be issued, signed by the most senior executive practical. Providing this draft for your client's clerical staff to type will be greatly appreciated:

> To Whom It May Concern
> This letter is to introduce <u>Your Name</u>, an international photographer who has been commissioned by <u>Client</u> to take photographs in connection with an important project.
> We shall be grateful if you could give him/her any assistance and cooperation he/she may require. Please feel free to contact me should you have any questions or concerns.

What are the loading and unloading procedures at the locale? Will you need special security clearances to enter and leave the locale with your equipment? Are there stairs to negotiate, or are ramps and elevators available? Is parking available, and will you need a permit? Where is the best place to leave your gear overnight (see "Hotels," later in this section and in section 2).

Who are the contacts on the site? Get their phone numbers, and if possible, call these people ahead of time to introduce yourself, confirm arrangements, and give them your number, should they have any questions or concerns.

Are sensitive political issues (corporate politics, labor difficulties, individual eccentricities) that might create diplomatic complications involved?

Expense Estimates

Use the latest ASMP/APA estimate forms. Your estimates should always include:

- Date of estimate
- Date of shoot
- Job/purchase order numbers
- Job description
- Usage of images
- Space for client confirmation

In addition to the obvious production and travel expenses, be sure your estimate includes costs for:

- Polaroids, both for casting/scouting and for the shoot
- Clip tests and push-processing charges for E6 film
- Rush services
- Intermediate rough prints on black-and-white jobs
- Messengers, shipping, and communications
- Airport taxes and documentation (such as visa or permit) charges
- Excess baggage
- Fare or reservation change or cancellation penalties
- Books, maps, information
- Stylists, scouts, electricians, grips, drivers, security personnel, caregivers for child models, home economists, animal handlers, model makers, caterers, casting services
- Petty cash expenses such as laundry and gratuities

Advances

Advances are critical to the location photographer. In addition to the traditional reasons for them—protection against client failure to perform, sign of good faith, and confirmation of a contract—the advance is essential if you are to meet the considerable expenses of a location shoot. In fact, I generally ask for an advance to cover my full projection of the expenses I will incur. Since the form for an advance invoice can be relatively simple, I generally prepare one for the planning sessions. If this is not convenient, I will fax or express-mail an invoice (some organizations will not accept faxed invoices, insisting on originals only). This document is too important

to risk losing in the mails, and express-mailing it indicates the importance you attach to its speedy submission. Ideally, the advance bill should be made payable upon receipt, but in reality large organizations often require several weeks to have the invoice processed and the check cut. But at least the advance money will be in the works and should arrive in time to meet your first round of credit card statements. I have never encountered a major organization that flatly refused an advance on principle and doubt that I would work for one that did.

Combining Assignments

Piggybacking several clients for a shoot is sometimes a way to make an expensive location shoot that could not be afforded by a single client possible. I don't relish the plan for a number of reasons. It is difficult to concentrate on the needs of two different clients at one time. Multiple assignments may involve a variety of different equipment and film stocks that are unnecessary for one client. Inevitably, the needs of the clients conflict, especially schedules. Clients do not want to hear that you cannot accommodate them on the road because of promises you have made to other clients.

However, if you are comfortable with serving two masters on the road, keep track in your client records of organizations that routinely need location work, particularly in remote locales. Learn which resources can direct you to locations where potential clients do business so that you can solicit new sources. The World Trade Academy Press (212–697–4999), for example, publishes the names and addresses of American companies' facilities abroad as well as a directory of foreign firms operating in the United States. Above all, be sure to make it clear to everyone that you are piggybacking. Determine in advance how the expenses will be shared and scheduling conflicts will be resolved.

RESEARCHING YOUR DESTINATION

Clearly it is advantageous to know something about the area you are visiting and its culture. The extensive Country Files in this book provide excellent information, some of which is difficult or impossible to obtain elsewhere. Consult the sources mentioned below as well.

Organizations

The embassy or consulate of your destination: The addresses of each country's major embassies and consulates are in the Country Files; a complete listing of U.S. locations is available from the Government Printing Office (202–783–3238) in a publication from the State Department called *Foreign Consular Offices in the United States.* Check your local telephone directory to see if a consulate is available in your city.

The destination country's tourism offices: The addresses for tourism offices in the United States are in the Country Files, as is the location of the central tourism office in each country's capital.

Your travel agent.

State, local, and foreign film commissions: A resource commonly used by the motion-picture industry, film commissions are underused by still photographers. They are in business to promote work done in their areas. They are also an excellent source of information on hiring local talent and locating services of all kinds. Appendix 2 contains the directory of the Association of Film Commissioners. This list is updated semiannually. For the most current information, contact the Association of Film Commissioners, 5820 Wilshire Boulevard, Los Angeles, CA 90036 (213–937–5514).

Books

Professional indexes for specific travel concerns are mentioned in related discussions later in this book. In addition, a plethora of general travel guides (the Michelin, Mobil, Baedeker, Fodor, Frommer, Fielding, Birnbaum, and Insight series, for example) are available at major bookstores.

You should also examine the literature of and about the culture you are visiting. An excellent bibliography is *The Traveler's Reading Guide*, edited by Maggy Simony (New York: Facts on File, 1987).

Stores specializing in travel books include:

Book Passage, San Francisco (415–927–0960)

The Complete Traveler, New York (212–685–9007)

Sandmeyer's Bookstore, Chicago (312–922–2104)

Travel Books Unlimited, Bethesda, Maryland (301–951–8533)

Traveller's Bookstore, New York (212–664–0995)

Mail-order travel specialists include:

Forsyth Travel Library (913–384–0496)

Wayfarer Books (319–355–3902)

Wide World Books and Maps (206–634–3453)

Three mail-order sources specializing in travel gadgets also carry books. Their catalogs are worth getting:

Le Travel Store (800–854–6677); call (619–544–0005) in California

The Travel Store (408–354–9909)

The Traveler's Checklist (203–364–0144)

Periodicals

In addition to your regular diet of travel subscriptions such as *National Geographic*, *Condé Nast Traveler*, and *Travel and Leisure*, you may want to look into the following newsletters, which offer information about particular locales as well as general travel tips and updates:

Frequent Flyer Magazine (800–323–3537); call (800–942–1888) in Illinois

International Travel News (916–457–3643)

Passport (312–332–3571)

Travel Smart (914–693–8300)

International League for Travelers' Affairs News (800–237–6615)

You might also want to refer to some trade publications that travel agents and professional travel managers use:

Travel Weekly (800–932–0017)

Corporate Travel (212–869–1300)

Business Travel News (516–562–5000)

One especially comprehensive publication is the *Weissmann Travel Report* (512–453–3719), a subscription service that provides regularly updated, three- to nineteen-page profiles on literally every country. It's not inexpensive, but it's well worth the cost for the heavy traveler.

The in-house newsletters and information sheets from organizations you may want to join can also be valuable. Several fine organizations offer special services to professional travelers, as well as representing their interests in such vital matters as flight safety, including:

International Airline Passengers Association (IAPA), P.O. Box 660074, Dallas, TX 75266-0074 (800–527–5888; 214–404–9980). Membership includes a subscription to an excellent magazine, *First Class*, which is packed with up-to-date information on air travel and issues. IAPA members are entitled to discounts at numerous participating service establishments. Colleagues have raved about their special luggage-tracking program that will assist you should an airline misplace your checked baggage.

Aviation Consumer Action Project, Box 19029, Washington, DC 20036. This non-profit consumer group founded by Ralph Nader in 1971 relies on the support of individual passengers. You might be interested in obtaining their excellent booklet, "Facts and Advice for Airline Passengers" (enclose $2.00).

The Aviation Safety Institute, Box 304, Worthington, OH 43085 (614-885-4242). Membership includes a subscription to their fine newsletter, *Monitor*, as well as access to a telephone service, FliteLine, that provides weather, air traffic, and other frequent-flyer information.

Flight Safety Foundation, 220 Wilson Blvd., Suite 500, Arlington, VA 22201-3306 (703-522-8300). Members receive periodic publications and copies of seminar proceedings.

Data Banks

As computers become as common as telephones, reliance on data banks, which are accessible via modems, will increase (see "High-tech Communications," later in this section). An excellent reference volume on subjects available in data banks is the *Directory of Online Databases*, published by Cuadra/Elsevier (52 Vanderbilt Avenue, New York, NY 10017).

A few of the more common data banks that you might find of interest are listed below:

CompuServe (800-848-8199; call 614-457-0802 in Ohio) carries three major flight reservation services: the *Official Airline Guide*, *Travelshopper*, and *Eaasy Sabre* (American Airline's system); a hotel information guide featuring 28,000 establishments; car rental information; travel planning; and a menu of State Department information services concerning visas, customs, country facts, and more. The State Department's travel advisory service (see "General Security Conditions," later in this section) is also online. CompuServe has a number of features just for photographers, including a photographers' forum, as well as a wide range of other information services too numerous to list here.

The Source (800-336-3366; call 703-734-7500 in northern and western Virginia) also carries the *Official Airline Guide*, as well as the *Mobil Hotel and Restaurant Guides* and the *ABC Online Travel Service*, which allows you to research 24,000 hotels by keywords, such as tennis, or water sports, as well as a large menu of general information services.

Newsnet (800-345-1301) is a premium database for news services of all kinds, including extensive business news. It also carries online several publications discussed elsewhere in this book, including the *Travelwriter Marketletter* (see "Promotional Assistance," later in this section) and the *International Travel Warning Service*.

Photonet (800–368–6638) offers a broad range of electronic information services as well as daily photo requests from buyers and the opportunity for photographers to advertise their stock collections and travel itineraries. An electronic mailing list called Creative Strategies is also part of the program.

Photosource International (715–248–3800) includes various electronic and hardcopy publications about the current needs of photographic buyers as well as general issues affecting the industry.

Maps

Graham Greene wrote a wonderful travel memoir called "Journey without Maps." This approach is not recommended for the working photographer. A very fine volume for those interested in complete details on map sources is *The Map Catalog*, edited by Joel Makower (New York: Vintage Books, 1986).

Photojournalists or those carrying out specialized commercial work may want a full complement of political, historical, economic, topological, or aerial maps like those outlined in *The Map Catalog*. Most of us, however, simply need a good boundary or road map. For convenience, some simple boundary maps are included in appendix 1. Briefly, the best other sources are as follows:

National tourism offices, listed in the Country Files.

The Government Printing Office (202–783–3238) and the National Technical Information Service (703–487–4650) for a variety of maps issued by a number of federal agencies. Maps produced by the CIA can be particularly valuable.

The American Automobile Association offers members access to an excellent variety of maps, including their individually prepared Triptiks. Contact your local automobile club.

Commercial sources include:

American Map Corporation (718–784–0055)

Frequent Traveler State and City Atlas (800–227–7346; call 800–321–0372 in California)

General Drafting Company (800–367–6277)

Hammond Inc. (201–763–6000)

Hippocrene Books (212–685–4371)

Michelin Guides and Maps (803–599–0850)

National Geographic Society, NW Washington, DC 20036

Prentice Hall Press—Baedeker/Shell maps (800–223–2348)

Rand McNally (800–323–1887; call 312–673–9100 in Illinois)

Several of these sources also publish fine full-size atlases. In addition, consider the *Times Atlas of the World* (New York: Times Books, 1985). You might also want to carry a color pocket atlas. The *Van Nostrand Pocket Atlas* (New York: Van Nostrand Reinhold, 1983) is a good choice, as is the *Bartholomew Mini World Atlas* (Edinburgh, Scotland: J. Bartholomew, 1987), which has a leather cover.

In addition to the stores specializing in travel books listed earlier under "Books," a list of special map stores is available from the International Map Dealers Association (815–939–4627).

Cross-cultural Understanding

A faulty understanding of the culture in the area you will visit is an open invitation for misadventure. Societies vary in profound and subtle ways. Comprehending the perplexing nuances that distinguish the peoples of the world is a lifetime effort. Consult the following:

The David M. Kennedy Center for International Studies, Brigham Young University, 280 HRCB, Provo, UT 84602 (801–378–6528), has a series of excellent publications.

Going International, by Lennie Copeland and Lewis Griggs (New York: Random House, 1985) is a basic primer on conducting business internationally.

Edward T. Hall has written a number of popular books, including *Beyond Culture, The Dance of Life, The Hidden Dimension,* and *The Silent Language,* all published by Doubleday.

Interacts and *Updates* are publications of The Intercultural Press, P.O. Box 768, Yarmouth, ME 04096, concerned with practical business and cultural information.

Visual Anthropology, by John Collier, Jr., and Malcolm Collier (Albuquerque: University of New Mexico Press, 1986) is an insightful analysis of how human behavior reveals itself in photographs.

The Country Files include brief comments on individual culture as well.

Although it is impossible to define the various cultures of the world in one book without stereotyping, some general differences between American mores and those of other cultures can be identified. Perceptions of time, priorities, physical space, the role of the individual, and a host of other issues vary enormously throughout the world. For example, once, when I asked my driver in the Philippines to meet me at 8 A.M., he asked me if this meant American time or Filipino time.

Hospitality rituals such as having coffee or making small talk are not insignificant gestures, especially in cultures where business hinges on a complex network of personal relationships. Be a good guest, and know the proper forms of reciprocation. Refusing coffee from a Cypriot, for example, is nothing less than a rude insult.

Public displays of affection between men and women are frowned upon in many

cultures. Physical contact between men in areas such as the Middle East, southern Europe, and Latin America is more common than in the United States.

Americans tend to use first names far more casually than do other peoples. Know the proper forms of address and correct titles. Respect social and business hierarchies even if they seem "undemocratic" to you. Exchanging business cards in most cultures is a formal transaction. Have plenty of cards with you, and exchange them with care and respect. Know when to present them with both hands, for example, and never flip them across the table.

Be polite, be discreet, be respectful. Be sensitive to dignity. An unpleasant situation that might cause an American bemused embarrassment can be a profound humiliation to individuals abroad. Many Asian cultures consider "face" among the most valuable possessions a human can have, a common birthright of both the simplest peasant and highest-born aristocrat. Asians place enormous emphasis on saving "face" and allowing it to others. Show respect for your own "face." Failing to do so will cause you to lose respect and will create difficulties for your foreign contacts, who will be shamed as well. Moreover, remember that displaying respect and understanding of other cultures does not require you to denigrate your own.

"Yes" is "no" and "no" is "yes" in some cultures. In Japan or Korea, for example, it is rude to say no directly, and your hosts there may seem to be acquiescing to a suggestion when they are merely being polite. Similarly, social graces in some countries may force an individual to reject a proposal when it is really quite welcome.

Individuals may understand less English than it seems. Use simple words and avoid slang and complex sentences, but be careful not to patronize. Speak in a normal tone. Some English words that may be neutral or complimentary to you have negative or insulting connotations abroad. For complicated or important discussions, arrange for a translator. Learn at least a few words of the host's language. Body language may be very meaningful in other cultures. Avoid embarrassing gestures or postures. Showing the soles of your shoes can be extremely rude in the Middle East; passing food with the left hand, grossly crude in parts of Asia. Offering a tip in Iceland will only make the recipient uncomfortable.

Accept the fact that there are subtleties that you will never understand permeating foreign cultures, and intimacies you will never be able to achieve. Recognize that as a photographer on the go you will always be struggling to strike a balance between cultural considerations and the urgent requirements of your assignment. Be firm and tactful in evading difficulties such as ceremonies that would irreparably upset your shooting schedule, local foods that might compromise your health, and arrangements that might violate your equipment's security.

Promotional Assistance

For those of you who are not on assignment but are photographing for stock or speculative features, keep in mind that you can often get considerable financial assistance from countries or organizations whose interests coincide with yours. Tourism

offices have been known to provide first-class air fare, deluxe hotels, meals, cars, drivers, guides—the works. Countries with large per-capita tourist industries are more likely to have budgets for visiting photographers. It never hurts to ask.

Although I would never accept assistance if I were carrying out hard political or social coverage, being sponsored for generic stock and soft features is not unprofessional as long as editors know you have traveled in this way. Be aware, however, that several major publications will *not* accept material from trips on which you received such support.

One excellent way to keep abreast of these invitations as well as other opportunities in the travel publishing market is to subscribe to the excellent *Travelwriter Marketletter*, edited by Robert Scott Milne (212–759–6744). It is also available online from Newsnet (see "Data Banks" earlier in this section). You might also want to consider membership, which is by invitation only, in the Society of American Travel Writers, 1155 Connecticut Avenue NW, no. 500, Washington, DC 20036 (202–429–6639). The Commerce Department's individual-country *Overseas Business Reports* list important organizations in the back and often include a country's trade development or promotion bureau.

Weather Forecasting

In addition to local radio and television, you might consider using a ham radio or special weather radio that continually broadcasts local weather conditions. We have the weather station tuned to one of the preset channels of our walkie-talkies and refer to it often.

You can also turn to outside services. Data banks, such as those described earlier in this section, credit card companies (see the discussion later in this section), and other organizations provide their subscribers with weather information. American Express is test marketing a nationwide weather number that can be accessed by cardmembers and non-cardmembers alike. WeatherTrak is an easy-to-use computerized telephone service that supplies the current weather conditions and next-day forecast for about 500 domestic and foreign cities. There is a nominal per minute cost for a call to: 1–900–370–8728. For a complete list of the cities covered, send a self-addressed, stamped envelope to: Cities, P.O. Box 7000, Dallas, TX 75209.

Certified Consulting Meteorologists offer customized service for photographers. They can tailor their level of service regarding frequency of reports, specific weather conditions, pinpoint locations, and other factors to your needs. A complete list of Certified Consulting Meteorologists is available from the American Meteorological Society, 45 Beacon Street, Boston, MA 02108 (617–227–2425). The list is sorted in order of seniority in the weather-consulting business. You might want to check which firms have experience with media clientele and, if you need it, which specialize in international forecasting. One New York service with a great deal of experience in the film and photographic fields is Compu-Weather, Inc. (718–939–6000).

PASSPORTS, VISAS, AND CUSTOMS

Passports

If you have never been issued a passport in your own name, you must apply in person to one of the following:

- A passport agent
- A state or federal court clerk or judge who accepts applications
- A designated postal employee at a post office that accepts applications
- A U.S. diplomatic or consular office abroad

If you are a native citizen, you must show your birth certificate to prove citizenship; if a naturalized citizen, a naturalization certificate. You must also submit two identical 2-by-2-inch photographs that are fairly recent and can satisfactorily identify you. There is a fee for the passport as well as for processing the application. The passport is valid for ten years.

To renew a passport, you can complete a passport-by-mail application and send it, along with your previous passport, two recent identical photos, and the passport fee, to the nearest passport agency. You will receive your new passport in a few weeks. If you cannot risk being without a passport for that long, renew in person— you can use your previous passport as proof of citizenship.

Remember that during busy holiday seasons you may have to wait several hours to get a passport in person, so plan ahead. If you expect to do a lot of traveling, you may ask for a larger forty-eight-page version. If you run out of visa pages, additional pages can be inserted by bringing your passport to one of the U.S. passport agencies. If you are planning travel to countries such as Israel or South Africa, you may want to apply for a special second passport for use in those countries, since their mention in your passport visa section may create difficulties for you elsewhere. Call 202–647–0518 or your nearest passport office for further details.

Visas

A visa, usually entered into your passport by a representative of the country you plan to visit, indicates that you are permitted to enter that country for a certain purpose and length of time. Be sure to check the latest in visa requirements, especially since you may need a special commercial or business visa. Photojournalists may also be required to obtain special permission to enter some countries. This can often be a time-consuming and frustrating experience, and clearly many photojournalists who travel with little equipment pass through borders as "tourists." Only you can determine how to proceed in this regard. Bear in mind, however, that in some countries individuals entering without proper visas will be put on the next plane out, no matter where it is destined, or may even be arrested. The Country Files contain the official visa requirements for commercial photographers and photo-

journalists as they were outlined to me in calls to the consulates and embassies at the time of writing.

You may want to use private visa agencies to help you. They can save you time and regularly deal with the various New York and Washington embassies and consuls:

Travel Agenda (212–265–7887)

Travisa (202–463–6166)

Visa Center, Inc. (212–986–0924)

Remember that your passport can be submitted to only one foreign representative at a time, so plan ahead. If there is simply no time to collect all your visas before you leave, it is possible to acquire some of them along the way, but be sure that the countries at the end of your trip have consular representation in the first countries you will be visiting and have work hours and processing times that will not delay your schedule. If you may someday visit important countries that issue long-term visas, it might be wise to explore applying for one even if you have no immediate plans to visit.

Customs

International customs can cause some of the most vexing problems for the location photographer. If you are carrying more than one or two cameras and a few lenses, you will most likely have to make arrangements for the temporary importation of your equipment into a foreign country. The concern of the country you are visiting is that you will sell the equipment there for a profit and avoid importation and sales duties. In effect, the country wants some form of guarantee should you leave the country without the gear you brought in.

For your convenience, the Country Files include the customs requirements of each country as stated by their consular officials at the time of this writing. Be aware that these policies change and have, in some cases, been arbitrarily stated by the particular officials consulted. It is highly recommended that you make your own inquiries before you leave.

In some cases, either because of bureaucracy or a subtle attempt to keep foreign professional photographers out of the country, the requirements for temporarily importing equipment are so onerous as to make your trip impossible. In these cases, the only solution may be to enter as a tourist and hope for the best. Only you can make this judgment.

CARNETS

A Carnet is a special customs document designed to simplify and streamline customs procedures. The Carnet is accepted by customs officials in participating countries

as a guarantee that all duties and excise taxes will be paid in the event that you exit that country without the gear you brought in. Participating countries include:

Australia	Greece	Poland
Austria	Hong Kong	Portugal
Belgium	Hungary	Romania
Bulgaria	Iceland	Singapore
Canada	Iran	South Africa
Canary Islands	Ireland	South Korea
Côte d'lvoire	Israel	Spain
Cyprus	Italy	Sweden
Czechoslovakia	Japan	Switzerland
Denmark	Luxembourg	Turkey
Finland	The Netherlands	United Kingdom
France	New Zealand	United States
Germany	Norway	Yugoslavia

Complete information and application forms are available from the U.S. Council for International Business at the following addresses:

New York: 1212 Avenue of the Americas, New York, NY 10036 (212–354–4480); telex 14-8361 NYK

Illinois: 1930 Thoreau Drive, Suite 101, Schaumburg, IL 60173 (312–490–9696)

Los Angeles: 3345 Wilshire Boulevard, Los Angeles, CA 90010 (213–386–0767)

San Francisco: 353 Sacramento Street, Suite 300, San Francisco, CA 94111 (415–956–3356)

Houston: 5300 Memorial Drive, Suite 460, Houston, TX 77007 (713–869–5693)

Boston: 21 Custom House Street, Boston, MA 02210 (617–737–3266)

Miami: 8725 NW, 18 Terrace, Suite 402, Miami, FL 33172 (305–592–6929)

Acquiring a Carnet will require at least five days for processing time. You must provide a fully itemized listing of your equipment, typed on the Carnet form. There is an issuing fee of up to $150, and you must put up security in the amount of 40 percent of the total value of your equipment in the form of a certified check or, as I recommend, an insurance bond. These are available from Roanoke International,

39 Broadway, Suite 1915, New York, NY 10006 (212–747–1800). Another Carnet-issuing office is at Roanoke, and you can have the Carnet processed there at the same time.

I strongly urge you to get a Carnet. Beyond the minor costs of the issuing fees and insurance bond, the only inconvenience in using the Carnet is that you will have to arrange for U.S. Customs to examine your equipment and initialize your documents every time you leave for a trip abroad. Obviously, this requires a bit more effort and time, but customs officials are efficient in this procedure, and it is a small price to pay for the knowledge that your entry into the participating countries will be considerably expedited.

COUNTRIES NOT PARTY TO THE CARNET CONVENTION

If a bond or professional help is necessary for a non-Carnet country with stringent requirements, contact a good customs broker with a wide network of offices and affiliates, such as the Meyers Group (718–656–2090). In some instances, you may have to provide a Temporary Importation Bond (TIB), either for presentation here or upon arrival.

In many cases your equipment can be imported without special bonds or financial guarantees as long as you can produce a detailed manifest of your equipment. It should include each item accompanied by its serial number and value. Having this document in a computer will make this chore much easier. You will be able to tailor the list for the itinerary of each trip in minutes, rather than crossing off items from a master list. Although crossing off items is the accepted procedure for adjusting the Carnet, it may arouse suspicions on the less official documents you may be using in non-Carnet countries.

Often you will have to register this list with a consular office here. Sometimes they will forward this list to officials in the foreign country; sometimes they will simply notarize it for you to carry with you. You may have to pay a small fee for this transaction.

When you arrive in the foreign country, if you are asked to produce your documentation, do so. Be sure to make several photocopies so that you can leave one with the officials at the point of entry and retain at least one for yourself. If you are whisked through customs without being asked for documents, do *not* volunteer unofficial paperwork.

Most important, be prepared to produce the documents and all equipment you brought into the country when you leave. You may well be asked to produce both. If all the equipment is there, you should be able to leave without difficulty. Any financial guarantees you have made should be returned or canceled. Be aware that some customs officials are corrupt and will expect a personal "customs duty" for the removal of your equipment. Forewarned is forearmed (see "Bribery Abroad" in section 2).

Upon departing a country where you have not posted a bond, it is still a good idea to complete the file on that importation, even if you have not been asked to.

Again, the information you receive from the consulate here in the United States

may be arbitrary or at variance with the importation requirements as understood by the officials at the border. Even so, the fact that you have gone to the trouble of getting some semblance of paperwork from someone in an official capacity here will often satisfy an honest local official.

Should you air-freight any of your equipment home ahead of you, be sure to have the gear eliminated from your manifest by customs officials. If the gear is stolen or lost during your visit, be sure to report it to the local police immediately and get copies of all the reports. You may still have some explaining to do at the border and may still be responsible for the taxes, however.

If for any reason you are unable to make advance arrangements for the importation of your equipment, you can at least fall back on the printed equipment list you always carry in your document bag. Often I have convinced the local customs official to accept it unnotarized. I find that the simple fact that I have such an exhaustively detailed document and have gone to the trouble of making a copy for the official to keep is indication of good faith.

Whenever you are traveling on behalf of a corporation or major news organization, be sure to inquire if they are willing to handle your customs problems. Many organizations with a foreign presence have employees hired just for this purpose or at least have access to local customs brokers who are expert at arranging fees and registration of your documentation.

Above all, be sure to have plenty of resources available should you be required to post some kind of financial guarantee in the absence of more formal documents.

U.S. CUSTOMS

Upon your return to the United States you will, of course, have to prove that all the equipment of foreign manufacture in your inventory (almost all these days) was not purchased abroad on this trip. It must be demonstrated that you either purchased it in the United States or have already paid the importation duties if you purchased the gear on a previous trip abroad. You can do this by registering the equipment with U.S. Customs before leaving the country with it for the first time. Simply bring the gear to the nearest customs office in your locality or at the airport of your departure (I recommend the former). The officials there will examine the equipment and enter the items on a registration form. Carry this document with you at all times when traveling abroad, and be sure to have it revised or updated as you change equipment or add to your inventory. If you do not want to run to customs every time you add a lens or flash unit, at least carry a copy of the bill of sale or importation duty receipt with you.

Incidentally, on several trips back to the United States through Kennedy Airport, I have been told that my forms were only good for "one time use" or that the form was only good for one year. This is *not* so. Customs officials in Washington have absolutely assured me that registration forms are good indefinitely for as many trips back and forth as you desire. Once you have produced the equipment for examination in the United States, this procedure does not need to be repeated.

TRAVEL ARRANGEMENTS
Travel Agents

In this era of computerized airline reservations, photographers who prefer to make their own travel arrangements can do so. However, while it is important for photographers to be able to fend for themselves when last-minute changes become necessary on the road, use a first-class travel agent. Why not have the benefit of an expert, especially when the commissions are paid by the airlines and hotels?

When shopping for an agent, look for one who specializes in individual business travel, rather than holiday packages for tourists. He or she should have clout with airlines and hotels, to squeeze out the last seat on a "sold-out" flight or the last room in an overbooked hotel. Do not be swayed by grandiose promises, however—your agent should be frank about areas of influence and expertise that are not his or her strong suit.

The agent's office should be close enough to your office to deliver last-minute tickets and documents to you quickly (although the industry is now experimenting with using fax machines to transmit tickets to customers). Airline tickets can be left for you at the airline ticket counter (which is how telephone ticket services often function), but I like to have my paperwork well in hand before I leave for the airport.

Check to be sure the agent's office hours suit your needs. Some business travel specialists maintain only 9-to-5 weekday hours, whereas the photographer often needs the agent's services on weekends.

Membership in ASTA, the American Society of Travel Agents (P.O Box 23992, Washington, DC 20026–3992, 703–739–ASTA) indicates proper training, ethical practice, and a commitment to the field. Feel free to verify the agent's status with ASTA's membership department. ASTA also maintains a consumer affairs department to assist you if you have a service complaint that cannot be resolved directly. Write for their booklet, "Avoiding Travel Problems," for details.

Along these same lines, the agent should have the title CTC, Certified Travel Counselor, which indicates he or she has earned a specialist's degree after hours of advanced study. And, of course, be sure he or she has a clean record with the local Better Business Bureau or Chamber of Commerce and a track record of many years of experience. Recommendations from other photographers are especially valuable.

A photographer's often changing schedule can vex the most veteran agent; be sure the one you choose is willing and able to put up with the headaches. (I have had to ask my superb agent, Agnes Warburton of Travel People in New York, 212–675–6566, to change my plans half a dozen times in a day.) He or she should also be happy to book travel arrangements that do not provide commissions.

Individual attention is important, and your agent should work with you personally whenever possible. At the same time, the agency should have knowledgeable back-up personnel who can service your account when your regular agent is absent. Your agent should keep a permanent file of your individual records that includes reach numbers and delivery instructions; credit card numbers; frequent flyer numbers;

list of preferred airlines, hotels, and rental car companies; special requirements for airline seating and hotel room comforts and security; and special health or dietary concerns.

Special services, such as long-distance communication or cancellation, sometimes cost extra. Your agent should always inform you of any add-on fees. Some may also want deposits before making certain travel arrangements.

With the complexity of today's ticket and reservations systems it is imperative that the agency has the latest in technological tools: powerful computers, an ample and sophisticated telephone system, fax or telex machines.

To assist the travel agent in providing better service, the photographer should recognize that the agent is human and capable of clerical errors. Learn how to read your travel documents (see figure 1, later in this section), and check the paperwork when you receive it. Ask for written confirmation of all reservations made on your behalf.

Give as much background information as possible about your needs and preferences in an organized fashion at the beginning of the relationship. Be as specific about your current itinerary as possible and, if there is time, transmit a complicated itinerary to the agent *in writing*. Keep your agent informed of changes in your plans as soon as you are aware of them.

Be willing and able to arrange simple travel changes on the road without calling on the agent (such as changing to a later flight for the same destination on the same airline).

A top business travel agent leads a hectic life. Ask agents if they have any particular hours or days that are slower and try to discuss less essential items at those times.

Airline Reservations

CHOOSING A FLIGHT

When possible, choose a direct flight, even if it is on a less favored airline or at a less convenient time. The "hub-and-spoke" system of domestic air transport has resulted in far fewer direct flights, as carriers route their planes through their hub cities. This is more convenient for the airline but less convenient for the traveler. Every time you change planes, you are also increasing the possibility of having to surrender your carry-on baggage to a ground supervisor who feels you are overloaded. You are also greatly increasing the risk of losing your checked luggage.

For the same reasons, try to fly on the same carrier if you must change planes. The chances of losing your luggage increase when you fly on more than one carrier (called interlining). In fact, the transfer of luggage from one carrier to another at an airport is often subcontracted to an independent baggage-handling agent, who frequently pays lower wages than the airlines.

Consider the overall record of an airline. You can request a copy of the latest monthly issue of the Department of Transportation's *Air Travel Consumer Report*, which tracks individual airline performance in such areas as lost baggage, safety,

flight delay, overbooking, number of consumer complaints, and on-time perfor-mance. Individually requested copies are free, and the agency is exploring the possi-bility of a paid subscription service. Summaries of the reports are reproduced in some of the newsletters listed in this book as well as by many newspapers and other media. To obtain a copy, write to: Office of Community and Consumer Affairs, U.S. Department of Transportation, 400 Seventh Street S.W., Room 10405, Wash-ington, DC 20590 (202–366–2220).

Learn a particular airline's policies on issues important to you, such as carry-on baggage allowances, lost-ticket procedures, and cancellation policies. Full details of these policies are in the carrier's Conditions of Contract, available on request. Con-sult your colleagues about their experiences with the carrier as well.

The type of aircraft a carrier flying to your destination employs might also affect your choice of flight. Obviously, aircraft with more storage area and bigger seats are desirable (see "Choosing a Seat," later in this section).

Your personal relationship with the airline will also play a role. Airlines are aware of some of their frequent and favored customers. As an important commercial or editorial photographer, you may qualify as a VIP who receives especially good ser-vice and may well be the first one "bumped up" into first class in the event that you are in an overbooked economy- or business-class section. Bear in mind that VIP status is not given lightly, so don't request it for routine travel, and expect to explain why it is necessary.

Try to resist the temptation to book flights based on the comparative riches of the airline's frequent-flyer program, but those of you who are frequent-flyer aficionados should know there is now a computer program to help you keep track: Frequent Flyer Award Trakker, C&H Enterprises (818–703–8944). You might also want to keep all your numbers on a laminated pocket card so that they are always available for confirmation at the check-in counter.

For those of you who want to make your own reservations or want to be prepared should a last-minute booking be necessary while on the road, an excellent resource is the *Official Airlines Guide*, or OAG (800–323–3537; call 800–942–1888 in Illinois). Abridged pocket editions of their domestic and worldwide reference versions are available that include schedules and even reservation numbers. You may also choose the *ABC Executive Flight Planner* (617–262–5000) or the *American Express Sky Guide*, for cardmembers (800–528–4800; call 212–477–5700 in New York). For pho-tographers traveling with a computer modem, the OAG is also available from popu-lar on-line data banks such as CompuServe and the Source.

Of course, the airline on which you have your original booking should be able to help you with flight changes, but they are not always unbiased in their recommenda-tions, eager as they are to keep you on their planes. They will not always give you all your alternatives, particularly the more creative ones. To assist you with your reservations, toll-free numbers for all the major carriers appear in appendix 3.

If you need a helicopter nationwide, either for photographing or to charter for local transportation, there is now an excellent computerized booking service that also offers auxiliary services such as limousines, charter aircraft, security personnel,

and catering: Helinet International (800–662–6886), David L. Harmon, III, president.

CHOOSING A CLASS AND FARE

Clearly, if the budget is available, first class is the first choice. My preference for it has less to do with amenities—I generally don't eat the food on airlines anyway (see "Health Suggestions for Plane Trips," in section 2)—than the fact that first-class attendants will always try to accommodate my carry-on luggage, even when the allowances are nominally the same for all classes. In this regard, my client is buying extra production "insurance." And, if it is an overnight flight with a shooting scheduled the next day, the opportunity to sleep may provide dividends in productivity worth the extra expense. However, on certain international routes, coach/economy sections can be far less crowded than first class, and if you can find a few empty seats together, you can have a better bed than a first-class recliner.

Business class is usually an excellent value. On some international routes, it is only a pittance more than coach. It is roomier, provides better service than coach, insulates you from crying infants and, if you want privacy, talkative tourists. Booking business class does not usually offend corporate accountants and budget managers who are used to seeing executives fly this way—you will avoid uncomfortable suggestions of extravagance. Unfortunately, business class, while still commonly available on international flights, is becoming a thing of the past for domestic routes. In any event, always have your travel agent cost out the business- and first-class tickets when planning your itinerary. A number of airlines offer the upgraded class at prices that are not much higher than full standard coach fares.

More often than not, you will find yourself flying coach. Since deregulation, there can be enormous differences in the cost of a coach ticket for the same seat on an airliner. Fare structures are infuriatingly complicated, and it is entirely possible that three different travel agents will get three different quotes on the same day for the same flight. If your travel can be planned in advance and you are unlikely to change plans, you can save your clients considerable money by booking discounted seats early on. However, if your itinerary is likely to change, be sure not to book any tickets that would incur penalties exceeding the cost of a full-fare coach ticket or with other restrictions such as "black-out" days. My travel agent always puts me on the flight with a cheaper fare first. If we have to change plans, I don't mind paying the difference, but I don't want to risk a penalty that cannot be recovered or a ticket that cannot be converted. I will not, however, choose a less expensive flight that hampers my schedule or involves a complication, such as an unnecessary change of plane.

One possibility you might consider is flying into a secondary airport, which can result in considerable savings and may not be farther from the location of your shoot. You may also want to consider a budget airline that routinely offers lower fares for fewer amenities, but be sure that they have interlining agreements with other carriers so that their tickets will be accepted in case you have to change plans, and that they

do not follow practices such as high rates of overbooking that might prevent your departure. For these reasons, I only used the now defunct People's Express on routes where there was little other choice (such as Miami to Costa Rica).

If you have a number of international locations on your itinerary, ask about an around-the-world ticket. If the cities on your list can be configured as stopovers with this fare, there may be a healthy savings over a back-and-forth round-trip ticket, particularly for first and business class.

CHOOSING A SEAT

Storage and seating configurations are usually customized by the individual airlines, and scores of different combinations exist. If you want more complete information, Carlson Publishing (P.O. Box 888, Los Alamitos, CA 90720) issues the *Airline Seating Guide* quarterly in two separate editions, one for U.S. airlines and one for overseas carriers. Each contains clear and precise seating plans that indicate number of seats across, location of storage closets and service areas, which seats recline, where the smoking and nonsmoking sections divide (this can change since airlines are required by the government to provide nonsmoking seats to all who have reserved one). Airlines and travel agents can provide you with these plans, but it is more convenient to have them collected in one volume. You may also want to subscribe to their excellent newsletter, *Airline Passenger Services*, which chronicles developments in passenger service and amenities.

The statistics on which seat is the most or least safe in the event of a crash are inconclusive (see "Airline Difficulties," in section 2). I look for a seat that facilitates the security and easy transfer of my equipment, rather than my comfort. For this reason I do not select the first seat in a section. Although they offer more leg room, these seats are also less private. Seats in the rear of the plane are generally less crowded and the first to board, but this is also the smoking section, and I will have to haul my carry-ons that much farther. Overhead bins in the back are also sometimes smaller on craft that taper toward the rear. If you like to sleep in your seat, it is usually best to avoid the very last row, as these seats often do not recline. I generally compromise by booking the middle of the plane.

If you are traveling with a companion, book an aisle and window seat, leaving the less desirable middle seat free. Middle seats tend to be booked last, and you will often find yourselves with all three seats. Lift the armrests, and the two of you will have plenty of elbow room. If someone has purchased the middle seat and you and your companion have business to discuss, you can almost always trade seats—the middle passenger rarely declines the chance to swap for an aisle or window.

EXAMINING YOUR TICKET

Be sure to examine your airline tickets carefully, even if issued by a travel agent. Figure 1 illustrates facsimiles of the most common ticket types, with a brief explanation of the more relevant entries.

A completed transitional automated ticket

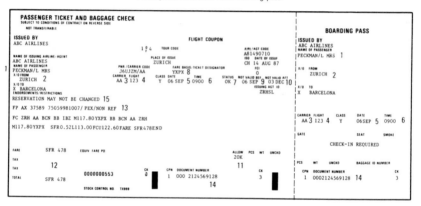

A completed automated ticket/boarding pass

A completed manually issued ticket

Figure 1. Comparison of the *(a)* transitional automated ticket (TAT) and *(b)* automated ticket/boarding pass (ATB) with *(c)* the manually issued ticket. (From the *Ticketing Handbook*, © International Air Transport Association, Montreal, Quebec, Canada)

1. Passenger's surname (family name), followed by an oblique and initials, and/or title.

2. Itinerary. If an X precedes the city name in the "X/O" column, it means that no stopover is allowed. Cities served by more than one airport should show the appropriate airport of arrival or departure with a slash after the city name. Unused boxes on the ticket may have *void* written across them, as will those legs of the journey not traveled by air. (Your ticket may well list your entire inventory, including portions traveled over land.)

3. Two-letter designator of your airline. See appendix 3 for a list of two-letter codes for all the major carriers.

4. Flight number followed by class of service. Class of service codes are:

R	Supersonic
P	First-class premium
F	First class
J	Business-class premium
C	Business class
Y	Economy class
M	Economy/tourist class
K	Thrift

5. Date of departure in numerals followed by the first three letters of the month, for example, 05MAR.

6. Local departure time based on the 24-hour clock, or expressed as A, P, N, M for A.M., P.M., noon, or midnight.

7. Status of your reservation at the time the ticket is issued. This is very important:

OK	Space confirmed.
RQ	Space requested but not confirmed, or space wait-listed.
SA	Subject to space being available, whenever fare or rule prohibits making advance reservations.

 If you are holding a reservation but have requested wait-listing or are wait-listed for another flight or different class of service, the status box will indicate your current reservation, while your request will be indicated in the "Endorsements/ Restrictions" box.

8. Fare basis. There isn't room for all the possible codes here, but be aware of a few important ones:

W	Weekend travel only			
X	Weekday travel only	OX	Excursion one-way fare	
N	Night flight	OW	One-way (single)	
AP	Advanced purchase fare	PX	Pex fare	
AB	Advanced purchase fare (lower level)	RP	Regular passenger fare	
B	Budget fare	RT	Round trip (return)	
BD	Budget discounted	RW	Round the world	
BP	Bonus program (frequent-flyer scheme)	S	Super-saver fare	
D	Discounted	SX	Super-pex fare	
E	Excursion	U	No advance reservation permitted, or standby	

9. Not Valid Before dates. Indicates if there are dates before which travel cannot be commenced or completed.

10. Not Valid After dates. Indicates expiration date of ticket. If there is no entry, the ticket is normally valid for one year.

11. Baggage allowance. Given in weight by kilograms. PC or no entry indicates the piece system.

12. Fare boxes showing fare in currency paid, taxes if any, and U.S. dollar equivalents.

13. Form of payment, indicating cash, credit card (a letter code with the account number), or other method. "NONREF" indicates a fare on which refunds may be restricted (see example).

14. Ticket number. This is important. If you have not photocopied your ticket or kept the rear coupon in a separate place, at least record this number.

15. Endorsements/restrictions. Observe this space. It will indicate such limitations as restricted refund, nonendorsable ticket (one that will not be accepted by another airline), requested or wait-listed rather than confirmed flight, and other restrictions.

16. Date and place of issue. Very important, this must be completed with the issuing agent's (airline, travel agent) validation. All tickets must be properly validated. A ticket with this space blank would be void.

Hotel Reservations

As with airlines, many personal factors will affect your choice of accommodations. Dealing with hotels is examined more closely in section 2, but in making a reservation, consider:

Location: Is the hotel close to your shooting destination (always desirable) or to the airport if schedules are tight?

Rating: Check the professional indexes (listed below) as well as standard travel guides that rate hotels. Foreign establishments are often rated by their governments, which is a particularly stringent system, one that many travel agents rely on first.

Security: Has the hotel a good security record, a means of securing your equipment, and plenty of good-sized safety-deposit boxes for your exposed film and other small valuables?

Twenty-four-hour room service: Photographers arrive at strange hours and often leave well before sunrise. Schedules often allow little time for meal breaks, and nothing is more depressing than to arrive at your hotel after not eating all day only to find that the kitchen closed down at 10 P.M. Also, if you are not confident about security, you may need to dine in the room with your gear.

Good restaurants: Many nights we are so tired after a long shoot that we just want to get to sleep. A hotel whose restaurants are decent (in cities such as London or Rome, they are among the best restaurants in town) may save you a trek to an outside restaurant.

A first-rate concierge: These are hard to find in the States, particularly if you have enjoyed their services in the great hotels of Europe and Asia. Photographers often have offbeat needs for unusual locales, props, or vehicles. A true concierge is better equipped to deal with these requests than the average desk clerk. Some hotels now feature special executive sections with concierges assigned just for those floors. They cost about $15 to $30 a night more but are recommended not only for the personal service but because they often offer their own business communications equipment and may well be more secure, having private entrances and greater supervision.

High-tech communications and business facilities: The hotel's computers and fax services can be vital to photographers not carrying their own. Are translation or secretarial services available? Does the hotel provide modular telephones that will allow you to plug your modem in directly? Is the telephone system efficient, with modern touch-tone phones? Does the hotel subscribe to plans such as AT&T's Teleplan, or do they have enormous service charges for long-distance calls? A list of Teleplan hotels can be obtained by calling 800–874–4000.

Rooms with a view: Hotels with unusual views of the city might offer interesting photographic possibilities.

Recommendations: Do you know colleagues who have stayed in the hotel? In a city where your client has a facility, follow his or her advice. Clients' recommendations are generally reliable, they know where the hotel is if they have to meet you, and they know what to expect when they receive your expense account.

Some travel agents prefer smaller hotels over the large chains because the service is sometimes better and more personalized. I find that service is a function of the individual quality of the establishment. A really fine large hotel can treat you like royalty, and many excellent small hotels lack some of the services listed above. Always ask for the corporate rate or discounts available to organizations to which you belong, such as IAPA or AAA. Corporate rates can result in substantial savings, but they are not necessarily the cheapest. You may find that a special promotional offering by the hotel is even less than a corporate rate, so be sure to inquire about all possibilities. Also, if you are traveling for a large client, the corporate rate to which they are entitled will probably exceed yours as a small business. They may also receive a direct rate discounted by the sales commission normally paid to the travel agent. Obviously, you should not expect your travel agent to book this for you.

As a rule, choose the cheapest room in the best hotel if you are on a tight budget. The hotel's idea of their less valuable rooms may be quite different from yours, and the general amenities of the hotel are, of course, available to all. If you arrive late and all the less expensive rooms are occupied, you may well be upgraded to a more luxurious room at no extra charge.

Consider the new breed of all-suite hotels, particularly for long stays. If you like the comfort of having two separate rooms, you might want to consult *The All-Suite Hotel Guide,* by Pamela Lanier (P.O. Box 20429, Oakland, CA 94620-0429).

Again, your travel agent will be of great help in selecting a hotel, but if you want to do some of your own research, you may want to acquire one of the following professional references in addition to your library of travel guides:

Official Airline Guide Travel Planner/Hotel and Motel Redbook (800–323–3537; call 800–942–1888 in Illinois): The American Hotel and Motel Association's official directory.

Official Hotel and Resort Guide, or OHRG (800–932–0017): With five volumes updated six times a year, the OHRG is the most comprehensive and expensive reference. It provides extensive information on 26,000 facilities worldwide, including ratings, amenities, contact information, and maps of locations.

Hotel and Travel Index: From the publishers of the OHRG, this book provides more compact information on 40,000 establishments worldwide. In one volume, updated quarterly, it is less expensive than the OHRG.

Regardless of who books your hotel, be sure to get written confirmation from the travel agent or the hotel itself with a confirmation number, the dates of your stay, and the agreed-upon price. Photocopy these documents for inclusion in your emergency kit (see "Master List," at the end of this section).

Take advantage of the guaranteed reservation programs commonly available. American Express, for example, has its Assured Reservations program, which holds your room until you arrive, regardless of when. You have until 6 P.M. of the day of your arrival to cancel without penalty. When canceling, be sure to get the name of the clerk, so you can confirm the conversation should there be any problem with the paperwork. American Express has a CARDeposit program to provide funds for hotels requiring larger advance deposits to guarantee longer stays (see "Credit Cards and Charge Cards," later in this section).

Citicorp has a World Travel Payment plan, which allows you to charge your deposits to credit cards even if the hotel does not accept them.

There are a few alternatives to the large chain and big city hotels. One is to look into a bed-and-breakfast establishment. Increasingly popular, these small, sometimes family-run hotels often offer quaint rooms, charming locales, and a hearty breakfast featuring the local cuisine. You are probably not going to encounter fax machines and may have to climb some stairs with your gear. For a listing of B&Bs, contact the local Chamber of Commerce of the town you are visiting or write for a list of B&B agencies throughout the country: The Bed & Breakfast League, Ltd./ Sweet Dreams and Toast, Inc., P.O. Box 9490, Washington, DC 20016 (include $3.50). For recommendations on European B&Bs, consult *Europe's Wonderful Little Hotels and Inns*, edited by Hilary Rubinstein (New York: St. Martin's Press, 1988), which is updated annually.

Bear in mind that many small hotels and bed-and-breakfast inns do not pay commissions to travel agents, so your agent may be unwilling to book them, or is doing so as a courtesy.

You might also consider renting a villa or condo. This is not as extravagant as it may sound, particularly for the larger production on location for more than a few days. The per-person cost, particularly in the off-season, may be no more, or even less, than a series of single rooms in a good hotel. One agency specializing in these arrangements is At Home Abroad, Inc. (212–421–9165).

CHOOSING YOUR EQUIPMENT

Clearly, the choice of gear a photographer brings on the road varies enormously according to the demands of the assignment, the number of staff available, and the personal traveling tastes of the photographer. Decisions on what to bring are always a tug-of-war between the sensible desire to travel light and the nagging fear of being caught without an essential piece of equipment. Below is an extensive list of items that you may want to consider in addition to the obvious choices in standard camera bodies, lenses, and tripods. Flash units are discussed in a separate section.

Foul-weather camera: Such as Nikonos, or a less cherished body for inclement conditions.

Body with at least 1/250 synchronization: For shooting flash outdoors in bright light.

Special application cameras: Such as panoramic, high-speed, super-wide, underwater, or perspective-control models.

Close-up diopters: The camera manufacturers' brands are getting to be excellent, and they take up much less room than extension tubes and additional macro lenses. This item may soon become unnecessary, as contemporary normal lenses increasingly offer macro features as standard.

Flash meters.

Color meter.

Spot meter.

Hand-held ambient meter: Get one that reads out on a scale, such as the Luna Pro SBC, particularly if it has null zero metering. I find these provide more information for calculation than the digital readouts of flash meters.

Color filters for black-and-white photography: To balance gray renderings.

81 series filters, magenta 30CC filters, and polarizers in glass: These are the filters I use most often. In fact, for many color emulsions, I use an 81A as my standard filter. As soon as I am in shadow or the weather becomes overcast, the 81B, C, and Ds come out. They restore the skin tones and warm colors that are normally dulled in cooler light. The magentas combat the green tones of fluorescent light. I generally eschew the specially designed fluorescent filters in favor of my color meter's readings (usually a 30 magenta CC) amplified by the appropriate 81-series warming filter or 80-series cooling filter as indicated.

3-inch filter holders: Carrying glass filters of all types for all thread sizes of lens is unreasonable on the road. Hence, I carry a huge supply of either Kodak or Lee filters stacked by category (such as color compensating, neutral density, special effect), held with rubber bands. They, of course, need to be replaced frequently,

but in the long run this is a far more convenient and (considering that we rarely use many of these filters) economical approach.

Diffusing device: A subtle softening of the edges for a more painterly image is sometimes in order. For this, you may choose a commercially manufactured filter, the traditional nylon stocking (black mesh will generally produce better results than beige), or a diffuser you make yourself by pressing a clear glass filter against a black foam stamping pad.

Extra body and lens caps.

Tabletop and/or C-clamp-type tripod: This also serves as a "low-boy" for positioning flash heads on the ground or in tight spaces.

Right-angle or waist-level viewfinders.

Sports finder: Allows the eye to be held an inch or so away from the viewfinder; for use with industrial safety glasses.

Jeweler's tools: Including flat- and Phillips-head screwdrivers, tweezers, and a jeweler's loupe for inspecting equipment problems up close.

Folding pocket magnifier: For examining Polaroids.

Swiss army knife: Stow it in your checked luggage to avoid complications with airport security.

Multiple-wire outlet: To attach several camera bodies to the same sync cord at one time (also known as an Octopus; available at any hardware store).

Compass and a Sundicator (805–969–7280): A device with a series of calculator disks that predict the true point on the horizon of sunrise and sunset for the position and time of year of your location.

All-surface marking pens: Such as Sanford Sharpie.

Small pressure-sensitive labels.

Changing bag.

Camera brush, small blower, lens tissue and fluid; small eraser for cleaning contacts.

PC tip conditioner: To re-form both the collar and tip of the cord. This device will greatly increase the reliability of your cords, particularly the older gold-tipped models. Conditioners, cords, and other accessories are available from Lia Flash Mount Corporation (914–965–8401) and Paramount Cords and Brackets, Inc. (212–325–9100).

Multifunction calculator or watch: Carry some that can serve as alarm clocks (don't rely on hotel wake-up calls), calculators, money converters, stopwatches, and back timers for Polaroids, with dual time zones to keep track of the hour at home.

Bullhorn (or other voice amplification device): For large or noisy outdoor locations.

Velcro: A few feet always come in handy.

Reusable silica gel: For keeping gear dry in humid environments.

Pocket flashlights: The Mini Maglights (714–947–1006) are powerful, durable, compact, and have a spare bulb cleverly stored in the tail cap. The head can even be removed to provide a candle's worth of ambient glow.

Small French Flag: A small black card with a flexible arm, this small device shades the lens without necessitating a separate stand.

Conversion ring: To allow the use of glass 35mm filters on a Hasselblad.

Kenyon Gyro Stabilizer: From Ken-Lab Inc. (203–434–1619), for aerial photography or other situations not conducive to the use of a tripod.

Remote radio or infrared flash synchronizer: This is a crucial item since strobe units are often far from the camera in the field. Even in closer quarters, it is nice not to be tethered to the power packs when you want to circulate freely, and a remote synchronizer eliminates the possibility of tripping over the sync cord or having it pull the camera out of your hands when it has insufficient slack. Carry a spare setup with the same radio frequency so that the parts of the two sets are interchangeable, and so that one transmitter can set off two receivers when needed. Be sure that your batteries are fresh! These units are wonderful but can mis-sync in ways that are not apparent until too late when the batteries are not dispensing their full charge (see "Batteries and Chargers," later in this section). Try to use a traditional sync cord to conserve batteries and lessen the chance of a problem when conditions don't really require the remote sync.

FM walkie-talkies: These enable you to communicate with your staff during the many times you will be separated on location. They allow you to direct distant subjects without shouting and to speak in normal tones in noisy environments such as factories or trading floors. They provide extra security both in emergencies and as a deterrent to crime (thieves are not keen on victimizing individuals who look like they might be police or other officials).

Black water-resistant ground covers: Available from Porter Camera (800–553–2001), these approximately 2-by-3½-foot cloths allow you to put down gear on wet or dirty surfaces; they protect delicate surfaces such as boardroom conference tables from photographic equipment; they can fill in as a black flag or shade when needed. Rolled up, they also serve as protective partitions in packing cases (see "Packing Your Gear," later in this section).

Small pocket combs, mirrors, lint brushes, and a small makeup kit: Even fashion photographers with stylists on board carry a few basic items, such as powder, brush, hair spray, and the like. Corporate photographers also use them to repair

an odd oily or blotched complexion. (The small mirrors can also double as a means of imposing a spot highlight on small tabletops and, if handled shrewdly, can create a false reflection like that of a body of water when held just partway into the field of view of a lens.)

Pocket voltmeter: I am always surprised to learn how few location photographers carry this inexpensive marvel. A very useful digital version, the size of a pocket calculator, is available from Radio Shack. It serves at least four important functions:

* It indicates if an AC outlet is live.
* It reveals if the outlet is 110 or 220 (they are sometimes mismarked, an error that can destroy your equipment—see "AC-dependent Strobes," later in this section). Voltmeters also tell you if the current is irregular or toward the extreme end of the normal range, as is sometimes the case in industrial situations (for example, 250 volts in a 220-volt environment).
* It serves as a highly accurate battery tester, taking up less room than the devices normally used to check batteries in camera stores and providing readings to the millivolt, rather than simple "good" or "bad" readings.
* It tests the integrity of electric cables and PC cords, since it can read the electrical resistance (ohms) in any wire circuit.

Gaffer's tape: In a variety of colors. I favor the brighter colors (red or yellow) because I often use it to tape down cable strung on the ground, and I prefer that people notice it when they walk by. I don't agree that gray tape is preferable because it will not show up as dramatically if it appears accidentally somewhere in the image. The set should always be checked to be sure no extraneous items are in camera view, and if anything, the brighter colors make this check easier. I carry several colors because little bits of tape serve as handy color-coding devices for such things as camera bodies or film emulsion batches. I also carry filament tape for strapping items or to use as temporary "cable" with which to hang things, as well as double-edge tape if possible. If there is room, I also take brightly colored warning tape with the words "Warning: Exposed Film—Open in Darkroom Only" or "DO NOT X-RAY" (available from the Set Shop in New York, 212–929–4845, or Alan Gordon Enterprises in Los Angeles, 213–466–3561) to discourage airport security agents from opening boxes without supervision and because this distinctive tape provides an unmistakable visual cue for that most important possession, exposed footage (see "Packing Film," later in this section, and "Couriers," in section 2).

Film shield bags (or foil): From Sima products.

Plastic bags: I usually bring several types. Food storage bags (particularly the self-closing type) protect gear in bad weather. (A large one can be used as a "raincoat" for a camera. Simply cut a hole for the front of the lens, and secure the bag around the camera with rubber bands.) They will also help organize small, loose items in your packing cases. Oven roasting bags are very hard to tear and make excellent

portable trash bags in situations where a garbage can is not available. And the small self-closing bags that jewelers and coin collectors use are particularly good for carrying tiny items such as bushings and screws.

Rain poncho: Made of lightweight disposable or reusable plastic.

Quick-release tripod head and plates: For all camera bodies and those telephoto or special application lenses that attach directly to the tripod.

Portable refrigerator: Or at least refreezable cooling bottles for film if traveling in warm climates.

Transformers and foreign plugs: See "AC-dependent Strobes," later in this section. The Country Files list the electrical currents and plug types available in different countries.

Doorstop: Using this is a trick photographer Gregg Martin picked up from local firemen, who carry them in their hats! A small wedge will keep doors open while you roll your carts through and also provides an extra bit of security for your hotel doors at night (see "Hotels," in section 2).

Bath towels: Always have one from home or the hotel if you are going to be on a boat or near water of any kind or simply plan to be shooting in hot, humid weather.

MagnaKROP magnetic cropping arms: These are extremely helpful when shooting to a tight layout where the aspect ratio of the final image has been predetermined. Simply draw a diagonal on the art director's layout and then scale the cropping arms accordingly. This enables you to crop your Polaroids very accurately. They are available from professional dealers or by calling 201–798–7133. You might also want to consider cutting small masks from construction paper (the black paper slide at the start of Polaroid packs does nicely in a pinch) to put inside your viewfinder. (For 35mm cameras, you will, of course, need a model with interchangeable viewfinders—do not attempt to attach the mask to the reflex mirror.)

Occupational safety items: Such as work gloves, special goggles or safety glasses, work shoes, earplugs, top hats, reflector sashes like those used by bikers.

The Pro Back II by Forscher: Last but not least, this item deserves special mention because it has changed the way photographers work. Before the Pro Back, a separate Polaroid camera was necessary to see the effects of high-speed strobe lights. While this was fine for evaluating the overall effect of the lighting, it did not detect problems that could be observed only from the point of view of the taking lens, such as flare and extraneous objects in the camera's view. We now have a way of "seeing" our strobe images precisely as the camera does, exactly as they will be composed by the angle of the camera and particular optic, whether it be a fisheye or 500mm mirror. It is often much easier to judge the composition of the frame with the Polaroid provided by the Pro Back than through the viewfinder.

This is particularly so when it must be cropped to a precise size or when you need to discuss the image with the art director, who can now view it with you.

Moreover, the Pro Back provides a warning about at least some of the gremlins that cause equipment malfunction. Certainly it will indicate problems that have arisen with the flash units and the taking lens during the actual shooting. In leisure moments, the Pro Back can be switched from body to body to gain information on camera function. You might also want to carry a Polaroid Autoprocessor and film for long assignments away from home, since the Pro Back naturally does not indicate difficulties with camera transports, pressure plate problems, or some light leaks. There are few moving parts on the Pro Back, and hence little that can fail, but you may want to pack an extra set of Polaroid rollers (they cost only about $20) if you are going on a long trip or to a remote region. A tip for users of the Pro Back with pre-high-eyepoint-model cameras: since its design makes bringing the eye close to the viewfinder difficult, use the special sports finders mentioned above.

The Pro Back was designed and patented by Marty Forscher and is manufactured by NPC. It is available at professional dealers, from Professional Camera Service (212–382–0550), or from NPC (617–969–3487).

Batteries and Chargers

As more and more tasks involve electronics, supervising the use of batteries becomes increasingly important.

DISPOSABLE BATTERIES

Replace all your batteries at once at regular intervals, depending on frequency of use, but certainly no less than every six months to a year. Although expensive and a bit wasteful, regular replacement is much easier than keeping track of which batteries were changed when. Battery failure during a shoot can be inconvenient and, in the case of radio syncs, for example, dangerous.

Make a list of all battery-dependent items in your inventory, noting the type of battery required next to each item. At the bottom, indicate the total number of batteries of each type needed to replace your entire inventory at once.

Carry plenty of spare batteries. Some types can be hard to find on the road.

Always carry your voltmeter (and spare batteries for it).

Observe the production codes of the battery brands you commonly use to determine their age. Rewrite this information in bold markings on your battery storage cases for instant identification. Pack your older batteries on top so that they are used first.

RECHARGEABLE BATTERIES

Commonly used rechargeable batteries are of two basic types, nickel cadmium and lead acid.

Nickel cadmium batteries, usually referred to as NiCads, are the most common type of rechargeable battery used in appliances. They are also available in the 1.5-volt AA, AAA, and 9-volt sizes to replace standard disposable batteries. However, NiCads will probably produce slightly less voltage than these ratings indicate, so be sure that your equipment will function well with less output. The radio sync, for example, will give irregular results unless its batteries provide full electrical output, so all-purpose NiCads are never recommended for them.

NiCads also can develop a "memory" from poor recharging habits. Briefly stated, if a NiCad is regularly recharged before it is near exhaustion, say when half full, it will "learn" to put out only half a charge. The best advice is to give new NiCads a healthy initial charge and then use them fully before recharging. However, like all batteries, NiCads should never be allowed to "sink" to complete exhaustion, which can destroy them. (Norman 200 power packs, for example, contain a cutoff circuit to turn the unit off before the battery hits bottom.) If you have used half a battery and need it fully charged the next day, occasional premature recharging will not create serious memory problems. Similarly, it is acceptable to "top off" NiCads that have been on the shelf a while and may need a little more juice.

Lead acid batteries, commonly called gel cells, are impervious to cold, have no memory problems, will endure more impact than NiCads, and "bleed" less on the shelf when inactive. NiCads can lose as much as 25 percent of their charge per week on the shelf, whereas gels tend to lose no more than 2 percent. Because they do not develop memories, recharging gel cells is easy—simply plug them back into the wall after every use, at the end of every day, or whenever they have been inactive for a while. Always keep them topped up. Never let a gel cell become completely exhausted.

When purchasing either type of battery, ask if the manufacturer supplies a "quick" charger. Although usually an optional item, it is well worth it. If your schedule is demanding, you may not have the eight to twelve hours in one spot (even overnight) that some batteries need for recharging. Check if you can use one charger for several items, but be sure to verify this carefully with the manufacturers of the equipment. There may be subtle reasons why items need their own chargers despite similar power ratings and receptacles.

AC-dependent Strobes

My purpose here is not to recommend one brand of strobe over another. You have already made those choices, and presumably, if you are often on location, you have chosen power packs that are relatively portable. What follows are some general thoughts. I am very grateful to Larry Farrell of Flash Clinic, who has supplied and serviced my strobes for more than fifteen years, for his many suggestions for this section.

CURRENT DRAW

When discussing technical needs with a site manager for a shoot, you will often be asked how much power will be needed for your strobes. It is a difficult question

because, while strobes can be rated at, say, 8 to 15 amps for their average draw, they surge, requiring much greater amounts of power for brief peaks as they recycle. So average ratings can be misleading; moreover, you cannot always be sure how good the electric lines are at the location. It is always best to arrange for an electrician to be on hand when you are working at a facility or, at least, to be briefed on where the circuit breakers are and how they can be reset.

Try to locate the various circuits at a location, and spread your power packs over several of them, even if this requires the inconvenience of extension cords. Be sure none of your packs are sharing circuits with your host's sensitive appliances, such as computers or emergency and medical equipment (see "Safety on the Set," later in this section).

You can minimize the chance of an overloaded circuit by shooting slowly, rather than at the instant the unit is recharged. Or, if your unit is so equipped, set it in the slower recycle mode.

TRANSFORMERS

Unless you are using a bivoltage power pack such as the Balcar A1200, 2400, 5000 series, or the Profoto 5 and the Bowens Voyager Monolite (which automatically adjust themselves to a range of voltage input, from 90 to 250 volts), your unit is wired only for the 110 to 120 volts commonly available in America. You will need to bring powerful transformers if you are going to countries where 220 to 240 volts are standard (see the Country Files for this information), or if you are shooting in industrial environments with 220-volt lines. Use only a good-quality transformer, comfortably rated for your unit. Using the smallest transformer physically possible for your unit is not recommended. Excellent transformers are available from Todd Systems Inc. directly (914–963–3400), or through your strobe dealer.

Table 1 lists transformers that are compatible with commonly used power packs. Get the heavy-duty grounded models. As you can see from figure 2, you will save considerable weight and space if you double or triple units up on one appropriate transformer. For example, two Dynalite 805s can run on one 1,000-watt transformer rather than two separate 500-watt transformers. However, bear in mind the following:

- Never exceed the total capacity of your transformer.
- Be sure to purchase a good-quality multiple-wire outlet (Todd's transformers come with only one outlet) that is physically configured to handle the grounded plugs of your packs (some of which are angle plugs, for example). A good "strip" outlet is recommended.
- If your units are all on one transformer, you run the risk of having them all on one circuit. They will also have to be run into one spot on your set, which can be very inconvenient if your packs needs to be placed at considerable distances from each other. By consolidating, you will also have less backup, but transformers rarely fail.

TABLE 1. COMPATIBLE TRANSFORMERS FOR COMMON POWER PACKS

Model	Output (in watt-seconds)	Transformer (in watts)
Balcar		
P4	varies with head	1,500–2,000
Bowens		
Mono 4000	N/A	550
Mono 9000	N/A	800
Mono 15000	N/A	1,500
Mono 24000	N/A	2,500
Broncolor		
Flashman	950	1,500
Flashman II	1,900	1,500
Comet		
CL 1200	1,200	1,000
CL 1250	1,250	1,500
CX 124A	1,200	1,500
CX 244A	2,400	2,000
Dynalite		
804/805	800	500
M500	500	250
M1000	1,000	1,000
M2000	2,000	2,000
Elinchrom		
23	400	1,500
25	500	1,500
50	500	1,500
100	1,000	1,500
Norman		
P800D	800	1,000
P800SL	800	1,000
P2000D	2,000	1,500
P2000X	2,000	1,500
Profoto		
Pro-41	varies with head	1,000
Pro-81	varies with head	1,000
Speedotron		
1205	1,500	1,500
2403	2,400	2,000
2401B	2,400	2,000
2403B	2,400	2,000

Remember to bring a smaller transformer for battery chargers and personal appliances. Simply look at the watt input listed on the plate of the AC adapter to determine the transformer needed. For constant-draw items such as battery chargers, you do not need a transformer much higher than the watt rating of the item.

Finally, I want to reiterate the importance of carrying a voltmeter. Actual output of current can vary throughout the world. Step-down transformers, like those in figure 2, can handle 240 volts but no more. More important, your line at the hotel or other facilities may already be stepped down to 110 volts without proper marking. Putting your transformer into this line and running a strobe from it will damage your equipment.

GENERATORS

Clearly, if you want to run the above units in an outdoor location, you will need a source of power. Photographers who do a great deal of large-scale local work often prefer to buy their own generators and favor such brands as Honda and Kawasaki. Be sure to get one with voltage stabilization, and be certain that it can meet the demands of your strobes when modeling lights and cooling fans are also on.

For safety reasons, gasoline and diesel generators cannot be shipped as passenger baggage. Out of town you will therefore have to hazard the vagaries of rental units. You may elect to carry an inverter instead, which will convert 12-volt DC auto, truck, tractor, or marine electricity to 120-volt AC current. They are not light, but airlines will accept them, and they are quieter than gas generators. Contact Vanner Inc., 745 Harrison Drive, Columbus, OH 43204 (614–272–6263).

Catalog number	Rating watts	Weight lbs.	Dimensions		
			M	W	D
SD-16LRG	100	$2\frac{1}{2}$	$3\frac{1}{8}$	$2\frac{5}{8}$	$3\frac{3}{8}$
SD-17LRG	150	$3\frac{1}{4}$	$3\frac{1}{8}$	$2\frac{5}{8}$	$3\frac{3}{4}$
SD-38LRG	200	$3\frac{3}{4}$	$3\frac{1}{8}$	$2\frac{5}{8}$	$4\frac{3}{16}$
SD-12LRG	250	$4\frac{1}{2}$	$3\frac{1}{8}$	$2\frac{5}{8}$	$4\frac{3}{16}$
SD-43LRG	300	$4\frac{1}{2}$	$3\frac{1}{8}$	$2\frac{5}{8}$	$4\frac{5}{8}$
SD-18LRG	350	$6\frac{3}{4}$	$4\frac{5}{8}$	$3\frac{7}{8}$	$4\frac{1}{8}$
SD-11LRG	500	$8\frac{3}{4}$	$4\frac{5}{8}$	$3\frac{7}{8}$	$4\frac{3}{4}$
SD-19LRG	750	$12\frac{3}{8}$	$4\frac{5}{8}$	$3\frac{7}{8}$	$5\frac{5}{8}$
SD-13LRG	1000	$13\frac{3}{4}$	$4\frac{5}{8}$	$3\frac{7}{8}$	6
SD-14LRG	1500	$18\frac{1}{8}$	$4\frac{5}{8}$	$3\frac{7}{8}$	$7\frac{1}{16}$
SD-20LRG	2000	$24\frac{1}{4}$	$5\frac{15}{16}$	$4\frac{3}{8}$	$6\frac{7}{16}$
SD-39LRG	2500	36	$6\frac{3}{8}$	$5\frac{5}{16}$	$7\frac{5}{8}$

Figure 2. A heavy-duty grounded step-down autotransformer: three-prong, line cord, receptacle, 220/240 input, 110/120 output, used to convert domestic appliances for use with foreign voltages. (Courtesy of Todd Systems, Inc., Yonkers, New York)

Battery-dependent Strobes

Although not generally equal in power to the 800- to 2,000-watt second strobes, the present generation of shoe-mounted, battery-dependent strobes is marvelous for the location photographer. I have gone off for two- or three-week assignments in South America and Asia with only a single case of them and have not been seriously disadvantaged.

The system I use is a series of Vivitar 285 high-voltage units powered by Armato Photo Services' Pro-Cycler batteries. Armato makes a whole line of interesting units ranging from the Pro-Cycler series, which are used to enhance universal strobes such as Vivitar and Sunpak, to complete outfits with their own modified flash heads. Armato also provides superb custom brackets and other professional modifications and repairs: Armato Photo Services (APS), 87–29 Myrtle Avenue, Glendale, NY 11385 (718–441–6888, 441–4412).

Other systems are available from Speedotron (312–421–4050), Quantum (516–222–0611), and Eliminator by Protech (212–239–8689). Norman 200s, Lumadyne, Minicam, and the unusually powerful Balcar model P2 (600 to 1600 watt seconds) are fine examples of complete battery and flash outfits.

But no matter which system you choose, battery-powered units have a number of advantages. Their compact size allows you to move quickly and not be stymied by small taxis or foreign rental cars. It is possible to fly with them as carry-on luggage (see "Carry-on Baggage," later in this section). They obviate the need for heavy transformers. Bivoltage charging units, which are not much bigger than 110 chargers, are generally available for these units, and even if you needed a transformer, it would be of the handy 20- to 50-watt kind.

You can shoot anywhere without being dependent on AC current, a particular advantage outdoors. The compact nature of the heads allows you to fit them in tight spaces on the set, a convenience even when AC-powered units are operating. Battery-powered strobes can be camera or bracket mounted for action shooting, and they are less of a hazard than AC-powered units.

Flash Accessories

The quality of your slave eyes is critical. If not built in, invest in a top unit such as the Master Slave (516–222–0611).

An extra-long PC cord can be valuable in backing up your remote radio sync or extending the reach of slave eyes into hard-to-see corners of the set. Kako (615–478–1405) makes a nice infrared shutter-tripping device, handy for nature, action, or remote photography. Lowel (718–921–0600) makes an excellent "scissor clamp," which is specially designed to allow mounting of flash heads in drop-panel ceilings. A safety chain to back up the clamp is available, as are special hooks to run the cable along the ceiling. Black cloth (either velvet or muslin) can eliminate unwanted background reflections or cover an overhead light that cannot be turned off; carry a few yards. Ball-joint adapters to attach small strobes to stands provide great flexibility.

Reflectors are not to be forsaken on the road. Simple 16-by-20-inch boards (we carry white, black, silver, and gold) can be taped together and packed in the lids of road cases or between the outer fabric and inner shell of the newer soft cases. Folding, flexible reflectors are made by a variety of manufacturers. Bogen makes a wonderful system called the Lightform Panel system. They also make the excellent Super Clamp system, very light and sturdy light stands, and a host of other handy supports and location devices available at most professional dealers or call (201–818–9500).

Safety on the Set

Recommending precisely how to lay wires or set up stands safely is difficult because photographers in the field must be certain that their operations comply with *local* fire, building, and electrical codes. You may feel that you have taped down a cable in a secure fashion, but is it violating a fire code by crossing an emergency exit? Bear in mind that, legally, "the public is not educable." This means that you alone are responsible for set safety—the public is not required or expected to heed or understand any warning notices you post or to comply with any precautions you have established. And, in fact, they may not be capable of understanding. The clearly marked warning sign you put up might be useless to a blind, non-English-speaking, illiterate, or retarded person, for example. Children pose an even greater problem, since many localities have laws concerning what are called "attractive nuisances" or "foreseeable abuses." This means you will be responsible if your setup attracts children to play or even to misbehave recklessly and aggressively in the area. Special-effects devices, particularly those that may involve toxic chemicals, require special care as well. If you are shooting in public spaces, it is always best to arrange for a secure area with the local police. Local film commissions may be helpful in this regard (see appendix 2).

Some good sources of information on safety are:

Arts, Crafts, and Theatre Safety (ACTS), 181 Thompson Street, no. 23, New York, NY 10012 (212–777–0062)

Center for Safety in the Arts, 5 Beekman Street, New York, NY 10038 (212–227–6220)

National Fire Protection Association (NFPA), Batterymarch Park, Quincy, MA 02269 (800–344–3555)

Be sure to contact local officials if you have any questions or doubts.

High-tech Communications

Laptop computers can weigh as little as 6 pounds. They allow you to streamline your bookkeeping on the road, catch up on general paperwork during down time in airport lounges and hotel rooms, carry mailing lists and business records with you, and access data banks from anywhere in the world with a built-in modem. We are

now on the eve of a whole new generation of checkbook-size computers. Modules to convert laptops into fax machines and small scanners that allow you to input material directly from the printed page are available.

Incidentally, although businesses in most developed countries are rapidly turning to fax machines as their normal mode of communication, the Third World (and some industries such as shipping) still rely heavily on old-fashioned telex machines. If you need to communicate in a country with a poor international telephone system, you might try sending messages by telex (if you do not belong to an electronic mail service such as MCI, you will be able to communicate only with another telex machine and will need to have that number with you). If you are in a major city, your hotel is likely to have a telex machine and will usually be willing to send a message for a fee. If not, they can often be sent from the country's general post office, or perhaps you can find a business or trading firm that allows you to use its machine.

Cellular phones are not much bigger than a standard telephone handset and can slip into your pocket. These marvels allow you to stay in touch in over 100 cities in a crisis. A shortwave will also improve your cross-cultural understanding and supply hours of entertainment.

PACKING YOUR GEAR

The inviting list of trinkets discussed above raises a tantalizing question: how much equipment will you need to cover yourself on the road, where Murphy's law prevails? Leaving your umbrella home guarantees rain and leaving a piece of gear home guarantees you will be lost without it. Yet, can you afford to bring the kitchen sink when you are squeezing onto airliners, through factory passageways, and into tiny foreign taxis?

The problem is particularly worrisome for those of you who are also studio photographers. Since I am always on the road, I always add new equipment to my inventory with an eye toward its portability and how well it will fit into the little remaining space in my cases. Although there is no satisfactory answer to this dilemma, it might help to ask yourself the following questions:

- Can all the gear we bring be carried or carted by available staff in one haul? Unless you are traveling locally, never bring so many cases that you have to ferry them back and forth.
- Once settled in a spot, do you find yourself rationalizing your position rather than moving to a potentially better place for taking a photo?
- Can the optional equipment be rented at your location in an emergency? (See "Renting Equipment on the Road," in section 2.)
- Is your back-up equipment evenly distributed? It makes no sense to bring a slew of spare power packs and only one flash meter.

The first factor to consider in packing gear is whether or not you will be traveling by air. If you are, you will need to arrange things so as to be able to carry on as

much film and equipment as possible (see "Airline Reservations," earlier in this section). Be sure that the things you do check are prepared for the rough treatment they will receive, and distribute your gear in such a way that the loss of a single case does not close down the entire production.

Carry-on Baggage

As of January 1988, the FAA guidelines concerning carry-on baggage changed. Prior to that time, the guidelines stipulated one piece of carry-on for domestic flights, a suggestion that was routinely ignored by airlines in the competitive climate of deregulation. Passengers were demanding more and more carry-ons because of the problems they were experiencing with checked baggage, as well as to reduce the time they were losing as a result of inordinate flight delays. The situation quickly got out of hand, with passengers carrying on a bizarre assortment of personal effects, from surfboards to Christmas trees.

The new rules leave it to the airlines to develop individual allowances for their aircraft, *provided that all baggage can be safely stowed under the seats or in the overhead compartments according to FAA specifications.* The FAA has suggested two pieces as a reasonable number but has indicated that safety is its main concern. Seating and storage capacity for the different airlines vary enormously (see "Airline Reservations," earlier in this section). If there is room for more than two items, the FAA has given its blessing as long as they can be safely stowed. But if the carry-ons cannot be stowed safely, they must be checked, even if that means only one carry-on per person on a crowded flight. Responsibility for monitoring the system is the airline's, with FAA inspectors making spot checks and issuing fines to carriers not properly screening overloads.

I prefer the new rules because almost all the major American carriers have agreed on a two-bag guideline. Prior to 1988, I was often restricted by airlines to one bag when they happened to be in the mood, because they "had to comply with the FAA rule of only one piece of carry-on." It is, therefore, extremely important that you familiarize yourself with the various airline policies by asking questions and sharing information with your colleagues before choosing a flight. Pan Am, for example, has a flexible policy, allowing business and first-class passengers more latitude because of the greater storage space in those sections and tolerating whatever can be properly stowed on flights that are lightly booked. The rules for each airline will change too quickly to be detailed here.

Bear in mind too that policies for international flights vary. And if you are changing carriers for different legs of a journey, you had better be equipped for the limitations of the most stringent carrier on the itinerary.

I have devised a packing plan built around four cases (two for myself and at least one assistant), which can all be stowed under a regulation airline seat. In this way all of my essential, hard-to-replace items, including bodies, lenses, meters, and film, are on board with us. We often have room for a whole complement of our battery-operated strobes as well. If our checked baggage is lost or delayed, we need only replace our tripods and stands to be back in action. On a recent trip through South America, this is exactly what happened. Our baggage was delayed a full day on a

leg from the Dominican Republic to Guatemala. Although we had to wear dirty clothes for a day, we were able to rent tripods and stands and were shooting by 10:00 A.M. However, without the carry-ons, replacing all our gear in Guatemala City would have been literally impossible, and had the luggage not eventually turned up, we would have had to discontinue the assignment and return home. All four cases fit nicely on a Nalpak luggage cart (see "Luggage Carts," later in this section).

Three of the four bags are superb Tenba models (212–966–1013). There are any number of excellent bags on the market, and it is not my intention to denigrate any of them. But I am compelled to mention the Tenbas because I believe that founder Bob Weinreb has pioneered many of the standards for soft-bag construction and because, after using these products rigorously in the field for almost a decade, I have found them to be flawless.

Some of the features you should consider for any soft bag are:

• Top-quality construction of the lightest, toughest materials, such as Cordura nylon, treated for water repellency and sewn with heavy-duty bar-tack and "box-x" stitching.
• Shock-absorbing padding of a "closed-cell" foam, such as Ethafoam, the material used in crash helmets and athletic padding. A good stiffener in the bottom panel to cushion the bag against the ground and prevent sagging is also essential.
• Easy access to gear, with fully adjustable and removable partitions, plus a sensible assortment of large, high-grade zippers and dependable quick-closure devices.
• An adjustable, comfortable strap that runs all the way under the bag and is supported by welded D rings that will not spread under heavy loads.
• Well-planned design features, such as rain flaps over zippers, pen pockets, properly proportioned cargo pockets, and interior document pockets.

The variety of accessories available to complement the bag might also be considered. Can the bag be converted to a backpack? Are short hand straps available? Can you attach a small tripod with special straps? One Tenba accessory I especially like is the top pocket liner. Although designed to pad and organize the top lid of their bags, I use them as small equipment "purses" throughout the entire packing system. They are fully enclosed and have dividers, so I can, for example, put a small strobe, battery, slave, and sync cord in one and thus have easy access to a complete item. They make it easy to grab what is needed quickly either for the shoot or to recharge batteries when storing the rest of the gear for the night. And they take up much less space than foam and plywood interior protectors, keeping the interiors of the larger cases organized.

The fourth carry-on case is an ADAPT-A-CASE aluminum suitcase manufactured by Fiberbilt Cases Inc. (800–847–4176; call 212–675–5820 in New York State). It is the P20 D model, and its outer dimensions are just over 8 by 14 by 18 inches. We carry the hard case if forced to check in a bag and because it creates a nice platform as the bottom piece of luggage on our cart.

Also fundamental to the strategy of maximizing your carry-on allowance is the use of photographic vests. I would feel naked without one and depend on them so much

that I had four or five custom-tailored on my last trip to Hong Kong. Commercially manufactured vests are available from a number of sources. You will want to select the vest that works best with the equipment you need to have on you, but I designed my vest with:

- Rows of filter-sized pockets (very hard to find on commercially available vests) for most commonly used glass filters
- Deep inside pockets with zippers the size of the whole vest for exposed film and wallets
- Epaulets with top-grade Velcro fasteners
- Pen pockets
- Multilayered, zippered outside pockets to hold lenses, meters, and the like
- A mesh or loose-fitting back panel for ventilation
- Tailoring that allows the vest's weight to rest squarely on the shoulders rather than bunching up tightly around the back of the neck

A vest secures your most valuable possessions, particularly in crowds. It allows you to have as much gear as possible with you when you need to climb to inaccessible places where it would be difficult to tote a bag. Similarly, if you are ever asked to surrender all but one of your carry-on bags, you can at least shove as many essentials as possible from the newly checked bag into your generous vest pockets.

Soft cases, jackets, and vests can be modified, incidentally, to meet your particular needs. Whether it be adding pockets, a shoulder epaulet, or special fasteners, zippers, and flaps, an excellent source is Leon Greenman and staff at Down East Service Center, 75 Spring Street, New York, NY 10012 (212–925–2632). Down East specializes in originating, customizing, and modifying outdoor equipment and garments. They have worked on everything from tepees to ship sails. They can even resole your hiking shoes.

Checked Baggage

The photographer has an almost overwhelming array of cases and bags from which to choose today. Certainly nothing is quite as strong as a hard case, whether it be aluminum, fiberglass, a metal and plywood "road" case, or the newer high-impact plastic models. I, however, have switched to the new generation of fabric shipping cases, pioneered by Lightware (303–455–4556). I find them lighter, less bruising to the body, and easier on delicate floors. Airline check-in clerks view them as less intimidating and hence are less likely to tag them for special handling. I also find they are a bit less likely to encourage excess baggage charges. Their narrow design saves space in tight shooting quarters. My Lightware cases have held up very well, although I have gone against the manufacturer's recommendations and inserted hard, thin boards between the fabric and the inner shell to provide greater rigidity and protection from puncture. Tenba also makes a fine fabric air case with air-channel plastic bonded to the foam inner shell. It meets with Air Transport Association specifications.

An enormous selection of hard and soft tubelike cases for tripods and stands is available. In soft versions, you may want to consider those with inner straps to organize interiors, handy sewn-in pockets for small items, and above all, good handles, stitching, and reinforced end panels. If you select a hard case, be sure it is not entirely round so that you have as little rolling as possible. It should telescope to adjust to the size of its contents. I use a Port-a-Brace (802–442–8171).

Luggage Carts

A good luggage cart is essential. I favor the Nalpak Video Sales TK-400 (619–258–1200). It hauls an incredible 300 pounds and features an excellent four-wheel design that swings down whenever you need it. It opens and closes in one quick movement and folds down to a smaller size than many less powerful carts. The TK-400 has very sturdy metal runners for sliding the cart down steps and curbs. It comes with a five-year warranty. If you use the four-wheel mode, be sure to experiment with loading your cases in different configurations for best balance. Try to put some weight higher along the column of the cart to give you better leverage when you want to tip it forward into the four-wheel position. An enormous selection of hand trucks, including some compact folding models, is available from Harper Trucks Inc. (800–835–4099).

Incidentally, while you are obviously not going to choose an airport based on the issue of whether or not it has ramps and elevators for your carts, this information has been compiled for the benefit of handicapped travelers in the form of a booklet entitled "Access Travel: Airports." It is available free of charge from Access America, Washington, DC 20202 and from Consumer Information Center, Pueblo, CO 81009.

Packing Suggestions

No matter what type of case you use, keep the weight of individual cases down as much as possible. Overly heavy cases will slow you down, encourage injury, create difficulties with baggage handlers, and build up that much more inertia when sliding down airline chutes.

Pack as tightly as possible. Empty spaces within packing cases will cause damage as contents shift. Distribute weight as evenly as practical within the case. If a heavier area is unavoidable, put it at the bottom of the case as it stands upright.

Good locks are a must. Consider road cases with sophisticated locking mechanisms. A&J cases (800–537–4000; call 213–678–3053 in California) even feature plastic security tabs to reveal tampering. If you are using your own padlock-style locks, consider either a series of combination locks that will all respond to the same number or a series of "keyed-alike" locks that can all be opened with the same key. Having one key for all your cases will reduce the nuisance of a bulky key ring and save precious minutes fumbling to unlock your gear.

Distributing your equipment by type (for example, all lenses in one case, all bodies in another, all flash heads in another) is more convenient when working quickly

but is a great security risk. The loss of one case stops the production. Pack in a modular fashion, putting complete sets of items in a case, so that if you lose one bag, you still have some operational equipment in the others.

Develop a careful packing plan and stick to it. It is easier to notice missing items when they always live in the same place. Cutout foam interiors provide excellent protection, but they do not use space efficiently and tend to degrade in time. Organize the spaces within a case using only a few partitions, and rely on cables and soft items such as changing bags and work gloves to cushion and tighten.

My real secrets are the Tenba top pocket liners and a series of foam and nylon pack cloth equipment wrappers that give excellent protection and take up little room. I do not know of any wrappers as good on the market today, but Down East can custom-make such an item for you. You may also want to carry along some 1/4-inch bubble pack for emergencies.

Keep a complete packing list, enumerating not only every item in your inventory but the individual components of that item if it breaks down into sections. For example, do not just list radio synchronizer, but rather remote transmitter/receiver/AC converter. Do not forget the tiny items, such as bushings, adapters, and slaves. Keep them in plastic bags or pouches.

If possible, prepare two separate packing systems, for either small and large jobs or local and out-of-town jobs. It saves a lot of rearranging.

Carry spares of as many items as you can. Having only one of an item almost guarantees its failure on the road. Avoid incompatible accessories as much as possible. If a new item is incompatible with your old system, either pass it up or change your system wholesale.

If you do primarily location work, store your equipment in its travel cases. Replenish supplies and attend to repairs as soon as you get home. If you have to repack (and you should always go through your checklist before starting out, even if you have just returned from location), *never, never, never* pack the day of your departure. Always prepare at least the night before.

Packing Film

Since I am exacting about the quality of emulsions, I never buy film on the road. Every roll I shoot is from a pretested emulsion number, purchased from the same source to ensure similar storage conditions. This is particularly important because I favor professional films that should be refrigerated when not in use (although they certainly can tolerate normal room temperatures for several weeks on the road). I carry hundreds of rolls with me, and they must be packed to withstand the elements and facilitate hand inspections at airport security (see "Airport Security," in section 2).

I used to leave my film in the original factory-packed bricks of twenty rolls. This obviously provided excellent protection and tended to reassure security personnel that I was not carrying contraband. However, in today's more treacherous climate, security people often want to open each roll, knowing that factory packing can be duplicated. I therefore recommend putting your film in some kind of see-through

container. I favor the Tupperware Classic Sheer 16-ounce Square Rounds. They are perfectly sized to fit sixteen rolls *without* the wrapper and plastic canister. Because Tupperware is firm and well sealed, the factory canisters are no longer necessary, saving space and reducing garbage. The Tupperwares stack nicely in film bags, and I can quickly grab sixteen rolls to shove into my vest if I must peel off from my assistant for some shooting. We label or color-code the containers, making it easier to keep track of exposed footage. In all regards, I feel they are superior to simple plastic bags. Call 800–858–7221 for the name of your nearest Tupperware salesperson. Here in New York, I receive excellent service from Doreen Diemer (914–496–8538).

Once film is exposed, we put it back in a Tupperware with a special strip of red warning tape (see "Choosing Your Equipment," earlier in this section) so that it can be instantly identified. It is relegated to the bottom of the bag so that it will be handled as infrequently as possible. I used to divide my take into two or three sections to protect against total loss, but I now favor keeping all the film together and never letting it out of our sight unless secure. If you are going to divide your film, do it after each shot. Dividing it randomly later will not ensure against a reshoot since you may not have any rolls of a given situation.

I also bring Polaroid film from home. Although keeping to one emulsion is not critical, it can be hard to find and very expensive in some countries. If space is tight, we remove the outside box and carry it in its white protective wrapper. If we need a lot of Polaroid, we also put some back-up packs in our checked luggage, wrapped in Sima Super Lead Shield bags. This usually protects them from the sometimes severe X rays of checked luggage; but even if damaged, the loss of back-up Polaroid is less critical. (At least we will know about it on the shoot rather than when we get home!)

Polaroid film is a superb product, manufactured to the highest standards. The ASA is remarkably accurate, but its color rendition is vulnerable to heat. It has a tendency to turn green, which can be particularly misleading for corporate photographers who are often shooting under fluorescent lights. If you get a very green image, check the black border around the picture. If it is a greenish black, suspect the film. If the border is a pure black, the green in the image might really be there. Use your color meter to verify your guess.

PACKING YOUR CLOTHING

Location photography books discuss camera equipment at length but often ignore clothing and the way it is packed. The choice of fashion is left to the individual, but do not underestimate the destructive potential of improper clothing.

For the Tropics

- Wear natural fibers, despite wrinkling.
- Pack lightweight clothes that still cover arms, legs, and feet when protection from direct sun and insects is required.

- Consider a vest, since it provides plenty of storage but is light and loose fitting.
- Remember to pack a hat. Choose one with a brim that can be turned down or up. For better protection, bring a peaked cap if you can get into the habit of quickly rotating it when you shoot.
- Research the clothing acceptable for business meetings at your destination (see the Country Files for dress codes in individual countries).

For Cold Weather

I am very grateful to Tom Armstrong, manager of product research and testing at L. L. Bean, for assistance with this section. L. L. Bean produces no less than twenty-two catalogs of excellent products that have all been thoroughly field-tested, and I would be surprised if you could not outfit yourself entirely from this one source; contact L. L. Bean, Inc., Customer Service, Freeport, ME 04033 (800–221–4221).

Bean's approach to cold-weather protection is designed around the time-proven theory of layering, the principle that several layers of protection are preferable to a single bulky garment of even the warmest material. The first layer next to your body, which serves as a "second skin," should have the virtue of drying quickly to remove perspiration from the skin. Far and away the best material in this regard is polypropylene, which dries four times faster than any other material available. Next comes an insulating layer for warmth. Recommended is another, thicker layer of polypropylene or wool, cashmere, chamois, or Polar Plus, which is a breathable synthetic fleece that dries quickly and is lighter and softer than wool. The outer layers can include a down parka or other good working jacket.* These can be lined with Thinsulate, which is as warm as wool of the same thickness, is lighter, and drapes better. You may also want a shell of Goretex or Helly-Tech to protect you from wind and water.

Protecting your head and neck is particularly important, since 60 to 70 percent of heat loss is from this part of the body. Make sure your parka has a hood, and supplement it with a wool cap, a Polar Plus hat, or a fur trooper's hat. Choose beaver or another tight fur. Some furs, such as rabbit, shed hairs, which could be lethal to your equipment. You may want to consider a neoprene face mask or a balaclava, which is a wool cap that rolls down to cover the face.

To avoid the hazards of frostbite, use polypropylene liners (the silk that is so popular with skiers is very susceptible to moisture) under either shooting gloves, which allow you to pull the fingers out from an attached mittenlike sheath when photographing, or Bean's all-purpose Super Grip Gloves. Also ask about their Dachstein glove, which is a special blend of four wools. You may want a pair of true Arctic mittens around for periods when you are not handling the cameras. Polypro-

*For the parka itself, I favor the Chelsea model by Countryside Outfitters (603–672–0767). It features 600-fill down and has: elastic drawcords to tighten the wrists and belt line around your body; epaulets to keep your camera securely on your shoulder (particularly important in a heavy coat, since you are less likely to feel it slipping); a built-in hood; large outer and inner pockets (including a secret one); a high-grade #10 zipper as well as quick-close Velcro tabs; and sturdy construction.

pylene foot liners covered with rag-wool socks are also recommended. Be sure they are loose fitting, since tight footwear prevents the blood circulation you need for warmth. In midseason, Bean's Maine Hunting Shoe is a good bet for comfort and water protection, and in winter, their Cold Weather Boot is excellent. For frigid extremes, nothing on the market compares with their Polar Boot, tested for two years in Antarctica, on Mount Everest, and by the famous Maine guides.

Be sure, by the way, that you avoid dehydration in winter by taking in plenty of fluids, since you will lose moisture in the dry air through the vaporization of your breath.

Suitcases

A wide variety of luggage in assorted shapes and sizes is available. Hard pullman cases, ranging from molded plastic to aluminum, are sturdy but heavy, and they will not expand if you have to add extra items. Frameless, completely flexible soft luggage is usually made of nylon. These are the lightest cases but offer the least protection. The key to successful use is packing them tightly to the brim so that the contents firmly structure the bag. Soft-sided pullman cases with a frame, often of a material like the Cordura found in camera bags, are the type I favor. Soft pullmans with frames are lighter and hold more than a hard case but provide greater protection than the soft cases for the odd spare photographic items you may want to carry in them.

If you are shooting high-level executive portraiture (I always wear suits for these shoots) or are on a sales trip with your portfolio, a garment bag is essential. Get one with flaps that open fully, such as the Walk-in Closet from Boyt of Iowa (515–648–4626) or the Organizer Plus from American Tourister (401–245–2100).

All soft-sided luggage is obviously vulnerable to tearing, but if you invest in a good set, only unusual stress will rip them. Wheels are an advantage, but again, be sure they are of the highest quality. Consider the cases that tilt back on two wheels rather than ride on four, and avoid attachable wheels—you can remove them before check-in but will find it a nuisance.

Packing Tips

- Never leave for a long trip without at least a week to ten days' supply of underwear and shirts. Dealing with laundry on the road can be more of a nuisance than carrying a few extra pounds of clothing.
- Consolidate your clothing by carrying only one color scheme. If you are fashion conscious, carry solids for basic clothing and rely on accessories in patterns or bright colors.
- Do not overlook appropriate business clothing. Carry ties (consider knit ties, which are less likely to crease), dress shirts, shoes, and belts, as well as collar stays and cufflinks. Women should determine whether suits or dresses are the rule and if trousers are acceptable. They must also bear in mind that it is sometimes wise to respect local traditions concerning modesty of dress, eschewing short hemlines, sleeveless tops, or low necklines.

- If possible, try to avoid mixing warm and cold climates on your itinerary. Being properly prepared for both will result in a great deal of extra clothing.
- Be as unstinting in the quality of your clothing bag as you are with your camera cases. Buy the best materials and closures, but avoid ostentatious designer cases, which are prone to theft.
- Carry a small, lightweight nylon bag inside your large bag for use on short one- or two-day side trips.
- Use a packing list for clothes and toilet articles as you do for gear. Lay all items out on the bed or floor before packing them.
- Put heavy, bulky items such as shoes at the bottom of the case. Stuff shoes with socks to save space and keep them better formed, and cover them with shoe mitts or plastic to keep them from soiling adjacent clothing. Fold jackets inside out; shirts and pants in thirds, not halves. Consider rolling sweaters, pajamas, and other casual items together, rather than folding, to save space and avoid creases. Use plastic makeup- or self-sealing bags for small items. Wrap ties around corrugated cardboard and secure with rubber bands.
- Use a large nylon kit for toilet articles. Pack all liquids in plastic bags, and squeeze the extra air out of them before tightly capping. Avoid aerosol cans. The finest shaving cream I have ever used is Euxesis Brushless, available from Caswell-Massey (212–620–0900), which comes in a small cold cream–size jar and can be applied very sparingly. Transfer toiletries into smaller plastic jars and bottles for short trips, or purchase special travel-size items individually or in kits from Travel Mini Pack (914–429–8281). Do not overlook a small sewing kit, disposable moist towelettes, cotton swabs, a gentle cold water detergent, extra plastic bags, and some small rubber bands. Always keep a travel toilet kit separate from the supplies you use at home. Replenish your toilet articles as soon as you get home so that they are ready for the next trip.

Medications

In addition to standard toilet articles, consider bringing the following:

- Alcohol and antiseptic
- Antibiotic—general purpose, such as Bactrim or Septra
- Antihistamine
- Antacid
- Deet insecticide
- Dental floss
- Diarrhea medication—over the counter and prescription (constipation is best combated naturally with high-fiber foods)
- Electric coil for boiling water (Franzus, 203–723–6664) and water purification tablets, which are available at camping supply shops
- Eyewash and antibiotic ointment
- Foot powder

- Painkillers (over the counter as well as prescription for emergencies)
- Skin moisturizer
- Sleeping tablets or tranquilizers to help with jet lag (see "Jet Lag," in section 2)
- Special items for extreme climates, such as antifungal or delousing agents and malaria medication (see "Special Recommendations for Vaccination and Prevention of Illness," later in this section)
- Sterile gauze and bandages
- Sunscreen
- Syringes—especially important when traveling in areas with questionable sanitary practices
- Tampons, which can be very hard to locate in some parts of the world
- Thermometer
- Vitamin supplements

Know the generic names of both your prescription and over-the-counter drugs, since brand names are not universal. Medications have a limited shelf life and should be replaced periodically. Bring spare prescriptions with generic names. Carry prescription medication in originally labeled vials, in your carry-on bags.

Comforts

When I was first starting out, I cared little for comforts on the road, obsessed as I was with building my career and succeeding in my work. After two decades of travel, I have come to appreciate certain comforts, recognizing that they can often provide relief from stress and improve productivity. On a night flight after an unfortunate day of strife, an opera recording on my portable CD player can be as refreshing for me as a sauna, contributing to my ability to cope with additional irritations.

As tight as you are for space, consider packing that portable CD or tape player; a hardcover book if it makes you feel more at home than a newsstand paperback; a portable chess set; framed pictures of the family; your favorite robe; a bathing suit. See also the discussion in section 2 on stress and fitness.

REPAIRING AND MAINTAINING EQUIPMENT IN ADVANCE

Having assembled your gear, you now want to be sure it is in good working order. Like your body, the essential pieces in your inventory should receive semiannual or annual checkups even if they seem to be functioning. Some problems can cause subtle degradations of performance, and a good repair expert can anticipate problems that have not yet reared their ugly heads (but will as soon as you leave town on assignment).

Inspections You Can Make

Marty Forscher, the world's premier camera repair and modification expert, recommends the following procedures to keep equipment humming.

Meter: Give the meter of your camera a good workout by getting it to read from one end of the scale to the other. Move the diaphragm and shutter speeds back and forth.

Automatic diaphragm: Open or remove the camera back and look through the film gate to be sure that the automatic diaphragm is stopping the lens down with each exposure.

Focus: Check your focus at infinity with the lens set at infinity. If it is way off, suspect a detached element in the lens (shake the lens and listen for a loose part). If nothing seems loose, attach the lens to another body and focus again. If you then suspect the first body, check its focusing screen or ground-glass system to be sure it is properly in place.

Batteries: Clean the contact points of your batteries and the battery chambers with an ordinary pencil eraser, being careful to remove the crumbs.

Shutter speeds: For focal-plane cameras, you should be able to sense if the speeds from 1 to 1/30 second do not sound or feel right. From 1/60 on up, it is not possible to judge accuracy by a simple inspection because the exposure is determined by the size of the slit between the first and second shutter curtain. But you can at least tell if the shutter is working. Hold the camera body up to the light with the lens removed and the back open, and trip the shutter at all the faster speeds. You should see the full frame of light on all exposures. If one of the shutter curtains is dragging, it will be apparent. If the first curtain is dragging, the aperture may be obscured partially or entirely. If the second curtain is dragging, you can tell by the sound or feel since it will resemble a prolonged exposure of 1/30 or slower. You might also stock a portable shutter-speed tester, manufactured by Calumet (312–860–7447).

Flash synchronization: Remove the camera back and lens, and point the camera and flash toward the wall. If the sync is functioning, you will see the full frame of the aperture. If it is out of sync, you will see partial or no aperture. If the sync is off, you might try using a slower shutter speed in a pinch, but of course you will be allowing more ambient light in your exposures.

Familiarity: Be sure you are familiar with the operation and control switches of your camera. Sometimes a little-used control mimics a repair problem, notably a "stuck" mirror that is actually being held in place by the mirror lock control.

Routine cleaning: Lenses and filters should be cleaned carefully with a small amount of fluid on a piece of uncontaminated lens tissue. Never apply the fluid directly to the lens, and avoid using breath vapor. Remove dirt and grit from lens flanges with the corner of a simple business card. Clean body surfaces with a piece

of tissue or cotton swab sparingly moistened with lens fluid. Avoid excess fluid at all costs. Clean out the inside of the camera with a small blower brush. Do not use canned air anywhere on or in a camera. Its propellants leave an oily residue and cool the air, creating potential condensation problems. Forceful air pressure can also damage the shutter curtains. Delicately clean out film chips and scraps from the film chambers. The pressure plate can be cleaned with a small amount of ordinary dish detergent and water (one to one) or alcohol on your fingertip. Wipe dry with a clean tissue. Do not forget to clean the photo eyes of thyristor strobes periodically—a buildup of dirt may cause improper exposures.

Camera bags: Vacuum the bags thoroughly with a household vacuum.

Loose screws: Inspect all the camera's screws, especially if they undergo the vibrations of frequent flight. Tighten loose screws only finger tight with a screwdriver big enough to fill the slot of the screw head completely. A speck of clear nail polish applied with a toothpick will help keep screws in place.

Rewind mechanism: Open the camera back and rotate the shaft of the rewind spool with your finger. There should be no resistance.

Flash and PC connectors: Re-form all with a good re-forming tool (see "Choosing Your Equipment," earlier in this section).

Frozen lens shades, filters, or accessories: Do not force these, as you could easily damage the focusing mounts of the lens. Apply one or two drops of a penetrating watch oil or kerosene, and tap with fingers to help the oil flow through the thread.

Unusual Climates

Most good cameras these days are well sealed and lubricated to withstand extreme temperatures. "Winterizing" cameras with special lubricants is necessary only for arctic climates. However, in very cold weather, taking cameras from outdoors into warm interiors may result in general condensation of the moisture in the room on the interior and exterior surfaces of the cold camera. Place cameras in self-sealing plastic bags before bringing them indoors so that the moisture condenses on the plastic. You might also want to wrap both in a sweater or other bit of clothing so that they adjust to the warmer temperature more gradually. Remember that this condensation becomes more serious if you return outdoors, where it will freeze and possibly jam or otherwise damage internal mechanisms of the camera.

Static electricity, common in cold, dry weather, can leave its mark on your images. Reduce static by wiping the camera interior carefully (avoiding the shutter curtain) with an antistatic chamois. Resist antistatic sprays because of their propellants and antistatic brushes because they may shed.

Heat, other than direct sun, does little damage to cameras, but the high humidity common in many warm climates can upset modern electronics in cameras as it would any computer. And another type of condensation problem arises—that of the moisture outside settling on the cold metal surfaces of the camera you have just brought out from an air-conditioned interior. Again, try to keep cameras in plastic and cloth

"jackets" to allow them to adjust to the temperature changes slowly. You might also want to warm the cameras up before leaving the room by gently running a hair dryer over them. The hair dryer will also dry the air around the cameras in your cases.

CREDIT CARDS AND CHARGE CARDS

It would be nearly impossible to run my business without credit and charge cards. Expenses on the road can total tens of thousands of dollars per month. Without credit and charge cards, this money would have to come out of bank accounts, a serious inconvenience when advances are not substantial and do not arrive on time. I would also have to carry thousands of extra dollars in cash to anticipate the unpredictable changes in marching orders received after leaving home. Acquiring and protecting your plastic is essential, for it is an important tool in your work.

Cards roughly are of two types. *Credit cards,* such as MasterCard and Visa, have preset spending limits but allow you to pay off balances over time with a revolving credit plan. *Charge cards* (sometimes also referred to as T&E cards), such as American Express and Diners Club, usually have no preset spending limit. You establish your own credit limits based on previous spending and payment habits, but monthly balances must be paid in full. American Express also offers the Optima Card, which offers cardmembers the option of extending payment on purchases and obtaining cash advances at favorable interest rates. The Optima Card is available only to American Express cardmembers whose credit history and payment record are in good standing.

The lines between these two types of card have merged in some areas. Credit cards, while still having preset limits, are offering premium cards that have substantial allowances into the five-figure range and are beginning to offer some of the deluxe services traditionally associated with charge cards. The charge cards, in turn, are offering revolving credit on either certain types of expenditures (airline tickets, for example) or on limited amounts of total expenditure. Have healthy supplies of both charge cards, for their spending power and the generally greater array of special privileges they offer, and revolving credit cards, for their ability to defer payment if cash flow is tight and because there are still some merchants who don't accept charge cards. See if you can arrange for your various cards to have different billing dates throughout the month. It will allow you to take full advantage of the twenty-eight-day billing cycle and will ease the burden of all your balances coming due at once.

Establishing Credit

First, find out your credit history. You are likely to be in the computer files of a credit-reporting agency. If you have been turned down for credit by a financial institution because of the report of such an agency, you should be able to get a copy of your file free of charge, but you can request one for a small fee at any time. One commonly used agency is TRW Credit Services (714–991–5100).

If you find a negative entry on your report that you feel is unfair or in error,

contact the credit agency for details on how to correct the information. You are entitled by law to the benefit of fair reporting. In addition to contacting the agency yourself, you may want to consult some excellent government booklets, such as the "Consumer Handbook to Credit Protection Laws," available from the Government Printing Office.

If you have a legitimately poor credit history, no one can "repair" it. Get advice from a local nonprofit Consumer Credit Counseling Service. They may be able to help you with future budget planning and assist in the preparation of a plan for repayment of existing debts. The importance of a healthy credit rating cannot be overemphasized.

If major cards are not available to you because you have little or no credit history, consider building your credit record with cards from department stores, oil companies, and airlines directly, as well as other charge accounts such as those of your professional suppliers. After a short period of prompt payment, apply for an American Express or Diners Club card, or for a MasterCard or Visa with a modest limit, which you eventually increase. If you are rejected by a credit card company, you are entitled to know why. If you feel the decision has been based on inaccurate or incomplete information, feel free to correct the situation and apply again.

Protecting Your Cards

Treat your cards like cash. On the road, leave cards that you don't need, such as department store cards, at home. Also leave a major card or two so that some spending power remains at home for emergencies.

Put some cards in the hotel safety-deposit box (not the safe in a small hotel) rather than carrying them all. Keep one card in a secret pocket of your camera bag along with some cash so that, if your wallet is lost or stolen, you have emergency funds immediately.

Have lists or photocopies of your cards with you and at home to facilitate replacement if they are lost. If you are concerned about the security of the lists themselves, change a designated digit by one for each entry. This coding will prevent someone from phoning in charges should they see these numbers.

Join a credit card registry like that offered through American Express. If all your cards are lost, you need only make one call to the registry's toll-free or collect number. They in turn will notify all the other banks and credit card institutions. Like any over-the-phone transaction, get a confirmation number or at least the operator code or ID of the individual on the line.

Be aware that, when you rent equipment, a merchant may call in an authorization for its full value as protection should the gear not be returned. In addition to destroying that back-up credit card voucher when you return the equipment, remind the merchant to remove the phone authorization, or it might limit your spending power for the billing cycle.

Request replacements for broken or fraying cards and try to keep the magnetic stripe on the back clean. Having your card read by computer saves your time as well as the merchant's.

If you are going on an expensive international trip, it is wise to let the major card companies know so they do not become alarmed when large charges start coming through from abroad. You can also learn your current balances so that you can pay them and clear the card before you leave.

Be alert to credit card fraud. Be sure the card a merchant returns to you is yours. The card should never leave your sight. Watch to see that only one imprint is made on the card. If an error occurs, be sure that the original voucher is destroyed. You may be asked to show more than one card for identification but you should never have to surrender more than the one card used for the charge itself. Never give your card number over the phone to anyone whose services you haven't solicited.

Special Features Offered by Credit and Charge Card Companies

In addition to their charging privileges, credit and charge card companies offer a wide range of special services that would require a separate book to detail fully. These services are constantly being enhanced, so it will be necessary to check with the various companies yourself for the latest news.

It is important to compare all the features offered by the different credit and charge card companies. American Express (800–528–4800; call 212–477–5700 in NY) features the following when you own their Personal Card: a network of 1,600 Travel Service Offices all over the world; Assured Hotel Reservations and Automatic Room Deposit; Express Check-in/Check-out services with participating hotels; Automatic Travel Insurance; Automatic Baggage Insurance; Emergency Cash programs; car rental loss and damage insurance; and cash withdrawals from over 22,000 automated teller machines. Cardmembers also receive copies of their actual charge slips with each monthly statement.

Of particular value to the location photographer is the Global Assist Hotline, a worldwide twenty-four-hour emergency medical and legal referral service that also assists cardmembers in setting up interpreters and transmitting urgent messages to family and associates. It also provides advance funds (charged to the card account) for hospitalization or bail up to $5,000 and emergency cash (in case of loss or theft) up to $500. It also offers pretrip Accu-weather reports for 220 cities around the world, as well as exchange rates and customs and inoculation information for trip planning. In the United States, call 800–554–AMEX; overseas, call collect 202–783–7474.

The American Express Moneygram enables you to send or receive your own funds instantly through American Express agents and a variety of service establishments, such as supermarkets and convenience stores, twenty-four hours a day.

Cardmembers have Purchase Protection and Buyer's Assurance plans automatically. Purchase Protection provides ninety days of automatic protection against accidental damage, loss, or theft of almost any retail item purchased with the card anywhere in the world. Buyer's Assurance automatically doubles—up to one additional year on manufacturer's warranties up to five years—the free repair period for products (except motor vehicles) purchased in the United States with the card.

In addition to the above, the American Express Gold Card offers a line of credit of at least $2,000 that can be transferred to you or used toward payment of your monthly statement; a year-end summary of charges broken down by expense category; Envoy, a twenty-four-hour personalized travel service; and car rental liability insurance.

If you qualify for and can afford it, the Platinum Card entitles you to a line of credit of $10,000 to $100,000; $500,000 automatic flight insurance; Travel Emergency Assistance, a twenty-four-hour worldwide legal and medical assistance program including free medical evacuation; Worldwide Personal Assistance, a multilingual network of telephone "concierges" to solve a variety of problems; complimentary nonresident membership at a number of private clubs; and Preferred Welcome at a number of exclusive service establishments in the United States, London, and Paris. You will also have a separate toll-free customer service number and, I have found, will get that extra touch of special service.

HEALTH, SECURITY, AND OTHER EMERGENCY PREPARATIONS

General Security Conditions

Keeping abreast of the world's hot spots is not easy these days, but it is vital to your security. In addition to keeping up to date with the press, consider consulting the following sources:

The *U.S. Government's Citizens Emergency Center* (202–647–5225) will provide the latest State Department travel advisories over the phone. (They are also available through CompuServe, the thirteen regional passport centers, travel agents, and other travel services. Travel advisories are issued when events abroad are likely to affect traveling Americans. They usually concern civil unrest, natural disasters, disease outbreaks, and long-term criminal activities directed against travelers. Many refer to temporary conditions and are canceled when the problem no longer poses a threat.

The Citizens Emergency Center can also inform you of the latest international visa requirements and is the number to call from anywhere in the world in an emergency when you cannot reach a U.S. consulate or embassy.

Bureau of Consular Affairs, Public Affairs Staff, Room 5807, Department of State, Washington, DC 20520. For a fine series of special pamphlets on travel tips to the Caribbean, Cuba, eastern Europe, Mexico, the Middle East, China, Saudi Arabia, southern Asia, and the USSR, send a stamped self-addressed envelope.

The International Travel Briefing Service, WSM Publishing Company, Box 466, Merrifield VA 22116 (800–322–4685) is an excellent commercial service covering a host of health and security dangers, as well as bureaucratic inconveniences awaiting the traveler. It is available by subscription monthly in two forms. One is a

convenient, densely packed, four-page world status map; the other a three-hundred-page computer diskette with more extensive one-to-three-page briefings on individual countries. The report relies on over 150 sources, the U.S. government among them.

Health Requirements and Concerns

Be as disciplined about routine maintenance of your body as you probably are about your cameras. I know several photographers who are obsessive about the acuity of their lenses but never visit an ophthalmologist. Schedule at least annual visits to your physician or internist and ophthalmologist and semiannual visits to your dentist. No one is immune from sudden health problems on the road, but the more you can anticipate difficulties, the better. Do not defer medical or dental procedures that are overdue. They will undoubtedly attack when you are hundreds of miles from the nearest physician.

At the end of this section are excerpts from the Centers for Disease Control's excellent publication, *Health Information for International Travel*, which is revised every June. It is available for purchase from the Government Printing Office (202–783–3238). The CDC updates important information every two weeks in their "Blue Sheets," which, while not available to the general public, are widely circulated to local health departments, physicians, travel agents, airlines, and other agencies advising the traveling public. In addition, you may want to refer to the following books and periodicals:

Control of Communicable Diseases in Man, American Public Health Association, 1015 Fifteenth Street N.W., Washington, DC 20005 (202–789–5600)

The Healthy Traveler, by Beth Weinhouse (New York: Pocket Books, 1987)

Health Guide for Travelers to Warm Climates, Canadian Public Health Association, 210–1335 Carling Avenue, Ottawa, Ontario K1Z 8N8 Canada

How to Stay Healthy Abroad, by Dr. Richard Dawood (New York: Penguin Books, 1988)

First Aid Book, U.S. Department of Labor, Mine Safety and Health Administration, 1980; contact the Government Printing Office (202–783–3238)

Travel Healthy: The Traveler's Complete Medical Kit, by Harold Silverman (New York: Avon, 1986)

You may want to consult the following sources, in addition to your regular physician:

Your local health department should be up to date on the latest health information. In some localities they will administer vaccinations, in others they do not, or do so only infrequently.

The Malaria Hotline of the Centers for Disease Control in Atlanta (404–639–1610): You should feel free to contact the CDC (404–639–3311) generally about esoteric or urgent information, but do not call them for routine inoculation or sanitary information. These inquiries should be directed to the local health department or a private clinic specializing in travel medicine (see below).

Immunization Alert, P.O. Box 406, Storrs, CT 06268 (203–487–0422): Dr. Kenneth Dardick's sophisticated health database is compiled from a number of sources and is used by many important corporations and organizations. A personalized report covering your itinerary can be purchased at reasonable cost even if you are not a subscriber.

International Association for Medical Assistance to Travelers, 417 Center Street, Lewistown, NY 14092 (716–754–4883): IAMAT's services are free, but this organization depends on contributions and is most worthy of your support. Contact them for an international list of English-speaking doctors as well as a superb medical record form to carry with you, information on malaria and other diseases, and sanitary conditions around the world.

Some clinics also specialize in emporiatrics, or travel health, including:

The New York Hospital–Cornell Medical Center, International Health Care Service, 440 East Sixty-ninth Street, New York, NY 10021 (212–746–1601)

Traveler's Medical Service, Dr. Martin S. Wolfe, 2141 K Street, Washington, DC 20037 (202–466–8109)

A free directory of specialists in traveler's health and tropical medicine, listing physicians who are members of the American Society of Tropical Medicine and Hygiene, is available by sending a self-addressed, stamped (90 cents) 9-by-12-inch envelope to Dr. Leonard C. Marcus, 148 Highland Avenue, Newton, MA 02160.

Be sure to carry your yellow World Health Organization inoculation record and all important medical information such as medication, allergy, and special illness requirements in your document kit. If you have any special medical conditions, you may want to wear a Medic Alert tag (800–344–3226). When you have your next blood test, find out your blood type for inclusion in your travel records. Remember that some inoculations require days or even weeks to incubate. Be sure to plan ahead.

GEOGRAPHICAL DISTRIBUTION OF POTENTIAL HEALTH HAZARDS TO TRAVELERS

This section was prepared by the World Health Organization, © World Health Organization 1989. It is reproduced, by permission, from International Travel and Health: Vaccination Requirements and Health Advice 1989 (Geneva: World Health Organization, 1989), pages 41 to 50.

This section is intended to give a broad indication of the health risks to which travelers may be exposed in various areas of the world and which they may not encounter in their usual place of residence.

In practice, to identify areas accurately and define the degree of risk likely in each of them is extremely difficult, if not impossible. For example, viral hepatitis A is ubiquitous, but the risk of infection varies not only according to area but also according to eating habits; hence, there may be more risk from communal eating in an area of low incidence than from eating in a private home in an area of high incidence. Generalizations may therefore be misleading.

Another factor is that tourism is an important source of income for many countries, and to label specific areas as being of high risk for a disease may be misinterpreted. However, this does not absolve national health administrations from their responsibility to provide an accurate picture of the risks from communicable diseases that may be encountered in various parts of their country.

Africa
Northern Africa (Algeria, Egypt, Libyan Arab Jamahiriya, Morocco, and Tunisia) is characterized by a generally fertile coastal area and a desert hinterland with oases that are often foci [centers] of infections.

The *arthropod-borne* diseases are unlikely to be a major problem to the traveler, though dengue fever, filariasis (focally [centered] in the Nile delta), leishmaniasis, malaria, relapsing fever, Rift Valley fever (in the east), sandfly fever, and typhus do occur. Small foci of plague have been reported in the Libyan Arab Jamahiriya.

Food-borne and water-borne diseases are endemic, the dysenteries and other diarrheal diseases being particularly common. The typhoid fevers and viral hepatitis A are common in some areas. Schistosomiasis (bilharziasis) is very prevalent both in the Nile delta area in Egypt and in the Nile valley; it occurs focally [in pockets] in other countries in the area. Alimentary helminthic infections, brucellosis, and giardiasis are common. Echinococcosis (hydatid disease) may occur.

Other hazards include poliomyelitis, trachoma, rabies, scorpion stings, and snake bite.

Sub-Saharan Africa (Angola, Benin, Burkina Faso, Burundi, Cameroon, Cape Verde, Central African Republic, Chad, Comoros, Congo, Côte d'Ivoire, Djibouti, Equatorial Guinea, Ethiopia, Gabon, Gambia, Ghana, Guinea, Guinea-Bissau, Kenya, Liberia, Madagascar, Malawi, Mali, Mauritania, Mauritius, Mozambique, Niger, Nigeria, Réunion, Rwanda, Sao Tome and Principe, Senegal, Seychelles, Sierra Leone, Somalia, Sudan, Togo, Uganda, United Republic of Tanzania, Zaire, Zambia, and Zimbabwe): In this area, entirely within the tropics, the vegetation varies from the tropical rain forests of the west and center to the wooded steppes of the east, and from the desert of the north through the Sahel and Sudan savannas to the moist orchard savanna and woodlands north and south of the equator.

Many of the diseases listed below occur in localized foci [pockets] and are confined to rural areas. They are mentioned so that the international traveler and the medical practitioner concerned may be aware of the diseases that may occur.

Arthropod-borne diseases are a major cause of morbidity [illness]. Malaria in the

severe falciparum, or malignant, form occurs throughout the area, except at over 3,000 meters [9,840 feet] altitude and on the islands of Cape Verde, Mauritius, Réunion, and Seychelles. Various forms of filariasis are widespread; endemic foci [regional pockets] of onchocerciasis, or river blindness, exist in all the countries listed except in the greater part of Kenya and in Djibouti, Gambia, Mauritania, Mozambique, Somalia, Zimbabwe, and the island countries of the Atlantic and Indian oceans. Both cutaneous [affecting the skin] and visceral [affecting the internal organs] leishmaniasis may be found, particularly in the drier areas. Human trypanosomiasis (sleeping sickness), mainly in small isolated foci, is reported from all countries except Djibouti, Gambia, Mauritania, Somalia, and the island countries of the Atlantic and Indian oceans. Relapsing fever and louse-, flea-, and tick-borne typhus occur. Natural foci of plague have been reported from Kenya, Madagascar, Mozambique, Uganda, the United Republic of Tanzania, and Zaire. Tungiasis is widespread in Africa. Many arthropod-borne virus diseases, including yellow fever, are endemic [found], with only scattered cases being reported and, from time to time, more extensive outbreaks.

Food-borne and water-borne diseases are highly endemic [prevalent]. Schistosomiasis (bilharziasis) is present throughout the area except in Cape Verde, Réunion, and the Seychelles. Alimentary helminthic infections, the dysenteries and diarrheal diseases, including cholera, giardiasis, the typhoid fevers, and viral hepatitis are widespread. Guinea-worm infection occurs in isolated foci [areas].

Poliomyelitis is endemic [found] in most countries except in Mauritius, Réunion, and the Seychelles. Trachoma is widespread. Among other diseases, certain frequently fatal arenavirus hemorrhagic fevers have attained notoriety. Lassa fever has a virus reservoir in a commonly found multimammate rat. Studies have shown that an appreciable reservoir exists in some rural areas of West Africa, and people visiting these areas should take particular care to avoid rat-contaminated food or food containers, but the extent of the disease should not be exaggerated. The animal reservoirs of Ebola and Marburg fevers have not yet been identified. Echinococcosis (hydatid disease) is widespread in animal-breeding areas.

Epidemics of meningococcal meningitis may occur throughout tropical Africa, particularly in the savanna areas during the dry season.

Other hazards include rabies and snake bites.

Southern Africa (Botswana, Lesotho, Namibia, Saint Helena, South Africa, and Swaziland) varies physically from the Namib and Kalahari deserts to fertile plateaus and plains and to the more temperate climate of the southern coast.

Arthropod-borne diseases such as malaria, plague, relapsing fever, Rift Valley fever, tick-bite fever, and typhus—mainly tick-borne—have been reported from most of this area except Saint Helena, but apart from malaria in certain areas, they are unlikely to be a major health problem for the traveler. Trypanosomiasis (sleeping sickness) may occur in Botswana and Namibia, and sporadic cases have been reported from northern Transvaal in South Africa.

Food-borne and water-borne diseases are common in some areas, particularly amebiasis and the typhoid fevers. Schistosomiasis (bilharziasis) is common in the northern and eastern parts of South Africa.

Snakes may be a hazard in some areas.

The Americas

North America (Bermuda, Canada, Greenland, Saint Pierre and Miquelon, and the United States of America, with Hawaii) extends from the Arctic to the subtropical cays of the southern United States.

The incidence of communicable diseases is such that they are unlikely to prove a hazard for the international traveler greater than that found in his or her own country. There are, of course, health risks, but in general the precautions required are minimal. Certain diseases occasionally occur, such as plague, rabies in wildlife including bats, Rocky Mountain spotted fever, tularemia, and arthropod-borne encephalitis. Other hazards include poisonous snakes, poison ivy, and poison oak. In the north, a serious hazard is the very low temperature in the winter.

In the United States, proof of immunization against diphtheria, measles, poliomyelitis, and rubella is now universally required for entry into school. In addition, the school entry requirements of most states include immunization against tetanus (forty-seven states), pertussis [whooping cough] (thirty-eight states), and mumps (thirty-four states).

Mainland Middle America (Belize, Costa Rica, El Salvador, Guatemala, Honduras, Mexico, Nicaragua, and Panama) ranges from the deserts of the north to the tropical rain forests of the southeast.

Of the *arthropod-borne* diseases, malaria exists in all eight countries, but in Costa Rica and Panama it is confined to a few areas and in Mexico, mainly to the west coast. Cutaneous [affecting the skin] and mucocutaneous [affecting the skin and mucous membranes] leishmaniasis occur in all eight countries. Onchocerciasis (river blindness) is found in two small foci [pockets] in the south of Mexico and four dispersed foci in Guatemala. American trypanosomiasis (Chagas' disease) has been reported to occur in localized foci in rural areas in all eight countries. Dengue fever and Venezuelan equine encephalitis may occur. There is a risk of contracting dengue fever in some areas of Mexico, especially during the months of July, August, and September.

The *food-borne and water-borne* diseases, including amebic and bacillary dysenteries and other diarrheal diseases, and the typhoid fevers are very common throughout the area, but cholera has not yet, during the current pandemic [outbreak], occurred here, nor in the Caribbean or South America. Viral hepatitis occurs throughout the area. Helminthic infections are common. Paragonimiasis (oriental lung fluke) has been reported in Costa Rica and Panama. Brucellosis occurs in the northern part of the area. Many *Salmonella typhi* infections from Mexico and *Shigella dysenteriae* type 1 infections from mainland Middle America as a whole have been caused by drug-resistant enterobacteria.

Poliomyelitis is reported from all countries except Costa Rica and Panama. Rabies in animals (usually dogs and bats) is widespread throughout the area. Snakes may be a hazard in some areas.

Caribbean Middle America (Antigua and Barbuda, Aruba, Bahamas, Barbados, British Virgin Islands, Cayman Islands, Cuba, Dominica, Dominican Republic, Grenada, Guadeloupe, Haiti, Jamaica, Martinique, Montserrat, Netherlands Antilles, Puerto Rico, Saint Kitts and Nevis, Saint Lucia, Saint Vincent and the Grenadines, Trinidad and Tobago, Turks and Caicos Islands, and the U.S. Virgin Islands:

The islands, a number of them mountainous, with peaks 1,000 to 2,500 meters [3,280 to 8,200 feet] high, have an equable tropical climate with heavy rainstorms and high winds at certain times of the year.

Of the *arthropod-borne* diseases, malaria occurs in endemic form [native to a region] only in Haiti and in the western part of the Dominican Republic; elsewhere it has been eradicated. Cutaneous [affecting the skin] leishmaniasis was recently discovered in the Dominican Republic. Bancroftian filariasis occurs in Haiti and some other islands and other filariases may occasionally be found. Outbreaks of dengue fever occur in the area, and dengue hemorrhagic fever has also occurred. Tularemia has been reported from Haiti.

Of the *food-borne and water-borne* diseases, bacillary and amebic dysenteries are common, and viral hepatitis is reported particularly in the northern islands. Schistosomiasis (bilharziasis) is endemic [found] in the Dominican Republic, Guadeloupe, Martinique, Puerto Rico, and Saint Lucia, in each of which control operations are in progress, and it may also occur sporadically in other islands.

Most of the islands are free from poliomyelitis, but it is still endemic in the Dominican Republic and Haiti. Other hazards may occur from spiny sea urchins and coelenterates (corals and jellyfish) and snakes. Animal rabies, particularly in the mongoose, is reported from several islands.

Tropical South America (Bolivia, Brazil, Colombia, Ecuador, French Guiana, Guyana, Paraguay, Peru, Suriname, and Venezuela) covers the narrow coastal strip on the Pacific Ocean, the high Andean range with numerous peaks 5,000 to 7,000 meters [16,000 to 23,000 feet] high, and the tropical rain forests of the Amazon basin, bordered to the north and south by savanna zones and dry tropical forest or scrub.

Arthropod-borne diseases are an important cause of ill health in rural areas. Malaria (in the falciparum, malariae, and vivax forms) occurs in all ten countries or areas, as do American trypanosomiasis (Chagas' disease) and cutaneous [affecting the skin] and mucocutaneous [affecting the skin and mucous membranes] leishmaniasis. There has been an increase of the latter in Paraguay. Visceral leishmaniasis [affecting the internal organs] is frequent in northeast Brazil, less frequent in other parts of Brazil and in Colombia and Venezuela, and rare in Bolivia, Paraguay, and Peru. Endemic onchocerciasis occurs in isolated foci [pockets] in rural areas in Ecuador, Venezuela, and northern Brazil. The bites of blackflies, the vectors [carriers] of onchocerciasis, may also transmit other filarial parasites or cause unpleasant and sometimes severe hemorrhagic reactions. Bancroftian filariasis is endemic [found] in parts of Brazil, French Guiana, Guyana, Suriname, and possibly Venezuela. Plague has been reported in natural foci in Bolivia, Brazil, Ecuador, and Peru. Among the arthropod-borne viral diseases, jungle yellow fever may be found in forest areas in all countries except Paraguay and areas east of the Andes; in Brazil it is confined to the northern and western states. Epidemics of viral encephalitis and dengue fever occur in some of the northern countries of this area. Bartonellosis, or Oroya fever, a sandfly-borne disease, occurs in arid river valleys on the western slopes of the Andes up to 3000 meters [9,840 feet]. Louse-borne typhus is often found in mountain areas of Colombia and Peru.

Food-borne and water-borne diseases are common and include amebiasis, diarrheal

diseases, helminthic infections, and viral hepatitis. The intestinal form of schistoso-miasis (bilharziasis) is found in Brazil, Suriname, and north-central Venezuela. Paragonimiasis (oriental lung fluke) has been reported from Ecuador and Peru. Brucellosis is common and echinococcosis (hydatid disease) occurs particularly in Peru.

Other diseases include a viral hemorrhagic fever that may be food-borne; this has been reported from Bolivia. Poliomyelitis is reported for all areas, but at a low incidence from French Guiana, Guyana, and Suriname.

Rabies has been reported from many of the countries in this area.

Meningococcal meningitis occurs in the form of epidemic outbreaks in Brazil.

Snakes and leeches may be a hazard in some areas.

Temperate South America (Argentina, Chile, Falkland Islands, and Uruguay): The mainland ranges from the Mediterranean climatic area of the western coastal strip over the Andes divide on to the steppes and desert of Patagonia in the south and to the prairies of the northeast.

The *arthropod-borne* diseases are relatively unimportant except for the widespread occurrence of American trypanosomiasis (Chagas' disease). Outbreaks of malaria occur in northwestern Argentina, and cutaneous [affecting the skin] leishmaniasis is also reported from the northeastern part of the country.

Of the *food-borne and water-borne* diseases, gastroenteritis (mainly salmonellosis) is relatively common in Argentina especially in suburban areas and among children below the age of five years. Typhoid fever is not very common in Argentina, but viral hepatitis and intestinal parasitosis are widespread, the latter especially in the coastal region. Taeniasis (tapeworm), typhoid fever, viral hepatitis, and echinococ-cosis (hydatid disease) are reported from the other countries.

No cases of poliomyelitis have been reported in recent years from Argentina, Chile, or Uruguay.

Among other diseases, anthrax is an occupational hazard in the three mainland countries. Animal rabies is endemic [found] in Argentina; it has increased in the last five years but is mainly confined to urban and suburban areas. Isolated cases of trachoma have been recorded in the northeast of Argentina and hemorrhagic fever is endemic in a limited zone of the pampas and in the center of the country.

Asia
East Asia (China, the Democratic People's Republic of Korea, Hong Kong, Japan, Macao, Mongolia, and the Republic of Korea): The area includes the high mountain complexes, the desert, and the steppes of the west, the various forest zones of the east, down to the subtropical forests of the southeast.

Among the *arthropod-borne* diseases, malaria now occurs only in China. Both Bancroftian and Malayan filariasis are reported, the former from China and the latter from China and the Republic of Korea. Visceral [affecting the internal organs] leishmaniasis and plague may be found in China. Epidemics of dengue fever, hemorrhagic fever with renal syndrome, and Japanese encephalitis may occur in this area, and tick-borne encephalitis is reported from China and the Republic of Korea. Mite-borne or scrub typhus may be found in scrub areas in southern China, certain river valleys in Japan, and in the Republic of Korea.

Food-borne and water-borne diseases such as the diarrheal diseases and viral hepatitis are common in most countries. Schistosomiasis (bilharziasis) can be acquired in many watercourses of southeastern and eastern China along the Chang Jiang (Yangtze) valley and its tributaries; active foci [areas of infection] no longer occur in Japan. Clonorchiasis (oriental liver fluke) and paragonimiasis (oriental lung fluke) are reported in China, Japan, and the Republic of Korea and fasciolopsiasis (giant intestinal fluke) in China.

Poliomyelitis has not been reported in recent years from Macao and Mongolia, and apart from China, the incidence is believed low in other countries in the area. Trachoma, brucellosis, and leptospirosis occur in China.

Eastern South Asia (Brunei Darussalam, Burma, Democratic Kampuchea, Indonesia, Lao People's Democratic Republic, Malaysia, the Philippines, Singapore, Thailand, and Vietnam): From the tropical rain and monsoon forests of the northwest, the area extends through the savanna and the dry tropical forests of the Indochina peninsula, returning to the tropical rain and monsoon forests of the islands bordering the South China Sea.

The *arthropod-borne* diseases are an important cause of morbidity [illness] throughout the area. Malaria and filariasis are endemic [found] in many parts of the rural areas of all the countries or areas—except for malaria in Brunei Darussalam and Singapore, where only imported cases occur. Foci [pockets] of visceral [affecting the internal organs] leishmaniasis and plague exist in Burma. Plague also occurs in Vietnam. Japanese encephalitis, dengue, and dengue hemorrhagic fever can occur in epidemics in both urban and rural areas. Mite-borne typhus has been reported in deforested areas in most countries.

Food-borne and water-borne diseases are common. Cholera and other watery diarrheas, amebic and bacillary dysentery, typhoid fever, and viral hepatitis may occur in all countries in the area. Schistosomiasis (bilharziasis) is endemic in the Philippines and in central Sulawesi (Indonesia) and occurs in small foci in the Mekong delta. Among other helminthic infections, fasciolopsiasis (giant intestinal fluke) may be acquired in most countries in the area; clonorchiasis (oriental liver fluke) in the Indochina peninsula; opisthorchiasis (cat liver fluke) in the Indochina peninsula, the Philippines, and Thailand; and paragonimiasis in the Philippines. Melioidosis can occur sporadically throughout the area.

Poliomyelitis is reported throughout the area, but the incidence is low in Malaysia, and it has been eliminated from Brunei Darussalam and Singapore. Trachoma exists in Burma, Indonesia, Thailand, and Vietnam.

Other hazards include rabies, snake bites, and leeches.

Middle South Asia (Afghanistan, Bangladesh, Bhutan, India, Islamic Republic of Iran, Maldives, Nepal, Pakistan, and Sri Lanka): Bordered for the most part by high mountain ranges in the north, the area extends from steppes and desert in the west to monsoon and tropical rain forests in the east and south.

Arthropod-borne diseases are endemic [found] in all of these countries except for malaria in the Maldives. In some of the other countries malaria occurs in urban as well as rural areas. Filariasis is common in Bangladesh and India. Visceral [affecting the internal organs] leishmaniasis and sandfly fever are on the increase. Cutaneous

[affecting the skin] leishmaniasis occurs in Afghanistan, India (Rajasthan), the Islamic Republic of Iran, and Pakistan. Tick-borne relapsing fever is reported from Afghanistan, India, and the Islamic Republic of Iran, and typhus occurs in Afghanistan and India. Epidemics of dengue fever may occur in Bangladesh, India, Pakistan, and Sri Lanka and the hemorrhagic form has been reported from eastern India and Sri Lanka. Japanese encephalitis has been reported from the eastern part of the area and Crimean-Congo hemorrhagic fever from the western part. Another tick-borne hemorrhagic fever has been reported in forest areas in Karnataka state in India and in a rural area of Rawalpindi district in Pakistan.

Food-borne and water-borne diseases are common throughout the area, in particular, cholera and other watery diarrheas, the dysenteries, typhoid fever, viral hepatitis, and helminthic infections. Giardiasis is said to be common in the Islamic Republic of Iran. A focus [pocket] of schistosomiasis (bilharziasis) exists in the southwest of the Islamic Republic of Iran. Foci of guinea-worm infection occur in India and in Sri Lanka.

Brucellosis and echinococcosis (hydatid disease) are found in many countries in the area.

Outbreaks of meningococcal meningitis have been reported in India and Nepal. Poliomyelitis is widespread. Trachoma is common in Afghanistan, India, the Islamic Republic of Iran, Nepal, and Pakistan. Snakes and the presence of rabies in animals are hazards in most of the countries in the area.

Western South Asia (Bahrain, Cyprus, Democratic Yemen, Iraq, Israel, Jordan, Kuwait, Lebanon, Oman, Qatar, Saudi Arabia, Syrian Arab Republic, Turkey, the United Arab Emirates, and Yemen): The area ranges from the mountains and steppes of the northwest to the large deserts and dry tropical scrub of the south.

The *arthropod-borne* diseases, except for malaria in certain areas, do not constitute widespread hazards for the traveler. Malaria does not exist in Kuwait, no longer occurs in Bahrain, Cyprus, Israel, Jordan, Lebanon, or Qatar, and its incidence in the Syrian Arab Republic is low, but elsewhere it is endemic [found] in certain rural areas. Cutaneous [affecting the skin] leishmaniasis and rare cases of visceral [affecting the internal organs] leishmaniasis are reported throughout the area. Murine [rodent-borne] and tick-borne typhus can occur in most countries. Tick-borne relapsing fever may occur. Crimean-Congo hemorrhagic fever has been reported from Iraq.

The *food-borne and water-borne* diseases are, however, a major hazard in most countries in the area. The typhoid fevers and viral hepatitis exist in all countries, and cholera has been reported from many of them. Schistosomiasis (bilharziasis) occurs in Democratic Yemen, Iraq, Saudi Arabia, the Syrian Arab Republic, and Yemen. Guinea-worm infection is found in some of these countries. Taeniasis (tapeworm) is reported from many countries in the area. Brucellosis is widespread, and there are foci [pockets] of echinococcosis (hydatid disease).

No cases of poliomyelitis have been reported from Cyprus in recent years, but it is endemic elsewhere in the area. In many countries trachoma and animal rabies may be a problem.

The greatest hazards to pilgrims to Mecca and Medina are heat and water depletion if the period of the hajj coincides with the hot season.

Europe
Northern Europe (Belgium, Czechoslovakia, Denmark—with the Faroe Islands) —Finland, German Democratic Republic, Federal Republic of Germany, Iceland, Ireland, Luxembourg, Netherlands, Norway, Poland, Sweden, USSR, United Kingdom—with the Channel Islands and the Isle of Man). The area encompassed by these countries extends from the broadleaf forests and the plains of the west to the boreal and mixed forest to be found as far as the Pacific Ocean.

The incidence of communicable diseases in most parts of the area is such that they are unlikely to prove a hazard to the international traveler greater than that found in his or her own country. There are, of course, health risks, but in the greater part of the area the precautions required are minimal.

Of the *arthropod-borne* diseases, there are very small foci [pockets] of malaria and cutaneous [affecting the skin] leishmaniasis in the southern USSR and tick-borne typhus in east and central Siberia. Tick-borne encephalitis, for which a vaccine exists, and hemorrhagic fevers may occur in the same areas.

The *food-borne and water-borne* conditions reported—other than the ubiquitous diarrheal diseases—are taeniasis (tapeworm) and trichinellosis in parts of northern Europe, and diphyllobothriasis (fish tapeworm) from the freshwater fish around the Baltic Sea area.

Rabies is endemic [found] in wild animals (particularly foxes) in rural areas of northern Europe excepting Finland, Iceland, Ireland, Norway, Sweden, and the United Kingdom.

A climatic hazard in part of northern Europe is the extreme cold in winter.

Southern Europe (Albania, Andorra, Austria, Bulgaria, France, Gibraltar, Greece, Hungary, Italy, Liechtenstein, Malta, Monaco, Portugal—with the Azores and Madeira—Romania, San Marino, Spain—with the Canary Islands—Switzerland, and Yugoslavia): The area extends from the broadleaf forests in the northwest and the mountains of the Alps to the prairies and, in the south and southeast, the scrub vegetation of the Mediterranean.

Among the *arthropod-borne* diseases, sporadic cases of murine [rodent-borne] and tick-borne typhus and mosquito-borne West Nile fever occur in some countries bordering the Mediterranean littoral [coast]. Both cutaneous [affecting the skin] and visceral [affecting the internal organs] leishmaniasis and sandfly fever are also reported from this area. Tick-borne encephalitis, for which a vaccine exists, and hemorrhagic fevers may occur in the eastern part of the area.

The *food-borne and water-borne* diseases—bacillary dysentery and other diarrheas, and typhoid fever—are more common in the summer and autumn months, with a high incidence in the southeastern and southwestern parts of the area. Brucellosis can occur in the extreme southwest and southeast and echinococcosis (hydatid disease) in the southeast.

Among other diseases, rabies in animals exists in most countries of southern Europe except Gibraltar, Malta, Monaco, Portugal, and Spain.

Oceania
Australia, New Zealand and the Antarctic. In Australia the mainland has tropical monsoon forests in the north and east, dry tropical forests, savanna and deserts in

the center, and Mediterranean scrub and subtropical forests in the south. New Zealand has a temperate climate, with the North Island characterized by subtropical forests and the South Island by steppe vegetation and hardwood forests.

International travelers to Australia and New Zealand will, in general, not be subjected to the hazards of communicable diseases to an extent greater than that found in their own country.

Arthropod-borne diseases (mosquito-borne epidemic polyarthritis and viral encephalitis) may occur in some rural areas of Australia. Dengue fever is present in parts of Northern Queensland and the Torres Strait islands.

Among the *food-borne and water-borne* diseases, amebic meningoencephalitis has been reported.

Coelenterates (corals, jellyfish) may provide a hazard to the sea bather, and effects from heat may occur in the northern and central parts of Australia.

Melanesia and Micronesia-Polynesia (American Samoa, Cook Islands, Easter Island, Fiji, French Polynesia, Guam, Kiribati, Nauru, New Caledonia, Niue, Palau, Papua New Guinea, Samoa, Solomon Islands, Tokelau, Tonga, Trust Territory of the Pacific Islands, Tuvalu, Vanuatu, and the Wallis and Futuna Islands): The area covers an enormous expanse of ocean with the larger, mountainous, tropical and monsoon rain-forest-covered islands of the west giving way to the smaller, originally volcanic peaks and coral islands of the east.

Arthropod-borne diseases occur in the majority of the islands. Malaria is endemic [found] in Papua New Guinea and is found as far east and south as Vanuatu. Neither malaria nor the anopheline vectors [mosquito carriers] are found in Fiji or the islands to the north and as far as French Polynesia and Easter Island in the east, nor in New Caledonia to the south. Filariasis is widespread, but its prevalence varies. Mite-borne typhus has been reported from Papua New Guinea. Dengue fever, including its hemorrhagic form, can occur in epidemics in most islands, and Japanese encephalitis has been reported.

Food-borne and water-borne diseases, such as the diarrheal diseases, typhoid fever, and helminthic infections, are commonly reported. Biointoxication may occur from raw or cooked fish and shellfish.

Poliomyelitis occurs in Papua New Guinea and trachoma in parts of Melanesia. Hazards to bathers are the coelenterates, poisonous fish, and sea snakes.

SPECIFIC RECOMMENDATIONS FOR VACCINATION AND PREVENTION OF ILLNESS

The following advice was prepared by the Centers for Disease Control to help international travelers prepare for and prevent health risks.

African Sleeping Sickness (trypanosomiasis) is confined to tropical Africa between 15° north and 20° south latitude. It is transmitted by the bite of the tsetse fly, a large gray-brown insect approximately the size of a honeybee, which bites by day. Chronic trypanosomiasis may not cause symptoms until months to years following travel to an endemic [infected] area, but acute trypanosomiasis frequently causes symptoms in travelers en route to or shortly after their return home, with incubation periods ranging from six to twenty-eight days. Fever, rash or skin lesions, lethargy, and confusion are usually the predominant signs and symptoms.

Although the risk to international travelers is relatively low, persons traveling to game parks and sparsely inhabited areas should take precautions. Tsetse flies appear to be attracted to moving vehicles and dark, contrasting colors. They are capable of biting through lighter-weight clothing. Areas of heavy infestation tend to be sporadically distributed and are usually well known to local inhabitants. Avoidance of such areas is the best means of prevention. Travelers at risk should use deet-containing insect repellents liberally and wear clothing of wrist and ankle length that blends with the background environment and is constructed of heavyweight fabric, such as canvas.

Amebiasis occurs worldwide, with a higher prevalence in areas of poor sanitation. It is a diarrheal disease caused by the protozoan parasite *Entamoeba histolytica*. Cysts (infectious stage of the parasite) are passed in human stools. Infection is acquired directly by the fecal–oral route or indirectly by ingesting cysts in fecally contaminated food or water.

American trypanosomiasis, or Chagas' disease, occurs throughout much of the Western Hemisphere from Central America to Argentina. It is usually transmitted by contact with feces of an infected reduviid bug; transmission may also occur through blood transfusion, transplacentally [to fetuses], or via breast milk. Reduviid bugs infest poorly constructed buildings, particularly those with cracks or crevices in the walls and roof. Avoidance of overnight stays in dwellings infested by the reduviid bug vector [carrier] eliminates the risk of acquiring the infection. Alternate control measures include insecticide spraying of infested houses and the use of bed netting.

Cholera is an acute intestinal infection caused by *Vibrio cholerae* O-group 1. The infection is often mild and self-limited or subclinical [not detectable with tests]. Persons with severe cases respond dramatically to simple fluid- and electrolyte-replacement therapy. Infection is acquired primarily by ingesting contaminated water or food; person-to-person transmission is rare.

Most countries do not require vaccination. Vaccination is not recommended routinely for travelers to countries that do not require an International Certificate of Vaccination against cholera as a condition for entry. The risk of cholera to U.S. travelers is so low that it is questionable whether vaccination is of benefit. Persons following the usual tourist itinerary who use standard accommodations in countries reporting cholera are at virtually no risk of infection. Travelers to cholera-infected areas are advised to avoid eating uncooked food and to peel fruits themselves. Carbonated bottled water and carbonated soft drinks are usually safe.

Currently available vaccines have been shown to provide only about 50 percent effectiveness in reducing clinical illness for three to six months after vaccination, with the greatest protection for the first two months.

For persons vaccinated in the United States for travel to countries that require vaccination, a single dose of vaccine is sufficient to satisfy country requirements. The complete primary series is suggested only for special high-risk groups that work and live in highly endemic [infected] areas under less than adequate sanitary conditions and those persons with compromised gastric defense mechanisms (such as antacid therapy, previous surgery for gastric or duodenal ulcer, or achlorhydria). The primary series need never be repeated for the booster doses to be effective.

Vaccination often results in one to two days of pain, erythema [redness of the skin], and induration [hardening] at the site of injection. The local reaction may be accompanied by fever, malaise, and headache. Serious reactions to vaccination are extremely rare. If a person has experienced a serious reaction to the vaccine, revaccination is not advisable. Specific information is not available on the safety of cholera vaccine during pregnancy. Therefore, it is prudent on theoretical grounds to avoid vaccinating pregnant women.

Dengue fever is a viral disease transmitted by mosquitoes, usually *Aedes aegypti* in urban outbreaks. Dengue viruses are endemic [found] in the South Pacific, in tropical countries of Asia, in most of the countries in the Caribbean, Mexico, and Central America, and in some South American and African countries. In 1986 and 1987, dengue activity in the Americas was reported mainly from Aruba, Brazil, El Salvador, Mexico, Nicaragua, and Puerto Rico. Small numbers of cases with severe and fatal hemorrhagic disease have been recognized in Aruba, El Salvador, Nicaragua, and Puerto Rico. It is not possible to predict future dengue incidence accurately; however, it is anticipated that there will be increased dengue transmission in the Americas during the next several years.

The illness is characterized by sudden onset, high fever, severe headache, joint and muscle pain, and rash. The rash appears three to four days after onset of fever and may spread from the torso to arms, legs, and face. Severe and sometimes fatal hemorrhagic disease may develop in a small percentage of cases.

The vector mosquito is active in the daytime and most frequently is found near human habitations where it breeds in containers containing relatively clean water such as discarded tires, cans, barrels, and cisterns.

The risk of dengue infection for the international traveler appears to be small; however, travelers to epidemic and endemic [infected] areas should take precautions to avoid mosquito bites. Travelers can reduce their risk of acquiring dengue by remaining in well-screened areas when possible. Outdoor exposure to mosquitoes can be reduced by wearing clothing that adequately covers the arms and legs and by applying mosquito repellent.

Travelers should advise their physician of any acute febrile [fever-related] illness occurring within one month after leaving an endemic area. There is no licensed vaccine against dengue fever.

Diphtheria, tetanus, and pertussis: Diphtheria remains a serious disease throughout much of the world. Most cases occur in unimmunized or inadequately immunized persons. Tetanus is a global health problem. The disease occurs almost exclusively in persons who are unimmunized or inadequately immunized or whose history is unknown. In developing countries most reported illness occurs in infants and young children. Pertussis [whooping cough] primarily occurs in children and is common in countries where immunization is not generally provided. It is highly communicable, often associated with complications, and has a relatively high case-fatality ratio in infants. [Most Americans receive the DTP series of vaccinations as children and so may be immune to them, but booster shots for diphtheria and tetanus may be advisable; check with your medical practitioner.]

Japanese encephalitis (JE) is a mosquito-borne viral encephalitis that may occur in epidemics in late summer and autumn in the temperate regions and the northern

part of tropical zones in Bangladesh, Burma, China, India, Japan, Kampuchea, Korea, Laos, Nepal, Thailand, Viet Nam, and eastern areas of the USSR. In endemic [infected] areas of JE, where there is no seasonal pattern, the risk is lower, but occasional outbreaks do occur. These areas include the tropical zones of south India, Indonesia, Malaysia, Philippines, Singapore, Sri Lanka, Taiwan, and south Thailand. Case fatality rates are generally reported to be about 20 percent. Children are most commonly infected in all regions, however, multiple factors, such as occupation, recreational exposure, sex (possibly reflecting exposure), previous vaccination, and naturally acquired immunity, alter the potential for age-related clinically evident disease. JE cases have a higher case-fatality rate in the elderly, whereas serious sequelae [aftereffects] are more frequent in the very young.

JE virus is transmitted by the bites of vector [carrier] mosquitoes; the species involved varies by geographic area. In China and many other areas, *Culex tritaeniorhyncus* is the principal vector [carrier]. This species feeds outdoors beginning at dusk and during evening hours and has a wide host range, including domestic animals, birds, and man. Larvae are found in flooded rice fields, marshes, and small stable collections of water around cultivated fields. The vectors [carriers] are present in greatest numbers from June through September throughout their distribution and are inactive in temperate zones during winter months. Swine and certain species of wild birds function as viremic reservoir hosts [the virus lives in their blood without harming them] in the transmission cycle. Habitats supporting the transmission cycle of JE virus are necessarily rural-agricultural. In many areas of Asia, however, the appropriate ecological conditions for virus transmission occur near or occasionally within urban centers.

The risk to short-term travelers and persons who confine their travel to urban centers is low. Persons at greatest risk are those living for prolonged periods of time in endemic or epidemic [infected] areas. In temperate areas such as China, the risk of transmission during the winter months is negligible. In subtropical and tropical areas, the risk of transmission is present throughout the year, but it is accentuated during the rainy season and early dry season when mosquito populations are highest. Travel in rural areas where rice culture and pig farming are common increases the risk of contracting JE. In such areas, use of window screens, insecticidal space sprays within screened quarters, mosquito repellent, and protective clothing to avoid mosquito bites is recommended.

JE vaccine is not produced in the United States, but it is made by several companies in Japan. The vaccine manufactured by Biken, Osaka, Japan,* has been in production for the longest time. Vaccination should be considered for persons who plan long-term residence in areas experiencing epidemic JE, especially when the traveler's activity will include trips into rural, farming areas or sleeping in unscreened quarters. Short-term travelers (less than one month), especially those restricting visits to major urban areas and staying in mosquito-proof quarters are at negligible risk of JE infection. Individual consideration of the level of risk should include an evaluation of the traveler's in-country activities relative to the risk factors

*Use of names is for identification only and does not imply endorsement by the Public Health Service or the U.S. Department of Health and Human Services.

described in the background information given above and recent information of the level of JE activity in the country. The location of a regional JE vaccination center in the United States may be obtained from DVBVD, CDC, Fort Collins (303–221–6429). Biken vaccine is not licensed for use in the United States but is available from CDC on a limited investigational basis.

The manufacturer recommends that JE vaccine should not be administered to persons acutely ill with fever and/or active infections, those with cardiac, renal, or hepatic disorders, leukemia, lymphoma, or other generalized malignancies, those with a history of hypersensitivities, and pregnant females. However, except for known hypersensitivity, most of these hypothetical contraindications should not preclude vaccination under medical supervision if the risk of exposure to the virus is significant.

Tick-borne encephalitis (TBE) is a viral infection of the central nervous system. It occurs in the USSR and eastern Europe from April through August when the principal tick vectors [carriers] are active. TBE is of particular importance in Austria, Czechoslovakia, the Germanys, Hungary, Poland, Switzerland, USSR, and northern Yugoslavia. It is less frequent in Bulgaria, Romania, Denmark, France, the Aland Islands and neighboring Finnish coastline, and along the coastline of southern Sweden, from Uppsala to Karlshamn. Serologic evidence for TBE infection or small numbers of cases have been found in Albania, Greece, Italy, Norway, and Turkey. Disease severity, incidence of sequelae [aftereffects], and case-fatality rates are higher in far eastern regions of the USSR and lower in central and eastern Europe.

Human infections are caused by tick bite, usually in persons who visit or work in forested areas or by consumption of unpasteurized dairy products from infected cows, goats or sheep. The risk to travelers who do not visit forested areas or consume unpasteurized dairy products is apparently low. The traveler should be advised to avoid tick-infested endemic [infected] areas or to institute rigorous tick protective measures including use of repellent formulations. The most effective repellents are those which contain the highest N,N diethyl-meta-toluamide (deet) concentration. Compounds containing permethrin that are used for treatment of clothing have an acaricidal [tick-killing] and repellent effect; clothing treated with this substance provides the most effective and long-term protection against tick bites. Consumption of unpasteurized dairy products should be avoided. Although an effective vaccine may be obtained in Europe from Immuno, Vienna, Austria, present data do not support a recommendation for its use in travelers to the endemic western European countries.

Giardiasis occurs worldwide. Transmission occurs from consumption of fecally contaminated water or food, exposure to fecally contaminated environmental surfaces, and by the fecal-oral route from person to person. Symptoms include diarrhea, abdominal cramps, fatigue, weight loss, flatulence, anorexia, or nausea, in various combinations, and usually last for more than five days. Fever and vomiting are uncommon. There is no known chemoprophylaxis [chemical preventive]. Persons who have prolonged gastrointestinal symptoms after returning from an endemic [infected] area should consult a physician.

Hepatitis A is an enterically transmitted [via the intestines] virus disease, which is highly endemic [often found] throughout the developing world but of low endemicity [rarely found] in developed countries such as the United States. In developing countries, hepatitis A is usually acquired during childhood, most frequently as an asymptomatic or mild infection. Transmission may occur by direct person-to-person contact; or from contaminated water, ice, or shellfish harvested from sewage-contaminated water; or from fruits, vegetables or other foods that are eaten uncooked but that may become contaminated during handling. The virus is deactivated by boiling or cooking to 85°C [185°F] (one minute); cooked foods cannot serve as vehicles for disease unless contaminated after cooking. Adequate chlorination of water as recommended in the United States will inactivate the hepatitis A virus.

The risk of acquiring hepatitis A for U.S. citizens traveling abroad varies with living conditions, length of stay, and incidence of hepatitis A in the area visited. Travelers to developed countries in Europe, North America, Japan, Australia, and New Zealand are at no greater risk of infection than in the United States. For travelers to developing countries, risk of infection can vary greatly and will be highest in those who live in or visit rural areas, trek in backcountry, or frequently eat or drink in settings of poor sanitation. Nevertheless, a recent study has shown that many cases of travel-related hepatitis A occur in travelers with "standard" tourist itineraries, accommodations, and food consumption behaviors.

In developing countries travelers should minimize their exposure to hepatitis A and other enteric [intestinal] diseases by avoiding potentially contaminated water or food. Drinking water (and beverages with ice) of unknown purity, uncooked shellfish, and uncooked fruits or vegetables that are not peeled or prepared by the traveler should be avoided.

Immune globulin (IG) prophylaxis (formerly called immune serum globulin and gamma globulin) is recommended for travelers to developing countries, especially those who will be living in or visiting rural areas, eating or drinking in settings of poor or uncertain sanitation, or who will have close contact with local persons, particularly young children, in settings with poor sanitation. Persons who plan to reside in developing countries should receive IG regularly.

Immune globulins prepared in the United States have few side effects (primarily soreness at the injection site) and have never been shown to transmit infectious agents (hepatitis B, non-A non-B hepatitis, or causative agent of AIDS (human immunodeficiency virus [HIV]). Recent specific laboratory studies have additionally shown that immune globulins prepared by the Cohn-Oncley procedure (the standard procedure used in U.S.-manufactured preparations) carry no risk of transmission of the AIDS virus (HIV). Pregnancy is not a contraindication to using immune globulin.

The risk of *hepatitis B virus* (HBV) infection for international travelers is generally low, except for certain travelers in countries with high HB endemicity [infection]. Factors to consider when assessing risk include: (1) the prevalence of HBV carriers in the local population, (2) the extent of direct contact with blood, or secretions, or of intimate sexual contact with potentially infected persons, and (3) the duration of travel.

The prevalence of HBV carriers is high (5 to 20 percent) in all socioeconomic groups in certain areas: all of sub-Saharan Africa, southeast Asia including China, Korea, and Indonesia, South Pacific Islands, interior Amazon Basin, and certain parts of the Caribbean, that is, Haiti and the Dominican Republic. It is moderate (1 to 5 percent) in North Africa, south-central and southwest Asia, Japan, eastern and southern Europe and the USSR, and most of Middle and South America. In northern and western Europe, North America, Australia, and New Zealand, HBV-carrier prevalence is low (less than 1 percent) in the general population.

Hepatitis B virus is primarily transmitted through activities that result in exchange of blood or blood-derived fluids; and through sexual activity, either heterosexual or homosexual, between an infected and a susceptible person. Principal activities that may result in blood exposure include work in health-care fields, that is, medical, dental, laboratory, which entail direct exposure to human blood; receipt of blood transfusions that have not been screened for HBV; and having dental, medical, or other exposure, such as acupuncture, tattooing, or drug abuse, to needles that have not been appropriately sterilized. In addition, in less developed areas, open skin lesions in children or adults due to factors such as impetigo, scabies, and scratched insect bites may play a role in disease transmission if direct exposure to wound exudates [oozing] occurs.

HB vaccination should be considered for several groups of travelers: health-care workers, persons residing for long-term in high-HB-endemicity [highly infected] countries, and certain short-term travelers to high-HB-endemicity areas. HB vaccination is currently recommended for all persons who work in health-care fields (medical, dental, laboratory, or other) that entail exposure to human blood. Previously unvaccinated persons who will work in health-care fields for any duration in high- or moderate-HB-endemicity [highly or moderately infected] areas are strongly advised to receive HB vaccine prior to such travel.

HB vaccination should also be considered for persons who plan to reside (for longer than six months) in areas with high levels of endemic [native] HB and who will have any of the previously discussed types of contact with the local population. In particular, persons who anticipate sexual contact with the local population, who will live in rural areas and/or have daily physical contact with local populations; and persons who are likely to seek medical, dental, or other treatment in local facilities during their stay should receive the vaccine. Vaccination should be considered for short-term travelers (less than six months) who will have direct contact with blood or sexual contact with residents of areas with high levels of endemic [native] HB infection.

The major side effects observed with hepatitis B vaccines during five years' use have been soreness and redness at the site of injection. Serious adverse reactions, including neurological events, have been reported rarely. The production process for the plasma-derived vaccine has been shown to inactivate representatives of all classes of viruses found in blood, including the causative agent of AIDS (HIV).

Specific data are not available on the safety of the vaccine for the developing fetus, but because it contains only noninfectious HBsAg particles, administration of vaccine to pregnant women is not considered to constitute a risk to the fetus. In con-

trast, HBV infection in a pregnant woman may result in serious disease for the mother and chronic infection for the newborn. Pregnancy is not a contraindication to the use of this vaccine for persons at risk.

In recent years, epidemic and endemic transmission of *non-A, non-B hepatitis* spread by water or close personal contact has been reported from several areas of southern Asia (southern USSR, Pakistan, Indian subcontinent, Burma, Indonesia), North Africa, and from rural areas of central Mexico. Such epidemics generally affect adults and cause an unusually high mortality in pregnant women. The disease has been transmitted to experimental animals and candidate viruses have been identified; however, no serologic tests have yet been developed. Several cases of this form of non-A, non-B hepatitis have been imported into the United States, but it is not known whether the causative agent is endemic [found] in the United States or western Europe.

Travelers to areas where enterically transmitted [via the intestines] non-A, non-B hepatitis occurs may be at some risk of acquiring this disease by close contact with cases or through contaminated food or water. The value of immune globulin (IG) in prevention of this infection is unknown. Travelers to these areas should receive IG for protection against hepatitis A, but they should not assume that they are protected against enterically transmitted non-A, non-B hepatitis. The best prevention of infection is to avoid potentially contaminated food and water, as with hepatitis A and other enteric [intestinal] infections.

Lassa fever is known to be endemic [found] only in rural western Africa. It is spread by direct or indirect contact with infected rodents and by direct person-to-person transmission. The risk of infection in international travel is considered small.

Leishmaniasis occurs in both a cutaneous [affecting the skin] and a visceral [affecting the internal organs] form. It is a disease of rural tropical and subtropical areas throughout the world and is a common problem in the Middle East, Africa, and Latin America. The disease is transmitted by the bite of the phlebotomine sandfly which is comparable in size to a gnat or midge. Visceral leishmaniasis causes fever, enlargement of the spleen and liver, and anemia, while the cutaneous form manifests as a painless, nonhealing ulcer at the site of a sandfly bite. Preventive measures include the avoidance of sandfly habitats and the use of insect repellents, protective clothing, and bed nets.

Malaria in humans is caused by one of four protozoan species of the genus *Plasmodium: P. falciparum, P. vivax, P. ovale, and P. malariae.* All are transmitted by the bite of an infected female *Anopheles* mosquito. Occasionally transmission occurs by blood transfusion or congenitally from mother to fetus. The disease is characterized by fever and flulike symptoms, including chills, headache, myalgias [muscle pain], and malaise, which may occur at intervals. Malaria may be associated with anemia and jaundice, and *P. falciparum* infections may cause kidney failure, coma, and death. Deaths due to malaria are preventable.

Malaria transmission occurs in large areas of Central and South America, sub-Saharan Africa, the Indian subcontinent, southeast Asia, the Middle East, and Oceania. The estimated risk of acquiring malaria varies markedly from area to area. This variability is a function of the intensity of transmission in both urban and rural areas

within the various regions and also a function of the itineraries of most travelers to the various areas. For example, during 1983 to 1986, 634 cases of *P. falciparum* among American civilians were reported to the CDC. Of these, 507 (80 percent) were acquired in sub-Saharan Africa, 44 (7 percent) were acquired in southeast Asia, and 63 (10 percent) were acquired in the Caribbean and South America. Of the 28 fatal infections, 21 were acquired in sub-Saharan Africa. Thus, the preponderance of imported malaria among American travelers was acquired in sub-Saharan Africa, despite the fact that only an estimated 90,000 Americans travel to sub-Saharan Africa each year, versus an estimated 900,000 American travelers to southeast Asia and South America each year. This disparity in the risk of acquiring malaria stems from the fact that travelers to Africa are at risk in most rural and many urban areas and moreover tend to spend considerable amounts of time, including evening and night-time hours, in rural areas where malaria risk is highest. In contrast, most travelers to southeast Asia (Thailand, Indonesia, Malaysia, People's Republic of China, and the Philippines) and South America spend most of their time in urban or resort areas where there is limited, if any, risk of exposure, and only travel to rural areas during daytime hours, when there is limited risk of infection.

All travelers to malarious areas of the world are advised to use an appropriate drug regimen and personal protection measures to prevent malaria. However, travelers must be informed that, regardless of methods employed, it is still possible to contract malaria. Malaria symptoms can develop as early as eight days after initial exposure in a malaria-endemic [infected] area and as late as months after departure from a malarious area, after chemoprophylaxis [chemical preventive treatment] has been completed. It is important for travelers to understand that malaria can be treated effectively early in the course of the disease but that delaying appropriate therapy can have serious or even fatal consequences. Individuals who have the symptoms of malaria should seek prompt medical evaluation, including thick and thin malaria smears, *as soon as possible.*

Because of the nocturnal feeding habits of *Anopheles* mosquitoes, malaria transmission occurs primarily between dusk and dawn. Travelers must be advised of the importance of measures to reduce contact with mosquitoes during those hours. Such measures include remaining in well-screened areas, using mosquito nets, and wearing clothes that cover most of the body. Additionally, travelers should be advised to purchase insect repellent before travel for use on exposed skin. The most effective repellents contain N,N diethylmetatoluamide (deet), an ingredient in many commercially available insect repellents. The actual concentration of deet varies among repellents (ranging up to 95 percent); the higher the concentration, the longer lasting the repellent activity. Travelers should also be advised to purchase a pyrethrum-containing flying-insect spray to use in living and sleeping areas during evening and nighttime hours.

Malaria chemoprophylaxis is the use of drugs to prevent the development of the disease. Malaria chemoprophylaxis should preferably begin one to two weeks prior to travel to malarious areas. In addition to assuring adequate blood levels of the drug, this allows any potential side effects to be evaluated and treated by the traveler's own physician. The exception to this is doxycycline, which should be begun

one to two days prior to entry into a malarious area. Chemoprophylaxis should continue during travel in the malarious areas and for four weeks after leaving the malarious areas.

In choosing an appropriate chemoprophylactic regimen prior to travel, several factors should be taken into consideration. The travel itinerary should be reviewed in detail and compared with the information on areas of risk within a given country to determine whether the traveler will actually be at risk of acquiring malaria. It should also be determined whether the traveler will be at risk of acquiring chloroquine-resistant *P. falciparum* (CRPF) malaria. In addition, it should be established whether the traveler has previously experienced an allergic or other reaction to the antimalarial drug of choice, and whether medical care will be readily accessible during travel. [Consult your medical practitioner for full details about antimalarial drugs.]

Measles (rubeola) is often a severe disease. Measles elimination efforts in the United States have resulted in record low numbers of reported measles cases. The low numbers of cases mean that there are decreasing chances that individuals will be exposed to natural measles; unvaccinated persons may reach older ages still susceptible to measles. The risk of exposure to measles outside the United States may be high. As many as 20 percent of all the cases reported in the United States between 1981 and 1987 were internationally imported cases or resulted from an imported case. Many of these were among returning U.S. citizens exposed abroad. Although vaccination against measles is not a requirement for entry into any country, all travelers are strongly urged to be immune to measles. In general, persons can be considered immune to measles if they have documentation of physician-diagnosed measles, laboratory evidence of measles immunity, or proof of adequate immunization with live measles vaccine on or after the first birthday. However, because measles vaccine is not 100 percent effective and because the risk of exposure to measles abroad may be substantially greater than in the United States, consideration should be given to providing persons born after 1956 who travel abroad a one-time dose of measles vaccine regardless of their prior immunization status, unless there is a contraindication. Most persons born before 1957 are likely to have been infected naturally and generally need not be considered susceptible. Live measles vaccine should not be given to females known to be pregnant. [Consult your medical practitioner to learn more about side effects of measles vaccine.]

Vaccination against *meningococcal disease* is not a requirement for entry into any country. Vaccine is indicated for travelers to countries recognized as having epidemic meningococcal disease. In sub-Saharan Africa epidemics of meningococcal disease occur frequently during the dry season (December through June), particularly in the savannah areas extending from Mali eastward to Ethiopia. Meningococcal disease in Americans traveling in such areas is rare. However, because of the lack of established surveillance and timely reporting from many of these countries, travelers to this region during the dry season should receive meningococcal vaccine, especially if prolonged contact with the local populace is likely. Advisories for travelers to other countries will be issued when epidemics of meningococcal disease are recognized.

The safety of meningococcal vaccines in pregnant women has not been established, although the use of the vaccine in pregnant women during an epidemic in Brazil resulted in no adverse effects. On theoretical grounds, it is prudent not to use the vaccines unless there is a substantial risk of infection.

Mumps is primarily a disease of young, school-age children. Vaccination against mumps is not a requirement for entry into any country. Susceptible children, adolescents, and adults should be vaccinated with a single dose of vaccine unless vaccination is contraindicated. Combination with measles and rubella vaccines should be considered. Mumps vaccine can be of particular value for children approaching puberty and for adolescents and adults, particularly males, who have not had mumps. Persons can be considered susceptible unless they have documentation of (1) previous vaccination on or after the first birthday, (2) physician-diagnosed mumps, or (3) laboratory evidence of immunity. Most adults are likely to have been infected naturally and generally may be considered immune, even if they did not have clinically recognizable disease. Because there is no evidence that persons who have previously either received the vaccine or had mumps are at any risk of local or systemic reactions from receiving live mumps vaccine, testing for susceptibility before vaccination is unnecessary. [Consult your medical practitioner for precautions for mumps vaccine.]

Plague continues to be enzootic [affecting animals in a particular area] in rural rodent populations on several continents with occasional outbreaks among rodents in villages and small towns. Wild rodent plague poses a real, though small, risk to humans. When domestic or peridomestic rodents become involved in urban or populated areas, humans are at markedly increased risk of exposure. Wild rodent plague exists in the western third of the United States, in widely scattered areas of South America, in north-central, eastern, and southern Africa, Iranian Kurdistan, along the frontier between Yemen and Saudi Arabia, central and southeast Asia (Burma, China, Indonesia, and Vietnam), and the USSR. In recent years, human plague has been reported from Angola, Kenya, Lesotho, Madagascar, Mozambique, Namibia, South Africa, Tanzania, Uganda, Zimbabwe, Zaire, Burma, China, Vietnam, United States, Brazil, Bolivia, Ecuador, and Peru. Risk to travelers in any of these areas is small.

Vaccination against plague is not required by any country as a condition for entry. There is no need to vaccinate persons other than those who are at particularly high risk of exposure because of research activities or certain field activities in epizootic areas [those with infected animals]. In most of the countries of Africa, Asia, and the Americas where plague is reported, the risk of exposure exists primarily in rural mountainous or upland areas. Vaccination is not indicated for most travelers to countries reporting cases, particularly if their travel is limited to urban areas with modern hotel accommodations.

Selective vaccination might be considered but not required for persons who will have direct contact with rodents or other animals in plague-epizootic areas [those with infected animals], persons who will reside or work in plague-enzootic rural areas [those with infected animals] where avoidance of rodents and fleas is difficult,

and laboratory personnel or veterinarians who work regularly with *Yersinia pestis* organisms or potentially plague-infected animals in enzootic [infected-animal] areas.

Travelers to countries where **poliomyelitis** is epidemic or endemic [found] are considered to be at increased risk of poliomyelitis and should be fully immunized. In general, travelers to developing countries should be considered to be at increased risk of exposure to wild poliovirus. Unvaccinated or partially vaccinated travelers should complete a primary series with the vaccine that is appropriate to their age and previous immunization status. Persons who have previously received a primary series may need additional doses of a polio vaccine before traveling to areas with an increased risk of exposure to wild poliovirus. [Consult your medical practitioner for details about polio vaccines.]

Travelers to **rabies**-endemic [infected] countries should be warned about the risk of acquiring rabies outside the United States. Rabies vaccination is not a requirement for entry into any country. Rabies is almost always transmitted by bites that introduce the virus into wounds. Very rarely, rabies has been transmitted by nonbite exposures which introduce the virus into open cuts or mucous membranes. Although dogs are the main reservoir [transmitter] of the disease in many developing countries, the epidemiology of the disease in animals differs sufficiently from one region or country to another to warrant the evaluation of all animal bites. Any animal bite or scratch should receive prompt local treatment. When wounds are thoroughly cleansed with copious amounts of soap and water, the risk of rabies is significantly reduced; but persons who are exposed should always contact local health authorities immediately for advice about postexposure prophylaxis [preventives] and, upon returning to the United States, should contact their physician or local health department.

Preexposure vaccination with human diploid cell rabies vaccine (HDCV) is recommended for persons living in or visiting (for more than thirty days) countries where rabies is a constant threat, as well as for most veterinarians, animal handlers, spelunkers, and certain laboratory workers. The risk of rabies is highest in countries where dog rabies remains highly endemic [prevalent], including but not limited to parts of Colombia, Ecuador, El Salvador, Guatemala, India, Mexico, Nepal, Philippines, Sri Lanka, Thailand, and Vietnam. The disease is also endemic [found] in dogs in most of the other countries of Africa, Asia, Central and South America except as noted in Table 2. For international travelers, preexposure prophylaxis [preventive measures] may provide protection when there is an inapparent or unrecognized exposure to rabies and when postexposure therapy is delayed. This is of particular importance for persons at high risk of being exposed in countries where the available rabies immunizing products carry a high risk of adverse reactions. Preexposure vaccination does not eliminate the need for additional therapy after a rabies exposure but simplifies postexposure treatment by eliminating the need for rabies immune globulin (RIG) and by decreasing the number of doses of vaccine required.

Table 2 lists countries that have reported no cases of rabies during the most recent two-year period for which information is available (formerly referred to as "rabies-

TABLE 2. COUNTRIES REPORTING NO CASES OF RABIES*

Africa	Mauritius.[†]
Americas	**North:** Bermuda; St. Pierre and Miquelon.
	Caribbean: Anguilla; Antigua and Barbuda; Bahamas; Barbados; Cayman Islands; Dominica; Guadeloupe; Jamaica; Martinique; Montserrat; Netherlands Antilles (Aruba, Bonaire, Curacao, Saba, St. Maarten, and St. Eustatius); Redonda; St. Christopher (St. Kitts) and Nevis; St. Lucia; St. Martin; St. Vincent; Turks and Caicos Islands; Virgin Islands (U.K. and U.S.).
	South: Uruguay.[†]
Asia	Bahrain; Brunei Darussalam; Japan; Kuwait; Malaysia (Malaysia-Sabah[†]); Maldives[†]; Oman[†]; Singapore; Taiwan.
Europe	Bulgaria[†]; Faroe Islands; Finland; Iceland; Ireland; Malta; Norway; Portugal[†]; Sweden; United Kingdom.
Oceania	American Samoa; Australia; Belau (Palau); Cook Islands; Federated States of Micronesia (Kosrae, Ponape, Truk, and Yap); Fiji; French Polynesia; Guam; Kiribati; New Caledonia; New Zealand; Niue; Northern Mariana Islands; Papua New Guinea; Samoa; Solomon Islands; Tonga; Vanuatu. Most of Pacific Oceania is "rabies-free." For information on specific islands not listed, contact the Centers for Disease Control, Division of Quarantine.

*Bat rabies should be considered separately.

[†]Countries that have only recently reported no cases of rabies; these classifications should be considered provisional.

free countries"). Additional information can be obtained from local health authorities of the country or the embassy or local consulate general's office in the United States.

Rift valley fever (RVF) is a viral disease that affects primarily livestock and humans. It is transmitted by several means including mosquitoes, and percutaneous [through the skin] inoculation or inhalation of aerosols from contaminated blood or fluids of infected animals. The risk of RVF infection to persons who travel to endemic [infected] areas is considered to be low. Rarely outbreaks occur involving large numbers of human cases, an example being the lower Nile delta, Egypt (1978) and the lower Senegal River basin of Mauritania (1987). Travelers can reduce the risk of exposure by avoiding contact with livestock and minimizing exposure to mosquito bites. No commercial vaccine is available for immunization of persons against RVF.

Rubella [German measles] infection may be associated with significant morbidity [illness] in adults and is associated with a high rate of fetal wastages or anomalies [miscarriage and deformity] if contracted in the early months of pregnancy. The risk of exposure to rubella outside the United States may be high. Therefore, although vaccination against rubella is not a requirement for entry into any country, all travelers, particularly women of childbearing age, should be immune to rubella. Persons should be considered to be susceptible to rubella unless they have documentation of

(1) previous vaccination on or after the first birthday or (2) laboratory evidence of immunity. A single dose of rubella virus vaccine is recommended for all susceptible children, adolescents, and adults, particularly females, unless vaccination is contraindicated. Combination with measles and mumps vaccines should be considered. Because there is no evidence that persons who have previously either received the vaccine or had rubella are at any risk of local or systemic reactions from receiving live rubella vaccine, testing for susceptibility before vaccination is unnecessary. [Consult your medical practitioner for details on precautions for rubella vaccine.]

Schistosomiasis, an infection estimated to occur worldwide among some 200 million people, is caused by flukes whose complex life cycles utilize specific freshwater snails as intermediate hosts. Infected snails release large numbers of minute free-swimming larvae (cercariae), which are capable of penetrating the unbroken skin of the human host. The risk of becoming infected and the intensity of infection is a function of the frequency and degree of water contact. Exposure to schistosomiasis is a health hazard for U.S. citizens who travel to endemic [infected] areas of the Caribbean, South America, Africa, and Asia. The countries where schistosomiasis is most prevalent include Brazil, Puerto Rico, and St. Lucia; Egypt and most of sub-Saharan Africa; and southern China, the Philippines, and southeast Asia. Those at greatest risk are travelers who engage in wading or swimming in fresh water in rural areas where poor sanitation and appropriate snail hosts are present; it cannot be acquired by wading or swimming in salt water (oceans or seas).

Clinical manifestations of acute infection can ensue as early as two to three weeks after water exposure. The most common acute symptoms are: fever, lack of appetite, weight loss, abdominal pain, weakness, headaches, joint and muscle pain, diarrhea, nausea, and cough. Rarely, the central nervous system can be involved. Chronic infections can cause disease of the lung, liver, intestines, and/or bladder. Many people who develop chronic infections can recall no symptoms of acute infection. Diagnosis of infection is usually confirmed by finding schistosome eggs on microscopic examination of stool and urine. Eggs can be found six to eight weeks after exposure. Safe and effective oral drugs are available for treatment of schistosomiasis.

Since there is no practical way for the traveler to distinguish infested from noninfested water, freshwater swimming in rural areas of endemic countries should be avoided. In such areas heating bathing water to 50°C (122°F) for five minutes or treating it with iodine or chlorine in a manner similar to the precautions recommended for preparing drinking water will destroy cercariae and make the water safe. Thus, swimming in chlorinated swimming pools is virtually always safe, even in endemic countries. Filtering water with a light woven cloth or with paper coffee filters may also be effective in removing cercariae from bathing water. If these measures are not feasible, allowing bathing water to stand for three days is advisable since cercariae survive only 48 hours. If accidental exposure to suspected water occurs, immediate and vigorous towel drying or rapid application of rubbing alcohol to the exposed areas will reduce the risk of infection. At this time there are no available drugs known to be effective as chemoprophylactic [chemical preventive] agents.

Upon return from foreign travel, if you think you may have been exposed to

schistosomiasis-infected fresh water, be sure to see a physician to undergo screening tests.

In May 1980 the World Health Organization (WHO) declared the global eradication of **smallpox**. There is no evidence of smallpox transmission anywhere in the world. The last reported case of endemic smallpox occurred in Somalia in October 1977, and the last reported case of laboratory-acquired smallpox occurred in the United Kingdom in 1978. WHO amended the International Health Regulations January 1, 1982, deleting smallpox from the diseases subject to the regulations. *Smallpox vaccination should **not** be given for international travel.* The risk from smallpox vaccination, although very small, now exceeds the risk of smallpox; consequently, smallpox vaccination of civilians is indicated ***only*** *for laboratory workers directly involved with smallpox or closely related orthopox viruses, for example, monkeypox, vaccinia, and others.*

Smallpox vaccine should never be used therapeutically. There is no evidence that vaccination has therapeutic value in the treatment of recurrent herpes simplex infection, warts, or any other disease.

In many countries **tuberculosis** is much more common than in the United States, but it is not a major hazard to U.S. travelers. To become infected, a person usually would have to spend a long time in a closed environment where the air was contaminated by a person with untreated tuberculosis who is coughing and has numerous organisms in secretions from the lungs. Tuberculosis infection is generally transmitted through the air; therefore, there is virtually no danger of its being spread by dishes, linens, and items that are touched, or by food; however, it can be transmitted through unpasteurized milk or milk products.

A traveler who anticipates possible prolonged exposure to tuberculosis should have a tuberculin skin test before leaving and, if negative, a repeat test after returning to the United States. Travelers who already have a significant tuberculin reaction are unlikely to be reinfected. Persons who are infected or who become infected can be treated to prevent tuberculosis. Travelers who suspect that they have been exposed to tuberculosis should inform their physician of the possible exposure.

Typhoid vaccination is not required for international travel, but it is recommended for travelers to areas where there is a recognized risk of exposure to *Salmonella typhi*, the organism that causes typhoid fever. *Salmonella typhi* is transmitted by contaminated food and water and is prevalent in many countries of Africa, Asia, and Central and South America. Vaccination is particularly recommended for travelers who will have prolonged exposure to potentially contaminated food and water in smaller cities and villages or rural areas off the usual tourist itineraries.

Several different preparations of typhoid vaccine have been shown to protect 70 to 90 percent of recipients, depending in part on the degree of subsequent exposure. However, even travelers who have been vaccinated should use caution in selecting food and water.

Information is not available on the safety of the vaccine during pregnancy; therefore, it is prudent on theoretical grounds to avoid vaccinating pregnant women.

Typhoid vaccination often results in discomfort at the site of injection for one to

two days. The local reaction may be accompanied by fever, malaise, and headache.

The effectiveness of paratyphoid A vaccine has never been established, and field trials have shown that the usually small amounts of paratyphoid B antigens contained in vaccines combining typhoid and paratyphoid A and B antigens ("TAB" vaccines) are not effective. Knowing this and recognizing that combining paratyphoid A and B antigens with typhoid vaccine increases the risk of vaccine reaction, typhoid vaccine should be used alone.

Vaccination against *typhus* is not required by any country as a condition for entry. Only in mountainous highlands or in areas where a cold climate and other local conditions favor louse infestation does a potential threat exist. Cases of epidemic typhus are generally reported from mountainous regions of Mexico, Central and South America, the Balkans, eastern Europe, Africa, and Asia. Even in these places, however, the risk of typhus for American travelers is extremely low, and treatment with tetracycline or chloramphenicol is curative. No typhus cases are known to have occurred in an American traveler since 1950.

Production of typhus vaccine in the United States has been discontinued, and currently there are no plans for commercial production of new vaccine.

Urban and jungle *yellow fever* occur only in parts of Africa and South America. Urban yellow fever is an epidemic viral disease of humans transmitted from infected to susceptible persons by the *Aedes aegypti* mosquito. Jungle yellow fever is an enzootic viral disease [affecting animals in a particular area] transmitted among nonhuman primate hosts by a variety of mosquito vectors [carriers].

For purposes of international travel, yellow fever vaccines produced by different manufacturers worldwide must be approved by WHO and administered at an approved Yellow Fever Vaccination Center. State and territorial health departments have the authority to designate nonfederal vaccination centers; these can be identified by contacting state or local health departments (CDC does not maintain a listing of the designated centers). Vaccinees should receive an International Certificate of Vaccination completed, signed, and validated with the center's stamp where the vaccine is given.

A number of countries require a certificate from travelers arriving from infected areas or from countries with infected areas. Some countries in Africa require evidence of vaccination from all entering travelers. Some countries may waive the requirements for travelers coming from noninfected areas and staying less than two weeks. Vaccination is also recommended for travel outside the urban areas of countries that do not officially report the disease but that lie in the yellow fever endemic [infected] zone [see figures 3 and 4]. It should be emphasized that the actual areas of yellow fever virus activity far exceed the infected zones officially reported and that, in recent years, fatal cases of yellow fever have occurred in unvaccinated tourists visiting rural areas within the yellow fever endemic zone.

Some countries require an individual, even if only in transit, to have a valid International Certificate of Vaccination if he or she has been in countries either known or thought to harbor yellow fever virus. Such requirements may be strictly enforced,

Figure 3. Yellow fever endemic zones in Africa. Note: Although the "yellow fever endemic zones" are no longer included in the International Health Regulations, a number of countries (most of them being not bound by the regulations or bound with reservations) consider these zones as infected areas and require an International Certificate of Vaccination against Yellow Fever from travelers arriving from those areas. The above map based on information from WHO is therefore included for practical reasons.

particularly for persons traveling from Africa or South America to Asia. [Consult your medical practitioner for details about yellow fever vaccine.]

Insurance

Insurance is an increasingly complicated affair, and you should discuss your needs with a trusted broker. Of particular interest are the comprehensive photographer's policies that have evolved in the last few years. Contact the brokers listed for full details; some features of the policies are summarized below.

Figure 4. Yellow fever endemic zones in the Americas. Note: Although the "yellow fever endemic zones" are no longer included in the International Health Regulations, a number of countries (most of them being not bound by the regulations or bound with reservations) consider these zones as infected areas and require an International Certificate of Vaccination against Yellow Fever from travelers arriving from those areas. The above map based on information from WHO is therefore included for practical reasons. In addition to areas shaded (WHO, 1988), CDC recommends vaccination for the entire state of Mato Grosso in Brazil.

Photopac, Burnham & Company, 482 Hudson Terrace, Box 1096, Englewood Cliffs, NJ 07632 (201–568--9800; 212–563–7000): In association with Chubb Insurance, this is an excellent policy that has pioneered the concept of "production" insurance for photographers. Some of its standard features include negative film, faulty stock, faulty camera and processing; equipment floater at replacement value; props, set, and wardrobe coverage; extra reshooting expenses, third party property damage liability. A number of optional coverages are also available.

Pro-Surance, Taylor & Taylor, Inc., 260 Madison Avenue, New York, NY 10016 (800–922–1184; 212–686–1406): Another fine policy, it has been officially en-

dorsed by ASMP and includes coverage for office contents and extra expense; equipment floater at replacement value; general commercial liability; workers' compensation; accounts receivable documents; transit of goods; bailee; fine art objects; valuable papers; tools; portfolio. Taylor & Taylor can also arrange for a production insurance policy for you.

Consider the following policies in addition to the ones mentioned above, making sure that your coverage extends beyond the United States:

- Foreign commercial liability
- Foreign workers' compensation
- Domestic and foreign hired and nonowned auto coverage if not covered by your standard auto insurance policy
- Errors and omissions—protects against lawsuits for libel, invasion of privacy, unauthorized use of your photographs, and copyright infringement
- Life insurance
- Disability
- Accidental death and dismemberment
- Key person insurance—coverage of designated key members of a business
- Kidnap ransom insurance
- Trip cancellation
- Rain insurance
- Flight insurance—use the insurance (with optional increases if you wish) offered by the credit and charge card companies; I always charge my tickets to American Express, which automatically provides flight insurance and so is much better value and far more convenient than stopping at airport insurance counters (which are not always available or open)

Also consider obtaining medical and evacuation insurance, which will cover medical expenses and the costs of transporting you home. Any number of insurers provide these policies, among them:

Access America, Inc. (800–284–8300)

International SOS Assistance, Inc. (800–523–8930)

MedHelp Worldwide (800–237–6615 in the United States)

Travel Assistance International (800–821–2828; call 202–347–2025 in Washington, DC)

Travel Guard International (800–826–1300 or 800–782–5151; call 800–634–0644 in Wisconsin)

Preparations at Home

Least welcome when you are on the road is a phone call from home about a problem with an old job or some personal difficulty. To reduce the chances of such interruptions, make it a rule to deal with potential problems before you leave.

Have you called clients to ensure that jobs have been received and approved? Do they have access to the photographs and documents that they need from your files? Have you completed your paperwork for those assignments?

Is your portfolio in the hands of an agent or associate willing to make it available to new clients?

Are bills paid and have procedures been established for paying new ones, particularly if you find yourself away longer than expected?

Have your loved ones attended to their medical problems in advance of your travels?

Have you secured your home and office (if no one will be occupying them while you are gone) by canceling newspaper and other deliveries, installing timer and security devices, arranging for an emergency signal to neighbors should the heating system fail, and so on?

Have you provided those at home with detailed records, including repair and insurance contacts and records for vital electrical, gas, fuel, water, and septic systems, as well as appliances and vehicles?

Have you left your itinerary and means of communication with anyone who might need to contact you while you are away?

On an even more unpleasant note, since traveling always involves hazards, have you properly executed a will? Although there are some risks involved, you may want to give power of attorney to a relative or other trusted associate should you be detained abroad for any reason and legal issues have to be resolved on your behalf. In the event of a terrorist or similar security incident, your family, under stress, is not necessarily the best choice. Are your finances in order and available to your executor? This is particularly important in the case of stock photo and other professional and artistic assets.

MASTER LIST

Use this checklist to verify you have all the documents necessary before leaving.

_____ Passports

_____ Spare passport photos for you and your staff—a great convenience should you need visas or other permits on the road

_____ Foreign visas

_____ Foreign equipment importation documents and/or Carnet

____ U.S. equipment registration forms from customs or bills of sale

____ Additional complete list of equipment with serial numbers as backup

____ Separate list or photocopies of credit and charge card numbers, passport numbers, traveler's check numbers, and any other crucial data

____ Domestic and international driver's licenses—contact your local automobile club to obtain an international license

____ Credit and charge cards

____ Traveler's checks—if you are planning to be in only one or two major countries, you may find it economical and more convenient to purchase traveler's checks in the foreign currency rather than in U.S. dollars

____ Cash: U.S. currency in large bills for funds, small bills for gratuities, plus a starter supply of foreign currencies; foreign currency can be obtained from Deak International (212–635–0515) or the New York Foreign Exchange, Inc. (800–FGN–EXCH; call 212–248–4700 in New York)

____ Personal or company checks

____ Health documents and record of inoculations

____ Health insurance cards and insurance claim forms

____ Business cards, translated if necessary

____ Standard model and property releases

____ Press cards and other special credentials

____ Transportation tickets and vouchers, as well as written confirmation of reservations

____ Ledger and other bookkeeping materials and/or computer spread sheets for keeping records on the road

____ General letter of introduction from client

____ Special letters of introduction to specific contacts

____ Copies of your letterhead

____ Planning calendar or diary: I always carry an 8½-by-11-inch monthly planner; when I first sit down to discuss a job with a client, I photocopy enough for all participants so that we can plan schedules together; having a monthly planning sheet will really help keep track of your travels and greatly assist when sudden changes occur (carry a pad of self-stick Post-its as well)

____ Pocket atlas, maps, and tourist information

____ Job bags with all the documents relating to the assignment, for example, written briefs, contracts, expense estimates, and contact phone numbers

_____ Special photography permits: in some localities you will need a permit to shoot in public places (Los Angeles, for example); these can sometimes be expedited by special permit brokers; also contact the office of the film commissioner if one is available

_____ ASMP or other organization membership roster

_____ Pocket-size foreign dictionaries or phrase books

_____ Copies of supplier lists and other information you might need, such as photocopied pages from reference books you prefer

In a spare emergency package, pack:

• Photocopies or extra originals of all the vital documents listed above
• Spare cash, traveler's checks, and a credit or charge card
• Spare keys
• Rear receipt of airline tickets in case of loss

FINAL CHECK

Have you:

_____ Reviewed and secured the above documents?

_____ Renewed medications and received the necessary inoculations? Have you checked the latest health and political conditions?

_____ Confirmed your flights and reservations?

_____ Secured your home and office?

_____ Cleaned, checked, and repaired your equipment?

_____ Thoroughly reviewed your packing list and cases?

_____ Replenished all your film, batteries, tape, and other expendables?

_____ Recharged all NiCads and gel cels?

_____ Researched the electric current of your destination?

_____ Received your advances?

_____ Reviewed your insurance needs?

_____ Checked the latest weather conditions?

_____ Called the credit card companies?

_____ Added new equipment to registration forms?

If so, bon voyage!

2

ON THE ROAD

When plowing your field,
look straight forward.
—Chinese proverb

It is the opening day of the assignment. You now discover that no matter how superbly you have organized the trip, the gods will test your patience in a Job-like fashion. Things may start to go wrong at every turn, so think of the fix you would be in if you were poorly prepared! You must now master the art of crisis management.

First and always: *don't panic!* Overreaction is your greatest enemy. In almost twenty years on the road, I have never encountered a problem that could not be solved or endured. Keep that all-important first goal—the safe and successful return of the production—in mind. And plan. How do I get over this hurdle? Is this really a crisis, or am I overwrought from too much work and too little sleep? Need I confront this problem head-on, or is it simpler to take another path? Think, calculate, plan, and above all, act. Procrastination has no place on the road.

Remember that a location assignment is the proverbial chain that is no stronger than its weakest link. Weeks of meticulous operation, fine shooting, and fair weather can be completely destroyed in one instance of carelessness: a theft in an unguarded moment; a hotheaded encounter with a foreign policeman; a thoughtless exposure of film to heat, moisture, or X ray. Just because things are going well, as they often do, do not slacken your procedures or determination to control events as much as possible.

Before discussing the particulars of routine dealings with airlines, hotels, and car rental agencies on the road, let's look at some of the most serious concerns.

SECURITY

While clearly Japan generally has less street crime than the U.S. and walking the streets of Amsterdam is safer than a jaunt through Beirut, the professional traveler should never feel completely immune from risk. Terrorists and common criminals operate anywhere in the world today. Paranoia is counterproductive and may encourage an act of stupidity in the face of a real threat, but healthy suspicion may save your life. A detailed breakdown of security risks, country by country, is available in the *International Traveler's Security Handbook*, by Anthony B. Herbert (New York: Hippocrene Books, 1985).

As a photographer, it will be difficult for you to observe one of the most sacred rules of security: keep a low profile. Your work methods will attract attention; your expensive belongings are a magnet for the common thief, and while the primary American targets of terrorists are businesspeople, you may be working and associating with American executives abroad. Naturally, the photojournalist will be drawn to areas of strife.

Avoiding Crime

Always keep a head count of your cases and any items you are hand-carrying. It is better to have at least one person surveying the transfer of cases who is not responsible for any lifting or ferrying. Items can be picked off while everyone on the team is preoccupied with hauling. In high-crime areas, I keep my walkie-talkie close to my mouth during loading. It looks official and tends to discourage thieves.

Beware of any distractions, particularly those presented by another individual. If a thief picks off a case, do not give chase unless there are two of you. The first grab may be intended to pull you away from the gear while confederates make off with the whole lot. Be aware of scams such as teams of thieves who distract you by spilling food on you or block your view of your bags with a large map as they ask directions. Never ask anyone to watch your gear for you unless you know them well or have hired them for this purpose.

Never agree to check in or transport any luggage or packages for individuals who are not *extremely* well known to you. As of this writing, one of my colleagues sits in a Spanish jail after being duped by a *client* into carrying drugs into the country.

Make duplicates of all your documents. Carry your wallet in an interior pocket secured by a zipper or other fastener, in a special money belt or purse, or in a front exterior pocket with a rubber band around the wallet. Never put your wallet down on a counter to remove a document or money. Keep it in your hands and place it back in your pocket as soon as possible.

Avoid sex-for-pay situations. They are dangerous for your security and your health.

Remember that you must secure your equipment from tampering as well as theft when it is unattended. If you feel that your client's facility is more secure than your hotel (see "Hotels," later in this section) or have to leave a setup in place overnight,

be sure a trusted security guard is personally responsible for it. Keep in mind that a well-meaning, honest employee or passerby might be tempted without thinking to handle a piece of gear and in the process damage it, drop it, or change a setting without your knowing it.

Never tolerate the use or transportation of any illicit recreational drugs by your staff. Drug laws are much harsher abroad than in the States. Carry all prescription medications in their original, labeled vials, accompanied by a physician's statement if possible.

If you are accosted and want to draw attention, yell "fire," not "help."

Avoiding Terrorism

It is unlikely that you will be the victim of a terrorist act, hijacking, or civil disturbance. Yet the consequences of victimization are so great that you must be aware of the threat and the appropriate response. This book can only skim the surface of the problem. For those of you interested in greater detail, obtain a copy of *Executive Safety and International Terrorism: A Guide for Travelers*, by Anthony J. Scotti (Englewood Cliffs, New Jersey: Prentice-Hall, Inc. 1986).

Be aware of your surroundings. Observe peculiarities such as the presence of the same automobile parked at the site of your activities or the same pair of "young lovers" always near your hotel room. Vary your daily routine and routes to and from your hotel. Only colleagues should know your itinerary.

Avoid carrying items with corporate logos, and do not advertise with whom you are working to strangers. While I like being met by corporate personnel at airports to facilitate customs clearances, security professionals recommend *against* being met by well-known corporate employees.

Do not linger in the public areas of airline terminals. Pass quickly into the secure area or better yet, consider membership in the airline club lounges. They are even more secure than the gate areas.

Keep an eye out for abandoned packages or briefcases. Report them to airport security or other authorities and leave the area promptly.

Keep your political ideas to yourself, and be circumspect in making any critical or negative comments about your host country.

Consult with your client's security professionals if you have any questions. They are the professionals who know the situation best.

Avoid the image of the "ugly American." Treat everyone with dignity and tip well. You do not want to engender the animosity of poorly paid service people in countries where they are sometimes a source of information for terrorists.

If you suspect you are being followed while driving, do not take dramatic evasive actions. Simply drive in a normal manner, but change course frequently. If someone is still on your tail, do not panic, but drive normally and directly to a safe haven. Never allow your gas tank to drop below half-full. Do not stop for "stranded" motorists. Always leave enough room between you and the car ahead of you at stoplights to pull away if necessary.

If you are the victim of a hijacking, kidnapping, or other terrorist act, think clearly, avoid despair, and do not give up hope. Remember, you are worth more to a terrorist alive than dead. Employ disciplined mental activity to relax and remain alert. If in captivity, keep your mind nimble in any way possible: write an imaginary book, try to recall every friend you ever had, build a house brick by brick. If isolated, try to keep track of time through some means. Eat everything that is given to you, no matter how unappealing.

Beware of the Stockholm syndrome, a situation in which longtime captives begin to sympathize with their captors and their aims. When isolated from other contact, communication with the terrorist can be therapeutic and may make him or her more reluctant to harm you, but understand that the terrorist is not your friend.

Do not do or say anything that will cause the terrorist to single you out from the group. Avoid looking a terrorist in the eye, particularly if from the Middle East. Understand that terrorists are usually highly intelligent and highly motivated. If you should become engaged in conversation with them, discuss neutral topics such as children or some other subject on which you may actually find yourself on common ground. The terrorists, while fully capable of killing, may see themselves as a devoted family people, carrying out this extreme act for love of home and family. Cooperate with the terrorists to the extent that you can, and do not become embroiled in political arguments or other contention. Do not volunteer unnecessary information. Never whisper (it can be construed as conspiratorial) or shout, and do not make any surprise moves—such as getting up to use the toilet—without asking permission. If you happen to be a dual national, try to conceal your American passport. All Americans should conceal any documents that link them in any way to the military (such as the National Reserve or a veteran's group) or any other official branch of government.

Disdain heroics—carry lethal weapons only if you are fully comfortable with them, are familiar with laws governing their use and transportation, and are fully prepared to use them. Nonlethal weapons such as mace are not recommended for use against terrorists and may get you killed. If a rescue attempt is made, hit the ground, behind cover if possible, and do not stand up until you have been told to by security personnel. If they instruct you to move, crawl on your stomach unless told otherwise. Do not try to help in the disarming or apprehension of the terrorist in any way.

Civil Disorder

Learn as much about your destinations as you can. Carry the best maps possible.

Register with the U.S. embassy or consulate upon arrival in a troubled area. Make contact with them as soon as possible in the event of a crisis. Do *not* proceed to the embassy or consulate until instructed to do so. It may be the center of the storm.

Stay in your hotel room under as much cover as possible. Should evacuation become necessary, have a preplanned escape route and make a mental note of safe havens such as hospitals or police stations. Avoid alcohol or anything that will dull your senses. Eat lightly.

Keep tuned to the shortwave. Be aware that local news and information broadcasts may not be accurate or impartial.

Always observe announced curfews. Shoot-to-kill orders are often in effect for violators.

Pray that you have been employing good travel manners until now. The goodwill you have gained among local people may save your life.

BRIBERY ABROAD

As a photographer traveling to a variety of cultures, some of which consider corruption (*baksheesh*, as it is known in the Middle East; *dash* in Africa; *mordida* in Mexico; *kumshaw* in southeast Asia; *jeito* in Brazil) a way of life, you should have some familiarity with this complex and troublesome situation. In many regions it is less a crime than a normal "spreading of the wealth." You may well find yourself in a situation where the authorities are more unlawful than the citizenry and where a sizable "gratuity" to a customs official or policeman may be your only passport through a difficult bottleneck. It is a moral issue about which only you can make the final decision. Understand too that no matter how common you perceive corruption to be in a foreign culture, you are always at risk if you rely on an illegal payment. If you are not opposed to the very idea of *baksheesh*, be aware of a few points.

If you are abroad, you would probably not be violating U.S. law in the examples above. The Corrupt Foreign Practices Act is basically aimed at businessmen using bribery to obtain contracts. You might want to read the entire act to be sure you are not violating it.

Never offer a bribe to resolve an impasse. When corrupt officials are looking for extra income, they are rarely subtle about it.

Carry plenty of cash if you anticipate giving this kind of "gratuity."

Avoid handing money to its recipient. Keep some currency concealed in a case and somehow arrange for the official to examine its contents. Whether or not he or she takes the money will, furthermore, reveal the official's intent in situations that are ambiguous.

It is sometimes safer and wiser to arrange for an intermediary. *Baksheesh* is not always a direct payment but sometimes a more subtle favor or consideration in some cultures.

Read the section concerning "Dealing with Arrest" (see page 96).

CHANGING MONEY

Illegal currency transactions can be dangerous. As a rule of thumb, the more restrictive the political climate of a country, the more severe the penalties for black-market transactions. Certainly, exchanging money through unofficial sources not sanctioned by the government should never be attempted in such places as the Soviet Union,

Eastern bloc, or Nigeria, where currency irregularities are taken very seriously. Caution is necessary even in countries where parallel money markets are reputed to be tolerated by the government. Never exchange money on the street or with someone you do not know. If you are going to chance it, make arrangements with a trusted local associate or perhaps the concierge of your hotel (not the bellhops).

Legal currency exchanges are best made at banks or official money changers. Only exchange at the hotel if you are pressed for time, for you can get as much as 15 to 20 percent less than the bank rate. Be aware that the rates you see quoted in the daily newspapers are the wholesale rates paid by banks—do not expect to receive the same rate anywhere as an individual. The major credit card companies provide decent exchange rates, so don't hesitate to use credit and charge cards instead of cash. However, understand that the exchange might take place weeks or even months after the purchase, so if the foreign currency has greatly appreciated against the dollar in that time, you will lose out.

Be aware that some countries insist on local currency for the payment of airport or departure taxes. Also, in some countries it will be difficult or impossible to reconvert your foreign currency back into dollars, so do not change more than you need (although some of these nations have daily or one-time minimum exchange requirements regardless of your actual needs).

DEALING WITH ARREST

It is difficult to make recommendations about dealing with the police because the quality and integrity of police varies so much around the world and even within the United States. Police are not always to be avoided, of course. They can often be helpful. At the same time, know that in many localities, police are a law unto themselves, capable in extreme cases of placing false evidence in your car or dispensing justice on the spot.

Arguing, and certainly displaying hostility, to police of any caliber are almost always unproductive and sometimes suicidal. Most police throughout the world consider themselves besieged. An astute display of sympathy and understanding for their position is more apt to bear fruit.

If you have clearly committed a minor infraction (such as going through a stop sign without coming to a full stop), do not irritate the cop with evasions and excuses. Admit you were wrong and that you accept the consequences. You will probably fare better. Never act nervous, secretive, or defensive about your activities when confronted by police. A confident (not cocky), open, even innocent, approach is usually best.

Being arrested is never fun. It is far less of a party abroad. Consider the following State Department warnings about jail conditions for those who possess or traffic in drugs, for example:

- Few countries provide a jury trial.
- Most countries do not accept bail.

- Pretrial detention, often in solitary confinement, may last for months.
- Prisons may lack even minimal comforts—bed, toilet, washbasin.
- Diets are often inadequate and require supplements from relatives and friends.
- Officials may not speak English.
- Physical abuse, confiscation of personal property, degrading or inhumane treatment, and extortion are possible.

The State Department has this to say about legal aid for Americans arrested abroad:

When living abroad, you are subject to local, i.e., foreign, laws. If you experience difficulties with the local authorities, remember American officials are limited by foreign laws, U.S. regulations, and geography as to what they can do to assist you. The U.S. Government has no funds for your legal fees or other related expenses.

Should you find yourself in a dispute that may lead to police or legal action, consult the nearest U.S. consular officer. Although consular officers cannot serve as attorneys or give legal advice, they can provide lists of local attorneys and help you find legal representation. However, neither the Department of State nor U.S. embassies or consulates can assume any responsibility for the caliber, competence, or professional integrity of these attorneys.

Consular officers will do whatever they can to protect your legitimate interests and ensure that you are not discriminated against under local law. Consular officers cannot get you out of jail. If you are arrested, immediately ask that the consular officer at the nearest U.S. embassy or consulate be notified. Under international agreements and practice in most countries, you have a right to get in touch with the American consul. If you are turned down, keep asking—politely, but persistently. If unsuccessful, try to have someone get in touch on your behalf.

Upon learning of your arrest, a U.S. consular officer will visit you, provide a list of local attorneys and, if requested, contact family and friends. Consuls can help you transfer money, food, and clothing from your family and friends. They also try to get relief if you are held under inhumane or unhealthful conditions or are treated less equitably than others in the same situation.

Additionally, you can contact the Citizens Emergency Center in Washington (202–647–5225). It monitors the cases of Americans arrested abroad and acts as liaison with the prisoner's family, friends, and congressional representatives in the United States. It assists in transferring private funds to posts abroad for delivery to American prisoners. When a prisoner's health or life is endangered by inadequate diet or medical care provided by the local prison, dietary food supplements and/or medical care may be arranged through a federal loan authorized under the Emergency Medical and Dietary Assistance Program.

You might also turn to commercial assistance programs, such as Global Assist from American Express. Another source is the Philadelphia-based International Legal Defense Counsel (215–977–9982), an organization that provides legal help for Americans abroad.

American consuls, in general, can be a resource in a variety of emergencies. The

names of consular personnel throughout the world can be obtained in *Key Officers of Foreign Service Posts*, available from the Government Printing Office (202–783–3238). However, it is important to understand what consuls can and cannot do:

> Consular officers are responsive to the needs of Americans traveling or residing abroad. However, the majority of their time is devoted to assisting Americans who are in serious legal, medical, or financial difficulties. Consular officers can provide the names of local doctors, dentists, medical specialists, and attorneys, and give you information about travel advisories. Consular officers also perform non-emergency services, including information on absentee voting, selective service registration, and acquisition and loss of U.S. citizenship. They can arrange for the transfer of Social Security and other U.S. Government benefits to beneficiaries residing abroad, provide U.S. tax forms, and notarize documents. They may also provide information on procedures to obtain foreign public documents.
>
> Because of the limited number of consular officers and the growing number of American tourists and residents abroad, consuls cannot provide tourism or commercial services. For example, consuls cannot perform the work of travel agencies, lawyers, information bureaus, banks, or the police. They cannot find you jobs, get residence or driving permits, act as interpreters, search for missing luggage, or settle commercial disputes with hotel managers.

TRAVEL ABROAD

Getting to the Airport

Confirm your reservations before departure, both with your airline and ground transportation service, particularly if you made the reservation well in advance. Always arrive at the airport as early as possible—at least one hour before a domestic departure and two hours before an international flight. Call ahead to be sure your flight has not been canceled or seriously delayed.

Use a reliable car or van service, and have plenty of back-up suppliers should they fail. Confirm the airport of your departure and carrier with the driver. Plan how to proceed if you must throw yourself on the mercy of a street taxi or public transportation to get to the airport.

Have an organized drill for loading and unloading the vehicle. This is the advantage of a regular service or use of your own vehicle—you know how the cases configure and do not have to solve the jigsaw puzzle each time. Count all your bags and parcels, including carts; the count will vary from job to job, so take a count on every trip. The real problem in loading and unloading is theft or accidental loss. Packing and unpacking in crowded terminals or in front of busy hotels offer one of those points of distraction when you are most vulnerable to loss. Carry the bags right to the sidewalk, out of the street where they can be damaged by oncoming cars. Separate baggage to be checked from carry-ons, and be sure your cases are not grouped with anyone else's. Take another count—"it looks like it's all here" is not good

enough. Double-check some of the odd places you might have stowed things in the vehicle, such as on the floor of the front seat.

Make sure your group knows who is responsible for paying the driver and for hailing the skycap or check-in attendant. Curbside personnel, by the way, may be more tolerant about overweight baggage—they work for tips.

As indicated in section 1, you should have a system worked out whereby all the cases can be moved at once by your team. If this is not possible, be sure you have a system for ferrying gear safely. Never allow gear to leave your sight. Make shorter trips. Assign someone just to guard and watch.

Airport Security

Airport security requirements can prove fatal to your progress if you are careless. Even if you clear the checkpoints without exposing your film to X rays, it is sometimes a confusing procedure that can delay your departure and leave you vulnerable to theft or loss.

X rays can most certainly ruin your film. Let's put to rest the canard that X-ray scanners are "film safe." Film is light-sensitive material, and X rays are light. While some machines are clearly less damaging than others, even low-ASA films can be affected by accumulated multiple exposures through several airports. The machines are, furthermore, not always properly used or adjusted. If you do not believe me, send a pack of Polaroid film through for the fun of it on your next long trip. *Never* allow your film to be X-rayed if you can avoid it.

Nevertheless, realize that airport security are professionals trying to do a difficult job, and that they are there to protect you as well—you're a passenger too!

In the United States, you are *entitled by FAA ruling* to a hand inspection of your film. This would not mean, however, that you should ignore the suggestions below or abuse this privilege in any way. It would not benefit any of us to someday see this rule revoked because of legitimate grievances by airline security people.

No such law exists abroad. Some countries voluntarily comply with the FAA guidelines. However, attempts by several organizations to produce a worldwide report on various countries' policies on hand inspections have failed miserably. Countries are either uninterested or unwilling to make their procedures public. Moreover, policies can change overnight in response to a terrorist incident. In some cases, these policies may not exist—compliance is simply a function of the mood and inclination of the officers on duty at the moment. Some countries where you may have difficulty obtaining a hand inspection include a number of European countries and Japan.

Get to security early to avoid the appearance of rushing the procedure, and to allow time to negotiate any problems. Before proceeding through the checkpoint, step back and observe. Where there is a choice of lanes, try to choose an officer who seems polite.

Before letting any bags out of your hands (I usually approach security well ahead of my assistant and gear), politely contact the most senior officer and inform him or her that you are a professional photographer carrying sensitive, high-speed film and would appreciate a hand inspection (even in the United States where such a request

must be granted). Tell the officer that you are early for your flight and will be glad to wait while the crush of passengers now storming the checkpoint is past. Harried officers will be less obliging; crowded checkpoints, more hazardous.

Always consolidate your film into one or two bags for the convenience of inspectors and tell the officer of this immediately. They will particularly appreciate this consideration, and it will often win you an inspection when one is not required.

Both here and abroad, a security officer will try to reassure you that the machines are "film safe" (airports such as Hong Kong's Kai Tak that openly do *not* employ "film-safe" machines will often allow a hand inspection). Politely tell the officer that you are carrying high-speed film (if he or she sees only ASA 100 film, simply explain that you plan to push-process the film when you return). If there is no language problem, patiently explain that you travel continuously and that the film could be exposed to dozens of cumulative exposures. They frequently accept this simple explanation. If you encounter a language problem, ask a representative of your airline to accompany you to translate, but keep in mind that they usually have no authority over the final decisions of the security people and may not even enjoy good relations with them. (It should be noted, by the way, that El Al of Israel has its own security check in addition to the airport's. They will be happy to provide a hand inspection if you make arrangements with their sales representatives or district office—not reservations clerks—in advance.)

Never joke about airport security—it can land you in jail. Always maintain your patience and polite manner. If you are getting no cooperation, diplomatically ask if you can appeal up the line to a superior officer.

If all appeals fail, offer to have the officer select a roll or two at random to put through the machine as proof that you have no nefarious intentions but are seriously concerned about the X-ray problem. If this fails, start putting your film in the Sima lead bags. They may allow them to go through this way, or the absurdity of the situation may register and they may finally comply with the hand inspection. If no ploys or entreaties succeed and you are faced with a total exposure, you can either put the film through and pray for the best (one exposure in a properly adjusted machine will probably not do too much damage), or you can turn around, cancel your flight, and take the train to the nearest border. Do *not* elect to put your film in the checked luggage—it is sometimes exposed to intense X-ray inspection.

Should the hand inspection be approved, you can proceed through the checkpoint. Have all your film in Tupperware or plastic bags as discussed in section 1 (see "Packing Film"). Have all the metal objects in your pockets consolidated for easy removal before you enter the metal detector—you do not want to be delayed there. Do not flash your walkie-talkies or Swiss army knife. They are not popular items at security. Do not go through the metal detector until you have seen all your other cases pass through the X-ray machine—you do not want them grabbed by someone still outside the checkpoint. Hand the film bag to an officer who knows you are getting the hand inspection and keep one eye on it to be sure it is not misplaced or mistakenly put through the machine.

Once past metal detection, again employ your powers of persuasion to assure a

careful and proper examination. Security officers are often not familiar with handling complicated and delicate professional gear. They will pull things out suddenly, wreaking havoc with your packing at best and causing lenses to fall at worst. Ask if you can open all the cases and handle any of the items. Make it clear that you are not trying to conceal things and that you will be glad to show them everything. No matter who handles the gear, do it over a spacious and preferably padded table. Like camera stores, security often has pads for just this purpose.

When finished, exchange some pleasantries with the officers if they are not harried, and thank them for their courtesy—you may well see them again soon. Remember that, though American security officers are required to give you a hand inspection, they can inconvenience you and still comply with the law if your manner offends. They can simply subject you to a time-consuming white-glove treatment, especially if you appear to be late for your flight. You asked for a hand inspection—you'll get one!

Never lose sight of your other bags during the examination. If there are two of you, have one person involved in the hand inspection while the other guards and consolidates the cases that have gone through the machines. Be aware that the X-rayed bags also may have to be hand-inspected since camera gear sometimes looks suspicious on the screens. Always remember to go through the cases before security to make sure there are no partially exposed rolls of film still in the camera bodies.

Airline Difficulties

LOST BAGGAGE

Of the millions of bags a year with which the industry copes, less than 1 percent are mishandled. Most "lost" bags are simply delayed or misdirected and will turn up later, sometimes shortly. Far less than 1 percent, then, are completely lost or end up in "bag heaven," the depot for unclaimed luggage that is the final resting place for an unidentified suitcase.

Nevertheless, the law of averages suggests that a well-traveled photographer will, before too long, become a PAWOB—Passenger Arriving Without Baggage, in airline jargon. And while the missing cases may appear within twenty-four hours, your shooting has been seriously delayed, your momentum stalled, your nerves frayed.

Adopt a system similar to the one discussed in section 1 in which most of your critical and hard-to-replace items are carried on board. The only true defense against lost checked baggage is to not check them in the first place.

Avoid interlining—using different airlines for different legs of a trip—if possible. It is here that bags are most vulnerable to loss.

If checking in at curbside, hang around until you see the cases on their way into the building. Pull bags away from the edge of the curb.

Carefully observe the ticketing process at the check-in counter. Be sure the agent has put the correct baggage claim ticket *for your final destination* on the case. The

official codes of the foreign airports are included in the Country Files. Keep your claim tickets in the same spot in your wallet or in the same pocket all the time. Remove them from the paper travel wallet they will probably be stapled to by the ticket agent, since these are sometimes thoughtlessly discarded.

Even photographic cases can look the same. Put some identifying mark on your cases, whether it be an unusual sticker or a piece of colored gaffer's tape.

Place identification *both* inside and outside the case. If possible, include your itinerary on a sheet inside. Clearly distinguish your family name from first name, since the airline should be tracking the bag with your last name.

Get to the baggage carousel without delay after touchdown. Not all airports have security guards checking claim tickets, and those that do are not always effective. Get to the carousel before your bags do. When off-loading the carousel, keep an eye on the bags already removed. If not alone, have one person off-load while the other person watches.

Always remove the old tags and any of the new zebra code stickers from cases as soon as you are out of the airport.

Consider membership in the International Airline Passengers Association (see "Periodicals," in section 1). One of their most important services is assisting members with lost baggage. You will also be issued special IAPA luggage tags to help in the tracking process.

If your baggage has not appeared when most of the flight's other suitcases have, report to the airline baggage office immediately. It might still be on the plane and can be retrieved before the plane leaves for its next destination.

If this is not the case, fill out the Property Irregularity Report. Be as detailed as you can. If your types of cases are not shown on the menu of standard cases, provide a full description and, perhaps, carry Polaroids of the cases to leave with them. List the tag numbers, and describe the special identifying markers you placed on the bags as well as their contents. Supply your local and home address and phone number. Get the names of the individuals taking the report and, if possible, the name of the baggage manager at the airport. They may be able to supply that extra effort in relocating the bags. Some airlines will give you a small amount on the spot ($40 to $50 or so) to purchase emergency supplies, but if your gear is missing, this will be cold comfort. If a bag has been damaged beyond use, airlines do have supplies of replacement bags, but they will be standard clothing suitcases and probably only of value to you in leaving the airport.

If a bag turns up later, it is better to retrieve it from the airport yourself, but if this is inconvenient, insist that it be delivered to your hotel. The airline should comply, but it sometimes will not. Be aware that if a bag has simply missed your connecting flight, it may be difficult for the computers to track because, in a sense, it is not "lost." That bag is probably still sitting in its container waiting for the next flight to your destination. Do not be too alarmed if, in the initial tracing, the bag is not found.

If the bag is seriously delayed, causing disruption of the shoot, it will be difficult, if not impossible, to obtain consequential damages from the airline. Consider buying production insurance in advance to cover this situation (see "Insurance," in section

1). Have contingency plans in effect, such as a list of local rental merchants or a means of having replacement items sent from home.

Airlines will not compensate for more than $1,250 per passenger in the event of irretrievable loss, and the process of collecting is slow and exhausting. Be sure your equipment is well insured. Incidentally, the fragile items waiver the airline may make you sign at check-in does not apply to loss and does not excuse negligent handling, indicated, for example, by external damage to the case.

OVERBOOKING

Airlines routinely overbook flights because of the enormous number of "no-show" travelers making reservations that they do not cancel when they change plans. Do not be among these selfish people who make the system worse for everyone—cancel any reservation you are sure you will not use. To avoid being "bumped," subscribe to the Department of Transportation's consumer reports discussed in section 1 (see "Airline Reservations") to track airlines with the worst overbooking records. Be sure to confirm your reservations according to the airline's requirements for international flights (usually seventy-two hours in advance). I confirm reservations for important domestic flights as well if there's time. Get to the airport as early as possible. The last ones *at the gate* are the most likely to get bumped. This is even more true of flights with open seating programs.

The airline is required to ask for volunteers to change their flights. Although there are compensations to the volunteer, I can't imagine that they are worth the time to a busy photographer, and I would never consider delaying my progress on the road for anything less than a princely sum.

There are also compensations for the traveler unlucky enough to be bumped involuntarily (although not if the flight is from a foreign country back to the United States, if you have not properly reconfirmed your flight, if a smaller craft has been substituted for safety reasons, or if a plane has sixty seats or less). This compensation is negotiable, but if it is not satisfactory and you turn it down, you may ultimately have to sue, which is never a pleasant prospect and does not solve your immediate problem.

If threatened with involuntary bumping, make it clear that you will demand damages for your interrupted assignment, presenting your press card or any other documents to support your claim. I have heard of passengers demanding that all reservations for the flight be reviewed and insisting that those who made the last reservations be the ones bumped. I do not know if this particular strategy works, but the carrier *will* try to avoid the more demanding passenger and seek out the more submissive ones.

FLIGHT CANCELLATIONS

Airlines may seriously delay or cancel flights for reasons of weather, mechanical problems, or absence of crew (although not for purely economic reasons such as few reservations for the flight). Most full-fare airlines will try to put you on the next

available flight, but be sure that if additional fares are involved, the offending airline pays the difference. The airlines also used to provide meals and accommodations for delayed passengers, but these amenities are becoming less common. Be aware, however, that the ground managers have considerable discretion to provide these comforts for delayed or stranded passengers, so speak up, particularly if the delay was caused by mechanical, rather than weather, problems.

AIRCRAFT EMERGENCIES

Responses to the variety of possible aircraft emergencies are too detailed to examine fully here. If you are interested in more information, read *Just in Case: A Passenger's Guide to Airplane Safety and Survival*, by Daniel A. Johnson (New York: Plenum Press, 1984). A few general guidelines follow.

Do read the in-seat safety card and listen to the flight attendant's briefing, no matter how experienced a flier you are. Aircraft configurations vary enormously. Be aware of the nearest exit (count the seats so that you can find it in a smoke-filled cabin) and note how to activate not only your oxygen supply but the other emergency equipment on board, such as rafts and safety exits.

Wear your seatbelt whenever seated. It should be strapped across your hips (not stomach) and worn loosely even when cruising.

During an emergency, follow the crew's instructions if they are not incapacitated, but be fully prepared to fend for yourself. Mentally rehearse your escape route from a crippled plane.

If you have survived the impact of an airline crash, you must act quickly to escape the fire and smoke that often ensue. Check for fire before opening an exit. Stay low in a smoke-filled cabin, and once out, get as far away from the craft as possible.

The type of incidents that can befall an aircraft vary so widely that it is impossible to determine which are the safest seat locations to choose. Which seats are more vulnerable depends on whether it is a land or sea disaster, an incident on takeoff or landing, and so on. In broadest terms most experts feel that the overwing or rear of the plane is statistically a bit safer than the front. Probably a choice of seat near an emergency exit is prudent.

Remember that an emergency is not a death warrant. Many people survive airline accidents if they are alert and lucky.

Hotels

CHECKING IN

When arriving, never allow the bell staff to take your gear to the rooms without you. You have carts or some system to drag it through airports and factories, so the extra leg of the journey from the hotel lobby should not pose a problem. Your handling of the baggage yourself may create ill feeling with the staff, who will think you are simply trying to avoid a tip. So make it clear you want them to accompany you to your room, and give them the same gratuity you would if they were doing the haul-

ing. For diplomatic reasons I always tell the bell staff that the carts are tipsy, fragile, and require a little experience to navigate. They usually accept this explanation. I also discourage eager doormen and bell staff from removing the cases from the car. It creates confusion (hence, an opportunity for loss or theft), and they are rarely prepared for the unusual weight, balance, and more fragile contents of some of the bags. Again, they get the same tip.

Feel free to ask to see the room first to be sure it meets your tastes and satisfies some of the fire and security provisions discussed under "Hotel Security" and "Hotel Fires." A good hotel will always comply with this request. If you later find that your room is noisy or has some other inconvenience, request a change—you are entitled to a good rest. Ask if the windows in the room open. You may not want to rely on the tyranny of hotel air conditioning.

Inquire if there is any express checkout system, should you need to leave quickly on your last morning. Also ask if the hotel is a partner in any of the frequent-flyer programs to which you belong.

Be sure everyone on your team has written down each other's room numbers. For security reasons, you may not be able to get room numbers from the front desk if you have forgotten them.

Inquire immediately about hotel laundry and dry cleaning if you think you will need them. Hotels often use outside suppliers who sometimes need several days to return clothes or do not operate on weekends. Expect to pay an enormous premium for hotel laundry—I have received laundry bills that exceeded the value of the clothing itself. Pack some liquid cold-water detergent and a portable clothesline for emergencies. Shampoo can be used in a pinch.

If you will be at a hotel for a while and think you might need some special services, introduce yourself to the manager or assistant manager as well as the concierge. They are often eager to please, and if one decides to become your guardian angel, as has happened to me in many fine hotels throughout the world, you will enjoy truly red-carpet treatment and encounter few problems that are not resolved immediately. A letter complimenting this employee to the hotel owners is the best reward you can offer for this special treatment and will guarantee an even finer welcome on your next visit.

If you arrive unexpectedly at a hotel in the evening without reservations, feel free to negotiate price. For the hotel, an empty room is a complete loss, so it may well offer you a special price or a deluxe room for a standard price.

If you are behind schedule and do not have a guaranteed late-arrival reservation, be sure to call in to the reservations manager to say you've been delayed. As with airlines, don't be a no-show.

DURING YOUR STAY

As soon as you arrive, carry out the fire-safety precautions suggested later in this section, under "Hotel Fires." Also check the front of the telephone book and record all the emergency phone numbers (fire, police, ambulance) in your diary.

Respect the privacy of other guests. If you particularly fancy the hotel's bathrobes,

towels, ashtrays, or other souvenirs, inquire about them at the desk. They are often for sale and in some cases will be offered to you with compliments. Do not embarrass yourself by being caught pinching a trinket.

Use the phones in the lobby for long-distance calls unless the hotel is part of AT&T's Teleplan or a similar program. If you've been overcharged for hotel telephone services, address your complaint to Chief of Informal Complaints, Federal Communications Commission, Room 6202, 2025 M Street NW, Washington, DC 20554. Copies of complaints may be sent to the two consumer groups at these addresses: Consumer Action, Suite 223, San Francisco, Calif. 94105, or Telecommunications Research and Action Center, Box 12038, Washington, DC 20005.

Avoid the temptation to spread out in your room. Keep your possessions in the same places in every room, concentrated in a few spots. You will be less likely to leave things behind. Always check the bathroom on your way out to be sure you have remembered your toilet articles. Close the door behind you—you don't want to be responsible for pilferage or damage occurring after you've vacated the room.

A trick some professional travelers use to spot inaccurate or unauthorized charges on their final bill quickly is to give gratuities that will round totals out to the same figure in the cents column. At checkout, any item not ending with that figure is questioned.

HOTEL SECURITY

Hotels are a thief's paradise. Even in a first-class establishment, you are not immune from victimization. In fact, the better hotels naturally attract the most determined and professional burglars. You may well be safer in a small hotel where you are well known to the staff and where it is more difficult for suspicious strangers to operate.

Use the hotel safety-deposit boxes. When making reservations, ask if the hotel has larger, locker-size boxes or only the shallow 2- or 3-inch variety. The larger boxes can usually hold all your film and even a few pieces of equipment. When opening the box, feel the outside to be sure the metal is cool—I once encountered a vault in a major hotel that shared a common wall with the furnaces. Keep the key unidentified and secure with your other keys. Empty your box the night before you leave, keeping your film and valuables in the room with you until morning. You may need to check out quickly, and the vault can be a bottleneck in the mornings, particularly if only one guest is allowed entry at a time.

Always secure your door with the chain, or better yet, your own doorstop or a portable door bolt such as the one available from the Travel Store (408–354–9909), especially when sleeping or in the shower. A favorite technique of hotel thieves is to listen for running water, loudly bang on the door yelling "chambermaid," and then make a quick raid with the help of a pass key. Be wary of sliding glass doors that give access to a patio or balcony.

Never open your door to an unexpected hotel employee. If any present themselves at the door unannounced, check with the front desk to see if they have been sent. All hotel employees carry ID of some kind. Ask to see it if in doubt. Be particularly wary of maintenance people who claim they need to make a repair. Except in emergencies, hotels generally send repair people through when they know you are out.

Never leave your key at the front desk when you leave for the day. It is best not to signal that you are out. Never reveal your room number to anyone you do not know or trust. Have your room key ready in your hand before you arrive at your door.

Avoid using the Please Make Up My Room sign. It announces that you are out. The Do Not Disturb sign may give some thieves pause, but you may also never see a chambermaid.

If you get a room in a remote or poorly lit area of the hotel, insist on a change. Avoid rooms on the first, second, or top floors of the hotel if they have easy access to the street or roof and poorly secured windows. Unfortunately, these are the better floors to be on in the event of fire (see "Hotel Fires," later in this section).

The thorniest issue, however, is what to do with all your gear when you want to leave the room for a meal or some leisure. If you are working for a client with a facility in the city, leaving it there is probably best. If this is not possible, what next? Many of my colleagues prefer to leave their equipment in the trunk of their vehicle (certainly never in the back seat or exposed portion of a hatchback). This is always against my rules—a parked car is an excellent target for theft. If I have strong doubts about a hotel's security provisions, I will actually babysit the gear and settle for room service if necessary. If you have an assistant along, you may want to consider dining out in shifts so that someone is always in the room with the valuables.

But if you must leave your equipment in the hotel, what is the best way to secure it? In the past I generally favored leaving the gear in a locked cage that the bellhops often have. I always make the arrangements with the bell captain or head porter, get a receipt and the name of the individual, and generously tip both the head person and the underlings to give the gear special attention. We always examine the cage and ask to wheel the gear in ourselves, since the cages are often cramped, and we do not want the carts left where they may be knocked over or bumped into by other suitcases. If a theft occurs while your equipment has been checked in with the staff, it will do nothing for your assignment, but you may at least get some compensation from the hotel. They certainly absolve themselves from responsibility if valuables are left in the room. Other alternatives may be the front office itself (although this can be quite an inconvenience to the reception staff) or the manager's office.

Nevertheless, as individual room security devices improve, I am tempted to rely on them more and more. Leaving the gear in a locked cage is not foolproof. A number of people have access to it, it is not always attended, and it makes the contents of the bags very public.

Nowadays I ask if the hotel has a double-lock security system. If the doors are equipped with this device, you must call a security person to your room when you are ready to leave. He or she will lock the door again with a deadbolt for which only security and the hotel manager have the key. Even you will not be able to enter the room without contacting them to let you in. All other hotel staff will not have access to your room. I find it particularly disturbing to see chambermaids, who in themselves might be quite honest, cleaning rooms with the doors wide open, sometimes leaving them that way as they run out to get a missing supply or chat with a co-worker.

Hotels do not usually advertise this double-lock feature when you check in, so be

sure to ask about it. You will be surprised how many hotels are equipped with it. You may also want to carry a device called the Clamshell, available from the Travel Store (408–354–9909), which covers the entire outside doorknob and keyhole, preventing entry by hotel staff. Some travelers leave a radio on or the water running to deter a thief. Both these techniques are insufficient, and the latter is a hazard.

You may also be willing to risk leaving gear in your room if the hotel has the latest in magnetic computerized locks, although it should be noted that these systems can be double-locked as well. Electronic locks cannot be picked. They are refigured after each guest leaves (or daily in some cases) to prevent a previous tenant from having access to your room. They can be coded to prevent entrée by lower-level hotel staff and also provide a record to the hotel of whose keys have been in the lock. These types of locks usually open with a magnetic card rather than a key, but there is a popular system produced by Gibraltar Locks that involves a plastic key with a narrow magnetic strip. It is a particularly fine system that allows the guest to throw the deadbolt from outside the room, which cannot be done with a magnetic card.

You might also select hotels with an open-plan design—all the rooms face an inner courtyard. Since the rooms are visible from a central point, they discourage theft and also make it easier to communicate with guests in an emergency.

HOTEL FIRES

It is no coincidence that you read of so many fatalities in hotel fires each year. According to the National Fire Protection Association, in a typical year one out of four hotels will have a fire requiring a response from the fire department. Although hotels are constantly improving their fire safety security and alarm systems, several human factors make hotels vulnerable to the threat of a serious blaze.

One is the carelessness of guests—a variety of personalities not on their own property, often drinking too much or smoking in bed, which alone causes half of all fatal hotel fires. Then there is the sometimes dangerous response of hotel staff to the first indications of fire. They have been known to investigate the source of smoke or a small fire themselves rather than call the fire department immediately. They will evacuate a full house of high-paying guests only when they are sure the threat is real. And, as one of many grumbling, pajama-clad guests thrown out into the streets of Dallas during two false alarms in one night, I can understand their reluctance. But this tragic delay has many times proven fatal.

As in the case of a flight emergency, be ready to follow the directions of the professional staff but be fully prepared to fend for yourself. Again, it is sometimes difficult to avoid the nauseating tide of panic, but if you have already mentally prepared your escape, you may be able to operate automatically, having made some critical decisions at an earlier, more tranquil moment.

Consider a room on the lower or top floors to be closer to ground or roof evacuation. One photographer I know never stays in a room above the third floor, to be sure he can always be evacuated.

Check to see that your room has working smoke detectors (look for the little blinking red light) and sprinklers. If not, try to obtain a room that does.

Read the fire safety information and map in the room, and look outside the room for the fire exit. Count the number of doors from your room to the fire exits to be sure you can find them in the dark. Be sure that the fire exits have not been locked or obstructed.

Make sure that your room key and emergency pocket flashlight is always in the same place next to your bed. *Never* leave your room without your key. Your hallway escape route may be impassable, and you may have to return to your room.

Know where the fire alarm is in your room. If you find a fire, sound the alarm, leave the building, and then call the fire department, as well as the hotel management. Do not depend on the hotel staff to deal with the emergency on their own.

As soon as you hear a fire alarm, *evacuate*. Do not procrastinate or investigate. Be sure you know how to unlock your door quickly, even in the dark.

If the fire is in your room, get out, close the door, and report the fire to the fire department and management. If the fire is outside your room, *first feel the door*. If it is cool, open it slowly and proceed to the nearest exit. Crawl low to the ground, where there is less smoke. More people are killed by smoke than flames in hotel fires. Keep against the wall, and hold onto handrails on the fire stairs to avoid being trampled by others in a panic. If you encounter thick smoke in the fire stairwells, do not attempt to go through it. Turn around and go back to upper floors or the roof. The roof may be your safest haven. Stay on the side of the roof from which the wind is coming.

If the door is hot, *do not open it*. Call the fire department to let them know you are trapped. Fill the tub with water. Seal all the room cracks with wet towels (or gaffer's tape). Turn off all fans and air conditioners. Signal at your window or balcony and wait to be rescued. Do not immediately break the window glass. You may need it to protect you from smoke coming in from outside. Cover your mouth and nose with a damp towel.

Never use the building elevators to escape. Many people have been incinerated as heat-sensitive elevators stopped right at the floor of the fire.

Car Rentals

The types of vehicles being offered by the car rental companies vary from year to year, so specific recommendations as to which makes and models are best cannot be made. Generally speaking, consider the following suggestions.

When traveling abroad, especially in developing countries, consider the possibility of a driver. They are often less expensive than you think, know the terrain, can increase your security precautions, and, for a little extra money, will often lend a hand with gear and other chores.

Reserve the largest vehicle possible in the United States. Abroad, you may want to consider the security implications of a flashy, ostentatious car.

Inquire about vans, but be sure that the back seat can be removed. They often cannot be, and in such instances you will actually have more access to your equip-

ment in the trunk of a large sedan. Station wagons and large hatchbacks are roomy but advertise the contents of the vehicle.

Request air conditioning so that you can leave windows closed in less secure areas, as well as to help protect your film from heat.

Rent from a major firm even if it is more expensive. It is more likely that they will have a large network of emergency services should you have a breakdown, more drop-off facilities, and so on. No matter whom you rent from, be sure that there are no restrictions as to where you may travel.

If you want special features in a vehicle, it is sometimes worth the expense of placing the reservation directly with the rental office at your destination, rather than using the national toll-free numbers.

Check the general functioning of the vehicle and examine the body for damage. If the body is damaged, be sure to confirm in writing that it has already been reported to avoid a problem when you return the vehicle. Check that the odometer reading corresponds to the mileage on your contract. Test the steering, brakes, lights, signals, windshield wipers, tires, air conditioning, and heating. Some experienced renters always note whether the rear seat ashtrays have been cleaned. If they are still full, it is a hint that the car has not been carefully serviced.

FEES AND INSURANCE

Find out if there are:

- Discounts and other benefits. Organizations to which you may belong, such as ASMP and IAPA, are entitled to discounts, as are some corporations for whom you may be working.
- Drop-off fees for bringing the car back to a location other than the one from which you picked it up.
- Additional driver fees for individuals other than the renter.
- Extra mileage fees.
- Fuel surcharges for tanks brought back less than full.
- Airport surcharges.
- Additional charges for changing the terms of certain promotional rates. For example, returning a car hired on a five- to seven-day weekly rate after only four days could cost you more than if you kept it for the full week.

Before purchasing rental insurance, be sure that you do not already have coverage as an extension of your home owner's or personal auto insurance, as part of a special hired and nonowned policy (see "Insurance," in section 1) or as a special benefit of your credit or charge card (see "Credit Cards and Charge Cards," in section 1). Be aware too that insurance provided by rental car companies, while convenient, is often poor value for money. Insurance policies are changing rapidly in the industry, but as of this writing you may purchase the following coverage:

- Collision damage waiver (CDW), which covers any damage to the rental car
- Personal accident insurance (PAI), which covers you and your passengers for injuries or death due to an accident while you are in the car
- Personal belongings or effects (PEC) coverage
- Liability insurance supplement, which extends your personal liability beyond the minimal (and in these days often inadequate) coverage that some rental car companies maintain

ON THE ROAD

- Never pick up hitchhikers.
- Be aware that some countries, such as Switzerland, require special road permits. Consult with a local motor club (see the individual countries in the Country Files).
- Avoid leaving your car on the street overnight. Spend the money for a secure garage.
- Familiarize yourself with international road signs.

Taxis and Car Services

What follows are a number of suggestions, particularly for dealing with taxis in foreign countries:

- Always use licensed taxis, never gypsy cabs. Know the colors and insignia of licensed taxis (where available, these are listed in the Country Files).
- Always know the approximate taxi rates. If you are using an unmetered taxi, do all negotiating beforehand to avoid an unpleasant scene upon arrival.
- In cities where the sharing of taxis by separate passengers is permitted, give the driver extra money to refuse other parties.
- Make it clear that you are familiar with the city. If you are completely at sea, try not to let on. Dishonest drivers often solicit this information for obvious reasons. If you do know the best route in familiar terrain, insist on it. If you are in strange surroundings and it is clear that the driver is unsure of the route, do not hesitate to take another cab.
- Know how to reach the local taxi and limousine authorities, should you encounter a serious problem.
- Since you will want a receipt for bookkeeping purposes anyway, note the taxi number or driver's license on it. It may come in handy later.
- It is always better to have the hotel, client, or another personal contact arrange for a taxi rather than hailing one on the street. Always arrange for the taxi in advance if you know your plans.
- If your group cannot fit in one cab, as is often the case abroad, give the drivers a little extra money to stay together as a caravan. Carry walkie-talkies—this is just the kind of situation in which they can really save the day.

- Whether home or abroad, carry a healthy supply of small bills to expedite payment. You don't want to be delayed waiting for a driver to make change in a nearby shop.
- Always double-check *all* parts of the cab for things you may have left behind, particularly if you have stowed anything next to the driver.
- Consider carrying some twine or an elastic cord of your own if you absolutely must secure the trunk in this way, but it is not recommended. It is very easy for a thief to slash the cord and make off with some gear while you are stopped. Similarly, ask the driver not to release the trunk lock from within the cab if it is so equipped until you are out of the cab and at the trunk.
- If, when you arrive at your destination, you are *sure* that your driver is suddenly presenting you with illegal and unagreed-upon charges, remove all your gear before confronting him or her about the matter. Be diplomatic until your staff has cleared the taxi. Then don't give in. The dishonest driver knows better than to make too much of a scene in these cases.

Dealing with Minor Crises

Low on the ladder of disasters are the standard snafus you will frequently encounter at airline terminals, hotel reservations desks, and car rental counters. Some of the most inefficient and unpleasant service I have ever received is here in the United States, land of high-tech and "Have a nice day." Despite all the press about the American service economy, really fine service can be in very short supply these days.

Whether because of human failings or the pure strain of an overburdened travel system, you will often find yourself ironing out difficulties that should never have arisen. Remember: You're the customer. I know you break your back to give your clients the very best. Why shouldn't you expect the same?

I admit without shame that I will ultimately cajole, threaten, beg, whine, wheedle, cry, bellow, humiliate, flatter, or any combination of the above to accomplish that one primary goal—to get over a hurdle and return home safely and successfully.

APPROACHING A SERVICE REPRESENTATIVE

A snafu has reared its ugly head. What do you do? Before racing off to a confrontation, pause for a moment and observe. First, have you chosen a service representative who seems cooperative? Next:

- Organize your thoughts so that you can present the problem succinctly and unemotionally. Anticipate the probable responses and questions you will immediately confront.
- Have all your documentation handy—service reps need to know things you take for granted (such as ticket numbers, credit card numbers, and the like).
- Use any special credentials you have.

- Do not forget that this is a moment of distraction. Is your crew minding the gear?
- Do some quick psychoanalyzing: is the rep the very reasonable type to whom a simple, logical explanation of events is adequate? If it is a complex problem, does he or she seem to have the intelligence to understand the issues? Will a soft or hard approach work best? Are you better off bullying a recalcitrant employee or posing as a helpless soul in need of help? Most employees reveal their nature quickly.

Always employ tact and diplomacy when possible. Often, in a situation in which you are one of many disgruntled customers (for example, among the irate passengers of a delayed or canceled flight), you will be approaching employees after they have had their heads bitten off by abusive or overly demanding fellow customers. In times like these, it is often shrewd to begin by expressing sympathy for the employee's position, a posture that may be welcomed and rewarded by the employee.

In all circumstances, give reps the benefit of the doubt. If they prove difficult, there is usually time to toughen up. Be especially careful in cultures not your own, where you may have a faulty impression of the interchange and where consumers may not enjoy the privileges they do in the States.

DEALING WITH AN UNSYMPATHETIC REP

However, have no illusions. Some folks who are supposed to be helping you are unsympathetic and will be unresponsive to reason. In this case, you had better not be the type who avoids confrontation at all cost. It is also a mistake to remain too soft for too long. It will delay results, and you will ironically only appear crueler and more manipulative if, after a lengthy and fruitless discussion, you become demanding. Your earlier posture will only seem insincere. If you are heading for a difficult exchange, bear in mind the following:

- Do not be so distracted with your anger and problems that you are not watching for signals from your negotiating partner that he or she now wants to help and is offering the olive branch. Above all, do not be preoccupied with right or wrong. You want to get the service to which you are entitled and move on.
- Introduce yourself firmly, as if the rep should know who you are.
- Address reps by their last name if evident on their badge. If they have no badge, ask for a last name, a business card, or at least an ID number. This lets them know you are holding them accountable. An employee who will give only a first name is being evasive.
- Ask for their help first. Explain the problem succinctly, and indicate if you have had many problems with the organization in the past. Display anger judiciously, only if all else fails, and never in cultures where it is inexcusable under any circumstance.
- Encourage and reward any positive gesture on the employee's part.

- Make it clear that you are willing to write a letter of compliment for good service, as well as one of complaint for bad service. Above all, follow through. If you have promised that letter of compliment, write it when you get home. Failure to do so is not playing by the rules and could come back to haunt you.
- Never hesitate to call over a manager, but be careful not to put the supervisor in the position of publicly overriding the employee if possible. Some managers will back up an employee who is wrong in the interests of a harmonious workplace rather than satisfy a solitary customer. Try to hold your conversation with the supervisor privately.
- Have the names of the firm's senior executives handy, and do not hesitate to use them if the managers are unsympathetic.
- Ask for written confirmation of transactions when necessary.
- Hang in there. Uncooperative service reps may try to wear you down. Don't let them. Actually, time may be on your side—they probably have a line of other unhappy customers behind you. Similarly, try to anticipate problems before they erupt. The disadvantage will be yours if you are the one rushing to catch a flight.
- Learn when to quit in an impossible situation. Sometimes all tactics fail. Discontinue the effort, and above all, do not get into an imbroglio that will prolong your delay and leave you open to detention by a security guard or police officer. You are not on home ground and some battles are best continued from the safety of home. Settling the score later won't help at the moment but may ensure better service for the next hapless traveler.

COMPLAINING IF DISSATISFIED

If you do wish to register a complaint to senior management, try calling first. Usually a company will ask for the complaint in writing, but if it is sympathetic, the matter may be resolved over the phone, saving you a lot of time. If that is not the case:

- Write to the highest executives in authority at the company. You may be informed that a middle or junior-level executive is the appropriate person to receive complaints, but if the disagreement was a serious one, that manager may only have to consult superiors, wasting time and creating a more complicated situation. It is more effective to have a senior executive direct the complaint downstairs than the other way around.
- Type your complaint letter, and keep it to one page if possible. Include a daytime telephone number where you can be reached.
- No matter how angry you might be, keep your letter businesslike in tone, and do not exaggerate what happened. If the complaint sounds hysterical or sarcastic, you might wait a day and consider rewriting it.
- Do not confuse the matter with petty gripes or irrelevant details. Focus on the important events and concerns.
- Send copies (never originals) of all supporting documents that might back up your claims.

- Include names of any employees who were rude or unhelpful, as well as those who were especially considerate. Complimenting the exemplary employee is the right thing to do and does not weaken your case. (In fact it lends credibility by suggesting you are not simply a misanthropic crank.)
- Let the company know if you have suffered any special inconveniences or monetary losses.
- Be clear in your demands. Indicate what it is you want, whether it be an apology or compensation.
- Be reasonable in your demands, and as in any negotiating situation, know your fall-back positions before discussions begin.
- Keep track of when you sent the complaint. If no response arrives in a reasonable amount of time, don't hesitate to write a second time. Some companies ignore a first complaint on the theory that many people write in a fit of anger that is often quickly forgotten.

If the company ignores your complaint or does not give you a satisfactory reply, consider bringing the matter to:

- Federal or local governmental agencies regulating the company or industry. The U.S. Department of Transportation Consumer Affairs division (202–366–2220) accepts complaints about airlines, for example. The Federal Aviation Administration Consumer Hotline (800–322–7873) deals with carry-on baggage and airport security complaints. Foreign hotels especially prize their governments' ratings.
- The local Better Business Bureau or chamber of commerce.
- A private advocacy group with an interest in that industry.
- Your professional organizations, particularly in cases that might establish useful precedents for your colleagues.
- The local media, particularly those with "action reporter" formats. But be sure you are truthful and thorough in telling your story. Vendors of services have rights too, and it can be very painful to be the subject of a libel or slander suit.

GRATUITIES

Throughout this book I have made clear my feeling that tipping with as much generosity *and* dignity as you can is excellent trip insurance. Local people who have benefited from your fairness and respect may well save the day in a crisis. When I lived in Hong Kong some years ago, it was my pleasure to know the late Richard Hughes, raconteur, bon vivant, and dean of the old-guard journalists in Asia. He was an enormous and graceful tipper, and it was always a delightful experience to observe the service he received wherever he went. Develop a reputation in an establishment as a thoughtful tipper, and you may find a battalion of guardian angels at your disposal.

You will find specific information in the Country Files, but here are some general suggestions.

A tip will not reward an individual you have insulted. Throwing money at people while treating them cruelly or disdainfully is absurd.

Be sensitive to situations in which a reward other than money is preferable. Offering a tip to a managerial person is mildly insulting (and will probably be refused). Far better is a letter of compliment to the owners or chief executives of the employee's business. These letters will provide dividends for years to come, as they are often put in an employee's file (I have discovered them being used as job references as long as a decade after being issued). Always send a copy both to the employee and his or her immediate supervisor. Include a line to the effect that "this employee's outstanding performance is clearly reason to be proud of your fine organization." This direct compliment to the recipient ensures a warm welcome for the letter and may win you a new friend in the bargain. Above all, never promise a letter of commendation and neglect to send it when you return home. You have incurred a debt. Incidentally, it is perfectly acceptable to send a letter of commendation to a lower-ranking worker whom you have also tipped if the service has been exemplary.

Know the local customs regarding tipping. Gratuities are forbidden in the Soviet Union (although informal procedures to evade this restriction are common—see the Country Files) and are unnecessary and rarely accepted in Japan and Iceland. Know when money can be given directly, when it must be concealed in an envelope, or when a gift should be substituted.

Know when service is included in a bill. In French, *service compris* indicates the tip is included; in Spanish, *servicio incluido;* in German, *Bedienung inbegriffen;* in Italian, *servizio compreso.* Always be willing to give a bit more when service has been good.

It is acceptable to put tips on the bill in restaurants or for room service. It conserves cash, documents expenses for clients and the IRS, and means that your tip will probably be more evenly divided among the hotel staff, particularly those behind the scenes who deserve some reward. However, cash is always appreciated more and should be the rule for special services.

Consider the beau geste. If the hotel telephone operators have been particularly helpful, flowers or a decorative item from the market may brighten their office.

Tip in advance of a service when encountering a new worker or one whom you will only encounter once. This is highly unorthodox advice. The general rule is to tip after a service has been performed to ensure that the worker will not ignore your needs now that he or she has the money in hand. I have almost never found this to be the case. By giving an initial tip, you are signaling your willingness to reward fine service and the courtesy will rarely be abused. Most service people know that you will still give a little extra afterward if the service rendered has been particularly expert.

In many places in the world, U.S. currency is perfectly acceptable for tips if it is inconvenient to use small denominations of the local currency. In fact, in many instances the dollar is preferred despite its decline in recent years.

BOOKKEEPING

Careful records, especially when the photographer is traveling without the client or art director to corroborate expenses, are essential for success. I have more than once inherited an account from a colleague who took splendid exposures, but whose record keeping was underdeveloped. The last thing you need is to have your integrity doubted because you could not substantiate legitimate expenditures.

It is my policy to present a client with a photocopy of receipts for every penny of expenditure. For undocumented petty cash, I keep a daily log that I attach. Most of these expenses are gratuities, and I break them down by the nature of the service rendered: skycaps, chambermaids, taxi drivers, and so on. Wherever possible, I put the gratuity on the service establishment bill. This conserves my cash, provides better records, and ensures that the gratuity is properly pooled with staff behind the scenes. However, when individuals render special services I reward them with a cash tip.

Some of my colleagues have indicated that they never want to be distracted by financial matters on the road and have delegated the matter completely to an assistant or production supervisor. I feel financial matters are too sensitive to leave beyond my control.

Creating this backup record is less exhausting than it sounds. And while you are bookkeeping for your client, you are also creating records for your partner, Uncle Sam. The key to successful bookkeeping on the road is to deal with each day's finances at the end of every day. Clearly, the last things you want to think about before turning in after an eighteen-hour day are receipts for hamburgers and rental cars. However, taking the extra five minutes to do so will guarantee accurate records and save you time in the long run.

It is extremely difficult to reconstruct financial events after several weeks on the road. Putting your financial house in order at the end of a trip leads to guesswork and errors. It is, moreover, much easier to spot the all-too-common missing receipt on a daily basis when you can readily remember your expenses. As tiresome as accounting can be at midnight in Des Moines, it is even less appealing when you've returned from weeks of effort eager to get on with the next assignment or a little rest.

My routine is simple: I carry a small tape recorder in my vest pocket. As soon as I encounter any expense, I record the type and amount on tape. I find this a bit quicker than reaching for a pen and diary. If it is a transaction that provides me with a written receipt, I always put the paper in the same spot in my travel wallet. No matter how rushed you are, never shove the paperwork in a stray coat or shirt pocket, only to be discovered weeks later before a trip to the dry cleaners. In the case of receipts such as hotel bills, I ask the clerk to staple my credit card voucher to the actual room bill, as card vouchers are sometimes not imprinted with the name of the service establishment. The client has a right to know the kind of services used at a hotel, the kind of insurance purchased with rental cars, and the like. To make life a bit easier, I sometimes ask a hotel to put the few personal services I have enjoyed on a separate bill, which I pay for privately.

At the end of the day, my staff give me the receipts they have collected. I quickly review the day's events to spot missing receipts or notations. The figures are then entered onto a ledger or into the portable computer's spread sheet. A computer has the advantage of providing daily and running totals so that I can better control cash flow and give budget reports to my client at any time. After the figures are entered, I put the day's receipts in a separate pouch.

Incidentally, since cash expenditures are the most elusive in record keeping, it is not a bad idea to start off a trip knowing exactly how much cash you have in your wallet so that you can reconcile your cash outlays when you get back.

Staff are given petty cash at the beginning of the trip and asked to keep this kitty separate from their personal monies. If you have a large production in which assistants are involved with financial transactions, corporate credit cards for trusted full-time employees might be worth considering.

CARING FOR FILM AND EQUIPMENT ON THE ROAD

Emergency Repairs

In this age of efficient overnight and same-day express mail, if a vital piece of equipment fails on the road I recommend that you send it back either to your regular repair shop or to well-known specialists, such as Professional Camera Service, 37 West Forty-seventh Street, New York, NY 10036 (212–382–0550). Contact Herb Zimmerman or Rick Rankin.

The experts at Professional are adept at responding to photographers' emergencies. On several occasions I have airlifted a damaged camera or lens to them and had it back at my next destination in two days. Be sure that the camera is properly wrapped first in a foam equipment wrapper or bubble pack and then packed in a sturdy box cushioned with bunched newspaper. Be sure to include as much information about the equipment's symptoms or the nature of its damage as possible, as well as a complete list of your contact numbers over the next days.

If you are too far from the United States to send a camera back to Professional, you may need to have an emergency repair done on location. I had originally planned to include a list of foreign repair shops in the Country Files but was concerned that, as personnel within these shops change, these recommendations might become unreliable. Instead, you might want to contact the offices of the local English-language newspaper or news service to see whom they use. Another possibility is to carry a list of the worldwide authorized repair centers for your brands of equipment. They should be of at least a minimum standard, although they may not be used to the turnaround time a location pro can require. And, of course, consult your organization membership roster to see if you might be near a helpful colleague.

Air-freighting Your Equipment

Occasionally it is advisable to air-freight equipment. Air freight has the virtue of being much cheaper than excess baggage, provides the opportunity to insure your equipment conveniently, and actually handles the gear better and with less chance

of loss than normal checked baggage. Its liability is that you must make special trips to the air cargo area of the airport and must understand that your cargo will not necessarily arrive when you do, but will be scheduled on the next available flight. Usually this is no more than a few hours or a day after you consign it. It is a technique I have used midway in an assignment when I want to return a quantity of heavy equipment that I am sure I will no longer need. Remember to buy lots of insurance, put plenty of ID on the cargo, check your paperwork carefully, and arrange for customs clearance, should the cargo be traveling internationally. I have never sent film this way and do not recommend it, but if you must, be sure it is labeled "Do Not X-Ray."

Renting Equipment on the Road

I almost never rent equipment on the road. The few times I have done it were because of a bizarre series of equipment failures or a completely unexpected change in the requirements of the brief. However, many colleagues routinely rent, preferring it to the serious problems of hauling heavy and delicate equipment from home.

I resist renting because picking up and returning expensive gear can slow progress. One of the few times I did it, we almost missed our flight.

Using unfamiliar and untested equipment is also disagreeable. When I was first starting out and had less gear than I do now, I rented strobes a few times. The first time, the power pack exploded like fireworks on the Fourth of July. The second time, I discovered that the 1,200-watt second pack had been "tuned down" to 600-watt/seconds to "preserve its useful life." Rented equipment may be incompatible with some of your accessories as well.

If you prefer to rent or find you must, I have included a list of rental specialists worldwide in the Country Files. I offer the following suggestions:

- Carefully check the reputation of the renting company.
- Check the equipment *before* you leave the shop, no matter how hurried you are. Examine it for visible defects and have them noted so you will not be responsible for them. Be sure that all the accessories and attachments you need are present.
- You may have to leave a deposit for the full value of the equipment. Are you carrying enough cash to cover it, or do you have enough credit on a credit card? Be sure to have the merchant remove the telephone authorization when you return the gear, or it might tie up your card for the billing cycle.
- Be sure that your camera floater insurance sufficiently covers rented equipment. Many place severe restrictions on items not listed on the policy.
- Reserve the gear as far in advance as possible, and confirm the order as soon as you get into town.
- Have *your* staff pick up and return the gear if time allows.
- Be sure that the equipment is relatively compatible with your own. All strobe lights, for example, can be synchronized with your camera, but do they all use the same type of PC cords? Are filter sizes on lenses uniform with the filters you carry? Are flash heads of a diameter to accept the same attachments? Will their brackets attach to your light stands?

Couriers

Someday—sooner than people think—electronic image making and transmission will obviate many worries on the road. Images will be, via modern communication links, on clients' desks moments after they are framed. I look forward to it. I will not miss the clammy feeling on a long flight back from Bangkok, worrying that maybe a camera malfunctioned or a slave mis-synced or perhaps the heat contamination of my film was greater than I sensed.

It will also obviate a difficult decision on the road: whether or not to send film to the client before you return. Avoid sending film back on its own from a shoot unless absolutely necessary. But, clearly, photojournalists and occasionally commercial photographers will have to part with their precious booty to meet a production deadline or because the next leg of the trip poses more of a threat to the film than the risk of sending it by courier.

CHOOSING A COURIER

From point to point within the United States, rely on the same overnight carriers you use for your business documents, such as Federal Express. Mark the package "Do Not X-Ray," to be on the safe side, even though X-raying is not routine, and follow the same packing suggestions listed below for international transmission. Consider dividing the film into two or three parcels and transmitting them from different points. Some of the carriers used to have a constant surveillance option, which for a few dollars more had your package picked up as a special delivery and signed for by an employee at every step of its trip. The few that offered this program (which they certainly did not promote) seem to be abandoning it.

If film must get there faster, use a same-day courier such as AAA (800–223–6707; call 212–239–0030 in New York) or Archer (800–223–5598; call 212–563–8800 in New York).

To courier film back to the United States from abroad, photojournalists often simply go to the airport and ask a tourist to hand-carry the film to the States, where the traveler will be met at the airport by a colleague. This can be the only option when normal transmission methods are disrupted by civil unrest, and it usually precludes customs problems since the film becomes part of the tourist's personal belongings. However, you will be trusting a stranger, and although they do not usually lose the film, tourists sometimes do not appreciate the urgency of the situation and have been known to deliver the film days later than expected. If you are shooting for a commercial client, inquire if the organization has employees or other associates traveling home. In both these situations, however, be sure that the travelers are aware of the hazards of airport X-rays.

If you cannot locate a personal courier, send the film by commercial courier. If a few days' delivery time is acceptable, call an organization such as DHL, Emery, Federal Express, Purolator, TNT, World, or a regional specialist such as Zoom (212–582–2940), which serves Latin America. They are generally experienced in clearing film through customs. However, be aware that they do sometimes rely on

sub-agents; particularly in remote locations, you may want to take the film to the airport yourself and consign it directly to the airlines.

The airlines will ship the film as a small packet to a port of entry in the United States. There you or your client will have to arrange for a customs broker to receive the package from the airline, clear it through customs, and organize delivery of the packet from the airport to its final destination. It is best to have the package clear customs in the port of entry. If, for example, you want to send a package to New York on an airline that flies into San Francisco and then on to New York, it should be received in San Francisco by your broker. If the airline were to carry it straight through to New York, it would have to be placed in bond. Similarly, do not address the package to a city other than the port of entry. If you address the package to a client in Phoenix when it is entering in San Francisco, customs may *truck* it to Phoenix to be surrendered there if for some reason your agents have not contacted them before processing. Always check your paperwork carefully. I know of one instance where a parcel intended for Dulles Airport ended up in Dallas, Texas.

If time is of the essence, get the film to a carrier who can link up with the Concorde system, even if it is a bit out of the way. You can reserve a "seat," or place for the film in the small package section of the Concorde flight in advance.

PACKING AND MARKING

Even if you are sending back only a few rolls, be sure that the package is at least 10 by 13 inches. Smaller packets tend to get lost or remain unnoticed. Carry a few yards of bubble pack with you. Put the film back in the original plastic canisters if you still have them, wrap them all in bubble, and put them in a sturdy corrugated box or a bubble-lined padded bag. You may also want to put the film in a lead-lined bag for X-ray protection. Put some identification inside the package in case the packing is destroyed. Remember to put any special processing or logging information on the individual rolls. I apply a pressure-sensitive label, pre-stamped with my name and phone number and with space for instructions on all my film.

In bold letters on the outside of the package, write:

PRESS MATERIAL—NO VALUE

DO NOT X-RAY

DO NOT CONTAINERIZE

The first item should help with customs. Be aware, of course, that by declaring the package to be of "No Value" you are reducing the chances of compensation should the packet be lost by a carrier and making it difficult to insure it for any value when you send it. However, I prefer to rely on production insurance for these contingencies in any case. The reason for the X-ray warning is obvious. You may also put on special "Do Not X-ray" stickers, available from Alan Gordon Enterprises (213–466–3561). The third line urges the airline transporting the goods to put the

film in a special small-packet section of their cargo area. Containerizing your film does not increase the risk of loss but encourages delays because of the time needed to empty large airline cargo containers.

Processing on the Road

As in the case of repairs, it is difficult to make too many recommendations about color labs abroad, but the Kodak and Fuji laboratories worldwide are included in the Country Files on the premise that they are of good international standard. However, processing tolerances are such that you will most probably experience differences from the color of the emulsion tests from your home laboratory.

Processing on the road has become more common since the ascendancy of professional E6 films in the last few years. I certainly do it when I need feedback on a doubtful shoot or am working for foreign clients in their home territory, but normally I try to process at home.

HEALTH AND PHYSICAL FITNESS

Health Suggestions for Plane Trips

The air on planes is very dry (often less than 2 percent humidity). Carry a skin moisturizer. Dehydration is common, so drink plenty of water or juices. Avoid alcohol and caffeine. Similarly, air pressure is different from what we are used to on the ground. Avoid carbonated drinks, tobacco, and overeating, particularly in first class.

To avoid indigestion or the possibility of food poisoning, consider not eating airline food at all. Try to schedule your meals around the flight, or even bring a nonperishable sandwich from home. One usually eats out of boredom on flights, not culinary curiosity. Remember that, when you return from a country with poor sanitation, the water (and ice) served to you was provided in your country of departure. Be forewarned.

Loosen your shoes, and try a few simple exercises, such as those suggested in Lufthansa's *Fitness in the Chair* publication (516–794–2020).

Avoid flying with ear or sinus infections, bad colds, or after dental treatment. Consult your doctor about some of the more serious effects of air travel on ailments, such as circulatory disease, anemia, glaucoma, and diabetes.

Jet Lag

Much has been written about combating the pernicious problem of jet lag. Aside from being as miserable as the flu, it can seriously cloud your perceptions and judgment. It is tricky too, because you often feel you have adjusted, only to realize that you have missed whole conversations or put the wrong film in the camera.

Strategies for dealing with jet lag involve deceiving the body's awareness of diet, light, and normal sleep patterns. The most interesting of these is the special dietary

recommendations of Dr. Charles F. Ehret at the Argonne National Laboratory; see *Overcoming Jet Lag*, by Dr. Charles F. Ehret and Lynne Waller Scanlon (New York: Berkley Books, 1986).

These plans are impractical, however, for the busy location photographer because of the demands of our daily routines and the chaotic patterns of our international travel.

I observe only a few common-sense rules and then grin and bear it:

- Try to travel east early in the day, west later in the day.
- Avoid alcohol and overeating.
- Set your watch and mentally project yourself into the time zone of your destination as soon as you get on the plane.
- Try to adapt to the routines of the new time zone as soon as possible. If you are traveling to Asia, for example, try to resist the temptation to sleep during the day and be awake all night. On my first trip there, my unwillingness to counter daytime naps prolonged the effects of jet lag to a full two weeks. If you need to force sleep a bit, there are sleeping tablets that leave the body after eight hours and so do not cause the drowsiness associated with other medications. If you do not want to use a prescription medication, consider tryptophan, an ordinary protein found in large quantities in turkey and milk. Tryptophan is available in health-food stores and should make you sleepy. Get plenty of sunshine.
- The first day or so after a major time change you are going to be worthless to yourself or your client. Don't schedule any shooting unless absolutely necessary.

Dealing with Stress

Stress can destroy your assignment as quickly as a bad emulsion or belligerent cop. It works stealthily and silently, undermining your outlook, relationships, creativity, and health. Below are some of the physiological reactions that can indicate poor management of stress. If they sound familiar, consult your doctor, since they can be symptoms of a variety of diseases, but also consider the role of stress in your life:

- Headaches
- Dizziness
- Vision disturbances
- Fatigue
- Numbness or prickly or cold sensations in limbs or joints
- Ringing in the ears
- Gastrointestinal problems
- Breathing difficulties
- Palpitations
- Chest pains, pressure, or tightness
- Itching, blotches, or other skin problems
- Lower back pain
- Excessive sweating

- Sleeping difficulties
- Teeth grinding, nervous twitches, nail biting, or other nervous habits

Some of the emotional signposts of stress include irrational or unfounded:

- Depression
- Anxiety
- Paranoia
- Excessive worrying
- Obsessive thinking
- Irritability or hostility
- Feelings of loneliness
- Pessimism or hopelessness
- Sensitivity to criticism and the need to always be right
- Guilt
- Feelings of worthlessness
- Feelings of not being in control of your body
- Inability to concentrate
- Avoidance of decisions

An acute or prolonged bout of any of these problems could obviously hamper your creativity or cause you to make poor decisions on the road, especially in the all too common moments of crisis. The photographer must be ruthless in recognizing these symptoms and wholehearted in the commitment to master them, for coping with a difficult environment productively is the core of professionalism. But, short of a major program of psychotherapy, how can the photographer respond to stress on the road, whether a chronic problem or just a result of a sudden onslaught of overwhelming job difficulties? Steven J. Kahan, a noted New York expert on stress-related illnesses, makes the following observations:

As inconvenient as it may be on the road, seek balance in your daily routines. Try not to abuse your needs for both leisure and rest. Avoid junk food at all costs. Provide yourself with the comforts that you enjoy.

Take action when necessary but learn when no further action is required or possible. If you are up against a stone wall, walk away. Recoup your resources, or devote yourself to another problem temporarily. Sometimes it is easier to walk around a stone wall than break through it.

Develop familiarity with a few simple "first-aid" responses to acute bouts of stress:

- Breathing exercises: Take two or three slow, deep, measured breaths, drawing the air in through the nostrils and exhaling with an audible sigh. Be aware of the breath itself, and surrender to the pleasure of "letting go" of the stress. Allow your body to go limp. You might also visualize the air coming in through imaginary holes in the bottom of your feet.
- Concentrate on relaxing your muscles starting from the top of the head down to the bottom of your feet.

• Positive visualization: Concentrate all your senses on images in the immediate environment: the sound of the car wheels; the sight of a patch of primary color; the feel of a rough or smooth texture. This sudden shift of focus can sometimes "ground" an overcharge of stress in seconds. Avoid complex thinking (a past pleasure or future plan, for example) in seeking the appropriate image, for it requires decision making and potentially allows an unfortunate loop of negative thought processes to come into play.

Your Eyes

• Regularly consult your ophthalmologist.
• Beware of the ultraviolet damage that can be done by prolonged exposure to bright sunlight. Get a good pair of sunglasses with ultraviolet screen (not necessarily the more expensive brands). Birth control pills, some diuretics for high blood pressure, tranquilizers, tetracycline, sulfa drugs, and other medications can increase your sensitivity to sunlight.
• Wear safety glasses in industrial situations.
• Carry a good eyewash in your medical kit. If you have none, water is also a good bath, but be sure to boil it first. If a piece of sand or grit gets in your eye, try to flush it out naturally with tears. Do *not* rub your eye. If the discomfort persists after several hours, consult a physician.
• Carry some antibiotic ointment for mild cases of conjunctivitis, characterized by a sticky discharge. Again, consult a physician if you have any doubts.
• If you wear contact lenses, be fully familiar with their care. Bring all care and cleaning supplies with you from home, as well as extra lenses or glasses in case of loss. Be aware of the effects of low humidity in airline cabins, aerosol insecticides, and other potential hazards.

Your Back

Several years ago I developed a slight but chronic and annoying lower back pain. The safe and simple exercises recommended in *Oh! My Aching Back*, by Leon Root and Thomas Kiernan (New York: New American Library, 1985), proved invaluable.

Photographers are more susceptible to back injury because they often lift heavy loads hurriedly, climb to strange places, or hold unusual positions for long periods of time.

When lifting a heavy case, keep your back straight and let your legs do the work. Do not rush when lifting. A back injury will cost you more time in the long run. If you absolutely must have a very heavy case, get one with handles for two people.

When renting or purchasing a work vehicle, avoid one with a tailgate that folds down—you will always be straining your back to lift over it. Choose a tailgate that lifts up (watch your head!) or better yet, one that swings open like a car door.

If the bed in a hotel room is very soft, ask for a change or put your bedding on the floor—you may actually have a more restful night.

Photographer Peter Roth, who has lectured and consulted on health matters for

photographers, suggests vigorously rubbing the skin two inches above the navel from left to right to stimulate adrenal production reflexively. He indicates this should ease stress tension on the sartorius muscle of the back.

Your Feet

Never break in new shoes on a shoot. For photographers who must dress in something better than running or casual walking shoes, a number of comfortable models with leather uppers are available from suppliers such as Lands End and L. L. Bean.

If your shoes fit well, you might very well be able to avoid blisters on even the most grueling day. Carry antiseptic solution and sterile gauze, should a blister need treatment. Be sure to sterilize a needle before you lance a blister. Be aware that blisters on the feet may also indicate insect bites, viral infections such as herpes, or exposure to plant or chemical toxins or extreme heat or cold. Carry a good foot powder for athlete's foot.

At night massage the feet with alternating cold and warm wet washcloths, soak in a solution of one cup Epsom salts to one gallon of water, and elevate the feet above the hip for several minutes. For relief of muscle tension, Peter Roth carries a golf ball that he vigorously kneads on the floor with the bottom of his foot as if he were making a ball of dough.

Exercise

If you are in the mood for some exercise while on a shoot and cannot get to a pool or jogging path there are a few portable options for your hotel room. A simple jump rope is very light and an excellent means of aerobic exercise, but consider your downstairs neighbor—try to use a public recreation area. Lifeline International, Inc. (800–553–6633) and Excel Safety Bar (213–699–0311) manufacture a line of portable exercise tools.

Health Hints for the International Traveler

The Centers for Disease Control have prepared the tips in this section, useful for anyone traveling abroad.

MOTION SICKNESS

Travelers with a history of motion sickness or sea sickness can attempt to avoid symptoms by taking anti-motion-sickness pills or antihistamines before departure.

PREGNANT WOMEN

The problems that a pregnant woman might encounter during international travel are basically the same as problems that other international travelers have. These have to do with exposure to infectious diseases and availability of good medical care.

There is the additional potential problem that air travel late in pregnancy might precipitate labor. [Some airlines have restrictions that stipulate how late in pregnancy you may travel. Check with your carrier.] Potential health problems vary from country to country; therefore, if the traveler has specific questions, she should check with the embassy or local consulate general office of the country in question before traveling.

RISKS FROM FOOD AND DRINK

Contaminated food and drink are common sources for the introduction of infection into the body. Among the more common infections that travelers may acquire from contaminated food and drink are *Escherichia coli* infections, shigellosis or bacillary dysentery, giardiasis, cryptosporidiosis, and hepatitis A. Other less common infectious disease risks for travelers include typhoid fever and other salmonelloses, cholera, infections caused by rotaviruses and Norwalk-like viruses, and a variety of protozoan and helminth parasites (other than those that cause giardiasis and cryptosporidiosis). Many of the infectious diseases transmitted in food and water can also be acquired directly through the fecal-oral route.

Water that has been adequately chlorinated, using minimum recommended waterworks standards as practiced in the United States, will afford significant protection against viral and bacterial waterborne diseases. However, chlorine treatment alone, as used in the routine disinfection of water, may not kill some enteric [intestinal] viruses and the parasitic organisms that cause giardiasis and amebiasis. In areas where chlorinated tap water is not available or where hygiene and sanitation are poor, travelers should be advised that only the following may be safe to drink:

- Beverages, such as tea and coffee, made with boiled water
- Canned or bottled *carbonated* beverages, including *carbonated* bottled water and soft drinks
- Beer and wine

Where water may be contaminated, ice (or containers for drinking) also should be considered contaminated. Thus, in these areas ice should not be used in beverages. If ice has been in contact with containers used for drinking, the containers should be thoroughly cleaned, preferably with soap and hot water, after the ice has been discarded.

It is safer to drink directly from a can or bottle of a beverage than from a questionable container. However, water on the outside of cans or bottles of beverages might be contaminated. Therefore, wet cans or bottles should be dried before being opened, and surfaces that are contacted directly by the mouth in drinking should first be wiped clean. Where water may be contaminated, travelers should avoid brushing their teeth with tap water.

Boiling is by far the most reliable method to make water of uncertain purity safe for drinking. Water should be brought to a vigorous boil and allowed to cool to room temperature—do not add ice. At very high altitudes, for an extra margin of

safety, boil for several minutes or use chemical disinfection. Adding a pinch of salt to each quart, or pouring the water several times from one container to another, will improve the taste.

Chemical disinfection with iodine is an alternative method of water treatment when it is not feasible to boil water. Two well-tested methods for disinfection with iodine are the use of tincture of iodine [2 percent tincture of iodine added to water as follows: for clear water, add five drops or 0.25 milliliters iodine per quart or liter of water and allow to stand for thirty minutes; for cold or cloudy water, add ten drops or 0.5 milliliters iodine per quart or liter of water and let stand for at least thirty minutes—very cold or turbid water should be allowed to stand for several hours if possible], and the use of tetraglycine hydroperiodide tablets (Globaline, Potable-Agua, Coghlan's, etc.). The tablets are available from pharmacies and sporting goods stores. The manufacturer's instructions should be followed. If water is cloudy, the number of tablets should be doubled; if water is extremely cold, an attempt should be made to warm the water, and the recommended contact time should be increased to achieve reliable disinfection. Cloudy water should be strained through a clean cloth into a container to remove any sediment or floating matter, and then the water should be treated with heat or iodine. Chlorine, in various forms, has also been used for chemical disinfection. However, its germicidal activity varies greatly with pH, temperature, and organic content of the water to be purified and is less reliable than iodine.

There are a variety of portable filters currently on the market, which according to the manufacturers' data will provide safe drinking water. Although the iodide-impregnated resins and the microstrainer-type filters will kill and/or remove many microorganisms, there are very few published reports in the scientific literature dealing both with the methods used and the results of the tests employed to evaluate the efficacy of these filters against water-borne pathogens. Until there is sufficient independent verification of the efficacy of these filters, CDC makes no recommendation regarding their use.

As a last resort, if no source of safe drinking water is available or can be obtained, tap water that is uncomfortably hot to touch is usually safe. After allowing such hot water to cool to room temperature in a thoroughly cleaned container, it may be used for brushing teeth, as well as for drinking.

To avoid illness, food should be selected with care. All raw food is subject to contamination. Particularly in areas where hygiene and sanitation are inadequate, the traveler should be advised to avoid salads, uncooked vegetables, unpasteurized milk and milk products, such as cheese, and to eat only food that has been cooked and is still hot, or fruit that has been peeled by the traveler. Undercooked and raw meat, fish, and shellfish may carry various intestinal pathogens.

The easiest way to guarantee a safe food source for an infant less than six months of age is to have the child breastfeed. If the infant has already been weaned from the breast, formula prepared from commercial powder and boiled water is the safest and most practical food.

Some species of fish and shellfish can contain poisonous biotoxins, even when

well cooked. The most common type of fish poisoning in travelers is ciguatera fish poisoning. Red snapper, grouper, barracuda, amberjack, sea bass, and a wide range of tropical reef fish contain the toxin at unpredictable times. The potential for ciguatera poisoning exists in all subtropical and tropical insular areas of the West Indies and Pacific and Indian oceans where the implicated fish species are consumed.

TRAVELERS' DIARRHEA

Travelers' diarrhea (TD) is a syndrome characterized by a twofold or greater increase in the frequency of unformed bowel movements. Commonly associated symptoms include abdominal cramps, nausea, bloating, urgency, fever, and malaise. Episodes of TD usually begin abruptly, occur during travel or soon after returning home, and are generally self-limited. The most important determinant of risk is the destination of the traveler. Attack rates in the range of 20 to 50 percent are commonly reported. High-risk destinations include most of the developing countries of Latin America, Africa, the Middle East, and Asia. Intermediate-risk destinations include most of the southern European countries and a few Caribbean islands. Low-risk destinations include Canada, northern Europe, Australia, New Zealand, the United States and a number of the Caribbean islands.

TD is slightly more common in young adults than in older people. The reasons for this difference are unclear but may include a lack of acquired immunity, more adventurous travel styles, and different eating habits. Attack rates are similar in men and women. The onset of TD is usually within the first week but may occur at any time during the visit and even after returning home.

TD is acquired through ingestion of fecally contaminated food and/or water. Both cooked and uncooked foods may be implicated if improperly handled. Especially risky foods include raw meat, raw seafood, and raw fruits and vegetables. Tap water, ice, and unpasteurized milk and dairy products may be associated with increased risk of TD; safe beverages include bottled carbonated beverages (especially flavored beverages), beer, wine, hot coffee or tea, or water boiled or appropriately treated with iodine or chlorine.

The eating place appears to be an important variable, with private homes, restaurants, and street vendors listed in order of increasing risk.

TD typically results in four to five loose or watery stools per day. The median duration of diarrhea is three to four days. Ten percent of the cases persist longer than one week, approximately 2 percent longer than one month, and less than 1 percent longer than three months. Persistent diarrhea is thus quite uncommon and may differ considerably from acute TD with respect to etiology [causes] and risk factors. Travelers may experience more than one attack of TD during a single trip. Approximately 15 percent experience vomiting, and 2 to 10 percent may have diarrhea accompanied by fever or bloody stools, or both. Rarely is TD life threatening.

Infectious agents are the primary cause of TD. Travelers from industrialized countries to developing countries frequently develop a rapid, dramatic change in the type of organisms in their gastrointestinal tract. These new organisms often include

potential enteric pathogens [intestinal-disease-causing agents]. Those who develop diarrhea have ingested an inoculum [dose] of virulent organisms sufficiently large to overcome individual defense mechanisms, resulting in symptoms.

Enterotoxigenic *Escherichia coli* (ETEC) are the most common causative agents of TD in all countries where surveys have been conducted.

Salmonella gastroenteritis is a well-known disease that occurs throughout the world. In the industrialized nations, this large group of organisms is the most common cause of outbreaks of food-associated diarrhea. In the developing countries, the proportion of cases of TD caused by salmonellae varies but is not high. Salmonellae also can cause dysentery, characterized by bloody mucus-containing small-volume stools.

Shigellae are well known as the cause of bacillary dysentery. However, few infected travelers have dysentery, but most have watery diarrhea. The shigellae caused TD in about 5 to 15 percent of travelers in the few countries that have been studied.

Campylobacter jejuni is a common cause of diarrhea throughout the world. Recent, limited data have shown that *C. jejuni* is responsible for a small percentage of the reported cases of TD, some with bloody diarrhea. Additional studies are needed to determine how frequently it causes TD.

Vibrio parahaemolyticus is associated with ingestion of raw or poorly cooked seafood and has caused TD in passengers on Caribbean cruise ships and in Japanese people traveling in Asia. How frequently it causes disease in other areas of the world is unknown.

Other potential bacterial pathogens include *Aeromonas hydrophila, Yersinia enterocolitica, Pleisiomonas shigelloides, Vibrio cholerae* (non-01), and *Vibrio fluvialis*.

Along with the newly acquired bacteria, the traveler may also acquire many viruses. In six studies, for example, 0 to 36 percent of diarrheal illnesses (median 22 percent) were associated with rotaviruses in the stools. However, a comparable number of asymptomatic travelers also had rotaviruses, and up to 50 percent of symptomatic persons with rotavirus infections also had nonviral pathogens. From 10 to 15 percent of travelers develop serologic evidence of infection with Norwalk-like viruses. The roles of adenoviruses, astroviruses, coronaviruses, enteroviruses, or other viral agents in causing TD are even less clear. Although viruses are commonly acquired by travelers, they do not appear to be frequent causes of TD in adults.

The few studies that have included an examination for parasites reveal that 0 to 9 percent have *Giardia lamblia* or *Entamoeba histolytica. Cryptosporidium* has recently been recognized in sporadic cases of TD.

Dientamoeba fragilis, Isospora belli, Balantidium coli, or *Strongyloides stercoralis* may cause occasional cases of TD. While not major causes of acute TD, these parasites should be sought in persisting, unexplained cases.

No data have been presented to support noninfectious causes of TD, such as changes in diet, jet lag, altitude, and fatigue. Current evidence indicates that in all but a few instances, such as drug-induced or preexisting gastrointestinal disorders, an infectious agent or agents cause diarrhea in tourists. However, even with the application of the best current methods for detecting bacteria, viruses, and parasites,

in various studies 20 to 50 percent of cases of TD remain without recognized etiologies [causes].

There are four possible approaches to prevention of TD. They include instruction regarding food and beverage preparation, immunization, use of antimicrobial medications, and prophylactic antimicrobial drugs.

Data indicate that meticulous attention to food and beverage preparation, as mentioned above, can decrease the likelihood of developing TD. Most travelers, however, encounter great difficulty in observing the requisite dietary restrictions.

No available vaccines and none that are expected to be available in the next five years are effective against TD.

Several antimicrobial agents have been advocated for prevention of TD. Available controlled studies indicate that prophylactic use of difenoxine, the active metabolite of diphenoxylate (Lomotil), actually increases the incidence of TD in addition to producing other undesirable side effects. No antiperistaltic agents, such as Lomotil and Imodium, are effective in preventing TD. No data support the prophylactic use of activated charcoal.

Bismuth subsalicylate, taken in liquid form as the active ingredient of Pepto-Bismol (2 ounces, four times daily), has decreased the incidence of diarrhea by 60 percent in one study. Available data are not extensive enough to exclude a risk to the traveler from the use of such large doses of bismuth subsalicylate over a period of several weeks. In patients already taking salicylates for arthritis, large concurrent doses of bismuth subsalicylate can produce toxic serum concentrations of salicylate. On the basis of its modest potential benefit achieved with large doses, together with its uncertain risks, bismuth subsalicylate is not recommended for prophylaxis of TD.

Controlled data are available on the prophylactic value of several antimicrobial drugs. Enterovioform and related halogenated hydroxyquinoline derivatives, such as clioquinol, iodoquinol, Mexaform, Intestopan, and others, are not helpful in preventing TD, may have serious neurological side effects, and should never be used for prophylaxis of TD.

Carefully controlled studies have indicated that two agents, doxycycline and trimethoprim/sulfamethoxazole (TMP/SMX), when taken prophylactically, are consistently effective in reducing the incidence of TD by 50 to 86 percent in various areas of the developing world. One study shows that trimethoprim alone is also effective.

The benefits of widespread prophylactic use of doxycycline or TMP/SMX or TMP alone in several million travelers must be weighed against the potential drawbacks. The known risks include allergic and other side effects (such as common skin rashes, photosensitivity of the skin, blood disorders, Stevens-Johnson syndrome and staining of the teeth in children) as well as other infections that may be induced by antimicrobial therapy (such as antibiotic-associated colitis, *Candida* vaginitis, and *Salmonella* enteritis). Because of the uncertain risk of widespread administration of these antimicrobial agents, their prophylactic use is not recommended. Nor is there any basis for recommending their use prophylactically for special groups of travelers. Furthermore, there is no documented evidence that there are any groups of disease

entities that are worsened sufficiently by an episode of TD to risk the rare undesirable side effects of prophylactic antimicrobial drugs. *On the basis of apparent risk/ benefit ratios, prophylactic antimicrobial agents are not recommended for travelers.* Available data support only the recommendation that travelers be instructed in regard to sensible dietary practices as a prophylactic measure. This recommendation is justified by the excellent results of early treatment of TD as outlined below. Some travelers may wish to consult with their physicians and may elect to use prophylactic antimicrobial agents for travel under special circumstances, once the risks and benefits are clearly understood.

Individuals with TD have two major complaints for which they desire relief—abdominal cramps and diarrhea. Many agents have been proposed to control these symptoms, but few have been demonstrated to be effective by rigorous clinical trials.

A variety of "adsorbents" have been used in the treatment of diarrhea. For example, activated charcoal has been found to be ineffective in the treatment of diarrhea. Kaolin and pectin have been widely used for diarrhea. The combination appears to give the stools more consistency but has not been shown to decrease cramps and frequency of stools nor to shorten the course of infectious diarrhea.

Lactobacillus preparations and yogurt have also been advocated, but no evidence supports these treatments for TD.

Bismuth subsalicylate preparation (1 ounce, every 30 minutes, for eight doses) decreased the rate of stooling by one-half in a study of travelers with diarrhea when compared with a placebo group. However, there was no difference between the two groups in stool output in the first four hours of the study. There is concern about taking, without supervision, large amounts of bismuth and salicylate, especially in individuals who may be intolerant to salicylates, who have renal insufficiency, or who take salicylates for other reasons.

Antimotility agents are widely used in the treatment of diarrhea of all types. Natural opiates (paregoric, deodorized tincture of opium, and codeine) have long been used to control diarrhea and cramps. Synthetic agents, diphenoxylate and loperamide, come in convenient dosage forms and provide prompt symptomatic but temporary relief. However, they should not be used in patients with high fever or with blood in the stool. These drugs should be discontinued if symptoms persist beyond forty-eight hours. Diphenoxylate and loperamide should not be used in children under the age of two.

Travelers who develop diarrhea with three or more loose stools in an eight-hour period, especially if associated with nausea, vomiting, abdominal cramps, fever, or blood in the stools, may benefit from antimicrobial treatment. A typical three- to five-day illness can often be shortened to one to one and a half days by effective antimicrobial agents. Those best studied to date are daily TMP/SMX (160 milligrams TMP and 800 milligrams SMX) or TMP alone, 200 milligrams taken twice daily. Preliminary evidence suggests that doxycycline, taken 100 milligrams twice daily, is also effective. Three days of treatment is recommended, although two days or fewer may be sufficient. Nausea and vomiting without diarrhea should not be treated with antimicrobial drugs.

Travelers should consult a physician, rather than attempt self-medication, if the diarrhea is severe or does not resolve within several days; if there is blood and/or mucus in the stool; if fever occurs with shaking chills; or if there is dehydration with persistent diarrhea.

Most cases of diarrhea are self-limited and require only simple replacement of fluids and salts lost in diarrheal stools. Fluid and electrolyte balance can be maintained by potable fruit juices, soft drinks (preferably caffeine-free), and salted crackers. Iced drinks and noncarbonated bottled fluids made from water of uncertain quality should be avoided. Dairy products aggravate diarrhea in some people and should be avoided. Travelers may prepare their own fruit juice from fresh fruit. A good formula for the treatment of the more common diarrheal diseases is the following. Prepare a glass containing 8 ounces of orange, apple, or other fruit juice (which is rich in potassium) plus 1/2 teaspoon of honey (which contains glucose, necessary for the absorption of essential salts) and a pinch of table salt (which contains sodium and chloride). In a second glass, combine 8 ounces of carbonated or boiled water with 1/4 teaspoon of baking soda (which contains sodium bicarbonate). Drink alternately from each glass until thirst is quenched. Supplement as desired with carbonated beverages, water, or tea made with boiled or carbonated water. Avoid solid foods and milk until recovery occurs. This formula can be used whether or not antidiarrheal drugs are taken. Individuals with severe dehydration may require special fluid and electrolyte replacement in the form of oral replacement solutions, such as those recommended by the World Health Organization.

CRUISE SHIP SANITATION

The CDC is responsible for a vessel sanitation program designed to achieve levels of sanitation that will minimize the potential for gastrointestinal disease outbreaks on international passenger vessels calling at U.S. ports. The CDC conducts unannounced sanitation inspections of cruise ships, provides the cruise ship industry with technical consultation, and investigates gastrointestinal disease outbreaks on board cruise ships if and when they occur. Standards for the program are based on the World Health Organization's "Guide to Ship Sanitation" and CDC recommendations on vessel sanitation. Ships are rated on the following items to determine if they meet CDC sanitation standards:

- Water
- Food preparation and holding
- Potential contamination of food
- General cleanliness, storage, and repair

A summary of cruise ship sanitation inspection results and/or a copy of the last inspection report of a specific vessel may be obtained from the office of the Chief, Vessel Sanitation Activity, Center for Environmental Health and Injury Control, 1015 North America Way, Room 107, Miami, FL 33132.

THE POST-TRAVEL PERIOD

Some diseases may not manifest themselves immediately. If travelers become ill after they return home, they should tell their physician where they have traveled.

Most persons who acquire viral, bacterial, or parasitic infections abroad become ill within six weeks after returning from international travel. However, some diseases may not manifest themselves immediately; for example, malaria may not cause symptoms for as long as six months to a year after the traveler returns to the United States. It is recommended that a traveler always advise a physician of the countries visited within the twelve months preceding onset of illness. Knowledge of such travel and the possibility the patient may be ill with a disease the physician rarely encounters will help the physician arrive at a correct diagnosis.

Health Emergencies

Should you need medical assistance, you will want to find an English-speaking doctor. Sources include the U.S. consulate, your hotel, and credit card programs such as American Express Global Assist. You can also carry your own list, available from the International Association for Medical Assistance to Travelers (IAMAT), 417 Center Street, Lewistown, NY 14092 (716-754-4883).

In extreme cases you may have to resort to evacuation procedures. You may have evacuation insurance as part of your private travel policy, with your foreign workers' compensation plan, or as a benefit of a credit card such as the American Express Platinum Card. Again, you may turn to the Citizen Emergency Center (202-647-5225), either directly or through a U.S. consulate. The center assists the consulate in handling Americans who become physically or mentally ill while abroad. In addition to providing guidance and support to the post abroad, the center locates family members and friends in the United States and advises them of the problem; identifies and transmits private funds when necessary; and frequently collects information on the individual's prior medical history and forwards it to the post abroad. When necessary, the center assists in the return of the ill or injured individual to the United States commercially with appropriate medical escort via special commercial air ambulance or, occasionally, by U.S. Air Force medical evacuation aircraft. However, the use of air force facilities for medical evacuation is authorized only under certain conditions when commercial evacuation is not possible, and the full expense must be borne by the citizen and his or her family.

Death of a Member of Your Team Abroad

In the unlikely event that an American citizen in your group dies, follow the recommendations of the State Department:

> When an American citizen dies abroad, the nearest U.S. embassy or consulate should be notified as soon as possible. Upon notification, the consular officer may do the following:

- Request proof of the decedent's citizenship (for example, U.S. passport, birth certificate, or naturalization certificate).
- Report the death to the next of kin or legal representative.
- Obtain instructions and funds from the family to make arrangements for local burial or return of the body to the United States.
- Obtain the local death certificate and prepare a "Report of the Death of an American Citizen" (Form OF-180) for forwarding to the next of kin or legal representative (this document may be used in U.S. courts to settle estate matters).
- Serve as provisional conservator of a deceased American's estate and arrange for disposition of those effects.

RELATIONSHIPS ON THE ROAD

Location photography is a high-pressure occupation no matter how effectively you manage stress. One particularly sensitive manifestation is in your relationships with your staff.

The relationship of photographer and assistant is a complex and subtle one. Photographers, some notoriously, are often guilty of venting job pressures on their teams. This is unwise. The morale of an assistant can either win the day or jeopardize the mission. While they have been hired to help in every way and can properly serve as advisers or even alter egos, assistants are neither slaves nor whipping posts. On the other hand, assistants can bring the anxieties and resentments of being on the bottom rungs of the industry's ladder to the job. In all, it is a potentially explosive situation. Photographic associations such as ASMP and APA have responded with seminars and the creation of referral files on assistants.

Understand that the assistant is working as long and as hard as you are for probably 5 to 10 percent of your income. While appreciating the value of learning from an experienced pro, they should not be made to kiss the ground you walk on. Moreover, be open to your staff's ideas. They should feel free to make suggestions in front of clients (your clients will only respect you for it), but advise your assistants as to when discretion is the rule, especially when accompanied by an anxious client.

Try to be democratic about the level of accommodations and amenities enjoyed by the whole team. If you are working on a large production, consider a good caterer. Provide single rooms for staff if budget allows. Pay your assistants shortly after completion of the assignment, and provide some advances to help with living expenses. Assistants should not have to use their own funds for petty cash expenditures.

Never forget that you are the team leader and have ultimate authority for critical decisions. Do not be ambiguous about your expectations. Have a clear chain of command and precise division of responsibilities when employing more than one

assistant. Some of the routine responsibilities I entrust to my assistant during the shoot include:

- Load and unload cameras.
- Check shutter speeds and aperture settings. I repack bodies at 1/60 of a second so that they tend to be at a safe strobe syncing speed when we next use them.
- Check for lens flare.
- Check and clean filters and lenses.
- Quickly check the camera sync before shooting.
- Confirm that film is going through the camera and that all flash heads are syncing.
- Watch for "blinkers" that I might not see through the reflex housing of my camera, as well as small styling details such as creases, loose tie knots, and exposed cuffs.
- Remember to get model releases.
- Log or label exposed film.
- Remind me to rotate bodies within shooting situations to ensure against silent failure.
- See to it that we have not spread out our belongings on location. It is more difficult to lose things if they are placed in a few concentrated work areas.

For their part, assistants should remember that the creative process is a mysterious and demanding one. The sequence of the photographer's thoughts are, of necessity, not always logical and precise but often crablike and meandering. Assistants must respect that process and understand that the photographer often needs time for reflection before a shoot and a moment to unwind directly afterward. Although a photographer might like to pitch in more with physical chores on a shorthanded shoot, it can sometimes be a lethal distraction. The photographer's comfort is sometimes critical to the progress of the shoot.

If an assistant feels the photographer is making unreasonable demands or behaving unprofessionally, he or she should discuss the matter directly and privately rather than behave subversively. They should dress appropriately, never be late, and never bring recreational drugs on location.

Assistants should carry the proper documents for travel abroad, such as a driver's license and passports. They should be sure to alert the photographer if their passport is from a country that might create visa problems. Each assistant should have his or her own kit that includes tape, pens, cords, and the like to supplement the photographer's. Assistants should leave some elbow room in their booking schedule when going on the road with a photographer.

Assistants might also keep in mind that the client is not especially interested in their sexual history or political views.

SOME FINAL THOUGHTS

- Never slow down because you feel you are ahead of schedule—future delays always await.

- Never torture yourself after you have left a location about how you might have done it better. If a serious lapse occurred, consider backtracking. But your main concern is now the future of the shoot. You will have to live with past decisions.
- When times get rough, avoid self-pity. There is no better profession in the world. As writer Mordecai Richler reminds himself on black days, "I wasn't drafted, I volunteered!"
- Beware of mistakes on the last day or two of the shoot. You and your crew are now tired and thinking about home. I have observed this to be a time when emotions become distorted and procedures may be ignored.
- Shoot it both ways.
- Oh yes, welcome home!

Country Files

The data in these files are intended to serve as guidelines. Before any trip, you should be sure to contact the resources given in the first section of this book (such as your local health department and the State Department) as well as the consulate or embassy of the country you will be visiting. Be sure to ask the foreign representatives about visas, photo restrictions, currency restrictions, health requirements, equipment importation, departure taxes, and dates of legal holidays in countries using the lunar calendar.

The information in these files was gathered from scores of sources, particularly the Central Intelligence Agency's *1988 World Factbook,* the State Department's *Background Notes,* and the Commerce Department's *Overseas Business Reports.* In addition, an embassy or consulate was consulted for every country listed for up-to-date information on issues that would not normally be found in printed sources, such as visas and equipment importation requirements for photographers. This information can be no better than the individuals who provided it. As indicated in the text, policies can change at a moment's notice. If a category does not appear in a certain country's files, it means that either the category wasn't applicable or that no information was available.

General travel recommendations, such as hotels and tourist attractions, are not included herein. These are often personal choices, and guidebooks with these recommendations abound.

The resources listed in the files are for international locations. When traveling within the United States, the photographer is advised to consult colleagues through

the professional association directories and to refer to the excellent *Professional Photo Source* (212–219–0993; available at professional photographic dealers), which features resources for over forty North American cities.

HOW TO USE THE COUNTRY FILES

The country files are arranged alphabetically. Each opens with the name of the country as it is commonly known in the United States, followed by its official name in English and in its official or most commonly spoken language. Each file then contains the following information.

Where applicable, brief travel alerts as posted by the State Department as of this writing appear in boldface type at the opening of the file. Be sure to obtain the most recent travel alerts before you go.

Location: Area of the world and countries bounding or nearby. See appendix 1 for maps of the countries. *Size:* Area in square miles, followed by a comparative reference to a location in the U.S.

Major cities: Capital cities are *italicized*. This is likely to be the city of entry by air. More than one city will be listed when the country is not dominated by its capital or if cities other than the capital are likely points of entry by air. Other important cities are sometimes listed under telephone codes. Each city is followed by its latitude, in parentheses, for use with the sunrise/sunset charts in appendix 9. *Airports:* The names of the primary airports for international entry, followed by their 3-letter airport codes, from the *Airline Coding Directory*, courtesy of the International Air Transport Association, and the distance from the closest city in miles.

General transportation: Information about international and domestic air links and ground transport. Indications that domestic flights, railways, and highways exist do not necessarily mean that using them is advisable. In many countries security and availability of accommodations along the way must be considered on the basis of up-to-date information. *U.S. license:* Acceptance of a U.S. driver's license—Yes or No—and any qualifying conditions. *IDP:* Acceptance of an international driver's permit—Yes or No—and any qualifying conditions. *Rule of the road:* The side of the road—Right or Left—used for driving. *Motor clubs:* Names, addresses, and phone numbers of clubs with an agreement with the American Automobile Association, plus an indication of whether they offer full or partial reciprocity with AAA services, courtesy of the American Automobile Association. *Taxi markings:* Colors commonly used for taxicabs; "marked TAXI" indicates that the cars are marked with such a sign, usually on top; based on U.S. government sources and conversations with the embassy. Also listed here is the standard method of charging—by metered mileage or based on a set price—as well as any special customs, such as if taxis are usually shared.

Population: According to the CIA's *1988 World Factbook*. *Type of government:* System in use, plus political information, such as legal system, ruling groups, as well as the status of current relations with the U.S., from the CIA's *1988 World Factbook* and the State Department's *Background Notes*.

Languages: Official language and prevalence of English where possible, based on U.S. government sources and personal experience. *Ethnic groups:* The ethnic heritage of the residents, broken down into percentages where possible. *Religion:* The dominant religions practiced, broken down into percentages where possible. The CIA's *1988 World Factbook* and the State Department's *Background Notes* are the sources for both Ethnic groups and Religion.

Time: EST +/−, the relation to Eastern Standard Time (no entry means the country is on Eastern Standard Time)—time may vary by an hour or two if daylight savings time is in effect in the U.S. or abroad. GMT +/−, the relation to Greenwich Mean Time. *Telephone codes:* Country code, major city codes, and general telecommunications information where possible. Unless indicated, credit card calls back to the U.S. are accepted. *Pay phone system:* Whether public phones take coins, tokens, or magnetic cards, as well as scarcity of public phones outside of post offices and major hotels if applicable, based on conversations with the embassy.

Holidays: Dates for both secular and religious holidays. Be sure to check with consulates for dates of holidays based on the lunar calendar, such as Muslim and Buddhist holidays. Some Muslim observances can, furthermore, only be projected several weeks in advance, since they depend on actual astronomical sightings. Days of observances may vary even for fixed holidays if they fall on weekends. In Muslim countries throughout the world, business is seriously curtailed during the weeks of Ramadan. Source: *Business America* and *Overseas Business Reports*, both issued by the Department of Commerce. *Date/month system:* Indicates whether the month or date—D/M or M/D—is written first; based on conversations with the embassy.

Business and government hours: The most common working hours and days, based on U.S. government sources and conversations with the embassy. *Business dress code:* Indications if business dress is generally the same as that of the U.S., more conservative, as it might be in parts of Europe or Japan (for example, darker suits, no sports jackets), or more informal, as it often is in warm climates, where a neat open shirt can replace a jacket and tie. Women should generally dress modestly in Muslim countries and countries such as Malawi, where strict government rules are in effect. It should be noted that being dressed for photography often means not complying with business standards. Based on U.S. government sources and conversations with the embassy.

Climate and terrain: Major geographical features and weather patterns, based on *Background Notes* (State Department) and *Climates of the World* (Commerce Department). *Temperature ranges:* Average high and low temperatures in degrees Fahrenheit on a quarterly basis in the major city (usually the capital). If temperatures are significantly different in other major cities, their temperature ranges are also included.

Visas: Requirements for entry, based on conversations with the embassy. In cases where photographers can enter as any tourist would, "Standard tourist entry" is noted, followed by the current entry requirements as compiled by the State Department. In cases where photographers will require special documents or visas, such as a business visa or photojournalism permit, the documents necessary for application are indicated, as well as the amount of time necessary for processing the applica-

tion and the length of time for which the document is valid. Also included in these cases *for comparison* are requirements for a tourist visa after the word *Tourists. In all cases, it is assumed the reader holds a U.S. passport.* Visa information also presumes that the photographer is not collecting monies in the country and that the length of stay is not such that would constitute residency (this might require an entirely different type of work permit). "Client letter" is a letter from your commercial client or publication. These and the photographer's letter (written by the photographer on his or her own behalf) should indicate the nature of the visit, expected dates of arrival and departure, and names and addresses of contacts residing in the country (often the most important element). *Health requirements:* Vaccinations required for entry (documentation of these is often necessary for visa application). Additional vaccination information from the Centers for Disease Control is also noted. The State Department can supply vaccination requirements when your country of departure is the U.S., but many countries require vaccinations for diseases if you have come from either an infected area (as indicated in the CDC "blue sheets") or from a country with an infection in any part of it. Given the nature of location photographers' itineraries, this is always possible—be sure to check with local health officials for the latest information. *Equipment importation:* In countries party to the Carnet treaty, no other recommendation is given—the photographer is urged to use the Carnet. For other countries, the information is based on conversations with the embassy. Whenever there is an indication to "bring equipment list," it is assumed that the list contains the descriptions, serial numbers, and dollar values of the equipment (I usually photocopy my Carnet list). Where the possibility of a temporary importation bond is indicated, a customs broker is strongly recommended.

Electricity: Voltage/frequency in Hertz. *Plug types:* Coded according to the diagrams in appendix 5. Source: Department of Commerce's *Electric Current Abroad* (1984).

Currency: Name of the currency and its abbreviation, plus the primary subdivision, which is in units of 100 unless otherwise noted. Exchange rates change too frequently for inclusion in this book. Currency importation restrictions are indicated if available.

U.S. embassy in the country: Address, phone, and telex numbers. *Consulates:* Names of the cities with U.S. consular offices and phone numbers. Source: *Key Officers of Foreign Service Posts,* January 1988 (Department of State).

Embassy in U.S.: Country's embassy address and phone number in the U.S., or the address and phone number of the group (such as the U.N. mission) handling the affairs in the U.S. when it lacks an embassy. *Consulates:* U.S. states with consular offices and their phone numbers. Source: State Department's *Foreign Visa Requirements.*

Tourism office in U.S.: Source: *Assembly of National Tourist Offices in New York (ANTOR) Membership Roster, 1987–88,* courtesy of the Portuguese National Tourist Office, and conversations with the embassy. Countries that do not have a tourist office here usually have a tourist or information section within their embassy or consulate. For a more comprehensive listing, write for the *Directory of Foreign Government Tourist Offices,* available from Travel Insider Publications, P.O. Box 14, Streamwood, IL 60107 (enclose $5.95).

Central tourism office in country: Based on conversations with the embassy. May be a public information center or, particularly in countries with smaller tourist industries, the ministry of tourism or information. *Note:* When communicating by post, be sure to include post office boxes, even when the street address is supplied—they tend to be more important to the accurate delivery of mail in many countries.

Health suggestions: Based on U.S. government sources. Indications of unsanitary conditions imply that precautions for water, fruits, uncooked foods, local dairy products and seafood, and the like should be taken (see section 2, "Health Hints for the International Traveler"). Many experienced travelers rely on bottled water even in developed countries with safe supplies, so as to expose their systems to as few unfamiliar organisms as possible. Again, these suggestions are merely recommendations as of this writing—be sure to get up-to-date information before your trip. Official health *requirements* of foreign countries are listed with Visa information. *Note:* An expanding number of countries are establishing regulations for AIDS testing, particularly for long-term visitors—be sure to check before departure. Also, resistant strains of malaria are common; be sure to get the latest information on appropriate preventive measures.

Cultural mores and taboos: Drawn from dozens of sources and personal experiences. This section is meant to alert the reader to the most outstanding cultural differences but naturally has the limitations of any generalization.

Photographic restrictions: Special restrictions based on conversations with the embassy and U.S. government sources. The listings are by no means complete, and the reader should generally be cautious near military and security sites, museums, religious institutions (particularly mosques and synagogues), and other sensitive locations.

Color labs: Names and addresses of Kodak and Fuji processing labs, on the assumption that they maintain acceptable standards of processing. You might also want to contact your colleagues for up-to-date recommendations on other custom labs. (See also Appendix 10, Kodak-Approval European Labs.)

Equipment rental/sales: Cities and phone numbers of the authorized rental/sales agents of the major flash manufacturers. Lighting equipment is probably the most common type of gear rented on location, and flash rental outlets often carry a wide range of other products. *Film commissions:* As of this writing, the latest membership of the Association of Film Commissions, whose roster is updated semiannually. See appendix 2 for U.S. members. Courtesy of the Association of Film Commissions.

Gratuity guidelines: As indicated in conversations with the embassy and U.S. government sources. These are minimum guidelines. It is not always common practice to tip taxi drivers, even in some countries where tipping is accepted. However, in view of the luggage you will be carrying, I recommend it in all cases except where tipping is generally forbidden or discouraged.

AFGHANISTAN
Democratic Republic of Afghanistan
De Afghanistan Democrateek Jamhuriat

All Americans are urged to avoid travel to Afghanistan by the State Department because of the anti-Soviet insurgency; flying Bakhtar (Ariana) Afghan Airlines is also discouraged.

Location: In Central Asia, bounded on the north by the USSR, the northeast by China, the east and south by Pakistan, and the west by Iran. *Size:* 250,775 square miles, slightly smaller than Texas.

Major cities: *Kabul* (lat. +34.30). *Airports:* Kwasja Rawash (KBL), 10 miles outside of Kabul.

General transportation: Air links to the Soviet Union on Aeroflot (and to New York via Moscow), and to Prague, Delhi, and Dubai on either Bakhtar (the national carrier) or Indian Airlines. Public transport is overcrowded and uncomfortable. Taxis are available in Kabul. *U.S. license:* No. *IDP:* Yes. *Rule of the road:* Right. *Taxi markings:* Yellow bottom, black top, marked TAXI; set price.

Population: 14.5 million. *Type of government:* Communist regime backed by Soviet forces. The U.S. has not recognized the Kabul regime and has a limited diplomatic presence.

Languages: 50% Pushtu, 35% Afghan Persian (Dari), 11% Turkish languages, 4% mixture of some 30 minor languages. Much bilingualism. *Ethnic groups:* 50% Pushtan, 25% Tajik, 9% Uzbek, 9% Hazara, plus several minor groups. *Religion:* 74% Sunni Muslim, 15% Shi'a Muslim, 11% other. Islamic practice pervades all aspects of life, despite the Marxist government.

Time: EST +9.5; GMT +4.5. *Telephone codes:* No direct dial from the U.S.—operator assistance only. No credit card or collect calls to the U.S. from this country. Limited domestic service. International calls may need to be booked weeks in advance and paid for in the central telephone office. Commercial cables may take 2 to 3 days. *Pay phone system:* coins.

Holidays: March 21, April 27, August 19, and religious (not fixed). *Date/month system:* D/M.

Business hours: Winter: 8 AM to 6 PM Saturday to Wednesday, 8 AM to 1:30 PM Thursday; summer: 8 AM to 12 noon, 1 PM to 3:30 PM Saturday to Wednesday, 8 AM to 12 noon Thursday. *Government hours:* Winter: 7 AM to 12 noon, 1 PM to 4 PM Saturday to Wednesday, 7 AM to 2 PM Thursday; summer: 8 AM to 12 noon, 1 PM to 4:30 PM Saturday to Wednesday, 8 AM to 12 noon Thursday. *Business dress code:* No set rule.

Climate and terrain: Mountains, including the towering Hindu Kush (an earthquake zone) and Pamir ranges in the northern and central regions, with deserts in the south. Dry and dusty. Winter is December through February; summer is mid-May to mid-September. Daily temperatures can vary widely, based on location in the country. *Temperature ranges* (Kabul): January: 18° to 36°F; April: 43° to 66°F; July: 61° to 92°F; October: 42° to 73°F.

Visas: *Photojournalists:* Passport, photographer letter, résumé including personal background, education, work experience, and organization memberships, copies of previous work, letter from agency; with 3 applications, 3 photos. *Commercial photographers:* Business visa, which requires passport, 3 applications, 3 photos; Afghan sponsor needs to process the application in Kabul; $10 fee. *Tourists:* Tourist visa.

Health requirements: Yellow fever vaccination required if coming from an infected area. *Equipment importation:* Covered by visa.

Electricity: 220/50. *Plug types:* D.

Currency: Afghani (AFG); puls.

U.S. embassy in the country: Wazir Akbar Khan Mina, Kabul; *tel.* 622230/5, 62436.

Embassy in U.S.: 2341 Wyoming Avenue NW, Washington, DC 20008; *tel.* 202–234–3770/1.

Central tourism office in country: Afghanistan Tourism Organization.
Health suggestions: No health controls or sanitary regulations. Take all precautions. Malaria suppressants are recommended.

Gratuity guidelines: Not included in the bill; tips are appreciated but not expected.

ALBANIA
People's Socialist Republic of Albania
Republika Popullore Socialiste e Shqipërisë

Because of its extreme political isolation, information on Albania is difficult to obtain. Americans are rarely allowed to visit, and most journalists who go there are from Europe.

Location: In southeastern Europe, on the east coast of the Adriatic Sea, between Yugoslavia and Greece. **Size:** 11,100 square miles, slightly larger than Maryland. **Major cities:** *Tiranë* (lat. +41.20). **Airports:** Rinas Airport (TIA), 19 miles outside of Tiranë.

General transportation: Travel to Albania is difficult to arrange and execute. All travel is arranged through ALBTURIST. Links to Zurich (and on to the U.S.) on Swissair; also to eastern Europe, Canada, Greece, and Rome. Taxis are available in Tiranë. **U.S. license:** No. **IDP:** Yes. **Rule of the road:** Right.

Population: 3,020,000. **Type of government:** Communist state (Stalinist), with rigid controls. Not recognized by the U.S. No American diplomatic contact, nor third-party representation.

Languages: Albanian (Tosk is official dialect), Greek. **Ethnic groups:** 96% Albanian, 4% Greek. **Religion:** Claims to be the world's first atheist state. Religion is outlawed. Some practice their religion privately.

Time: EST +6; GMT +1. **Telephone codes:** Inadequate domestic and international service.
Holidays: November 29. **Date/month system:** D/M.
Business hours: 7 AM to 2 PM Monday to Saturday, 5 PM to 8 PM Monday to Tuesday.
Climate and terrain: Mostly hills and mountains, with 20% flat to rolling coastal plain. The Buenë (Bojana) is the only navigable river. Along the coast, winters are wet, and summers are dry and hot. The interior is cooler and rainy. **Temperature ranges** (Durrës, on the coast): January: 42° to 51°F; April: 55° to 63°F; July: 74° to 83°F; October: 58° to 68°F.
Visas: Apply to the Albanian mission, 131, rue de la Pompe, Paris 16e, France, or Via Asmara 9, Rome, Italy, or to a mission in any other country that maintains relations with Albania. **Health requirements:** Yellow fever vaccinations are required if coming from an infected area.
Currency: Lek (LEK); Qindarkes.
U.S. embassy in the country: None.
Embassy in U.S.: None.
Central tourism office in country: ALBTURIST.
Health suggestions: The water is not potable.

ALGERIA
Democratic and Popular Republic of Algeria
al-Jumhuriya al-Jazāiriya ad-Dimuqratiya ash-Shabiya

Location: In northern Africa, bounded on the north by the Mediterranean Sea, the east by Tunisia and Libya, the south by Niger and Mali, the west by Mauritania, Spanish Sahara, and Morocco. **Size:** 896,588 square miles, more than 3 times the size of Texas.
Major cities: *Algiers* (lat. +36.46). **Air-**

ports: Houari Boumedienne (ALG), 13 miles outside of Algiers.
General transportation: Many international air links. Air Algerie (AH) serves Oran, Constantine, Annaba, and many Saharan cities. There is rail service between major northern cities, with bus service to smaller towns. Good paved roads (one linking Morocco and Tunisia) cover the north. The Trans-Saharan Highway is surfaced from Ghardaïa to Tamanrasset; rental cars are available. *U.S. license:* Yes, with French translation certified by the Algerian consulate or embassy. *IDP:* Yes. *Rule of the road:* Right. *Motor clubs:* Touring Club d'Algérie, B.P. 18 les Verges, Birkhadem; *tel.* (213) 56 90 16; partial AAA reciprocity. *Taxi markings: Petit* with meters, and *Grand* with fixed prices. *Note:* Algiers has a chronic hotel shortage, so make reservations in advance.

Population: 24,200,000, 91% living along coast. *Type of government:* Republic. Defines its foreign policy as nonaligned. Algeria is a strong proponent of the Third World viewpoint.

Languages: Arabic (official), French. English is rarely spoken. *Ethnic groups:* 99% Arab-Berber, 1% European. *Religion:* 99% Sunni Muslim (state religion), 1% Christian and Jewish.

Time: EST +6; GMT +1. *Telephone codes:* Country: 213. No city codes. Long-distance calls can be made from any post office, but it is not possible to use credit cards or call collect. Domestic and international service is adequate in the north, sparse in the south. *Pay phone system:* Coins; in post offices and hotels.

Holidays: January 1; May 1; June 19; July 5; November 1. Religious holidays are based on the Islamic calendar and must be determined annually. July and August are popular vacation months. *Date/month system:* D/M.

Business hours: 8:30 AM to 12 noon, 2:30 PM to 6 PM, Saturday to Wednesday; limited business on Thursday mornings. *Business dress code:* Conservative for both men and women.

Climate and terrain: Roughly 3 regions parallel to the Mediterranean Sea and divided by the two mountain ranges (which are subject to earthquakes). From north to south, these are: a relatively fertile coastal plain, the Tell or Little Atlas Mountains, a high plateau region, the Saharan Atlas Mountains, and the northern Sahara Desert. Mild (but often wet) winters and hot summers along the coast; less rain and colder winters in the plateau area. Considerable daily temperature variation in the desert, with sandstorms from February to May. *Temperature ranges* (Algiers): January: 49° to 59°F; April: 55° to 68°F; July: 70° to 83°F; October: 63° to 74°F.

Visas: Photojournalists need authorization involving passport, 3 applications (accreditation request form), 3 photos, client letter, and résumé; allow at least 1 month for processing. *Tourists:* Tourist visa is valid for 3 months; needed for it are a passport, 2 photos, 2 applications, $11.25 fee, and proof of return ticket and of sufficient funds. *Health requirements:* Yellow fever vaccination is required if coming from an infected area. *Equipment importation:* Arrange with the authorization.

Electricity: 220/50 and 127/50. *Plug types:* C, D.

Currency: Dinar (ALD); Centimes.

U.S. embassy in the country: 4 Chemin Cheich Bachir Brahimi, B.P. Box 549 (Alger-Gare) 16000, Algiers; *tel.* 601–425/255/186; *telex* 66047. *Consulates:* Oran, *tel.* 334–509/335–499.

Embassy in U.S.: 2118 Kalorama Road NW, Washington, DC 20008; *tel.* 202–328-5300.

Central tourism office in country: Algerian Tourist Office (ONAT), 25–27 rue Khelifa Boukhalfa, Algiers.

Health suggestions: Medical care is poor. Water is not potable. Typhoid, tetanus, and polio inoculations are recommended. There is a very limited malaria risk in the Sahara region.

Cultural mores and taboos: Personal visits in business are warmly welcomed. Business cards in French are desirable. Muslim

injunctions against alcohol and pork prevail. Do not cross legs, point, or gesture at someone with the hand, show the soles of the feet, or pass or accept items with the left hand. If invited to a mosque, dress to cover the entire body, remove shoes (tip the attendant who gives you slippers), and do not walk in front of others praying. Wives rarely attend social functions, which are usually in restaurants and hotels rather than the home. Appointments may not start on time. Avoid personal topics.

Gratuity guidelines: Usually included in the bill, but always give extra. Tip taxi drivers.

ANGOLA
People's Republic of Angola
República Popular de Angola

Because Angola is at war, travel to this country, particularly outside Luanda, is considered dangerous.

Location: In southwestern Africa, bounded on the north and northeast by Zaire, the southeast by Zambia, the south by South-West Africa (Namibia), and the west by the Atlantic Ocean. *Size:* 481,351 square miles, twice the size of Texas.

Major cities: *Luanda* (lat. −8.49). *Airports:* 4 de Feverio Airport (LAD), 3 miles outside of Luanda.

General transportation: Air links to Europe (with connections to the U.S.), to several African capitals via the Angolan airline TAAG (DT), and to Cuba and Brazil. Public transport is limited, even in Luanda. *U.S. license:* No. *IDP:* Yes. *Rule of the road:* Right.

Population: 8,200,000. *Type of government:* Marxist people's republic, a one-party state allied with the Soviet Union and Cuba. No diplomatic relations with the U.S., but the two countries have had frequent contact to discuss regional and bilateral matters, including discussions concerning solutions to the current military conflict. No other countries officially represent the U.S. in Angola.

Languages: Portuguese (official); various Bantu dialects. *Ethnic groups:* 37% Ovimbundu, 25% Kimbundu, 13% Bakongo, 2% Mestico, 1% European. *Religion:* 68% Roman Catholic, 20% Protestant, about 12% indigenous beliefs.

Time: EST +6; GMT +1. *Telephone codes:* No direct-dial from the U.S.—operator assistance only. No credit card or collect calls to U.S. from the country. International service is relatively good. Domestic service within Luanda is fair, but calls to, from, and within the interior are difficult.

Holidays: February 4; August 1; September 17; November 11; December 10, 25.

Business and government hours: 8 AM to 12 noon, 2:30 PM to 6 PM Saturday to Wednesday; shorter hours in summer. *Business dress code:* Informal, with safari suits the norm. Western-style dress is worn occasionally.

Climate and terrain: The narrow coastal plain rises abruptly to a high, vast plateau (3,000 to 7,000 feet). Very diverse climate. Southern regions and coastal area up to Luanda are semiarid, with desert in the southwest. The north, especially on the plateau, has two seasons: from May to October, it is dry and cool, with occasional freezing temperatures; from November to April is the rainy season, extremely hot and humid. *Temperature ranges* (Luanda): January: 74° to 83°F; April: 75° to 85°F; July: 65° to 74°F; October: 71° to 79°F.

Visas: Apply to the Angolan Permanent Representative to the U.N., 747 Third Avenue, 18th Floor, New York, NY 10017, *tel.* 212–752–4612, to receive permission from Luanda. Required are a passport, photographer letter, and 2 photos; processing can take 1 day or many months. No tourist visas are issued. *Equipment importation:* Arrange with visa.

Electricity: 220/50. *Plug types:* C.

Currency: Kwanza (AKZ); Lweis. Strict currency exchange controls.

U.S. embassy in the country: None.
Embassy in U.S.: None; communicate via U.N. representative; see address under **Visas.**
Tourism office in U.S.: None.
Central tourism office in country: None.
Health suggestions: Shortage of medical personnel and sophisticated equipment. If stricken with serious health problem, arrange for earliest possible transportation to a country with adequate facilities. Water is not potable. Malaria suppressants are recommended, as is yellow fever vaccination for travel outside urban areas. Cholera infection is present.

ANTIGUA AND BARBUDA

Location: In the eastern West Indies, southeast of Puerto Rico, north of Guadeloupe. *Size:* 171 square miles, over twice the size of Washington, DC.
Major cities: *St. Johns* (lat. + 17.08). *Airports:* V. C. Bird International Airport (ANU), 6 miles outside of St. Johns.
General transportation: Direct flights to the U.S. LIAT (LI) flies to other Caribbean islands. *U.S. license:* Yes, if presented to the Traffic Department for a 3-month temporary license for a fee. *IDP:* Yes, if validated by the Traffic Department, with fee. *Rule of the road:* Left. *Taxi markings:* License plate H plus number; no special colors.
Population: 82,000. *Type of government:* Independent state that recognizes Elizabeth II of Britain as head of state. Commonwealth member; free elections; constitutional safeguards including freedom of speech, press, worship, movement, and association. Judicial system based on the British system. Excellent human rights record. Excellent relations with the U.S. American citizens enjoy the same legal protections as local citizens.
Languages: English (official) and some local dialects. *Ethnic groups:* Almost entirely blacks of African origin. *Religion:* Predominantly Anglican, with some other Protestant sects and Roman Catholics.
Time: EST +1; GMT −4. *Telephone codes:* Direct-dial from the U.S. using the 809 area code. Good domestic and international service. *Pay phone system:* Coins.
Holidays: January 1; February 14; Good Friday; Easter Monday; April 21 (queen's birthday); May 1; Whit Monday (varies—early June); Carnival (first Monday and Tuesday in August); November 1; December 25, 26. *Date/month system:* D/M.
Business hours: 8 AM to 12 noon, 1 PM to 4 PM Monday to Saturday (mornings only on Thursday). *Government hours:* 8:30 AM to 12 noon, 1 PM to 4 PM Monday to Friday; 8:30 AM to 11:30 AM Saturday. *Business dress code:* Informal except for high-level business meetings.
Climate and terrain: The country consists of three islands, Antigua, Barbuda, and Redonda. Antigua and Barbuda have excellent beaches; Redonda is rocky. The islands have a tropical climate but are drier than most other Caribbean islands. *Temperature ranges:* Average daily from 76°F in January to February to 81°F in August to September, with 60° to 65°F nighttime temperatures in the cooler season.
Visas: Standard tourist entry for up to 6 months; required are proof of U.S. citizenship, proof of return ticket and of sufficient funds. *Health requirements:* Yellow fever vaccination required if coming from an infected area. *Equipment importation:* Make advance arrangements with the Collector of Customs, Ministry of Finance, High Street, St. Johns, Antigua; *telex:* 2055 FINANCE. A bond may be required.
Electricity: 230/60. *Plug types:* A, B, and G.
Currency: East Caribbean Dollar (EC$); Cents.
U.S. embassy in the country: FPO Miami 34054, St. Johns, Antigua; *tel.* 462-3505/06; *telex:* 2140 USEMB.

Embassy in U.S.: 3400 International Drive NW, #2H, Washington, DC 20008; *tel.* 202–362–5122.

Tourism office in U.S.: 610 Fifth Avenue, New York, NY 10020; *tel.* 212–541–4117.

Central tourism office in country: Tourist Bureau, Long and Thames, St. Johns, Antigua; *tel.* 809–462–0480.

Health suggestions: Good medical services are available.

Gratuity guidelines: Often included in bill at hotels; if not, leave at least 10%.

ARGENTINA
Argentine Republic
República Argentina

Location: Southern South America, bounded on the north by Bolivia and Paraguay, the east by Brazil, Uruguay, and the Atlantic Ocean, and the south and west by Chile. **Size:** 1,072,156 square miles, 4 times the size of Texas.

Major cities: *Buenos Aires* (lat. −34.35). Argentina's capital is scheduled to move to Viedma, but this has not happened as of this writing and is unlikely to occur for several years. **Airports:** Ministro Pistarini—Ezeiza (BUE), 28 miles outside of Buenos Aires.

General transportation: Extensive international and domestic air links. Aeroparque Jorge Newberry (AEP), near downtown Buenos Aires, serves many provincial cities. Roads are good; rental cars are available. Buenos Aires has an excellent subway *(subte)* and bus service, and plentiful taxis. **U.S. license:** No. **IDP:** Yes. **Rule of the road:** Right. **Motor clubs:** Automóvil Club Argentino (ACA), Avenida del Libertador no. 1850, Buenos Aires; *tel.* 802–0522; full AAA reciprocity. **Taxi markings:** Usually yellow and black, marked TAXI, metered. A telephone-dispatched taxi, called a *remise*, is available.

Population: 31,500,000. **Type of government:** Republic. The political and human rights climate has greatly improved since the early 1980s. High inflation is one of a number of economic difficulties. Enjoys good relations with the U.S., particularly after the strains of the 1970s and the U.S. position during the military conflict with England.

Languages: Spanish. English usage is growing but still somewhat limited generally, although many in business understand English. **Ethnic groups:** 85% Caucasian, largely of Spanish and Italian descent, some of English and other European ancestry; 15% mestizo, Indian, or other. **Religion:** 90% nominally Roman Catholic (less than 20% practicing), 2% Protestant, 2% Jewish, 6% other.

Time: EST +2; GMT −3. **Telephone codes:** Country: 54. Bahía Blanca 91; Buenos Aires 1, Córdoba 51, Corrientes 783, La Plata 21, Mar del Plata 23, Mendoza 61, Merlo 220, Posadas 752, Resistencia 722, Río Cuarto 586, Rosario 41, San Juan 64, San Rafael 627, Santa Fe 42, Tandil 293. Adequate domestic and international service. **Pay phone system:** Tokens *(fichas)* available at newsstands and kiosks.

Holidays: January 1; Holy Thursday; Good Friday; May 1, 25; June 20; July 9; August 17; October 12; December 25; plus several variable feast days that are holidays for the government, banks, insurance companies, and some businesses. **Date/month system:** D/M.

Business hours: 8 or 8:30 AM to 5:30 or 6 PM, Monday to Friday. Avoid appointments from noon to 3 PM unless a business lunch. Vacations are taken in January to March. **Business dress code:** Conservative.

Climate and terrain: Topography is as varied as in the U.S., with hot, subtropical lowlands in the north, the towering Andes Mountains in the west, and cold, rainy, windswept steppes in the south. The heartland is the rich temperate plains known as the *pampas*, which fan out for 500 miles from

Buenos Aires in east-central Argentina. The climate of Buenos Aires is similar to that of Washington, DC, with milder winters. *Temperature ranges* (Buenos Aires): January: 63° to 85°F; April: 53° to 72°F; July: 42° to 57°F; October: 50° to 69°F.

Visas: *Temporary work visa:* Requires client letter, passport; no fee with U.S. passport. *Tourists:* Multiple-entry visa, good for up to 4 years. *Health requirements:* No vaccinations required. *Equipment importation:* Bring list of equipment, date of arrival, flight, and departure date to consulate. It will contact Buenos Aires to arrange for importation. A bond may not be required. Allow as much time in advance for this procedure as possible, even though Argentine officials are extremely efficient.

Electricity: 220/50. *Plug types:* C and G.

Currency: Austral (ARA); Centavos.

U.S. embassy in the country: 4300 Colombia, 1425 Buenos Aires; *tel.* 774–7611/8811/9911; *telex:* 18156 USICA AR.

Embassy in U.S.: 1600 New Hampshire Avenue NW, Washington, DC 20009; *tel.* 202–939–6400. *Consulates:* California: 415–982–3050; Florida: 305–373–1889; Illinois: 312–263–7435; New York: 212–397–1400;

Louisiana: 504–523–2823; Maryland: 301–837–0445; Texas: 713–871–8935.

Tourism office in U.S.: Argentina Tourist Information, 330 West Fifty-eighth Street, New York, NY 10019; *tel.* 212–765–8833.

Central tourism office in country: Secretaría de Turismo, Buenos Aires; *tel.* 312–5611.

Health suggestions: Sanitary conditions are good, and no special precautions are necessary. Tapwater is potable.

Cultural mores and taboos: Business meetings begin with much handshaking. *Porteños* (residents of Buenos Aires) are extremely cosmopolitan, with strong opinions. Beef is a national passion. Avoid discussing the Malvinas (Falklands) conflict and border disputes with Chile.

Photographic restrictions: Avoid military and some political subjects.

Color labs: Kodak Argentina S.A.I.C., Casilla Correo Central 5200, Buenos Aires 1000.

Gratuity guidelines: Service (can be 20 to 25%) sometimes is included in bills, but even so, giving a little extra is customary.

AUSTRALIA
Commonwealth of Australia

Location: Continent south of Asia, bounded on the north by the Timor and Arafura seas, the northeast by the Coral Sea, and the east by the South Pacific Ocean, and the south and west by the Indian Ocean. *Size:* 2,967,909 square miles, slightly smaller than the U.S.

Major cities: *Canberra* (lat. −35.18), Sydney (lat. −33.52), Melbourne (lat. −37.49), Perth (lat. −31.56). *Airports:* Canberra Airport (CBR), 5 miles outside of Canberra; Kingsford Smith International Airport (SYD), 7 miles outside of Sydney; Tullarmarine (MEL), 12 miles outside of Melbourne; Perth International Airport (PER), 6 miles outside of Perth.

General transportation: Because of distances, use of fine domestic air service is common. Charter flights are easily booked—there are over 400 airports. All forms of public transport are excellent. *U.S. license:* Yes. *IDP:* Yes. *Rule of the road:* Left. *Motor clubs:* Australian Automobile Association (AAA); Sydney branch: 151 Clarence Street; *tel.* 260–9222; full AAA reciprocity. *Taxi markings:* Variety of colors often with advertising, marked TAXI, metered.

Population: 16,200,000. *Type of government:* Federal parliamentary state, recognizing Elizabeth II of Britain as sovereign or head of state. Constitution patterned partly

on U.S. Constitution. The leader of the parliamentary party or coalition with a majority is the prime minister. Exceptionally close and friendly ties with U.S.

Languages: English, and indigenous languages. *Ethnic groups:* 95% Caucasian, 4% Asian, 1% aboriginal and other. *Religion:* 26.1% Anglican, 26% Roman Catholic, 24.3% other Christian denominations.

Time: EST +15 (Sydney); GMT +8 to +10. *Telephone codes:* Country: 61. Adelaide 8, Ballarat 53, Brisbane 7, Canberra 62, Darwin 89, Geelong 52, Gold Coast 75, Hobart 02, Launceston 03, Melbourne 3, Newcastle 49, Perth 9, Sydney 2, Toowoomba 76, Townsville 77, Wollongong 42. Excellent domestic and international service. *Pay phone system:* Coins.

Holidays: January 1, 26; Good Friday; Easter Monday; April 25, queen's birthday (celebrated second Monday in June); December 25, 26; plus a variety of regional holidays. Summer vacations are taken from December to February. *Date/month system:* D/M.

Business and government hours: 9 AM to 5 PM Monday to Friday. *Business dress code:* Same as that for the U.S. in Melbourne and Sydney, a bit more informal elsewhere.

Climate and terrain: Most of the continent is low, irregular plateau; the center is generally flat, barren, and arid. Mountain ranges lie in the center and west, the highest point being Mount Kosciusko (7,314 feet). The Great Barrier Reef, the longest coral reef in the world, lies off the east coast of Queensland. The climate varies because of the country's size. It is subject to severe droughts and floods. The west coast enjoys an invigorating summer sea breeze called "the doctor." Seasons are opposite those of the U.S. Most of the population lives in the major urban centers along the coast. *Temperature ranges* (Sydney—Melbourne and Perth are almost the same): January: 65° to 78°F; April: 58° to 71°F; July: 46° to 60°F; October: 56° to 71°F.

Visas: *Work visa:* Application, 1 photo, passport, client letter; processing time is 24 hours if received in person or by Federal Express or U.S. Postal Service Express (only) with return express postage paid. Normal mail service with self-addressed stamped envelope can take several weeks. *Tourists:* Multiple-entry visa valid for 5 years, for up to 6 months, requires passport, no fee, 1 photo, proof of return ticket on arrival. *Transit visa:* Not required for stays of up to 72 hours. *Health requirements:* Yellow fever vaccination required if traveler has visited yellow fever–infected area in the last 10 years. *Equipment importation:* Carnet, or bond required.

Electricity: 240/50. *Plug types:* I.

Currency: Dollar (A$); Cents.

U.S. embassy in the country: Moonah PL, Canberra, A.C.T. 2600; *tel.* 705–000; *telex:* 62104 USAEMB. *Consulates:* Sydney: 261–9200; Melbourne: 697–7900; Perth: 221–1177; Brisbane: 839–8955.

Embassy in U.S.: 1601 Massachusetts Avenue NW, Washington, DC 20036; *tel.* 202–797–3000. Consulates: California: 213–380–0980; Hawaii: 808–524–5050; Illinois: 312–329–1740; New York: 212–245–4000.

Tourism office in U.S.: Australian Tourist Commission, 489 Fifth Avenue, New York, NY 10017; *tel.* 212–687–6300.

Central tourism office in country: The Australian Tourist Commission has offices throughout the country.

Health suggestions: Sanitary conditions and medical services are excellent. Tapwater is potable.

Cultural mores and taboos: Australians are informal, direct, and have little patience for pretense. First names are commonly used immediately, but wait to be invited. Meetings begin quickly after a little small talk. Business is often conducted over drinks, which are paid for strictly in turn (when it is your "shout")—don't offer to pay before your turn. Punctuality is extremely important. Avoid using the thumbs-up gesture to signify okay—it is a rude insult in Australia.

Color labs: *Kodak (Australia) Pty. Ltd.:* G.P.O. Box W2051, Perth 6001; G.P.O. Box 260, Brisbane 4006; G.P.O. Box 46, Adelaide 5001; P.O. Box M16, Sydney 2012. *Fuji:* Hanimex Color Services, P.O. Box 57, Brookvale N.S.W. 2100.

Equipment rental/sales: *Balcar:* Baltronics, North Sydney, *tel.* 959–5200; Borg Anderson, Melbourne, *tel.* 589–5205. *Broncolor:* Photopro, Brisbane, *tel.* 854–1822; George's Camera Store, Sydney, *tel.* 267–2283; George's Camera Store, Adelaide, *tel.* 223–3449; Ted's Camera Store, Melbourne, *tel.* 663–4477. *Comet:* C. R. Kennedy, Melbourne, *tel.* 387–4611. *Profoto:* L&P, Sydney, *tel.* 957–4464. **Film commissions:** Melbourne Film Commission, 409 King Street, Melbourne VI, 3000; *tel.* 329–7033. Queensland Film Industry Development, 100 George Street, 6th Floor, Brisbane QN 4000.

Gratuity guidelines: Sometimes included in bills of better hotels and restaurants; otherwise has recently become more like the American system. Tipping is new to Australia and is a bit less expected, since it did not really exist before the recent influx of foreign visitors.

AUSTRIA
Republic of Austria
Republik Österreich

Location: In central Europe, bounded on the north by Czechoslovakia and West Germany, the east by Hungary, the south by Yugoslavia and Italy, and the west by Liechtenstein, Switzerland, and West Germany. *Size:* 32,375 square miles, slightly smaller than Maine.

Major cities: *Vienna* (lat. +48.15). **Airports:** Schwechat International Airport (VIE), 11 miles outside of Vienna.

General transportation: All forms are excellent. Roads and highways are good but can be steep. Cities have excellent networks of subways, streetcars, or buses. **U.S. license:** Yes, with German translation. **IDP:** Yes. **Rule of the road:** Right. **Motor clubs:** Österreichischer Automobil Motorrad und Touring Club (OAMTC), Schubertring 1–3, Vienna; *tel.* 711 990; full AAA reciprocity. *Taxi markings:* Generally deluxe, Mercedes-type cars; 24-hour stands throughout Vienna.

Population: 7,600,000. *Type of government:* Federal republic. A stable democracy with excellent ties to the U.S.

Languages: German; English is widely understood. *Ethnic groups:* 99.4% German. *Religion:* 85% Roman Catholic, 6% Protestant, 9% other.

Time: EST +6; GMT +1. *Telephone codes:* Country: 43. Bludenz 5552, Graz 316, Innsbruck 5222, Kitzbühel 5356, Klagenfurt 4222, Krems an der Donau 2732, Linz 732, Neunkirchen am Steinfeld 2635, Salzburg 662, St. Pölten 2742, Vienna 1, Villach 4242, Wels 7242, Wiener Neustadt 2622. Excellent domestic and international service. *Pay phone system:* Coins.

Holidays: January 1, 6; Easter Monday; May 1; June 10; August 15; October 26; November 1; December 8, 25, 26; plus Whit Monday and Ascension Day (40 days after Easter). Banks are closed on December 24, 31. *Date/month system:* D/M.

Business hours: 8 or 9 AM to 4:30 or 5 PM, Monday to Friday. Some businesses are closed for lunch. *Government hours:* 8 AM to 4 PM Monday to Friday. *Business dress code:* Conservative.

Climate and terrain: Mostly mountainous (Alps) and hilly. The eastern provinces and Vienna are located in Danube (Donau) River basin. The climate is similar to that of the northeastern U.S. *Temperature ranges* (Vienna): January: 26° to 34°F; April: 41° to 57°F; July: 59° to 75°F; October: 44° to 55°F.

Visas: Standard tourist entry, which re-

quires a passport; no visa is needed for up to 3 months. *Health requirements:* No vaccinations required. *Equipment importation:* Carnet.

Electricity: 220/50. *Plug types:* F.

Currency: Schilling (AUS); Groschen.

U.S. embassy in the country: Boltzmanngasse 16, A–1091 Vienna; *tel.* 31–55–11; *telex:* 114634. *Consulates:* Salzburg: 28601.

Embassy in U.S.: 2343 Massachusetts Avenue NW, Washington, DC 20008; *tel.* 202–483–4474. *Consulates:* California: 213–380–7550; Illinois: 312–222–1515; New York: 212–737–6400.

Tourism office in U.S.: Austrian National Tourist Office, 500 Fifth Avenue, New York, NY 10110; *tel.* 212–944–6880.

Central tourism office in country: For country: Austrian National Tourist Office, Margaretenstrasse #1, A–1040 Vienna; *tel.* (1) 58–86–60. For Vienna: Vienna Tourist Office (Fremdenverkehrsverband für Wien), Kinderspitalgasse #5, A–1095 Vienna; *tel.* (1) 43–16–08.

Health suggestions: Sanitation and medical facilities are excellent. The Viennese are particularly proud of their water, piped in from mountain springs.

Cultural mores and taboos: Business etiquette is similar to that in the U.S, with perhaps greater emphasis on titles and formality. Be punctual. It is considered polite to greet strangers in public.

Color labs: *Kodak Ges.m.b.H.:* Albert Schweitzer-Gasse 4, A–1148 Vienna; Josepf Mayburger Kai 114, Postfach 33, A–5021 Salzburg. *Fuji Color Service Österreich:* Postfach 94, A–1103 Vienna.

Equipment rental/sales: *Balcar:* H.S.R. Techniische Producte, Loquaiplatz 13, A–1060 Vienna; *tel.* 597–3867; *fax:* 597–3869. *Profoto:* Ing. Herbert Slach KG, Vienna; *tel.* 346–315. *Film commissions:* Cine Austria, 11601 Wilshire Boulevard, Los Angeles, CA 90025; *tel.* 213–477–3332.

Gratuity guidelines: 10% to 15% is usually added to the bill, but an additional 5% or so is customary. Tips are expected if not included on the bill.

THE BAHAMAS
The Commonwealth of the Bahamas

Location: In the West Indies, southeast of Florida and north of Cuba. *Size:* 5,386 square miles, slightly larger than Connecticut.

Major cities: *Nassau* (lat. +25.05). *Airports:* Nassau International Airport (NAS), 11 miles outside of Nassau.

General transportation: Good international air links. Buses are small and crowded. There are no railroads. Many roads are paved. The islands are linked by air (over 50 airstrips) and sea. *U.S. license:* Yes. *IDP:* Yes. *Rule of the road:* Left. *Motor clubs:* Bahamas Automobile Club, West Avenue, Centreville, Nassau; *tel.* 325–0514; partial AAA reciprocity. *Taxi markings:* Marked TAXI, all colors, metered.

Population: 240,000. *Type of government:* Independent commonwealth, recognizing Elizabeth II of Britain as head of state.

Multiparty parliamentary democracy with regular elections. Political and legal traditions similar to those of England. Close ties with the U.S.

Languages: English, with some Creole among Haitian immigrants. *Ethnic groups:* 85% black, 15% white. *Religion:* 29% Baptist, 23% Anglican, 22% Roman Catholic, other small Protestant, Greek Orthodox, and Jewish groups.

Time: EST; GMT-5. *Telephone codes:* Direct-dial from the U.S., using 809 area code. Excellent domestic and international service. *Pay phone system:* Coins.

Holidays: January 1; Good Friday; Easter Monday; Whit Monday (varies—early June); Labor Day (first Friday in June); July 10; Emancipation Day (first Monday in August); October 12; December 25, 26. *Date/month system:* D/M.

Business hours: 9 AM to 5 PM Monday to Friday. *Government hours:* 9 AM to 5 PM Monday to Thursday in winter, to 4 PM in summer; 9 AM to 3 PM Friday year-round. *Business dress code:* Conservative, in the British tradition.

Climate and terrain: Series of 700 (29 inhabited) long, flat coral islands in a 750-mile arc. Semitropical climate. June to November is hurricane season. *Temperature ranges* (Nassau): January: 65° to 77°F; April: 69° to 81°F; July: 75° to 88°F; October: 73° to 85°F.

Visas: *Work permit:* Obtain from Director of Immigration, P.O. Box N831, Nassau; *tel.* 809–322–7530. *Tourists:* Proof of U.S. citizenship, photo ID, proof of return ticket, for up to 8 months. *Health requirements:* Yellow fever vaccination is required if coming from an infected area. *Equipment importation:* Contact Director of Immigration (see *Work permit,* above) for information.

Electricity: 120/60. *Plug types:* A and B.

Currency: Dollar (BM$); Cents.

U.S. embassy in the country: Mosmar Building, Queen Street, P.O. Box N–8197, Nassau; *tel.* 322–1181, 328–2206; *telex:* 20–138 AMEMB NS138.

Embassy in U.S.: 600 New Hampshire Avenue NW, Washington, DC 20037; *tel.* 202–944–3390. *Consulates:* Florida: 305–373–6295; New York: 212–421–6420/2.

Tourism office in U.S.: Bahamas Tourist Office, 150 East Fifty-second Street, New York, NY 10022; *tel.* 212–758–2777.

Central tourism office in country: Bahamas Tourist Office, Bay Street, Nassau; *tel.* 322–7500.

Health suggestions: Very good medical care is available. Water is potable but saline; most rely on bottled water.

Photographic restrictions: Contact Director of Immigration (see **Visas,** above).

Film commissions: Bahamas Film Promotion Bureau, P.O. Box N–3701, Nassau; *tel.* 326–0634/5.

Gratuity guidelines: Sometimes included in the bill; if not, leave tip.

BAHRAIN
State of Bahrain
Dawlat al-Bahrayn

Location: In the Persian Gulf, off the eastern coast of the Arabian peninsula, northwest of Qatar. *Size:* 255 square miles, smaller than New York City.

Major cities: Manama (lat. +26.12). *Airports:* Bahrain International Airport (BAH), 4 miles outside of Manama.

General transportation: Excellent international air links. Gulf Air (GF) provides many regional connections. New Bahrain–Saudi Arabia causeway connects the country to the mainland; good road network. *U.S. license:* Yes. *IDP:* Yes. *Rule of the road:* Right. *Taxi markings:* Marked TAXI in Arabic and English, with orange fenders.

Population: 480,000, concentrated in the two principal cities. *Type of government:* Traditional monarchy. The amir and prime minister, of the al-Khalifa family, govern in consultation with a council of ministers. Maintains good relations with the U.S.

Languages: *Arabic;* English is spoken in government and business establishments. *Ethnic groups:* 63% Bahraini, 13% Asian, 10% other Arab, 8% Iranian, 6% other. *Religion:* 70% Shi'a Muslim, 30% Sunni Muslim.

Time: EST +8; GMT +3. *Telephone codes:* Country: 973. No city codes. Excellent international services, good domestic. *Pay phone system:* Coins.

Holidays: December 16 (National Day), plus Islamic holidays. *Date/month system:* D/M.

Business hours: 7:30 AM to 12:30 AM, 3 PM to 6 PM, Saturday to Thursday. *Government hours:* 7 AM to 1 PM Saturday to Thursday. During Ramadan, daily hours are curtailed and some businesses are open at night. *Business dress code:* Conservative for men and women.

Climate and terrain: Group of islands; the

island of Bahrain has an interior plateau of 100 to 200 feet, with its highest point at 445 feet. Little rainfall. Very hot and humid from March to November; cooler from December to February. *Temperature ranges:* January 66°F; April 81°F; July 93°F; October 82°F.

Visas: Contact the embassy for consideration on a case-by-case basis; include equipment list. No tourist visas are issued. A transit visa is available at Bahrain International Airport for stays of up to 72 hours with proof of return or continued-trip ticket. *Health requirements:* Yellow fever vaccination is required if coming from an infected area. *Equipment importation:* Arrange with visa.

Electricity: 230/50. *Plug types:* D and G.

Currency: Dinar (BHD); 1,000 Fils.

U.S. embassy in the country: Shaikh Isa Road, P.O. Box 26431, Manama; *tel.* 714151; *telex:* 9398 USATO BN.

Embassy in U.S.: 3502 International Drive NW, Washington, DC 20008; *tel.* 202-342-0741/2. U.N. Mission: New York: 212-223-6200.

Central tourism office in country: Ministry of Information, Department of Public Relation and Journalism, P.O. Box 253, Manama; *tel.* 681–555; *telex:* 8399.

Health suggestions: Adequate medical care is available. Water is generally safe but a bit saline for Western tastes. "Sweet" water, as well as bottled water, can be purchased. Malaria suppressants are recommended.

Cultural mores and taboos: As in most Arab countries, patience and courtesy are paramount. Titles are important, as are hospitality rituals at business meetings. Make eye contact. Muslim injunctions against alcohol and pork prevail. Do not cross legs, point, or gesture at someone with the hand, show the soles of the feet, or pass or accept items with the left hand. If invited to a mosque, dress to cover the entire body, remove shoes (tip the attendant who gives you slippers), and do not walk in front of others praying.

Photographic restrictions: Contact the Ministry of Information for further information (see **Central tourism office in country,** above).

Gratuity guidelines: Tips are appreciated but not required. Service is often included in hotel and restaurant bills.

BANGLADESH
People's Republic of Bangladesh
Gama Prajātantrï Bangladesh

Location: In southern Asia, bounded on the north and east by India, the southeast by India and Burma, the south by the Bay of Bengal, and the west by India. *Size:* 55,126 square miles, slightly smaller than Wisconsin.

Major cities: Dacca (lat. +23.42) *Airports:* Zia International Airport (DAC), 13 miles outside of Dacca.

General transportation: International and domestic air links are adequate. Railroad service is limited. Roads are crowded but adequate to most cities. River transport is extensive. *U.S. license:* No. *IDP:* Yes. *Rule of the road:* Right. *Motor clubs:* Automobile Association of Bangladesh, 3/B, Outer Circle Road, Dacca; *tel.* 24 34 82; par-tial AAA reciprocity. *Taxi markings:* Yellow roof, black body; some metered, but be sure to agree on price in advance in all cases (bargaining is common).

Population: 110,000,000. *Type of government:* Republic; elements of legal system and civil liberties suspended in 1987 state of emergency. Moderate, nonaligned foreign policy. Enjoys warm, positive relations with the U.S.

Languages: Bengali (or Bangla). English is widely understood in government and business circles. *Ethnic groups:* 98% Bengali. *Religion:* 83% Muslim, 16% Hindu, 1% Buddhist, Christian, and other.

Time: EST +11; GMT +6. *Telephone codes:* Country: 880. Barisal 431, Bogra 51,

Chittagong 31, Comilla 81, Dacca 2, Khulna 41, Maulabi Bazar 861, Mymensingh 91, Rajshahi 721, Sylhet 821. No credit card or collect calls to U.S. Fair domestic service, adequate international. *Pay phone system:* Coins; not commonly available on the street, but in hotels and public facilities.

Holidays: February 21; March 26; May 1; November 7; December 16, 25, plus Islamic holidays. *Date/month system:* D/M.

Business hours: 9 AM to 6 PM, Saturday to Thursday. *Government hours:* 7 AM to 2 PM in Dacca; 9 AM to 5 PM elsewhere. *Business dress code:* Comfort is the rule. Open-collar sport or safari shirts are acceptable in business. Lightweight tropical suits are worn occasionally. Women not wearing saris wear conservative dresses covering the legs. Dress for social events is informal.

Climate and terrain: Low-lying, riverine, with marshy jungle coastline. Subject to drought and flood. Tropical monsoon climate with periodic cyclonic storms. Although Bangladeshis recognize six distinct seasons, a foreigner normally distinguishes only three: high humidity and daytime heat from March to mid-June, the monsoon season with high humidity but cooler, cloudy days from mid-June to October, and the cool season of clear, dry, comfortable weather from November to February.

Visas: Contact the Minister of Press at the embassy in the U.S., who will consult with Bangladesh. Indicate purpose of visit; bring equipment list, passport, client letter. Reply could take two weeks. *Tourists:* Passport, no visa needed for stays of up to 14 days. *Health requirements:* Yellow fever vaccination required if coming from infected country. *Equipment importation:* Handled with visa. Also ask to speak to the commercial counselor to assist with customs. If paperwork is in order, a bond may not be required.

Electricity: 220/50. Brief power failures and voltage fluctuations are common. *Plug types:* C and D.

Currency: Taka (BDT); Poisha.

U.S. embassy in the country: Adamjee Court Building, 5th Floor, Motijheel Commercial Area, GPO Box 323, Ramna, Dacca; *tel.* 237161/3, 235093/9, 235081/9; *telex:* 642319 AEDKA BJ.

Embassy in U.S.: 2201 Wisconsin Avenue NW, Washington, DC 20007; *tel.* 202–342–8372/6.

Central tourism office in country: Parjatan Corporation, Old Airport Road, Tejgaon, Dacca; *tel.* 325155.

Health suggestions: Sanitary precautions are necessary. Tetanus, typhoid, gamma globulin, and polio immunizations are recommended. Obtain malaria suppressants for travel outside of Dacca.

Cultural mores and taboos: Businesspeople are very hospitable, often wanting to greet visitors at the airport and assist with local personal arrangements. Luncheons and dinners are a common part of business transactions.

Gratuity guidelines: Service included (15%) on the bill at most better hotels and restaurants; a bit extra is greatly appreciated if deserved. A 15% tip is sufficient if none is included on the bill.

BARBADOS

Location: In the West Indies, the easternmost island; east of St. Vincent, southeast of St. Lucia. *Size:* 166 square miles, about half the size of San Diego.

Major cities: *Bridgetown* (lat. +13.08). *Airports:* Grantley Adams International Airport (BGI), 11 miles outside of Bridgetown.

General transportation: Very good international air links. Good local transport. *U.S.* *license:* Yes, on presentation to the police and payment of fee. *IDP:* Yes, on presentation to the police and payment of fee. *Rule of the road:* Left. *Taxi markings:* All colors, marked TAXI; set price beforehand.

Population: 260,000; densely populated. *Type of government:* Independent sovereign state within the British Commonwealth, recognizing Elizabeth II as head of state. Parlia-

mentary democracy based on the British system. Enjoys friendly relations with the U.S. **Languages:** English. *Ethnic groups:* 80% black of African descent, 16% mixed, 4% European. *Religion:* 70% Anglican, 9% Methodist, 4% Roman Catholic, 17% other. **Time:** EST +1; GMT −4. *Telephone codes:* Direct-dial from the U.S. using the 809 area code. Domestic and international service good throughout. *Pay phone system:* Coins.

Holidays: January 1; Good Friday; Easter Monday; May Day; Whit Monday (varies—early June); August 1; October 3; November 30; December 25, 26. *Date/month system:* D/M.

Business hours: 8 AM to 4 PM Monday to Friday, 8 AM to 12 noon Saturday. *Government hours:* 8:15 AM to 4:30 PM Monday to Friday, 8 AM to 12 noon Saturday. *Business dress code:* More informal than U.S. but no shorts or jeans.

Climate and terrain: Comparatively flat, with a series of gently rising terraces from the west coast to a central ridge (highest point, 1,104 feet). Hurricane season extends from June to November. *Temperature ranges* (Bridgetown): January: 70° to 83°F; April: 72° to 86°F; July: 74° to 86°F; October: 73° to 86°F.

Visas: *Work visa:* Contact the Chief Immigration Officer, Customs House, The Wharf, Bridgetown; *tel.* 809–426–1011. They will send you forms (C3 for visits of less than 6 months). The Barbados consulate in New York may have the forms, so you might want to contact them first. Return them in duplicate, with 4 photos, 100 Barba-dos dollars. If the application is approved, an additional fee of 110 Barbados dollars per month is required in advance. They will deal with couriers if all freight charges are paid in advance. *Tourists:* Proof of U.S. citizenship, photo ID, proof of return ticket for stays of up to 3 months. **Health requirements:** Yellow fever vaccination required if coming from an infected country. *Equipment importation:* Since a bond will be necessary, it is recommended that you use a customs broker in New York or a local broker in Barbados, which can be recommended by the Barbados Board of Tourism (see **Central tourism office in country,** below).

Electricity: 115/50. *Plug types:* A and B. **Currency:** Dollar (BD$); Cents.

U.S. embassy in the country: P.O. Box 302, Canadian Imperial Bank Building, Broad Street, Bridgetown; *tel.* 809–436–4950/7; *telex:* 2259 USEMB BG1 WB.

Embassy in U.S.: 2144 Wyoming Avenue NW, Washington, DC 20008; *tel.* 202–939–9200. *Consulates:* New York: 212–867–8435.

Tourism office in U.S.: Barbados Board of Tourism, 800 Second Avenue, New York, NY 10017; *tel.* 212–986–6516.

Central tourism office in country: Barbados Board of Tourism, Prescott and Harbour Roads, P.O. Box 242, Bridgetown; *tel.* 809–427–2623.

Health suggestions: Health and sanitation are generally good. Water is potable.

Gratuity guidelines: Service is usually included in the bill (10%); otherwise tips are expected.

BELGIUM
Kingdom of Belgium
Koninkrijk België/Royaume de Belgique

Location: In northwestern Europe, bounded on the northwest by the North Sea, the north by the Netherlands, the east by West Germany, the southeast by Luxembourg, and the south and west by France. *Size:* 11,781 square miles, about the size of Maryland.

Major cities: *Brussels* (lat. +50.50). *Airports:* National Airport (BRU), 8 miles outside of Brussels. *Note:* Belgian airports are unyielding in their policy of *not* providing hand inspections for film. Either exit the country by train or bring lead bags—your film will be X-rayed.

General transportation: Excellent in all forms, although there is no internal air network in this small country. *U.S. license:* Yes. *IDP:* Yes. *Rule of the road:* Right. *Motor clubs:* Royal Automobile Club de Belgique, rue d'Arlon 53, Brussels; *tel.* 230–0810; partial AAA reciprocity. *Taxi markings:* Found at taxi stands; difficult to hail from the street. Telephone-dispatched taxis are commonly used. Taxis are usually black but can be other colors. They are metered and fare includes tips.

Population: 9,900,000. *Type of government:* Constitutional monarchy. A parliamentary democracy, with the judiciary based on the French system. Excellent relations with the U.S.

Languages: 55% Dutch (Flemings), 33% French (Walloons). Brussels is nominally bilingual. English is widely understood. *Ethnic groups:* 55% Fleming, 33% Walloon, 12% mixed or other. *Religion:* 75% Roman Catholic, remainder Protestant or other.

Time: EST +6; GMT +1. *Telephone codes:* Country: 32. Antwerp 3, Brugge 50, Brussels 2, Charleroi 71, Ghent 91, Hasselt 11, Kortrijk 56, La Louvière 64, Libramont-Chevigny 61, Liège 41, Louvain 16, Mechlin 15, Mons 65, Namur 81, Ostend 59, Verviers 87. Excellent domestic and international service. *Pay phone system:* Coins; in some cases magnetic cards are available at post offices.

Holidays: January 1; Easter Monday; May 1; Ascension Day (40 days after Easter); Whit Monday (varies–early June); July 21; August 15; November 1, 11; December 25. Banks closed on May 29, August 17, November 2. July and August are popular vacation months. *Date/month system:* D/M.

Business hours: 8:30 AM to 5:30 PM, Monday to Friday. *Business dress code:* Conservative.

Climate and terrain: The fertile, coastal plain gives way to central rolling hills and valleys south of Brussels. The mountainous Ardennes Forest lies farther to the southeast. Frequent rain, but temperate, with cooler summers and milder winters than the northeastern U.S. *Temperature ranges* (Brussels): January: 30° to 40°F; April: 41° to 58°F; July: 54° to 73°F; October: 45° to 60°F.

Visas: Standard tourist entry, which requires a passport; no visa is needed for stays of up to 3 months. *Health requirements:* No vaccinations required. *Equipment importation:* Carnet.

Electricity: Mostly 220/50; also 127/50 in some areas. *Plug types:* C and E.

Currency: Franc (BFR); Centimes.

U.S. embassy in the country: 27 boulevard du Regent, B-1000 Brussels; *tel.* 513–3830; *telex:* 846–21336. *Consulates:* Antwerp: 225–0071.

Embassy in U.S.: 3330 Garfield Street NW, Washington, DC 20008; *tel.* 202–333–6900. *Consulates:* California: 213–385–8116; Georgia: 404–659–2150; Illinois: 312–263–6624; New York: 212–586–5110; Texas: 713–784–8077.

Tourism office in U.S.: Belgian Tourist Office, 745 Fifth Avenue, Suite 714, New York, NY 10151; *tel.* 212–758–8130.

Central tourism office in country: For French-speaking region of Wallonia: Office de la Promotion de Tourisme, rue du Marche aux Herbes #61, B-1000 Brussels; *tel.* (2) 513–9090. For Flemish-speaking region of Flanders: VCGT, Grasmarkt 61, Brussels 1000, *tel.* (2) 513–9090.

Health suggestions: Conditions are the same as in the U.S. At least one pharmacy is open in a given neighborhood at all times. Its address is posted at all other pharmacies and in newspapers.

Cultural mores and taboos: Business dealings are conservative; first names are reserved for friends. Punctuality is important. Respect—and do not discuss—the differences between the Dutch-speaking and French-speaking cultures. Avoid personal discussion in general—Belgians are very private.

Color labs: N.V. *Kodak* S.A., Steenstraat 20, 1800 Koningslo-Vilvoorde.

Equipment rental/sales: *Balcar:* S.A. Masson-Draguet N.V., Wauthier Braine

(near Brussels); *tel.* 366–1720. *Profoto:* Fotronics s.p.r.i., Braine-L'Alleud; *tel.* (2) 385–0963.

Gratuity guidelines: Service is often included in the bill, but giving a bit extra is customary.

BELIZE

Location: In Central America, bounded on the north by Mexico, the east by the Caribbean Sea, and the south and west by Guatemala. *Size:* 8,867 square miles, slightly larger than Massachusetts.

Major cities: Belize City (lat. +17.31), *Belmopan* (50 miles inland from Belize City). *Airports:* Belize International Airport (BZE), 10 miles outside of Belize City, 60 miles from Belmopan. Municipal Airport (TZA), 1 mile outside of Belize City, provides domestic service.

General transportation: Air links to Central America and U.S. Maya Airways (MW) flies domestic routes, mostly from Municipal Airport. Buses, taxis, light aircraft, and boats provide internal transport (no railways). *U.S. license:* Yes, for 3 months. *IDP:* Yes, for 3 months. *Rule of the road:* Right. *Taxi markings:* Green license plates, cars unmarked; set rates in advance.

Population: 170,000. *Type of government:* Parliamentary. Commonwealth democracy based on British system. Enjoys close, cordial relations with the U.S.

Languages: English (official), Spanish, Maya, Garifuna (Carib). *Ethnic groups:* 39.7% Creole, 33.1% mestizo, 9.5% Maya, 7.6% Garifuna, 2.1% East Indian, 6.8% other. *Religion:* 60% Roman Catholic, 40% Protestant (variety).

Time: EST −1; GMT −6. *Telephone codes:* Country: 501. Belize City—no code required, Belmopan 08, Benque Viejo del Carmen 093, Corozal 04, Dangviga 05, Independence 06, Orange Walk 03, Punta Gorda 07, San Ignacio 092. Adequate domestic and international service. *Pay phone system:* None.

Holidays: January 1; March 9; Good Friday; Easter Monday; May 1, 24; September 10, 21; October 12; November 19; December 25, 26. *Date/month system:* D/M.

Business and government hours: 8 AM to 12 noon, 1 PM to 4 PM Monday to Friday; 8 AM to 12 noon Saturday. *Business dress code:* Informal.

Climate and terrain: The flat, swampy coastline, fringed by cays and a spectacular barrier reef, rises gradually to the low peaks of the Maya Mountains in the south (highest point, Victoria Peak, 3,680 feet). Hot and humid; tempered along the coast by sea breezes. The rainy season runs from May to February. Devastating hurricanes and coastal flooding are not uncommon from September to December—the capital was moved inland, from Belize City to Belmopan, for this reason. *Temperature ranges* (Belize City): January: 67° to 81°F; April: 74° to 86°F; July: 75° to 87°F; October: 72° to 86°F.

Visas: Standard tourist entry, which requires a passport; no visa is needed for stays of up to 30 days. *Health requirements:* Yellow fever vaccination is required if coming from an infected area. *Equipment importation:* Bring an equipment list; no bond is necessary.

Electricity: 110/60 and 220/60. *Plug types:* A and B.

Currency: Dollar (BN$); Cents.

U.S. embassy in the country: Gabourel Lane and Hutson Street, P.O. Box 286, Belize City; *tel.* 7161/3; *telex:* 213 AMCONSUL BZ.

Embassy in U.S.: 3400 International Drive NW, Suite 2J, Washington, DC 20008; *tel.* 202–363–4505.

Central tourism office in country: Belize Tourist Board, P.O. Box 325, Belize City; *tel.* 2–77236 or 73255. Belize Tourism Industry Association, P.O. Box 62, 7 Cork Street, Belize City; *tel.* 2–77351.

Health suggestions: Adequate medical services are available in the capital. Food

served in local restaurants is usually safe. Yellow fever vaccination is recommended by the CDC for travel outside urban areas. Water is sometimes contaminated. Malaria suppressants are recommended for some areas.

Film commissions: Belize Foreign Film Commission, 1769 North El Cerrito Place, #309, Hollywood, CA 90028; *tel.* 213-874-2499.

Gratuity guidelines: Not included in bills; a 10% tip is appreciated.

BENIN
People's Republic of Benin
République Populaire du Benin

Location: In western Africa, bounded on the north by Niger, the east by Nigeria, the south by the Gulf of Guinea, the west by Togo, and the northwest by Burkina Faso. *Size:* 43,483 square miles, slightly smaller than Pennsylvania. **Major cities:** *Porto-Novo* (lat. +6.21), Cotonou (lat. +6.21). *Airports:* Cotonou Airport (COO), 20 miles outside of Cotonou.

General transportation: Flights to several African capitals, Amsterdam, Copenhagen, Nice, Paris, and Stockholm. No scheduled internal air links. Two rail lines serve the coast, a third extends north to Parakou. Roads from Cotonou to Lagos, Nigeria, and Lomé, Togo, are good, but many other roads are poor and impassable in the rainy season. Rental cars are available. *U.S. license:* No. *IDP:* Yes. *Rule of the road:* Right. *Taxi markings:* Yellow body with green top, marked TAXI; set price beforehand. **Population:** 4,500,000. *Type of government:* Soviet-modeled civilian government; many coups since Benin (known as Dahomey before 1976) gained independence in 1960. Relations with the U.S. are improving. **Languages:** French (official), various tribal languages. *Ethnic groups:* 99% African from 42 ethnic groups, including Fon, Adja, Yoruba, Bariba; 5,500 Europeans. *Religion:* 70% indigenous beliefs, 15% Muslim, 15% Christian. **Time:** EST +6; GMT +1. *Telephone codes:* Country: 229. No city codes. No credit card or collect calls to U.S. Service can be interrupted during rainy season. Service to other French-speaking West African countries is good, but contact with Ghana and Nigeria is more problematic. Other international service is adequate and improving. *Pay phone system:* Coins; few available.

Holidays: January 1, 16; April 1; May 1; October 26; November 30; December 23, 25, 31, plus two Muslim holidays—check with consulate. *Date/month system:* D/M.

Business and government hours: 8 AM to 12:30 PM, 3 PM to 6:30 PM Monday to Friday, plus Saturday mornings for government and some businesses. *Business dress code:* Open shirt is acceptable except for formal receptions. Shorts are not worn on the street.

Climate and terrain: Mostly flat with dense vegetation. Two rainy seasons in the south, from April to July and October to November. The north has one, from June to October. The coast is hot and humid most of the year, tempered by sea breezes. The harmattan, a dust-laden wind, blows in December and January. *Temperature ranges* (Cotonou): January: 74° to 80°F; April: 78° to 83°F; July: 74° to 78°F; October: 75° to 80°F.

Visas: Standard tourist visa, which requires a passport, 3 applications, 3 photos, $12 fee, proof of yellow fever and cholera vaccinations, copy of ticket, and return postage. Allow 48 hours for processing. Benin will not issue visas in passports with Israeli, South African, or Taiwanese visas. *Health requirements:* Yellow fever and cholera vaccinations. *Equipment importation:* Bring equipment list; no bond is necessary. **Electricity:** 220/50. *Plug types:* D. **Currency:** Franc (CFA).

U.S. embassy in the country: Rue Caporal Anani Bernard, B.P. Box 2012, Cotonou; *tel.* 30–06–50.

Embassy in U.S.: 2737 Cathedral Avenue NW, Washington, DC 20008; *tel.* 202–232–6656.

Central tourism office in country: Society for the Promotion of Tourism, P.O. 1508, Cotonou; *tel.* 300584; *telex:* 5143.

Health suggestions: Only the most basic medical services are available. Water is not potable, and full food-preparation precautions are necessary. Malaria is endemic, and hepatitis is a hazard. Limited quantities of French patent medicine are available.

Gratuity guidelines: Tipping is not expected but will be accepted.

BERMUDA

Location: In the western North Atlantic Ocean, east of North Carolina. *Size:* 20 square miles, one-third the size of Washington, DC.

Major cities: *Hamilton* (lat. +32.17). **Airports:** Kindley Airport (BDA), 10 miles outside of Hamilton.

General transportation: Numerous international flights, including daily flights from several U.S. cities. Ferries connect Hamilton with points across the harbor. Network of scheduled buses. *U.S. license:* No. **IDP:** No. *Rule of the road:* Left. *Taxi markings:* All colors, marked TAXI, metered. More than 200 drivers have attained "qualified tour guide" status by completing special government exams (blue flags indicate them).

Population: 58,000. *Type of government:* Although a British dependent territory, Bermuda enjoys almost complete internal autonomy. The U.K. handles its external affairs in consultation with the colony. You may reenter U.S. Immigration and Customs in Bermuda.

Languages: English. *Ethnic groups:* 61% black, 39% white and other. *Religion:* 37% Anglican, 14% Roman Catholic, 10% African Methodist Episcopalian (Zion), 6% Methodist, 5% Seventh Day Adventist, 28% other.

Time: EST +1; GMT −4. *Telephone codes:* Direct-dial from U.S. using the 809 area code. Modern, fully automatic domestic and international service. *Pay phone system:* U.S. coins; not as common on the street as in the U.S.

Holidays: January 1; Good Friday; May 30; Queen's Birthday (June); Cup Match Holiday (June); September 5; November 11; December 25, 26. *Date/month system:* D/M.

Business hours: 9 AM to 5 PM Monday to Friday. *Business dress code:* Conservative, even for dinner and social engagements.

Climate and terrain: An archipelago comprising 7 main islands and many smaller ones, 24 miles long. Low hills are separated by fertile depressions. Mild climate, with rainfall evenly distributed throughout the year; high winds possible from December to April. Winter can be chilly. *Temperature ranges* (Hamilton): January: 58° to 68°F; April: 59° to 71°F; July: 73° to 85°F; October: 69° to 79°F.

Visas: Officially, a professional photographer wanting to photograph in Bermuda will need permission from Immigration, *tel.* 809–295–5151. *Tourists:* Passport; no visa required for stays of up to 6 months; proof of U.S. citizenship, return ticket, photo ID. *Health requirements:* No vaccinations required. *Equipment importation:* A bond of approximately one-third the value of the equipment is necessary—employing a customs broker is recommended.

Electricity: 120/60. *Plug types:* Mostly A and B, but some G and I.

Currency: Dollar (BE$); Cents. You may also use U.S. currency freely.

U.S. embassy in the country: Vallis Building, Fronth Street, P.O. Box 325, Hamilton; *tel.* 809–295–1342.

Embassy in U.S.: Care of the British Em-

bassy, 3100 Massachusetts Avenue NW, Washington, DC; *tel.* 202–462–1340.

Tourism office in U.S.: Bermuda Department of Tourism, 310 Madison Avenue, #201, New York, NY 10017; *tel.* 212–818–9800.

Central tourism office in country: Ber-

muda Department of Tourism, 43 Church Street, Hamilton; *tel.* 809–292–0023.

Health suggestions: No special precautions are necessary.

Gratuity guidelines: Service is usually included in the bill (15%); if not, give 10% to 15%.

BHUTAN
Kingdom of Bhutan
Druk-Yul

Location: In south-central Asia, bounded on the north by China (Tibet) and the east, south, and west by India. *Size:* 18,147 square miles, the size of New Hampshire and Vermont combined.

Major cities: *Thimbu* (lat. +27.32); Paro Dzong is the administrative capital. *Airports:* Paro Airport (PBH), 30 miles outside of Paro Dzong.

General transportation: Druk Airlines flies small craft to India and Pakistan. Fairly good mountain roads connect the country with India. A little more than a third of the country's roads are paved. Within most of the country, travel is by foot or pack animal. *U.S. license:* No. *IDP:* Yes. *Rule of the road:* Left. *Taxi markings:* No taxis (however, visitors will have their own vehicle and driver). See **Visas.**

Population: 1,500,000. *Type of government:* Monarchy; special treaty relationship with India. Popular king is moving country toward a number of representative institutions. Other important leader is the spiritual head, the *je khempo.* The monastic order is involved with the government at many levels. No formal diplomatic relations are maintained with the U.S., but informal and friendly contact exists.

Languages: Various Tibetan dialects, the most widely used being Dzongkha (official). Nepalese speak various Nepalese dialects. English, the official working language and medium of instruction in schools and colleges, is widely spoken. *Ethnic groups:* 60% Bhote (Tibetan), 25% ethnic Nepalese, 15%

indigenous or migrant tribes. *Religion:* 75% Lamaistic Buddhism, 25% Indian- and Nepalese-influenced Hinduism.

Time: EST +10.5; GMT +5.5. *Telephone codes:* No direct-dial from the U.S. —operator-assisted calls only. No credit card or collect calls to U.S. Domestic service inadequate; international telephone and telegraph service is available but of uncertain reliability. *Pay phone system:* None.

Holidays: May 2; June 2; July 21; November 11; December 17. *Date/month system:* D/M.

Business and government hours: 9 AM to 5 PM Monday to Friday, plus Saturday mornings. *Business dress code:* Same as that in the U.S. for Americans.

Climate and terrain: Mostly mountainous, with some fertile valley and savanna. The north is dominated by snow-capped, inaccessible peaks of the Himalayas, reaching as high as 24,000 feet. The more densely populated western mountains range in elevation from 5,000 to 9,000 feet. Climate varies with altitude. Central valleys are temperate, while southern valley and plains are subtropical. Violent storms originate in the Himalayas, where winters are severe and summers cool.

Visas: No visitors may circulate independently without an extremely rare invitation from the government. The only way to enter is with a tourist group, but you can pay for an extension of your visit (can be as high as $200 per day; however, this includes hotel, 3 meals, car, driver, and guide). Apply 2

months in advance. Government is determined to prevent tourism that cannot be supported by its infrastructure. *Health requirements:* Yellow fever vaccination is required if coming from an infected area. *Equipment importation:* No restriction on still photography. **Electricity:** 220/50. *Plug types:* Data unavailable.
Currency: Ngultrum/Rupee (INR)
U.S. embassy in the country: None.
Embassy in U.S.: None. Contact is via the U.N. representative, 2 UN Plaza, New York, NY 10017; *tel.* 212–826–1919.
Tourism office in U.S.: None.
Central tourism office in country: Bhutan Tourism Corporation, P.O. Box 159, Thimbu.

Health suggestions: Special food handling and water purification are essential. Immunizations for tetanus, typhoid, poliomyelitis, and hepatitis are recommended. Some malaria risk near the Indian border.
Cultural mores and taboos: The Bhutanese are tolerant and understanding of foreigners. Take off shoes in temples still open to the public. Be discreet at religious ceremonies, particularly avoiding flash at night. Never offer a tip or gift to take someone's photograph, although requesting permission is acceptable.
Photographic restrictions: Temples may not be photographed without permission.
Gratuity guidelines: Tips are strictly forbidden and considered insulting.

BOLIVIA
Republic of Bolivia
República de Bolivia

Location: In west-central South America, bounded on the north and east by Brazil, the southeast by Paraguay, the south by Argentina, and the west by Peru and Chile. *Size:* 424,162 square miles, 3 times the size of Montana.
Major cities: *La Paz*, seat of government (lat. − 16.30); *Sucre*, legal capital and seat of judiciary (lat. − 19). *Airports:* El Alto Airport (LPB), 8 miles outside of La Paz.
General transportation: Connections to U.S. through Miami. Overland travel from neighboring countries is possible but complicated. Internal flights are recommended because of the terrain, but railways with sleepers are available. Bus service is extensive but crowded. Hydrofoils cruise Lake Titicaca. *U.S. license:* No. *IDP:* Yes; must be stamped by authorities after 3 months. *Rule of the road:* Right. *Motor clubs:* Automóvil Club Boliviano, Avenida 6 de Agosto 2993, San Jorge, La Paz; *tel.* 351–667; partial AAA reciprocity. *Taxi markings:* All colors, marked TAXI; set price in advance. Sharing is common—you effectively rent a seat. Taxis in La Paz with colored flags indi-

cating their routes are called *trufis.* Tipping is not customary.
Population: 6,500,000. *Type of government:* Republic. Has a long history of difficult relations with Chile. Except for a brief interruption in 1980 to 1981, U.S. has maintained diplomatic relations. Bolivia is a recipient of U.S. aid programs. There are some strains over the issue of coca cultivation in Bolivia.
Languages: Spanish, Quechua, and Aymará (all official). English is widely understood in the business community and by many government officials. *Ethnic groups:* 55% Indian (30% Quechua, 25% Aymará), 20% to 30% mestizo, 5% to 15% European (mostly Spanish). *Religion:* 95% Roman Catholic, with active Protestant minority.
Time: EST + 1; GMT − 4. *Telephone codes:* Country: 591. Cochababa 42, Cotoca 388, Guayafamerin 47, La Belgica 923, La Paz 2, Mineros 984, Montero 92, Oruro 52, Portachuelo 924, Saavedra 924, Santa Cruz 33, Trinidad 46, Warnes 923. No credit card calls to U.S. Domestic service is steadily improving; direct-dial to the U.S. is available

164 Country Files

in major cities. *Pay phone system:* Tokens. You may also pay newsstands and other shops to use their phones.

Holidays: January 1, Carnaval (varies—late February to early March); Good Friday; May 1; Corpus Christi (varies—June); August 6; November 1; December 25; plus regional holidays. *Date/month system:* D/M.

Business hours: Usually 9 AM to 12 noon, 2 PM to 6:30 or 7 PM Monday to Friday. *Business dress code:* Conservative in La Paz; Santa Cruz is a bit more informal.

Climate and terrain: High plateau *(altiplano)* splits the Andes into two chains and cradles Lake Titicaca, the highest navigable lake in the world. The terrain flattens out southward through the Yungas (hills and valleys) region on toward the tropical lowland plains *(llano* region). Rainy summers (December to March), dry winters (March to November), varying with altitude. La Paz ranges from cool to cold. Santa Cruz can be hot and humid. *Temperature ranges* (La Paz): January: 43° to 63°F; April: 40° to 65°F; July: 33° to 62°F; October: 40° to 66°F.

Visas: Business visa requires a $50 fee, passport, client letter, 1 photo, 1 application submitted to nearest consulate. Processing takes 1 day, can be done same day if urgent. *Health requirements:* No vaccinations required. *Equipment importation:* Bring equipment list to consulate when applying for visa; no bond is necessary.

Electricity: 115/50 in La Paz, mostly 220/ 50 elsewhere. *Plug types:* A, B, C, and F.

Currency: Boliviano (BOB); Centavos.

U.S. embassy in the country: Banco Popular del Peru Building, corner of Calles Mercado and Colon, P.O. Box 425, La Paz; *tel.* 350–251, 350–120; *telex:* AMEMB BV 3268.

Embassy in U.S.: 3014 Massachusetts Avenue NW, Washington, DC 20008; *tel.* 202–483–4410/2. *Consulates:* California: 213–680–0190, 415–495–5173; Florida: 305–358–3450; Louisiana: 504–523–7488; New York: 212–687–0532; Texas: 713–780–1648.

Central tourism office in country: Instituto Boliviano de Turismo, Edificio Mariscal Ballivian, 18th Floor, Calle Mercado, La Paz; *tel.* 36–74–42, 35–82–13.

Health suggestions: La Paz's 12,500-foot altitude (the highest capital in the world) requires extreme caution, particularly for anyone with heart or lung problems. Proceed very slowly for a few days until adjustment is made. Water is not potable, and sanitation is poor. Yellow fever inoculation is recommended. Malaria is a risk in some rural areas.

Cultural mores and taboos: Reserve first names for friends unless encouraged to do otherwise. Avoid discussing difficult relations with Chile. Attempts to speak Spanish will be greatly appreciated. Make direct eye contact.

Gratuity guidelines: Service is usually included in the bill (10%), but giving a bit more (5%) is customary.

BOTSWANA
Republic of Botswana

Although stable itself, Botswana is surrounded by nations experiencing conflict. Exercise caution at border areas.

Location: In southern Africa, bounded on the west and north by South-West Africa (Namibia), the northeast by Zimbabwe, and the southeast and south by South Africa. *Size:* 219,916 square miles, slightly smaller than Texas.

Major cities: *Gaborone* (lat. −24.45). *Airports:* Sir Seretse Khama International Airport (GBE), 8 miles outside of Gaborone.

General transportation: Flights to several African capitals and Europe (most U.S. connections through London's Gatwick Airport). Rental cars are available. *U.S. license:* Yes. *IDP:* Yes. *Rule of the road:*

Left. *Taxi markings:* All colors, marked TAXI; set price in advance.
Population: 1,200,000. *Type of government:* Parliamentary democracy, with an open political system that is stable politically and economically. Enjoys good relations with the U.S.
Languages: English (official); Setswana is spoken by much of the population. *Ethnic groups:* 95% Batswana; 4% Kalanga, Basarwa, and Kgalagadi; 1% white. *Religion:* 50% indigenous beliefs, 50% Christian.
Time: EST +7; GMT +2. *Telephone codes:* No direct-dial from the U.S.—operator-assisted calls only. Modest, adequate system. *Pay phone system:* Coins.
Holidays: January 1, 2; Good Friday through Easter Monday; Ascension Day (40 days after Easter); July 20, 21; September 30; October 1; December 25, 26. *Date/month system:* D/M.
Business hours: 8 AM to 1 PM, 2:15 PM to 5:30 PM Monday to Friday; many businesses are open 8 AM to 1 PM Saturday. *Government hours:* 7:30 AM to 12:30 PM, 1:45 PM to 4:30 PM, Monday to Friday. *Business dress code:* For high-level meetings, wear a tie and jacket; otherwise more informal.
Climate and terrain: Wide-open tableland. Rolling sands and grassy areas of the Kalahari Desert cover the southwest. In the north and northwest, the Okavango and Chobe rivers water the land, forming an inland delta commonly known as the Okavango Swamps. Climate is generally subtropical but varies with altitude and latitude. Rainy season is from October to April;

dry season runs from May to September. *Temperature ranges* (Gaborone): Can vary from well above 100°F to below freezing at night.
Visas: Officially standard tourist entry, but the embassy suggests contacting the Office of the President, P.B. 001; *tel.* 355–434 upon arrival to get list of subjects restricted for photography. Tourist entry requires a passport; no visa is needed for stays of up to 90 days. *Equipment importation:* Bring equipment list; no bond is required.
Electricity: 220/50. *Plug types:* D and G.
Currency: Pula (BTP); Thebe.
U.S. embassy in the country: P.O. Box 90, Gaborone; *tel.* 353–982/4; *telex:* 2554 AMEMB BD.
Embassy in U.S.: 4301 Connecticut Avenue NW, Washington, DC 20008; *tel.* 202–244–4990. *Consulates:* California: 213–626–8484; Florida: 305–563–2804; Texas: 713–864–8686.
Central tourism office in country: Department of Wildlife and National Parks, Tourism Division, Gaborone; *tel.* 353–024.
Health suggestions: Water is considered potable in major towns, but bottled water is still recommended. Seek advice before swimming in freshwater because of bilharzia (schistosomiasis). Hepatitis is a problem in urban areas. Malaria suppressants are recommended in the north (above latitude 21°S).
Photographic restrictions: See **Visas,** above.
Gratuity guidelines: Not included in the bill, tips are appreciated.

BRAZIL
Federative Republic of Brazil
República Federativa do Brasil

Location: In east-central South America, bounded on the northwest by Colombia, the north by Venezuela, Guyana, Suriname, and French Guiana, the east by the Atlantic Ocean, the south by Uruguay, and the west by Argentina. *Size:* 3,284,426 square miles, slightly smaller than the U.S.

Major cities: Rio de Janeiro (lat. −22.55), São Paulo (lat. −23.37), *Brasília* (lat. −15.51). *Airports:* Galeao Airport (GIG), 15 miles outside of Rio de Janeiro; Viracopos (VCP), 65 miles outside of São Paulo; Brasília International Airport (BSB), 12 miles outside of Brasília.

General transportation: Many international flights and good domestic air links (domestic flights may leave from the major cities' smaller airports). Air charters and a shuttle between Rio and São Paulo are available. Intercity trains are limited; buses run frequently but are crowded. The highway system in southeastern Brazil as far north as Salvador is adequate, but road maintenance is sometimes incomplete. Rio and São Paulo have subways. *U.S. license:* No. *IDP:* Yes. *Rule of the road:* Right. *Motor clubs:* Automóvil Club de Brasil, Rua do Passeio 90, Rio de Janeiro; *tel.* 297–4455; partial AAA reciprocity. *Taxi markings:* All colors, with red license plates with white digits; marked TAXI; metered. Good fixed-price luxury cabs are available from the major airports.

Population: 150,000,000. *Type of government:* Federal republic with a democratically elected president since March 1985; unrestricted media. The U.S. is Brazil's largest trading partner.

Languages: Portuguese; English is understood by a good number of businesspeople. Many Brazilians understand Spanish but can be sensitive about its use—Brazil is not part of Latin America. *Ethnic groups:* Four major groups: indigenous Indians, the Portuguese, descendants of African slaves, and various European and Asian immigrant groups who have arrived since the mid-nineteenth century. The largest Japanese community outside of Japan is in São Paulo. About 55% of Brazilians consider themselves white, 38% mixed, 6% black. *Religion:* 90% Roman Catholic (nominal).

Time: EST +2 (Rio); GMT −2 to +5. *Telephone codes:* Country: 55. Belém 91, Belo Horizonte 31, Brasília 61, Curitiba 41, Fortaleza 85, Goiânia 62, Niterói 21, Pelotas 532, Pôrto Alegre 512, Recife 81, Rio de Janeiro 21, Salvador 71, Santo André 11, Santos 132, São Paulo 11, Vitória 27. General service is good. *Pay phone system:* Tokens *(fichas)*.

Holidays: January 1; Carnaval (4 days and 3 nights preceding Ash Wednesday, which is a half-holiday); Good Friday; April 21; May 1; Corpus Christi (varies—June); September 7; October 12; November 2, 15; December 25; plus local holidays: January 20 (Rio), January 25 (São Paulo), December 8 (Brasília). Vacations are often taken in December and January, and business shuts down for Carnaval. *Date/month system:* D/M.

Business hours: 8:30 AM to 5:30 PM with decision makers tending to arrive and leave later. Lunch is two hours. *Business dress code:* Same as that of the U.S. in São Paulo; Rio is a bit more informal.

Climate and terrain: About 90% of the population lives on 10% of the land in a 200-mile-wide zone from Forteleza down the coast to Uruguay. The other 3 regions include: the densely forested northern lowlands, containing the undeveloped Amazon basin; the semiarid northeast scrubland; and the rugged hills and mountains, interspersed with gentle rolling plains, in the central west and south. Northern and coastal regions have a warm humid climate, with moderate to heavy rainfall. June to August (winter) is cool and dry. The southernmost portion of the country can see freezing temperatures, and frost has occurred as far north as São Paulo. *Temperature ranges* (Rio de Janeiro): January: 73° to 84°F; April: 69° to 80°F; July: 63° to 75°F; October: 66° to 77°F. São Paulo averages 8 to 10 degrees cooler.

Visas: *Business visa:* Client letter, passport, 1 photo, 1 application. *Tourists:* Visa, proof of return ticket and sufficient funds, 1 photo, passport. *Health requirements:* Yellow fever vaccination is required if coming from an infected area and is recommended by the CDC for travel to some areas. *Equipment importation:* Bring equipment list; a bond might be required.

Electricity: Rio, São Paulo, Recife, Belém, and Salvador, 110–127/60; other cities vary. Brasília is 220/60. *Plug types:* All types can be found.

Currency: Cruzado (BRZ); Centavos.

U.S. embassy in the country: Avenida da Noches, Lote 3, Brasília; *tel.* 223–0120;

telex: 061–1091. *Consulates:* Rio: 292–7117; São Paulo: 881–6511; Pôrto Alegre: 26–4288/4697; Recife: 221–1412.

Embassy in U.S.: 3006 Massachusetts Avenue NW, Washington, DC 20008; *tel.* 202–745–2828. *Consulates:* California: 213–282–3133; Florida: 305–377–1734; Georgia: 404–659–0660; Hawaii: 808–536–5105; Illinois: 312–372–2177; Louisiana: 504–588–9187; New York: 212–757–3080; Texas: 214–651–1854.

Tourism office in U.S.: Brazil Tourism Board, 551 Fifth Avenue, New York, NY 10176; *tel.* (212) 286–9600.

Central tourism office in country: Brazilian Tourist Authority (EMBRATUR), Rua Marize Barros, Rio de Janeiro 20270; *tel.* 273–2212.

Health suggestions: Some precautions are necessary. Tap water is not potable. Yellow fever, rabies, gamma globulin, typhoid, and polio immunizations are recommended. Malaria suppressants are recommended for some rural areas, including the interior Amazon basin.

Cultural mores and taboos: Brazilians can be a bit casual about appointments, except in São Paulo, where business customs are very similar to those in New York. Warm, relaxed atmosphere; men express their emotions. The American gesture for "okay" with thumb and index finger in a circle is obscene; the thumbs-up gesture is fine.

Color labs: *Kodak Brasileira Comercio e Industria Ltda.:* Caixa Postal 849, Rio de Janeiro; Setor Comercial Lado Norte 103, Bloco C No. 63167, Brasília 70.732; Caixa Postal 225, São Paulo 01000; Caixa Postal 988, Pôrto Alegre, Rio Grande do Sul 90.000; Caixa Postal 201, Recife 50.000, Pernambuco; Rua Padre Aspicuelta, 9, Largo dos Aflitros-Edif. Dom Pedro, 40.000 Salvador, Bahia.

Gratuity guidelines: Service is often included in the bill, but a little extra is appreciated; if not included, leave 10% to 15%.

BRUNEI
Negara Brunei Darussalam

Location: In southeast Asia, on the Malaysian island of Borneo; surrounded by Malaysia, except for the northern coast, on the South China Sea. *Size:* 2,226 square miles, slightly larger than Delaware.

Major cities: *Bandar Seri Begawan* (lat. +4.55). *Airports:* Brunei International Airport (BWN), 8 miles outside of Bandar Seri Begawan.

General transportation: Direct flights to several Asian destinations with connections to the U.S. (often through Manila); many flights to Singapore. Road network is being expanded. Public transport is limited. River vessels can be hired. *U.S. license:* No. *IDP:* Yes. *Rule of the road:* Left. *Motor clubs:* Persatuan Automobil Brunei, Sukatan dan Timbangen, Kementerian Hal-Ehwal Dalam Negri, Negara Brunei Darussalem; *tel.* 24306; partial AAA reciprocity. *Taxi markings:* Yellow tops, marked TAXI; set price in advance.

Population: 300,000. *Type of government:* Constitutional sultanate; the royal family has ruled for 29 generations.

Languages: Malay (official), English, Chinese. *Ethnic groups:* 64% Malay, 20% Chinese, 16% other. *Religion:* 60% Muslim (official), 32% Buddhist and indigenous beliefs, 8% Christian.

Time: EST +13; GMT +8. *Telephone codes:* Country: 673. Bandar Seri Begawan 2, Kuala Belait 3, Mumong 3, Tutong 4. No credit card calls to the U.S. Domestic and international service is adequate and improving rapidly. *Pay phone system:* Coins; very few available.

Holidays: January 1; Chinese New Year (varies); February 23; May 31; July 15; December 25; plus several Muslim holidays—check with consulate. *Date/month system:* D/M.

Business and government hours: 8:30 AM to 12:15 PM, 1:15 PM to 4:40 PM Satur-

day to Thursday. *Business dress code:* Men usually wear jackets for government business, but rarely otherwise. Women should dress conservatively.

Climate and terrain: Brunei is divided into two parts, separated by the state of Sarawak, in Malaysia. Its flat coastal plain rises to mountains in the east, hilly lowlands in the west. The interior consists primarily of tropical rain forests. Climate is consistently hot, humid, and rainy, with slightly heavier rains from November to January. Typhoons, earthquakes, and flooding are rare. *Temperature ranges* (Bandar Seri Begawan): January: 76° to 85°F; April: 77° to 87°F; July: 76° to 87°F; October: 77° to 86°F.

Visas: Permission might be required from Brunei. Contact the nearest consulate: 2 photos, 1 application, passport, $7.50 fee, client letter, list of your contacts in Brunei. Photojournalists must fill out a special form. *Tourists:* Tourist visa. *Health requirements:* Yellow fever vaccination is required if coming from an infected area (or traveling through an infected area 6 days or less before entering). *Equipment importation:* Include equipment list with visa application so that customs arrangements can be made in advance. No bond is required.

Electricity: 220/50. *Plug types:* Data unavailable.

Currency: Dollar (BR$); Cents.

U.S. embassy in the country: P.O. Box 2991, Bandar Seri Begawan; *tel.* 29670; *telex:* BU 2609 AMEMB.

Embassy in U.S.: 2600 Virginia Avenue NW, Suite 300, Washington, DC 20037; *tel.* 202–342–0159. *Consulates:* New York: 212–838–1600.

Central tourism office in country: Contact the tourist office at Brunei International Airport.

Health suggestions: Bandar Seri Begawan is free of most diseases associated with the Far East, including malaria and cholera. Medical services are heavily subsidized by the government and are generally free.

Cultural mores and taboos: Remove shoes before entering homes. Muslim injunctions against alcohol and pork prevail for Muslims, but the rest of the community has access to and may enjoy them. Do not pass or accept items with the left hand.

Gratuity guidelines: Tips are optional.

BULGARIA
People's Republic of Bulgaria
Narodna Republika Bŭlgariya

Location: In southeastern Europe, bounded on the north by Romania, the east by the Black Sea, the southeast by Turkey, the south by Greece, and the west by Yugoslavia. *Size:* 42,823 square miles, slightly larger than Tennessee.

Major cities: Sofia (lat. +42.42). *Airports:* Sofia International Airport (SOF), 9 miles outside of Sofia.

General transportation: No direct flights from U.S., but connections can be made in many European cities. Good rail service from Europe; air and rail links from Sofia to Black Sea resorts. Sofia has streetcars, trolleys, and buses. Main roads are good. *U.S. license:* Yes, with Bulgarian translation.

IDP: Yes. *Rule of the road:* Right. *Motor clubs:* Union de Automobilistes Bulgares, 3 Place Positano, Sofia; *tel.* 87–88–01; partial AAA reciprocity. *Taxi markings:* All colors, marked TAXI; metered. Taxis are available at stands or by telephone. Private taxis have set prices equivalent to metered.

Population: 9,000,000. *Type of government:* Communist state, closely allied with the Soviet Union, with strict controls but political stability. Has diplomatic relations with the U.S., but cultural and other exchanges have been less frequent than other eastern European nations.

Languages: Bulgarian. Secondary languages closely correspond to ethnic commu-

nities. Russian is widely understood. *Ethnic groups:* 85.3% Bulgarian, 8.5% Turk, 2.6% gypsy, 2.5% Macedonian, 0.3% Armenian, 0.2% Russian. *Religion:* Government promotes atheism; religious background is 85% Bulgarian Orthodox, 13% Muslim, the balance Christian, Jewish, and other. **Time:** EST +7; GMT +2. *Telephone codes:* Country: 359. Kŭrdzhali 361, Pazardzhijk 34, Plovdiv 32, Sofia 2, Varna 52. Adequate local and international service available. *Pay phone system:* Coins.

Holidays: January 1, May 1, 2, 24; September 9, 10; November 7. When holidays fall on weekends, days off are often added to the beginning or end of week. Days preceding official holidays are often half-days. *Date/month system:* D/M.

Business and government hours: 8:30 AM to 4:30 or 5 PM, Monday to Friday. *Business dress code:* Conservative.

Climate and terrain: Mostly mountains with lowlands in the north and south. Climate similar to that of the American midwest: hot, dry summers; cold, damp winters, with considerable snowfall. *Temperature ranges* (Sofia): January: 22° to 34°F; April: 41° to 62°F; July: 57° to 82°F; October: 42° to 63°F.

Visas: *Business visa:* For stays of up to 60 days; supply passport, 1 photo, $15 fee; requires invitation from a Bulgarian organization; allow 7 working days to process. *Tourists:* Tourist visa, for stays of up to 30 days; $15 fee. *Transit visa:* For stays of up to 30 hours; $10 fee, proof of onward ticket, and visa for next destination if appropriate.

Health requirements: No vaccinations required. *Equipment importation:* Carnet, or bring a list; no bond is required.

Electricity: 220/50. *Plug types:* C and F.

Currency: Lev (LEV); Stotinki.

U.S. embassy in the country: 1 A. Stamboliski Boulevard, Sofia; *tel.* 88–48–01/5; *telex:* 22690 BG.

Embassy in U.S.: 1621 Twenty-second Street NW, Washington, DC 20008; *tel.* 202–387–7969.

Tourism office in U.S.: Balkan Holidays (USA) Ltd. represents Balkantourist in the U.S.: 161 East Eighty-sixth Street, New York, NY 10028; *tel.* 212–722–1110.

Central tourism office in country: Balkantourist, #1 Votsha Boulevard, Sofia.

Health suggestions: No special health problems apart from winter smog. Water is potable.

Cultural mores and taboos: Shaking the head means yes; a nod means no. Appointments must be made in advance, and decision making can be slow. Men and women are often addressed with the title Comrade. First names are reserved for close friends.

Photographic restrictions: Be careful around military, security, industrial, strategic, and border areas.

Equipment rental/sales: *Profoto:* AHG Hemus, Sofia; *tel.* 870 365.

Gratuity guidelines: Service charge is often included in the bill, but giving a bit more is customary. If not included in the bill, a tip is not officially expected but is accepted and appreciated.

BURKINA FASO

Location: In western Africa, bounded on the west and north by Mali, the east by Niger, the southeast by Benin, and the south by Togo, Ghana, and Ivory Coast. *Size:* 105,869 square miles, slightly larger than Colorado.

Major cities: *Ouagadougou* (lat. +12.22). *Airports:* Ouagadougou Airport (OUA), 1 mile outside of Ouagadougou.

General transportation: Air links to Paris and other African capitals. Air/Burkina provides domestic and other inter-African flights. Ouagadougou is linked by paved road to Lomé, Togo; Abidjan, Ivory Coast; Niamey, Niger; and Bamako, Mali; and by rail to Abidjan. Road conditions are uncertain elsewhere. *U.S. license:* Yes. *IDP:* Yes. *Rule of the road:* Right. *Taxi mark-*

ings: Yellow, marked TAXI; set price in advance.

Population: 8,500,000. *Type of government:* Military, established by coup on August 4, 1983. (Burkina Faso was known as Upper Volta before 1984.) Political process suspended; no talk of returning to constitutional rule. Enjoys friendly relations with the U.S.

Languages: French (official); tribal languages belonging to the Sudanic family spoken by 90% of the population. *Ethnic groups:* More than 50 tribes, the most important being the Mossi (about 2.5 million). Others include the Gurunsi, Senufo, Lobi, Bobo, Mande, and Fulani. *Religion:* 65% indigenous beliefs, about 25% Muslim, 10% Christian (mostly Roman Catholic).

Time: EST +5; GMT 0. *Telephone codes:* No direct-dial from the U.S.—operator-assisted calls only. All services only fair. Long-distance service available via satellite. *Pay phone system:* None.

Holidays: January 1, 3; Easter Monday; May 1; Ascension Day (40 days after Easter); Whit Monday (varies—early June); August 4, 15; Tebaski (varies); November 1; Birth of Prophet (varies); December 25. *Date/month system:* D/M.

Business hours: 8:30 AM to 12 noon, 3 PM to 6 PM Monday to Friday. *Business dress code:* Same as that of the U.S., but safari suits are also acceptable.

Climate and terrain: Mostly flat, undulating plains. Hills in west and southeast. Subject to drought. Tropical climate, with warm, dry winters and hot, wet summers.

Rainy season extends from June to October. *Temperature ranges* (Ouagadougou): January: 60° to 92°F; April: 79° to 103°F; July: 74° to 91°F; October: 74° to 95°F.

Visas: Contact the Ministry of Works, Social Security and Public Function, P.O. Box 7006, Ouagadougou; *tel.* 332 100, 334 100. Allow 1 to 3 months for a reply. Contacting the embassy or consulate in the U.S. will be slower. *Tourists:* Tourist visa, which requires passport, 2 photos, $20 fee; good for stays of up to 3 months. *Health requirements:* No vaccinations required. *Equipment importation:* Bring equipment list; bond should not be required.

Electricity: 220/50. *Plug types:* C.

Currency: Franc (CFA).

U.S. embassy in the country: B.P. 35, Ouagadougou; *tel.* 30–67–23/5; *telex:* AEMB 5290 BF.

Embassy in U.S.: 2340 Massachusetts Avenue NW, Washington, DC 20008, *tel.* 202–332–5577.

Central tourism office in country: Ouagadougou, *tel.* 33–34–04, 30–63–94.

Health suggestions: Medical services are limited. Take full water and sanitary precautions. Malaria suppressants are needed throughout the country. Typhoid and gamma globulin treatments are recommended for rural travel. Yellow fever vaccination is recommended. Do not swim in freshwater lakes or streams, to avoid bilharzia (schistosomiasis).

Gratuity guidelines: Same as those in the U.S.

BURMA
Socialist Republic of the Union of Burma
Pyidaungsu Socialist Thammada Myanma Naingngandaw

The State Department suggests deferring travel to Burma because of civil disturbances; see notes under Visas as well.

Location: In southeastern Asia, bounded on the north by India and China, the east by China, Laos, and Thailand, the south by Thailand and the Andaman Sea, and the

west by the Bay of Bengal, Bangladesh, and India. *Size:* 261,789 square miles, slightly smaller than Texas.

Major cities: *Rangoon* (lat. +16.47). *Airports:* Mingaladon Airport (RGN), 12 miles outside of Rangoon.

General transportation: All visitors must

enter or exit through Rangoon. Air links to Europe. Burma Airways (UB) flies to other Asian capitals and to domestic cities, where foreigners are allowed to travel freely. Schedules are not always reliable, and flights are often heavily booked. No U.S. carriers service Burma. Travel by car, train, or river steamer is possible but somewhat arduous. Public transport in Rangoon and Mandalay is inadequate, unsafe, and overcrowded. **U.S. license:** No. **IDP:** Yes; present to police in Rangoon for issuance of temporary visitor's license. **Rule of the road:** Right. **Taxi markings:** Private taxis and mini-pickups are used; many are uncomfortable and in poor condition.

Population: 39,600,000. **Type of government:** Republic; Council of State rules through a Council of Ministers; one legal party.

Languages: Burmese and minority ethnic languages. English is spoken among educated and official members of society, but its use has declined. **Ethnic groups:** 68% Burman, 9% Shan, 7% Karen, 4% Raljome, 3% Chinese, 2% Indian, 7% other. **Religion:** 85% Buddhist, 15% other indigenous beliefs, Muslim, Christian, or other.

Time: EST +11.5; GMT +6.5. **Telephone codes:** No direct-dial from the U.S.—operator-assisted calls only. No credit card or collect calls to U.S. Service in Rangoon is adequate, other internal communications are minimal. International service is available, but delays are not uncommon. **Pay phone system:** Coins; few available.

Holidays: January 4; February 12; March 2, 27; April 13–17 (approx.); May 1; July 19; December 3, 25; plus several Buddhist holidays—check with consulate. **Date/month system:** D/M.

Business and government hours: 9:30 AM to 5 PM Monday to Friday. **Business dress code:** Conservative for high-level meetings; otherwise, a bit more informal.

Climate and terrain: Central lowlands ringed by steep, rugged highlands. Tropical monsoon climate: cloudy, rainy, hot, humid summers (monsoons in the southwest from June to September). Less cloudy, with scant rainfall, mild temperatures, lower humidity in winter (monsoons in the northeast from December to April). Subject to destructive earthquakes and cyclones, with flooding and landslides, during the rainy season, June to September. **Temperature ranges** (Moulmein, near Rangoon): January: 65° to 89°F; April: 77° to 95°F; July: 74° to 83°F; October: 75° to 88°F.

Visas: All visits to Burma must be with a group organized by Tourist Burma, a branch of the official hotel and tourist corporation. Tourist travel is normally restricted to major cultural centers, including Rangoon, Mandalay, Pagan, Pegu, and Taunggyi. Travel to border areas is normally prohibited. **Health requirements:** Yellow fever vaccination is required if coming from an infected area. **Equipment Importation:** Data unavailable. **Electricity:** 230/50. **Plug types:** D and G. **Currency:** Kyat (BUR); Pyas.

U.S. embassy in the country: 581 Merchant Street (GPO Box 521), Rangoon; tel. 82055, 82181; telex: 21230 AIDRGN BM. **Embassy in U.S.:** 2300 S Street NW, Washington, DC 20008; tel. 202–332–9044. **Consulates:** New York: 212–535–1311.

Central tourism office in country: Tourist Burma, 77–91 Sule Pagoda Road, Rangoon; tel. 78376.

Health suggestions: Check latest yellow fever and cholera inoculation requirements for Burma and countries following it on your itinerary. Water is not potable; full health precautions are necessary. Tuberculosis, plague, leprosy, and typhoid are endemic. Malaria is a problem in rural areas, but uncommon in Rangoon, although dengue fever is present there. Bacillary and amebic dysenteries are prevalent, along with various other intestinal parasites, but can be avoided with care, at least in major cities.

Cultural mores and taboos: Burmese law and custom has traditionally promoted equality of the sexes.

Gratuity guidelines: Tipping is not widespread; a modest tip is fine if not included in the bill.

BURUNDI
Republic of Burundi
Republika y'Uburundi

Location: In east-central Africa, bounded on the north by Rwanda, the east and south by Tanzania, and the west by Zaire. *Size:* 10,759 square miles, slightly larger than Maryland.
Major cities: *Bujumbura* (lat. −3.22).
Airports: Bujumbura International Airport (BJM), 9 miles outside of Bujumbura.
General transportation: Direct flights from Europe and other African capitals (with connections to U.S.). Bus service within capital city is of minimal utility to tourists; irregular public transport is provided by small, privately owned buses and pickup trucks. The national tourist office rents cars and minibuses. Gasoline can be scarce outside of Bujumbura. Accommodations in the capital can be limited and almost nonexistent in the interior, except from some religious missions. *U.S. license:* Yes. *IDP:* No. *Rule of the road:* Right. *Motor clubs:* Club Automobile Burundi, Boîte Postal 2715, Bujumbura; partial AAA reciprocity. *Taxi markings:* All colors; be sure to negotiate fare in advance. Many can be rented by hour or day.
Population: 5,200,000. *Type of government:* Republic. Constitution suspended. The Tutsi-led Party of Unity and Progress (UPRONA) is the sole political party. Violence between Hutus and Tutsis has plagued country since independence in 1962. The U.S. maintains friendly relations.
Languages: Kirundi and French (official). Swahili is spoken along Lake Tanganyika and in Bujumbura area. *Ethnic groups:* 85% Hutu (Bantu), 14% Tutsi (Hamitic), 1% Twa (pygmy). Other groups include around 70,000 refugees (mostly Rwandans and Zairians), 3,000 Europeans, 2,000 Asians. *Religion:* 62% Roman Catholic, 32% indigenous beliefs, 5% Protestant, 1% Muslim.
Time: EST +7; GMT +2. *Telephone codes:* No direct-dial from the U.S.—operator-assisted calls only. No credit card or collect calls to U.S. Domestic service is sparse. International service via Brussels is generally unsatisfactory due to delays. *Pay phone system:* None.
Holidays: January 1; May 1; Ascension Day (40 days after Easter); July 1; August 15; September 18; November 1; December 25. *Date/month system:* D/M.
Business hours: 8:30 AM to 12:30 PM, 2 PM to 5 PM Monday to Saturday. *Government hours:* 8 AM to 12 noon, 2 PM to 4 PM Monday to Friday. *Business dress code:* Informal except for high-level meetings.
Climate and terrain: High, rolling countryside. A short dry season in January is followed by the major rainy season, from February to May. The major dry season is from May to September. *Temperature ranges* (Bujumbura): 71°–85°F throughout the year.
Visas: *Standard tourist visa:* Passport, 3 photos, 3 applications, proof of return ticket and no criminal record, $15 fee; good for stays of up to 1 month. *Transit visa:* For stays of up to 48 hours, $15. *Health requirements:* Yellow fever vaccination is required if coming from an infected area and is recommended by the CDC for travel outside urban areas. *Equipment importation:* Bring equipment list.
Electricity: 220/50. *Plug types:* C, E, and F.
Currency: Franc (FRB); Centimes.
U.S. embassy in the country: B.P. 1720, Avenue du Zaire, Bujumbura; *tel.* 234–54/6.
Embassy in U.S.: 2233 Wisconsin Avenue NW, Washington, DC 20007, *tel.* 202–342-2574. *Consulates:* Illinois: 312–271-2530; New York: 212–687-1180.
Central tourism office in country: National Tourist Office; *tel.* 22023.
Health suggestions: Medical care is limited. Malaria suppressants are necessary throughout the country. Water is not potable; take full sanitary precautions. Cholera infection is present.

CAMEROON
United Republic of Cameroon

Location: In western Africa, bounded on the north and northeast by Chad, the east by the Central African Republic, the south by Congo, Gabon, and Equatorial Guinea, the southwest by the Bight of Biafra, and the west and northwest by Nigeria. *Size:* 183,591 square miles, slightly larger than California.

Major cities: Douala (lat. +3.53); Yaoundé (lat. +3.53). *Airports:* Douala Airport (DLA), 3 miles outside of Douala; Yaoundé Airport (YAO), 2 miles outside of Yaoundé.

General transportation: Air links to other African cities and Europe through Douala. Good domestic system of trains, buses, and planes via Cameroon Airlines (UY), but roads are substandard. *U.S. license:* Yes. *IDP:* Yes. *Rule of the road:* Right. *Motor clubs:* Yaoundé Automobile Club, B.P. 1032, Yaoundé; *tel.* 22–39–55; partial AAA reciprocity. *Taxi markings:* Yellow cars, TAXI written on door; set price in advance. **Population:** 10,500,000. *Type of government:* Republic with one-party presidential regime. Nonaligned foreign policy. Enjoys excellent relations with the U.S.

Languages: English and French (official). Over 80 indigenous languages. About 80% of the population lives in the eastern French-speaking portion of the country. *Ethnic groups:* Over 200 widely differing tribes. *Religion:* 51% indigenous beliefs, 33% Christian, 16% Muslim (both greatly influenced by the indigenous religions).

Time: EST +6; GMT +1. *Telephone codes:* Country: 237. No city codes. Domestic and international service are good. *Pay phone system:* Coins; in post office only.

Holidays: January 1; February 11; Good Friday; May 1, 20; Ascension Day (40 days after Easter); End of Ramadan; August 15; November 1; December 25. *Date/month system:* D/M.

Business and government hours: 8 AM to 12 noon, 2:30 PM to 5:30 PM Monday to Friday; 8 AM to 12 noon Saturday. *Business*

dress code: More formal than much of Africa.

Climate and terrain: Diverse terrain: coastal plain with equatorial rain forests in southwest; dissected plateau in center; mountains in west (highest peak, 13,500 feet); plains in north. Climate varies from tropical along the coast to semiarid and hot in the north. Rainy season is from April to September, with August the wettest month. *Temperature ranges* (Yaoundé): January: 67° to 85°F; April: 66° to 85°F; July: 66° to 80°F; October: 65° to 81°F.

Visas: *Standard tourist visa:* Passport, 2 photos, 2 applications, bank statement, certificate of accommodation from contacts in Cameroon with signature from local authorities; good for stays of up to 20 days, 1 entry, may be extended 10 days. However, commercial photographers or those taking "advertising photographs or photographs capable of commercial exploitation" need authorization from the Ministry of Information and Culture in Yaoundé to carry out their work: P.O. Box 2085, Douala; *tel.* 42–61–60 or 46–66–69. Some fees may be involved. See also **Photographic restrictions,** below. *Health requirements:* Yellow fever vaccination. Health requirements change—be sure to check with embassy or consulate. *Equipment importation:* There appear to be no restrictions on temporary importation of photographic equipment; bring equipment list.

Electricity: 127/50 and 220/50. *Plug types:* C and E.

Currency: Franc (CFA).

U.S. embassy in the country: Rue Nachtigal, B.P. 817, Yaoundé; *tel.* 234014; *telex:* 8223KN.

Embassy in U.S.: 2349 Massachusetts Avenue NW, Washington, DC 20008; *tel.* 202–265–8790/4.

Central tourism office in country: Ministry of Tourism, Yaoundé; *tel.* (237) 22–21–37, 22–44–41.

Health suggestions: Water is not potable. Sanitary precautions are necessary. Malaria

suppressants are recommended throughout the country. Tetanus, typhoid, paratyphoid, polio, and hepatitis treatments are recommended. Cholera infection is present. Recent volcanic activity released deadly poisonous gases.

Photographic restrictions: The government has ruled that the following categories require prior authorization: commercial photography as specified under **Visas,** above; aerial photography; official ceremonies and celebrations; sensitive strategic areas such as airports, military, telecommunications installations, presidential palaces, and ports. Assuming the photos are not indecent, general photographs *do not* require any special permission. Many local officials and police may not be aware of these rulings. It is strongly recommended that you contact the U.S. embassy upon arrival, which will gladly and quickly furnish you with an English and French letter outlining the rules to carry with you.

Gratuity guidelines: Service charges are often included in the bill; otherwise, give 10%. Taxi drivers appreciate but do not demand tips.

CANADA

Location: In northern North America, bounded on the north by the Arctic Ocean, the east by the Atlantic Ocean, the south by the U.S., and the west by the U.S. and the Pacific Ocean. *Size:* 3,851,809 square miles, slightly larger than the U.S.

Major cities: Montreal (lat. +45.30), Toronto (lat. +43.40), Vancouver (lat. +49), *Ottawa* (lat. +45.19). *Airports:* Dorval International Airport (YUL), domestic and U.S. service, 13 miles outside of Montreal; Mirabel International Airport (YMX), international service, 34 miles outside of Montreal; Lester B. Pearson International Airport (YYZ), 17 miles outside of Toronto; Vancouver International Airport (YVR), 9 miles outside of Vancouver; Ottawa International Airport (YOW), 11 miles outside of Ottawa.

General transportation: Excellent in general. Toronto and Montreal have subways. **U.S. license:** Yes. **IDP:** Yes. *Rule of the road:* Right. *Motor clubs:* Contact the Canadian Automobile Association (CAA) in each province. *Taxi markings:* Taxis in all cities can be hailed on the street but are frequently telephone dispatched.

Population: 26,100,000. *Type of government:* Constitutional monarchy with a bilingual federal system (10 provinces), a parliamentary form of government, and strong democratic traditions. Recognizes Elizabeth II of Britain as head of state.

Languages: English and French (both official). *Ethnic groups:* 40% British origin, 27% French origin, 20% other European, 1.5% indigenous Indian and Eskimo. *Religion:* 46% Roman Catholic, 16% United Church, 10% Anglican, 28% other.

Time: Same zones as the U.S.; GMT −3.5 to −9. *Telephone codes:* Dial Canadian cities with area codes as you would in the U.S. Area codes are: Alberta 403; British Columbia 604; Manitoba 204; New Brunswick 506; Newfoundland 709; Nova Scotia and Prince Edward Island 902; Ontario 416 (Toronto area), 519 (Windsor area), 613 (Ottawa area), 705 (Sault Ste. Marie and much of the province), 807 (Thunder Bay and much of the province); Quebec 418 (Quebec area), 514 (Montreal area), 819 (Trois-Rivières); Saskatchewan 306. Domestic and international service are excellent. *Pay phone system:* Coins.

Holidays: Official holidays falling on a weekend are observed on the following Monday. January 1; Good Friday; Easter Monday; Monday before May 24; July 1; first Monday in September; second Monday in October; November 11; December 25; Boxing Day (day after official Christmas holiday); plus provincial holidays. *Date/month system:* D/M.

Business hours: Same as those in the U.S. *Business dress code:* Same as that for the U.S.

Climate and terrain: Greatly varied terrain and climate, which ranges from mild to arctic, but is best generally described as having moderate summers and long, cold winters. About 80% of the population lives within approximately 100 miles of the U.S. border. *Temperature ranges* (Montreal): January: 6° to 21°F; April: 33° to 50°F; July: 61° to 78°F; October: 40° to 54°F; (Toronto): January: 16° to 30°F; April: 34° to 50°F; July: 59° to 79°F; October: 40° to 56°F.

Visas: *Work visa:* Contact consulate with client letter or photographer letter explaining nature of visit, passport (or other proof of U.S. citizenship), $40 fee; visa will be issued the same day. *Tourists:* Proof of U.S. citizenship and ID for stays of up to 90 days (no passport needed). Note: As the Free Trade Agreement is implemented, many regulations will change; contact Canadian Consulate for latest information. *Health requirements:* No vaccinations required. *Equipment importation:* Carnet.
Electricity: 120/60. *Plug types:* A and B.
Currency: Dollar (C$); Cents.
U.S. embassy in the country: 100 Wellington Street, Ottawa, Ontario K1P 5T1; P.O. Box 5000, Ogdensburg, NY 13669; *tel.* 613–238–5335; *telex:* 1533582. *Consulates:* Calgary: 403–266–8962; Halifax: 902–429–2480/1; Montreal: 514–281–1886; Quebec: 418–692–2095; Toronto: 416–595–1700; Vancouver: 604–685–4311.
Embassy in U.S.: 1746 Massachusetts Avenue NW, Washington, DC 20036; *tel.* 202–785–1400. *Consulates:* California: 213–687–7432, 415–981–2670; Georgia: 404–577–6810; Illinois: 312–427–1031; Massachusetts: 617–262–3760; Michigan: 313–567–2340; Minnesota: 612–336–4641; New York: 212–586–2400; Ohio: 216–861–1660; Texas: 214–922–9806; Washington: 206–447–3800.

Tourism office in U.S.: Canadian Consulate General, Tourist Division, 1251 Avenue of the Americas, New York, NY 10020; *tel.* 212–586–2400.
Central tourism office in country: Each province has an independent organization. Check with tourism office at home before your visit.
Health suggestions: Excellent standards; no precautions are necessary.
Cultural mores and taboos: Business customs are the same as those in the U.S. Avoid discussions of disharmony between English- and French-speaking Canada.
Color labs and equipment rental/sales: Consult *Professional Photo Source* (212–219–0993; available at bookstores and photo dealers). *Film commissions:* Quebec's Department of External Trade, 770 West Sherbrooke #1400, Montreal, Quebec H3A 1G1; *tel.* 514–873–5027. Montreal Film Commission, 425 Place Jacques Cartier, Montreal, Quebec H2Y 3B1; *tel.* 514–872–2883. Victoria Film Commission, 525 Fort Street, Victoria, British Columbia V8W IE8; *tel.* 604–386–3976. Calgary Economic Development Authority, 401 237 Eighth Avenue, Calgary, Alberta T2P 2M5; *tel.* 403–268–2771. British Columbia Film Commission, 750 Pacific Boulevard, Vancouver, British Columbia V6B 5E7; *tel.* 604–660–2732. Department of Economic Development, 111 Sussex Drive-301, Ottawa, Ontario K1N 5A1; *tel.* 613–564–4147. Toronto Film Liaison, New City Hall, 18th Floor, E Tower, Toronto, Ontario M5H 2N2; *tel.* 416–392–7570. Alberta Economic Development and Trade, 9940 106 St Sterling Place, Edmonton, Alberta T5K 2PG; *tel.* 403–427–2005.
Gratuity guidelines: Same as those for the U.S.

CAPE VERDE
Republic of Cape Verde
República de Cabo Verde

Location: In the Atlantic Ocean, west of Mauritania and Senegal. *Size:* 1,557 square miles, slightly larger than Rhode Island.

Major cities: *Praia* (lat. +14.54). *Airports:* Francisco Mendez (RAI), within city limits.

General transportation: International air link to Dakar, Senegal. Domestic air service links the islands, as do small, unscheduled vessels. *U.S. license:* No. *IDP:* Yes. *Rule of the road:* Right. *Taxi markings:* Black and green, marked TAXI; set price by zone. **Population:** 350,000. *Type of government:* Republic. Constitution promulgated in 1981 calls for National Assembly as supreme organ of state. Only political party permitted is the PAICV. Nonaligned foreign policy. Cordial relations with U.S.

Languages: Portuguese (official) and Crioulo (national language spoken by most), a blend of Portuguese and West African words. *Ethnic groups:* 71% Creole (mulatto), 28% African, 1% European. *Religion:* Roman Catholicism fused with indigenous beliefs.

Time: EST +4; GMT −1. *Telephone codes:* No direct-dial from U.S.—operator-assisted calls only. No credit card or collect calls to U.S. Domestic service is adequate; international service via satellite. *Pay phone system:* Coins.

Holidays: January 1, 20; March 8; Good Friday; May 1; June 1; September 12; December 24, 25. *Date/month system:* D/M.

Business hours: 8 AM to 12 PM, 2:30 PM to 6 PM Monday to Friday, 8 AM to 11:30 AM Saturday. *Business dress code:* Informal, safari suit.

Climate and terrain: Archipelago of 10 islands, 5 islets, divided into windward and leeward groups. All but 1 of the 10 islands are inhabited. Most are steep, rugged, rocky

volcanic terrain. Rainfall is very irregular (usually falling from July to October when it does come), causing periodic droughts and famines. Dry, temperate climate. Sandstorms from the Sahara sometimes form a "mist" that obscures the sun, but sunny days are frequent. *Temperature ranges* (Praia): January: 68° to 77°F; April: 69° to 79°F; July: 75° to 83°F; October: 76° to 85°F.

Visas: *Business visa:* One photo, passport valid for next 6 months, $13.50 fee. *Tourists:* Tourist visa. *Health requirements:* Yellow fever vaccination is required if coming from an infected area. *Equipment importation:* Data unavailable.

Electricity: 220/50. *Plug types:* C and F.

Currency: Escudo (CVE); Centavos.

U.S. embassy in the country: Rua Hojl Ya Yenna 81, C.P. 201, Praia; *tel.* (61)4 363, (61)4 253; *telex:* 6068 AMEMB CV.

Embassy in U.S.: 3415 Massachusetts Avenue NW, Washington, DC 20007; *tel.* 202–965–6820. *Consulates:* Massachusetts: 617–353–0014.

Central tourism office in country: Department of Tourism, Praia; *tel.* (61) 1342.

Health suggestions: Sanitation is only fair. Medical care is inadequate, and water is not potable. Typhoid, tetanus, and gamma globulin treatments are recommended. Malaria suppressants are not needed unless traveling to mainland Africa.

Gratuity guidelines: Tips are appreciated but not required; not generally included in the bill.

CENTRAL AFRICAN REPUBLIC
République Centrafricaine

Location: In central Africa, bounded on the north by Chad, the east by Sudan, the south by Zaire and Congo, and the west by Cameroon. *Size:* 240,376 square miles, slightly smaller than Texas.

Major cities: *Bangui* (lat. +4.22). *Airports:* Bangui M'Poko International Airport (BGF), 3 miles outside of Bangui.

General transportation: Air links to Paris and several African capitals. Nearest railroad

is in Cameroon. Buses are available but not generally used by tourists. 810 miles of the Trans-African Highway are in the country, 113 miles of which are paved, the rest laterite (a residual soil). Roads often flood during rainy seasons. No commercial transportation in the game areas. *U.S. license:* No. *IDP:* Yes. *Rule of the road:* Right. *Taxi markings:* Yellow; marked TAXI; some for hire, some with fixed routes; set price in advance.

Population: 2,700,000. *Type of government:* Republic. One-party presidential regime since 1986. One of world's least developed countries. Close ties to France. Excellent relations with U.S.

Languages: French (official but spoken by few), Sangho (lingua franca and national language); Arabic, Hunsa, Swahili. *Ethnic groups:* About 80 groups with different languages and ethnic characteristics (34% Baya, 27% Banda, 21% Mandjia); 6,500 Europeans (3,600 French). *Religion:* 25% Roman Catholic, 25% Protestant (both influenced by local animistic beliefs), 24% indigenous beliefs, 15% Muslim, 11% other.

Time: EST +6; GMT +1. *Telephone codes:* No direct-dial from U.S.—operator-assisted calls only. No credit card or collect calls to U.S. Facilities meager; international service is available. *Pay phone system:* Coins, where available.

Holidays: January 1; March 29; Easter Monday; Ascension Day (40 days after Easter); Whit Monday, May 1, 29; August 13, 15; September 1; November 1; December 25. Holidays falling on Sunday are celebrated on Monday. *Date/month system:* D/M.

Business hours: 7:30 AM to 6:30 PM Monday to Saturday. *Government hours:* 7:30 AM to 4 PM Monday to Friday.

Climate and terrain: Mainly vast, monotonous plateau, drained by two major river systems, mostly unnavigable with spectacular waterfalls. Vegetation varies from tropical rain forest in the extreme southwest to semidesert in the northeast tip. Wildlife abounds in nearly uninhabited northeast and eastern sections but is being rapidly depleted by poachers. Ample rainfall without the oppressive tropical climate of the coastal areas.

Most rain falls from June to November, but heavy rains occur intermittently throughout the year. Sunny and warm from December to April. *Temperature ranges* (Bangui): January: 68° to 90°F; April: 71° to 91°F; July: 69° to 85°F; October: 69° to 87°F.

Visas: Passport, 2 photos, $20 fee, proof of return ticket, client letter. *Tourists:* Tourist visa. *Health requirements:* Yellow fever vaccination. *Equipment importation:* Bring equipment list to the embassy, which will telex the Central African Republic to make arrangements. No bond is necessary.

Electricity: 220/50. *Plug types:* C.

Currency: Franc (CFA).

U.S. embassy in the country: Avenue President Dacko, B.P. 924, Bangui; *tel.* 61–02–00, 61–25–78, 61–43–33; *telex:* 5287 RC.

Embassy in U.S.: 1618 Twenty-second Street NW, Washington, DC 20008; *tel.* 202–483–7800/1.

Central tourism office in country: Ministry of Tourism, BP850, Bangui; *tel.* 61–02–16, 61–24–31.

Health suggestions: Malaria suppressants are recommended throughout the country. Typhoid, polio, and hepatitis treatments are suggested for remote areas. Water is not potable. Medical facilities are available for routine problems.

Photographic restrictions: Do not display or use photographic equipment without special permission from the Ministry of Communications, BP940, Bangui; *tel.* 61–43–95. Residents may be resistant to photos; always ask first. A small tip will be appreciated.

Gratuity guidelines: Tips are not expected but are appreciated; taxi drivers are rarely tipped.

CHAD
Republic of Chad
République du Tchad

The State Department urges caution when traveling to Chad because of armed conflict with Libya.

Location: In north-central Africa, bounded on the north by Libya, the east by Sudan, the south by the Central African Republic, the southwest by Cameroon, and the west by Niger and Nigeria. *Size:* 495,752

square miles, slightly more than 3 times the size of California.

Major cities: N'Djamena (lat. +12.07).
Airports: N'Djamena Airport (NDJ), 2.5 miles outside of N'Djamena.
General transportation: Air links to Paris, Saudi Arabia, and several African capitals. Air Tchad runs scheduled but irregular domestic flights to Moundou, Sarh, Bol, Mao, and Abéché, with service to Bangui, Central African Republic. Road travel is possible by sturdy vehicle through most of the country in the dry season. Rental cars are available. **U.S. license:** No. **IDP:** Yes. **Rule of the road:** Right. **Taxi markings:** Yellow, marked TAXI; set meter, often shared.

Population: 4,800,000. **Type of government:** Republic. Constitution is currently suspended. A return to stable government continues to be hampered by tribal and regional antagonism although the situation has improved compared to recent years of civil war and Libyan intervention. Libya still occupies the northern strip of the country. Extremely cordial relations with the U.S.

Languages: French and Arabic; Sara and Sango in the south; more than 100 different languages and dialects are spoken in Chad. **Ethnic groups:** Some 200 distinct ethnic groups, mostly Muslim in the north and non-Muslim blacks in the south; 150,000 nonindigenous including 1,000 French. **Religion:** 44% Muslim, 33% Christian, 23% indigenous beliefs.

Time: EST +6; GMT +1. **Telephone codes:** No direct-dial from U.S.—operator-assisted calls only. No credit card or collect calls to U.S. Fair domestic service; international service to Europe and the U.S. (with direct-dial to France and neighboring African countries). **Pay phone system:** None.

Holidays: January 1; Easter Monday; May 1, 25; June 7; August 11; November 1, 28; December 25; plus several Muslim holidays—check with consulate. **Date/month system:** D/M.

Business and government hours: 8 AM to 5 PM Monday to Friday; lunch hour varies.

Business dress code: Same as that of the U.S.

Climate and terrain: Broad, arid plains in the center, Sahara Desert in the north, mountains in the northwest, lowlands in the south. Tropical climate in the south; desert climate in the north with rain very rare. Rainy season in the south extends from May to early October, in the center, from June to late September. **Temperature ranges** (N'Djamena): January: 57° to 93°F; April: 74° to 107°F; July: 72° to 92°F; October: 70° to 97°F.

Visas: *Standard tourist visa:* Passport, 3 applications, 3 photos, photographer or client letter, proof of return ticket; processed in 1 day. *Transit visa:* For stays of up to 1 week, $12.25 fee, proof of return/in-transit ticket. **Health requirements:** Yellow fever and cholera vaccinations. **Equipment importation:** Contact the Ministry of Information, N'Djamena, Chad, *tel.* 51–56–56, in advance to certify the entry of your equipment.

Electricity: 220/50. **Plug types:** D, E, and F.

Currency: Franc (CFA).

U.S. embassy in the country: Avenue Felix Eboue, B.P. 413, N'Djamena; *tel.* 51–32–69, 51–35–13, 51–28–62, 51–23–29, 51–32–29, 51–30–94, 51–28–47; *telex:* 5203 KD.

Embassy in U.S.: 2002 R Street NW, Washington, DC 20009; *tel.* 202–462–4009.

Central tourism office in country: Ministry of Tourism and Environment, P.O. Box 447, N'Djamena; *tel.* 51–56–56, 51–45–26.

Health suggestions: Medical facilities are extremely limited. Limited and expensive French medicines. Sanitation is poor. Insects, rats, and rabies are problems. Water is not potable. Malaria suppressants are necessary throughout the country. Typhoid and gamma globulin treatments are recommended. Check the latest inoculation requirements.

Gratuity guidelines: Service is included in the bill; giving a bit more is customary.

CHILE
Republic of Chile
República de Chile

Location: In southwestern South America, bounded on the north by Peru and Bolivia, the east by Argentina, the south by Drake Passage, and the west by the Pacific Ocean. *Size:* 292,257 square miles, slightly less than twice the size of California. **Major cities:** *Santiago* (lat. −33.27). *Airports:* Arturo Merino Benitez Airport (SCL), 13 miles outside of Santiago.

General transportation: Many international links, including direct flights from the U.S. Domestic flights to most major cities. Roads are good and overland travel is possible, but snows may block main pass from Argentina for weeks. Public transport is very good. Santiago has a subway. *U.S. license:* No. *IDP:* Yes. *Rule of the road:* Right. *Motor clubs:* Automóvil Club de Chile (ACC), Avenida Pedro e Valdivia 195, Santiago; *tel.* 225–7253; full AAA reciprocity. *Taxi markings:* Black with yellow stripe; metered, expect off-hour surcharges.

Population: 12,600,000. *Type of government:* Republic, with military government giving way to return to civilian democracy. Relations with U.S. are improving after strains of the past 20 years.

Languages: Spanish; many Chilean businesspeople speak English. *Ethnic groups:* 95% European and European-Indian, 3% Indian, 2% other. *Religion:* 89% Roman Catholic, 11% Protestant, small Jewish minority.

Time: EST +1; GMT −4. *Telephone codes:* Country: 56. Chiquayante 41, Concepción 41, Penco 41, Recreo 31, San Bernardo 2, Santiago 2, Talcahuano 41, Valparaíso 32, Viña del Mar 32. Good domestic service in most of the country, good international service. *Pay phone system:* Coins.

Holidays: January 1; Good Friday; Easter Saturday; May 1, 21; August 15; September 11, 18, 19; October 12; November 1; December 8, 25. January and February are popular vacation months. *Date/month system:* D/M.

Business hours: 9 AM to 5 PM Monday to Friday; some businesses are open Saturday morning. *Government hours:* 8:30 or 9 AM to 1 PM. *Business dress code:* Conservative.

Climate and terrain: Chile is 2,650 miles long, averaging only 100 miles wide. Dramatic variety of terrain: low coastal mountains; fertile central valley; rugged Andes in the east; northern desert (Atacama). Lake region 500 miles south of Santiago is called the "Switzerland of South America." About 82% of population lives in urban centers, 36% in Santiago. Summers (December to March) are dry with warm days and cool nights. Winter (June to September) is cold and rainy with snow at higher altitudes. *Temperature ranges* (Santiago): January: 53° to 85°F; April: 45° to 74°F; July: 37° to 59°F; October: 45° to 72°F.

Visas: No visa is required, but contact DINACOS (the Communications Ministry), Edificio Diego Portales, Santiago, *tel.* 222–1202, for a work authorization. *Health requirements:* No vaccinations required. *Equipment importation:* Bring equipment list; no bond is required.

Electricity: 220/50. *Plug types:* C.

Currency: Peso (CHP); Centisimos.

U.S. embassy in the country: Codina Building, 1343 Agustina, Santiago; *tel.* 710–133/90, 710–326/75; *telex:* 240062-USIS-CL.

Embassy in U.S.: 1732 Massachusetts Avenue NW, Washington, DC 20036; *tel.* 202–785–3159. *Consulates:* California: 415–982–7662; Florida: 305–373–8623; Illinois 312–726–7097; New York: 212–370–1455.

Tourism office in U.S.: Chile National Tourism Board, 630 Fifth Avenue, Suite 809, New York, NY 10111; *tel.* 212–582–3250.

Central tourism office in country: Servicio Nacional de Turismo (SERNATUR), Catedral 1159–1165, Santiago; *tel.* 696–

0474, 698–2151; *telex:* SERNACL 24 0137.
Health suggestions: Health standards are generally good, especially in big cities. Water is potable in major cities. Santiago has a smog problem as a result of dependency on diesel motors during the oil shortages of the last decade. Swimming can be treacherous because of the undertow at some of Chile's beautiful beaches. Chile's mountains are subject to earthquakes.

Cultural mores and taboos: Chileans are extremely cosmopolitan and proud of their beautiful country. Avoid discussions of border disputes with Bolivia and Argentina.

Photographic restrictions: Contact DINACOS (see **Visas,** above).

Color labs: Kodak Chilena S.A.F., Casilla 2797, Santiago.

Equipment rental/sales: *Balcar:* Edit Lord Cochrane S.A., Santiago; *tel.* 58 888. *Film commissions:* Chile Films S.A., La Capitania 1–200, Santiago; *tel.* 222–9721.

Gratuity guidelines: Service is usually included in the bill; giving a bit more is customary. Taxi drivers do not expect tips.

CHINA
People's Republic of China
Zhonghua Renmin Gonghe Guo

Travel to some areas in China is still forbidden—be sure to check with the U.S. embassy.

Location: In eastern Asia, bounded on the north by the USSR and Mongolia, the northeast by North Korea, the east by the Yellow, East China, and South China seas, the south by Vietnam, Laos, Burma, Bhutan, Nepal, and India, and on the west by India, Afghanistan, and the USSR. *Size:* 3,691,502 square miles, slightly larger than the U.S.

Major cities: *Beijing* (lat. 39.44); Shanghai (lat. +31.12); Guangzhou (lat. +23.10). *Airports:* Capital International Airport (PEK), 18 miles outside of Beijing; Hongqiao International Airport (SHA), 9 miles outside of Shanghai; Baiyun Airport (CAN), 8 miles outside of Guangzhou.

General transportation: Direct flights to the U.S. Domestic air network; railway with some deluxe service, but older equipment and long distances make it less than ideal. Roads are often poor. Accommodations are still limited but expanding rapidly. *U.S. license:* N/A. *IDP:* N/A. *Rule of the road:* N/A. *Taxi markings:* Marked TAXI; some cities metered (Guangzhou), most set (Beijing, Shanghai).

Population: 1.1 billion. *Type of government:* Communist state. Relations with the U.S. were normalized in 1979.

Languages: Standard Chinese (Putonghua) or Mandarin (based on Beijing dialect), with regional dialects. Limited English understood in major cities. *Ethnic groups:* 93.3% Han Chinese, 6.7% other nationalities. *Religion:* Officially atheist. Traditional religions were Confucianism, Taoism, and Buddhism.

Time: EST +13; GMT +8. *Telephone codes:* Country: 86. Beijing 1, Fuzhou 591, Guangzhou 20, Shanghai 21. Domestic and international service exists primarily for official purposes; unevenly distributed and overburdened internal system serves principal cities, industrial centers, and most townships. International calls through an English-speaking operator are available but quite expensive—call collect or use a telephone credit card, which is accepted. *Pay phone system:* Coins; there are pay phones in major cities but fewer than in U.S.

Holidays: January 1; Spring Festival (3 days in January or February); May 1; October 1, 2. *Date/month system:* M/D.

Business and government hours: 8 AM to 12 noon, 2 PM to 6 PM Monday to Saturday.

Business dress code: Dress is generally informal, but conservative dress is recommended for meetings with officials.

Climate and terrain: Two-thirds mountainous or semidesert; only one-tenth cultivated. Climate is mostly temperate, with southern areas tropical. Climate is heavily affected by the regional monsoon. Summers are hot and humid; winters, dry and unusually cold for the latitude. Heavy rains in summer cause frequent floods. *Temperature ranges* (Beijing): January: 16° to 33°F; April: 45° to 68°F; July: 73° to 90°F; October: 48° to 68°F; (Guangzhou): January: 49° to 65°F; April: 65° to 77°F; July: 77° to 91°F; October: 67° to 85°F; (Shanghai): January: 32° to 47°F; April: 49° to 67°F; July: 75° to 91°F; October: 56° to 75°F.

Visas: Photojournalists should contact the First Secretary of the Press Office at the Chinese embassy to request an invitation from the All China Journalists Association in China. Write indicating the dates of your visit and subjects. If approved, they will also arrange for the temporary importation of your equipment. Commercial photographers should have their clients make arrangements on their behalf. *Health requirements:* Yellow fever vaccination is required if coming from an infected area. *Equipment importation:* See **Visas,** above.

Electricity: 220/50. *Plug types:* C and J.

Currency: Yuan; which equals 10 Jiao and 100 Fen. Use only the local currency.

U.S. embassy in the country: Xiu Shui Bei Jie 3, Beijing; *tel.* [86](1) 523–831; *telex:* AMEMB CN 22701. *Consulates:* Guangzhou: 669–900; Shanghai: 379–880; Shenyang: (24) 290–000; Chengdu: (1) 24481.

Embassy in U.S.: 2300 Connecticut Avenue NW, Washington, DC 20008; *tel.* 202–328–2500. *Consulates:* California: 415–563–4885; Illinois: 312–346–2087; New York: 212–868–7752; Texas: 713–524–0780.

Tourism Office in U.S.: China National Tourist Office, 60 E. 42 St., New York, NY 10017: 212–867–0271.

Central tourism office in country: CITS (China International Travel Service) in every city.

Health suggestions: Excellent medical care is often available in big cities, but practices differ from those of Western medicine. Water is often not potable. Malaria suppressants are recommended in some areas. Cholera infection is present.

Cultural mores and taboos: Refer to the "People's Republic (PRC)" or just "China," but not "Red China" or "Communist China." Surnames come before given names. Punctuality is important. A slight bow of the head is customary in greetings. Business cards with English on one side and Chinese on the other are essential. Courtesy and respect for "face" are paramount. Patience is necessary—decisions take time. Entertaining is often done in restaurants; expect much toasting and be the first to leave after dinner. Religious preaching or pamphlets are severely restricted. Never press for a reply from an individual who seems reticent. Never refer to Taiwan as a country, only as a province of China.

Photographic restrictions: Be cautious around military, security, strategic, industrial, and border areas, but generally the policy is more liberal than that of other Communist countries.

Equipment rental/sales: *Comet:* Guandong Photo Business, Guangzhou; *tel.* 335–758.

Gratuity guidelines: Tips are officially forbidden and in many cases are considered insulting. Give a small gift discreetly if you want to show appreciation. Service charges are sometimes included on bills at international hotels.

COLOMBIA
Republic of Colombia
República de Colombia

Travel in some localities can be hazardous because of guerilla activity—check with the State Department before visit.

Location: In northwestern South America, bounded on the north by the Caribbean Sea, the east by Venezuela and Brazil, the south by Peru and Ecuador, and the west by the Pacific Ocean and Panama. **Size:** 439,735 square miles, about the size of Texas, Arkansas, and New Mexico combined.

Major cities: Bogotá (lat. +4.42). **Airports:** El Dorado Airport (BOG), 10 miles outside of Bogotá.

General transportation: Many international flights, including direct links to the U.S. Domestic air links, trains in populated areas (although the service has deteriorated), intercity buses. **U.S. license:** Yes, but with formalities on arrival. **IDP:** Yes. **Rule of the road:** Right. **Motor clubs:** Touring y Automóvil Club de Colombia, Avenida Caracas no. 46–72, Bogotá; tel. 232–7580; partial AAA reciprocity. **Taxi markings:** Yellow and black, marked TAXI; metered, often shared.

Population: 31,300,000. **Type of government:** Republic, in which executive branch dominates. Has constitution that guarantees basic freedoms. Enjoys traditionally close relationship with the U.S., despite some strains in recent years.

Languages: Spanish; many businesspeople understand English. **Ethnic groups:** 58% mestizo, 20% white, 14% mulatto, 4% black, 3% black-Indian, 1% Indian. **Religion:** 95% Roman Catholic.

Time: EST; GMT −5. **Telephone codes:** Country: 57. Armenia 60, Barranquilla 5, Bogotá 1, Bucaramanga 73, Cali 23, Cartegena 59, Cartago 66, Cúcuta 70, Girardot 832, Ibagué 82, Manizales 69, Medellín 4, Neiva 80, Palmira 31, Pereira 61, Santa Marta 56. Adequate to good domestic and international service. **Pay phone system:** Coins; available in major cities.

Holidays: January 1, 6; St. Joseph's Day (late March); Holy Thursday; Good Friday; May 1; Ascension Day (40 days after Easter); Corpus Christi (varies—June); Sacred Heart (varies—June or July); July 20; August 7, 15; October 12; All Saints Day (November 1); Independence of Cartagena (November); December 25; plus regional holidays. Banks are closed on December 30, 31. Popular vacation months are December and January. **Date/month system:** D/M.

Business hours: 7 AM to 12 noon, 3 PM to 5:30 PM Monday to Friday. **Government hours:** 8 AM to 3 PM Monday to Friday. **Business dress code:** Conservative in Bogotá, more informal elsewhere.

Climate and terrain: Consists of 3 topological regions: flat coastal areas broken by the high Sierra Nevada de Santa Marta; central highlands; sparsely settled eastern plains (llanos) drained by tributaries of the Orinoco and Amazon rivers. In November 1985, Volcano Nevado del Ruiz, 50 miles west of Bogotá, erupted, causing severe mudslides as the glacier atop melted, killing 20,000 people. Climate varies with altitude, from tropical heat on the coast to cooler, frequently rainy weather in the highlands. The highlands experience two dry seasons, from December to February and June to August. **Temperature ranges** (Bogotá): January: 48° to 67°F; April: 61° to 67°F; July: 50° to 64°F; October: 50° to 66°F.

Visas and equipment importation: Contact the press attaché at the embassy, who will assist with documents and equipment. It may not be necessary to post a bond. **Health requirements:** No vaccinations required. **Electricity:** Mostly 110/60, but can be 150/60 in Bogotá. **Plug types:** A and C. **Currency:** Peso (COP); Centavos.

U.S. embassy in the country: Calle 38,

no. 8–61, Bogotá; *tel.* 285–1300/1688; *telex:* 44843. *Consulates:* Barranquilla: 45–7088/ 7560.

Embassy in U.S.: 2118 Leroy Place NW, Washington, DC 20008; *tel.* 202–332–7573. *Consulates:* California: 415–362–0080; Florida: 305–448–5558; Illinois: 312–341– 0658; Louisiana: 504–525–5580; New York: 212–949–9898; Texas: 713–527–8919.

Tourism office in U.S.: Colombian National Tourist Office, 140 East Fifty-seventh Street, New York, NY 10022; *tel.* 212–688– 0151.

Central tourism office in country: Corporación Nacional del Turismo, Calle 28, no. 13A–15, 16th, 17th, 18th Floors, Bogotá; *tel.* 283–9466, 283–8945.

Health suggestions: Medical facilities are satisfactory, with many U.S.-trained doctors. Tap water is usually not potable; use precautions. Bogotá is 8,650 feet above sea level; its altitude may require some adjustment. Yellow fever vaccination is recommended for some areas. Malaria suppressants are recommended for some rural areas (but not Bogotá and vicinity).

Cultural mores and taboos: Much business will be done over cups of Colombian coffee *(tintos)*. Avoid political discussions.

Photographic restrictions: Military, police, and other security-related installations.

Color labs: Foto Interamericana de Colombia Ltd.: Apartado 3919, Bogotá; Calle 43, no. 43–50, Apartado Aereo 59, Barranquilla.

Gratuity guidelines: Same as those in the U.S.

COMOROS
Federal Islamic Republic of the Comoros
Jumhurīyat al-Qumur al-Itthādīyah al-Islāmīyah

Location: In the Mozambique Channel, between Mozambique, in southeastern Africa, and Madagascar. *Size:* 863 square miles, about half the size of Delaware.

Major cities: *Moroni* (lat. −11.40). *Airports:* Iconi Airport (YVA), 1 mile outside of Moroni.

General transportation: Air links to Paris, Amsterdam, and several African capitals. Daily flights connect the islands, but there are no regular ships. *U.S. license:* Yes. *IDP:* Yes. *Rule of the road:* Right. *Taxi markings:* All colors, but they are all Renaults; marked TAXI; set price by zone. Taxis are commonly shared, but you can pay more to monopolize.

Population: 430,000. *Type of government:* Independent republic, with 1 legal political party (UCP). Mayotte Island is claimed by Comoros but administered by France.

Languages: Shaafi Islam (a Swahili dialect), Malagasy, French. *Ethnic groups:* Antalote, Cafre, Makoa, Oimatsaha, Sakalava.

Religion: 86% Sunni Muslim, 14% Roman Catholic (Mayotte).

Time: EST +9; GMT +3. *Telephone codes:* No direct-dial from U.S.—operator-assisted calls only. No credit card or collect calls to U.S. International calls can be difficult, but the local system is new. *Pay phone system:* None.

Holidays: July 6, plus Muslim holidays— check with consulate. *Date/month system:* D/M.

Business and government hours: 7 AM to 12 noon, 3 PM to 5PM Monday to Friday; 7 AM to 12 noon Saturday. *Business dress code:* Clean trousers and shirt but no necktie, except for formal official functions.

Climate and terrain: Consists of 4 volcanic islands and satellites, each with its own topography; lush vegetation. Typical tropical marine climate. Rainy season extends from November to May. *Temperature ranges:* winter: 65°F; summer: 75°F.

Visas: Standard tourist card issued at airport, requiring passport, proof of return

ticket. *Health requirements:* No vaccinations required. *Equipment importation:* No restrictions expected.
Electricity: Data unavailable. *Plug types:* Data unavailable.
Currency: Franc (CFA).
U.S. embassy in the country: Boîte Postal 1318, Moroni; *tel.* 73–12–03; *telex:* 257 AMEMB KO.
Embassy in U.S.: U.N. Mission, 336 East Forty-fifth Street, New York, NY 10017; *tel.* 212–972–8010.

Central tourism office in country: Department of Transportation and Tourism, Ministry of Foreign Affairs, P.O. Box 428, Moroni; *tel.* 73–08–47; *telex:* 219, *callback:* KO.
Health suggestions: Malaria is widespread; take sanitary precautions. Seek advice before ocean swimming.
Gratuity guidelines: Usually included in the bill; giving a bit more is accepted but not customary.

CONGO
People's Republic of the Congo
République Populaire du Congo

Location: In west-central Africa, bounded on the north by Cameroon and the Central African Republic, the east and south by Zaire, the southwest by Angola and the Atlantic Ocean, and the west by Gabon. *Size:* 132,047 square miles, slightly smaller than Montana.
Major cities: *Brazzaville* (lat. −4.15).
Airports: Maya Maya (BZV), 3 miles outside of Brazzaville.
General transportation: Good links to Africa and Europe (with most connections to U.S. through Paris). Lina Congo (GC), the domestic airline, and air charters provide domestic service; Brazzaville and Pointe-Noire are linked by rail; public transport is inadequate. *U.S. license:* No. *IDP:* Yes. *Rule of the road:* Right. *Taxi markings:* Green with white top; set price and be sure to agree on it in advance.
Population: 2,200,000. *Type of government:* People's republic, with 1 legal party (PCT), based on Marxist principles. Enjoys good relations with the U.S.
Languages: French (official); many indigenous languages. English is rarely spoken or written, even in business and government activities. *Ethnic groups:* About 15 ethnic groups, divided into some 75 tribes, almost all Bantu: 48% Kongo (south), 12% Sangha and M'Bochi (north), 17% Teke (center).

Religion: 50% Christian, 42% indigenous animist, 2% Muslim.
Time: EST +6; GMT +1. *Telephone codes:* No direct-dial from U.S.—operator-assisted calls only. No credit card or collect calls to U.S. Domestic service adequate for governmental purposes but otherwise often unreliable. International link to Paris via satellite, usually available. Be sure to use post office P.O. boxes in postal addresses; telex is common. *Pay phone system:* Coins; very few available.
Holidays: January 1; March 18; May 1; July 31; August 13, 14, 15; November 1; December 25, 31. *Date/month system:* D/M.
Business hours: 8 AM to 12 noon, 3 PM to 6 PM Monday to Saturday; some offices closed Saturday afternoon. *Government hours:* 7:30 AM to 11:30 AM, 2:30 PM to 4:30 PM Monday to Friday; 8 AM to 12 noon Saturday. *Business dress code:* For high-level meetings, wear a tie and jacket; otherwise more informal.
Climate and terrain: Four topological regions: coastal plain extending inland about 40 miles to foothills of the Mayombe Mountains; fertile Niari Valley in south-central region; central Bateke Plateau separates basins of Ogooué and Congo Rivers; Congo River basin in north. Most of country is densely

forested. About 70% of the population lives in Brazzaville and Pointe-Noire or along the rail link between them. Tropical climate; hot and almost always humid. Four seasons: dry (mid-May to September), light rains (October to mid-December), dry (mid-December to mid-January), heavy rains (mid-January to mid-May). The period between mid-June to September is best for travel. *Temperature ranges* (Brazzaville): January: 69° to 88°F; April: 71° to 91°F; July: 63° to 82°F; October: 70° to 89°F.

Visas: Standard tourist visa requires passport, 3 applications, 3 photos, photographer letter, $15 for single entry, $20 for multiple; good for stays of up to 3 months. *Health requirements:* Yellow fever vaccination is required if coming from an infected area and is recommended by the CDC for travel outside urban areas. *Equipment importation:* Bring equipment list; no bond is required.

Electricity: 220/50. *Plug types:* C.

Currency: Franc (CFA).

U.S. embassy in the country: Avenue Amilcar Cabral, B.P. 1015, Brazzaville; *tel.* 83–20–70, 83–26–24; *telex:* 5367 KG.

Embassy in U.S.: 4891 Colorado Avenue NW, Washington, DC 20011; *tel.* 202–726–5500/1.

Central tourism office in country: Direction du Tourisme, Brazzaville; *telex:* 5210 KG.

Health suggestions: Hospitals only in major towns; health care is only basic. Malaria suppressants are necessary throughout the country; polio, typhoid, and hepatitis treatments are recommended for remote areas. Water is not potable.

Photographic restrictions: There are a number of restrictions. Contact the Direction du Tourisme (*tel.* 81–09–53) upon arrival to get list.

Gratuity guidelines: Some restaurants include service in the bill; otherwise a small tip (about 5%) is common. Taxi drivers do not expect tips.

COSTA RICA
Republic of Costa Rica
República de Costa Rica

Location: In southern Central America, bounded on the north by Nicaragua, the east by the Caribbean Sea and Panama, and the south and west by the Pacific Ocean. *Size:* 19,652 square miles, slightly smaller than West Virginia.

Major cities: *San José* (lat. +9.56). *Airports:* Juan Santa Maria International Airport (SJO), 12 miles outside of San José.

General transportation: Many international links, including direct flights from the U.S. Principal cities are connected by air, road, or rail with San José; which also has a good internal bus service. The country's road network is only fair. *U.S. license:* Yes. *IDP:* Yes. *Rule of the road:* Right. *Motor clubs:* Automóvil Club de Costa Rica, Apartado 4646, San José; *tel.* 20 04 43; partial AAA reciprocity. *Taxi markings:* Red,

marked TAXI; some metered, some set price.

Population: 2,900,000. *Type of government:* Democratic republic with a long tradition of having an orderly, constitutional government with checks and balances. No army, navy, or air force. Enjoys a very cordial relationship with the U.S., based on mutual traditions.

Languages: Spanish. Many businesspeople understand English. *Ethnic groups:* 96% white (including mestizo), 3% black, 1% Indian. *Religion:* 95% Roman Catholic.

Time: EST −1; GMT −6. *Telephone codes:* Country: 506. No city codes. Domestic and international service are both very good. *Pay phone system:* Coins.

Holidays: January 1; St. Joseph's Day (March); Holy Thursday; Good Friday; May

1; Corpus Christi (June); September 15; October 12; December 25. *Date/month system:* D/M.

Business and government hours: 9 AM to 12 noon, 1 PM to 5 PM Monday to Friday. *Business dress code:* Same as that of the U.S.

Climate and terrain: Coastal plains separated by volcanic mountain ranges (almost 13,000 feet at zenith); two-thirds of the country is forested. Tropical climate, with a rainy season from May to November and a dry season from December to April, but the Caribbean plain receives heavy rainfall all year. *Temperature ranges* (San José): January: 58° to 75°F; April: 62° to 79°F; July: 62° to 77°F; October: 60° to 77°F.

Visas: Standard tourist entry; tourist card available at airport for stays of up to 30 days; visa available at consulate for stays of over 30 days. *Health requirements:* No vaccinations required. *Equipment importation:* Bring equipment list; no bond is necessary.

Electricity: 120/60. **Plug types:** A, D, I, and J.

Currency: Colon (CRC); Centimos.

U.S. embassy in the country: Avenida 3 and Calles I, San José; *tel.* 33–11–55.

Embassy in U.S.: 1825 Connecticut Avenue NW, Washington, DC 20009; *tel.* 202–328–6628. *Consulates:* California: 415–392–8488; Florida: 305–377–4242; Illinois: 312–263–2772; Louisiana: 504–525–5445; New York: 212–425–2620; Texas: 713–664–4463.

Tourism office in U.S.: Costa Rica National Tourist Bureau, 1101 Brickell Avenue, Suite 801, Biv Tower, Miami, FL 33131; *tel.* 800–327–7033.

Central tourism office in country: Instituto Costarricense, P.O. 777, San José; *tel.* 23–17–33.

Health suggestions: Medical facilities are essentially good. Amebic dysentery, malaria, and typhoid exist outside capital. Malaria suppressants are recommended for a few limited rural areas. Water is not always safe; take precautions.

Cultural mores and taboos: Costa Rica has a courteous culture, where respect and honor for the individual are paramount.

Film commissions: Costa Rican Film Commission, 9000 West Sunset Boulevard, Suite 1000, Los Angeles, CA 90069; *tel.* 213–271–5858.

Gratuity guidelines: Not usually included in the bill; leave 15%.

CÔTE D'IVOIRE (IVORY COAST)
Republic of the Ivory Coast
République de la Côte d'Ivoire

Location: In western Africa, bounded on the north by Mali and Burkina Faso, the east by Ghana, the south by the Atlantic Ocean, and the west by Liberia and Guinea. *Size:* 124,503 square miles, slightly larger than New Mexico.

Major cities: *Abidjan* [legal capital city changed to Yamoussoukro in 1983 but not recognized by U.S. Seat of Govt. remains in Abidjan (lat. +5.19)]. *Airports:* Port Bouet Airport (ABJ), 10 miles outside of Abidjan.

General transportation: Direct air links with New York and Europe. Air Ivoire (VU) and private charters serve principal domestic cities. Most roads are paved; an excellent

network links all major towns. Overnight trains to the north are available. Unpaved roads are dusty in the dry season, slippery in the wet—4-wheel-drive vehicles are essential for isolated areas. *U.S. license:* No. *IDP:* Yes. *Rule of the road:* Right. *Taxi markings:* Red, marked TAXI, metered; rates double from 12 midnight to 5 AM.

Population: 11,200,000. *Type of government:* Republic; one-party presidential regime since 1960; has enjoyed moderate, stable leadership since independence. Friendly and close relations with the U.S.

Languages: French. English is rarely spoken. *Ethnic groups:* Over 60 indigenous ethnic groups: 23% Baule, 18% Bete, 15%

Senufo, 11% Malinke; 2 million foreign Africans; about 130,000 to 330,000 non-Africans (30,000 French, the rest mostly Lebanese). *Religion:* 63% indigenous, 25% Muslim, 12% Christian.

Time: EST +5; GMT 0. *Telephone codes:* Country: 225. No city codes. Adequate to good domestic service; direct-dial international service to U.S. and many other countries. *Pay phone system:* Coins.

Holidays: January 1; Good Friday; Easter Monday; May 1; Ascension Day (40 days after Easter); Whit Monday (varies—early June); Tabaski (varies—August); August 15; November 1; December 7, 24, 25, 31. *Date/month system:* D/M.

Business and government hours: 8 AM to 12 noon, 2:30 PM to 5:30 PM Monday to Friday. *Business dress code:* Conservative.

Climate and terrain: Mostly flat. Coast has heavy surf and no natural harbors. Dense forest in western portion. Tropical climate, with a rainy season from May to October that is characterized by cloudy, hot, and humid weather interspersed with frequent showers of up to monsoon force in the first 3 months of the season. The November to April dry season is very sunny, slightly warmer, and less humid, with frequent cooling sea breezes, especially in the evening. *Temperature ranges* (Abidjan): January: 73° to 88°F; April: 75° to 90°F; July: 73° to 83°F; October: 74° to 85°F.

Visas: *Business visa:* Client letter to consular general, 4 applications, 4 photos, passport, copy of round-trip ticket; requires 2 working days. *Tourists:* Tourist visa. *Health requirements:* Yellow fever vaccination.

Equipment importation: Carnet.
Electricity: 220/50. *Plug types:* C.
Currency: Franc (CFA); primary subdivision, plural.

U.S. embassy in the country: 5, rue Jesse Owens, 01 B.P. 1712, Abidjan; *tel.* 32–09–79; *telex:* 23660.

Embassy in U.S.: 2424 Massachusetts Avenue NW, Washington, DC 20009; *tel.* 202–483–2400.

Tourism office in U.S.: Tourist Information, 516 Fifth Avenue, New York, NY 10036; *tel.* 800–537–2939. Or call the embassy's tourism section, *tel.* 202–797–4352, 797–0344.

Central tourism office in country: Director of Promotion of Tourism and Artifacts, Ministry of Tourism, P.O. Box V 184, Abidjan; *tel.* 32–70–49.

Health suggestions: English-speaking doctors are available. Malaria suppressants are recommended throughout the country. Cholera infection is present. Water is not potable.

Cultural mores and taboos: Social greetings and handshakes are always exchanged before asking questions or attending to business. Be flexible if appointments do not begin on time.

Photographic restrictions: National museum, airports, a few other strategic locations. As in much of Africa, it is advisable to request permission before photographing people on the street.

Gratuity guidelines: Service charge is not included on the bill; tips are expected, except by cab drivers, who appreciate but do not expect tips.

CUBA
Republic of Cuba
República de Cuba

U.S. citizens need a Treasury Department license to travel to and within Cuba. Contact the Office of Foreign Assets Control, Department of the Treasury, 1331 G Street NW, Washington, DC 20220; *tel.* 202–376–0922. Visitors' activities are monitored; register with the Swiss embassy upon arrival.

Location: Westernmost island of the West Indies, just south of Florida and the Bahamas. *Size:* 44,218 square miles, slightly smaller than Pennsylvania.

Major cities: *Havana* (lat. +23.08). *Airports:* José Martí International Airport (HAV), 11 miles outside of Havana.

General transportation: No regularly scheduled flights from the U.S., but charter flights can be arranged in Miami, or connections can be made in Mexico, Canada, or Jamaica. Cubana Airlines serves the major cities and flies to a number of other countries. AeroCaribbean, a charter company, provides unscheduled service to Western Europe and the Caribbean basin. Good intercity bus service to major cities along main roads. Public transport is crowded. *U.S. license:* Yes, for 6 months. *IDP:* Yes. *Rule of the road:* Right. *Taxi markings:* All colors, marked TAXI. Metered and set price, agree in advance; not always easy to hail.

Population: 10,400,000. *Type of government:* Communist state with strict controls. Indications of improved relations with the U.S. in the last decade or so have not substantially materialized.

Languages: Spanish. *Ethnic groups:* 51% mulatto, 37% white, 11% black, 1% Chinese. *Religion:* Traditionally 85% Roman Catholic. Religious activity is discouraged by the government.

Time: EST; GMT −5. *Telephone codes:* No direct-dial from U.S.—operator-assisted calls only. No credit card calls to U.S. *Pay phone system:* Coins.

Holidays: January 1; May 1; July 25, 26, 27; October 10. June through September are popular vacation months. *Date/month system:* D/M.

Business and government hours: 8:30 AM to 12:30 PM, 1:30 PM to 5:30 PM Monday to Friday; 8:30 AM to 12 noon Saturday. *Business dress code:* Same as that of the U.S.

Climate and terrain: Indented coastline with hundreds of bays and inlets and some of the best harbors in the world. Most of the northern coast is steep and rocky, and the southern coast (except for the mountainous eastern end) is low and marshy. The rivers, generally short, narrow, and shallow, are navigable only for short distances. Three-fifths of the country is flat or gently rolling fertile valley or plain. The rest is mountainous or hilly, with the 3 main mountain groups being in the east, center, and west. Cuba is in the tradewind belt, making the climate subtropical despite its location in the tropics. The dry season is from November to April; the wet season, from May to October, is characterized by short, heavy downpours. Subject to hurricanes. *Temperature ranges* (Havana): January: 65° to 79°F; April: 69° to 84°F; July: 75° to 89°F; October: 73° to 85°F.

Visas: Contact the Cuban Interest Section, 2630 Sixteenth Street NW, Washington, DC 20009, *tel.* 202–797–8518, with a photographer letter and equipment list. Approval takes 3 weeks minimum. *Tourists:* Tourist visa, with permission from Treasury Department, as noted at the opening of this discussion. *Health requirements:* No vaccinations required. *Equipment importation:* Apply for with visa request, see **Visas,** above.

Electricity: 110. *Plug types:* Data unavailable.

Currency: Peso (CUP); Centavos.

U.S. embassy in the country: None. U.S. interests are represented by the Swiss embassy, Calzada entre L & M, Vedado Sección, Havana; *tel.* 320–551, 320–543; *telex:* 512206.

Embassy in U.S.: None. Contact the Cuban Interests Section in Washington, DC— see **Visas,** above.

Health suggestions: Water is not potable.

Cultural mores and taboos: All business is state owned, and decisions take time—patience is the key. Be discreet—surveillance is practiced. Cubans are sports fanatics, and this is always a good topic.

Gratuity guidelines: Tipping is prohibited.

CYPRUS
Republic of Cyprus
Kypriaki Dimokratia/Kibris Cumhuriyeti

Location: In the Mediterranean Sea, west of Syria and south of Turkey. *Size:* 3,572 square miles, smaller than Connecticut. **Major cities:** *Nicosia* (lat. +35.09). *Airports:* Larnaca International Airport (LCA), 2 miles outside of Larnaca, 30 miles outside of Nicosia.

General transportation: Larnaca and Paphos airports and the ports of Limassol, Larnaca, and Paphos are the only legal points of entry and exit. Airports servicing the north are served by Turkish Airlines but are not recognized by the International Civil Aviation Organization. Travel to the north is not generally permitted, but check with the U.S. embassy—short visits can sometimes be arranged. You will be expected to return to the south for your departure. Visitors entering the island from the north will not be permitted into the Republic of Cyprus. Many international flights with links to the U.S. through Europe. Buses and taxis are the only form of public transport. *U.S. license:* Yes. *IDP:* Yes. *Rule of the road:* Left. *Motor clubs:* Cyprus Automobile Association, 12 Chrysanthou Mylona Street, Nicosia; *tel.* 31 32 33; partial AAA reciprocity. *Taxi markings:* Commonly Mercedes, marked TAXI; metered.

Population: 700,000. *Type of government:* Republic. A disaggregation of ethnic communities began after the outbreak of communal strife in 1963 and was solidified following a Turkish invasion in July 1974 that gave Turkish Cypriots de facto control in the north; Greek Cypriots control the only internationally recognized government. Turkish Cypriots declared independence and the formation of a Turkish Republic of Northern Cyprus in 1983, which has been recognized only by Turkey. Both sides have called for a resolution of differences and creation of a new federal system of government. U.S. enjoys friendly relations with Republic

of Cyprus, while also maintaining informal contact with Turkish Cypriots.

Languages: Greek, Turkish (both official), with English the second language for both. *Ethnic groups:* 78% Greek, 18% Turkish, 4% other. *Religion:* 78% Greek Orthodox; 18% Muslim, 4% Maronite Armenian, Apostolic, other.

Time: EST +7; GMT +2. *Telephone codes:* Country: 357. Kythrea 2313, Lapithos 8218, Larnaca 41, Lefkonico 3313, Limassol 51, Moni 5615, Morphou 71, Nicosia 2, Paphos 61, Platres 54, Polis 63, Rizokarpaso 3613, Yialousá 3513. Famagusta 536, Kyrenia 581, and Lefka 57817 are handled by the Turkish telephone network (country code 90 for Turkey). No direct links between northern and southern divisions. Otherwise, domestic and international services are very good. *Pay phone system:* Coins, on street; in shops and private shops, there are metered phones that record charges to be paid at the end of call. These can be used for international calls.

Holidays: January 1, 6; first day of Lent; March 1, 25; Good Friday through Easter Monday; May 1; August 3, 15; October 1, 28; December 25, 26; plus other Greek holidays. Should you visit the north: January 1; April 23; May 19; August 30; October 29; November 15; plus several Muslim holidays. *Date/month system:* D/M.

Business hours: 7:30 or 8 AM to 12 noon, 1 PM to 4:30 PM Monday to Friday. *Business dress code:* Same as that of the U.S. (a bit less formal in summer—tie, no jacket).

Climate and terrain: The island consists of a central plain with mountain ranges in the north and south. Rain falls almost exclusively from December to March. Summers are hot but dry. *Temperature ranges* (Nicosia): January: 42° to 58°F; April: 50° to 74°F; July: 69° to 97°F; October: 58° to 81°F.

Visas: Standard tourist visa available at airport; carrying a client introduction letter is recommended. **Health requirements:** No vaccinations required. **Equipment importation:** Carnet. **Electricity:** 240/50. **Plug types:** G. **Currency:** Pound (CY£); 1,000 Mils. **U.S. embassy in the country:** Therissos Street and Dositheos Street, Nicosia; tel. 465–151; telex: 4160 AME CY. **Embassy in U.S.:** 2211 R Street NW, Washington, DC 20008; tel. 202–462–5772. **Consulates:** California: 415–893–1661; Illinois: 312–421–3979; Missouri: 314–781–7041; New York: 212–686–6016. **Tourism office in U.S.:** Cyprus Tourist Organization, 13 East Fortieth Street, New York, NY 10016; tel. 212–213–9100. **Central tourism office in country:** Cyprus Tourism Organization, 18 Th. Theodotou, Nicosia; tel. 443–374. **Health suggestions:** No unusual health problems. Sanitation standards are higher than in most Middle Eastern countries and comparable to most of southern Europe.

Cultural mores and taboos: Considered very rude to decline social invitations. Food and drink are always passed with the right hand.

Photographic restrictions: The greenline buffer zone (it is marked with warning signs) separating the Free Republic area from the northern area occupied by the Turkish military cannot be photographed. Permits are not required for archaeological sights and antiquities. The tourist office can advise when it is inconvenient to shoot during tourist season and may arrange special hours in some cases.

Gratuity guidelines: Usually included in the bill (10% plus 3% for food and beverages), but leaving an extra bit of change is customary. If not included, leave 15%.

CZECHOSLOVAKIA
Czechoslovak Socialist Republic
Československá Socialistická Republika

Location: In central Europe, bounded on the northwest by East Germany, the north by Poland, the east by the USSR, the south by Hungary and Austria, and the west by West Germany. **Size:** 49,371 square miles, slightly larger than New York State. **Major cities:** *Prague* (lat. +50.05). **Airports:** Ruzyne Airport (PRG), 10 miles outside of Prague.

General transportation: Many international flights, with direct links to the U.S. Countrywide network of air, bus, and rail services; main roads are adequate. Prague has a subway, streetcars, and trolleys. Rental cars are available. **U.S. license:** Yes. **IDP:** Yes. **Rule of the road:** Right. **Motor clubs:** Ustredni Automotoklub CSSR, Na Strzi 9, Prague; tel. 43 17 55; partial AAA reciprocity. **Taxi markings:** All colors, marked TAXI; metered. **Population:** 15,600,000. **Type of government:** Communist state with strict controls.

U.S. relations have improved modestly in the 1980s, particularly after the complications of the 1968 Soviet invasion.

Languages: Czech, Slovak (official), Hungarian. **Ethnic groups:** 64.3% Czech, 30.5% Slovak, 3.8% Hungarian; other European ethnic minorities. **Religion:** 77% Roman Catholic, 20% Protestant, 2% Greek Orthodox, 1% other. Religious activity is tolerated but rigorously regulated and limited by the state.

Time: EST +6; GMT +1. **Telephone codes:** Country: 42. Banská Bystrica 88, Bratislava 7, Brno 5, České Budějovice 38, Děčín 412, Havířov 6994, Hradec Kralové 49, Jablonec nad Nisou 428, Karviná 6993, Košice 95, Most 35, Ostrava 69, Plzeň 19, Prague 2, Ústí nad Labem 47, Žilina 89. Domestic and international services are adequate. Czechoslovak rates for calls to the U.S. are considerably higher than in the U.S.—consider calling collect. **Pay phone**

system: Coins.

Holidays: January 1; Easter Monday; May 1, 9; December 24, 25, 26. February 25 is an unofficial holiday. August 29 is a holiday in Slovakia. June, July, and August are popular vacation months. *Date/month system:* D/M.

Business and government hours: 7 or 8 AM to 3 or 4 PM Monday to Friday; factories a bit earlier. *Business dress code:* Same as that of the U.S. or a bit more conservative. Do not attend theater and cultural events in casual clothing.

Climate and terrain: Three regions: politically and economically dominant Bohemia (includes Prague) in the west, with rolling plains, hills and plateaus with low mountains; Central Moravia, an industrial and agricultural region with mountains in the north; Slovakia in the east, with rugged mountains in the north and center and important agricultural lowlands in the south. Bohemia and Moravia have moderate climates with lush springs and pleasant autumns, cool summers and cold, overcast winters. Slovakia is characterized by wider extremes. *Temperature ranges* (Prague): January: 25° to 34°F; April: 40° to 55°F; July: 58° to 74°F; October: 44° to 54°F.

Visas: *Photojournalists:* Passport, 2 applications, 4 photos, photographer letter, $16 fee; allow 20 days for processing. *Commercial photographer:* Standard tourist visa, requiring passport, 2 applications, 4 photos, $16 fee for single entry, $32 for two entries; valid for 5 months. *Health requirements:* No vaccinations required. *Equipment importation:* Carnet.

Electricity: 220/50. *Plug types:* E.

Currency: Koruna (CKR); Halers. Tourists are required to exchange fixed amounts of money per day.

U.S. embassy in the country: Trziste 15–12548, Prague; *tel.* 53–6641/9; *telex:* 121 196 AMEMBC.

Embassy in U.S.: 3900 Linnean Avenue NW, Washington, DC 20008; *tel.* 202–363–6315.

Tourism office in U.S.: Cedok Czechoslovak Travel Bureau, 10 East Fortieth Street, New York, NY 10016; *tel.* 212–689–9720.

Central tourism office in country: Cedok, Naprikobe #18, 11135 Prague 1; *tel.* 212–7111.

Health suggestions: Sanitary conditions are good; water is generally safe. Medications can be in short supply. There is a special clinic for foreigners at Karlovo Namesti in Prague.

Cultural mores and taboos: Decisions take time; be patient. Use titles when addressing people. First names are reserved for friends.

Photographic restrictions: Military, police, industrial, and strategic locations, museums.

Gratuity guidelines: Not usually included in the bill; leave 10%.

DENMARK
Kingdom of Denmark
Kongeriget Danmark

Location: In northwestern Europe, bounded on the north by the Skagerrak, the east by the Kattegat, Øresund, and Baltic Sea, the south by West Germany, and the west by the North Sea. *Size:* 16,629 square miles (excluding Greenland and the Faeroe Islands), slightly more than twice the size of Massachusetts.

Major cities: *Copenhagen* (lat. +55.41).

Airports: Kastrup-Copenhagen Airport (CPH), 6 miles outside of Copenhagen.

General transportation: Many international flights with direct links to the U.S. Excellent public transport in general. Ferries connect the country with Oslo, Norway; Stockholm, Sweden; Helsinki, Finland; and points in the United Kingdom and West Germany. *U.S. license:* Yes. *IDP:* Yes, for

1 year. *Rule of the road:* Right. *Motor clubs:* Forenede Danske Motorejere (FDM), Blegdamsvej 124, Copenhagen; *tel.* 38–21–12; full AAA reciprocity. *Taxi markings:* Marked TAXI; metered.

Population: 5,100,000. *Type of government:* Constitutional monarchy with long-standing democratic traditions. Enjoys a close and friendly relationship with the U.S.

Languages: Danish, with a few pockets of minority languages. English is widely understood. *Ethnic groups:* Scandinavian, Eskimo, Faaroese, German. *Religion:* 97% Evangelical Lutheran, 2% other Christian, 1% other.

Time: EST +6; GMT +1. *Telephone codes:* Country: 45. Ålborg 8, Allerod 2, Ansager 5, Århus 6, Assens 9, Billund 5, Copenhagen 1 or 2, Esbjerg 5, Haderslev 4, Holstebro 7, Korsør 3, Nykøbing (Sjælland) 3, Odense 7, Randers 6, Sønderborg 4, Vorgod 7. Domestic and international services are excellent. *Pay phone system:* Coins.

Holidays: January 1; Maundy Thursday to Easter Monday; fourth Friday after Easter; Ascension Day (40 days after Easter); Whit Monday (June); December 25, 26. Vacations are popular from mid-June through July. *Date/month system:* D/M.

Business hours: 8 or 9 AM to 4 or 5 PM Monday to Friday. *Business dress code:* Same as that of the U.S.

Climate and terrain: Denmark proper (excluding Greenland) has a flat or rolling terrain (highest elevation is only 568 feet). Temperate climate with ample rain; windy winters, cool summers. *Temperature ranges* (Copenhagen): January: 29° to 36°F; April: 37° to 50°F; July: 55° to 72°F; October: 42° to 53°F.

Visas: Standard tourist entry, requiring passport; no visa is needed for stays of up to 3 months (period starts after entering any Scandinavian country—Denmark, Finland, Iceland, Norway, or Sweden). *Health requirements:* No vaccinations required. *Equipment importation:* Carnet.

Electricity: 220/50. *Plug types:* C.

Currency: Krone (DKK); Øre.

U.S. embassy in the country: Dag Hammarskjölds Alle 24, 2100 Copenhagen O; *tel.* 42–31–44; *telex:* 22216.

Embassy in U.S.: 3200 Whitehaven Street NW, Washington, DC 20008; *tel.* 202–234–4300. *Consulates:* California: 213–387–4277; Illinois: 312–329–9644; New York: 212–223–4545; Texas: 713–850–9520.

Tourism office in U.S.: Danish Tourist Board, 655 Third Avenue, New York, NY 10017; *tel.* 212–949–2333.

Central tourism office in country: Danish Tourist Board, Vesterbrogade 6D, Copenhagen 1629; *tel.* (01) 11–14–15.

Health suggestions: Health conditions are excellent.

Cultural mores and taboos: Danes are friendly, informal, and tolerant.

Photographic restrictions: Military sites. **Color labs:** *Kodak and H-Color:* Roskildevej 16, 2620 Albertlund; Kodakvej 6, 4220 Korsør; Lystrupvej 62, 8240 Risskov. *Fuji Color Service*, Postbox 30, 8100 Århus.

Equipment rental/sales: *Broncolor:* Hother Import ApS, Palaegade 5, 1261 Copenhagen K; *tel.* 13–13–97. *Profoto:* James Polack A/S, Birkerød; *tel.* 81–71–11.

Gratuity guidelines: Service is included in the bill; extra is appreciated but not expected.

DJIBOUTI
Republic of Djibouti
Jumhouriyya Djibouti

Location: In eastern Africa, bounded on the northeast by Bab al-Mandab Strait, the east by the Gulf of Aden, the southeast by Somalia, and the south, west, and north by Ethiopia. *Size:* 8,494 square miles, slightly larger than Massachusetts.

Major cities: *Djibouti* (lat. +11.36). *Airports:* Ambouli Airport (JIB), 4 miles outside of Djibouti.

General transportation: Air links to Paris, the Middle East, and Addis Ababa, Ethiopia. Domestic flights on small airstrips.

Rail link to Addis Ababa, but tourists are allowed to travel only to the border town of Ali Sabih. One hard-surfaced road links Djibouti with the Aseb–Addis Ababa highway. All other roads are merely tracks, often impassable because of volcanic activity, and otherwise only by 4-wheel-drive vehicles. Do not venture out of the capital without a guide. *U.S. license:* Yes, but with formalities on arrival. *IDP:* Yes. *Rule of the road:* Right. *Taxi markings:* Green and white, marked TAXI; set price.

Population: 320,000. *Type of government:* Republic, ruled by a National Assembly with one party; political competition between the minority Afars and majority Somali Issas, who dominate the government, civil service, military, and ruling party. Women enjoy more public status than in most Islamic countries but are not in senior positions. The U.S. has had an embassy in Djibouti since 1980.

Languages: French (official); Arabic, Somali, and Afar are widely spoken. *Ethnic groups:* 60% Somali Issa, 35% Afar, 5% foreign, mostly French and Arab. *Religion:* 94% Muslim, 6% Christian.

Time: EST +8; GMT +3. *Telephone codes:* No direct-dial from U.S.—operator-assisted calls only. No credit card or collect calls to U.S. Fair urban service, generally reliable international service. *Pay phone system:* Coins; few available.

Holidays: January 1; May 1; June 27, 28; December 25; plus Muslim holidays—check with consulate. *Date/month system:* D/M.

Business hours: 7 AM to 12:30 PM, 3:30 PM to 7:30 PM Saturday to Thursday. *Government hours:* 7 AM to 12 noon, 3:30 PM to 5:30 PM Sunday to Thursday. *Business dress code:* Less formal than U.S. due to extreme heat.

Climate and terrain: Coastal plains lead inward to mountains and then plateau. The land is bare, dry, and desolate, marked by sharp cliffs, deep ravines, burning sands, and thorny shrubs. Dry, torrid desert climate. *Temperature ranges* (Djibouti): January: 73° to 84°F; April: 79° to 90°F; July: 87° to 106°F; October: 80° to 92°F.

Visas: *Business visa:* passport, 2 applications, 2 photos, proof of return ticket and sufficient funds, client letter, $15 fee; allow 1 or 2 days for processing. *Tourists:* Tourist visa with similar requirements. *Health requirements:* Yellow fever and cholera vaccinations. *Equipment importation:* Bring equipment list; no bond is required.

Electricity: 220/50. *Plug types:* C and E.

Currency: Franc (DFR); primary subdivision (plural).

U.S. embassy in the country: Plateau du Serpent, Boulevard Maréchal Joffre, B.P. 185, Djibouti; *tel.* 35–38–49, 35–39–95, 35–29–16/7.

Embassy in U.S.: 1430 K Street NW, Washington, DC 20005; *tel.* 202–347–0254. *Consulates:* New York: 212–753–3163.

Central tourism office in country: Office of Tourism Development, *tel.* 35–37–90.

Health suggestions: Malaria is prevalent, and wounds are prone to infection, but Djibouti is free of many diseases otherwise common in Africa. Although city water is pure at its oasis source, it can become contaminated—exercise precautions. There are few doctors, and the one civilian hospital is less than adequate.

Cultural mores and taboos: Americans will meet with a friendly reception.

Gratuity guidelines: Tips are not expected.

DOMINICA
Commonwealth of Dominica

Location: In the West Indies, south of Guadeloupe and north of Martinique. *Size:* 289 square miles, slightly smaller than New York City.

Major cities: *Roseau* (lat. +15.18). *Airports:* Melville Hall Airport (DOM), 36 miles outside of Roseau; Canefield Airport (DCF), 5 miles outside of Roseau.

General transportation: Commercial air service on the island is provided by Leeward Islands Air Transport (LIAT). Air Guadeloupe and Air Martinique fly into Melville Hall from these adjacent French islands. **U.S. license:** Yes, if presented to the traffic department for issuance of a 3-month temporary license for a fee. **IDP:** Yes, if presented to the traffic department for issuance of a 3-month temporary license for a fee. **Rule of the road:** Left. **Taxi markings:** All colors, some marked TAXI; set price.

Population: 98,000. **Type of government:** Independent state within the British Commonwealth, with a parliament, prime minister, and president. Ruled by the first female prime minister in the Caribbean, Mary Eugenia Charles; legal system is based on British law. Enjoys excellent relations with the U.S.

Languages: English (official), French patois widely spoken, reflecting long period of French domination. **Ethnic groups:** Almost all black, with a tiny Carib-Indian population. **Religion:** 80% Roman Catholic, 20% Anglican, Methodist, and other Protestant.

Time: EST +1; GMT −4. **Telephone codes:** Direct-dial from the U.S. using 809 area code. Domestic and international services are available. **Pay phone system:** Very rare.

Holidays: January 1; Carnaval; Good Friday; Easter Monday; May 1; Whit Monday (varies—early June); first Monday in August; November 3, 4; December 25, 26. **Date/month system:** D/M.

Business and government hours: 8 AM to 1 PM, 2 PM to 4 PM Monday to Friday; government offices remain open until 5 PM on Monday. **Business dress code:** Informal except for high-level meetings.

Climate and terrain: Rugged volcanic peaks (over 4,700 feet at highest point) carpeted by wild, lush forests, punctuated by lakes, waterfalls, and over 350 rivers. Rich agriculture, few beaches. Tropical climate moderated by northeast trade winds. Dry weather predominates from January to April; frequent rain from May to August. Hurricanes occur, as do flash floods. **Temperature ranges** (Roseau): May to August: 85°F to 90°F; September to April: 77°F to 85°F.

Visas: *Work permit:* Immigration Department, Ministry of Legal Affairs, Ministerial Building, Roseau; tel. 809–448–2401. *Tourists:* Proof of U.S. citizenship, ID, return ticket, for stays of up to 6 months. **Health requirements:** No vaccinations required. **Equipment importation:** Apply for with work permit; see **Visas,** above.

Electricity: 230/50. **Plug types:** G.

Currency: East Caribbean Dollar (EC$); Cents.

Embassy in U.S: Care of British Embassy, 3100 Massachusetts Avenue NW, Washington, DC; tel. 202–462–1340.

Tourism office in U.S.: % Caribbean Tourism Association, 20 East 46 Street, New York, NY 10017; tel. (212) 682–0435.

Central tourism office in country: Dominica Tourist Board, PO Box 73, Roseau, tel. 809–448–2351; telex 8649 Tourist DO; fax 809–448–5840.

Health suggestions: Water is potable.

Gratuity guidelines: Service is sometimes included in the bill; otherwise, leave 10% to 15%.

DOMINICAN REPUBLIC
República Dominicana

Location: In the West Indies, on the island of Hispaniola, which it shares with Haiti, southeast of Cuba, east of Jamaica, west of Puerto Rico. **Size:** 18,657 square miles, about the size of New Hampshire and Vermont combined.

Major cities: *Santo Domingo* (lat. + 18.29). **Airports:** Las Americas (SDQ), 16 miles outside of Santo Domingo.

General transportation: Direct flights from U.S., both to Santo Domingo and the northern resort of Puerto Plata (airport code

POP). A national airline and buses link the major cities. **U.S. license:** Yes, for 6 months. **IDP:** Yes, for 6 months. **Rule of the road:** Right. **Taxi markings:** Any color, no top hat, recognize by license on dashboard.

Population: 7,100,000. **Type of government:** Republic; representative democracy with direct elections for president every 4 years. Close relations with U.S.

Languages: Spanish. English is understood by many businesspeople. **Ethnic groups:** 73% mixed, 16% white, 11% black. **Religion:** 95% Roman Catholic.

Time: EST; GMT −5. **Telephone codes:** Direct-dial from the U.S. using 809 area code. Good domestic and international service. **Pay phone system:** Coins.

Holidays: Jan 1, 6, 21, 26; February 27; Good Friday; May 1; Corpus Christi (June); August 16; September 24; October 12; December 25. **Date/month system:** D/M.

Business hours: 8 AM to 12 noon, 2 PM to 6 PM Monday to Friday. **Government hours:** 7:30 AM to 1:30 PM Monday to Friday. **Business dress code:** Same as that of the U.S., perhaps slightly more informal.

Climate and terrain: Rugged highlands and mountains interspersed with fertile valleys. The Cordillera Central has the highest point in the Caribbean (Pico Duarte, 10,414 feet). Maritime tropical climate with trade winds modifying the heat. Rainy season extends from May to October or November in the south, December to April in the north. **Temperature ranges** (Santiago): January: 66° to 84°F; April: 69° to 85°F; July: 72° to 88°F; October: 72° to 87°F.

Visas: Standard tourist entry; tourist card available from consulate or airline. **Health requirements:** No vaccinations required. **Equipment importation:** Data unavailable; recommend contacting a customs broker.

Electricity: 120/60. **Plug types:** A and J.

Currency: Peso (DOP); Centavos.

U.S. embassy in the country: Corner of Calle César Nicolás Penson and Calle Leopoldo Navarro, Santo Domingo; *tel.* 541–2171; *telex.* 3460013.

Embassy in U.S.: 1715 Twenty-second Street NW, Washington, DC 20008; *tel.* 202–332–6280. **Consulates:** California: 415–982–5144; New York: 212–265–0630.

Tourism office in U.S.: Dominican Tourist Information Center, 485 Madison Avenue, New York, NY 10022; *tel.* 212–826–0750.

Central tourism office in country: Ministry of Tourism, George Washington Avenue, Santo Domingo; *tel.* 682–8181.

Health suggestions: Santo Domingo has many U.S.-trained doctors. Water is not potable. Malaria suppressants are recommended for most rural areas.

Gratuity guidelines: Service is often included in the bill; giving a bit more is customary.

ECUADOR
Republic of Ecuador
República del Ecuador

Location: In northwestern South America, bounded on the north by Colombia, the east and south by Peru, and the west by the Pacific Ocean. **Size:** 109,483 square miles, slightly smaller than Nevada.

Major cities: *Quito* (lat. −0.08), Guayaquil (lat. −2.10). **Airports:** Mariscal Sucre Airport (UIO), 5 miles outside of Quito; Simón Bolívar Airport (GYE), 3 miles outside of Guayaquil.

General transportation: Direct flights from U.S. to Quito and Guayaquil. Domestic services to most large and medium-sized cities in Ecuador. Few rail links, but good bus services for intercity travel. Buses and taxis are plentiful in cities. **U.S. license:** Yes, for tourists, for 90 days. **IDP:** Yes. **Rule of the road:** Right. **Motor clubs:** Automóvil Club del Ecuador, Eloy Alfaro 218 y Berlin, Quito; *tel.* 23 77 79; partial AAA rec-

iprocity. *Taxi markings:* Normally yellow, marked TAXI; metered.

Population: 10,200,000. *Type of government:* Republic, ruled by a president, elected every 4 years, who may not run for reelection. Congressmen must sit out a term before running for a second term. Enjoys close ties with the U.S.

Languages: Spanish (official); Indian languages, especially Quechua. Some businesspeople speak English. Spanish is mandatory in dealing with the government. *Ethnic groups:* 55% mestizo, 25% Indian, 10% Spanish, 10% black. *Religion:* 95% Roman Catholic.

Time: EST; GMT −5. *Telephone codes:* Country: 593. Ambato 2, Cayambe 2, Cuenca 7, Esmeraldas 2, Guayaquil 4, Ibarra 2, Loja 4, Machachi 2, Machala 4, Portoviejo 4, Quevedo 4, Quito 2, Salinas 4, Santo Domingo 2, Tulcán 2. Adequate to good domestic and international service. *Pay phone system:* Coins.

Holidays: January 1; Carnaval (2 days before Ash Wednesday), Holy Thursday; Good Friday; May 1, 24; July 24, 25 (Guayaquil); August 10; October 9, 12; November 2, 3; December 6, 25. *Date/month system:* D/M.

Business and government hours: 8:30 AM to 12:30 PM, 2:30 PM to 6:30 PM Monday to Friday. Some businesses open Saturday mornings in Quito. *Business dress code:* Same as that of the U.S.

Climate and terrain: The coastal plain *(costa)* is rich in agriculture. Two Andean mountain chains *(cordilleras)* are separated by a highlands plateau *(sierra)*. A dense tropical jungle in the east leads to the Amazon *(oriente)*. The unique archipelago of the Galápagos Islands lies 600 miles off the coast. Wide range of climates: hot and humid in the tropical lowlands; moderate along the coast; springlike weather throughout the year in the Andean plateau. Rainy season in the region, including in the cities, is roughly from November to March. *Temperature ranges* (Quito): January: 46° to 67°F; April:

47° to 69°F; July: 44° to 71°F; October: 46° to 71°F; (Guayaquil): January: 72° to 87°F; April: 72° to 88°F; July: 67° to 84°F; October: 68° to 86°F.

Visas: Standard tourist entry, requiring a migratory control card, available at no charge; passport; proof of return ticket; good for stays of up to 3 months. *Health requirements:* Yellow fever vaccination for travelers coming from infected areas. *Equipment importation:* Bring equipment list to the nearest consulate for notarization. No bond is required.

Electricity: 120–127/60. *Plug types:* A and C.

Currency: Sucre (SUC); Centavos.

U.S. embassy in the country: Avenida 12 de Octubre y Avenida Patria, P.O. Box 538, Quito; *tel.* 562–890; *telex:* 02–2329 USICAQ ED. *Consulates:* Guayaquil: 323–570.

Embassy in U.S.: 2535 Fifteenth Street NW, Washington, DC 20009; *tel.* 202–234–7166. *Consulates:* California: 415–391–4148; Florida: 305–371–8366; Illinois: 312–642–8579; Louisiana: 504–523–3229; Missouri: 816–474–3350; New York: 212–683–7555; Texas: 713–977–8750; Washington: 206–324–4151.

Tourism office in U.S.: Efeprotour, 7270 Northwest Twelfth Street, Suite 400, Miami, FL 33126; *tel.* 800–553–6673.

Central tourism office in country: Dirección Nacional de Turismo, Reina Victoria 514, Quito; *tel.* 239–044, 527–002, 527–074.

Health suggestions: Quito is 9,300 feet above sea level; allow at least a day in your schedule to adjust to the altitude. Typhoid, polio, tetanus, and hepatitis treatments recommended. Malaria suppressants and yellow fever inoculations are recommended for the lowlands. Take food and water precautions; water is usually not potable.

Cultural mores and taboos: Businesspeople are a bit less reserved than in other South American cities.

Gratuity guidelines: Same as those of the U.S., although service is sometimes included in the bill.

EGYPT
Arab Republic of Egypt
Jumhūrīyah Miṣr al-Arabiya

Location: In northeastern Africa, bounded on the north by the Mediterranean Sea, the east by Israel and the Red Sea, the south by Sudan, and the west by Libya. *Size:* 386,900 square miles, about the size of Texas, Oklahoma, and Arkansas combined. **Major cities:** *Cairo* (lat. +30.03). *Airports:* Cairo International Airport (CAI), 15 miles outside of Cairo. **General transportation:** Many international flights with direct links to U.S. Domestic air links from Cairo to Alexandria, Aswān, Luxor, Hurghada, and the Sinai. Good rail service from Cairo to Aswān in the south and Alexandria (ALY) in the north. *U.S. license:* No. *IDP:* Yes. *Rule of the road:* Right. *Motor clubs:* Automobile et Touring Club d'Egypte, 10, rue Kasr el Nil, Cairo; *tel.* 74 31 76; partial AAA reciprocity. *Taxi markings:* Black and white, marked TAXI; metered. Can be difficult to find at peak hours; a car and driver might be advisable for tight schedules. In any event, agree on price before entering. Taxis are often shared. **Population:** 53,400,000. *Type of government:* Republic; constitution calls for a strong executive, elected every 6 years, and a people's assembly; parties along religious or class lines are forbidden (although one, the Muslim Brotherhood, is tolerated and recently gained seats in the new people's assembly). Continuing political liberalization. Enjoys excellent relations with U.S. **Languages:** Arabic (official); English and French are widely understood among the educated classes. *Ethnic groups:* 90% Eastern Hamitic origins, 10% Greek, Italian, Syro-Lebanese. *Religion:* 94% Muslim (mostly Sunni), 6% Coptic Christian and other. **Time:** EST +7; GMT +2. *Telephone codes:* Country: 20. Alexandria 3, Al-Mahalla al-Kubra 43, Al-Mansūra 50, Aswān 97, Asyūt 88, Benha 13, Cairo 2, Damanhūr

45, Luxor 95, Port Said 66, Shībin al-Kōm 48, Sōhāg 93, Tanta 40. Domestic service is overburdened. International service is erratic, with delays and poor reception common. *Pay phone system:* Coins; rarely available on street; ask to use private phones.

Holidays: March 8; April 25; May 1; June 18; July 23; September 1; October 6, 24; plus Islamic holidays. *Date/month system:* D/M.

Business hours: 8:30 AM to 1:30 PM, 4:30 PM to 7 PM Saturday to Thursday, with earlier closings on Thursday. *Government hours:* 8 AM to 2 PM Saturday to Thursday. *Business dress code:* Same as that of the U.S.

Climate and terrain: Four regions: Nile valley and delta, the world's most extensive oasis; the Western Desert, accounting for two-thirds of the country; the Eastern, or Arabian, Desert, largely uninhabited except for a few towns on the Red Sea coast; and the Sinai Peninsula, closely akin to desert, with a mountainous south and flat coastal plains in the north. The 2-season climate is characterized by long hours of blazing sunshine, a severe lack of rainfall, and a hot, driving windstorm in spring called the *khamsin*. The hot summer is from April to October; the cooler winter from November to March. *Temperature ranges* (Cairo): January: 47° to 65°F; April: 57° to 83°F; July: 70° to 96°F; October: 65° to 86°F.

Visas: *Business visa:* For multiple entries, requires passport, client letter, $12 fee (cash or money order), 1 photo; issued same day. *Tourists:* Tourist visa available at airport with 1 photo, $15 fee. Tourists and businesspeople must register with local authorities or at hotel within 7 days of arrival. *Transit visa:* For stays of up to 48 hours. *Health requirements:* Yellow fever vaccination is required if coming from an infected area or any country with an infected area. *Equipment impor-*

tation: Bring a *notarized* equipment list to the nearest Egyptian consulate to have it legalized. In most cases, this should be adequate. However, in a minority of cases, a bond might be required.
Electricity: 220/50. *Plug types:* C.
Currency: Pound (EG£); Piastres. No more than 20 Egyptian pounds can be imported or exported; no limits on foreign currency, as long as it is declared on "Form D," which must be presented along with bank receipts upon departure.
U.S. embassy in the country: 5 Sharia Latin America, Cairo; *tel.* 355–7371; *telex:* 93773 AMEMB. *Consulates:* Alexandria: 821–911, 825–607.
Embassy in U.S.: 2310 Decatur Place NW, Washington, DC 20008; *tel.* 202–234–3903. *Consulates:* California: 415–346–9700; Illinois: 312–670–2633; New York: 212–759–7120; Texas: 713–961–4915.
Tourism office in U.S.: Egyptian Tourist Authority, 630 Fifth Avenue, New York, NY 10111; *tel.* 212–246–6960.
Central tourism office in country: Tourist Information Bureau, 5 Adly Street, Cairo; *tel.* 923–657.
Health suggestions: Typhoid, tetanus, polio, and hepatitis (gamma globulin) treatments are advisable. Malaria and rabies exist in some outlying areas. Well-equipped hospitals and qualified medical care are available in Cairo. Water is considered potable in Cairo and Alexandria, not elsewhere.
Cultural mores and taboos: Things move at a slower pace; be patient and courteous. Get business cards in Arabic and English. Muslim injunctions against alcohol and pork prevail. Do not cross legs, point or gesture at someone with the hand, show the soles of the feet, or pass or accept items with the left hand. If invited to a mosque, dress to cover the entire body, remove shoes (tip the attendant who gives you slippers), and do not walk in front of others praying. Egyptian businessmen are very generous and warm and entertain lavishly. Business meetings are frequently interrupted by phone calls, tea, and other social niceties.
Photographic restrictions: Observe restrictions at antiquities; a fee is sometimes required.
Color labs: *Kodak (Egypt) S.A.:* 45 Safia Zaghloul Street, Alexandria; 20 Adly Street, Cairo; 3 Haroun El Rashed Street, Heliopolis, Cairo.
Gratuity guidelines: Service is included in the bill, but a little extra is expected. People performing numerous small services expect tips.

EL SALVADOR
Republic of El Salvador
República de El Salvador

Guerrilla warfare has resulted in travel difficulties—be sure to check with the State Department about dangers before going to El Salvador.
Location: Central America, bounded on the northwest by Guatemala, the north, northeast, and east by Honduras, and the south and southwest by the Pacific Ocean.
Size: 8,260 square miles, slightly smaller than Massachusetts.
Major cities: *San Salvador* (lat. +13.42).
Airports: El Salvador International Airport (SAL), 8 miles outside of San Salvador.
General transportation: Many international flights, with direct links to U.S. *U.S. license:* Yes, for 30 days with formalities on arrival. *IDP:* Yes. *Rule of the road:* Right. *Motor clubs:* Automóvil Club de El Salvador, Alameda Roosevelt y 41 Avenida sur 2173, San Salvador; *tel.* 23 80 77; partial AAA reciprocity. *Taxi markings:* Usually yellow, marked TAXI; set price.
Population: 5,400,000. *Type of government:* Republic. Democracy becoming established; human rights abuses decreasing. Violent insurgency still exists. Has traditionally close, cordial relations with the U.S.
Languages: Spanish, Nahua (among

some Indians). *Ethnic groups:* 89% mestizo, 10% Indian, 1% white. *Religion:* 97% Roman Catholic, with activity by Protestant groups throughout the country.

Time: EST −1; GMT −6. *Telephone codes:* Country code: 503. No city codes. Adequate domestic and international service. *Pay phone system:* Coins.

Holidays: January 1; Holy Thursday; Good Friday; May 1; August 3–6; September 15; October 12; November 2; December 25. *Date/month system:* D/M.

Business hours: 8 AM to 12 noon, 2 PM to 6 PM Monday to Friday; 8 AM to 12 noon Saturday. *Government hours:* 7:30 AM to 3:30 PM Monday to Friday. *Business dress code:* Same as that of the U.S.

Climate and terrain: Mountain ranges running east to west divide the country into 3 regions: a tropical, narrow Pacific coastal belt in the south; a subtropical central region of valleys and plateaus, where most live; a mountainous northern region. About 90% of the land is volcanic. Subject to violent earthquakes. The rainy season extends from May to October; the dry season, from November to April. *Temperature ranges* (San Salvador): January: 60° to 90°F; April: 65° to 93°F; July: 65° to 89°F; October: 65° to 87°F.

Visas: Standard tourist visa, requiring passport, $10 fee, 1 photo, proof of employ-ment and no criminal record; good for stays of up to 3 months; allow approximately 10 working days for approval. You must have at least $300 with you upon arrival. *Health requirements:* Yellow fever vaccination is required if coming from an infected area. *Equipment importation:* Bring equipment list to nearest Salvadoran consulate.

Electricity: 115/60. *Plug types:* A, B, G, I, and J.

Currency: Colon (SAC); Centavos.

U.S. embassy in the country: 25 Avenida Norte, no. 1230, San Salvador; *tel.* 267–100.

Embassy in U.S.: 2308 California Street NW, Washington, DC 20008; *tel.* 202–265–3480. *Consulates:* California: 415–781–7924; Florida: 305–371–8850; Louisiana: 504–522–4266; New York: 212–889–3608; Texas: 713–270–6239.

Central tourism office in country: Oficina Calle Rubin Diario, 619 San Salvador; *tel.* 266–666, 228–088.

Health suggestions: Water is considered potable in major urban areas. Malaria suppressants are recommended for some rural areas.

Cultural mores and taboos: Refer to "U.S. citizens" rather than "Americans"—Salvadorans also think of themselves as Americans, as indeed they should.

Gratuity guidelines: Same as those of the U.S.

EQUATORIAL GUINEA
Republic of Equatorial Guinea
República de Guinea Ecuatorial

Location: In western Africa, bounded on the north by Cameroon, the east and south by Gabon, and the west by the Atlantic Ocean; includes the islands of Bioko and Annobón. *Size:* 10,825 square miles, slightly larger than Maryland.

Major cities: *Malabo* (lat. +3.45). *Airports:* Santa Isabel (SSG), 5 miles outside of Malabo, on Bioko.

General transportation: Air links to a few other African capitals and Madrid. Air and maritime transport from Malabo to Bata on the mainland is irregular. Air charters can be arranged. Bus service is available from Malabo to Luba and Riaba. Accommodations in the four hotels in Malabo and the one in Bata are difficult to obtain. They have no restaurants, and utilities are occasionally interrupted. None are screened—bring mosquito netting and repellent. *Taxi markings:* Yellow, marked TAXI; set price; in short supply.

Population: 350,000. *Type of government:* Republic. Some progress toward sta-

bility has been made after the chaos of the Macias regime in the 1970s, which resulted in the death or exile of a third of the population and destruction of the economy, education, and infrastructure, but effective rule of law and political freedom does not yet exist. Diplomatic relations with the U.S. were reestablished in 1979.

Languages: Spanish (official), pidgin English, Fang. *Ethnic groups:* Indigenous population of Bantu origins: Bioko (15%), primarily Bubi, some Fernandinos; Río Muni (80%), primarily Fang; less than 1,000 Europeans, mostly Spanish. *Religion:* Almost all are at least nominally Roman Catholic, with strong indigenous influence.

Time: EST +6; GMT +1. *Telephone codes:* No direct-dial from U.S.—operator-assisted calls only. No credit card or collect calls to U.S. Domestic service is poor, with adequate service for government use. International service via Madrid is sometimes available in the daytime. *Pay phone system:* None.

Holidays: January 1; May 1; June 5; Corpus Christi (June); August 3, 15; October 12; December 10, 25. *Date/month system:* D/M.

Business hours: 8 AM to 6 PM Monday to Saturday. *Government hours:* 8 AM to 3 PM Monday to Friday; 8 AM to 12 noon Saturday.

Climate and terrain: The island region including Bioko is quite far from mainland Río Muni. Bioko is composed of two volcanic formations separated by a valley. The coastline is high and rugged in the south but more accessible in the north, with an excellent harbor at Malabo. Río Muni has a coastal plain that gives way to a succession of valleys, low hills, and a few mountain spurs. Its main river, Río Benito, is mostly nonnavigable. The climate is tropical, with heavy rainfall, high humidity, and violent windstorms. *Temperature ranges* (Malabo):

Visas: *Business visa:* Passport, 2 application forms, 2 photos, $20 fee, client letter, carry at least US$200 on person; good for stays of up to 30 days; allow 2 to 3 days for processing. *Tourists:* Tourist visa with similar requirements. *Health requirements:* Yellow fever and cholera vaccinations. *Equipment importation:* Bring equipment list to the consulate, where it will be notarized for a small fee. A bond will probably not be necessary.

Electricity: 220/50. *Plug types:* C.

Currency: Franc (CFA); subdivision (plural).

U.S. embassy in the country: Calle de Los Ministris, P.O. Box 597, Malabo; *tel.* 2406, 2507.

Embassy in U.S.: 801 Second Avenue, New York, NY 10017; *tel.* 212–599–1523.

Central tourism office in country: Ministry of Tourism, Malabo; *tel.* 3426.

Health suggestions: Extremely poor health and sanitary conditions exist. Tap water is not only unsafe but often unavailable—many bring bottled water. There is no adequate hospital and few trained physicians, no dentists. Medicines and equipment are limited. Typhoid, tetanus, polio, and measles inoculations are recommended. Malaria suppressants are necessary throughout the country. Insect protection (repellents, long clothing, netting) is a must.

Gratuity guidelines: Service is not usually included in the bill; tips are appreciated but not expected.

ETHIOPIA
People's Republic of Ethiopia
Hebretasebawit Etyopia

Travel is extremely restricted and potentially dangerous. Long history of warfare with separatist insurgents and border disputes make travel precarious outside of the capital. Foreigners might need government permit to leave Addis Ababa in any event.

Location: In eastern Africa, bounded on the north by the Red Sea, the east by Djibouti and Somalia, the south by Somalia and

Kenya, and the west and northwest by Sudan. *Size:* 471,775 square miles, slightly less than twice the size of Texas. **Major cities:** *Addis Ababa* (lat. +9.20). *Airports:* Bole Airport (ADD), 4 miles outside of Addis Ababa. **General transportation:** Air links to Europe, Africa, and the Middle East. Ethiopian Airlines serves the interior, flying to 43 airfields and 21 landing strips. Buses provide public transport, but they are crowded. Rental cars are available, but roads outside the cities are poor. The National Tour Organization (see **Central tourism office in country**) can arrange excursions. *U.S. license:* Yes, provided it is validated by stamp or slip in Amharic, available from police, travel agents, or motor club. *IDP:* Yes, with formalities on arrival. *Rule of the road:* Right. *Taxi markings:* Cream-colored Mercedes stationed outside hotels and airport; set price. Small blue-and-white taxis circulate, but they have their own itineraries and routes, and fares must be negotiated. **Population:** 48,300,000. *Type of government:* Communist state. Relations with the U.S. are strained, but as of this writing Ethiopia has indicated a desire for improved relations. **Languages:** Amharic (official), Tigrinya, Orominga, Arabic, English (most widely spoken foreign language and the one taught in school). *Ethnic groups:* 40% Oromo, 32% Amhara and Tigrean, 9% Sidamo, 6% Shankella, 6% Somali, 4% Afar, 2% Gurage, 1% other. *Religion:* 35% to 40% Ethiopian Orthodox (mostly in highlands), 40% to 45% Muslim and 15% to 20% animist (both mostly in lowlands), 5% other. **Time:** EST +8; GMT +3. *Telephone codes:* Country: 251. Addis Ababa 1, Akaki 1, Asmara 4, Aseb 3, Awash 6, Debre Zeit 1, Dese 3, Dire Dawa 5, Harer 5, Jima 7, Mekele 4, Mesewa 4, Nazereth 2, Shashemene 6. Service is adequate for government use; some domestic and international service available. *Pay phone system:* None. **Holidays:** January 7, 19; March 2; April 6; Ethiopian Good Friday and Easter; May 1; September 11, 12, 27; plus several religious holidays that vary—check with the consulate. *Date/month system:* Ethiopia follows the Julian calendar, which consists of 12 months of 30 days and a 13th month of 5 or 6 days. It is 7 years and 8 months behind the Gregorian calendar. The year starts in September.

Business hours: 8:30 AM to 1 PM, 3 PM to 8 PM Monday to Friday; 9 AM to 1 PM Saturday. *Government hours:* 8:30 AM to 1 PM, 3 PM to 6 PM Monday to Friday; 9 AM to 1 PM Saturday. *Business dress code:* Conservative.

Climate and terrain: High central plateau ranging from 6,000 to 10,000 feet, with peaks of 15,000 feet, gradually sloping to the lowlands of the Sudan on the west and the Somali-inhabited plains to the southeast. Great Rift Valley splits the plateau diagonally. A number of rivers cross the plateau, notably the Blue Nile rising from Lake Tana. Ethiopia is prone to drought. The climate is temperate on the plateau and hot in the lowlands. In Addis Ababa, the weather is usually sunny and dry, with intermittent showers from February to April and the "big rains" from late June to mid-September. *Temperature ranges* (Addis Ababa): January: 43° to 75°F; April: 50° to 77°F; July: 50° to 69°F; October: 45° to 75°F.

Visas: It is best if your contacts in the country contact the Ministry of Foreign Affairs on your behalf; failing that, contact the Ministry of Foreign Affairs, P.O. Box 393, Addis Ababa; *tel.* 447–345. They will also arrange for customs, so include an equipment list. Business and tourist visa forms are available at the embassy in the U.S.; visa requires passport, 1 photo, application, $9.65 fee. *Health requirements:* Yellow fever vaccination. *Equipment importation:* See **Visas,** above.

Electricity: 220/50. *Plug types:* C, D, and F.

Currency: Birr (ETB); Cents. Import/export allowed; no restrictions on foreign currency, but it must be declared; can be reconverted at airport. *Credit cards are not accepted for payment or cash advance*—be sure to be prepared to settle all accounts in cash.

U.S. embassy in the country: Entoto Street, P.O. Box 1014, Addis Ababa; *tel.* 110–666/117/129; *telex:* 21282.
Embassy in U.S.: 2134 Kalorama Road NW, Washington, DC 20008; *tel.* 202–234–2281/2.
Central tourism office in country: National Tourist Organization (NTO), P.O. Box 579, Addis Ababa; *tel.* 153–827; *telex:* 21370.
Health suggestions: Addis Ababa and Asmara have basic medical facilities. Water is not potable. Altitude can create problems (Addis Ababa is 8,000 feet above sea level). Health conditions in countryside and drought-relief camps have deteriorated with outbreaks of cholera, measles, and other diseases. Malaria suppressants are recommended except for Addis Ababa and areas over 6,000 feet above sea level.
Cultural mores and taboos: Food is generally eaten with the fingers, although utensils may be available for the visitor; never use the left hand. Never point. People are known for their stoicism and ability to endure hardship with complacency.
Photographic restrictions: Strict restrictions—be sure to check with your NTO representative.
Gratuity guidelines: Usually included in the bill; leaving a bit extra is customary. If not included, leave 10% to 15%.

FIJI
Dominion of Fiji

Location: In the southwestern Pacific Ocean, south of Tuvalu, east of Vanuatu, west of Tonga, north of New Zealand. *Size:* 6,938 square miles, slightly smaller than New Jersey.
Major cities: *Suva* (lat. −18.08). *Airports:* Nausori Airport (SUV), 15 miles outside of Suva.
General transportation: Small planes fly frequently to all major centers. Many paved roads, including a highway between Suva and Nandi and one encircling the main island of Viti Levu. Rental cars and air-conditioned intercity transport are available. *U.S. license:* Yes. *IDP:* Yes. *Rule of the road:* Left. *Taxi markings:* All colors, marked TAXI; metered.
Population: 741,000. *Type of government:* A military coup formally declared Fiji a republic on October 6, 1987.
Languages: English (official), Fijian, Hindustani (spoken by Indian population). *Ethnic groups:* 49% Indian, 46% Fijian, 5% European, other Pacific Islanders, overseas Chinese. *Religion:* Fijians are mainly Christian (78% Methodist, 8.5% Roman Catholic); Indians are mainly Hindu, with a Muslim minority.
Time: EST +17; GMT +12. *Telephone codes:* Country: 679. No city codes. Modern domestic and international service. *Pay phone system:* Coins.
Holidays: January 1; Good Friday; Easter Monday; Queen's Birthday (June); first Monday in August; Fiji Day (October); November 16; December 25, 26; plus a few varying holidays. *Date/month system:* D/M.
Business hours: 8 AM to 1 PM, 2 PM to 4 PM Monday to Friday. *Government hours:* 8 AM to 1 PM, 2 PM to 4:30 PM Monday to Friday, closing at 4 PM on Friday. *Business dress code:* Informal.
Climate and terrain: Consists of 322 islands, some tiny, about 100 of which are inhabited. The larger ones are mountainous. On the southeastern windward side, rainfall is heavy, creating dense tropical forests. Interior lowlands have less timber, are sheltered by the mountains, and have a well-marked dry season favorable to crops such as sugar. Tropical marine climate with high humidity and only slight seasonal temperature variations. Hurricanes occur from November to January. *Temperature ranges* (Suva): January: 74° to 86°F; April: 73° to 84°F; July: 68° to 79°F; October: 70° to 81°F.
Visas: Photographers should apply to the

Fijian embassy, where an application will be faxed to Fiji for a $25 fee. Approval can take 21 days. Include equipment list. *Tourists:* Passport and proof of return ticket for visa, which is available upon arrival for stays of up to 30 days; extensions to 6 months are available. *Health requirements:* Yellow fever vaccination is required if coming from an infected area. *Equipment importation:* Processed with visa.

Electricity: 240/50. *Plug types:* I.

Currency: Dollar (FI$); Cents.

U.S. embassy in the country: 31 Loftus Street, P.O. Box 218, Suva; *tel.* 314–466, 314–069; *telex:* 2255 AMEMBASY FJ.

Embassy in U.S.: 2233 Wisconsin Avenue NW, Washington, DC 20007; *tel.* 202–337–8320. *Consulates:* New York: 212–355–7316.

Tourism office in U.S.: Fiji Visitors Bureau, Los Angeles, California; *tel.* 213–417–2234.

Central tourism office in country: Fiji Visitors Bureau, Thomson Street, GPO Box 92, Suva; *tel.* 22867.

Health suggestions: Fiji is free of most tropical diseases, including malaria. Health care is adequate for routine problems. Drinking water is safe in all cities and major tourist resorts.

Cultural mores and taboos: It is customary to remove shoes when visiting a house; never refuse the cup of *kava* or *yagona* (a bitter drink made from root) that will be offered. A nod of the head or flick of the eyebrow is a greeting. It is respectful to fold one's arms while talking to Fijians. Fijians are known for hospitality, friendliness, and a relaxed manner. Strict punctuality is not observed.

Photographic restrictions: Military sites.

Gratuity guidelines: Tips are appreciated but not expected.

FINLAND
Republic of Finland
Suomen Tasavalta

Location: In northern Europe, bounded on the north by Norway, the east by the USSR, the south by the Gulf of Finland, and the west by the Gulf of Bothnia and Sweden. *Size:* 130,128 square miles, about the size of New England, New York, and New Jersey combined.

Major cities: *Helsinki* (lat. +60.10). *Airports:* Helsinki-Vantaa (HEL), 11 miles outside of Helsinki.

General transportation: Excellent, with one of the finest domestic air systems in Europe, well-maintained roads, and fine public transport, including a subway system in Helsinki. *U.S. license:* Yes. *IDP:* Yes. *Rule of the road:* Right. *Motor clubs:* Autolitto, Automobile and Touring Club of Finland, Kansakoulukatu 10, Helsinki; *tel.* 694–0022; partial AAA reciprocity. *Taxi markings:* All colors, all types, marked TAKSI; metered. Taxi drivers are not customarily tipped.

Population: 4,900,000. *Type of govern-*

ment: Constitutional republic; democracy with parliament (Eduskunta) and strong president who serves for 6 years. Firm policy of neutrality in international affairs as well as good relations with Soviet neighbor. Enjoys cordial relations and active trade with U.S.

Languages: Officially Finnish and Swedish. English and German are commonly understood in business. *Ethnic groups:* Finns, Swedes, Lapps, gypsies, Tatars. *Religion:* 97% Evangelical Lutheran, 1.2% Eastern Orthodox, 1.8% other.

Time: EST +7; GMT +2. *Telephone codes:* Country: 358. Espoo (Esbo) 15, Helsinki 0, Joensuu 73, Jyväskylä 41, Kuopio 71, Lahti 18, Lappeenranta 53, Oulu (Uleåborg) 81, Pori 39, Tampere (Tammerfors) 31, Turku 21, Vaasa 61, Vantaa (Vanda) 0. Excellent domestic and international service. *Pay phone system:* Coins.

Holidays: January 1; Good Friday; Easter Monday; May 1; Midsummer night (Friday

nearest June 24); December 6, 24, 25, 26; plus several religious holidays adjusted to fall on Saturdays: Epiphany (January), Ascension Day (40 days after Easter), Whitsunday, or Pentecost (June), and All Saints Day (November). *Date/month system:* D/M.

Business hours: 9 AM to 5 PM Monday to Friday. *Government hours:* 8:15 AM to 4:15 PM Monday to Friday (with shorter hours in summer). *Business dress code:* Same as that of the U.S.

Climate and terrain: Mostly low, flat to rolling plains interspersed with lakes and low hills. Heavily forested (76%), population concentrated on small southwestern coastal plain. Northern Lapland has distinct character. Cold temperate climate, its subarctic potential moderated by the influence of the North Atlantic Current off the northern Norwegian coast, the Baltic Sea in the south, and its extensive forests and 60,000 lakes. *Temperature ranges* (Helsinki): January: 17° to 27°F; April: 31° to 43°F; July: 57° to 71°F; October: 37° to 45°F.

Visas: Standard tourist entry, requiring passport; no visa is needed for stays of up to 3 months (period begins after entering Scandinavian country—Finland, Denmark, Iceland, Norway, and Sweden). *Health requirements:* No vaccinations required. *Equipment importation:* Carnet.

Electricity: 220/50. *Plug types:* C and F. **Currency:** Markkaa (FIM); Penni.

U.S. embassy in the country: Itainen Puistotie 14, ASF-00140, Helsinki; *tel.* 171–931; *telex:* 121644 USEMB SF.

Embassy in U.S.: 3216 New Mexico Avenue NW, Washington, DC 20016; *tel.* 202–363–2430. *Consulates:* California: 213–203–9903; New York: 212–832–6550.

Tourism office in U.S.: Finnish Tourist Board, 655 Third Avenue, New York, NY 10017; *tel.* 212–949–2333.

Central tourism office in country: Finnish Tourist Board, Unioninkatu 26, Helsinki; *tel.* 144–511.

Health suggestions: Excellent health standards and medical care. Water is potable.

Cultural mores and taboos: Punctuality is essential in business. An invitation to the sauna is an important compliment.

Photographic restrictions: Military sites; check about aerial photography permits and restrictions.

Color labs: *Kodak* Oy, PL 19, 01511 Vantaa 51. *Fuji Film* Kuvuapalvelu, Biopta OY, Pl 4, 00211 Helsinki 21.

Equipment rental/sales: *Balcar:* Mv Kuvat, Helsinki; *tel.* 582–246. *Broncolor:* EIRI, Eino Riihela Ky, Lahti; *tel.* (18) 339–211. *Comet:* Pohjoismainen Koulukuva, Vaasa; *tel.* (61) 221–601. *Profoto:* Finlandia Kuva OY, Helsinki; *tel.* 848–455.

Gratuity guidelines: Service is always included in the bill; giving a bit more is customary but by no means necessary.

FRANCE
French Republic
République Française

Location: In western Europe, bounded on the north by the English Channel, the northeast by Belgium and Luxembourg, the east by West Germany, Switzerland, and Italy, the south by the Mediterranean Sea, Spain, and Andorra, and the west by the Bay of Biscay. *Size:* 212,918 square miles, slightly more than twice the size of Colorado.

Major cities: *Paris* (lat. +48.49). *Airports:* Charles de Gaulle Airport (CDG), 15 miles outside of Paris; Orly Airport (ORY),

9 miles outside of Paris; Le Bourget (LBG), 8 miles outside of Paris.

General transportation: Excellent; Paris has a particularly fine subway. *U.S. license:* Yes. *IDP:* Yes. *Rule of the road:* Left. *Motor clubs:* Automobile-Club de France, 6–8, Place de la Concorde, Paris; *tel.* 42–65–43–70; partial AAA reciprocity. *Taxi markings:* All colors, marked TAXI; metered.

Population: 55,800,000. *Type of govern-*

ment: Republic, with president whose previously wide powers have been somewhat curtailed by current power-sharing arrangement with prime minister. Active, close relations with the U.S.
Languages: French, with rapidly declining regional dialects. English is understood by many in business circles. *Ethnic groups:* Celtic and Latin with Teutonic, Slavic, North African, Indochinese, and Basque minorities. *Religion:* 90% Roman Catholic, 2% Protestant, 1% Jewish, 1% Muslim, 6% unaffiliated.
Time: EST + 6; GMT + 1. *Telephone codes:* Country: 33. Aix-en-Provence 42, Bordeaux 56, Cannes 93, Chauvigny 49, Cherbourg 33, Grenoble 76, Le Havre 35, Lourdes 62, Lyons 7, Marseilles 91, Nancy 8, Nice 93, Paris 1 (all codes in the Paris area are 1 plus 8 digits; the first of the 8 digits will be 3, 4, or 6), Rouen 35, Toulouse 61, Tours 47. Excellent domestic and international service. *Pay phone system:* Coins or *jetons* (tokens), but increasingly cards are available at newsstands.
Holidays: January 1; Easter Monday; May 1, 8; Ascension Day (40 days after Easter); Whit Monday (varies—early June); July 13, 14; August 15; November 1, 2, 11; December 25, 26. August is the traditional vacation month, life in Paris particularly slows down. *Date/month system:* D/M.
Business hours: 9 AM to 12 noon, 2 PM to 6 PM Monday to Friday. *Government hours:* 8:30 AM to 12 noon, 2 PM to 6 PM Monday to Friday. *Business dress code:* Conservative.
Climate and terrain: Two-thirds flat plains or gently rolling hills, one-third mountainous, meeting the Pyrenees in the southwest and the Alps in the east. Principal rivers include the Rhone in the south, the Loire and Garonne in the west, the Seine in the north, and the Rhine on the eastern border with Germany. Northern and western France have cool winters and mild summers. Southern France enjoys a Mediterranean climate of hot summers and mild winters. *Temperature ranges* (Paris): January: 32° to

42°F; April: 41° to 60°F; July: 55° to 76°F; October: 44° to 59°F.
Visa: Standard tourist visa, requiring passport (valid for 2 months beyond the length of the visa), 1 application, 1 photo (optional); must be obtained in advance; $9 fee for multiple-entry visa valid for 3 months; $15 for multiple-entry visa valid for 1 to 3 years for stays not exceeding 90 days. *Transit visa:* $3 for 1 to 3 days. *Health requirements:* No vaccinations required. *Equipment importation:* Carnet.
Electricity: Mostly 220/50, some 110V. *Plug types:* C, E, F, and G.
Currency: Franc (FFR); Centimes.
U.S. embassy in the country: 2 Avenue Gabriel, 75382 Paris; *tel.* 42–96–12–02, 42–61–80–75; *telex:* 650–221. *Consulates:* Bordeaux: 56–52–65–95; Lyons: 78–24–68–49; Marseilles: 549–200; Strasbourg: 88–35–31–04.
Embassy in U.S.: 4101 Reservoir Road NW, Washington, DC 20007; *tel.* 202–944–6000. *Consulates:* California: 213–653–3120, 415–397–4330; Florida: 305–372–9798; Hawaii: 808–599–4458; Illinois: 312–787–5359; Louisiana: 504–897–6381; Massachusetts: 617–266–1680; Michigan: 313–568–0990; New York: 212–535–0100; Texas: 713–528–2183.
Tourism office in U.S.: French Government Tourist Office, 610 Fifth Avenue, New York, NY 10020; *tel.* 212–757–1125.
Central tourism office in country: Maison de la France, Service Accueil, 10 Avenue de la Opéra, 75001 Paris; *tel.* (1) 42–96–10–23.
Health suggestions: Health and medical standards are good. Water is potable (and, by law, is marked when it is not).
Cultural mores and taboos: Punctuality is important. France is very bureaucratic; decisions can take time. Patience is required. Privacy is highly prized; avoid personal and family questions as well as inquiries about business affairs. No country is more proud of its culture.
Photographic restrictions: Significant shooting on the street in Paris requires a per-

mit, but this can take 3 weeks to acquire. A policeman can force you to leave without one.

Color labs: *Kodak-Pathe:* 6 locations: Sevran, Marseilles, Bordeaux, Rennes, Nice, Chalon-sur-Saône. **Equipment rental/sales:** *Balcar:* Balcar S.A., 32 Boulevard Flandrin, Paris 75116, *tel.* 4503–0030, *telex:* 842/611628; Intercolor, Lyons, *tel.* 727571; Photorep, Stras-

bourg, *tel.* 60–44–31; Studio Pyramide, Nice, *tel.* 85–51–45; Paris Occitanie Présentations, Montpellier, *tel.* (67) 64 59 62. *Broncolor:* Broncolor Sarl, 38 rue de Gerardmer, 68200 Mulhouse-Bourtzwiller; 8 rue Nouvelle, 94200 Ivry-sur-Seine. *Profoto:* Techni Cinephot, Saint-Ouen, *tel.* (14) 257–1130.

Gratuity guidelines: Service is usually included in the bill; a bit more is given for exceptional service.

FRENCH GUIANA
Department of French Guiana
Guyane Française

Location: In northeastern South America, bounded on the north by the Atlantic Ocean, the east and south by Brazil, and the west by Surinam. **Size:** 35,135 square miles, slightly smaller than Indiana. **Major cities:** *Cayenne* (lat. +4.56). **Airports:** Rochambeau (CAY), 11 miles outside of Cayenne.

General transportation: International flights to Miami, Paris, Puerto Rico, and several other destinations in South America and the Caribbean. Air transport and motorized canoe trips are available to the unspoiled interior. Kourou was the center of the old Devil's Island penal colony and is now a commercial space center. Rental cars are available. *U.S. license:* No. *IDP:* Yes. *Rule of the road:* Right. *Taxi markings:* Only unmarked, telephone-dispatched cabs are available.

Population: 91,000. *Type of government:* Overseas department (territory) of France, sending 1 senator and 1 deputy to the French parliament. Administered locally by a prefect and a council general of 16 elected members.

Languages: French; very little English is spoken. *Ethnic groups:* 66% black or mulatto, 12% white, 12% East Indian, Chinese, Amerindian, 10% other. *Religion:* predominantly Roman Catholic.

Time: EST +2; GMT −4. *Telephone codes:* Country: 594. No city codes. No

credit card calls to U.S. Fair domestic and international service. *Pay phone system:* Coins.

Holidays: January 1; Carnaval preceding Lent and including Ash Wednesday; Good Friday; Holy Saturday; May 1, 8; Ascension Day (40 days after Easter); Whit Monday (varies—early June); July 13, 14; August 15; November 1, 2, 11; December 25. *Date/month system:* D/M.

Business hours: 8 AM to 6 PM Monday to Friday. *Business dress code:* More informal than U.S.

Climate and terrain: Low coastal plain rising to hills and small mountains. Most of the country is an unsettled wilderness of tropical rain forest of the Amazon basin. Hot, humid tropical climate; the wet season is from December to June. *Temperature ranges* (Cayenne): January: 74°–84°F; April: 75° to 86°F; July: 73° to 88°F; October: 74° to 91°F.

Visas: See France for visa details. *Health requirements:* Yellow fever vaccination may be required and is recommended by CDC for travel outside urban areas. *Equipment importation:* Data unavailable, but Carnet should be accepted.

Electricity: 220/50. *Plug types:* C, D, and E.

Currency: French Franc (FFR); Centimes.

U.S. embassy in the country: None. The U.S. consulate in Martinique handles mat-

ters for all French departments in the region. Contact the consulate at 14 rue Blenac, B.P. 561, Fort-de-France, Martinique; *tel.* 63–13–03; *telex:* 912670, 912315 MR.

Embassy in U.S.: Care of the French embassy, 4101 Reservoir Road NW, Washington, DC 20007; *tel.* 202–944–6000.

Health suggestions: Malaria suppressants are recommended throughout the territory.

Water is considered potable in major towns. Medical facilities are available for basic needs but have few English-speaking personnel. Few American drugs, but a wide range of French pharmaceuticals is available. Insects are a problem.

Gratuity guidelines: Tips are not usually included in the bill; leaving 10% to 15% is customary.

GABON
Gabonese Republic
République Gabonaise

Location: In west-central Africa, bounded on the northwest by Equatorial Guinea, the north by Cameroon, the east and south by Congo, and the west by the Atlantic Ocean. *Size:* 102,317 square miles, slightly smaller than Colorado.

Major cities: *Libreville* (lat. +0.23). *Airports:* Libreville Airport (LBV), 8 miles outside of Libreville.

General transportation: International flights to Europe (with connections to U.S.) and Africa. Air Gabon and several charters operate one of the densest air networks in Africa. Nearly all population centers are linked by jet. No bus service in Libreville. Rental cars are available. *U.S. license:* Yes. *IDP:* Yes. *Rule of the road:* Right. *Taxi markings:* Black with numbers on door; set price. Taxis are usually shared but can be monopolized by paying more. Taxis with chauffeurs are inexpensive and more commonly used by visitors.

Population: 1,050,000. *Type of government:* Republic; one-party presidential regime since 1964; open participation; excellent relations with the U.S.

Languages: French (official), indigenous languages. English is rarely understood. *Ethnic groups:* About 40 Bantu tribes, including four major groupings (Fang, Eshira, Bapounou, Bateke); about 100,000 expatriate Africans and Europeans, including 27,000 French. *Religion:* 55% to 75% Christian, less than 1% Muslim, remainder animist.

Time: EST +6; GMT +1. *Telephone codes:* Country: 241. No city codes. Adequate domestic and international service. International rates are about 10 times higher than in the U.S. *Pay phone system:* Coins.

Holidays: January 1; March 12; Easter Monday; May 1; Pentecost Monday; August 16, 17, 18; December 25; plus a few Muslim holidays. *Date/month system:* D/M.

Business hours: 8 AM to 12 noon, 3 PM to 6 PM Monday to Saturday; some offices closed Saturday afternoon. *Government hours:* 9:30 AM to 12 noon, 3:30 PM to 5:30 PM Monday to Friday; 9:30 AM to 12 noon Saturday. *Business dress code:* Same as that of the U.S., but heat is a consideration.

Climate and terrain: Dense equatorial rain forest. Narrow coastal plain; hilly interior; savanna in east and south. The Ogooué River is navigable from N'Djolé to the Atlantic. Tropical heat and humidity year-round. Cooler, cloudy, and only slightly less humid in the dry season from June to September. Occasional rain in December to January; heavy rainfall the remaining months. *Temperature ranges* (Libreville): January: 73° to 87°F; April: 73° to 89°F; July: 68° to 83°F; October: 71° to 86°F.

Visas: *Business visa:* 2 applications, 2 photos, passport, client letter including contacts in Gabon, $20 fee; good for 4 months; allow 2 days for processing. *Tourists:* Tourist visa with many of the same requirements, including extensive travel plan information but

without client letter. *Health requirements:* Yellow fever and cholera vaccinations. *Equipment importation:* Bring equipment list; no bond is necessary.

Electricity: 220/50. *Plug types:* C and E.

Currency: Franc (CFA); subdivision (plural).

U.S. embassy in the country: Boulevard de la Mer, B.P. 4000, Libreville; *tel.* 762003/4, 761337, 721348, 740248; *telex:* 5250 GO.

Embassy in U.S.: 2034 Twentieth Street NW, Washington, DC 20009; *tel.* 202–797–1000.

Tourism office in U.S.: Gabon Tourist Office, 516 Fifth Avenue, Suite 205, New York, NY 10036; *tel.* 212–719–2031.

Central tourism office in country: Minis-try of Tourism, P.O. Box 403, Libreville; *tel.* 764–959.

Health suggestions: In addition to the required yellow fever and cholera vaccinations, malaria suppressants are recommended. Hospitals and private clinics are available in major centers for routine problems, with some U.S.-trained doctors. Tap water is not potable.

Photographic restrictions: Presidential palace, airports, ports, radio stations, military. Advisable to ask permission before photographing people on the street.

Gratuity guidelines: Service is usually not included in the bill. Smaller tips of 5% are common.

GAMBIA
Republic of the Gambia

Location: In northwestern Africa, bounded on the north, east, and south by Senegal, and the west by the Atlantic Ocean. *Size:* 4,003 square miles, smaller than Connecticut.

Major cities: *Banjul* (lat. +13.28). *Airports:* Yundum International Airport (BJL), 20 miles outside of Banjul.

General transportation: A few international flights to London; only 25 minutes by air to Dakar, where worldwide connections are frequent and excellent. *U.S. license:* Yes, for 3 months, with formalities on arrival. *IDP:* Yes, for 3 months, with formalities on arrival. *Rule of the road:* Right. *Taxi markings:* All colors; set prices, to be agreed upon ahead of time; available at stands.

Population: 780,000. *Type of government:* Republic. On February 1, 1982, the Gambia and Senegal formed a loose confederation named Senegambia that calls for eventual integration of their armed forces and economic cooperation. Constitutional, genuinely multiparty system with a good human rights record. With exception of bloody coup attempt in 1981, Gambia is politically stable. Friendly ties with U.S.

Languages: English (official), indigenous languages. *Ethnic groups:* 42% Mandinka, 18% Fula; 16% Wolof, 10% Jola, 9% Serahuli, 4% other; 1,200 non-Gambian including about 500 Europeans, mostly British. *Religion:* 90% Muslim, 9% Christian, 1% indigenous beliefs.

Time: EST +5; GMT 0. *Telephone codes:* Country: 220. No city codes. No credit card or collect calls to U.S. Adequate domestic and international service. *Pay phone system:* Coins.

Holidays: January 1; February 1, 18; Good Friday; May 1; August 15; December 25; plus several Muslim holidays. *Date/month system:* D/M.

Business hours: 8 AM to 12 noon, 2 PM to 5 PM Monday to Friday; 8 AM to 12 noon Saturday. *Government hours:* 8 AM to 2:45 PM Monday to Thursday; 8 AM to 12:45 PM Friday to Saturday. *Business dress code:* Same as that of the U.S. for high-level government or business meetings, otherwise a bit more informal.

Climate and terrain: Long strip around the Gambia river, completely surrounded by Senegal. Floodplain flanked by some low hills. Thick mangrove swamps border the lower half of the Gambia River, with vegeta-

tion as high as 100 feet tall. Subtropical climate with marked hot rainy season from June to October; cooler dry season from November to May. *Temperature ranges* (Banjul): January: 59° to 88°F; April: 65° to 91°F; July: 74° to 86°F; October: 72° to 89°F. **Visas:** *Tourists:* Tourist visa, requiring passport, 2 applications, 2 photos, $8 fee; valid for 3 months. *Health requirements:* Yellow fever vaccination is required if coming from an infected area or any country in the endemic zone and is recommended by CDC for travel outside urban areas. *Equipment importation:* Send equipment list to the Ministry of Information and Tourism (see **Central tourism office in country,** below) to assist with customs, but a bond is probably not necessary. **Electricity:** 220/50. *Plug types:* G. **Currency:** Dalasi (GAD); Butut. **U.S. embassy in the country:** Fajara, Kairaba Avenue, P.M.B. No. 19, Banjul; *tel.* Serrekunda 92856, 92858, 91970/1; *telex:* 2229 AMEMB GV. **Embassy in U.S.:** 1030 Fifteenth Street

NW, Suite 720, Washington, DC 20005; *tel.* 202-842-1356, 842-1359. *Consulates:* New York: 212-949-6640.

Central tourism office in country: Ministry of Information and Tourism, The Quadrangle, Banjul; *tel.* 28496.

Health suggestions: Sanitation in Banjul is fair; water is considered potable. Yellow fever, typhoid, typhus, tetanus, and rabies treatments and malaria suppressants are recommended. Swamps around Banjul breed mosquitoes.

Cultural mores and taboos: Great emphasis on courtesy and polite manners. Muslim injunctions against alcohol and pork prevail.

Photographic restrictions: Photograph for publication will require permission from the Ministry of Information and Tourism (see **Central tourism office in country,** above). They may also require copies of the finished product and may suggest a guide from their film unit.

Gratuity guidelines: Tips are usually included in the bill.

GERMANY, EAST
German Democratic Republic
Deutsche Demokratische Republik

Location: In north-central Europe, bounded on the north by the Baltic Sea, the east by Poland, the south by Czechoslovakia and West Germany, and the west by West Germany. *Size:* 41,766 square miles, slightly smaller than Tennessee.

Major cities: *East Berlin*—not officially recognized by France, the United Kingdom, and the U.S., which together with the USSR have special rights and responsibilities in Berlin (lat. +52.27). *Airports:* Schoenfeld Airport (SXF), 12 miles outside of East Berlin.

General transportation: Direct flights from some western capitals but not U.S. Good public transport. *U.S. license:* Yes. *IDP:* Yes. *Rule of the road:* Right. *Taxi markings:* Marked TAXI; metered.

Population: 16,600,000. *Type of government:* Communist state. Higher standard of living than other Communist countries. Established relations with the U.S. in September 1984. Since then, there has been a modest but steady expansion of trade and cultural and other contacts.

Languages: German. *Ethnic groups:* 99.7% German, .03% Slavic (Serbs) and other. *Religion:* Traditionally 47% Protestant, 46% unaffiliated or other, 7% Roman Catholic; less than 5% of Protestants and 25% of Roman Catholics are active participants.

Time: EST +6; GMT +1. *Telephone codes:* Country: 37. Cottbus 59, Dresden 51, East Berlin 2, Erfurt 61, Gera 70, Halle 46, Karl-Marx-Stadt 71, Leipzig 41, Magdeburg

91, Neubrandenburg 90, Potsdam 33, Rostock 81, Schwerin 84, Suhl 66, Zittau 522. **Pay phone system:** Coins.

Holidays: January 1; Good Friday; May 1; Whit Monday (varies—early June); October 7; December 25, 26. If May 1 or October 7 falls on a Tuesday or Thursday, most offices will be closed the preceding Monday or following Friday to create a 4-day weekend. **Date/month system:** D/M.

Business and government hours: 8 AM to 4 PM Monday to Friday. **Business dress code:** Conservative.

Climate and terrain: Mostly flat plains with hills and mountains in the south, with several important rivers. Climate is temperate. Cloudy, cold winters with frequent rain and snow; cool, wet summers. **Temperature ranges** (East Berlin): January: 26° to 35°F; April: 38° to 55°F; July: 55° to 74°F; October: 41° to 55°F.

Visas: Professional trips require application to the Embassy Press Attaché or directly to the Department of Journalistic Relations, Ministry of Foreign Affairs, Berlin; *tel.* 233–3300; *telex:* 114621. Include photographer letter with itinerary, passport number, date of birth, address, client affiliation if possible (this will help), and equipment list to arrange for customs. *Official (nontourist) travelers should consult the Department of State before traveling or applying for visas. Tourists:* Visas are issued by embassy or at border-crossing points upon presentation of travel vouchers (based on confirmed hotel reservations) or visa entitlement certificates (for making private arrangements such as staying

with relatives or friends, obtained from the GDR Reisebüro or travel agents; requires 6 weeks processing); 15 GDR single-entry fee, 40 GDR multiple-entry fee. One-day visits to East Berlin from West Berlin can be arranged without advance application at the sector-crossing line. **Health requirements:** No vaccinations required. **Equipment importation:** Apply for with visa (see above).

Electricity: 220/50. **Plug types:** C and F.

Currency: Mark (GDR); Pfennig. Very strict currency controls. Serious offense to import or export currency. Keep all exchange receipts with you at all times.

U.S. embassy in the country: Neustädtische Kirchstrasse 4–5, 1080 Berlin; *tel.* 220–2741; *telex:* 112479 USEMB DD.

Embassy in U.S.: 1717 Massachusetts Avenue NW, Washington, DC 20036; *tel.* 202–232–3134.

Central tourism office in country: Reisebüro der DDR, PF 77, Berlin 1020; *tel.* 2150; *telex:* 114648, 114651.

Health suggestions: Water is potable.

Cultural mores and taboos: Decisions take time; patience is necessary. Be discreet.

Photographic restrictions: The government is sensitive about photography, and forbids photos of police, military, bridges, fortifications, railways, elevated trains, border areas, East/West Berlin barriers, and photographs from moving trains, but permission can be obtained from the Foreign Ministry.

Gratuity guidelines: Tipping has been officially abolished, but tips are accepted in major tourist hotels and restaurants.

GERMANY, WEST
Federal Republic of Germany
Bundesrepublik Deutschland

Location: In west-central Europe, bounded on the north by the North Sea and Denmark, the east by East Germany and Czechoslovakia, the southeast by Austria, the south by Austria and Switzerland, the southwest by France, and the west by Luxembourg, Belgium, and the Netherlands.

Size: 95,936 square miles, slightly smaller than Oregon.

Major cities: Frankfurt (lat. +50.07), Munich (lat. +48.09), Hamburg (lat. +53.33), West Berlin (lat. +52.27), *Bonn* (lat. +50.44). **Airports:** Frankfurt International Airport (FRA), 6 miles outside of

Frankfurt; Riem Airport (MUN), 6 miles outside of Munich; Fuhlsbüttel (HAM), 8 miles outside of Hamburg; Berlin-Tegel International Airport (TXL), 5 miles outside of West Berlin. **General transportation:** Frankfurt is the center of European air traffic. Express trains are available, and the famous Autobahn connects most major cities by road. Mass transit is crowded but efficient. *U.S. license:* Yes, with German translation. *IDP:* Yes. *Rule of the road:* Right. *Motor clubs:* Allgemeiner Deutscher Automobil-Club E.V. (ADAC), Am Westpark 8, Munich; *tel.* 76 76-0; full AAA reciprocity. *Taxi markings:* All colors; metered; at stands and telephone-dispatched. **Population:** 61,000,000. *Type of government:* Federal republic; parliamentary system with constitution and protection of individual freedoms. Politically stable since 1949. Enjoys very close relations with the U.S. **Languages:** German; English is widely understood. *Ethnic groups:* Primarily German, with a 7.1% population of foreign guest workers and dependents and a small Danish minority in the north. *Religion:* 45% Roman Catholic, 44% Protestant, 11% other. **Time:** EST +6; GMT +1. *Telephone codes:* Country: 49. Bad Homburg 6172, Berlin (West) 30, Bonn 228, Bremen 421, Cologne (Köln) 221, Düsseldorf 211, Essen 201, Frankfurt 69, Hamburg 40, Heidelberg 6221, Koblenz 261, Mannheim 621, Munich 89, Nürnberg 911, Stuttgart 711, Wiesbaden 6121. Excellent domestic and international service. *Pay phone system:* Coins. **Holidays:** January 1; Good Friday; Easter Monday; May 1; Ascension Day (40 days after Easter); Whit Monday (varies—early June); June 17; November 1 (with some exceptions); Repentance Day (November); December 25, 26; plus other religious holidays celebrated regionally. Business slows down considerably in July and August, popular vacation months. *Date/month system:* D/M. **Business hours:** 9 AM to 5 PM Monday to Friday. *Government hours:* 9 AM to 12:30

PM, 2 PM to 5 PM Monday to Friday. *Business dress code:* Conservative.

Climate and terrain: Plains in the northern lowlands, central uplands, Bavarian Alps in the south. The Rhine in the west is the most important commercial waterway in Europe. In the southwest is the Black Forest, so named because the deep green firs and thick cover keep the ground in twilight. Climate varies but is mostly maritime and temperate. Cool, cloudy, wet winters and summers. Sometimes, during a low-pressure system, the country experiences the Föhn, a warm, tropical wind similar to the French Mistral or American Chinook. *Temperature ranges* (Frankfurt): January: 29° to 37°F; April: 41° to 58°F; July: 56° to 75°F; October: 43° to 56°F.

Visas: Standard tourist entry, requiring a passport; no visa is needed for stays of up to 3 months. *Health requirements:* No vaccinations required. *Equipment importation:* Carnet.

Electricity: 220/50. *Plug types:* F.

Currency: Deutsche Mark (DMK); Pfennig.

U.S. embassy in the country: Deichmanns Avenue, 5300 Bonn; *tel.* 3391; *telex:* 885–452. *Consulates:* Berlin: 83240 87; Frankfurt: 75305-0 or 75304-0; Hamburg: 44 1061; Munich: 23011; Stuttgart: 21 02 21.

Embassy in U.S.: 4645 Reservoir Road NW, Washington, DC 20007; *tel.* 202–298–4000. *Consulates:* California: 415–775–1061; Florida: 305–358–0290; Georgia: 404–659–4760; Illinois: 312–263–0850; Massachusetts: 617–536–4414; Michigan: 313–962–6526; New York: 212–308–8700; Texas: 713–627–7770.

Tourism office in U.S.: German National Tourist Office, 747 Third Avenue, New York, NY 10017; *tel.* 212–308–3300.

Central tourism office in foreign country: Deutsches Zentrale für Tourismus, Beethoven Street; #69, Frankfurt 6000-CD; *tel.* 75720.

Health suggestions: Health standards and water quality equal or exceed those in the U.S.

Cultural mores and taboos: Business eth-

ics are strictly regulated by law. Avoid any large gifts in business. Punctuality is important. Academic and job titles are important and should be used where possible. First names are reserved for friendship. Business meetings get straight to the point. Secrecy is important in business, and decisions often require consultation at the top. Refer to the "Federal Republic of Germany," not "West Germany."
Color labs: *Kodak Farblabor,* Postfach 600345, 7000 Stuttgart 60 (Wangen). *Fuji Color Service,* Postfach 3131, D-4000 Düsseldorf II.
Equipment rental/sales: Balcar: P.P.S.

Photo Professional Service, Hamburg; *tel.* 431–061. C.C.D. Creative Color, Düsseldorf; *tel.* 384–1010. K. Truckenmuller Fotovertretungen, Munich; *tel.* 448–9610. Blitzmuller Reinhard Muller, Munich; *tel.* 570–3714. *Broncolor:* 11 locations throughout Germany—contact Sinar Bron, 201–754–5800, for complete list. *Profoto:* Linhol Vertriebs, Munich; *tel.* 72492 248. *Film commissions:* Film Information Office, Türkenstrasse 93, 8000 Munich 40; *tel.* 819–0431/2.
Gratuity guidelines: 10% to 15% is often included, but leaving an extra 5% to 10% is customary.

GHANA
Republic of Ghana

Be particularly careful to avoid arrest in Ghana. Americans arrested here have endured extremely harsh conditions and had difficulties notifying the U.S. embassy.
Location: In western Africa, bounded on the north and northwest by Burkina Faso, the east by Togo, the south by the Gulf of Guinea, and the west by Côte d'Ivoire. *Size:* 92,100 square miles, slightly smaller than Oregon.
Major cities: *Accra* (lat. +5.33). *Airports:* Kotoka Airport (ACC), 8 miles outside of Accra.
General transportation: Flights to Europe (with connections to U.S.), Africa, and several other international destinations. Domestic flights, railways, and roads connect the three major regional capitals of Accra, Kumasi, and Sekondi-Takoradi. Mini *tro-tro* buses provide public transport. Rental cars are available. *U.S. license:* No. *IDP:* Yes. *Rule of the road:* Right. *Motor clubs:* Automobile Association of Ghana, Fanum House, no. 1 Valley View, Osu'Accra; *tel.* 75 98 3, 74 22 9; partial AAA reciprocity. *Taxi markings:* Yellow fenders, marked TAXI; set price, agree on price in advance.
Population: 14,400,000. *Type of government:* Military. After 1981 coup, the constitution was suspended, the president and cabinet were dismissed, parliament was

dissolved, and existing political parties were outlawed. U.S. relations were strained after the coup but were resumed in June 1984 and have improved since then.
Languages: English is the language of business, government, and social life. *Ethnic groups:* 44% Akan, 16% Moshi-Dagomba, 13% Ewe, 8% Ga, 0.2% European and other. *Religion:* 38% indigenous beliefs, 30% Muslim, 24% Christian, 8% other.
Time: EST +5; GMT 0. *Telephone codes:* No direct-dial from U.S.—operator-assisted calls only. No credit card or collect calls to U.S. Fair domestic service. International service is improving but is subject to delays. *Pay phone system:* Coins.
Holidays: January 1; March 6; Good Friday; Easter Monday; September 24; December 25, 26. *Date/month system:* D/M.
Business hours: 8 AM to 12 noon, 2 PM to 4:30 PM Monday to Friday; some businesses are open on Saturday morning. *Government hours:* 8 AM to 12:30 PM, 2 PM to 5 PM Monday to Friday. *Business dress code:* Same as that of the U.S. *Note: Wearing military apparel, such as camouflage jackets or pants or any clothing that may appear military in nature, is strictly prohibited.*
Climate and terrain: Low, sandy coastline backed by plains and scrub and intersected by several rivers and streams, most of which

are navigable only by canoe. A tropical rain forest belt, known as the Ashanti, broken by heavily forested hills and rivers and streams, extends northward from the shore near the western border. North of this belt the country is covered by low bush, parklike savanna, and grassy plains. Lake Volta, the world's largest artificial lake, dominates the southeast. The climate is tropical. The eastern coastal belt is warm and comparatively dry; the southwest corner, hot and humid; the north, hot and dry. Except for the north, where the rainy seasons tend to merge, two rainy seasons are separated by a short, fairly dry period from July to August and a longer period from December to February. A dry, northeasterly wind, the harmattan, blows from January to February. *Temperature ranges* (Accra): January: 73° to 87°F; April: 76° to 88°F; July: 73° to 81°F; October: 74° to 85°F.

Visas: Standard tourist visa, valid for 30 days, requiring passport, 4 photos, proof of return ticket/sufficient funds; allow 3 days for processing. *Health requirements:* Yellow fever and cholera vaccinations. *Equipment importation:* Bring equipment list; bond is probably unnecessary.

Electricity: 220/50. *Plug types:* C, D, and G.

Currency: Cedi (GHC); Pesewas. Strict currency controls.

U.S. embassy in the country: Ring Road East, P.O. Box 194, Accra; *tel.* (chancery) 775347/8/9, (annex) 776601/2, 776008. **Embassy in U.S.:** 2460 Sixteenth Street NW, Washington, DC 20009; *tel.* 202–462–0761. *Consulates:* New York: 212–832–1300.

Tourism office in U.S.: Ghana Tourist Center, 407 South Dearborn, Suite 1245, Chicago, IL 60605; *tel.* 312–922–2950.

Central tourism office in country: Ministry of Information, Accra.

Health suggestions: Tap water is not safe; sanitary precautions are necessary. Malaria suppressants are recommended throughout the country. Do not swim in freshwater streams or lagoons because of bilharzia (schistosomiasis). Cholera infection is present.

Cultural mores and taboos: Refer to "ethnic groups" rather than "tribes." Foreign visitors are expected to be punctual, but local perceptions of time may differ. Sociable and relaxed pace. Great pride in being first sub-Saharan nation to gain independence from the Europeans. Do not gesture with the left hand.

Gratuity guidelines: Sometimes included in the bill, but leaving extra is customary. If not included, leave a tip. Although discouraged by the government, *dash*, or a small tip, is usually expected before a wide range of small services will be rendered.

GREECE
Hellenic Republic
Ellinaki Dimokratia

Location: In southern Europe, on the southwestern part of the Balkan Peninsula, bounded on the north by Albania, Yugoslavia, and Bulgaria, the northeast by Turkey, the east by the Aegean Sea, the south by the Mediterranean Sea, and the west by the Ionian Sea. *Size:* 50,944 square miles, slightly smaller than Alabama.

Major cities: Athens (lat. +37.58). *Airports:* Hellinikon Airport (ATH), 6 miles outside of Athens.

General transportation: Many international flights with direct links to the U.S.;

Olympic Airways (OA) offers excellent domestic service to at least 25 airports. Streets and highways are hard-surfaced; smaller roads are sometimes rough and ungraded. Intercity and local public transport is adequate but crowded at rush hours. Athens has a subway. *U.S. license:* No. *IDP:* Yes. *Rule of the road:* Right. *Motor clubs:* Automobile and Touring Club of Greece (ELPA), 2–4 Messogion Street, Athens; *tel.* 779–1615; full AAA reciprocity. *Taxi markings:* Mostly yellow, marked TAXI, metered. Taxis are blue in Salonika.

Population: 10,000,000. *Type of government:* Presidential, parliamentary government. The U.S. and Greece have long-standing political, cultural, and historical ties. **Languages:** Greek; English and French are widely understood. *Ethnic groups:* 97.7% Greek, 1.3% Turkish, 1% other. *Religion:* 98% Greek Orthodox, 1.3% Muslim, 0.7% other. **Time:** EST +7; GMT +2. *Telephone codes:* Country: 30. Argos 751, Athens (Athínai) 1, Corinth 741, Iráklion (Krítis) 81, Kavalla 51, Larissa 41, Patras 61, Piraeus 1, Rhodes 241, Salonika (Thessaloníki) 31, Sparta 731, Tripolis 71, Volos 421, Zagora 426. Adequate, with satisfactory service in Athens and to the U.S. *Pay phone system:* Coins.

Holidays: January 1, 6; March 25; Good Friday; Easter Monday; May 1; Whit Monday (varies—early June); August 15; October 28; December 24, 25; plus other regional and religious holidays. *Date/month system:* D/M.

Business hours: 8 AM to 1:30 PM, 5 PM to 8:30 PM Monday to Friday, May to October; 8 AM to 1 PM, 4:30 PM to 7:30 PM Monday to Friday, 8 AM to 1 PM Saturday, October to May. *Government hours:* 8 AM to 2:30 PM Monday to Saturday. *Business dress code:* Same as that of the U.S.

Climate and terrain: Large mainland with over 1,400 islands. About 80% is rocky, with dry mountains or hills. Athens suffers from air pollution. Climate is temperate, with mild, wet winters and hot, dry summers. *Temperature ranges* (Athens): January: 42° to 54°F; April: 52° to 67°F; July: 72° to 90°F; October: 60° to 74°F.

Visas: Standard tourist entry, requiring passport; no visa is needed for stays of up to 3 months. *Health requirements:* Yellow fever vaccination is required if coming from an infected area. *Equipment importation:* Carnet.

Electricity: 220/50. *Plug types:* C, D, and F.

Currency: Drachma (DRA); Lepta.

U.S. embassy in the country: 91 Vasilissis Sophias Boulevard, 10160 Athens; *tel.* 721-2951, 721-8401; *telex:* 21-5548. *Consulates:* Salonika: 266-121.

Embassy in U.S.: 2221 Massachusetts Avenue NW, Washington, DC 20008; *tel.* 202-667-3168. *Consulates:* California: 415-775-2102; Georgia: 404-261-3313; Illinois: 312-372-5356; Louisiana: 504-523-1167; Massachusetts: 617-542-3240; New York: 212-988-5500.

Tourism office in U.S.: Greek National Tourist Office, 645 Fifth Avenue, New York, NY 10022; *tel.* 212-421-5777.

Central tourism office in country: Greek National Tourist Office, #2 Amerikis Street, Athens; *tel.* 322-3111.

Health suggestions: Water is potable only in Athens and major resorts.

Cultural mores and taboos: Hospitality is extremely important; do not refuse coffee or ouzo. The Greeks take great pride in their extraordinary history and culture. Self-praise among men is common and not considered bragging. Punctuality is not expected.

Photographic restrictions: Be sure to get permits for using tripods, flash, or for larger productions at sites of antiquities and museums. Contact the Greek Press and Information Service in Ministry of Foreign Affairs, 601 Fifth Avenue, New York, NY 10017; *tel.* 212-751-8788. Make these arrangements some time in advance.

Color labs: *Kodak* (Near East) Ltd., P.O. Box 8253, GR-100 10 Athens.

Equipment rental/sales: *Balcar:* Salcofot S.A., Salonika, *tel.* 547-120/1, or Athens, *tel.* 325-1294, 321-7500. *Comet:* Cooperative Society of Greek Professional Photographers, Athens, 524-6452.

Gratuity guidelines: Leave 8% to 10% above any included charges. A separate tip to the restaurant busboy is customary.

GRENADA
State of Grenada

Location: In the West Indies, north of Trinidad, south of St. Vincent and the Grenadines. **Size:** 133 square miles, about the size of Philadelphia. **Major cities:** *Saint George's* (lat. +12.03). **Airports:** Port Saline International Airport (GND), 19 miles outside of St. George's. **General transportation:** Air links to other Caribbean countries with onward connections. Public buses and rental cars available. **U.S. license:** Yes, if presented to main police stations, to obtain local driving license for a fee. **IDP:** Yes. **Rule of the road:** Left. **Taxi markings:** All colors, unmarked; set price. **Population:** 84,000. **Type of government:** Independent state recognizing Elizabeth II of Britain as head of state. Democratic government reinstated in 1984. U.S. embassy was established in 1983. **Languages:** English (official), some French patois. **Ethnic groups:** Mainly black of African descent; little trace of early Arawak and Carib Indians; a few East Indians and descendants of early European settlers. **Religion:** Largely Roman Catholic (at least 63%); some Anglican and other Protestant denominations. **Time:** EST +1; GMT −4. **Telephone codes:** Direct-dial from the U.S. using 809 area code. Modern digital system has just been installed; international service is greatly improved. **Pay phone system:** Coins; few available. **Holidays:** January 1, 2; February 7; Good Friday; Easter Monday; May 1; Whit Monday (varies—early June); Corpus Christi (June); August 1, 2; October 25; December 25, 26. **Date/month system:** D/M. **Business hours:** 8 or 9 AM to 5 PM Monday to Saturday with lunch break; some businesses closed Thursday afternoon. **Government hours:** 9 AM to 5 PM Monday to Friday. **Business dress code:** For high-level meetings, wear a tie and jacket; otherwise, more informal. **Climate and terrain:** Verdant rain forest covers the center of the island. White sandy beaches and the picturesque harbor of St. George's on the corrugated southern coast. A volcanic mountain range with crater lakes forms a spine down the length of the island. Rich soil, suited for agriculture, resulted in the name "Isle of Spice." Tropical climate tempered by northern trade winds. A mild dry season from January to May; rainfall the rest of the year. On the edge of the belt that experiences hurricanes from June to November. **Temperature ranges** (St. George's): January: 73° to 84°F; April: 74° to 86°F; July: 76° to 86°F; October: 76° to 86°F. **Visas:** Standard tourist entry, requiring 2 proofs of citizenship, one having a photo; no visa is required for stays of up to 6 months. **Health requirements:** Yellow fever vaccination is required if coming from an infected area. **Equipment importation:** Bring equipment list; bond is generally not required. **Electricity:** 230/50. **Plug types:** C, D, and G. **Currency:** East Caribbean Dollar (EC$); Cents. **U.S. embassy in the country:** Ross Point Inn, P.O. Box 54, St. George's; *tel.* 1731/4. **Embassy in U.S.:** 1701 New Hampshire Avenue NW, Washington, DC 20009; *tel.* 202-265-2561. **Tourism office in U.S.:** Grenada Tourist Office, 141 East Forty-fourth Street, Suite 701, New York, NY 10017; *tel.* 212-687-9554. **Central tourism office in country:** Grenada Tourism Department, P.O. Box 293, St. George's; *tel.* 440-2001, 2279, 3377, 2872; *telex:* 3422 MINTCA. **Health suggestions:** Water is potable. **Gratuity guidelines:** If not included in the bill, same as those of the U.S.

GUADELOUPE
Department of Guadeloupe

Location: In the West Indies, north of Dominica, south of Antigua and Barbuda. **Size:** 683 square miles, about half the size of Rhode Island. **Major cities:** *Basse-Terre* (lat. +16), Pointe-à-Pitre (lat. +16.01). *Airports:* Le Raizet (PTP), 2 miles outside of Pointe-à-Pitre. **General transportation:** Connecting flights to the U.S. Public buses available. *U.S. license:* No. *IDP:* Yes. *Rule of the road:* Right. *Taxi markings:* All colors, marked TAXI; set price. **Population:** 340,000. *Type of government:* Overseas department (territory) of France, with 2 senators and 3 deputies in the French parliament. Ruled locally by a prefect (governor) and an elected general council. **Languages:** French, creole patois. *Ethnic groups:* 90% black or mulatto, 5% white, less than 5% East Indian, Lebanese, Chinese. *Religion:* 95% Roman Catholic, 5% Hindu and original African beliefs. **Time:** EST +1; GMT −4. *Telephone codes:* Country: 590. No city codes. Inadequate domestic service; fair international service. *Pay phone system:* Coins or cards.

Holidays: January 1; Carnaval preceding Lent and including Ash Wednesday; Good Friday; Holy Saturday; May 1, 8; Ascension Day (40 days after Easter); Whit Monday (varies—early June); July 13, 14; August 15; November 1, 2, 11; December 25. *Date/month system:* D/M.

Business and government hours: 7:30 AM to 12 noon, 2:30 PM to 5 PM Monday to Friday; some offices are open on Saturday mornings. *Business dress code:* Informal; suits are rarely worn except for very high level meetings.

Climate and terrain: The western, volcanic Basse-Terre island is separated from the flatter, limestone Grande-Terre by a narrow saltwater stream. Some smaller islands are also administered as part of Guadeloupe, as is the French portion of St. Martin. Pointe-à-Pitre is the principal city and commercial center. Subtropical climate modified by trade winds; usually high humidity. November to April is the cooler, drier period. Subject to hurricanes from June to October. *Temperature ranges* (Pointe-à-Pitre): January: 64° to 77°F; April: 65° to 79°F; July: 68° to 81°F; October: 68° to 81°F.

Visas: Standard tourist entry, requiring French visa, available at border—supply 1 application, 1 photo (optional), and a passport valid for 2 months beyond the length of the visa. *Health requirements:* Yellow fever vaccination is required if coming from an infected area. *Equipment importation:* Carnet.

Electricity: 220/50. *Plug types:* C, D, and E.

Currency: French Franc (FFR); Centimes.

U.S. embassy in the country: None. The U.S. consulate in Martinique handles matters for all French departments in the region. Contact the consulate at 14 rue Blenac, B.P. 561, Fort-de-France, Martinique; *tel.* 63–13–03; *telex:* 912670, 912315 MR.

Embassy in U.S.: Care of the French embassy, 4101 Reservoir Road NW, Washington, DC 20007; *tel.* 202–944–6000.

Central tourism office in country: Office Départemantal du Tourisme de la Guadeloupe, B.P. 1099, Angle des rues Schoelcher et Delgres, 97110 Pointe-à-Pitre; *tel.* 820930.

Health suggestions: Water is potable in major towns. Basic medical care is available, with few English-speaking personnel.

Gratuity guidelines: Service is usually included in the bill; leaving a bit extra is not customary.

GUATEMALA
Republic of Guatemala
República de Guatemala

Although travel conditions have steadily improved, exercise extreme caution in western Guatemala.

Location: In Central America, bounded on the west and north by Mexico, the east by Belize and the Gulf of Honduras, the southeast by Honduras and El Salvador, and the south by the Pacific Ocean. *Size:* 42,042 square miles, slightly smaller than Tennessee. **Major cities:** *Guatemala City* (lat. +14.37). *Airports:* La Aurora (GUA), 5 miles outside of Guatemala City. **General transportation:** A hub of Central American air traffic, with direct connections to the U.S. Paved roads link the capital to Mexico, El Salvador, Honduras, and most regions of the country except the far north, with first-class buses and rental cars available (trains are below par). *U.S. license:* Yes. *IDP:* Yes. *Rule of the road:* Right. *Taxi markings:* All colors; set price by zone.

Population: 8,800,000. *Type of government:* Republic; civilian democratic government reinstated in 1986 after 15 years of military rule. Traditionally good relations with the U.S.

Languages: Spanish, although it is not universally understood by all Indians, 40% of whom have one of 18 indigenous dialects as their primary tongue. English understood by some in business and government. *Ethnic groups:* 56% Ladino (mestizo and westernized Indian), 44% Indian. *Religion:* Predominantly Roman Catholic with some Protestant and traditional Mayan beliefs.

Time: EST −1; GMT −6. *Telephone codes:* Country: 502. Guatemala City 2, all others 9. Fairly modern domestic and international service. *Pay phone system:* Coins.

Holidays: January 1; Holy Thursday; Good Friday; Holy Saturday; May 1; June 30; August 15; September 15; November 1; December 25. *Date/month system:* D/M.

Business hours: 9 AM to 6 PM Monday to Friday. *Government hours:* 8 AM to 4:30 PM Monday to Friday. *Business dress code:* Same as that of the U.S.

Climate and terrain: Mostly mountains with narrow coastal plains and rolling limestone plateau (Petén) in the north. Mountains are volcanic and subject to earthquakes. Tropical climate with two seasons, rainy from May to October and dry from November to May, except along the Caribbean coast, where rainfall is plentiful throughout the year. This region is also subject to hurricanes. *Temperature ranges* (Guatemala City): January: 53° to 73°F; April: 58° to 82°F; July: 60° to 78°F; October: 60° to 76°F.

Visas: Standard tourist entry, requiring proof of citizenship with tourist card or passport with visa. Tourist card is issued by consulate or airline; must be used within 30 days, for stays of up to 6 months. A visa, issued by the consulate, is valid for 5 years, allows multiple entries, and requires no fee or forms. Length of stay is determined by immigration authorities upon arrival. *Health requirements:* Yellow fever vaccination is required if coming from a country with any infected areas. *Equipment importation:* Bring equipment list; no bond is required.

Electricity: 120/60. *Plug types:* A and I. **Currency:** Quetzal (QUE); Centavos.

U.S. embassy in the country: 7–01 Avenida de la Reforma, Zone 10, Guatemala City; *tel.* 31–15–41.

Embassy in U.S.: 2220 R Street NW, Washington, DC 20008; *tel.* 202–745–4952/4. *Consulates:* California: 415–781–0118; Florida: 305–463–5857; Louisiana: 504–525–0013; New York: 212–686–3837; Texas: 713–953–9531.

Tourism office in U.S.: Guatemala Tourist Commission, P.O. Box 523850, Miami, FL 33152; *tel.* 305–358–5110.

Central tourism office in country: Tourist Commission of Guatemala, Seventh Avenue, #1–17 Civic Center, Guatemala City; *tel.* 31–13–33.

Health suggestions: Medical facilities are good in Guatemala City, which, because of its altitude, is free of most tropical diseases. Malaria is a risk in some areas, and typhoid, tetanus, polio, and hepatitis treatments are recommended for extended stays. Water is not potable.

Cultural mores and taboos: Hospitable and quite proud of their culture, businesspeople in Guatemala City are cosmopolitan and direct. Outside the capital, traditional (as distinguished from modern, cosmopolitan) mores prevail.

Gratuity guidelines: Service is not included in the bill; 10% is standard, 15% for excellent service.

GUINEA
Republic of Guinea
République de Guineé

Location: In western Africa, bounded on the north by Senegal and Mali, the east by Mali and Côte d'Ivoire, the south by Liberia and Sierra Leone, the west by the Atlantic Ocean, and the northwest by Guinea-Bissau. **Size:** 94,925 square miles, slightly smaller than Oregon. **Major cities:** *Conakry* (lat. +9.31). **Airports:** Conakry Airport (CKY), 10 miles outside of Conakry.

General transportation: Flights to Europe (with connections to the U.S.), Africa, and several other international destinations. Air Guineé (GI) operates domestic flights (schedules can occasionally change on short notice; check flights at the last minute). Buses are unreliable; an irregular train service runs from the capital to Kankan. Rental cars are available. *U.S. license:* No. *IDP:* Yes. *Rule of the road:* Right. *Taxi markings:* Yellow, but difficult to hail in the street. Rely on those circulating at hotels and common tourist points. Exercise caution otherwise. **Population:** 6,900,000. *Type of government:* Republic, under military committee since a 1984 coup, when the constitution was suspended and all political activity was banned. Nonaligned foreign policy, balancing good relations with most Communist states and the West, including the U.S. **Languages:** French (official). Each tribe has its own language. English is not commonly spoken. *Ethnic groups:* Fulani, Ma-

linké, Sousou, 15 smaller tribes. *Religion:* 85% Muslim, 10% Christian, 5% indigenous beliefs.

Time: EST +5; GMT 0. *Telephone codes:* No direct-dial from U.S.—operator-assisted calls only. No credit card or collect calls to U.S. Fair domestic and international services. *Pay phone system:* available in post offices and hotels, not on the street.

Holidays: January 1; April 3; Easter Monday; May 1; August 15; October 2; December 25; plus several Muslim holidays—check with consulate. *Date/month system:* D/M.

Business and government hours: 7:30 AM to 3 PM Monday to Saturday; 7:30 AM to 1 PM Friday. *Business dress code:* Informal because of heat, but for high-level meetings wear a tie and jacket if possible.

Climate and terrain: Generally flat coastal plain, hilly to mountainous interior. Mostly hot and humid tropical climate, with a rainy season from June to November and a dry season from December to May with north-easterly harmattan winds. *Temperature ranges* (Conakry): January: 72° to 88°F; April: 73° to 90°F; July: 72° to 83°F; October: 73° to 87°F.

Visas: Standard tourist visa, requiring passport, 3 applications, 3 photos, $10 fee. Upon arrival, contact the Ministry of Information in the main government offices in Conakry to arrange any necessary permits and learn of any photographic restrictions.

Health requirements: Yellow fever vaccination. *Equipment importation:* Bring equipment list; bond is probably not required. **Electricity:** 220/50. *Plug types:* C and E. **Currency:** Franc (GNF); subdivision (plural). **U.S. embassy in the country:** Second Boulevard and Ninth Avenue, B.P. 603, Conakry; *tel.* 44–15–20/4. **Embassy in U.S.:** 2112 Leroy Street NW, Washington, DC 20008; *tel.* 202–483–9420. **Central tourism office in country:** Ministry of Information and Tourism, Conakry, *Tel.* 44–11–47/11.

Health suggestions: Sanitation is poor; water is not potable. Typhoid, tetanus, and typhus treatments are recommended. Malaria suppressants are necessary. Cholera infection is present.

Photographic restrictions: Consult the Ministry of Information and Tourism (see **Central tourism office in country,** above).

Gratuity guidelines: Not always expected but appreciated.

GUINEA-BISSAU
Republic of Guinea-Bissau
Republica da Guiné-Bissau

Location: In western Africa, bounded on the north by Senegal, the east and southeast by Guinea, and the southwest and west by the Atlantic Ocean. *Size:* 13,948 square miles, about the size of Indiana. **Major cities:** *Bissau* (lat. +11.52). *Airports:* Osvaldo Vieira (BXO), 5 miles outside of Bissau.

General transportation: Air links to a few African capitals, Lisbon, and Budapest. Aircraft into the interior may be chartered. Road conditions make land transportation to Senegal difficult and to Guinea almost impossible. Accommodations in Bissau are limited. *U.S. license:* Yes, with formalities on arrival. *IDP:* Yes. *Rule of the road:* Right. *Taxi markings:* Blue with white top, marked TAXI; set price.

Population: 95,000. *Type of government:* Republic; highly centralized one-party regime since 1974; has constitution and national assembly. Nonaligned policy, balancing good relations with most Communist states and the West, including the U.S. **Languages:** Portuguese (official), Criolo, and numerous African languages. *Ethnic groups:* 30% Balanta, 20% Fula, 14% Manjaca; 13% Mandinga, 7% Papel, less than 1% European, mostly Portuguese. *Religion:* 65% indigenous beliefs, 30% Muslim, 5% Christian.

Time: EST +5; GMT 0. *Telephone codes:* No direct-dial from U.S.—operator-assisted calls only. No credit card or collect calls to U.S. Adequate domestic service. International calls are routed through Lisbon and must be arranged in advance. Satellite service is scheduled. *Pay phone system:* Available only in post offices and hotels.

Holidays: January 1, 20; February 28; March 8; May 1; August 3; September 12, 24; November 14; December 25. *Date/month system:* D/M.

Business hours: 7:30 AM to 12:30 PM, 3 PM to 6 PM Monday to Friday; 7:30 AM to 11:30 AM Saturday. *Business dress code:* Business suits.

Climate and terrain: Low coastal plain gradually rising toward savanna in the east. Several large rivers mark the coastline. Palm trees and mangrove thickets cover most of the lowland along the coast and rivers. Tropical climate, with a rainy season from June to October and a dry season from November to May with dusty harmattan winds from the Sahara.

Visas: Standard tourist visa, valid for 1 to 90 days, requiring passport, 3 applications, 3 photos, $15 fee, proof of return ticket and sufficient funds. *Health requirements:* Yellow fever vaccination. *Equipment importation:* Bring equipment list to consulate when applying for visa, to make arrangements in advance.

Electricity: 220/50. *Plug types:* C, D, and F.

Currency: Peso (GWE); Centavos.
U.S. embassy in the country: Avenida Domingos Ramos, C.P. 297, Bissau; *tel.* 212816/7.
Embassy in U.S.: Care of the Guinea-Bissau U.N. Mission, 211 East Forty-third Street, Suite 604, New York, NY 10017; *tel.* 212–661–3977.
Central tourism office in country: Ministry of Commerce and Tourism, Bissau.

Health suggestions: Sanitation is poor; water is not potable. The two hospitals are inadequately staffed and short of supplies. Typhoid, tetanus, and typhus treatments are recommended. Malaria, gastrointestinal infections, bilharzia, and tuberculosis are endemic.
Gratuity guidelines: Service (10%) included in the bill at hotels and restaurants. Tipping taxi drivers is optional.

GUYANA
Cooperative Republic of Guyana

Location: In northern South America, bounded on the north and northeast by the Atlantic Ocean, the east and southeast by Suriname, the south and southwest by Brazil, and the west by Brazil and Venezuela.
Size: 83,000 square miles, slightly smaller than Idaho.
Major cities: *Georgetown* (lat. +6.50).
Airports: Timehre Airport (GEO), 25 miles outside of Georgetown.
General transportation: Several direct flights to Caribbean islands; Caracas, Venezuela; Europe; and the U.S. Guyana Airways (GY) provides some domestic flights. Two-lane paved roads connect Georgetown with Corriverton and Linden, but many other roads do not meet modern standards. Decent long-distance bus service is available. Some ferry and riverboat service. Buses in Georgetown run irregularly. Taxis are usually available but are scarce during rush hour and at night. *U.S. license:* Yes. *IDP:* Yes, with formalities on arrival. *Rule of the road:* Left. *Taxi markings:* All colors; shared; available at stands.
Population: 77,000.
Languages: English, Amerindian dialects. *Ethnic groups:* 51% East Indian, 43% black and mixed, 4% Amerindian, 2% European and Chinese. *Religion:* 57% Christian, 33% Hindu, 9% Muslim, 1% other.
Time: EST +2; GMT −3. *Telephone codes:* Country: 592. Anna Regina 71, Bartica 5, Beteryerwaging 20, Cove & John 29, Georgetown 2, Ituni 41, Linden 4, Mabar-

uma 77, Mahaica 28, Mahaicony 21, New Amsterdam 3, New Hope 66, Rosignol 30, Timehri 61, Vreed-en-Hoop 64, Whim 37. Fair domestic and international service. *Pay phone system:* Coins; few available.
Holidays: January 1; February 23; Good Friday; Easter Monday; May 1; July 4; August 1; December 25, 26; plus Muslim holidays—check with consulate. *Date/month system:* D/M.
Business and government hours: 8 AM to 11:30 AM, 1 PM to 4 PM Monday to Friday; 8 AM to 12 noon Saturday. *Business dress code:* Because of the heat, informal, including the popular tieless shirt-jac.
Climate and terrain: A narrow coastal plain watered by four rivers; a grass-covered savanna in the hinterland; an inland forest covering 85% of the land. The tropical climate is moderated along the coast by northeast trade winds. Coastal rainy seasons extend from April to July and November to January. *Temperature ranges* (Georgetown): January: 74° to 84°F; April: 76° to 85°F; July: 75° to 85°F; October: 76° to 87°F.
Visas: *Business visa:* Passport, client letter acknowledging responsibility for photographer, proof of sufficient funds, 3 applications, 3 photos, no fee; single entry for stays of up to 3 months. *Tourists:* Tourist visa with similar requirements, except for client letter. For travel to certain portions of the interior, permission from the Ministry of Home Affairs in Georgetown is needed; arrange in

advance with the embassy. *Health requirements:* Yellow fever vaccination is required if coming from an infected area and is recommended by CDC for travel outside urban areas. *Equipment importation:* Bring equipment list; no bond is necessary. **Electricity:** Georgetown 110/50, others 110/60. *Plug types:* A, B, C, D, and G. **Currency:** Dollar (GY$); Cents. **U.S. embassy in the country:** 31 Main Street, Georgetown; *tel.* 54900/9; *telex:* 213 AMEMSY GY. **Embassy in U.S.:** 2490 Tracy Place NW,

Washington, DC 20008; *tel.* 202-265-6900/3. *Consulates:* California: 213-389-7565; Florida: 904-763-7689; Indiana: 219-398-3720; New York: 212-527-3215; Texas: 817-799-3611.

Health suggestions: Doctors and hospitals are limited in Georgetown and inadequate throughout the rest of the country. Malaria is endemic in some areas outside the capital. Dengue fever is also a hazard. Water is not potable.

Gratuity guidelines: Tips are customary; leave 10% to 15%.

HAITI
Republic of Haiti
République d'Haïti

Political affairs in Haiti have been turbulent; caution is necessary.

Location: In the West Indies, on the island of Hispaniola, which it shares with the Dominican Republic, southeast of Cuba, east of Jamaica, west of Puerto Rico. *Size:* 10,714 square miles, slightly larger than Maryland. **Major cities:** *Port-au-Prince* (lat. + 18.33). *Airports:* Mais Gate Airport (PAP), 8 miles outside of Port-au-Prince. **General transportation:** Direct flights to the U.S. Public transport is undependable. Roads are poor in the capital; highways to regional centers are better. Port-au-Prince has taxis and jitneys. *U.S. license:* Yes. *IDP:* Yes. *Rule of the road:* Right. *Taxi markings:* Red ribbon on mirror inside; set price. **Population:** 6,300,000. *Type of government:* Republic; military dominated. Has traditionally friendly relations with the U.S. **Languages:** Officially French, which is understood by only 10% of the population. Creole is more universally spoken. English is widely understood in business. *Ethnic groups:* 95% black, 5% mulatto and European. *Religion:* 75% to 80% Roman Catholic, of which an overwhelming majority also practice voodoo, 10% Protestant. **Time:** EST; GMT −5. *Telephone codes:*

Country: 509. Cap Haitien 3, Cayes 5, Gonaïves 2, Port-au-Prince 1. Domestic service is barely adequate, international facilities are slightly better. *Pay phone system:* Coins; few available, mostly at airports and hotels.

Holidays: January 1, 2; Mardi Gras (varies); Good Friday; May 1, 18; Ascension Day (40 days after Easter); May 22, Corpus Christi (June); June 22; August 15; October 17, 24; November 1, 18; December 5, 25. *Date/month system:* D/M.

Business hours: 8 AM to 4 PM Monday to Friday. *Government hours:* 8 AM to 2 PM Monday to Friday. *Business dress code:* Same as that of the U.S.

Climate and terrain: Mostly rough, mountainous terrain. The mountains that divide it from the Dominican Republic cut off the moist trade winds, creating a semiarid climate. Evening rainfall is heavy in spring and fall. *Temperature ranges* (Port-au-Prince): January: 68° to 87°F; April: 71° to 89°F; July: 74° to 94°F; October: 72° to 90°F.

Visas: Standard tourist entry, requiring proof of citizenship; no visa is needed for stays of up to 3 months; a tourist card ($5 fee) is available at the airport. *Health requirements:* Yellow fever vaccination is required if coming from an infected area.

Equipment importation: Bring equipment list; no bond is required.

Electricity: 110–120/60. *Plug types:* A, B, I, and J.

Currency: Gourde (GOU); Centimes.

U.S. embassy in the country: Harry Truman Boulevard, P.O. Box 1761, Port-au-Prince; *tel.* 20354, 20368, 20612, 20200.

Embassy in U.S.: 2311 Massachusetts Avenue NW, Washington, DC 20008; *tel.* 202-332-4090/2. *Consulates:* California: 415–957–1189; Florida: 305–377–3547; Illinois: 312–337–1603; New York: 212–697–9767.

Central tourism office in country: Office National du Tourisme, Port-au-Prince; *tel.* 21729.

Health suggestions: Sanitation is poor. Water is not potable. There are a few foreign-trained doctors in the capital, but treatment for more than the most minor problems is virtually nonexistent. Malaria suppressants are recommended throughout the country.

Photographic restrictions: Consult the Department of Information: 9 Rue Salave, Delmas 27, Port-au-Prince; *tel.* 61762.

Gratuity guidelines: Not included in the bill; leave at least 10%.

HONDURAS
Republic of Honduras
República de Honduras

Exercise caution when traveling in the El Salvador and Nicaragua border areas.

Location: In Central America, bounded on the north by the Gulf of Honduras and the Caribbean Sea, the east by the Caribbean Sea, the south by Nicaragua and the Gulf of Fonseca, the southwest by El Salvador, and the west by Guatemala. *Size:* 43,277 square miles, about the size of Ohio.

Major cities: *Tegucigalpa* (lat. +14.03), San Pedro Sula (lat. +15.26), La Ceiba (lat. +15.45). *Airports:* Toncontin Airport (TGU), 3 miles outside of Tegucigalpa; La Mesa Airport (SAP), 11 miles outside of San Pedro Sula; La Ceiba International Airport (LCE), 6 miles outside of La Ceiba.

General transportation: Good links to Tegucigalpa, San Pedro Sula, and La Ceiba from several U.S., Central American, and Mexican cities. Tan Sahsa, the domestic carrier, is among the airlines that provide internal service. Good roads and intercity bus service; rental cars are available. Limited rail service is confined to the Caribbean coast. City transport is provided by crowded buses, minibuses, and taxis, both telephone-dispatched and hailed; shared cabs on the street. *U.S. license:* Yes. *IDP:* Yes. *Rule of the road:* Right. *Taxi markings:* All colors, marked TAXI; set price—agree ahead of time.

Population: 4,970,000. *Type of government:* Republic; strengthening democratic institutions. The 1985 elections saw the first peaceful transfer of power from one democratically elected president to another in half a century. Enjoys traditionally close, cooperative relations with the U.S.

Languages: Spanish. English is spoken on the Bay Islands and in certain areas of the north coast, and it is widely understood in business and government. *Ethnic groups:* 90% mestizo, 7% Indian, 2% black, 1% white. *Religion:* About 97% Roman Catholic, small Protestant minority.

Time: EST −1; GMT −6. *Telephone codes:* Country: 504. No city codes. No credit card calls to U.S. Domestic and international services are adequate. *Pay phone system:* Coins.

Holidays: January 1; Holy Thursday through Easter Sunday (many take vacations for the whole week preceding Easter); April 14; May 1; September 15; October 3, 12, 21; December 25. *Date/month system:* D/M.

Business hours: 8 AM to 12 noon, 2 PM to 6 PM Monday to Friday; 8 AM to 12 noon Saturday. *Government hours:* 7 AM to 3 PM

Monday to Friday. *Business dress code:* Same as that of the U.S., although local men sometimes wear the decorative *guayabera* shirt instead of a suit and tie, especially along the coast.

Climate and terrain: Two mountain ranges bisect Honduras, northwest to southwest. The climate is tropical in the coastal lowlands, moderate in the mountains. The dry season extends from November to May. Tegucigalpa is fresh and springlike, with warm days and cool nights, except in winter, when days are chilly. *Temperature ranges* (Tegucigalpa): January: 43° to 78°F; April: 50° to 88°F; July: 52° to 85°F; October: 53° to 86°F.

Visas: Courtesy visa, requiring passport, client letter stating purpose and dates of visit; equipment list to be notarized by embassy for $15; return postage; allow 1 or 2 days for processing. *Health requirements:* Typhus, plague, yellow fever, cholera inoculations. *Equipment importation:* No bond is required if above procedure for obtaining a visa is followed.

Electricity: 110/60. *Plug types:* A and B.

Currency: Lempira (LEM); Centavos.

U.S. embassy in the country: Avenida La Paz, Tegucigalpa; *tel.* 32–3120.

Embassy in U.S.: 4301 Connecticut Avenue NW, Suite 100, Washington, DC 20008; *tel.* 202–966–7700/2. *Consulates:* California: 213–623–2301; Florida: 305–358–3477; Illinois: 312–772–7090; Louisiana: 504–522–3118; New York: 212–889–3858; Texas: 713–622–4572.

Tourism office in U.S.: 501 Fifth Avenue, New York, NY 10017; *tel.* 212–490–0766.

Central tourism office in country: Instituto de Turismo, Parque la Merced (across from Banco Central), Tegucigalpa.

Health suggestions: Basic medical care is available in the cities. Sanitary precautions are necessary. Water is not potable and can be in short supply during the dry season. The main health hazards include rabies, various intestinal diseases, typhoid, hepatitis, parasites, and dysentery. Malaria suppressants are necessary outside of the capital.

Cultural mores and taboos: Traditional Latin American concepts of machismo, stoicism in the face of an unchangeable world, and relaxed schedules prevail.

Gratuity guidelines: Not usually included in the bill; leave at least 10%.

HONG KONG
Hong Kong and the New Territories

Location: In southeast Asia, southeast of China, on the South China Sea. *Size:* 398 square miles, slightly smaller than Los Angeles. [Lat. +22.18] (Kai Tak International Airport (HKG), in Kowloon.

General transportation: Many international flights serve this leading manufacturing, commercial, and tourist center. There is an enormous demand for hotels and flights; be sure to book as early as possible. Trams, buses, minibuses, an excellent subway (MTR), and taxis provide crowded but plentiful public transport (although taxis can be scarce at peak hours). Hong Kong Island is linked with Kowloon and the mainland by several ferries and a cross-harbor tunnel. Express trains to Guangzhou, 90 miles north, are available. *U.S. license:* Yes, at the discretion of the Commissioner for Transport. *IDP:* Yes. *Rule of the road:* Left. *Motor clubs:* Hong Kong Automobile Association, 405 Houston Centre, 63 Mody Road, Tsim Sha Tsui East, Kowloon; *tel.* (3) 739–5273; partial AAA reciprocity. *Taxi markings:* Red and black, marked TAXI; metered, available at stands or hailed.

Population: 5,600,000. *Type of government:* Colony of the United Kingdom, scheduled to revert to China in 1997, which promises to retain its current economic character and life-style for another 50 years. Legal system is based on British common law.

Languages: Chinese (Cantonese) and English. *Ethnic groups:* 98% Chinese, 2% other (mostly European). Less than 60% of the population was born in Hong Kong. *Religion:* 90% eclectic mix of local religions, 10% Christian.
Time: EST +13; GMT +8. *Telephone codes:* Country: 852. Castle Peak 0, Cheung Chau 5, Fan Ling 0, Hong Kong 5, Kowloon 3, Kwai Chung 0, Lamma 5, Lantau 5, Ma Wan 5, Peng Chau 5, Sek Kong 0. Sha Tin 0, Tai Po 0, Ting Kau 0, Tsun Wan 0. Excellent domestic and international service. *Pay phone system:* Coins; phones are on the street but since local calls are free, people commonly use restaurant and shop phones.
Holidays: Many holidays are based on the lunar calendar and will vary from year to year: January 1; Chinese New Year (late January to mid-February); Ching Ming (April); Good Friday; Saturday before Easter; Easter Monday; Queen's Birthday and the Monday following (mid-June); Dragon Boat Day (mid-June); Saturday before the last Monday in August; last Monday in August; day following mid-Autumn festival (September to October); Chung Yeung Festival (October); December 25, 26. *Date/month system:* D/M.
Business and government hours: 9 AM to 1 PM, 2 PM to 5 PM Monday to Friday; 9 AM to 1 PM Saturday. Many firms are open on Saturday mornings, but the trend is toward a 5-day week. Some Chinese businesses open around 10 AM and close at 8 PM. *Business dress code:* Same as that of the U.S.
Climate and terrain: Hong Kong boasts one of the world's great harbors (and now the busiest). It consists of Hong Kong Island (on which is the city center), the Kowloon Peninsula (the other major urban concentration), the New Territories (a rural area on the frontier of Guangdong Province), and some 200 small islands (one of which, Lan Tao, is larger than Hong Kong Island). The islands are hilly and steeply sloped, the only agricultural flatlands being in the New Territories. The climate is unusual. September to December bring the best weather, mild, dry, and sunny; January and February can

be quite chilly, particularly since the architecture of the city is designed for the long hot periods. The balance of the year is a mix of very hot and humid conditions, frequently overcast or rainy. *Temperature ranges:* January: 56° to 64°F; April: 67° to 75°F; July: 78° to 87°F; October: 73° to 81°F.
Visas: Standard tourist entry, requiring passport, proof of return ticket; no visa is needed for stays of up to 1 month; can be extended a month at a time to 3 months by application to the Immigration Department. *Health requirements:* No vaccinations required. *Equipment importation:* Carnet, but few restrictions on photographic equipment in any event.
Electricity: 200/50. *Plug types:* D and G.
Currency: Dollar (HK$); Cents.
U.S. embassy in the country: 26 Garden Road, Hong Kong; *tel.* (5) 239–011; *telex:* 63141 USDOC HX.
Embassy in U.S.: Care of the British embassy, 3100 Massachusetts Avenue NW, Washington, DC 20008; *tel.* 202–462–1340.
Tourism office in U.S.: Hong Kong Tourist Association, 548 Fifth Avenue, New York, NY 10036; *tel.* 212–869–5008.
Central tourism office in country: Hong Kong Tourist Association, 35th Floor, Connaught Centre, Hong Kong; *tel.* (5) 244–191.
Health suggestions: Medical facilities are good, with a number of Western-trained doctors. Water is potable, although some (even local residents) prefer to boil it.
Cultural mores and taboos: Courtesy and respect for "face" are the most important guidelines in all transactions. Be patient; direct replies, particularly negative ones, may be ill-mannered. Aggressive behavior is offensive; modesty and humility are prized. Sumptuous banquets are the primary form of business entertaining for the Chinese. As a guest, always be the first to leave after dinner. European expatriates tend to entertain with dinner parties in the home. Hong Kong is a cosmopolitan and sophisticated place with a keen interest in outside influences. While its cultural life is growing, money and business are still the great obsessions.

Photographic restrictions: Many people, particularly traditional ones, dislike being photographed by strangers on the street. **Color labs:** *Kodak* (Far East) Ltd., P.O. Box 48, General Post Office. **Equipment rental/sales:** *Balcar:* Universal Suppliers; *tel.* (5) 227–962, 211–225/6.

Broncolor: J. H. Trachsler (H.K.) Ltd.; *tel.* (5) 708–673. *Comet:* Multi M Co. Ltd., Kowloon; *tel.* (3) 723–6201. *Profoto:* Jebsen & Co.; *tel.* (5) 873–7878. **Gratuity guidelines:** Service is usually included in the bill, but leaving a bit extra is expected.

HUNGARY
Hungarian People's Republic
Magyar Népköztársaság

Location: In central Europe, bounded on the north by Czechoslovakia, the northeast by the USSR, the east and southeast by Romania, the south and southwest by Yugoslavia, and the west by Austria. *Size:* 35,919 square miles, slightly smaller than Indiana. **Major cities:** *Budapest* (lat. +47.31). **Airports:** Ferihegy (BUD), 9 miles outside of Budapest. **General transportation:** Direct flights to the U.S. and Europe, as well as other international destinations. Train service is available from Vienna, as is a 4-hour hovercraft ride down the Danube. Fine internal network of trains and buses, but no domestic flights. Budapest has a subway and very good public transport. Ibusz has an excellent program in which you may reside at the home of a Hungarian family for your visit at very little cost. If you do not need hotel amenities, it is recommended. *U.S. license:* No. *IDP:* Yes. *Rule of the road:* Right. *Motor clubs:* Magyar Autoklub, Romer Floris u 4/a, Budapest; *tel.* 152–040; partial AAA reciprocity. *Taxi markings:* Marked TAXI; metered; both state owned and private; the private cabs cost a bit more. Leave a tip. Taxis are frequently found at stands or by telephones. **Population:** 10,600,000. *Type of government:* Communist state. Since the 1960s, it has been pursuing a policy of improved living standards and has a degree of relaxed economic, cultural, and political controls. U.S. relations have also greatly improved. **Languages:** Hungarian. Some officials and businesspeople understand English in

varying degrees. *Ethnic groups:* 96.6% Hungarian, 1.6% German, 1.1% Slovak, 0.3% Southern Slav, 0.2% Romanian. *Religion:* 67.5% Roman Catholic, 20% Calvinist, 5% Lutheran, 7.5% atheist and other. **Time:** EST +6; GMT +1. *Telephone codes:* Country: 36. Abasar 37, Balatonaliga 84, Budapest 1, Dorgicse 80, Fertoboz 99, Gyöngyös 37, Kaposvár 82, Kazincbarcika 48, Komló 72, Miskolc 46, Nagykanizsa 93, Székesfehérvár 22, Szolnok 56, Várpalota 80, Veszprém 80, Zalaegerszeg 92. Good domestic and international service. *Pay phone system:* Coins. **Holidays:** January 1; April 4; Easter Monday; May 1; August 20; November 7; December 25, 26. *Date/month system:* Y/M/D is the Hungarian system; however, when dealing with foreigners, they use D/M/Y. **Business hours:** 8:30 AM to 4:30 PM Monday to Friday; some offices and ministries are open on Saturday. *Business dress code:* Same as that of the U.S. **Climate and terrain:** Mostly flat plain, with low mountains in the north-central and northeastern sections and to the north and south of Lake Balaton. Temperate climate with chilly, overcast, wet winters and warm, pleasant summers. *Temperature ranges* (Budapest): January: 26° to 35°F; April: 44° to 62°F; July: 61° to 82°F; October: 45° to 61°F. **Visas:** Standard tourist visa, good for stays of up to 30 days, valid 6 months from issuance; single entry: passport, $10 fee, 1 application, 2 photos; double entry: pass-

port, $20 fee, 3 applications, 4 photos; multiple entry, valid 1 year for stays of up to 30 days: passport, $40 fee, 1 application, 2 photos (visas are best obtained from the consulate in advance, rather than at border crossings, where delays have been experienced). *Transit visa:* For stays of up to 48 hours. **Health requirements:** No vaccinations required. **Equipment importation:** Carnet. **Electricity:** 220/50. *Plug types:* F. **Currency:** Forint (FOR); Fillers. **U.S. embassy in the country:** V. Szabadsag Ter 12, Budapest; *tel.* 126–450; *telex:* 18048 224–222. **Embassy in U.S.:** 3910 Shoemaker Street NW, Washington, DC 20008; *tel.* 202–362–6730. *Consulates:* New York: 212–879–4127. **Tourism office in U.S.:** Ibusz Hungarian Travel Bureau, 630 Fifth Avenue, Suite 2455, New York, NY 10111; *tel.* 212–582–7412.

Central tourism office in country: Ibusz, Felszabadulas Ter #5, Budapest; *tel.* 186–866, 182–430.

Health suggestions: Water is potable. Health care and medications are widely available and of an acceptable standard.

Cultural mores and taboos: Official decisions can take time. Hungary has the most relaxed atmosphere and prosperous economy in Eastern Europe.

Photographic restrictions: Military sites. Restricted areas are posted. Far fewer restrictions than in most of Eastern Europe.

Equipment rental/sales: *Profoto:* Ofotert, Budapest; *tel.* 290–022.

Gratuity guidelines: Not included in the bill; leave 10% to 15%. Tips are customary for a wide range of services.

ICELAND
Republic of Iceland
Lyoreldio Ísland

Location: In the northern Atlantic Ocean, east of Greenland. *Size:* 39,702 square miles, slightly smaller than Kentucky.

Major cities: *Reykjavík* (lat. +64.09).

Airports: Reykjavík Airport (REK), 3 miles outside of Reykjavík.

General transportation: Direct connections to the U.S. and Europe. Good network of domestic flights available. No railroads or streetcars, but excellent buses and taxis. Most roads outside the capital are dirt or gravel and are of poor to fair quality. Four-wheel-drive vehicles can be rented. *U.S. license:* Yes, with formalities on arrival. **IDP:** Yes. *Rule of the road:* Right. *Motor clubs:* Felag Íslenzkra Bifreidaeigenda (Iceland Automobile Association), Borgartun 33, Reykjavík; *tel.* 29999; partial AAA reciprocity. *Taxi markings:* All colors, marked TAXI; metered.

Population: 250,000. *Type of government:* Republic. The president has limited powers; most executive functions are exercised by the prime minister and cabinet; parliament (Althing). The only NATO member without forces of its own. Close and cooperative relations with the U.S.

Languages: Icelandic. English is the language of international commerce. *Ethnic groups:* Homogeneous, descendants of Norwegians and Celts. *Religion:* 95% Evangelical Lutheran, 3% other Protestant and Roman Catholic, 2% no affiliation.

Time: EST +5; GMT 0. *Telephone codes:* Country: 354. Akureyri 6, Hafnarfjördhur 1, Húsavík 6, Keflavík Naval Base 2, Rein 6, Reykjavík 1, Reyoarjorour 7, Sandgeroi 2, Selfoss 9, Siglufjördhur 6, Stokkseyri 9, Suoavík 4, Talknafjorour 4, Varma 1, Vík 9. Good domestic and international service. *Pay phone system:* Coins.

Holidays: January 1; fourth Thursday in April; Holy Thursday through Easter Monday; May 1; Ascension Day (40 days after Easter); Whit Monday (varies—early June); June 17; December 25, 26. December 24 and 31 are no more than half-days. *Date/month system:* D/M.

Business hours: 9 AM to 12 noon, 1 PM to 5 PM Monday to Friday; till 4 PM during the summer. Some businesses are open on Saturday mornings (except in the summer). *Business dress code:* Basically the same as that of the U.S., perhaps a bit more conservative, particularly for evening social events.

Climate and terrain: About 80% of the land (which is of recent volcanic origin) is an unusual mix of glaciers, lakes, and a mountainous lava desert (6,590 feet at its highest point). The remaining 20% is used for agriculture. The inhabited areas are on the coast, particularly in the southwest. Despite its latitude, the climate is temperate, modified by the North Atlantic Current, which results in damp, cool summers and mild, very windy winters. *Temperature ranges* (Reykjavík): January: 28° to 36°F; April: 33° to 43°F; July: 48° to 58°F; October: 36° to 44°F.

Visas: Standard tourist entry, requiring passport; no visa is needed for stays up to 3 months (period starts after entering any Scandinavian country—Iceland, Finland, Denmark, Norway, and Sweden). *Health requirements:* No vaccinations required. *Equipment importation:* Carnet.

Electricity: 220/50. *Plug types:* C and F.
Currency: Krona (IKR); Aur.
U.S. embassy in the country: Laufasvegur 21, Reykjavík; *tel.* 29100; *telex:* USEMB IS3044.
Embassy in U.S.: 2022 Connecticut Avenue NW, Washington, DC 20008; *tel.* 202–265–6653/5. *Consulates:* New York: 212–686–4100.
Tourism office in U.S.: Iceland Tourist Board, 655 Third Avenue, New York, NY 10017; *tel.* 212–949–2333.
Central tourism office in country: Laugarvegur #3, 101 Reykjavík; *tel.* 27488.
Health suggestions: No endemic health problems, good sanitation, adequate medical facilities. Water is potable.
Cultural mores and taboos: Social use of the first rather than last name is the custom. Great pride in the egalitarian, literate, crime-free, and clean country.
Equipment rental/sales: *Profoto:* Beco, Reykjavík; *tel.* 23411.
Gratuity guidelines: Tipping is considered an insult in Iceland. Simply compliment good service.

INDIA
Republic of India
Bharat

Location: In southern Asia, bounded on the north by China, Nepal, and Bhutan, on the east by Burma, Bangladesh, and the Bay of Bengal, on the south by the Indian Ocean, and on the west by the Arabian Sea and Pakistan. *Size:* 1,229,424 square miles, about one-third the size of the U.S.
Major cities: *New Delhi* (lat. +28.35), Bombay (lat. +19.06), Calcutta (lat. +22.32), Madras (lat. +13.04). *Airports:* Indira Gandhi International Airport (DEL), 9 miles outside of New Delhi; Bombay Airport (BOM), 23 miles outside of Bombay; Calcutta Airport (CCU), 17 miles outside of Calcutta; Meenambarkkam Airport (MAA), 10 miles outside of Madras.
General transportation: Many interna-tional and domestic flights servicing all the major cities, with direct links to the U.S. Railway runs throughout the country. It is possible to travel almost everywhere by road during the dry season, but outside urban areas, roads may be impassable during the monsoon season. Local transport includes three-wheeled scooters, cycle rickshaws, and horse-drawn tongas. Buses are overcrowded, with irregular service. Taxis are plentiful in large cities. *U.S. license:* Yes, with formalities on arrival. *IDP:* Yes. *Rule of the road:* Left. *Motor clubs:* Federation of Indian Automobile Associations, 76 Vir Narinam Road, Bombay; *tel.* 204–1085, 204–1885; partial AAA reciprocity. *Taxi markings:* Black and yellow in large cities, marked

TAXI on the side; both metered and set price. Rates change frequently, and meters are not always calibrated for them—insist on seeing the latest rate cards. **Population:** 817,000,000. *Type of government:* Federal republic, with greater power in the central government than the U.S. system, patterned after the British parliamentary system. India continues to be plagued by communal and sectarian violence. Despite differing views on a number of important issues, India has cordial relations and many shared political traditions with U.S.

Languages: Hindi is the national language and the primary tongue of 30% of the population, but almost all Indians in government and business speak English, and many government and private publications are also written in English. There are 14 other official languages and 24 languages spoken by at least a million people each. Hindustani, a variant of Hindi/Urdu, is spoken widely throughout the north. *Ethnic groups:* 72% Indo-Aryan, 25% Dravidian, 3% Mongoloid and other. *Religion:* 82.6% Hindu, 11.4% Muslim, 2.4% Christian, 2% Sikh, 0.7% Buddhist, 0.5% Jains, 0.4% other.

Time: EST + 10.5; GMT 5.5. *Telephone codes:* Country: 91. Ahmadabad 272, Amritsar 183, Bangalore 812, Baroda 265, Bhopal 755, Bombay 22, Calcutta 33, Chandigarh 172, Hyderabad 842, Jaipur 141, Jullundur 181, Kanpur 512, Madras 44, New Delhi 11, Poona 212, Surat 261. Poor domestic service, fair international service. *Pay phone system:* Coins (as in the English system, the coin is deposited when the party answers). Pay phones are unreliable; it is preferable to phone from hotels, shops, and restaurants. Calls are not free, so if you are not a customer, you may be expected to pay for the call.

Holidays: January 1, 26; August 15; October 2; December 25; plus many national, regional, and religious holidays. Be sure to check with the Indian consulate in advance. *Date/month system:* D/M.

Business hours: 9:30 AM to 1 PM, 2 PM to 5 PM Monday to Friday. *Government hours:* 10 AM to 1 PM, 2 PM to 5 PM Monday to Saturday (except the second Saturday of each month). *Business dress code:* Tie and white shirt, but not a heavy suit if it is hot.

Climate and terrain: Upland plain in the south (Deccan Plateau); flat to rolling heavily populated plain along the Ganges River; deserts (Rajasthan) in the west; Himalaya Mountains in the north. Ranges from tropical in the south to temperate in the north. There are 3 well-defined seasons throughout most of the area: a cool season from November to March, a dry, hot season from March to June, and a hot, rainy season during the remainder of the year. Southeastern India is subject to a second rainy period from November to January: *Temperature ranges* (Bombay): January: 62° to 88°F; April: 74° to 93°F; July: 75° to 88°F; October: 73° to 93°F; (Calcutta): January: 55° to 80°F; April: 76° to 97°F; July: 79° to 80°F; October: 74° to 89°F; (Madras): January: 67° to 85°F; April: 78° to 95°F; July: 79° to 96°F; October: 75° to 90°F; (New Delhi): January: 43° to 71°F; April: 68° to 97°F; July: 80° to 95°F; October: 64° to 93°F.

Visas: Professional photographers are expected to get an entry visa by applying to the public relations officer of the nearest consulate. Permission can take a few weeks for a commercial photographer to several months for a photojournalist in some circumstances. Travel to some areas of the country requires a special permit from the Ministry of Home Affairs. *Tourists:* Tourist visa, good for stays of up to 3 months, requires passport, $15 fee, 1 application, 2 photos, proof of return ticket and sufficient funds. Must be obtained in advance. *Health requirements:* Yellow fever vaccination is required if coming from an infected area and a number of countries infected in part. In all cases, be sure to check on the latest health requirements. *Equipment importation:* If an entry visa has been granted, arrangements will be made with customs. A bond is not necessary. Be sure to

bring several copies of documents, as photocopy machines are not common and you may be asked for several copies. Customs paperwork can be complicated.
Electricity: 230/50. *Plug types:* C and D.
Currency: Rupee (INR); Paise. Hotel bills must be paid in foreign currency, not rupees. Strict currency rules in effect: no import/export of rupees; no limit on U.S. or foreign currency, but all amounts over $1,000 must be declared; exchange only at authorized banks/money changers; keep all receipts. Rupees can be reconverted before return.
U.S. embassy in the country: Shanti Path, Chanakyapuri 110021, New Delhi; *tel.* 600651; *telex:* 031-65269 USEM IN. *Consulates:* Bombay: 822-3611; Calcutta: 44-3611/6; Madras: 473-040 or 477-542.
Embassy in U.S.: 2536 Massachusetts Avenue NW, Washington, DC 20008; *tel.* 202-939-9839/9851. *Consulates:* California: 415-668-0683; Illinois: 312-781-6280; New York: 212-879-7800.
Tourism office in U.S.: India Government Tourist Office, 30 Rockefeller Plaza, Suite 15, New York, NY 10020; *tel.* 212-586-4901.
Central tourism office in country: Government of India Tourist Bureau, 88 Janpath, New Delhi, *tel.* 320-005; Bombay, *tel.* 293-144; Calcutta, *tel.* 441-402; Madras, *tel.* 86240.
Health suggestions: English-speaking medical staff are available. Water is unsafe throughout India. Typhoid, tetanus, diphtheria and hepatitis inoculations are recom-

mended. Malaria suppressants are recommended throughout the country.
Cultural mores and taboos: Business is conducted at a more leisurely pace, and exchanges of pleasantries and tea often precede business discussions. Government dealings are highly bureaucratic. India's diverse ethnicity makes general rules difficult. You may be expected to take off shoes in some conservative homes; Hindus do not eat beef and are often vegetarian; alcohol is consumed in moderation by Hindus and not at all by Muslims. Pass food only with the right hand. Traditional Indian women do not normally shake hands, but instead prefer the *namaste*, where palms of the hands are pressed together, pointing upwards, with the head slightly bowed. Expect many personal questions—they are not considered rude but a sign of interest. Great sensitivity about the country's poverty and secular problems.
Photographic restrictions: Airports, railway stations, and other places where posted. Check on the latest rules for archaeological sites.
Color labs: *Kodak:* India Photographic Co., Ltd., P.O. Box 343, Bombay, *tel.* 400-001; P.O. Box 9086, Calcutta, *tel.* 700-016; P.O. Box 318, New Delhi, *tel.* 110-001; P.O. Box 2259, Madras, *tel.* 600-026.
Gratuity guidelines: Hotels and restaurants usually include 10% in the bill, but giving an additional 10% to the staff is customary. Tip in advance, and do not push a tip on those who refuse it. Resist giving money to beggars.

INDONESIA
Republic of Indonesia
Republik Indonesia

Location: In southeastern Asia, south of the Philippines, Malaysia, and Thailand, north of Australia. *Size:* 779,675 square miles, slightly less than 3 times the size of Texas.
Major cities: Jakarta (lat. −6.11). *Air-

ports:* Sukarno-Hatta International Airport (CGK), 16 miles outside of Jakarta; Halem Pardana Kusama Airport (HLP), 18 miles outside of Jakarta.
General transportation: Many international flights, with direct links to the U.S.

Several domestic carriers link major cities, as does interurban rail service. Buses are generally overcrowded; pedicabs are sometimes dangerous. Main roads are generally reasonable, but traffic is heavy and driving standards are poor. Roads on more remote islands are very poor. It is best to have a local guide for overland travel. *U.S. license:* No. *IDP:* Yes. *Rule of the road:* Left. *Motor clubs:* Ikatan Motor Indonesia, c/o Gedung Koni Pusat, Senayan, Jakarta; *tel.* 581–102; partial AAA reciprocity. *Taxi markings:* "Bluebirds" company taxis are excellent. They are blue with the company logo on the side. There are also yellow "President" taxis. Use these large, legal firms—avoid unmarked illegal taxis. Legal taxis have meters (insist on their use). Tips are appreciated. Taxi service outside of Jakarta is generally poor.

Population: 184,000,000. *Type of government:* Republic; based on 1945 constitution with elected president as the dominant political figure. Since the establishment of the Suharto government, relations with the U.S. have been close and cordial.

Languages: Indonesian (modified form of Malay; official), local dialects, the most widely used of which is Javanese. English is the leading foreign language and is spoken by many in government and business. *Ethnic groups:* Majority of Malay descent, including 45% Javanese, 14% Sundanese, 7.5% Madurese, 7.5% coastal Malay, 26% other. *Religion:* 88% Muslim, 6% Protestant, 3% Roman Catholic, 2% Hindu, 1% other.

Time: EST +12 (Jakarta); GMT +7 to +9. *Telephone codes:* Bandung 22, Cirebon 231, Denpasar (Bali) 361, Jakarta 21, Madiun 351, Malang 341, Medan 61, Padang 751, Palembang 711, Sekurang 778, Semarang 24, Solo 271, Surabaya 31, Tanjungkarang 721, Yogyakarta 274. Domestic service is fair to poor. International service is generally reliable (direct dialing is being gradually introduced). *Pay phone system:* Coins.

Holidays: January 1; Good Friday; Ascension Day (40 days after Easter); August 17; December 25; plus several Muslim and Buddhist holidays. *Date/month system:* D/M.

Business hours: 9 AM to 1 PM, 2 PM to 5 PM Monday to Friday; 9 AM to 1 PM Saturday. *Government hours:* 8 AM to 3 PM Monday to Thursday; 8 AM to 11 AM Friday; 8 AM to 2 PM Saturday. *Business dress code:* Tie and jacket are necessary only on official calls. Batik shirt is considered formalwear.

Climate and terrain: Indonesia is an archipelago of 13,500 islands (6,000 inhabited) extending 3,000 miles. Mostly lowlands along the coasts with mountains on the larger islands. Hot and very humid tropical climate year-round along the lowlands, cooler in the mountains. Rainy season is from November to April. Occasional floods and droughts. *Temperature ranges* (Jakarta): January: 74° to 84°F; April: 75° to 87°F; July: 73° to 87°F; October: 74° to 87°F.

Visas: *Business visa:* Passport, client letter, 1 application, 2 photos; have another photo with you on arrival; allow 2 weeks for normal processing. Photojournalists might need special permission, requiring 1 to 2 months processing, through the consulate. *Tourists:* Passport (valid for 6 months beyond arrival); no visa is needed for stays of up to 2 months (nonextendable). *Health requirements:* Yellow fever vaccination is required if coming from an infected area and countries in the endemic zone. *Equipment importation:* Bring a list; no bond is required.

Electricity: 127/50. *Plug types:* C, E, and F.

Currency: Rupiah (RPA); Sen.

U.S. embassy in the country: Medan Merdeka Selatan 5, Jakarta; *tel.* 360–360; *telex:* 44218 AMEMB JKT. *Consulates:* Medan: 322200; Surabaya: 69287/8.

Embassy in U.S.: 2020 Massachusetts Avenue NW, Washington, DC 20036; *tel.* 202–775–5200. *Consulates:* California: 213–383–5126, 415–474–9571; Hawaii: 808–524–4300; Illinois: 312–938–0101; New York: 212–879–0600; Texas: 713–626–3291.

Tourism office in U.S.: Indonesian Tourist Promotion Office, 3457 Wilshire Boulevard, Los Angeles, CA 90010; *tel.* 213–387-2078.

Central tourism office in country: Director General of Tourism, Jalan Kramat Raya #81, Jakarta Pusat; *tel.* 359–001/6, 348–480.

Health suggestions: General level of health and sanitation is below U.S. standards. Water is not potable. Typhoid, hepatitis, tuberculosis, and parasitic diseases are prevalent. Malaria suppressants are recommended for a number of areas. Cholera infection is present. Adequate routine medical care is available in major cities.

Cultural mores and taboos: Telephone problems, heavy traffic, and difficulty in making business appointments make conducting business more time consuming than in most developed countries. Business decisions and transactions are not completed quickly, and patience is the key. Never visibly lose your temper or show emotion. A direct "no" is rare. Business cards are important. Businessmen commonly exchange small gifts. Indonesians are hospitable and like to avoid confrontation and disharmony. Most of the population is Muslim; do not use the left hand, do not point, and do not gesture with the foot. Keep the feet and legs down. Avoid turning your back when leaving. Smiling, bowing, or nodding is considered more gracious than handshakes, but the latter have become quite accepted in major cities. Never touch a person's head—not even a child's.

Equipment rental/sales: *Comet:* Futura Photography, Jakarta; *tel.* 769–3130.

Gratuity guidelines: Tips are appreciated but not required except in major hotels, where service is normally included in the bill.

IRAN
Islamic Republic of Iran
Jomhorie-e-Islami-e-Irān

The State Department strongly advises U.S. citizens against any travel to Iran because of the war with Iraq and anti-American policies.

Location: In southwestern Asia, bounded on the north by the USSR and the Caspian Sea, the east by Afghanistan and Pakistan, the south by the Gulf of Oman and the Persian Gulf, the west by Iraq, and the north by Turkey. *Size:* 635,932 square miles, one-fifth the size of the U.S.

Major cities: *Tehran* (lat. +35.41). **Airports:** Mehrabad Airport (THR), 8 miles outside of Tehran.

General transportation: Flights to Europe, with connections on to the U.S. Public buses, minibuses, and car rentals are available. *U.S. license:* Yes, for 6 months; IDP recommended. *IDP:* Yes. *Rule of the road:* Right. *Motor clubs:* Touring and Automobile Club of the Islamic Republic of Iran, Martyr Dr. Fayazbakhsh no. 37, Tehran; *tel.* 679–142/147; partial AAA reciprocity. *Taxi markings:* Marked TAXI; orange cars, metered.

Population: 52,000,000. *Type of government:* Theocratic republic; 1979 constitution grants broad powers to Shi'a Muslim clergy. Diplomatic relations with the U.S. were broken in 1984; there are limited commercial relations but serious obstacles to renewed diplomatic relations.

Languages: Farsi, Turki, Kurdish, Arabic, English, French. *Ethnic groups:* 63% ethnic Persian, 18% Turkic, 13% other Iranian, 3% Kurdish, 3% Arab and other Semitic. *Religion:* 93% Shi'a Muslim, 5% Sunni Muslim, 2% Zoroastrian, Jewish, Christian, Baha'i.

Time: EST +8.5; GMT +3.5. *Telephone codes:* Country: 98. Ābādān 631, Ahvāz 61, Arak 2621, Eşfahān 31, Ghazvin 281, Ghome 251, Hamadān 261, Karadj 2221, Kermān 341, Mashhad 51, Rasht 231, Re-

zai'yeh 441, Shīrāz 71, Tabrīz 41, Tehran 21. *Pay phone system:* Coins.
Holidays: Shi'a Islamic holidays plus February 11; April 1. The end of March to the first days in April are the Iranian New Year; businesses close. *Date/month system:* D/M.

Business hours: 8 AM to 5 PM Saturday to Thursday in the winter; 8 AM to 1 PM, 6 PM to 8 PM Saturday to Thursday in the summer, with some offices closed on Thursday afternoon. *Government hours:* 8 AM to 4:30 PM Saturday to Wednesday. **Business dress code:** Conservative dress for men and women (no short-sleeved shirts for men).

Climate and terrain: Scarcity of water, irregular terrain, and climatic extremes have restricted habitation mainly to the western and northern portions of Iran, particularly along the Caspian coast, metropolitan Tehran, and the provinces of East and West Azerbaijan. About 70% of the land is uninhabited. A rugged mountainous rim surrounds a high interior basin, composed of desert plains and two smaller mountain ranges. Lowlands run along the narrow strip bordering the Caspian Sea, the Plain of Khūzestān in the southwest, and the long barren coastal strip along the Persian Gulf and Gulf of Oman. Wide climatic variations prevail. Seasonal changes are abrupt, with a short spring and fall. Most of Iran experiences long, hot, dry summers. Along the gulf and Caspian coasts, oppressively high humidity accompanies the heat. Winter is cold in the north, more moderate along the Caspian coast and the Plain of Khūzestān. *Temperature ranges* (Tehran): January: 27° to 45°F; April: 49° to 71°F; July: 72° to 99°F; October: 53° to 76°F.

Visas: Special permission is needed from Tehran. Contact the Iranian Interest Section of the Algerian Embassy: required are passport, 1 application, 2 photos, photographer letter, and client letter. Response takes 6 to 8 weeks at least. *Health requirements:* Yellow fever vaccination is required if coming from an infected area or countries in the endemic zone. *Equipment importation:* Include equipment list with visa application.
Electricity: 220/50. *Plug types:* Data unavailable.
Currency: Rial (IRI); Dinars.
U.S. embassy in the country: None. U.S. interests are represented by Switzerland, although the State Department warns that the Swiss have often been prevented from providing even minimal assistance to U.S. citizens.
Embassy in U.S.: None. Iranian interests are represented here by Algeria (Iranian Interest Section), *tel.* 202-965-4990.

Central tourism office in country: Office of Tourism, Ministry of Guidance, Boulevard Keshavarz, Tehran.

Health suggestions: Water in major cities is considered potable; elsewhere it is not. Malaria suppressants are recommended for some areas. Cholera infection is present.

Cultural mores and taboos: Handshakes are the customary greeting, with a slight bow or nod of the head to show respect. Iranians, including men, may kiss each other on the cheek as a greeting. Appointments may not begin on time. Tilting the head up quickly means no; tilting it down means yes; twisting the head means "what?" Individual Iranians often like foreigners; their contempt is for the American government, and it may not extend to individuals. Muslim injunctions against alcohol and pork prevail. Do not cross legs, point or gesture at someone with the hand, show the soles of the feet, or pass or accept items with the left hand. If invited to a mosque, dress to cover the entire body, remove shoes (tip the attendant who gives you slippers), and do not walk in front of others praying.

Equipment rental/sales: *Profoto:* Irtaiphco Co. Ltd., Tehran; *tel.* 68 66

Gratuity guidelines: Service is usually included; a bit more is appreciated.

IRAQ
Republic of Iraq
Al Jumhouriya al 'Iraqia

Travel in some areas of the country is dangerous because of the war with Iran. The State Department also advises that Iraqi Airlines has been unwilling to endorse tickets to other carriers and has not allowed carry-on luggage. There have also been reports of luggage being detained without receipt.

Location: In southwestern Asia, bounded on the north by Turkey, the east by Iran, the southeast by Kuwait and the Persian Gulf, the south by Saudi Arabia, and the west by Jordan and Syria. **Size:** 168,927 square miles, about the size of California.

Major cities: *Baghdad* (lat. +33.20). **Airports:** Saddam International Airport (SDA), 11 miles outside of Baghdad; Al Muthana Airport (BGW), 18 miles outside of Baghdad.

General transportation: Many international flights, with direct links to the U.S. through Europe. International flight schedules change without notice. Basra and Umm Qasr seaports are closed because of proximity to war zone. A railroad connects Basra to Baghdad, but the Syrian segment of the railroad linking Iraq to Turkey and Europe has been closed since 1982. Border crossing points between Iraq and Syria and Iraq and Iran are closed. Paved highways connect major cities and neighboring countries, but some have deteriorated since the war. Buses and taxis provide good public transport. **U.S. license:** No. **IDP:** No. **Rule of the road:** Right. **Motor clubs:** Iraq Automobile and Touring Association, Al-Mansour, Baghdad; *tel.* 35–862, 36–001; partial AAA reciprocity. **Taxi markings:** Marked TAXI; all colors, some metered, some set price. Negotiate prices.

Population: 17,600,000. **Type of government:** Republic; Ba`th party in control since 1968 coup; diplomatic relations with U.S. resumed in 1984.

Languages: Arabic (official), Kurdish (official in Kurdish regions), Assyrian, Armenian. English is the most commonly spoken foreign language. **Ethnic groups:** 75% to 80% Arab, 15% to 20% Kurdish, 5% Turkoman, Assyrian, or other. **Religion:** 60% to 65% Shi'a Muslim, 32% to 37% Sunni Muslim, 3% Christian or other.

Time: EST +8; GMT +3. **Telephone codes:** No direct-dial from U.S.—operator-assisted calls only. No credit card or collect calls to U.S. Poor to fair domestic and international service, with delays and interruptions. **Pay phone system:** Coins.

Holidays: January 1, 6; February 8; March 21; May 1; July 14, 17; plus Muslim holidays—check with consulate. **Date/month system:** D/M.

Business hours: 8:30 AM to 2:30 PM, 5 PM to 7 PM Saturday to Wednesday, 8:30 AM to 2:30 PM Thursday in the winter; 8 AM to 2 PM, 5 PM to 7 PM Thursday in the summer. **Government hours:** 8:30 AM to 2:30 PM Saturday to Wednesday, 8:30 AM to 1:30 PM Thursday in the winter; 8 AM to 2 PM Saturday to Wednesday, 8 AM to 1 PM Thursday in the summer. **Business dress code:** Conservative for men and women.

Climate and terrain: Much of the country is desert or wasteland. Mountains along the border with Turkey and Iran (10,000 feet); reedy marshes in the southeast. Mild to cool winters; hot, dry, cloudless summers. A bit of rain falls from December to April. **Temperature ranges** (Baghdad): January: 39° to 60°F; April: 57° to 85°F; July: 76° to 110°F; October: 61° to 92°F.

Visas: Need approval from the Ministry of Information in Baghdad. Contact the press attaché at the embassy (202–835–0022) with a letter proposing the trip, a résumé, and an equipment list for customs. Response takes 1 to 4 weeks at least. If approved, visa requires passport, 1 application, 2 photos; processing takes only 1 or 2 days more. *Tourists:* Apply for a visa as well. **Health require-**

ments: Yellow fever vaccination is required if coming from an infected area. *Equipment importation:* Handled with visa. **Electricity:** 220/50. *Plug types:* C, D, and G.

Currency: Dinar (IRD); 1,000 Fils.

U.S. embassy in the country: Opposite the Foreign Ministry Club (Masbah Quarter), P.O. Box 2447 Alwiyah, Baghdad; *tel.* 719-6138/9, 718-1840, 719-3791; *telex:* 212287 USINTIK, 213966 USFCSIK. **Embassy in U.S.:** 1801 P Street NW, Washington, DC 20036; *tel.* 202-483-7500.

Health suggestions: Baghdad's facilities suffice for routine problems, but doctors are overworked and facilities are crowded. Water is not potable. Malaria suppressants are recommended in northern areas.

Cultural mores and taboos: Muslim injunctions against pork prevail (Iraq is one of the few Muslim countries where drinking alcohol is socially acceptable). Do not cross legs, point or gesture at someone with the hand, show the soles of the feet, or pass or accept items with the left hand. If invited to a mosque, dress to cover the entire body, remove shoes (tip the attendant who gives you slippers), and do not walk in front of others praying. Appointments may not begin on time—never display impatience. Interruptions are frequent.

Photographic restrictions: Contact Ministry of Information (see **Visas,** above).

Gratuity guidelines: Service is sometimes included but a bit extra is appreciated.

IRELAND
Republic of Ireland
Eire

Location: In northwestern Europe, on the island of Ireland, which it shares with Northern Ireland; west of Great Britain. *Size:* 26,600 square miles, slightly larger than West Virginia.

Major cities: *Dublin* (lat. +53.22), Limerick (lat. +53). *Airports:* Dublin Airport (DUB), 6 miles outside of Dublin; Shannon Airport (SNN) 15 miles outside of Limerick.

General transportation: Excellent links to the U.S. and Europe through Dublin or Shannon airports. Good public transport. *U.S. license:* Yes. *IDP:* Yes. *Rule of the road:* Left. *Motor clubs:* The Automobile Association (AA), 23 Suffolk Street, Dublin; *tel.* 775-520; full AAA reciprocity. *Taxi markings:* All colors, marked TAXI; metered.

Population: 3,500,000. *Type of government:* Republic; sovereign, independent democratic state with a parliamentary system of government. Traditionally cordial relations with the U.S.

Languages: Irish (Gaelic) and English (official). English is widely spoken. *Ethnic groups:* Celtic with English minority. *Reli-*

gion: 94% Roman Catholic, 4% Anglican, 2% other.

Time: EST +5; GMT 0. *Telephone codes:* Country: 353. Arklow 402, Cork 21, Dingle 66, Donegal 73, Drogheda 41, Dublin 1, Dundalk 42, Ennis 65, Galway 91, Kildare 45, Killarney 64, Sligo 71, Tipperary 62, Tralee 66, Tullamore 506, Waterford 51, Wexford 53. Modern domestic and international service. *Pay phone system:* Coins.

Holidays: Celebrated on the next business day if they fall on a weekend: January 1; March 17; Good Friday; Easter Monday; first Mondays in June and August; last Monday in October; December 25, 26. *Date/month system:* D/M.

Business hours: 9:30 AM to 5 PM Monday to Friday. *Business dress code:* Same as that of the U.S.

Climate and terrain: Undulating, fertile central plain almost surrounded by coastal highlands. Temperate maritime climate modified by North Atlantic Current. Mild winters; cool summers. Overcast skies, rain, and dampness, responsible for Ireland's famous greenery, are common. May, June,

and September are usually the sunniest months. *Temperature ranges* (Dublin): January: 35° to 47°F; April: 38° to 54°F; July: 51° to 67°F; October: 43° to 57°F.

Visas: Standard tourist entry, requiring passport; no visa is needed for stays of up to 90 days; proof of return ticket may be required. *Health requirements:* No vaccinations required. *Equipment importation:* Carnet.

Electricity: 220/50. *Plug types:* F and G.
Currency: Punt (IR£); Pence.

U.S. embassy in the country: 42 Elgin Road, Ballsbridge, Dublin; *tel.* 688–777, *telex:* 93684.

Embassy in U.S.: 2234 Massachusetts Avenue NW, Washington, DC 20008; *tel.* 202–462–3939. *Consulates:* California: 415–392–4214; Illinois: 312–337–1868; Massachusetts: 617–267–9330; Missouri: 618–

274–0886; New York: 212–319–2555.
Tourism office in U.S.: Irish Tourist Board, 757 Third Avenue, 19th Floor, New York, NY 10017; *tel.* 212–418–0800.

Central tourism office in country: Irish Tourist Board (Bord Failte), Baggot Street Bridge, Dublin 2, 765–871.

Health suggestions: Good sanitation and medical services. Water is potable.

Cultural mores and taboos: Avoid discussion of the "troubles," relations between Catholics and Protestants in Northern Ireland, as well as relations with the United Kingdom.

Color labs: *Fuji* Processing Lab, P.O. Box 524, Rathmines, Dublin 6.

Gratuity guidelines: Usually included in the bill; not customary to leave more unless service is quite special.

ISRAEL
State of Israel
Medinat Israel

Location: In southwestern Asia, bounded on the north by Lebanon, the east by Syria and Jordan, the southwest by Egypt, and the west by the Mediterranean Sea. *Size:* 7,992 square miles, slightly larger than New Jersey.

Major cities: *Jerusalem* (lat. +32), Tel Aviv–Jaffa (lat. +32.06). *Airports:* Ben Gurion Airport (TLV), 12 miles outside of Tel Aviv–Jaffa.

General transportation: Many international flights, with direct links to U.S., and several domestic links to major cities. A well-developed highway system, good bus network, and state-owned railway provide excellent domestic links. Taxis are plentiful. *U.S. license:* Yes. *IDP:* Yes. *Rule of the road:* Right. *Motor clubs:* Automobile and Touring Club of Israel (Memsi), 19 Petah Tikva Road, Tel Aviv–Jaffa; *tel.* 662–961; full AAA reciprocity. *Taxi markings:* Marked TAXI; metered. *Sherut* taxis (shared Mercedes) are available at airports and special stands for fixed routes; taxis have

25% surcharge at night; tips are not expected.

Population: 4,300,000. *Type of government:* Republic; parliamentary (Knesset) democracy. Close relations with the U.S.

Languages: Hebrew and Arabic (official); English is a widely spoken second language. *Ethnic groups:* 83% Jewish, 17% non-Jewish (mostly Arab). *Religion:* 83% Jewish, 13.1% Muslim (mostly Sunni), 2.3% Christian, 1.6% Druse.

Time: EST +7; GMT +2. *Telephone codes:* Country: 972. Acre 4, 'Afula 65, Ashqelon 51, Bat Yam 3, Beersheba 57, Dimona 57, Hadera 63, Haifa 4, Holon 3, Jerusalem 2, Natanya 53, Nazareth 65, Rehovot 8, Safad 67, Tel Aviv–Jaffa 3, Tiberias 67. Efficient domestic and international service. *Pay phone system:* Tokens, officially available only in post offices, but you might be able to get them at your hotel or at a newsstand.

Holidays: Based on the Jewish calendar, their dates vary from year to year: Passover

(first and last day); Independence Day; Shavuoth; Rosh Hashanah; Yom Kippur; Succoth; Simhat Torah. Some businesses close for the entire Passover holiday, some close half-days between the first and last day of Succoth. Some factories are also on leave for Succoth. *Date/month system:* D/M. **Business hours:** 8 AM to 1 PM, 4 PM to 7 PM Sunday to Thursday; some businesses are open all day. *Government hours:* Open for visitors 9 AM to 1 PM Sunday to Friday, although government offices function into the afternoon and usually can address urgent matters. *Business dress code:* Open shirt instead of tie is acceptable; business dress is far more informal than in U.S.

Climate and terrain: Four regions: the Negev desert (50% of the land); low coastal plain; central mountains; Jordan Rift Valley. At 396 feet below sea level, the Dead Sea is the lowest point on earth. Climate is temperate except in the Negev, where it is hot and dry year-round. In the rest of the country, most rain falls from October to April. *Temperature ranges* (Tel Aviv–Jaffa): January: 50° to 64°F; April: 57° to 70°F; July: 72° to 82°F; October: 65° to 79°F.

Visas: Standard tourist entry, requiring passport (valid 9 months beyond arrival); no visa is needed for stays of up to 3 months (may be extended in Israel). Photojournalists may apply for local press credentials if they wish from the Government Press Office: Jerusalem: 243–161, 243–091; Tel Aviv: 216–222. Have your U.S. press credentials and a letter from your publication with you. *Note:* Having a second passport for trips to Israel is advisable, to avoid problems when traveling to countries in conflict with Israel.

Health requirements: No vaccinations required. *Equipment importation:* Carnet. **Electricity:** 230/50. *Plug types:* C, D, and J.

Currency: Shekel (ILS); Agorot.

U.S. embassy in the country: 71 Hayarkon Street, Tel Aviv–Jaffa, *tel.* 654–338; *telex:* 33376 or 371386 US FCS IL.

Embassy in U.S.: 3514 International Drive NW, Washington, DC 20008; *tel.* 202–364–5500. *Consulates:* California: 213–651–5700 and 415–398–8885; Florida: 305–358–8111; Georgia: 404–875–7851; Illinois: 312–565–3300; Massachusetts: 617–542–0041; New York: 212–697–5500; Pennsylvania: 215–546–5556; Texas: 713–627–3780.

Tourism office in U.S.: Israel Government Tourist Office, 350 Fifth Avenue, New York, NY 10118; *tel.* 212–560–0650.

Central tourism office in country: Israel Government Tourist Office, King George Street #24, Jerusalem; *tel.* 241–281, 282; Mendele #7, Tel Aviv–Jaffa; *tel.* 223–266, 267.

Health suggestions: Comparable health standards to U.S. Adequate medical and dental care. One pharmacy in a neighborhood must always be open by law. Water is potable.

Cultural mores and taboos: Informal and inquisitive, Israelis welcome frank and open discussions and do not generally hesitate to express their opinions. However, you should be a bit discreet in political discussions. Punctuality is important.

Photographic restrictions: Posted.

Gratuity guidelines: Same as those of the U.S.

ITALY
Italian Republic
Repubblica Italiana

Location: In southern Europe, bounded on the north by Switzerland and Austria, the northeast by Yugoslavia, the east by the Adriatic and Ionian seas, the south by the Mediterranean Sea, the southwest by the Tyrrhenian Sea, and the west by the Ligurian Sea and France. *Size:* 116,313 square miles, about the size of Georgia and Florida combined.

Major cities: *Rome* (lat. +41.48), Milan

(lat. +48.28). *Airports:* Leonardo da Vinci (Fiumicino, FCO), 22 miles outside of Rome); Ciampino (CIA), 7 miles outside of Rome; Malpensa Airport (MXP), 30 miles outside of Milan—Malpensa is a long drive and often fogged in; be sure to check on flights before heading to it; Linate Airport (LIN), 6.5 miles outside of Milan. **General transportation:** Many international flights, with direct links to the U.S. and domestic flights to major cities. Public transport is modern and efficient. Rome has a subway (the Metropolitana). *U.S. license:* Yes, with Italian translation or declaration. *IDP:* Yes. *Rule of the road:* Right. *Motor clubs:* Automobile Club D'Italia (ACI), Via Marsala 8, 00185 Rome; *tel.* 4998; full AAA reciprocity. *Taxi markings:* All colors, marked TAXI. Beware of unmetered taxis. **Population:** 57,500,000. *Type of government:* Republic; stable parliamentary democracy despite frequent turnovers of leadership. Warm and friendly relations with the U.S. **Languages:** Italian. Some ethnic pockets retain their own language. English is understood by some in business and government. *Ethnic groups:* Primarily Italian, with small clusters of other European ethnic groups. *Religion:* Almost 100% nominally Roman Catholic. *Time:* EST +6; GMT +1. *Telephone codes:* Country: 39. Bari 80, Bologna 51, Brindisi 831, Capri 81, Como 31, Florence 55, Genoa 10, Milan 2, Naples 81, Padua 49, Palermo 91, Pisa 50, Rome 6, Turin 11, Trieste 40, Venice 41, Verona 45. Good domestic and international service. *Pay phone system:* Tokens. **Holidays:** January 1, 6; Easter Monday; April 25; May 1; August 15; November 1; December 7 (Milan only), 8, 25, 26. *Date/month system:* D/M. **Business hours:** 8 or 9 AM to 12 noon or 1 PM, 3 PM to 6 or 7 PM Monday to Friday. *Government hours:* 8 AM to 2 PM Monday to Friday. *Business dress code:* Same as that of the U.S.

Climate and terrain: Except for the Po Valley area in the north, the heel of the "boot" in the south, and small coastal areas, Italy is rugged and mountainous. Climate is generally mild and Mediterranean, but there are some wide variations. Sicily is warmer; the northern Alps, cooler. *Temperature ranges* (Rome): January: 39° to 54°F; April: 46° to 68°F; July: 64° to 88°F; October: 53° to 73°F; (Palermo): January: 47° to 58°F; April: 53° to 67°F; July: 71° to 86°F; October: 62° to 75°F; (Venice): January: 33° to 43°F; April: 49° to 63°F; July: 67° to 82°F; October: 52° to 65°F. **Visas:** Photographers commonly enter as tourists. Officially, a visa for independent work is required for carrying out commercial assignments. Requirements are extensive and processing takes 2 to 3 months. Contact the nearest consulate for details. *Tourists:* Passport; no visa is needed for stays of up to 3 months. **Health requirements:** No vaccinations required. **Equipment importation:** Carnet. **Electricity:** Mostly 220/50 (some 127 V). *Plug types:* C and F. **Currency:** Lira (LIT); subdivision (pl.). **U.S. embassy in the country:** Via Veneto 119/A, 00187 Rome; *tel.* 46741; *telex:* 622322 AMBRMA. *Consulates:* Florence: 298–276; Genoa: 282–741/5; Milan: 652–841/5; Naples: 660966; Palermo: 291532/35; Turin: 517437. **Embassy in U.S.:** 2700 Sixteenth Street NW, Washington, DC 20009; *tel.* 202–328-5500. *Consulates:* California: 213–826–5998, 415–931–4924; Illinois: 312–467–1550; Louisiana: 504–524–2272; Massachusetts: 617–542–0483; New York: 212–737–9100; Pennsylvania: 215–592–7369; Texas: 713–850–7520. **Tourism office in U.S.:** Italian Government Travel Office, 630 Fifth Avenue, New York, NY 10111; *tel.* 212–245–4822. **Central tourism office in country:** ENIT, Via Marghera #2, Rome; *tel.* 49711 (system is decentralized—they can give you the other provincial headquarters).

Health suggestions: Medical facilities are available in the cities. No special immunizations are necessary. Water is potable, but mineral water is more popular. **Cultural mores and taboos:** Punctuality is more prized in the north. Lunch and dinner invitations are important and should not be refused lightly. **Photographic restrictions:** Tripods require permits for use, even in the street.

Color labs: *Fuji:* Via De Sanctis 41, 20141 Milan. **Equipment rental/sales:** *Balcar:* Bancolini, in Bologna, *tel.* 392–943; in Milan, *tel.* 839–7766. *Balcar and Broncolor:* Studio 117, Milan, *tel.* 546–1142. *Profoto:* Upper s.n.c., Verona, *tel.* 569596. **Gratuity guidelines:** Service is usually included in the bill; leaving a bit more is customary.

JAMAICA

Location: In the West Indies, south of Cuba. *Size:* 4,471 square miles, slightly smaller than Connecticut. **Major cities:** *Kingston* (lat. +17.58), Montego Bay (lat. +18.27). *Airports:* Norman Manley (KIN), 11 miles outside of Kingston; Tinson (KTP), 2 miles outside of Kingston; Sangster International Airport (MBJ), 2 miles outside of Montego Bay. **General transportation:** Good international links, with direct flights to the U.S. Air service between Kingston and Montego Bay. Almost all roads are paved but, because of the mountainous terrain, are narrow and winding with uneven surfaces; driving manners are aggressive. Buses provide regular service but are overcrowded. Rail service is available, but it is slow. *U.S. license:* Yes, to drive privately owned vehicles only; commercial vehicles require a "General" Jamaica license. *IDP:* Yes; same restrictions as for U.S. license. *Rule of the road:* Left. *Motor clubs:* Jamaica Automobile Association, 14 Ruthven Road, Kingston; *tel.* 91200/1; partial AAA reciprocity. *Taxi markings:* Red license plate with PPV, usually yellow or checkered (as in Kingston) but can be all colors in other parts; set price, agree in advance. **Population:** 2,500,000. *Type of government:* Independent state within the British Commonwealth, recognizing Elizabeth II as head of state. Parliamentary and legal system based on the English. Stable politically, but serious economic conditions have led to serious problems, including high crime rate, es-

pecially in Kingston. Close relations with the U.S. **Languages:** English, Creole. *Ethnic groups:* 76.3% African descent, 71.3% Afro-European, 3.4% East Indian and Afro–East Indian, 3.2% white, 1.2% Chinese and Afro-Chinese, 0.8% other. *Religion:* Predominantly Protestant (including Anglican and Baptist), some Roman Catholic, some spiritualist cults. **Time:** EST; GMT −5. *Telephone codes:* Direct-dial from the U.S. using 809 area code. Good, fully automatic domestic and international service. *Pay phone system:* Coins. **Holidays:** January 1; Ash Wednesday; Good Friday; Easter Monday; May 23; August 1; October 17; December 25, 26. *Date/month system:* D/M. **Business hours:** 8:30 AM to 4:30 PM Monday to Friday. *Government hours:* 8 AM to 5 PM Monday to Thursday; 8 AM to 4 PM Friday. *Business dress code:* Same as that of the U.S. **Climate and terrain:** Mostly mountainous, with narrow, discontinuous coastal plain (highest peak, 7,402 feet). Climate is tropical and humid most of the year, with cooler temperatures from November to March, particularly along the north shore. Rainfall is seasonal and varies widely by region (from 200 inches per year in northern spots to almost none in some southern and southwestern areas). Subject to hurricanes from May to December; Gilbert in 1988 caused extensive damage. *Temperature*

ranges (Kingston): January: 67° to 86°F; April: 70° to 87°F; July: 73° to 90°F; October: 73° to 88°F.

Visas: Contact consulate for special visa: Passport, client letter, application, equipment list; can be processed quickly. *Tourists:* Proof of U.S. citizenship, photo ID, proof of return ticket and sufficient funds; good for stays of up to 6 months if traveling directly from the U.S., Puerto Rico, or U.S. Virgin Islands; a tourist card will be issued on arrival. *Health requirements:* Yellow fever vaccination is required if coming from an infected area. *Equipment importation:* Arrange for with visa.

Electricity: 110/50. *Plug types:* A and B.

Currency: Dollar (JA$); Cents.

U.S. embassy in the country: Jamaica Mutual Life Center, 2 Oxford Road, 3d Floor, Kingston; *tel.* 929–4850.

Embassy in U.S.: 1850 K Street NW, Suite 355, Washington, DC 20006; *tel.* 202–

452–0660. *Consulates:* California: 213–735–4950; Florida: 305–374–8431; Illinois: 312–751–5675; New York: 212–935–9000.

Tourism office in U.S.: Jamaica Tourist Board, 866 Second Avenue, New York, NY 10017; *tel.* 212–688–7650.

Central tourism office in country: Jamaica Tourist Board, 21 Dominica Drive, Kingston 5 (New Kingston); *tel.* 99–200.

Health suggestions: Medical services are available in Kingston and resort areas. Water is potable.

Cultural mores and taboos: Attitudes about time are casual.

Film commissions: Jamaica Film Office, 35 Trafalgar Road, 3d Floor, Kingston 10; *tel.* 929–9450.

Gratuity guidelines: Usually included in the bill; a bit more is accepted; if not included, leave a tip.

JAPAN
Nippon

Location: In western Asia, east of the USSR and North and South Korea. *Size:* 143,619 square miles, slightly smaller than California.

Major cities: *Tokyo* (lat +35.41), *Ōsaka* (lat. +34.47). *Airports:* Narita (NRT), 40 miles outside of Tokyo; Haneda (HND), 11 miles outside of Tokyo; Ōsaka International Airport (OSA), 10 miles outside of Ōsaka.

General transportation: Excellent public transport, including high-speed intercity bullet trains (often more convenient than flying, particularly between Tokyo and Osaka).

U.S. license: No. *IDP:* Yes. *Rule of the road:* Left. *Motor clubs:* Japan Automobile Federation (JAF), 3–5–8 Shibakoen, Minato-ku, Tokyo; *tel.* 436–2811; full AAA reciprocity. *Taxi markings:* All colors, marked TAXI, red light on the left in front window is lit when free; metered. Do not be surprised if drivers in Tokyo ask directions.

Population: 122,600,000. *Type of government:* Constitutional monarchy; stable

parliamentary government. Close, friendly relations with the U.S.

Languages: Japanese. English is spoken by some in business and government and its comprehension is increasing, but translation services are suggested for important transactions. In addition to consulting your hotel, you might want to contact the Japan Guide Association, *tel.* (03) 213–2706. *Ethnic groups:* 99.4% Japanese, 0.6% other (mostly Korean). *Religion:* Most observe Shinto and Buddhist rites, about 16% belong to other faiths including 0.8% Christianity.

Time: EST +14; GMT +9. *Telephone codes:* Country: 81. Chiba 472, Fuchu (Tokyo) 423, Hiroshima 82, Kawasaki 44, Kōbe 78, Kyōto 75, Nagasaki 958, Nagoya 52, Naha (Okinawa) 988, Ōsaka 6, Sapporo 11, Sasebo 956, Tachikawa (Tokyo) 425, Tokyo 3, Yokohama 45, Yokosuka (Kanagawa) 468. Excellent domestic and international service. *Pay phone system:* Coins, magnetic cards.

Holidays: January 1 (plus several days around it), 15; February 11; March 21; April 29; May 3, 5; September 15, 23; October 10; November 3, 23. *Date/month system:* Y/M/D if the year of the Emperor (or Heisei) calendar is used; M/D/Y when using the Gregorian calendar.

Business hours: 9 AM to 5 PM Monday to Friday. *Business dress code:* Conservative, dark suits.

Climate and terrain: Four-fifths of Japan has rugged mountainous terrain, with a large earthquake zone. Ranges from subtropical in Okinawa (similar to southern Florida) to cooler in Hokkaidō (like southern Maine). Most of Japan is dominated by the Asiatic monsoons, which bring a pronounced summer rainy season (most intense in early July) and drier winters. *Temperature ranges* (Tokyo): January: 29° to 47°F; April: 46° to 63°F; July: 70° to 83°F; October: 55° to 69°F.

Visas: As of December 15, 1988, business or tourist visas are no longer necessary for visits of up to 90 days; passport only is needed. *Health requirements:* No vaccinations required. *Equipment importation:* Carnet.

Electricity: 100/50 cycles in eastern Japan (including Tokyo), 60 cycles in west (including Ōsaka, Kōbe). *Plug types:* A.

Currency: Yen (¥); Sen.

U.S. embassy in the country: 10-1, Akasaka 1-chome, Minato-ku (107), Tokyo; *tel.* 583–7141; *telex:* 2422118. *Consulates:* Naha, Okinawa 876–42118; Ōsaka-Kōbe: 361–9600; Sapporo: 641–1115/7; Fukuoka: 751–9331/4.

Embassy in U.S.: 2520 Massachusetts Avenue NW, Washington, DC 20008; *tel.* 202–939–6700. *Consulates:* California: 213–624–8305, 415–921–8000; Georgia: 404–892–2700; Hawaii: 808–536–2226; Illinois: 312–280–0400; Louisiana: 504–529–2101; Massachusetts: 617–973–9772; Missouri: 816–471–0111; New York: 212–371–8222; Oregon: 503–221–1811; Texas: 713–652–2977; Washington: 206–862–9107.

Tourism office in U.S.: Japan National Tourist Office (JNTO), 630 Fifth Avenue, New York, NY 10111; *tel.* 212–757–5640.

Central tourism office in country: *Tokyo:* Promotion department, public relations group for foreign press, Japan National Tourist Office, 10-1 Yurakucho, 2-chome, Chiyoda-ku, 100; *tel.* (03) 216–1902; *fax:* (03) 214–7680. Ōsaka: Tourist Information Center, Kyoto Tower Building, Higashi-Shiokojicho, Shimogyo-ku, Kyoto; *tel.* (075) 371–5649. *Kyōto:* Kyōto Tower Building, Higashi-Shiokojicho, Shimogyo-ku, 600; *tel.* (075) 371–5649.

Health suggestions: Water quality and general conditions are excellent.

Cultural mores and taboos: To spare your feelings, you will rarely be told "no" directly, and decisions almost always take time because of the need for consultations. Patience and politeness are the order of the day. Never put forth your proposals immediately, and be aware that to progress well you will need proper introductions. Present business cards immediately with both hands, and study their cards with interest; put theirs in the breast pocket, not trouser pocket. Airlines and important business hotels will print cards overnight. A bow is still the traditional greeting, but handshakes are becoming more common. Remove shoes before entering a home, and bring a small gift. Do not excessively compliment the host on any item in the home—it may obligate the host to give it to you. Modesty is greatly valued. Laughter may indicate embarrassment or discomfort as well as amusement. One's obligations to the group override personal prestige.

Photographic restrictions: No official restrictions, but permission for photographing official institutions (and many private ones, such as department stores) will require written applications, with date, number of persons, names, affiliation, equipment, purpose, etc. Fees may be involved.

Color labs: *Kodak:* Imagica Corp., 2-14-1, Higashigotanda, Shinagawa-ku, Tokyo 141; 1-8-14 Doshin, Kita-ku, Ōsaka 530.

Equipment rental/sales: *Balcar:* KFC Interfoto, Tokyo; *tel.* 589–4305, 589–4308.

Broncolor: Sinar (Japan) K.K., Tokyo; *tel.* 423-1051. *Comet:* Comet Corp., Tokyo; *tel.* 264-8621. *Profoto:* Jardine, Matheson and Co., Tokyo; *tel.* 595-1640.

Gratuity guidelines: Tips are not neces-

sary and not accepted. Porters charge a set fee, however, for carrying suitcases. Rely on a small, carefully wrapped gift if you want to show appreciation.

JORDAN
Hashemite Kingdom of Jordan
Al Mamlaka al Urduniya al Hashemiyah

Location: In southwestern Asia, bounded on the north by Syria, the northeast by Iraq, the east and south by Saudi Arabia, and the west by Israel. *Size:* 37,737 square miles (including the Israeli-occupied West Bank of the Jordan), slightly smaller than Indiana. **Major cities:** *Amman* (lat. +31.58). *Airports:* Queen Alia International Airport (AMM), 22 miles outside of Amman.

General transportation: Good international links, with direct flights to U.S. Domestic link from Amman to 'Aqaba. Good roads; intercity bus and train service are available, but taxis are preferred. *U.S. license:* Yes, for vehicles not registered in Jordan. *IDP:* Yes. *Rule of the road:* Right. *Motor clubs:* Royal Automobile Club of Jordan, Wadi Seer Cross Roads (8th Circle), Amman; *tel.* 81–52–61, 81–54–10; partial AAA reciprocity. *Taxi markings:* Most single-passenger cabs are telephone-dispatched; 5-passenger service cars go from city to city. On the street, yellow, TAXI on top or side, metered. Tipping cab drivers is not customary.

Population: 2,850,000. *Type of government:* Constitutional monarchy; the king is the central figure in the government, but the national assembly was reconvened in 1984. Jordan has close relations with the U.S.

Languages: Arabic (official); English, the second language, is widely spoken. *Ethnic groups:* 98% Arab, 1% Circassian, 1% Armenian. *Religion:* 95% Sunni Muslim, 5% Christian.

Time: EST +7; GMT +2. *Telephone codes:* Country: 962. Al-Karak 3, Al-Mafraq 4, Amman 6, 'Aqaba 3, Irbid 2, Jerash 4, Ma'an 3, Ramtha 2, Sueeleh 6, Sult 5, Zarqa

9. Good domestic and international service; direct-dial to U.S. available. *Pay phone system:* Coins.

Holidays: January 1, 15; March 22; May 1; Independence Day (late May); June 10; August 11; November 14; December 25; plus Muslim holidays. Business is greatly curtailed during Ramadan. *Date/month system:* D/M.

Business hours: 8 AM to 1:30 PM, 4 PM to 7 PM Saturday to Thursday. In winter, offices tend to close at 6 PM and on Sunday afternoons. Sunday is the day of rest for Christians. *Government hours:* 9AM to 2 PM Saturday to Thursday. *Business dress code:* Same as that of the U.S. for men. Women need not fully cover their legs for business dress. Bikinis and running shorts for leisure attire are frowned on.

Climate and terrain: Rocky deserts, mountains, and rolling plains. About 88% is desert or wasteland, 11% agricultural, 1% forested. Summers are hot but dry, with cool nights. Winters are cool with rainfall from November to April (and snow in the mountains). *Temperature ranges* (Amman): January: 39° to 54°F; April: 49° to 73°F; July: 65° to 89°F; October: 57° to 81°F.

Visas: Standard tourist visa, requiring passport, 1 application, 1 photo, letter from photographer outlining purpose and itinerary, no fee; valid for 5 years, multiple entry. *Health requirements:* No vaccinations required. *Equipment importation:* Bring equipment list; no bond is necessary. **Electricity:** 220/50. *Plug types:* C, F, and G. **Currency:** Dinar (JOD); 1,000 Fils.

U.S. embassy in the country: Jebel Am-

man, P.O. Box 354, Amman; *tel.* 64–43–71; *telex:* 21510 USEMB JO.

Embassy in U.S.: 3504 International Drive NW, Washington, DC 20008; *tel.* 202–966–2664. **Consulates:** California: 213–216–4296; Florida: 305–655–1844, 313–353–5140; Texas: 713–224–2911.

Tourism office in U.S.: Jordan Tourist Office, Royal Jordanian Airline, 535 Fifth Avenue, New York, NY 10017; *tel.* 212–949–0060.

Central tourism office in country: Ministry of Tourism and Antiquities, Tourism Authority, P.O. Box 224, Amman; *tel.* 642–311.

Health suggestions: Good medical services are available in Amman. Water is not potable.

Cultural mores and taboos: Appointments may not start on time. Do not refuse hospitality lightly. Muslim injunctions against alcohol and pork prevail. Do not cross legs, point or gesture at someone with the hand, show the soles of the feet, or pass or accept items with the left hand. If invited to a mosque, dress to cover the entire body, remove shoes (tip the attendant who gives you slippers), and do not walk in front of others praying.

Gratuity guidelines: Tips are sometimes included in the bill; if not, a tip is expected.

KAMPUCHEA
Democratic Kampuchea

The Department of State advises strongly against travel to Kampuchea. The U.S. does not recognize its government, maintains no embassy or consulate, and has no third-party diplomatic representation there.

Location: In southeastern Asia, bounded on the west and north by Thailand and Laos, the east and southeast by Vietnam, and the southwest by the Gulf of Siam. **Size:** 69,898 square miles, slightly smaller than Oklahoma.

Major cities: *Phnom Penh* (lat. +11.33).

Airports: Pochentong Airport (PNH), 8 miles outside of Phnom Penh.

General transportation: Only international flights to Moscow, Laos, and Vietnam. **U.S. license:** No. **IDP:** Yes. **Rule of the road:** Right.

Population: 6,900,000. **Type of government:** In 1978, Vietnam invaded the country known as Cambodia, installing a client regime that calls itself the People's Republic of Kampuchea (PRK). A Vietnamese army of 140,000 controls most of the country.

Languages: Khmer (official); some French is still spoken. **Ethnic groups:** 90% Khmer (Cambodian), 5% Chinese, 5% other. **Religion:** 95% Theravada Buddhism

(suppressed in the 1970s, it is now being restored but is no longer the state religion).

Time: EST +12; GMT +7. **Telephone codes:** None. Service is barely adequate for government operations, and virtually nonexistent for the general public. International service is limited to Vietnam and other adjacent countries. **Pay phone system:** None.

Holidays: Data unavailable. **Date/month system:** D/M.

Business and government hours: 7:30 AM to 1:30 PM Monday to Saturday. **Business dress code:** Data unavailable.

Climate and terrain: Mostly low, flat plains; rice paddies and forests of the Mekong River and Tonle Sap. Mountains in southwest and north. Tropical monsoon climate, with a dry season from November to May. Humidity is consistently high. December and January are the most comfortable months. **Temperature ranges** (Phnom Penh): January: 71° to 88°F; April: 76° to 95°F; July: 76° to 90°F; October: 76° to 87°F.

Visas: Travel to areas of Kampuchea under Vietnamese control is by invitation of the Heng Semrin regime. Application for a visa must be arranged through a country that maintains diplomatic relations with Kampu-

chea. Few tourists are granted visas. *Health requirements:* Yellow fever vaccination is required if coming from an infected area. *Equipment importation:* Inquire with visa application. **Electricity:** 220/50 in Phnom Penh; mostly 120/50 otherwise. *Plug types:* Data unavailable.

Currency: Riel (J); Sen.
U.S. embassy in the country: None.
Embassy in U.S.: None.
Health suggestions: Water is not potable. Malaria suppressants are recommended throughout the country.

KENYA
Republic of Kenya
Jamhuri ya Kenya

Location: In eastern Africa, bounded on the northwest by Sudan, the north by Ethiopia, the east by Somalia, the southeast by the Indian Ocean, the south by Tanzania, and the west by Uganda. *Size:* 224,960 square miles, slightly smaller than Texas. **Major cities:** *Nairobi* (lat. −1.16), Mombasa (lat. +4.03). **Airports:** Jomo Kenyatta International Airport (NBO), 11 miles outside of Nairobi; Wilson (WIL), 5 miles outside of Nairobi; Moi International Airport (MBA), 8 miles outside of Mombasa.

General transportation: Many international flights, with direct links to the U.S. Direct travel between Kenya and Tanzania may be impossible. Kenya Airways (KQ) links most major towns. Charter and light aircraft companies serve points of special interest. Good but slow railway and intercity bus services. Taxis are plentiful in Nairobi. *U.S. license:* Yes. *IDP:* Yes, for vehicles registered in Kenya. *Rule of the road:* Left. *Motor clubs:* Automobile Association of Kenya, AA Nyaku House, Hurlingham, Nairobi; *tel.* 720–382; partial AAA reciprocity. *Taxi markings:* Yellow stripe, marked TAXI on side; be sure to discuss price first.

Population: 23,300,000. *Type of government:* Republic within the British Commonwealth. Political stability, despite many changes in the form of government. Now a one-party state. The standard of living in major cities is among the highest in sub-Saharan Africa. Enjoys cordial relations with the U.S.

Languages: Swahili. English is widely used in business and commerce. *Ethnic groups:* 21% Kikuyu, 14% Luhya, 13% Luo, 11% Kelenjin, 11% Kamba, 6% Kisii, 6% Meru, 1% Asian, European, and Arab. *Religion:* 38% Protestant, 28% Roman Catholic, 26% indigenous beliefs, 6% Muslim.

Time: EST +8; GMT +3. *Telephone codes:* Country: 254. Anmer 154, Bamburi 11, Embakasi 2, Gigiri 2, Kabete 2, Karen 2882, Kiambu 154, Kikuyu 283, Kisumu 35, Langata 2, Mombasa 11, Nairobi 2, Nakuru 37, Sanzu 11, Thika 151, Uthiru 2. Domestic and international service are among the best in Africa. *Pay phone system:* Coins.

Holidays: January 1; Good Friday; Easter Monday; May 1; Id-ul-Fitr (varies—3 days, approximately late May); June 1; October 20; December 12, 25, 26. *Date/month system:* D/M.

Business and government hours: 8 AM to 1 PM, 2 PM to 5 PM, Monday to Friday. Some businesses are open Saturday mornings. *Business dress code:* Same as that of the U.S.

Climate and terrain: Striking topological and climatic variety supports abundant and varied wildlife. Northern three-fifths is arid, much of it semidesert, inhabited only by nomadic pastoralists. About 85% of the population and almost all economic activity is in the southern two-fifths. South of the Tana River, along the coast, tropical temperatures and beautiful beaches provide a well-developed tourist industry. The western Great Rift Valley contains great mountain peaks (to 17,040 feet) and among the most fertile

land in Africa. More than 6 million acres of land have been set aside as national parks or game preserves. Nairobi, at 5,400 feet, is temperate year-round. The coast is warmer (average 80°F); the climate in higher altitudes is cool and invigorating. Two rainy seasons, the "long rains" from April to June, and the "short rains" from October to December. *Temperature ranges* (Nairobi): January: 54° to 77°F; April: 58° to 75°F; July: 51° to 69°F; October: 55° to 76°F; (Mombasa): January: 75° to 87°F; April: 76° to 86°F; July: 71° to 81°F; October: 74° to 84°F.

Visas: Still photographers may enter on a tourist visa, valid for 6 months (in some cases 12 months), requiring passport, $10 fee for single entry, $50 for multiple. Video and film makers should apply for a permit. *Transit visa:* $6 for stays of up to 7 days. *Health requirements:* Yellow fever vaccination is required if coming from any country with an infected area; recommended by the CDC for travel to northwestern forest areas. *Equipment importation:* Prepare a declaration with equipment list attached (3 copies), stating that you are visiting for the purpose of professional photography and that you will be exiting with the equipment. Leave a copy with customs in Nairobi, and sign out with them when you leave. No bond is required.

Electricity: 240/50. *Plug types:* D and G.

Currency: Shilling (KES); Cents.

U.S. embassy in the country: Moi/Haile Selassie Avenue, P.O. Box 30137, Nairobi; *tel.* 334141. *telex:* 22964. *Consulates:* Mombasa: 315101.

Embassy in U.S.: 2249 R Street NW, Washington, DC 20008; *tel.* 202-387-6101. *Consulates:* California: 213-274-6635; New York: 212-468-1300.

Tourism office in U.S.: Kenya Tourist Office, 424 Madison Avenue, New York, NY 10017; *tel.* 212-468-1300.

Central tourism office in country: Ministry of Tourism and Wildlife, P.O. Box 30027, Nairobi; *tel.* 331-030.

Health suggestions: In Nairobi, no special health precautions are necessary; medical treatment is available. Outside Nairobi, water is not always potable. Typhoid, polio, and hepatitis treatments are recommended for remote regions. Malaria suppressants are recommended except for Nairobi and areas above 7,500 feet.

Cultural mores and taboos: Politeness is a must. Always show great respect for the president and all he represents. Expect to drink a great deal of tea or coffee at business meetings. Pronounce the country's name with a short *e*, as in Ken, not "Keenya," as is popular among the British.

Photographic restrictions: Prisons, courts of law, military sites, official buildings. It is often recommended to ask people's permission first before photographing them; tipping subjects is sometimes expected.

Color labs: *Kodak* (Kenya) Ltd., P.O. Box 18210, Nairobi; P.O. Box 90303, Mombasa.

Gratuity guidelines: Service is usually included in the bill, but a bit extra is appreciated.

KOREA, NORTH
Democratic People's Republic of Korea
Chosŏn Minjujuŭi In'min Konghwaguk

Location: In eastern Asia, bounded on the north by China, the northeast by the USSR, the east by the Sea of Japan, the south by South Korea, and the west by the Yellow Sea and Korea Bay. *Size:* 46,609 square miles, slightly smaller than Mississippi.

Major cities: *P'yŏngyang* (lat. +39.01). **Airports:** Sunan (FNJ), 19 miles outside of P'yŏngyang.

General transportation: Flights only to the USSR and Beijing, with a connection to New York through Moscow. Railway is the primary means of transport. P'yŏngyang has

an extensive bus system and a subway. Few private automobiles. *Taxi markings:* All colors, marked TAXI; metered. **Population:** 22,000,000. *Type of government:* Communist state; one-man rule; strict controls. No diplomatic or trade relations with the U.S. There are no restrictions by the U.S. on travel by private citizens to North Korea. **Languages:** Korean. *Ethnic groups:* Homogeneous Korean. *Religion:* Traditional Buddhism and Confucianism are now almost nonexistent. Veneration of Kim Il-Sung borders on the religious. **Time:** EST +14; GMT +9. *Telephone codes:* No telephone service to the U.S. *Pay phone system:* Coins.

Holidays: January 1; February 16; April 15; May 1; August 15; September 9; October 10; December 27. *Date/month system:* Not available.

Business hours: 9 AM to 5 PM Monday to Friday. *Business dress code:* Same as that of the U.S.

Climate and terrain: Numerous ranges of moderately high and partially forested mountains and hills separated by deep, narrow valleys and small cultivated plains. The most rugged areas are the north and east coasts. Mountainous interior is isolated, nearly inaccessible, and sparsely populated. Climate is temperate, with warm summers and cold winters. Rainfall is concentrated in the summer. Snowfall is generally light, but the ground can remain covered for long periods. *Temperature ranges* (P'yŏngyang): January: 8° to 27°F; April: 38° to 61°F; July: 69° to 84°F; October: 43° to 65°F.

Visas: Visa required. No U.S. diplomatic or consular relations or third-party representation, so application for a visa must be arranged through a country that maintains diplomatic relations with North Korea. *Health requirements:* No vaccinations required. *Equipment importation:* Inquire about when arranging for visa.

Electricity: 220/60. *Plug types:* A and F. **Currency:** Won (W); Jun.

U.S. embassy in the country: None. **Embassy in U.S.:** None.

Cultural mores and taboos: Formality is the rule, with bowing the custom. Intense nationalism, on the verge of paranoia, with attachment to the state overtaking traditional family loyalties. Marriage is arranged or approved of by parents, minimum ages of 27 for men, 25 for women, established by law. Austerity prevails.

Gratuity guidelines: Tipping is prohibited.

KOREA, SOUTH
Republic of South Korea
Tae Han Min'guk

Location: In eastern Asia, bounded on the north by North Korea, the east by the Sea of Japan, the south by the Korea Strait, and the west by the Yellow Sea. *Size:* 38,022 square miles, slightly larger than Indiana. **Major cities:** *Seoul* (lat. +37.31), Pusan (lat. +35). *Airports:* Cheju Airport, 30 minutes outside of the town of Cheju, on the northern coast. Kimpo International Airport (SEL), 15 miles outside of Seoul; Kimhae (PUS), 18 miles outside of Pusan; a new international airport at Ch'ŏngju is due for completion in 1992.

General transportation: Many international flights, with direct links to the U.S. *Note:* Carry-on baggage may not be allowed on internal flights. Intercity and local public transport is excellent. Good paved roads. Seoul has a subway. *U.S. license:* No. *IDP:* Yes. *Rule of the road:* Right. *Motor clubs:* Korea Automobile Association, Ssangma-Building, 9th Floor, Yuido-Dong, Young Dung Po-Ku, Seoul; *tel.* 785–5057; partial AAA reciprocity. *Taxi markings:* All colors, marked TAXI, often have advertising; metered, can be scarce at peak hours.

Population: 42,800,000. *Type of government:* Republic, with power centralized in a strong executive. Communist activity has been banned; martial law was ended in 1981

but the government retains broad legal powers to control dissent. One of the most important American allies in Asia, despite strains over trade imbalances.

Languages: Korean. English is spoken by many in business and widely taught in school but may be uncommon in some areas. *Ethnic groups:* Homogeneous Korean, some 20,000 Chinese. *Religion:* Strong Confucian tradition; vigorous Christian minority (28%); Buddhism; pervasive folk religion (Shamanism); Chondokyo (religion of the heavenly way), eclectic religion with nationalist overtones founded in the nineteenth century claims about 1.5 million adherents. **Time:** EST +14; GMT +9. *Telephone codes:* Country: 82. Ch'ungju 431, Ch'unch'ŏn 361, Ich'ŏn 336, Inch'ŏn 32, Kwangju 62, Masan 551, Osan 339, P'ohang 562, Pusan 51, Seoul 2, Suwŏn 331, Taegu 53, Ulsan 522, Wŏnju 371. Very good domestic and international service. *Pay phone system:* Coins; some take magnetic cards; available at post offices.

Holidays: January 1, 2, 3; Lunar New Year; March 1, 10 (for business but not government); April 5; Buddha's Birthday (lunar); May 5; June 6; July 17; August 15; Korean Thanksgiving Day (lunar); October 1, 3, 9; December 25. *Date/month system:* Y/M/D.

Business and government hours: 9 AM to 12 noon, 1 PM to 5 PM Monday to Friday; 9 AM to 1 PM Saturday. *Business dress code:* Conservative.

Climate and terrain: Rugged, mountainous terrain, particularly along the east coast and in the central interior. Most of the population inhabits the northwest region and the fertile southern plains. One of the world's highest densities of population. Climate is hot and rainy in summer; dry, cold, and windy with light snowfall in winter. Best time of year is fall, with warm days, cool nights, and clear skies, often lasting until mid-December. *Temperature ranges* (Seoul): January: 15° to 32°F; April: 41° to 62°F; July: 70° to 84°F; October: 45° to 67°F; (Pusan): January: 29° to 43°F; April: 47° to

62°F; July: 71° to 81°F; October: 54° to 70°F.

Visas: Letter from photographer describing plans, passport, 1 application, 1 photo; valid for 5 years, for stays of up to 90 days (fine imposed for overstaying); overnight processing. *Tourists:* Passport; no visa is needed for stays of up to 15 days. *Health requirements:* No vaccinations required. *Equipment importation:* Carnet. **Electricity:** 220/60. *Plug types:* A and F. **Currency:** Won (W); Chon.

U.S. embassy in the country: 82 Sejong-Ro; Chongro-ku, Seoul; *tel.* 732–2601; *telex:* AMEMB 23108. *Consulates:* Pusan: 23–7791.

Embassy in U.S.: 2600 Virginia Avenue NW, Suite 200, Washington, DC 20037; *tel.* 202–939–5654/63. *Consulates:* California: 213–931–1331; Georgia: 404–522–1611; Illinois: 312–822–9485; New York: 212–752–1700; Texas: 713–961–0186; Washington: 206–682–0132.

Tourism office in U.S.: Korea National Tourism Corporation, 460 Park Avenue, Suite 400, New York, NY 10022; *tel.* 212–688–7543.

Central tourism office in country: Korea National Tourism Corporation, 10 Tadong Hungku, Seoul; *tel.* 757–0086.

Health suggestions: Medical services are fair to good in most cities, with many Western-trained physicians. Water is not potable.

Cultural mores and taboos: Formal, traditional relationships are the rule; modesty is prized. Use two hands to give and receive business cards, and treat them with great respect. Koreans are reluctant to say "no" directly. Be sensitive to hints that proposals are not acceptable. Avoid argumentative or adversarial exchanges. Punctuality is expected. Avoid using the left hand. Remove shoes before entering homes. The people take great pride in the country's cultural and economic achievements.

Photographic restrictions: Military sites; exercise caution in the demilitarized zone; other restricted areas are marked.

Equipment rental/sales: *Balcar:* Sesung

Trading, Seoul; *tel.* 265–1777, 265–9321. *Comet:* Hyon Dae Commercial Co., Ltd., Seoul; *tel.* 714–0188. *Profoto:* Wooho Co. Ltd., Seoul; *tel.* 267–0088.

Gratuity guidelines: Service is usually included in the bill; leaving additional tips, or tips when not included, is not customary.

KUWAIT
State of Kuwait
Dowlat al-Kuwait

Location: In southwestern Asia, bounded on the northwest and north by Iraq, the east by the Persian Gulf, and the south and southwest by Saudi Arabia. *Size:* 6,200 square miles, slightly smaller than New Jersey. **Major cities:** *Kuwait City* (lat. +29.21). *Airports:* Kuwait International Airport (KWI), 10 miles outside of Kuwait City. **General transportation:** Many international flights, with direct links to the U.S. Most principal roads are at least four lanes, and all-weather highways run to Iraq and Saudi Arabia. Rental cars are available. *U.S. license:* Yes, if accompanied by a local temporary driving license and visitor is sponsored by a local resident. *IDP:* Yes, for period of visa. *Rule of the road:* Right. *Motor clubs:* Automobile Association of Kuwait and the Gulf, Airport Road, Khaldiyah; *tel.* 483–2406/2192/2388; partial AAA reciprocity. *Taxi markings:* Orange, marked TAXI on top; set price; tipping drivers is not customary. **Population:** 1,900,000. *Type of government:* Nominal constitutional monarchy. Ruled by the Sabah family since 1751. No political parties. The National Assembly was suspended in mid-1987. One of the wealthiest countries in the world. Good, cooperative relations with the U.S. **Languages:** Arabic. English is widely understood in business and government. *Ethnic groups:* 39% Kuwaiti (70% Sunni, 30% Shi'a), 39% other Arab, 9% South Asian, 4% Iranian, 9% other. *Religion:* 85% Muslim (45% Sunni, 30% Shi'a, 10% other), 15% Christian, Hindu, Parsi, other. **Time:** EST +8; GMT +3. *Telephone codes:* Country: 965. No city codes. Excel-

lent domestic and international service. *Pay phone system:* Coins. **Holidays:** January 1; February 25; plus Muslim holidays—consult the consulate. *Date/month system:* D/M. **Business hours:** 7:30 AM to 1 PM, 4 PM to 7:30 PM Saturday to Wednesday; 8 AM to 12 noon Thursday. *Government hours:* 8 AM to 1 PM Saturday to Thursday. Offices generally close an hour earlier in summer and have much shorter hours during Ramadan. *Business dress code:* Conservative for high-level meetings, more informal for less important meetings, but always dress modestly. **Climate and terrain:** Flat to slightly undulating desert plain. Intensely hot, dry summers, and short, cool winters. *Temperature ranges* (Kuwait City): January: 49° to 61°F; April: 68° to 83°F; July: 86° to 103°F; October: 73° to 91°F. **Visas:** Photographer letter, with client letter attached if possible, to Press Counselor at the Kuwait embassy in Washington (see *Embassy in U.S.,* below; allow 7 to 10 days to receive permission. Then send 2 photos, 2 applications, passport, to process the visa itself; allow a few days more. *Tourists:* Tourist visa obtained before arrival. *Transit visa:* 2 photos, no fee, proof of return ticket; for stays of up to 72 hours. *Health requirements:* No vaccinations required. *Equipment importation:* Bring equipment list; no bond is required. **Electricity:** 240/50. *Plug types:* C, D, and G. **Currency:** Dinar (KUD); 1,000 Fils. **U.S. embassy in the country:** P.O. Box 77 Safat, 13001 Safat; *tel.* 242-4151/9; *telex:* 2039 HILTELS KT. **Embassy in U.S.:** 2940 Tilden Street

NW, Washington, DC 20008; *tel.* 202–966–0702. *Consulates:* New York; 212–973–4318.

Tourism office in U.S.: Information area in the Kuwait embassy in Washington, DC; see address above.

Central tourism office in country: Ministry of Information, P.O. Box 193, Safat 13002; *tel.* 241–5301, 242–7141.

Health suggestions: Drinking water is considered safe; Kuwait has some of the world's largest desalinization plants. Many European- and Western-trained doctors.

Cultural mores and taboos: Eye contact is important; handshakes are the rule. Use titles when addressing people. Be patient if appointments do not start on time. Sexes are strictly segregated. Muslim injunctions against alcohol and pork prevail. Do not cross the legs, point or gesture at someone with the hand, show the soles of the feet, or pass or accept items with the left hand. If invited to a mosque, dress to cover the entire body, remove shoes (tip the attendant who gives you slippers), and do not walk in front of others praying.

Photographic restrictions: Always ask permission in mosques. Be cautious about photographing women on the street.

Equipment rental/sales: *Balcar, Profoto:* Boushahri Color Film Co., Safat; *tel.* 629–000, 644–311.

Gratuity guidelines: Service is sometimes included in the bill; if not, a tip is appreciated but not required.

LAOS
Lao People's Democratic Republic
Sathalanalat Paxathipatai Paxaxōn Lao

Location: In southeastern Asia, bounded on the north by China and Vietnam, the east by Vietnam, the south by Kampuchea, the west by Thailand, and the northwest by Burma. **Size:** 91,428 square miles, slightly smaller than Oregon. **Major cities:** *Vientiane* (lat. +17.58). *Airports:* Wattay (VTE), 2.5 miles outside of Vientiane.

General transportation: Flights to Bangkok, Moscow, Hanoi, Phnom Penh, and several domestic cities. Laos has no railroads, and public transport in Vientiane is poor and unreliable. Traffic is haphazard and dangerous. Foreigners may not go beyond Vientiane city limits without government permission. *U.S. license:* Yes, if accompanied by translation; IDP recommended. *IDP:* Yes. *Rule of the road:* Right. *Taxi markings:* TAXI on top. Taxis have either meters or fixed rates. **Population:** 3,850,000. *Type of government:* Communist state, with rigorous controls. Relations with the U.S. deteriorated in 1975, at which time the last ambassador left. Small embassies exist in both countries, headed by chargés d'affaires.

Languages: Lao (official), French (in decline), and some English. *Ethnic groups:* 50% Lao, 15% Phoutheung (Kha), 20% tribal Thai, 15% Meo, Hmong, Yao, and other. *Religion:* 85% Buddhist, 15% animist and other.

Time: EST +12; GMT +7. *Telephone codes:* No direct-dial from U.S.—operator-assisted calls only. No credit card or collect calls to U.S. General domestic service to public is poor. International service exists between 7 AM and 10 PM local time but is poor and unreliable. Telegraph service is slow and expensive. *Pay phone system:* None.

Date/month system: D/M.

Business and government hours: 8 AM to 5 PM Monday to Friday. *Business dress code:* Informal, because of weather.

Climate and terrain: Dense jungle and rugged mountains (as high as 9,000 feet), particularly along the eastern frontier. Most of the population lives along the Mekong delta. Monsoon climate; heavy rains from May to September taper off to a cooler, drier season through January. From February to April, it is hot and dry. Humidity is high

throughout the year. Subject to flooding. *Temperature ranges* (Vientiane): January: 58° to 83°F; April: 73° to 95°F; July: 75° to 89°F; October: 71° to 88°F.

Visas: Apply to Laos embassy: letter from photographer, client letter (include résumé for both), 3 application forms, 3 photos, passport. Processing can take as long as a month or 2. *Tourists:* Tourist visas for stays of a variety of durations also involve approval of the Lao foreign ministry. *Transit visa:* 1 entry; proof of return ticket and visa for next destination, for stays of up to 7 days. *Health requirements:* Yellow fever vaccination is required if coming from an infected area. *Equipment importation:* Bring equipment list; no bond is required.

Electricity: 220/50. *Plug types:* A and C. **Currency:** New Kip (K); Centimes. **U.S. embassy in the country:** Rue Bartholonie, B.P. 114, Vientiane; *tel.* 2220, 2357, 2384; 3570 or 2357 after hours. **Embassy in U.S.:** 2222 S Street NW, Washington, DC 20008; *tel.* 202–332–6416/7.

Health suggestions: Medical and dental facilities are extremely limited. Sanitation is poor; water is not potable. Eating in the few Vientiane restaurants is relatively safe. Malaria suppressants are recommended except for Vientiane.

Photographic restrictions: Photographers are accompanied by government guides.

LEBANON
Republic of Lebanon
Al-Jumhouriya al-Lubnāniya

The Department of State has determined that the situation in Lebanon has become so dangerous for Americans that no U.S. citizen can be considered safe from terrorist acts. The Secretary of State has therefore exercised his authority to invalidate U.S. passports for travel to, in, and through Lebanon. Using a U.S. passport for travel to Lebanon would constitute a violation of the law and may be punishable by a fine and/or prison. Exceptions to this restriction may be granted; see information under *Visas*, below.

Location: In western Asia, bounded on the north and east by Syria, the south by Israel, and the west by the Mediterranean Sea. *Size:* 3,949 square miles, about half the size of New Jersey.

Major cities: *Beirut* (lat. +33.54). *Airports:* Beirut International Airport (BEY), 10 miles outside of Beirut.

General transportation: Much of the infrastructure has been destroyed by the civil war. The airport is often closed; contact Middle East Airlines, *tel.* (212) 664–7300, for latest information. Buses and taxis provide public transport. *U.S. license:* Yes, if validated by the Automobile Service of the Ministry of the Interior, for 6 months and may be extended. *IDP:* Yes. *Rule of the road:* Right. *Motor clubs:* Automobile et Touring Club du Liban, Avenue Sami Solh—Imm. Kalot, Beirut; *tel.* 221698/9, 229222; partial AAA reciprocity. *Taxi markings:* Standard hailed taxis, red license plates; usually unmetered; shared-service taxis with fixed routes.

Population: 2,670,000. *Type of government:* Republic; site of one of the bloodiest and most complicated civil wars in modern times.

Languages: Arabic and French (both official), Armenian, English. *Ethnic groups:* 93% Arab, 6% Armenian, 1% other. *Religion:* 75% Muslim, 25% Christian.

Time: EST +7; GMT +2. *Telephone codes:* No direct-dial from U.S.—operator-assisted calls only. No credit card or collect calls to U.S. Domestic and international services have been seriously disrupted by the civil war. *Pay phone system:* System largely interrupted by the war.

Holidays: January 1; February 9; Good Friday; Easter Monday; May 1; August 15; November 1, 22; December 25; plus several

Muslim holidays—check with consulate. *Date/month system:* D/M.

Business hours: 8:30 AM to 1 PM, 3 PM to 6 PM Monday to Friday, 8:30 PM to 12:30 PM Saturday in the winter; 8 AM to 1 PM Monday to Saturday in the summer. *Government hours:* 8 AM to 1:30 PM Monday to Saturday. *Business dress code:* Conservative.

Climate and terrain: Narrow coastal plain behind which are the high Lebanon Mountains, the fertile Bekaa Valley, and the Anti-Lebanon Mountains extending to the Syrian border. *Temperature ranges* (Beirut): January: 51° to 62°F; April: 58° to 72°F; July: 73° to 87°F; October: 69° to 81°F.

Visas: Professional journalists and others with compelling humanitarian considerations may be granted permission to enter Lebanon, as will those traveling to further national interests. Exceptions will be scrutinized carefully on a case-by-case basis in light of the level of threat to the prospective traveler's safety. Requests for exceptions should be forwarded in writing to: Deputy Assistant Secretary of State for Passport Services, U.S. Department of State, Washington, DC 20520, Attn: Office of Citizenship Appeals and Legal Assistance. You may get additional information by calling 202–326-6180. If permission from the State Department is granted, contact the nearest Lebanese consulate with: passport, photographer letter, client letter, 1 application, 1 photo; an interview with the consular officer will be necessary. *Health requirements:* Yellow fever vaccination is required if coming from an infected area. *Equipment importation:* Arranged with visa.

Electricity: 110/50. *Plug types:* C.

Currency: Pound (LE£); Piasters.

U.S. embassy in the country: Antelias, P.O. Box 70–840, Beirut; *tel.* 417774, 415802/3, 402200, 403300.

Embassy in U.S.: 2560 Twenty-eighth Street NW, Washington, DC 20008; *tel.* 202–939–6300. *Consulates:* California: 213–467–1253; Michigan: 313–567–0233; New York: 212–744–7905.

Health suggestions: Some medical care is available. Avoid tap water; bottled water is plentiful.

Cultural mores and taboos: Hospitality rituals are extremely important. An upward movement of the head or raised eyebrows, sometimes accompanied by a clicking sound of the tongue, means "no." Never show the soles of the feet. Although a traditional Arab culture, there are many powerful Western influences. Very strong family relationships.

Color labs: *Kodak* (Near East) Inc., P.O. Box 11-0761, Boulevard Sin El Fil, Beirut.

LESOTHO
Kingdom of Lesotho

Location: In southern Africa, bounded on all sides by South Africa. *Size:* 11,716 square miles, slightly larger than Maryland.

Major cities: *Maseru* (lat. −29.19). *Airports:* Maseru (MSU), 12 miles outside of Maseru.

General transportation: Most routes pass through South Africa, and travelers without South African visas will not be allowed to leave the international area in Johannesburg airport (although hotel rooms are available in the airport for those remaining overnight to make onward connections). Short flight from Johannesburg; Lesotho Airlines (QL) has daily flights. Flights to a few other African capitals, and to several domestic locations, with 28 secondary fields suitable for light aircraft. A few buses, minibuses, and taxis. The capital is very small and can be easily walked. Car rentals are available. *U.S. license:* No. *IDP:* Yes. *Rule of the road:* Left. *Taxi markings:* All colors, marked TAXI; usually telephone-dispatched, set price.

Population: 1,700,000. *Type of government:* Constitutional monarchy; independent member of the British Commonwealth; real power rests with 6-man Military Coun-

cil, established after bloodless 1986 coup. Some indications of gradual return to civilian government. Enjoys friendly relations with the U.S.

Languages: English, Sesotho (both official); also Zulu and Xhosa. English is used in business. *Ethnic groups:* 99.7% Sotho; 1,600 Europeans, 800 Asians. *Religion:* 80% Christian (mostly Roman Catholic), 20% indigenous beliefs.

Time: EST +7; GMT +2. *Telephone codes:* Country: 266. No city codes. Modest domestic and international service; parts of the interior are linked only by radio. *Pay phone system:* Coins.

Holidays: January 1, 20; March 12, 21; Good Friday; Easter Monday; May 2; Ascension Day (40 days after Easter); Family Day (first Monday in July); October 4; Sports Day (first Monday in October); December 25, 26. *Date/month system:* D/M.

Business hours: 8 AM to 5 PM Monday to Friday; 8 AM to 1 PM Saturday. *Government hours:* 8 AM to 5 PM Monday to Friday. *Business dress code:* Same as that of the U.S.

Climate and terrain: Part of the western sector of the country is lowland (5,000 to 6,000 feet); the rest of the country is highlands, rising to 11,000 feet. Most rain falls from October to April, but most months have at least 0.6 inches. Temperatures have a more extreme range in the highlands.

Visas: Standard tourist entry, requiring passport; no visa is needed for stays of up to 3 months. However, to carry out your photographic work, you will need a permit; contact the Director of Information, P.O. Box 36, Maseru; *tel.* 323561, or 322485. *Health requirements:* Yellow fever and cholera vaccinations are required if coming from an infected area. *Equipment importation:* Bring equipment list; a bond might be required.

Electricity: 220/50. *Plug types:* C.

Currency: Maloti (LSM); Leicente.

U.S. embassy in the country: P.O. Box 333, Maseru 100; *tel.* 312666; *telex:* 4506 USAID.

Embassy in U.S.: 2511 Massachusetts Avenue NW, Washington, DC 20008; *tel.* 202–797–5533.

Central tourism office in country: Lesotho Tourist Board, P.O. 1378 (fifth floor of Lesotho Bank Building, Kingsway), Maseru; *tel.* 322896.

Health suggestions: Basic medical services are available in Maseru, with more extensive facilities available in Bloemfontein, South Africa, 81 miles away. A "flying doctor" service is available for emergencies. Tap water in Maseru is potable.

Cultural mores and taboos: The country's name is pronounced "le-SOO-too." Very proud, courteous, and hospitable people.

Photographic restrictions: Need express permission for airport, police stations, military facilities, royal palace, banks, railway, and other sites.

Gratuity guidelines: Service is not included in the bill. Tips are appreciated but not required.

LIBERIA
Republic of Liberia

Location: In western Africa, bounded on the north by Guinea, the east by Côte d'Ivoire, the south by the Atlantic Ocean, and the northwest by Sierra Leone. *Size:* 43,000 square miles, about the size of Oregon.

Major cities: Monrovia (lat. +6.18). *Airports:* Roberts International Airport (ROB), 36 miles outside of Monrovia; Spriggs-Payne (MLW).

General transportation: Ample international flights, with direct links to U.S. (to Roberts); limited domestic flights out of Spriggs-Payne airport. Unpaved interior roads are difficult for travel in the rainy season; tourist facilities outside Monrovia are limited. *U.S. license:* Yes, after local formalities are complete. *IDP:* Yes. *Rule of the road:* Right. *Taxi markings:* All colors,

marked TAXI; set price, often shared. Be sure to agree on price for trips outside Monrovia. Cab drivers are not usually tipped.

Population: 2,500,000. *Type of government:* Republic; constitution suspended and martial law imposed after 1980 coup, but semblance of civilian rule returned after 1985 elections. Traditionally friendly relations with the U.S.

Languages: English is the official and commercial language, used by about 20% of the population; more than 20 languages of the Niger-Congo group. *Ethnic groups:* 95% indigenous African, including Kpelle, Bassa, Gio, Kru, Grebo, Mano, Krahn, Gola, Gbandi, Loma, Kissi, Vai, and Bella; 5% descendants of repatriated slaves known as America-Liberians; some 15,000 foreigners, mostly Lebanese and Indian trading community, 3,000 Americans. *Religion:* 70% traditional, 20% Muslim, 10% Christian (mostly Protestant).

Time: EST +5; GMT 0. *Telephone codes:* Country: 231. No city codes. Domestic and international services are available. *Pay phone system:* None on street.

Holidays: January 1; February 11; second Wednesday in March; March 15; Good Friday; April 12; May 14; July 26; August 25; first Thursday in November; November 29; December 25. Holidays falling on Sunday may be observed on Monday. *Date/month system:* D/M.

Business hours: 8 AM to 12 noon, 2 PM to 6 PM Monday to Friday; 8 AM to 12 noon Saturday. *Government hours:* 8 AM to 4 PM, with varying lunch hours. *Business dress code:* Same as that of the U.S.

Climate and terrain: From the narrow, level coastal strip dotted with lagoons, tidal creeks, and marshes, the country rises in a series of plateaus. Low mountains are found intermittently throughout the country but are rarely higher than 3,000 feet, except for a few along the eastern border. Six principal rivers flow into the Atlantic. Lies within the tropical rain forest belt, with a rainy season from April to November. Warm and humid year-round. *Temperature ranges* (Monrovia): January: 71° to 89°F; April: 72° to 90°F; July: 72° to 80°F; October: 72° to 86°F.

Visas: Standard tourist visa, requiring passport, application, 2 photos, round-trip ticket, police certificate of clean record; no fee; valid for 3 months; must apply in person at embassy or consulates. *Transit visa:* With onward ticket; can remain at airport 48 hours. *Health requirements:* Yellow fever vaccination, certificate of good health. *Equipment importation:* Bring equipment list; no bond is required.

Electricity: 120/60. *Plug types:* A and G.

Currency: Dollar (LI$); Cents.

U.S. embassy in the country: 111 United Nations Drive, P.O. Box 98, Monrovia; *tel.* 222991/4.

Embassy in U.S.: 5201 Sixteenth Street NW, Washington, DC 20011; *tel.* 202–723–0437/40. *Consulates:* California: 213–277–7692; Michigan: 313–342–3900; Georgia: 404–753–4754; Illinois: 312–643–8635; Louisiana: 504–523–7784; New York: 212–687–1025.

Central tourism office in country: Ministry of Information and Culture, Capitol Hill, Monrovia; *tel.* 222447.

Health suggestions: Marginal medical facilities, chronically short of medications and supplies. Malaria suppressants are recommended. Water is not potable. Do not swim in fresh water up-country, and avoid ocean swimming.

Gratuity guidelines: Same as those of the U.S. (except for taxis, as noted above).

LIBYA
Socialist People's Libyan Arab Jamahiriya
Al-Jamahiriya al-Arabiya al-Libya al-Shabiya al-Ishtirakiya

A U.S. passport is not valid for travel in, to, or through Libya without express validation for such travel by the Department of State. The U.S. government can pro-

vide no diplomatic or consular representation in Libya, except very limited services through the Belgian embassy, acting as the U.S. protecting power.

Location: In northern Africa, bounded on the north by the Mediterranean Sea, the east by Egypt, the southeast by Sudan, the south by Chad and Niger, the west by Algeria, and the northwest by Tunisia. *Size:* 679,358 square miles, slightly larger than Alaska.

Major cities: *Tripoli* (lat. +32.54), Benghazi (lat. +32.06). *Airports:* Tripoli International Airport (TIP), 21 miles outside of Tripoli; Benina (BEN), 20 miles outside of Benghazi.

General transportation: Many international flights, including some to Europe. *U.S. license:* Yes. *IDP:* Yes. *Rule of the road:* Right. *Motor clubs:* Automobile and Touring Club of Libya, Maidan al-Ghazala, Tripoli; *tel.* 33310, 33515, 33066; partial AAA reciprocity.

Population: 3,960,000. *Type of government:* A "state of the masses," in theory governed by the populace through local councils; in fact, a military dictatorship. Very limited and strained relations with the U.S., through third-party (Belgian) representation.

Languages: Arabic; Italian, French, and English are widely understood in major cities. *Ethnic groups:* 97% Berber and Arab, about 375,000 foreign residents of many nationalities. *Religion:* 97% Sunni Muslim.

Time: EST +6; GMT +1. *Telephone codes:* Country: 218. Agelat 282, Benghazi 61, Benina 63, Derna 81, Misurata 51, Sabrata 24, Sebha 71, Taigura 26, Tripoli 21, Tripoli International Airport 22, Zawia 23, Zwara 25. No credit card or collect calls to U.S. Modern domestic system, some international satellite transmission. *Pay phone system:* None.

Holidays: March 2, 8, 28; June 11; July 23; September 1; October 7; plus several Muslim holidays. *Date/month system:* D/M.

Business hours: 8:30 AM to 12 noon, 3 PM to 5 PM Saturday to Wednesday. *Government hours:* 8:30 AM to 2 PM Saturday to Wednesday; 8:30 AM to 12 noon Thursday. *Business dress code:* Conservative for men and women.

Climate and terrain: About 93% desert or semidesert. Coastal rock-strewn plains and sand seas with some areas of hills and mountains. No permanent rivers. Special climatic characteristic is the ghibli, a very hot, dry, dust-laden southern wind lasting for 1 to 4 days, usually in fall or spring. *Temperature ranges* (Tripoli): January: 47° to 61°F; April: 57° to 72°F; July: 71° to 85°F; October: 65° to 80°F.

Visas: Since December 1981, a special validation by the passport office is required to travel to Libya. Travelers seeking validation should contact the nearest U.S. embassy, consulate or passport office in the U.S. Travelers to Libya must also obtain a Libyan visa. Visitors are required by Libyan law to bear passports printed in Arabic, but an official transcription of relevant passport information on a page of the passport is acceptable. U.S. embassies are authorized to provide this service for Americans whose passports have been validated for Libya. Application for a visa must be arranged through a country that maintains diplomatic relations with Libya. *Health requirements:* Yellow fever vaccination is required if coming from an infected area. *Equipment importation:* Arrange for with visa.

Electricity: Varies; Tripoli, 127/50; Benghazi, 230/50. *Plug types:* D.

Currency: Dinar (LBD); 1,000 Dirham.

U.S. embassy in the country: None. Some services are provided by the Belgian embassy.

Embassy in U.S.: None.

Tourism office in U.S.: None.

Central tourism office in country: Libya Tourist Board.

Health suggestions: Some basic medical care is available. Water is considered potable. Limited malaria risk in 2 small sections of the southwest.

Cultural mores and taboos: Muslim injunctions against alcohol and pork prevail. Do not cross legs, point or gesture at someone with the hand, show the soles of the feet, or pass or accept items with the left hand. If

invited to a mosque, dress to cover the entire body, remove shoes (tip the attendant who gives you slippers), and do not walk in front of others praying.

Gratuity guidelines: Sometimes included in the bill; otherwise, officially discouraged but widely accepted.

LUXEMBOURG
Grand Duchy of Luxembourg
Grand-Duché de Luxembourg/Grossherzogtum Luxemburg

Location: In western Europe, bounded on the west and north by Belgium, the east by West Germany, and the south and west by France. *Size:* 999 square miles, slightly smaller than Rhode Island. **Major cities:** *Luxembourg City* (lat. +49.37). *Airports:* Findel (LUX), 5 miles outside of Luxembourg City. **General transportation:** Many flights, including direct links to the U.S., and excellent rail service to the rest of Europe. Good urban bus system and plentiful taxis. Good paved highways to European cities. *U.S. license:* Yes. *IDP:* Yes. *Rule of the road:* Right. *Motor clubs:* Automobile Club du Grande-Duché de Luxembourg (ACL), Route de Longwy 13, Bertrange; *tel.* 450045; full AAA reciprocity. *Taxi markings:* TAXI indicated. **Population:** 370,000. *Type of government:* Constitutional monarchy; parliamentary system. Warm, close relations with the U.S. **Languages:** French, German, and Luxembourgian, an indigenous blend of Moselle-Frankish with French and German elements. English is widely understood. *Ethnic groups:* Celtic base, with French and German blend; also guest workers from Portugal, Italy, and other European countries. *Religion:* 97% Roman Catholic, 3% Protestant and Jewish. **Time:** EST +6; GMT +1. *Telephone codes:* Country: 352. No city codes. Very good domestic and international service. *Pay phone system:* Coins. **Holidays:** January 1; Shrove Monday (early February); Easter Monday; May 1; Ascension Day (40 days after Easter); Whit Monday (varies—early June); June 23; August 15; Fall Fair Day (early September; November 1, 2; December 25, 26. *Date/month system:* D/M. **Business hours:** 8:30 AM to 5:30 PM Monday to Friday. *Business dress code:* Conservative. **Climate and terrain:** Northern half of the country is a continuation of the Belgian Ardennes and is heavily forested and slightly mountainous. The Lorraine plateau extends from France into the southern part, creating an open, rolling countryside. The Our, Sauer, and Moselle rivers form the north-south frontier with Germany. Cool, temperate, rainy climate. *Temperature ranges* (Luxembourg City): January: 29° to 36°F; April: 40° to 58°F; July: 55° to 74°F; October: 43° to 56°F. **Visas:** Standard tourist entry, requiring passport; no visa is needed for stays of up to 3 months. *Health requirements:* No vaccinations required. *Equipment importation:* Carnet. **Electricity:** Mostly 220/50, some 120V. *Plug types:* C and F. **Currency:** Franc (LFR); Centimes. **U.S. embassy in the country:** 22 Boulevard Emmanuel-Servais, 2535 Luxembourg; *tel.* 460123. **Embassy in U.S.:** 2200 Massachusetts Avenue NW, Washington, DC 20008; *tel.* 202-265-4171. *Consulates:* California: 213-394-2532; Florida: 305-373-1300; Georgia: 404-952-1157; Illinois: 312-726-0355; Missouri: 816-474-4761; New York: 212-370-9850; Ohio: 513-422-2001; Texas: 817-332-1161. **Tourism office in U.S.:** Luxembourg

National Tourist Office, 801 Second Avenue, New York, NY 10017; *tel.* 212–370–9850.

Central tourism office in country: National Tourist Office, 77 Rue d'Anvers, 1130 Luxembourg; *tel.* 496666, 487999.

Health suggestions: Same standards as in the U.S.

Cultural mores and taboos: Business etiquette is formal; first names are reserved for friendship. The pace is a bit slower than in other western European countries.

Gratuity guidelines: Service is usually included in the bill; a bit extra is appreciated but not expected.

MACAO
Macau

Location: In eastern Asia, at the southeastern edge of China, just west of Hong Kong. *Size:* 6 square miles, about half the size of Jersey City, New Jersey.

Major cities: *Macao* (lat. +22.13). *Airports:* None, although an international airport capable of handling 747s is under study.

General transportation: Most enter by hoverferry (1 hour from Kowloon), or jetfoil (50 minutes), hydra-foil (70 minutes), or ferry (3 hours) from Hong Kong (all from Shun Tak Center wharf west of Central). Local transport is by public bus, pedicabs, and taxis, which are plentiful and inexpensive. Ferries and causeways connect the islands. Rental cars are available in limited quantities. Book hotels and transport in advance, especially for weekends and special events. *U.S. license:* No. *IDP:* Yes. *Rule of the road:* Left. *Taxi markings:* All colors, marked TAXI; metered; can be hired by the day.

Population: 430,000. *Type of government:* Chinese territory under Portuguese administration, scheduled to revert to China in 1999 with a high degree of autonomy promised; the oldest European colony in southeast Asia. The U.S. has no offices in Macao—U.S. interests are handled by the consulate in Hong Kong.

Languages: Portuguese (official); Cantonese is commonly spoken. English is spoken by some in business. *Ethnic groups:* 95% Chinese (mostly Cantonese and some Hakka), 3% Portuguese, 2% other. *Religion:* Mainly Buddhist; 17,000 Roman Catholic, of whom about half are Chinese.

Time: EST +13; GMT +8. *Telephone codes:* Country: 853. No city codes. No credit card or collect calls to U.S. Fair domestic and international service, which is currently being upgraded. *Pay phone system:* None on the street.

Holidays: January 1; Chinese New Year (varies); Good Friday and Saturday before Easter; Ching Ming Day; Easter Monday; April 25; May 1; June 10; Dragon Boat Festival (varies); June 24; day after Mid-Autumn Festival (varies); October 1, 5; Chung Yeung Festival (varies); November 2; December 1, 8, 24, 25, 26. *Date/month system:* D/M.

Business and government hours: 9 AM to 1 PM, 2 PM to 6 PM (or later) Monday to Friday; 9 AM to 1 PM Saturday. *Business dress code:* Informal; open shirt and slacks, except on formal occasions, when a conservative suit is the norm.

Climate and terrain: The province consists of the municipality of Macao, situated on a narrow peninsula, and Taipa and Colôane islands to the south. Low and flat terrain, 90% urban. Cool winters, and warm, tropical summers, not dissimilar from Hong Kong.

Visas: Standard tourist visa; apply at Portuguese consulate in Hong Kong or upon arrival. *Health requirements:* No vaccinations required. *Equipment importation:* Bring equipment list; no bond is necessary.

Electricity: 220/50. *Plug types:* C and D.

Currency: Pataca (P); Avos.

U.S. embassy in the country: Care of the Hong Kong embassy, 26 Garden Road,

Hong Kong; *tel.* (5) 239–011; *telex:* 63141 USDOC HX.

Embassy in U.S.: Care of the Portuguese embassy, 2310 Tracey Place NW, Washington, DC 20008; *tel.* 202–332–3007.

Tourism office in U.S.: Macao Tourist Information Bureau, 3133 Lake Hollywood Drive, Los Angeles, CA 90068; *tel.* 213–851–3400. Branches at: 608 Fifth Avenue, Suite 309, New York, NY 10020; *tel.* 212–581–7465; Honolulu, 808–528–1732.

Central tourism office in country: Direc-

cao do Servicios de Turismo, Travessa do Paiva #1, Macao; *tel.* 75156.

Health suggestions: Adequate basic medical services are available. Water is considered potable.

Cultural mores and taboos: Similar to those of other Chinese cultures; see Hong Kong.

Photographic restrictions: People may resist being photographed on the street.

Gratuity guidelines: Not usually included in the bill; leave 10% to 15%.

MADAGASCAR
Democratic Republic of Madagascar
Repoblika Demokratika Malagasy

Location: Off the southeastern coast of Africa, in the Indian Ocean. *Size:* 226,657 square miles, about twice the size of Arizona.

Major cities: *Antananarivo* (lat. −18.52).

Airports: Ivato (TNR), 11 miles outside of Antananarivo.

General transportation: International air service has been reduced, and flights are often booked in advance; European destinations include Paris (with a connection to New York), Marseilles, Amsterdam, and Zurich. Domestic air links are good. Some parts of the country can be reached by train, bus, rural taxi, or hired car, but the road network is deteriorating rapidly, and many areas are no longer accessible except by 4-wheel-drive vehicles. *U.S. license:* Yes. *IDP:* Yes. *Rule of the road:* Right. *Motor clubs:* Automobile-Club de Madagascar, rue Ravoninahitriniarivo–Alorobia, Antananarivo; *tel.* 420–30; partial AAA reciprocity. *Taxi markings:* Marked TAXI; set price.

Population: 11,070,000. *Type of government:* Real authority is in the hands of the president, although the supreme revolutionary council is theoretically the ultimate executive authority. A historical rivalry exists between the Catholic coastal Cotiers, considered underprivileged, and the Protestant Merina, who are predominant in the civil service, business, and professions. Re-

lations with the U.S. have improved after strains in the late 1970s.

Languages: French and Malagasy. *Ethnic groups:* Basic split between highlanders of mostly Malayo-Indonesian origin (Merina, 1.6 million, and related Betsileo, 0.76 million) on one hand, and mixed African, Malayo-Indonesian, and Arab coastal tribes, collectively termed Cotiers, on the other. Also 11,000 European French, 5,000 Indians of French nationality, and 5,000 Creoles. *Religion:* 52% indigenous beliefs, 41% Christian (about half Roman Catholic, half Protestant, but incorporating indigenous ancestor worship), 7% Muslim.

Time: EST +8; GMT +3. *Telephone codes:* No direct-dial from U.S.—operator-assisted calls only. No credit card calls to U.S. Domestic and international services are available, but the latter, at least, is unreliable. *Pay phone system:* In post offices only.

Holidays: January 1; March 29; Easter Monday; May 1; Ascension Day (40 days after Easter); Whit Monday (varies—early June); June 26; August 15; December 30. *Note:* Holidays are determined each year—be sure to check with the consulate. *Date/month system:* D/M.

Business and government hours: 8 AM to 12 noon, 2 PM to 6 PM Monday to Friday. Some businesses may be open longer hours and on Saturdays. *Business dress code:* Like

the U.S. in the capital, more informal elsewhere.

Climate and terrain: The world's fourth-largest island, with varied and spectacular scenery. The interior is a high plateau averaging 2,500 to 6,000 feet (9,450 feet at its zenith). Highlands have a temperate climate, warm and rainy from November to April, cooler from May to October. The coastal region has a hot, tropical climate year-round, with heavier rainfall in the east. Southern Madagascar is arid.

Visas: *Business visa:* Passport, 4 applications, proof of return ticket and sufficient funds, client letter, 4 photos, $22.50 fee; for a visit of 30 days (can be extended there); allow 2 days for processing. *Tourists:* Tourist visa with similar requirements. *Health requirements:* The Madagascar government recommends cholera vaccinations. A yellow fever vaccination is required if coming from an infected area (including in-transit visitors). *Equipment importation:* Bring

equipment list; a bond is probably not required.

Electricity: Mostly 220/50, some 127. *Plug types:* C and E.

Currency: Franc (FMG); Centimes.

U.S. embassy in the country: 14–16 Rue Rainitovo, Antsahavola, B.P. 620, Antananarivo; *tel.* 212–57, 209–56, 200–89, 207–18; *telex:* USA EMB MG 22202, 101.

Embassy in U.S.: 2374 Massachusetts Avenue NW, Washington, DC 20008; *tel.* 202–265–5525/6. *Consulates:* California: 415–323–7113; New York: 212–986–9491; Pennsylvania: 215–893–3067.

Central tourism office in country: Bureau du Tourisme, *tel.* 2628.

Health suggestions: Malaria suppressants are recommended throughout the country, but particularly for coastal areas. Water is not potable. Do not swim in salt or fresh water without local advice.

Gratuity guidelines: Tips are sometimes included in the bill; otherwise, leave one.

MALAWI
Republic of Malawi

Location: In southeastern Africa, bounded on the north and northeast by Tanzania, the east, south, and southwest by Mozambique, and the west by Zambia. *Size:* 45,193 square miles, slightly larger than Pennsylvania.

Major cities: *Lilongwe* (lat. −13.58). *Airports:* Kamuzu International Airport (LLW), 7 miles outside of Lilongwe; Chileza (BLZ), 11 miles outside of Blantyre.

General transportation: Air links to Europe (with connections to the U.S.) and other African capitals. Flights from Lilongwe to Blantyre. Most intercity roads and the road to Lusaka, Zambia, are paved. Rental cars are available. *U.S. license:* Yes, for 3 months. *IDP:* Yes. *Rule of the road:* Left. *Taxi markings:* All colors, marked TAXI; some metered, most set price.

Population: 7,700,000. *Type of government:* One-party state; modified version of the British system; constitution calls for

presidential elections every 5 years, but Dr. Hastings Kamuzu Banda was named president for life in 1966. Strict censorship is practiced—visitors' luggage is subject to inspection. Pro-Western foreign policy; cordial relations with the U.S.

Languages: English and Chichewa (official), Tombuka a second African language.

Ethnic groups: Chewa (central), Nyanja (south), Tumbuka (north), Yao (southeastern border), Lomwe, Sena, Tonga (north), Ngoni, Asian, European. *Religion:* 55% Protestant, 20% Roman Catholic, 20% Muslim; traditional indigenous beliefs are also practiced by some members of these groups.

Time: EST +7; GMT +2. *Telephone codes:* Country: 265. Domasi 531, Likuni 766, Luchenza 477, Makwasa 474, Mulanje 465, Namadzi 534, Njuil 664, Thondwe 533, Thornwood 486, Thyolo 467, Zomba 50. No city codes for other cities. Adequate domes-

tic and good international service. *Pay phone system:* Coins; few available.

Holidays: January 1; March 3; Good Friday; Easter Monday; May 16; July 6; October 17; December 25, 26. *Date/month system:* D/M.

Business and government hours: 7:30 AM to 4:30 PM Monday to Friday; 7:30 AM to 12 noon Saturday. *Business dress code:* The government bans slacks or shorts for women except for sports; dresses must cover the kneecap. Men's hair may not extend below the nape of the neck.

Climate and terrain: Traversed from north to south by part of the Great Rift Valley. In this trough lies Lake Malawi, third-largest in Africa, constituting 20% of the country's area. Shire River flows from the south of the lake. Subtropical climate, with a rainy season from November to May and a dry season for the remaining months. Warmer along the lake and Shire Valley. *Temperature ranges* (Zomba): January: 65° to 80°F; April: 62° to 78°F; July: 53° to 72°F; October: 64° to 85°F.

Visas: Standard tourist entry, requiring passport; no visa needed for stays of up to 1 year. *Health requirements:* Yellow fever vaccination is required if coming from an infected area. *Equipment importation:* Data unavailable.

Electricity: 230/50. *Plug types:* G.

Currency: Kwacha (MWK); Tambala.

U.S. embassy in the country: P.O. Box 30016, Lilongwe; *tel.* 730–166; *telex:* 4627.

Embassy in U.S.: 2408 Massachusetts Avenue NW, Washington, DC 20008; *tel.* 202–797–1007. *Consulates:* New York: 212–949–0180.

Central tourism office in country: Department of Tourism, P.O. Box 402, Blantyre.

Health suggestions: Medical facilities are few; malaria is endemic throughout. Tap water in cities is considered potable but must be boiled elsewhere. Bilharzia (schistosomiasis) organisms may infect freshwater lakes and streams. Get local advice about swimming in Lake Malawi, although established beach resorts are considered safe.

Gratuity guidelines: Service is usually included in the bill; leaving a bit more is customary.

MALAYSIA

Location: In southeastern Asia, south of Thailand and Burma, north of Indonesia. *Size:* 128,727 square miles, slightly larger than New Mexico.

Major cities: *Kuala Lumpur* (lat. +3.06), Penang (lat. +5.30). *Airports:* Subang International Airport (KUL), 12 miles outside of Kuala Lumpur; Penang International Airport (PEN), 11 miles outside of Penang.

General transportation: Many international flights, with direct links to U.S., and good domestic network. Daily trains connect Kuala Lumpur with Penang, Singapore, and Bangkok, Thailand. Roads (particularly on the peninsula) are very good. Buses are available. *U.S. license, IDP, Rule of the road:* Data unavailable; contact the Automobile Association of Malaysia, Lots 21/24, Lower Ground Floor, Hotel Equatorial, Jalan Sul-

tan Ismail, Kuala Lumpur; *tel.* 261–7137/7204/3713/2727. *Taxi markings:* Yellow, marked TAXI, metered (set price in Sabah and Sarawak); air-conditioned cabs cost more.

Population: 16,400,000. *Type of government:* Federation formed in 1963, nominally headed by a paramount ruler (king), with a bicameral parliament, from which is chosen a prime minister and cabinet. Of the 13 states, 9 have hereditary rulers, 4 appointed governors. Sabah and Sarawak are self-governing states with some powers delegated to the federal government. Friendly relations with the U.S.

Languages: Bahasa Malaysia (official). English is widely understood in business and government. Several Chinese languages and Tamil are spoken among Chinese and Indian

minorities. *Ethnic groups:* 59% Malay and other indigenous groups, 32% Chinese, 9% Indian. *Religion:* Malays on the peninsula are nearly all Muslim; Chinese are predominantly Buddhist; Indian, mostly Hindu. On Sabah, 38% Muslim, 17% Christian, 45% other. On Sarawak, 35% tribal religions, 24% Buddhist and Confucianist, 20% Muslim, 16% Christian, 5% other.

Time: EST +13 (Kuala Lumpur); GMT +8. *Telephone codes:* Country: 60. Alor Setar 4, Baranang 3, Broga 3, Cheras 3, Dengil 3, Ipoh 5, Johore Bahru 7, Kajang 3, Kepala Batas 4, Kuala Lumpur 3, Machang 97, Maran 95, Port Dickson 6, Semenyih 3, Seremban 6, Sungei Besi 3, Sungei Renggam 3. Good, modern domestic and international service (although service on Sabah and Sarawak is a bit less developed). *Pay phone system:* Coins.

Holidays: January 1, Muhammad's Birthday (varies); City Day (Kuala Lumpur only), February 1; Chinese New Year (varies); May 1; Wesak Day (varies); June 3; Hari Raya Puasa (varies); August 31; Hari Raya Haji (varies); Deepavali (varies); first day of Muharam (varies); December 25; plus many regional and religious holidays—check with Malaysian consulate. *Date/month system:* D/M.

Business hours: 8:30 or 9 AM to 4:30 or 5 PM, Monday to Friday; plus Saturday mornings. Lunch break is one hour at noon or 1 PM. *Government hours:* 8 AM to 12:45 PM, 2 PM to 4:15 PM Monday to Thursday; 8 AM to 12:15 PM, 2:30 PM to 4:15 PM Friday; 8 AM to 12:45 PM Saturday. *Business dress code:* Same as that of the U.S. in Kuala Lumpur; perhaps a bit more informal elsewhere.

Climate and terrain: Peninsular Malaysia has forested mountains running north to south along the center, flanked on the east and west by coastal plains. Half the area is tropical jungle, half rubber, palm oil, and other agricultural plantations. Sarawak contains a broad, frequently swampy coastal plain, drained by wide rivers, which merges into the jungle-covered hills and mountains

of the interior. Sabah's narrow coastal plain gives way to a mountainous jungle interior, culminating in Mount Kinabalu, highest peak in southeast Asia (13,455 feet). Tropical climate, with southwest monsoon from April to October, northeast monsoon from October to February. *Temperature ranges* (Kuala Lumpur): January: 72° to 90°F; April: 74° to 91°F; July: 72° to 90°F; October: 73° to 89°F.

Visas: Photojournalists need a special visa from Kuala Lumpur. Contact nearest consulate; send passport, 3 applications, 3 photos, client letter; processing can take 2 to 3 months. Rely on contacts in Malaysia if possible. Commercial photographers should contact consulate to determine if consultation with Kuala Lumpur is necessary. If not, allow a few days for this process. *Tourists:* Passport (valid 1 month beyond stay); no visa is needed for stays of up to 3 months. *Health requirements:* Yellow fever vaccination is required if coming from an infected area or any countries in the endemic zone. *Equipment importation:* Bring equipment list; check with your contacts in Malaysia to see if any duties can be avoided (although still cameras are generally duty free).

Electricity: 240/50. *Plug types:* G.

Currency: Ringit (RGT); Sen.

U.S. embassy in the country: 376 Jalan Tun Razak, 50400 Kuala Lumpur; P.O. Box 10035, 50700 Kuala Lumpur; *tel.* 248–9011; *telex:* FCSKL MA 32956.

Embassy in U.S.: 2401 Massachusetts Avenue NW, Washington, DC 20008; *tel.* 202–328–2700. *Consulates:* California: 213–621–2991; Hawaii: 808–525–8144; New York: 212–490–2722; Oregon: 503–246–0707.

Tourism office in U.S.: 420 Lexington Avenue, New York, NY 10170; *tel.* 212–697–8995.

Central tourism office in country: TDC Information Center, Wisma, MPI, 17th and 18th Floors, Jalan Raja Chulan, Kuala Lumpur; *tel.* 423033.

Health suggestions: Kuala Lumpur and other major cities are generally free of most

diseases commonly associated with the Far East. Tap water is considered potable in large cities. Malaria suppressants are recommended in some areas. Cholera infection is present. **Cultural mores and taboos:** Customs vary in this ethnically diverse culture, but Muslim practice prevails among the ethnic Malays. Many businesses are dominated by Chinese—carry English and Chinese business cards. Try not to refuse dinner invita-

tions—they are especially meaningful. Appointments may not start on time. Shoes are often removed in the home. A slight bow instead of a handshake is not uncommon. **Equipment rental/sales:** *Comet:* Bee Loh Photo Suppliers & Enterprises (PVT) Ltd., Kuala Lumpur; *tel.* 241–5176. **Gratuity guidelines:** Service is usually included in the bill; not customary to leave more unless service is exceptional.

MALDIVES
Republic of Maldives
Divehi Jumhuriya

Location: In the Indian Ocean, southwest of Sri Lanka and India. *Size:* 115 square miles, about the size of Denver. **Major cities:** *Male* (lat. +4.00). *Airports:* Male International Airport (MLE). **General transportation:** International links to Europe, Asia, and the Middle East. Boats are the primary means of transport between islands. Limited taxi service is available in Male. *U.S. license:* Yes, but will need permit. *IDP:* Yes, but will need permit. *Rule of the road:* Left. Car rentals available. *Taxi markings:* All colors; telephone-dispatched; set price. **Population:** 200,000. *Type of government:* Republic with executive, legislative, and judicial branches; no organized political parties; all candidates run independently. Islamic law and custom prevail. Nonaligned foreign policy; friendly relations with the U.S. **Languages:** Dhivehi (official), thought by some scholars to be a dialect of Sinhala (the language of Sri Lanka), but considered by Maldivians to be a language that developed concurrently from a common root, Elu. English spoken by most in government. *Ethnic groups:* Admixture of Sinhalese, Dravidian, Arab, and black. *Religion:* Sunni Muslim. **Time:** EST +10; GMT +5. *Telephone codes:* No direct-dial from U.S.—operator-assisted calls only. Service in Male is adequate; connections to other islands are not

always reliable. International service is available but minimal. *Pay phone system:* None. **Holidays:** January 1; Huravee Day (varies); Martyrs Day (varies); July 27; November 11, 12; plus Muslim holidays—check with consulate. *Date/month system:* D/M. **Business and government hours:** 7:30 AM to 1:30 PM Monday to Thursday. *Business dress code:* Informal, except for high-level meetings. **Climate and terrain:** Consists of 19 atolls, 502 miles from north to south, of 1,200 coral islands, of which some 200 are inhabited; only 33 have more than 1,000 residents because fresh water and arable land are scarce. Land is flat (rarely higher than 6 feet above sea level), with tropical vegetation varying from scrub and grass to fruit tree and coconut groves. Among the world's most beautiful beaches. Climate is equatorial, hot and humid with little daily variation. Most of the area is subject to the "wet" southwest monsoon (May to October) and "dry" northwest monsoon (December to March). *Temperature ranges* (Male): 25°C to 30°C year-round. **Visas:** Standard tourist visa, requiring passport, proof of return ticket, and funds of $10 per day of visit; no photos or fees; available upon arrival. *Health requirements:* Yellow fever vaccination if coming from infected area. *Equipment importation:* Con-

tact the Department of Information and Broadcasting, *tel.* 323424, 322251, *telex:* 66085, *answer-back:* HOADHUN MF, to arrange photography permits and equipment importation.
Electricity: 230/50. *Plug types:* D.
Currency: Rufiyaa (MVR); Laari.
U.S. embassy in the country: None (the embassy in Sri Lanka handles matters), but there is a consulate: Mahduedurage, Violet Magu, Henveru, Male; *tel.* 2581; *telex:* 66028.

Embassy in U.S.: Care of the Maldive U.N. mission in New York; *tel.* 212–599–6195.
Central tourism office in country: Ministry of Tourism, Male; *tel.* 323–229.
Health suggestions: Facilities are adequate by Third World standards. Male has a small, modern hospital, and medical rescue services function in the atolls. Most islands except Male pose a malaria risk.
Gratuity guidelines: Tips are discouraged; do not tip.

MALI
Republic of Mali
République du Mali

Location: In western Africa, bounded on the north and northwest by Algeria, the east and southeast by Niger, the south by Burkina Faso and Côte d'Ivoire, the southwest by Guinea, and the west by Senegal and Mauritania. *Size:* 478,652 square miles, slightly less than twice the size of Texas.
Major cities: *Bamako* (lat. +12.39). *Airports:* Senou (BKO), 9 miles outside of Bamako.
General transportation: International links to Europe, with connections to the U.S., as well as several African capitals. Few, if any, domestic flights. Buses are available in Bamako, as are taxis at stands, but privately owned vehicles are the principal means of transport for Americans. The road from Bamako to Mopti and those which then branch southward to Bougouni and Sikasso are paved. Others are laterite and usually passable in the dry season without a 4-wheel-drive vehicle. The Niger River is navigable by larger ships from August to December. *U.S. license:* Yes. *IDP:* Yes. *Rule of the road:* Right. *Taxi markings:* TAXI indicated; set price.
Population: 8,660,000. *Type of government:* Republic; single-party constitutional government. Still struggling with effects of disastrous drought and famine cycles. Good relations with the U.S.
Languages: French (official); 80% of eth-

nically diverse Malians can communicate in Bambara. Little English is spoken. *Ethnic groups:* 50% Mande (Bambara, Malinke, Sarakole), 17% Peul, 12% Voltaic, 6% Songhai, 5% Taureg and Moor. *Religion:* 90% Muslim, 9% indigenous beliefs, 1% Christian.
Time: EST +5; GMT 0. *Telephone codes:* No direct-dial from U.S.—operator-assisted calls only. No credit card or collect calls to U.S. Domestic service is poor, with only minimal facilities, but is improving. International service is available but unreliable. *Pay phone system:* At post offices; pay there.
Holidays: January 1, 20; Easter Monday; May 1, 25; September 22; November 19; December 25; plus Muslim holidays. *Date/ month system:* D/M.
Business and government hours: 7:30 AM to 12 noon, 3 PM to 6 PM Monday to Friday; 7:30 AM to 12:30 PM Saturday. Government offices are closed on Saturdays. *Business dress code:* Informal.
Climate and terrain: The northern third is Saharan desert. Land is flat with butte outcroppings in the west and south and east of Mopti. Two river systems: the Niger, below which lies the savanna that is the productive part of the country, and the Senegal. Seasonal floods inundate the Niger delta. The Niger is navigable from Koulikoro to Gao by

large riverboats from mid-July to mid-December and by small craft for most of the year. The climate is characterized by a short rainy season from mid-May to mid-October and a long dry season the rest of the year. Rainfall is heaviest in the southeast. November to February are the best months to travel. *Temperature ranges* (Bamako): January: 61° to 91°F; April: 76° to 103°F; July: 71° to 89°F; October: 71° to 93°F.

Visas: Standard tourist visa, requiring passport, 2 applications, 2 photos, $17 fee; valid for 1 week (may be extended in Mali). However, photography requires a permit from the Ministry of Information and Telecommunications in Bamako, *tel.* 222647, 224670. *Health requirements:* Yellow fever vaccination if coming from infected area. *Equipment importation:* Bring equipment list; no bond is necessary.

Electricity: 220/50. *Plug types:* C and E. **Currency:** Franc (CFA); Centimes.

U.S. embassy in the country: Rue Testard and Rue Mohamed V, B.P. 34, Bamako; *tel.* 225834; *telex:* 448 AMEMB.

Embassy in U.S.: 2130 R Street NW, Washington, DC 20008; *tel.* 202–332–2249. *Consulates:* California: 213–476–9369.

Central tourism office in country: Ministry of Tourism, B.P. 191, Bamako; *tel.* 225673.

Health suggestions: Several doctors are available in Bamako, but facilities are extremely limited, with medications in short supply. Sanitation is poor. Malaria suppressants are strongly recommended. Insects, rats, and rabies are prevalent. Avoid freshwater swimming because of bilharzia (schistosomiasis). Cholera infection is present. Tap water is not potable.

Cultural mores and taboos: Shoes are often removed indoors. Strict social hierarchies and caste system; some tensions between lighter and darker Malians. Discussions with a village chief require one or more intermediaries—he should not be addressed directly. Malians have a strong streak of fatalism.

Photographic restrictions: Permits required, but visitors often photograph without them.

MALTA
Republic of Malta
Repubblika Ta'Malta

Location: In the Mediterranean Sea, south of Italy, west of Tunisia, north of Libya. *Size:* 122 square miles, about twice the size of Washington, DC.

Major cities: *Valletta* (lat. + 35.54). *Airports:* Luqa (MLA), 4 miles outside of Valletta.

General transportation: Many international flights, with direct links to U.S. connecting through Europe. Car ferry service from Naples and Sicily. Buses service the island, but roads are often poor and congested. Hotels can be hard to book during peak tourist seasons. Be sure to make arrangements early. *U.S. license:* Yes. *IDP:* Yes. *Rule of the road:* Left. *Motor clubs:* The Automobile Federation—Malta, 93 St.

John's Street, Valetta; *tel.* 621 655; partial AAA reciprocity. *Taxi markings:* All colors, marked TAXI; metered (if not, agree on price first); available by phone or at stands.

Population: 370,000. *Type of government:* Parliamentary democracy, independent republic within the British Commonwealth; two parties dominate the polarized and evenly divided political scene. Good relations with the U.S.

Languages: Maltese and English (both official). *Ethnic groups:* Mixture of Arab, Sicilian, Norman, Spanish, Italian, and English. *Religion:* 98% Roman Catholic.

Time: EST + 6; GMT + 1. *Telephone codes:* Country: 356. No city codes. No credit card calls to U.S. Modern automatic

system in Valletta. International service is limited but improving. *Pay phone system:* Coins.

Holidays: January 1; February 10; March 19; Good Friday; May 1; August 15; September 8, 21; December 8, 13, 25. *Date/ month system:* D/M.

Business hours: 8 AM to 5 PM Monday to Friday. Government and a few businesses work only half-days (to 1:30 PM) from June 16 to the end of October. *Business dress code:* Same as that of the U.S.

Climate and terrain: Mostly low, rocky plains with coastal cliffs. Numerous bays, inlets, rocky coves, and some beaches. Densely populated. Climate is subtropical in summer, temperate the rest of the year, with virtually no rain from May to September. The little rain that falls is usually from October to January. *Temperature ranges* (Valletta): January: 51° to 59°F; April: 56° to 66°F; July: 72° to 84°F; October: 66° to 76°F.

Visas: Standard tourist entry, requiring passport; no visa is needed for stays of up to 3 months. *Health requirements:* Yellow fever vaccinations are required if coming from infected areas. *Equipment importa-*

tion: Bring equipment list; no bond is required.

Electricity: 240/50. *Plug types:* G.

Currency: Lira; Cents.

U.S. embassy in the country: P.O. Box 535, 2d Floor, Development House, St. Anne Street, Floriana, Valletta; *tel.* 623653, 620424, 623216.

Embassy in U.S.: 2017 Connecticut Avenue NW, Washington, DC 20008; *tel.* 202–462–3611/2. *Consulates:* California: 415–468–4321; Massachusetts: 617–523–7895; Minnesota: 612–228–0935; New York: 212–725–2345; Pennsylvania: 412–624–5205; Texas: 713–497–2100.

Tourism office in U.S.: Malta Tourist Information Office, 249 East Thirty-fifth Street, New York, NY 10016; *tel.* 212–725–2345.

Central tourism office in country: Malta National Tourist Office, Harper Lane, Floriana, Valletta; *tel.* 224444, 228282.

Health suggestions: Health care is adequate but basic. Sanitary standards are adequate. Tap water is very saline; bottled water is recommended.

Gratuity guidelines: Service is sometimes included in the bill; otherwise, leave a tip.

MARTINIQUE
Department of Martinique

Location: In the West Indies, north of St. Lucia and south of Dominica. *Size:* 425 square miles, slightly smaller than Los Angeles.

Major cities: *Fort-de-France* (lat. +14.37). *Airports:* Lamintin (FDF), 4 miles outside of Fort-de-France.

General transportation: Connecting flights to the U.S. Ferry available from Fort-de-France to Pointe du Boit. Buses are available, but taxis are very plentiful, and car rentals are available. *U.S. license:* No. *IDP:* Yes. *Rule of the road:* Right. *Taxi markings:* Often shared.

Population: 350,000. *Type of government:* Overseas department of France, with

2 senators and 3 deputies in the French parliament.

Languages: French, creole patois. *Ethnic groups:* 90% African and African-Caucasian-Indian mixture, 5% Caucasian, less than 5% East Indian, Lebanese, Chinese. *Religion:* 95% Roman Catholic, 5% Hindu and original African beliefs.

Time: EST +1; GMT −4. *Telephone codes:* Country: 596. No city codes. Adequate domestic and international service. *Pay phone system:* Coins and cards.

Holidays: January 1, Carnaval preceding Lent and including Ash Wednesday; Good Friday; Holy Saturday; May 1, 8; Ascension Day (40 days after Easter); May 22, Whit

Monday (varies–early June); July 13, 14; August 15; November 1, 2, 11; December 25. *Date/month system:* D/M.

Business and government hours: 7:30 AM to 12 noon, 2:30 PM to 5 PM Monday to Friday; some businesses are open on Saturday mornings. *Business dress code:* Informal; suits are rare except for very high level meetings.

Climate and terrain: Mountainous with indented coastline; subject to flooding, hurricanes, and volcanic activity. The tropical climate is moderated by trade winds, with a rainy season from June to October. *Temperature ranges* (Fort-de-France): January: 69° to 83°F; April: 71° to 86°F; July: 74° to 86°F; October: 73° to 87°F.

Visas: Standard tourist visa for France, which can be obtained upon arrival. *Health requirements:* Yellow fever vaccination is required if coming from an infected area.

Equipment importation: Carnet. **Electricity:** 220/50. *Plug types:* C, D, and E.

Currency: French Franc; Centimes.

U.S. embassy in the country: 14 Rue Blenac, B.P. 561, Fort-de-France 97206; *tel.* 63–13–03; *telex:* 912670; 912315 MR.

Tourism office in U.S.: % Caribbean Tourism Association, 20 East 46 St., New York, NY 10017, *tel.* (212) 682–0435.

Central tourism office in country: Office Départemental du Tourisme de Martinique, Boulevard Alfassa, Fort–de–France, 97206; *tel.* 637960.

Health suggestions: Water is potable in major towns. Basic medical care is available, but there are few English-speaking doctors. Freshwater may be infected with bilharzia (schistosomiasis).

Gratuity guidelines: If not included in the bill, leave 10% to 15%.

MAURITANIA
Islamic Republic of Mauritania
République Islamique de Mauritanie

Location: In western Africa, bounded on the northwest by Western Sahara, the north by Western Sahara and Algeria, the east and south by Mali, the southwest by Senegal, and the west by the Atlantic Ocean. *Size:* 397,955 square miles, 3 times the size of New Mexico.

Major cities: *Nouakchott* (lat. +18.07). *Airports:* Nouakchott (NKC), 3 miles outside of Nouakchott.

General transportation: Flights to Europe (with connections to the U.S. through Paris), Africa (with connections to Washington, DC, through Dakar, Senegal), and several other international destinations. Public transport is by road and air. There is a small bus service, and taxis are plentiful. Travel to the interior requires planning. Rental cars are available. *U.S. license:* Yes, for a limited time. *IDP:* Yes. *Rule of the road:* Right. *Taxi markings:* Green or yellow; set price on fixed routes, special destinations can cost

more; often shared. Tipping drivers is not customary.

Population: 1,900,000. *Type of government:* Republic; political parties abolished; military junta rules. Some liberalizing trends are in effect. Friendly relations with the U.S.

Languages: Hasaniya Arabic (national), French (official), Toucouleur, Fula, Sarakole, Wolof. *Ethnic groups:* 75% heterogeneous Arab-Berber stock, divided—on social and descent criteria rather than skin color—into Bidan or "white" Moors and Haratin or "black" Moors. The balance are blacks (Toucouleur, Soninke, Bambara, and Wolof) concentrated in a narrow zone in the south, especially along the Senegal River; some 2,000 Europeans, mostly French. *Religion:* Nearly 100% Muslim.

Time: EST +5; GMT 0. *Telephone codes:* No direct-dial from U.S.—operator-assisted calls only. No credit card or collect calls to U.S. Poor domestic and international

service, with some radiophone links via Paris. *Pay phone system:* None.
Holidays: January 1; May 1, 25; July 10; November 28; December 12; plus Muslim holidays. *Date/month system:* D/M.
Business and government hours: 8 AM to 3 PM Sunday to Thursday. *Business dress code:* Suits or national dress is acceptable.
Climate and terrain: Mostly flat, barren Saharan plains; some central hills. Desert climate that is constantly hot, dry, and dusty, with some cultivation along the Senegal River. Hot, dusty sirocco winds blow in March and April. *Temperature ranges* (Nouakchott): January: 57° to 85°F; April: 64° to 90°F; July: 74° to 89°F; October: 71° to 91°F.
Visas: Photographers need a special permit, applied for through the consulate to Mauritania. No further information is available. *Tourists:* Tourist visa requiring passport, 2 applications, 4 photos, $10 fee, proof of return ticket/sufficient funds; valid for 3 months. *Health requirements:* Yellow fever and cholera vaccinations. *Equipment importation:* No bond is required.
Electricity: 220/50. *Plug types:* C.
Currency: Ouguiya; 5 Khoums.

U.S. embassy in the country: B.P. 222, Nouakchott; *tel.* 52660/3; *telex:* AMEMB 558 MTN.
Embassy in U.S.: 2129 Leroy Place NW, Washington, DC 20008; *tel.* 202-232-5700/1. *Consulates:* New York: 212-737-7780.
Central tourism office in country: Ministry for Women, Crafts and Tourism. Contact via the Ministry of Foreign Affairs switchboard, *tel.* 25 26 82.
Health suggestions: Nouakchott has one government-run hospital with French-speaking doctors. Health care is otherwise extremely limited, although there are some other hospitals and dispensaries in other towns. No U.S. drugs are available, only French pharmaceuticals. Sanitary conditions in the capital are fair, but there have been instances of cholera, hepatitis, meningitis, and other diseases. Malaria suppressants are recommended except for parts of the north. Water is not potable.
Cultural mores and taboos: Do not drink alcohol in public, although it is served in large hotels.
Gratuity guidelines: Tipping is not expected but is appreciated.

MAURITIUS

Location: In the Indian Ocean, east of Madagascar. *Size:* 720 square miles, about the size of Rhode Island.
Major cities: *Port Louis* (lat. −20.06).
Airports: Sir Seewoosagur Ramgoolam International Airport (MRU), 18 miles outside of Port Louis.
General transportation: Ample international flights, with direct links to the U.S. through Europe. Narrow, twisting roads are good but crowded, despite the mountainous terrain (90% paved). No railway. Intercity bus service is regular but limited within towns. Rental cars are available. *U.S. license:* Yes, if endorsed by the local police department. *IDP:* Yes. *Rule of the road:* Left. *Taxi markings:* Special license plate, usually has black numbers on white (private cars are white on black); some marked TAXI; set price.
Population: 1,100,000. *Type of government:* Independent state recognizing Elizabeth II of Britain as head of state; parliamentary system; amalgam of French and British legal systems. Enjoys good relations with the U.S.
Languages: English (official), Creole, French, Hindi, Urdu, Hakka, Bojpoori. French patois is the more commonly spoken language, with French the language of most newspapers. *Ethnic groups:* 68% Indo-Mauritian, 27% Creole, 3% Sino-Mauritian, 2% Franco-Mauritian. *Religion:* 51% Hindu, 30% Christian (mostly Roman Catholic with a few Anglicans), 17% Muslim.
Time: EST +9; GMT +4. *Telephone*

codes: No direct-dial from U.S.—operator-assisted calls only. No credit card or collect calls to U.S. Good domestic and international service. *Pay phone system:* Very few available.

Holidays: January 1, 2; Chinese Spring Festival (varies); March 12; May 1; November 1; December 25; plus several religious holidays with varying dates. *Date/month system:* D/M.

Business and government hours: 9 AM to 4 PM Monday to Friday; some businesses are open on Saturday mornings as well. *Business dress code:* More informal; bush shirt is acceptable.

Climate and terrain: Small coastal plain rising to central plateau surrounded by mountains that may have once been the rim of a volcano. Coral reefs almost entirely surround the island. Humid throughout the year, the lowlands are tropical. The hot, wet season is from December to April; the cooler, dry season, from June to September. Subject to cyclones from November to April. *Temperature ranges* (Port Louis): January: 73° to 86°F; April: 70° to 82°F; July: 62° to 75°F; October: 64° to 80°F.

Visas: Unless you are a tourist, you will need permission from the Permanent Secretary, Prime Minister's Office, Government House, Port Louis; *telex:* 4249. *Tourists:* Passport, proof of return ticket; no visa is needed for stays of up to 3 months. *Health*

requirements: Yellow fever vaccination is required if coming from infected area or countries in the endemic zone. *Equipment importation:* Carnet.

Electricity: 230/50. *Plug types:* C, D, and G.

Currency: Rupee (Re); Cents.

U.S. embassy in the country: Rogers Building, 4th Floor, John Kennedy Street, Port Louis; *tel.* 082347.

Embassy in U.S.: 4301 Connecticut Avenue NW, Washington, DC 20008; *tel.* 202–244–1491/2. *Consulates:* California: 818–788–3720.

Tourism office in U.S.: Mauritius Tourist Information Office, 415 Seventh Avenue, 18th Floor, New York, NY 10001; *tel.* 212–239–8350.

Central tourism office in country: Mauritius Government Tourist Office, Emmanuel Anquetil Building, Sir Seewoosagur Ramgoolam Street, Port Louis; *tel.* 011703, 011691.

Health suggestions: Local hospitals and pharmacies are adequate. Tap water is potable. Malaria suppressants are recommended for rural areas.

Cultural mores and taboos: Great tradition of hospitality, with frequent impromptu visiting; relaxed atmosphere.

Gratuity guidelines: Service is not included in the bill; tips are expected.

MEXICO
United Mexican States
Estados Unidos Mexicanos

Location: In southern North America, bounded on the north by the U.S., the east by the Gulf of Mexico, the southeast by Guatemala, Belize, and the Caribbean Sea, and the south and west by the Pacific Ocean. *Size:* 759,530 square miles, about 3 times the size of Texas.

Major cities: *Mexico City* (lat. +19.26). **Airports:** Benito Juarez (MEX), 4 miles outside of Mexico City.

General transportation: Many interna-

tional flights, with direct links available from a number of U.S. cities to several Mexican destinations. Many domestic flights. Bus service is good, highways extensive. Mexico City has a subway. *U.S. license:* Yes, if issued in country of vehicle's registration. *IDP:* Yes. *Rule of the road:* Right. *Motor clubs:* Asociación Mexicana Automovilística, Orbazaba no. 7, Mexico City; *tel.* 511 10 84, 511 62 85; partial AAA reciprocity.

Taxi markings: All colors but usually two

colors, marked TAXI; some are metered but some legal taxis set a price by zone. Beware of illegal taxis at the airport—book a legal taxi in advance at the airport transportation counter. **Population:** 83,500,000. *Type of government:* Federal republic operating under a centralized government with a dominant executive branch. Close and friendly relations with the U.S.
Languages: Spanish. Many Mexicans speak English in the cities and along the U.S. border. *Ethnic groups:* 60% mestizo, 30% Amerindian or predominantly Amerindian, 9% white or predominantly white, 1% other. *Religion:* 97% nominally Roman Catholic, 3% Protestant.
Time: EST +1 (Mexico City); GMT −6 to −8. *Telephone codes:* Country: 52. Mexico can be dialed directly from the U.S. if you have international dialing in your area, by dialing 011 + 52 + city code + local number. Even if international dialing is not in effect in your area, you can still dial calls to Mexico City and northwestern Mexico: Mexico City: 1 + 90 + 5 + local number; northwestern Mexico: 1 + 70 + city code (2 or 3 digits beginning with 6) + local number (contact AT&T if it is not your long-distance company). Acapulco 748, Cancún 988, Celaya 461, Chihuahua 14, Ciudad Juárez 16, Culiacán 671, Guadalajara 36, Hermosillo 621, Mérida 99, Mexico City 5, Monterrey 83, Puebla 22, Puerto Vallarta 322, San Luis Potosí 481, Tampico 121, Tijuana 66, Torreón 17, Veracruz 29. Highly developed domestic and international service. *Pay phone system:* Coins.
Holidays: January 1; February 5; March 21; Holy Thursday; Good Friday; May 1, 5; September 16; October 12; November 2, 20; December 25. *Date/month system:* D/M.
Business hours: 9 AM to 6 PM Monday to Friday. Most still close for lunch, but it is increasingly common to stagger lunch hours to stay open throughout the day. Some businesses are open on Saturdays. *Government hours:* Open to the public 8:30 AM to 2:30 PM. *Business dress code:* Same as that of the U.S.

Climate and terrain: Beginning at the Isthmus of Tehuantepec in the south, an extension of a South American mountain range runs north almost to Mexico City, where it divides to form the coastal Occidental (west) and Oriental (east) Ranges of the Sierra Madre. Between them lies the great central plateau, a rugged tableland 1,500 miles long and as much as 500 miles wide, rising to 8,000 feet near Mexico City. The coast is often characterized by low plains and jungle. The climate is more closely related to altitude and rainfall than latitude. Most of the country is dry; only 12% receives adequate rainfall. Tropical along the coastal lowlands to cooler in the higher elevations. Mexico City and Guadalajara are springlike much of the year, a bit cooler in winter, warmer in summer. Yucatán, the U.S. border areas, and the Monterrey region are very hot in summer, pleasant in winter. *Temperature ranges* (Mexico City): January: 42° to 66°F; April: 52° to 78°F; July: 54° to 74°F; October: 50° to 70°F; (Monterrey): January: 48° to 68°F; April: 62° to 84°F; July: 71° to 90°F; October: 64° to 80°F; (Acapulco): January: 70° to 85°F; April: 71° to 87°F; July: 75° to 89°F; October: 74° to 88°F.
Visas: *Business visa:* Passport, client letter, 3 photos, $30.80 fee; allow 24 hours for processing. Large productions might require a special work visa involving permission from the Ministry of Interior, Secretaría de Jobernación, Dirección General de Servicios Migratorios, Alvanidas no. 19, Esquina Eduardo Molina, Mexico City 15350; *tel.* 789–5915, 789–5296. *Tourists:* Proof of citizenship, sufficient funds, photo ID; no visa is needed for stays of up to 3 months. Tourist card is issued at border. *Health requirements:* Yellow fever vaccination is required if coming from infected area. *Equipment importation:* Bring equipment list and declare at border.
Electricity: 127/60. *Plug types:* A.
Currency: Peso (MEP), Centavos.
U.S. embassy in the country: Paseo de la Reforma 305, Mexico 5, D.F., *tel.* 211–0042; *telex:* 017–73–091, 017–75–685. *Con-*

sulates: Ciudad Juárez: 134–048; Guadalajara: 25–29–98, 25–27–00; Hermosillo: 3–89–23/5; Matamoros: (891) 2–52–50/2; Mazatlán: (678) 1–29–05; Mérida: 5–54–09, 5–50–11; Monterrey: 45–21–20; Nuevo Laredo: (871) 4–05–12, 4–06–18; Tijuana: 817–400, 817–700.

Embassy in U.S.: 1019 Nineteenth Street NW, Suite 810, Washington, DC 20036; *tel.* 202–293–1710/2. *Consulates:* California: 415–392–5554; Colorado: 303–830–0523; Illinois: 312–855–1380; Louisiana: 504–522–3596; New York: 212–689–0456; Texas: 214–522–9740.

Tourism office in U.S.: Mexican Government Tourist Office, 405 Park Avenue, Suite 1002, New York, NY 10022; *tel.* 212–755–7261.

Central tourism office in country: Mexican Government Tourism Office, Shiller # 138, 9th Floor, Chapultepec, Mexico City; *tel.* 250–4298, 250–4626, 531–0886.

Health suggestions: Water is often not potable. Medical facilities are fair to good in major cities. Malaria suppressants are recommended for some areas. At least a day of adjustment is recommended for Mexico City's altitude.

Cultural mores and taboos: The traditional slow pace is quickening a bit. Courtliness is highly prized. Avoid referring to "Americans," rather, say "U.S. citizens." Personal relations and connections are all-important. Never appear at social functions ahead of time; Mexicans are traditionally late for appointments, although punctuality may be expected of you.

Photographic restrictions: Historical places may require special permission, especially for flash and tripods.

Color labs: *Kodak* Mexicana, S.A. de C.V., Administración de Correos 68, Mexico City 22 D.F., Mexico 04870.

Gratuity guidelines: Service is sometimes but usually not included in the bill; leave 15% and expect to tip for a number of small services.

MONACO
Principality of Monaco

Location: In south-central Europe, bounded on the north, east, and west by France and the south by the Mediterranean Sea. *Size:* 370 acres, about the size of Central Park in New York City.

Major cities: *Monaco-Ville* (lat. +43.44). **Airports:** None; use Nice's Côte d'Azur Airport (NCE), about 12 miles outside of Monaco.

General transportation: Many international flights via Nice's airport. Train and helicopter connections are also available. Buses and taxis provide public transport. No highways; all city streets. *U.S. license:* Yes. **IDP:** Yes. *Rule of the road:* Right. *Motor clubs:* Automobile Club of Monaco, 23 Boulevard Albert-ler; *tel.* 93 30 32 20; partial AAA reciprocity. *Taxi markings:* All colors; marked TAXI; metered.

Population: 29,000. *Type of government:* Constitutional monarchy; prince is chief of state and shares power with the unicameral national council. Traditionally good relations with the U.S.

Languages: French (official), English, Italian, Monegarque (French and Italian mixture). *Ethnic groups:* 47% French, 16% Monegarque, 16% Italian, 21% other. *Religion:* 95% Roman Catholic.

Time: EST +6; GMT +1. *Telephone codes:* Country: 33. All points, 93. Excellent domestic and international service (part of the French system). *Pay phone system:* Coins, cards.

Holidays: January 1, 27; Shrove Tuesday (varies); Mid Lent (varies); Good Friday; Easter Monday; May 1, 8; Ascension Day and Eve (40 days after Easter); Whit Monday (varies—early June); June 18; July 13, 14; August 15; September 3; November 2, 11, 19; December 8, 24, 25. *Date/month system:* D/M.

Business hours: 9 AM to 12 PM and 2 PM to 7 PM, Monday to Friday. *Business dress code:* Same as that of the U.S.

Climate and terrain: Traditionally 3 sections: Monaco-Ville, the old city on a rocky promontory extending into the Mediterranean; La Condamine, the section along the port; and Monte Carlo, the new city and principal residential and resort area. Development in Fontvielle, the new industrial area reclaimed from the sea near La Condamine, has expanded rapidly. Sunny climate with mild, wet winters and hot, dry summers. *Temperature ranges:* January: 46° to 54°F; April: 53° to 61°F; July: 70° to 77°F; October: 60° to 67°F.

Visas: Standard tourist visa for France.

Health requirements: No vaccinations required. *Equipment importation:* Carnet.

Electricity: Mostly 220/50, but some 127 volt. *Plug types:* C, D, E, and F.

Currency: French Franc; Centimes.

U.S. embassy in the country: None; affairs are handled at the U.S. consulate in Nice, France: 31, rue Maréchal Joffre, 06000 Nice; *tel.* (93) 88–89–55.

Embassy in U.S.: Care of the French embassy, 4101 Reservoir Road NW, Washington, DC; *tel.* 202–944–6000.

Tourism office in U.S.: Monaco Government Tourist Office, 845 Third Avenue, New York, NY 10022; *tel.* 212–759–5227.

Health suggestions: Adequate medical facilities and supplies.

MONGOLIA
Mongolian People's Republic
Bügd Nayramdakh Mongol Ard Uls

Location: In east-central Asia, bounded on the north by the USSR and the east, south, and west by China. *Size:* 604,247 square miles, slightly larger than Alaska.

Major cities: *Ulaanbaatar* (lat. +47.54). *Airports:* Ulaanbaatar (ULN), 9 miles outside of Ulaanbaatar.

General transportation: Individual visits to Mongolia are rare. All travel is arranged with a group. If you are entering the country by air from the Soviet Union, luggage space is extremely restricted—sometimes as little as one carry-on total. *Taxi markings:* Yellow, marked TAXI in Mongolian.

Population: 2,070,000. *Type of government:* Communist state; modeled on the Soviet system with close links to the Soviet Union. Diplomatic relations with the U.S. established in January 1987.

Languages: Khalka Mongol, used by 90% of population; Turkic, Russian, and Chinese. Few speak English. *Ethnic groups:* 90% Mongol, 4% Kazakh, 2% Chinese, 2% Russian, 2% other. *Religion:* Predominantly Tibetan Buddhist, about 4% Muslim. Religious activity is suppressed by the government.

Time: EST +13; GMT +7 to +9. *Telephone codes:* No direct-dial from U.S.—operator-assisted calls only. No credit card or collect calls to U.S. Archaic phone service. *Pay phone system:* Coins.

Holidays: January 1, 2; March 8; May 1; July 10, 11, 12; November 7. *Date/month system:* D/M.

Business hours: 9 AM to 5 PM Monday to Friday.

Climate and terrain: Sparsely populated Gobi Desert in the southeast. North and west of the Gobi, the landscape changes gradually to rugged mountains rising to elevations of more than 13,000 feet. The highest peak is Nayramdal Uul (14,350 feet). Salt lakes and steppes are common. Water is more abundant in the north, but rivers are rough and uncontrolled. The climate offers little precipitation and sharp seasonal variations: short summers and long, cold winters from October to April. *Temperature ranges* (Ulaanbaatar): January: −2° to −27°F; April: 18° to 45°F; July: 50° to 71°F; October: 17° to 44°F.

Visas: Travel will probably have to be arranged through a group. Contact the U.N.

mission (see **Embassy in U.S.**, below) to begin arrangements, which take some time. *Health requirements:* No vaccinations required. *Equipment importation:* Include equipment list when arranging for visa.

Electricity: 220 volts. *Plug types:* Data unavailable.

Currency: Tugrik; Mungs.

Embassy in U.S.: 6 East Seventy-seventh Street, New York, NY 10021; *tel.* 212–861–9460 (U.N. mission).

Cultural mores and taboos: Mongolians are very hospitable, but be careful about asking sensitive questions. Be aware that the level of English comprehension may be far lower than it appears.

Gratuity guidelines: Tips are not illegal but are not encouraged. They should always be given discreetly (Mongolian citizens are allowed to hold foreign currency); giving a small gift instead is always the safest approach.

MOROCCO
Kingdom of Morocco
Al-Mamlakah al-Maghribīyah

Location: In northwestern Africa, bounded on the north by the Mediterranean Sea, the east and south by Algeria, the southwest by Western Sahara, and the west by the Atlantic Ocean. *Size:* 172,413 square miles, slightly larger than California.

Major cities: *Rabat* (lat. +34.00), Casablanca (lat. +33.35), Tangier (lat. +35.48), Fès (lat. +34.05), Marrakech (lat. +31.36).

Airports: Salé (RBA), 5 miles outside of Rabat; Anfa Airport (CAS), 19 miles outside of Casablanca; Mohamed V (CMN), 19 miles outside of Casablanca; Boukalef Souahel (TNG), 9 miles outside of Tangier; Menara (RAK), 4 miles outside of Marrakech.

General transportation: Many international flights, with direct links to the U.S. Adequate public transport by air, rail, and bus. Car ferries link points on the coast and Europe. Good, clearly marked highway system. *U.S. license:* Yes, for 3 months. *IDP:* Yes. *Rule of the road:* Right. *Motor clubs:* Royal Automobile Club Marocain, 16 rue de Foucault, Casablanca; *tel.* 36 60 14, 36 60 05; partial AAA reciprocity. *Taxi markings:* Marked TAXI; metered. *Petit* taxis that circulate only within the city are red in Casablanca, blue in Rabat, brown in Marrakech, but can be difficult to find. Larger taxis, such as Mercedes, circulate at hotels and airports, and may go from city to city at about twice the cost of the *petit* taxis.

Population: 25,000,000. *Type of govern-* *ment:* Constitutional monarchy; claims and administers Western Sahara, but sovereignty is unresolved; armed conflict with the Polisario, a guerrilla group advocating independence, over the issue. U.S.–Moroccan relations are characterized by mutual respect and friendship. Morocco recognized the U.S. in 1777 and is its partner in the longest unbroken treaty relationship in U.S. history.

Languages: Arabic (official), several Berber dialects. French is the language of business, government, diplomacy, and post–primary education. *Ethnic groups:* 99.1% Arab-Berber, 0.7% non-Moroccan, 0.2% Jewish. *Religion:* 98.7% Muslim, 1.1% Christian, 0.2% Jewish.

Time: EST +5; GMT 0. *Telephone codes:* Country: 212. Agadir 8, Al-Jadida 34, Beni-Mellal 48, Berrechid 33, Casablanca—no city code required; Fès 6, Kenitra 16, Marrakech 4, Meknes 5, Mohammedia 32, Nador 60, Oujda 68, Rabat 7, Tangier 9, Tétouan 96. Adequate to good domestic and international service. *Pay phone system:* Coins.

Holidays: January 1; March 3; May 1, 23; July 9; August 14; November 6, 18; plus several Muslim holidays—check with consulate. Some Christian and Jewish holidays are celebrated by portions of the population. *Date/month system:* D/M.

Business hours: 8 AM to 12 noon, 2 PM to 6:30 PM Monday to Friday; 4 PM to 7 PM in

summer. *Business dress code:* Conservative for men and women.

Climate and terrain: Divided into open, agriculturally rich plains in the northwest and economically poor mountains and plateaus in the east and south. The coastal areas are separated from the interior by encircling mountains. Peaks of the High and Middle Atlas range reach 13,600 feet; those of the Rif Massif, 7,000 feet. The coastal plains are the more densely populated, most economically advanced, and most "Arab" portion of the country, with most of the cities. Beyond the mountains is a series of arid, rolling plateaus, gradually dropping into the Sahara Desert in the south and southeast. Population is concentrated in scattered oases along the Draa and Ziz rivers. Mediterranean climate along the coast, becoming a more extreme desert climate in the interior. *Temperature ranges* (Rabat): January: 46° to 63°F; April: 52° to 71°F; July: 63° to 82°F; October: 58° to 77°F; (Marrakech): January: 40° to 65°F; April: 52° to 79°F; July: 67° to 101°F; October: 57° to 83°F. Temperatures in Casablanca and Tangier are similar to those of Rabat.

Visas: Send photographer letter and passport to the tourist office in New York outlining your plans. They will provide a letter to assist you both in entering the country and obtaining customs arrangements for your equipment; allow a few days for processing. *Tourists:* Passport; no visa is needed for stays of up to 3 months. *Health requirements:* No vaccinations required. *Equipment importation:* Arrange for with visa.

Electricity: Mostly 220/50, but some 127 volt. *Plug types:* C, D, E, and F.

Currency: Dirham (MDH); Centimes.

U.S. embassy in the country: 2 Avenue de Marrakech, P.O. Box 120, Rabat; *tel.* 622–65; *telex:* 31005. *Consulates:* Casablanca: 22–41–49; Marrakech: 327–58; Tangier: 359–04/6.

Embassy in U.S.: 1601 Twenty-first Street NW, Washington, DC 20009; *tel.* 202–462–7979/82. *Consulates:* New York: 212–758–2625/7.

Tourism office in U.S.: Moroccan National Tourist Office, 20 East Forty-sixth Street, 5th Floor, New York, NY 10017; *tel.* 212–557–2520.

Central tourism office in country: Moroccan National Tourist Office, 22 rue d'Anger, Rabat; *tel.* 21252/3/4.

Health suggestions: Health standards are below those of the U.S. but are improving rapidly. Water is generally not potable but may be safe in major cities. Very limited malaria risk in rural areas of coastal provinces.

Cultural mores and taboos: Hospitality is extremely important. Muslim injunctions against alcohol and pork prevail. Do not cross legs, point or gesture at someone with the hand, show the soles of the feet, or pass or accept items with the left hand. If invited to a mosque, dress to cover the entire body, remove shoes (tip the attendant who gives you slippers), and do not walk in front of others praying.

Photographic restrictions: People may be wary of being photographed, especially traditional women. Be sure to ask permission first.

Gratuity guidelines: Service is often included in the bill; if not, leave 10% to 15%.

MOZAMBIQUE
People's Republic of Mozambique
República Popular de Moçambique

The State Department warns that all travel outside the provincial capitals is extremely hazardous due to guerrilla insurgency by the Mozambique National Resistance (RENAMO). Food is also scarce throughout except in the best hotels. Be sure to register with the U.S. embassy upon arrival.

Location: In southeastern Africa, bounded on the north by Tanzania, the east

by the Indian Ocean, the south by South Africa, and the west by Zimbabwe, Zambia, and Malawi. *Size:* 297,846 square miles, about twice the size of California. **Major cities:** *Maputo* (lat. +25.58). *Airports:* Maputo International Airport (MPM), 5 miles outside of Maputo.

General transportation: A number of links to Europe and Africa, with domestic service to several major cities. A rail link connects to South Africa, but service is sporadic and not recommended. Paved roads connect major towns south of the Zambezi River and extend to the South African and Zimbabwean frontiers, but note the warning above. Taxis are scarce in Maputo, but rental cars are available. Buses are few, erratic, and overcrowded. *U.S. license:* No. *IDP:* Yes. *Rule of the road:* Left. *Taxi markings:* Usually yellow, marked TAXI on side; both metered and set price.

Population: 15,000,000. *Type of government:* People's republic, a one-party socialist state; relations with the U.S. are improving after strains in the late 1970s and early 1980s.

Languages: Portuguese (official), many indigenous dialects. An increasing number of Mozambicans understand English. *Ethnic groups:* Mostly from 10 diverse ethnic groups (with many subgroups), the largest being Makua and Tsonga; 10,000 Europeans, 35,000 Euro-Africans, 15,000 Indians. *Religion:* 60% indigenous beliefs, 30% Christian, 10% Muslim.

Time: EST +7; GMT +2. *Telephone codes:* No direct-dial from U.S.—operator-assisted calls only. No credit card or collect calls to U.S. Fair domestic and international service, sometimes subject to delays. *Pay phone system:* Coins; few available.

Holidays: January 1; February 3; April 7; May 1; June 25; September 7, 25; December 25. *Date/month system:* D/M.

Business hours: Vary; usually start and end a bit later than government hours. *Government hours:* 7 AM to 12 noon, 2 PM to 5 PM Monday to Friday; plus Saturday mornings. *Business dress code:* Same as that of the U.S.

Climate and terrain: Coastal lowlands rise to a central plateau (600 to 1,800 feet), to a high plateau (1,800 to 3,000 feet), to mountains along the western frontier. Africa's fourth-largest river, the Zambezi, divides the country in half. Climate varies from tropical to subtropical except in the high plateaus and mountains. The wet season extends from November to April, with warmer temperatures and irregular rainfall. Subject to cycles of drought and flood in the south. *Temperature ranges* (Maputo): January: 71° to 86°F; April: 66° to 83°F; July: 55° to 76°F; October: 64° to 82°F.

Visas: *Photojournalists:* Obtain permission from the Minister of Information through the embassy; requires 2 to 14 days (but can take up to 6 weeks). All visitors need a visa issued through Maputo. *Tourists:* Entry permit obtained in advance, requiring passport, 2 photos, $9 fee; valid up to 30 days from issue. All currency must be declared; carry your passport with you at all times. *Health requirements:* Yellow fever and cholera vaccinations. *Equipment importation:* Bring equipment list; no bond is required.

Electricity: 220/50. Plug types: C and F.

Currency: Metical (MZM), Centavos. Credit cards are rarely accepted; be sure to have ample cash and traveler's checks.

U.S. embassy in the country: 35 Rua Da Mesquita, 3d Floor, P.O. Box 783, Maputo; *tel.* 74279, 743167, 744163; *telex:* 6–143 AMEMB MO.

Embassy in U.S.: 1990 M Street NW, Suite 570, Washington, DC 20036; *tel.* 202–293–7146.

Central tourism office in country: Secretary of Tourism, Av. 25 de Setembro, Maputo.

Health suggestions: Water is not potable. Doctors are few; hospitals, overcrowded. Malaria suppressants are recommended throughout the country; tetanus and typhoid inoculation are also advised.

Photographic restrictions: Military, police, and security installations.

Gratuity guidelines: Service is not included in the bill; tips are appreciated but not expected.

NEPAL
Kingdom of Nepal
Sri Nepala Sarkar

Location: In south-central Asia, bounded on the north by China and the east, south, and west by India. **Size:** 54,362 square miles, slightly larger than Arkansas. **Major cities:** Kathmandu (lat. +27.42). **Airports:** Tribhuvan (KTM), 4 miles outside of Kathmandu. **General transportation:** Royal Nepal Airlines Corp. provides domestic service to some areas. Traditionally, transportation is by foot (Nepal has the lowest ratio of roads to area or population of any country on earth), and trekking agencies in the capital can outfit and staff expeditions to your specifications, from spartan to luxurious. *The State Department cautions you to check with the U.S. embassy before embarking on any trekking expeditions. U.S. license:* No. *IDP:* Yes, for 15 days, then local license must be obtained. *Rule of the road:* Left. *Motor clubs:* Automobile Association of Nepal, Traffic Police, Ramshah Path of Opp. Sindwar, Kathmandu; *tel.* 11 093, 15 662; partial AAA reciprocity. *Taxi markings:* All colors but license plate is black, some marked TAXI; metered. **Population:** 18,250,000. *Type of government:* Nominally a constitutional monarchy; the king exercises autocratic control over multitiered system of government. Enjoys friendly relations with the U.S. **Languages:** Nepali (official); 20 languages divided into numerous dialects. Hindi is spoken by about 90% of the population, and English is understood by many in business and government. *Ethnic groups:* Newars, Indians, Tibetans, Gurungs, Magars, Tamangs, Bhiotas, Rais, Limbus, Sherpas, and others. *Religion:* Only official Hindu kingdom in the world, although no sharp distinction between many Hindu (about 88%) and Buddhist groups; small Muslim and Christian minority. **Time:** EST +10.5; GMT +5.5. *Telephone codes:* No direct-dial from U.S.—operator-assisted calls only. No credit card or collect calls to U.S. Poor to fair domestic and international service. *Pay phone system:* Coins, where available.

Holidays: January 11; February 19; March 8; plus many religious and commemorative days—be sure to check with the consulate. *Date/month system:* D/M. **Business and government hours:** 10 AM to 5 PM Sunday to Friday. *Business dress code:* More informal than that of the U.S.

Climate and terrain: In the south a flat, fertile strip called the Terai is part of the Ganges basin plain. Central Nepal, known as the "hill country," is crisscrossed by the lower ranges of the Himalayas and swiftly flowing mountain rivers. The high Himalayas form the border with Tibet, China, in the north. Eight of the world's highest peaks are in this area, including Mount Everest at 29,028 feet. Kathmandu is in a broad valley in the middle hill region (4,300 feet). Climate ranges from subtropical in the south to cool summers and severe winters in the northern mountains. The monsoons from June to September bring considerable rain. Showers occur every day and can last for several days. October to March brings sunny days and cool nights. *Temperature ranges* (Kathmandu): January: 36° to 65°F; April: 53° to 84°F; July: 69° to 84°F; October: 56° to 80°F.

Visas: Standard tourist visa, requiring passport, 1 photo, $10 fee; allow 1 day for processing; valid for 3 months, for stays of up to 30 days. A 15-day visa is also available at Kathmandu's airport upon arrival for $10. A tourist visa permits travel to Kathmandu Valley, Pokhara, and Chitwan; permits for travel to other regions are required from immigration authorities in Kathmandu. Permission to climb the higher mountains should be acquired from the Ministry of Foreign Affairs well in advance. *Health requirements:* Yellow fever vaccination is required if coming from an infected area. *Equipment importation:* Bring equipment list; no bond is required.

Electricity: 220/50. *Plug types:* D.
Currency: Rupee (NER); Paise.
U.S. embassy in the country: Pani Pokhari, Kathmandu; *tel.* 411179, 412718, 411601; *telex:* NP 2381 AEKTM.
Embassy in U.S.: 2131 Leroy Place NW, Washington, DC 20008; *tel.* 202–667–4550.
Consulates: New York: 212–370–4188.
Central tourism office in country: Central Immigration Office, Central Tourist Office, Ghantaghar, Kathmandu; *tel.* 2–11203.

Health suggestions: Hepatitis treatment recommended for all areas; malaria suppressants and polio, typhus, and meningitis inoculations recommended for travel outside the capital.
Cultural mores and taboos: Avoid passing anything with the left hand. Remove shoes before entering homes or temples.
Gratuity guidelines: Tipping is not common, but tips for unusual service are accepted.

NETHERLANDS
Kingdom of the Netherlands
Konindrijk der Nederlanden

Location: In northwestern Europe, bounded on the west and north by the North Sea, the east by West Germany, and the south by Belgium. *Size:* 14,140 square miles, about the size of Massachusetts, Connecticut, and Rhode Island combined.
Major cities: *Amsterdam* (lat. +52.23), with the government residing at the Hague, Rotterdam. *Airports:* Schiphol (AMS), 12 miles outside of Amsterdam; Rotterdam International Airport (RTM), 6 miles outside of Rotterdam.
General transportation: Most international flights arrive at Schiphol, but a few land in Rotterdam and Maastricht. Excellent public transport and air or rail links to the rest of Europe, as well as transport on inland waterways. Amsterdam has a subway. *U.S. license:* Yes. *IDP:* Yes. *Rule of the road:* Right. *Motor clubs:* ANWB (Royal Dutch Touring Club), Wassenaarseweg 220, The Hague; *tel.* 14 14 20, 14 71 47; full AAA reciprocity. *Taxi markings:* All colors (usually black), marked TAXI; metered.
Population: 14,700,000. *Type of government:* Constitutional monarchy; no party has been dominant; generally centrist coalition governments. Excellent relations with the U.S.
Languages: Dutch. English is extremely common. *Ethnic groups:* 99% Dutch, 1% Indonesian and other. *Religion:* 40% Roman Catholic, 31% Protestant (predominantly Dutch Reformed Church), 24% unaffiliated, 5% none.
Time: EST +6; GMT +1. *Telephone codes:* Country: 31. Amsterdam 20, Arnhem 85, Eindhoven 40, Groningen 50, Haarlem 23, Heemstede 23, Hillegersberg 10, Hoensbroek 45, Hoogkerk 50, Hoogvliet 10, Loosduinen 70, Nijmegen 80, Oud Zuilen 30, Rotterdam 10, the Hague 70, Utrecht 30. Excellent domestic and international service. *Pay phone system:* Coins.
Holidays: January 1; Good Friday; Easter Monday; April 30; Ascension Day (40 days after Easter); Whit Monday (varies—early June); December 5, 25, 26. *Date/month system:* D/M.
Business hours: 8:30 or 9 AM to 5 or 5:30 PM Monday to Friday. *Business dress code:* Same as that of the U.S., perhaps a bit more conservative.
Climate and terrain: Mostly flat and very low, resulting in a constant battle to reclaim the land from the North Sea. Damp and rainy much of the year. Except for June to September, the weather is cold, made more penetrating by the dampness. *Temperature ranges* (Amsterdam): January: 34° to 40°F; April: 43° to 52°F; July: 59° to 69°F; October: 48° to 56°F.
Visas: Standard tourist entry, requiring passport; proof of return ticket/sufficient funds may be required; no visa is needed for stays of up to 90 days. *Health requirements:*

No vaccinations required. *Equipment importation:* Carnet.
Electricity: 220/50. *Plug types:* C and F.
Currency: Guilder/Florin (DFL); Cents.
U.S. embassy in the country: Lange Voorhout 102, the Hague; *tel.* 62–49–11; *telex:* (044) 31016. *Consulates:* Amsterdam: 64–56–61, 79–03–21.
Embassy in U.S.: 4200 Linnean Avenue NW, Washington, DC 20008; *tel.* 202–244–5300. *Consulates:* California: 213–380–3440; 415–981–6454; Illinois: 312–856–0110; New York: 212–246–1429; Texas: 713–622–8000.
Tourism office in U.S.: Netherlands Board of Tourism, 355 Lexington Avenue, New York, NY 10017; *tel.* 212–370–7360.
Central tourism office in country: VVV

Stationsplein (in front of central station), 1012 AB Amsterdam; *tel.* 26–64–44.
Health suggestions: Excellent health standards, good medical care.
Cultural mores and taboos: Punctuality and privacy are very important.
Color labs: *Kodak* Nederland B.V., Fototechnisch Bedrif, Treubstaat 11, 2288 EG Rijswijk (Z-H); *Fujicolor* Service, Postbus 75, Lelystad.
Equipment rental/sales: *Balcar:* Capi-Lux VAC, Amsterdam, *tel.* 586–6333. *Broncolor:* Marx En Schuuring B.V., Amsterdam, *tel.* 11 22 12; Photal, Wijchen, *tel.* 08894, 20334. *Profoto:* Kubus Nieuw Vennep BV, Nieuw Vennep, *tel.* 87356.
Gratuity guidelines: Service is included in the bill; leave a bit more only if you wish.

NETHERLANDS ANTILLES

Location: In the West Indies, 2 groups of islands—Aruba, Bonaire, and Curaçao, north of Venezuela; and Statia (formerly St. Eustatius), Saba, and St. Maarten (the southern third of the island; the northern two-thirds are part of Guadeloupe), which are southeast of Puerto Rico. *Size:* 385 square miles, slightly larger than New York City.
Major cities: *Willemstad,* Curaçao (lat. 12.06). *Airports:* Reina Beatrix (AUA), 3 miles outside of Oranjestad, Aruba; Flamingo Field (BON), 4 miles outside of Kralendijk, Bonaire; Aerepuerto Hato (CUR), 8 miles outside of Willemstad, Curaçao; Princess Juliana (SXM), 7 miles outside of Philipsburg, St. Maarten.
General transportation: Curaçao and Aruba have buses, privately owned automobiles operating as buses, and taxis. Roads are in fair condition. Rental car agencies on Aruba, Bonaire, Curaçao, and St. Maarten. *U.S. license:* No. *IDP:* Yes. *Rule of the road:* Right. *Taxi markings:* In Aruba, Curaçao, St. Maarten, marked TAXI, set price; in Bonaire, has TX on the license plate.
Population: 240,000. *Type of government:* Autonomous part of the Netherlands.

Aruba is self-governing, due for independence in 1996. Constitutional parliamentary government; each island has its own representative body, the Island Council.
Languages: Dutch (official), Papiamento (a Spanish-Portuguese-Dutch-English dialect), English (widely spoken), Spanish.
Ethnic groups: Varied mixture of European, African, Carib, Indian. *Religion:* Roman Catholic, Protestant, Jewish, Seventh Day Adventist, Hindu, Muslim, Confucian.
Time: EST +1; GMT −4. *Telephone codes:* Country: 599. Aruba 2978 (no 599 country code), Bonaire 7, Curaçao 9, Saba 4, Statia 3, St. Maarten 5. Generally adequate domestic and international service. *Pay phone system:* Coins; few available.
Holidays: January 1; Carnaval Monday; Good Friday; Easter Monday; April 30; May 1; Ascension Day (40 days after Easter); December 25, 26. *Date/month system:* D/M.
Business hours: Aruba, 9 AM to 5 PM Monday to Friday. Bonaire, 8 AM to 12 noon, 2 PM to 5 or 6 PM Monday to Friday. Curaçao, 9 AM to 12 noon, 2 PM to 5 PM Monday to Friday. St. Maarten, 8 AM to 5 PM Monday to Friday. *Business dress code:* A bit more informal than that of the U.S.,

but varies from island to island. Bonaire is very informal, whereas ties and jackets are a bit more common in Curaçao, for example. **Climate and terrain:** Generally hilly, volcanic interiors. The climate is tropical, modified by trade winds, with rainfall scarce on the Aruba, Bonaire, and Curaçao. Vegetation is consequently sparse there, but parts of the other islands can be lush. *Temperature ranges* (Curaçao): January: 75° to 83°F; April: 76° to 86°F; July: 77° to 87°F; October: 78° to 88°F.

Visas: Standard tourist entry, requiring proof of citizenship; proof of return ticket/ sufficient funds may be required; no visa is needed for stays of up to 90 days. *Health requirements:* Yellow fever vaccination is required if coming from an infected area. *Equipment importation:* In Aruba, bring equipment list; bond might be required. In Bonaire and Curaçao, bring equipment list; bond is probably not required. St. Maarten is an open port. **Electricity:** 115–127/60. *Plug types:* A, B, C, D, E, and F. **Currency:** Guilder/Florin (AFL); Cents. **U.S. embassy in the country:** St. Anna Boulevard 19, P.O. Box 158, Willemstad, Curaçao; *tel.* 613066; *telex:* 1062 AMCON NA.

Embassy in U.S.: Care of the Dutch embassy, 4200 Linnean Avenue NW, Washington, DC 20008; *tel.* 202–244–5300. **Tourism office in U.S.:** All are in New York. Aruba: 212–246–3030; Bonaire: 212–242–7707; Curaçao: 212–751–8266; St. Maarten, Saba, Statia: 212–989–0000. **Central tourism office in country:** Aruba: Aruba Tourism Authority, L. B. Smith Boulevard, *tel.* 23771 Oranjestad. Bonaire: Bonaire Tourist Bureau, Kaya Simon Bolivar #23, Kralendijk; *tel.* 8322/ 8649. Curaçao: Curaçao Tourist Board, Schouwburgweg Z–N, Willemstad; *tel.* 77339/77121. St. Maarten: St. Maarten Tourist Bureau, Little Pier, Philipsburg; *tel.* 22337.

Health suggestions: Because of the lack of fresh water, sea water is distilled, producing a water so pure it must be passed through a lime filter to give it taste. Sanitation standards are generally adequate.

Gratuity guidelines: Aruba, same as those of the U.S.; Bonaire, service is generally included in the bill; Curaçao, service is sometimes included in the bill, giving a bit more is customary, leave at least 10% if not included; St. Maarten, 15% is usually included in the bill, if not, leave 15%.

NEW ZEALAND

Location: In the southwestern Pacific Ocean, southeast of Australia. *Size:* 103,736 square miles, about the size of Colorado. **Major cities:** *Wellington* (lat. −41.17), Auckland (lat. 37.00). *Airports:* Wellington (WLG), 5 miles outside of Wellington; Auckland (AKL), 14 miles outside of Auckland; Mechanics Bay (MHB). **General transportation:** Many international flights, with direct links to the U.S. Good public transport by air, rail, bus, within and between cities. *U.S. license:* Yes. *IDP:* Yes. *Rule of the road:* left. *Motor clubs:* New Zealand Automobile Association Inc. (NZAA), 342 Lambton Quay, Wellington; *tel.* 738–738; full AAA reciprocity.

Taxi markings: All colors, marked TAXI; metered. **Population:** 3,340,000. *Type of government:* Independent state within the British Commonwealth recognizing Elizabeth II as head of state; parliamentary system based on the British. Enjoys friendly relations with the U.S. **Languages:** English (official), Maori. *Ethnic groups:* 88% European, 8.9% Maori, 2.9% Pacific Islander, 0.2% other. *Religion:* 81% Christian,, 18% none or unspecified, 1% Hindu, Confucian or other. **Time:** EST +17; GMT +12. *Telephone codes:* Country: 64. Auckland 9, Christchurch 3, Dunedin 24, Hamilton 71, Has-

tings 70, Invercargill 21, Napier 70, Nelson 54, New Plymouth 67, Palmerston North 63, Rotorua 73, Tauranga 75, Timaru 56, Wanganui 64, Wellington 4, Whangarei 89. Excellent domestic and international service. *Pay phone system:* Coins.

Holidays: January 1, 2, 20 (provincial), 27 (provincial); February 6; Good Friday; April 25; Queen's Birthday (June); October 27; November 14 (provincial); December 25, 26. *Date/month system:* D/M.

Business and government hours: 9 AM to 5 or 5:30 PM Monday to Friday. *Business dress code:* Same as that of the U.S.

Climate and terrain: North Island, with 74% of the population, including 93% of the Maoris, has a high, volcanic central plateau containing the scenic thermal district. The northern part is a narrow, indented, sparsely populated peninsula. Across its base lie the fertile plains of the Waikato, Piak, and Waihou rivers—the great dairy regions. South Island has a major mountain range, the Southern Alps, with rugged peaks to 10,000 feet. West of the Alps is Westland, a narrow forested strip that experiences torrential rainfall. To the east are the Canterbury Plains, with 3 million acres of rich, alluvial land for grain and sheep pasture. In the southwest section, the coastline is broken by magnificent fjords, where the mountains rise abruptly from the sea. Climate is temperate, with sharp regional contrasts but few extremes. Freezing temperatures are rare. It is warmest in the subtropical "winterless north" of the Auckland peninsula and increasingly colder to the south. Rainfall is heavy throughout, particularly on the west coasts. Seasons are opposite those of the U.S. *Temperature ranges* (Wellington): January: 56° to 69°F; April: 51° to 63°F; July: 42° to 60°F; October: 48° to 88°F; (Auckland): January: 60° to 73°F; April: 56° to 67°F; July: 46° to 56°F; October: 52° to 63°F.

Visas: Standard tourist entry, requiring a passport valid for 3 months beyond stay, proof of return ticket and sufficient funds; no visa is needed for stays of up to 3 months. If you have questions about your status once you are there, contact the Department of Labor in any major city. *Health requirements:* No vaccinations required. *Equipment importation:* Carnet.

Electricity: 230/50. *Plug types:* I.

Currency: Dollar (NZ$); Cents.

U.S. embassy in the country: 29 Fitzherbert Terrace, Thorndon, Wellington; *tel.* 722–068; *telex:* NZ 3305. *Consulates:* Auckland: 32–724.

Embassy in U.S.: 37 Observatory Circle NW, Washington, DC 20008; *tel.* 202–328–4800. *Consulates:* California: 213–477–8241; New York: 212–586–0060.

Tourism office in U.S.: New Zealand Tourist and Publicity Office, 630 Fifth Avenue, New York, NY 10111; *tel.* 212–698–4680.

Central tourism office in country: New Zealand Tourist and Publicity, Head Office, 256 Lambton Quay, Wellington; *tel.* 728–860.

Health suggestions: Health standards are excellent. No sanitary precautions are needed.

Cultural mores and taboos: Open, friendly atmosphere. New Zealanders call themselves kiwis.

Color labs: *Kodak* New Zealand, Ltd.: P.O. Box 2198, Auckland; P.O. Box 700, Christchurch; P.O. Box 3003, Wellington. *Fuji:* Poland Road, Glenfield, Auckland, 10, P.O. Box 40041.

Equipment rental/sales: *Balcar:* Film Facilities Ltd., Wellington, *tel.* 844–192. *Profoto:* Photographic Wholesalers, NZ, Auckland, *tel.* 769–780. *Film commissions:* New Zealand Tourist and Publicity Office, 10960 Wilshire Boulevard, Suite 1530, Los Angeles, CA 90024; *tel.* 213–477–8241.

Gratuity guidelines: Service is not included in the bill. Tips signify exemplary service and are accepted but not expected.

NICARAGUA
Republic of Nicaragua
República de Nicaragua

The State Department has issued an extensive warning about travel to Nicaragua due to residual military conflict and the poor state of U.S.–Nicaraguan relations. Be sure to check before you go.

Location: In Central America, bounded on the north by Honduras, the east by the Caribbean Sea, the south by Costa Rica, and the west by the Pacific Ocean. *Size:* 49,579 square miles, slightly larger than New York State.

Major cities: *Managua* (lat. +12.08).
Airports: Aeropuerto Internacional Augusto C. Sandino (MGA), 8 miles outside of Managua.

General transportation: Frequent flights to the rest of Central America, with indirect connections to the U.S. Managua is served by a bus system and many taxis. Roads were always relatively poor, and the infrastructure has been extensively damaged by a 1988 hurricane; repairs will take years. Rental cars are available. *U.S. license:* Yes, for 30 days, then local license must be obtained. *IDP:* Yes, for 30 days, then local license must be obtained. *Rule of the road:* Right. *Taxi markings:* All colors, some marked TAXI; set price.

Population: 3,400,000. *Type of government:* Republic; the Sandinista National Liberation Front (FSLN) is the ruling party and dominates political life; it is in armed conflict with its opposition. Nicaragua has diplomatic relations with the U.S., but there is little sign of reconciliation between the two governments' political viewpoints.

Languages: Spanish (official); English- and Indian-speaking minorities on the Atlantic coast. *Ethnic groups:* 69% mestizo, 17% white, 9% black, 5% Indian. *Religion:* 95% Roman Catholic.

Time: EST −1; GMT −6. *Telephone codes:* Country: 505. Boaco 54, Chinandega 341, Diriamba 42, Estelí 71, Granada 55, Jinotepe 41, León 311, Managua 2, Masatepe 44, Masaya 52, Nandaime 45, Rivas 461, San Juan del Sur 466, San Marcos 43, Tipitapa 53. Low-capacity domestic and international services are being expanded. International calls are available. *Pay phone system:* Coins; few available.

Holidays: January 1; Holy Thursday; Good Friday; May 1; July 19; September 14, 15; December 25, 26. *Date/month system:* D/M.

Business hours: 8 or 9 AM to 5 PM Monday to Friday, with a lunch break some time between 12 and 2. *Business dress code:* More informal than that of the U.S.; open shirt is acceptable. *Note: any military-style clothing or fatigues are subject to confiscation.*

Climate and terrain: Lake Managua and Lake Nicaragua, the region's largest bodies of water, are in the west; north of them, coastal plains rise gradually to rugged mountains. Beyond the mountains lies a sparsely inhabited area of forested plains and hills. The eastern coast is swampy. The country is traversed from north to south by the Inter-American Highway and from east to west by rivers, by a road to Puerto Cabezas, and by road and river to Bluefields. Subject to destructive earthquakes; the Managua quake of 1972 killed over 10,000, left 300,000 homeless, and destroyed much of the city. Climate is tropical; cooler in the highlands. *Temperature ranges* (Managua): January: 69° to 88°F; April: 73° to 94°F; July: 73° to 88°F; October: 72° to 88°F.

Visas: Standard tourist entry, requiring a passport valid 6 months beyond stay, proof of return ticket and sufficient funds. No visa is needed for stays of up to 30 days; after that, arrange an extension with the immigration department (usually granted). *Health requirements:* Yellow fever vaccination is required if coming from an infected area. *Equipment importation:* Bring equipment list; no bond is required.

Electricity: 120/60. *Plug types:* A.

Currency: Cordoba (COR); Centavos. Sixty dollars must be exchanged upon arrival. *Credit cards and traveler's checks in U.S. dollars are often not accepted, and bank cash transfers can be difficult to make—be sure to bring ample cash with you.* **U.S. embassy in the country:** Km. 4-1/2 Carretera Sur, Managua; *tel.* 66010, 66013, 66015/8, 66026/7, 66032/4. **Embassy in U.S.:** 1627 New Hampshire Avenue NW, Washington, DC 20009, *tel.* 202–939–6531/4.

Central tourism office in country: Office of Tourism (Inturismo), Plaza España, Managua; *tel.* 22498/26790.

Health suggestions: Basic medical care is available, but shortages exist. General sanitation standards are below those of the U.S., but the water supply in Managua is considered safe. Malaria suppressants are recommended for rural areas and outskirts of some cities.

Cultural mores and taboos: Hospitality and personal honor are greatly valued.

Photographic restrictions: Prohibitions on photographing military activities and installations can be strictly enforced.

Gratuity guidelines: Service is not usually included in the bill; leave a tip.

NIGER
Republic of Niger
République du Niger

Location: In western Africa, bounded on the north by Algeria and Libya, the east by Chad, the south by Nigeria, the southwest by Benin and Burkina Faso, and the west by Mali. *Size:* 459,073 square miles, almost 3 times the size of California.

Major cities: *Niamey* (lat. +13.31). *Airports:* Niamey (NIM), 8 miles outside of Niamey.

General transportation: Flights to Europe (with connections to U.S.) and Africa; most major centers are served by air. Rental cars are available. Of the 3 major roads from Niamey, one is paved for 60 miles, another for 920 miles, the third for 770 miles. Other roads in Niger are paved for short distances. Adequate public transport is provided only by taxis. *U.S. license:* No. *IDP:* Yes. *Rule of the road:* Right. *Taxi markings:* Orange top; marked TAXI; set price.

Population: 7,200,000. *Type of government:* Republic; military regimes in power since 1974; some attempts to return to more popular participation. Close and friendly relations with the U.S.

Languages: French (official), Hausa, Djerma. *Ethnic groups:* 56% Hausa, 22% Djerma, 8.5% Fula, 8% Taureg, 4.3% Beri Beri (Kanouri), 1.2% Arab, Toubou, and Gourmantche; about 4,000 French. *Religion:* 80% Muslim, the rest indigenous beliefs and Christian.

Time: EST +6; GMT +1. *Telephone codes:* No direct-dial from U.S.—operator-assisted calls only. No credit card or collect calls to U.S. Niamey has telephone service. Calls to U.S. can be made at any time but quality varies. *Pay phone system:* Coins; few available.

Holidays: January 1; April 15; Easter Monday; May 1; August 3; December 18, 25; plus some Muslim holidays. *Date/month system:* D/M.

Business hours: 7:30 AM to 12:30 PM, 4 PM to 6 PM Monday to Friday; Saturday mornings. *Business dress code:* Informal; neckties are rarely worn.

Climate and terrain: Lies on the southern edge of the Sahara, and two-thirds of the country is desert. The northern border is also mountainous, and therefore 90% of the population lives along the southern border. One-third of the country is savanna suitable for livestock and limited cultivation. The Niger River flows for 300 miles along the southwest border, permitting cultivation of rice and vegetables. Mostly rural population. Hot, dry, dusty climate, especially in April

and May; the rainy season runs from June to September. Recent devastating drought. *Temperature ranges* (Niamey): January: 58° to 93°F; April: 77° to 108°F; July: 74° to 94°F; October: 74° to 101°F. **Visas:** Standard tourist or business visa is valid for 3 months from date of issue; requires $6.60 fee for 1-week stay, $16.50 for 30 days, $23.10 for 90 days, plus passport, 3 photos, letter from travel agent as proof of return ticket. Business travelers need a client letter stating purpose of trip and accepting responsibility for visitor. If traveling by road, a bank letter showing at least $500 in savings is required. Obtaining a photography permit once in the country is required; contact the Ministry of Interior (government offices are located in one complex well known to any taxi driver) or the prefecture in Agadès. *Health requirements:* Yellow fever vaccination; cholera vaccination if traveling by road. *Equipment importation:* Bring equipment list; no bond is required. It is recommended that you register the equipment

with the Niger consulate or embassy here. **Electricity:** 220/50. *Plug types:* C. **Currency:** Franc (CFA); Centimes. **U.S. embassy in the country:** B.P. 11201, Niamey; *tel.* 72–26–61/4, 72–26–70; *telex:* EMB NIA 5444NI. **Embassy in U.S.:** 2204 R Street NW, Washington, DC 20008; *tel.* 202–483–4224/7.
Central tourism office in country: Office of Tourism in the capital's government complex.
Health suggestions: Water is not potable, despite a filtering plant. Typhoid, tetanus, polio, hepatitis treatments are advisable. Malaria suppressants are recommended throughout the country.
Cultural mores and taboos: Be a bit more modest in dress than in the U.S.
Photographic restrictions: Permit required; see **Visas,** above.
Gratuity guidelines: If service is not included in the bill, tips are appreciated but not expected.

NIGERIA
Federal Republic of Nigeria

Location: In western Africa, bounded on the northwest and north by Niger, the northeast by Chad, the east by Cameroon, the south by the Gulf of Guinea, and the west by Benin. **Size:** 356,669 square miles, about twice the size of California. **Major cities:** *Lagos* (lat. +6.27). *Airports:* Murtala Muhammed (LOS), 16 miles outside of Lagos. **General transportation:** Many international flights, with direct links to the U.S. Nigeria Airways (WT) and private carriers provide domestic service. Many paved roads, including some 4-lane highways, provide basis of surface travel by bus or car. Railways are primarily for freight; passenger service is available but very slow. Buses and taxis provide urban transport. *U.S. license:* No. *IDP:* No. *Rule of the road:* Right. *Motor clubs:* Automobile Club of Nigeria, 48

Adegbola Street, Anifowoshe, Lagos; *tel.* 96 05 14; partial AAA reciprocity. *Taxi markings:* In Lagos, yellow, metered or price set by zone or hour; in Aduja, green and white, set price. Negotiate fares in advance, particularly from the airport—overcharging visitors is common. Traffic can be extremely heavy. **Population:** 112,000,000. *Type of government:* Military government since 1983. Previous constitution was based on that of the U.S. Return to some civilian rule is proposed for 1990. Cordial relations with the U.S. **Languages:** Officially English, although it is a second language for some who have been raised speaking indigenous tongues. Most officials and businesspeople speak English very well. *Ethnic groups:* More than 250 tribal groups; Hausa and Fulani in north,

Yoruba in southwest, Ibos in southeast combine to form 65% of population; about 27,000 non-Africans. *Religion:* 50% Muslim, 40% Christian, 10% indigenous beliefs. **Time:** EST +6; GMT +1. *Telephone codes:* Country: 234. Lagos 1 (the only direct-dial city; all others require operator assistance). The above-average telephone system is unreliable because of poor maintenance. *Pay phone system:* Coins; few available.

Holidays: January 1; Good Friday; Easter Monday; October 1; December 25, 26; plus Muslim holidays of Eid-El-Maulud, Eid-El-Fitri, and Eid-El-Kabir. Holidays falling on a Saturday are normally celebrated on the preceding Friday. Those falling on Sunday are celebrated on the following Monday. *Date/month system:* D/M.

Business and government hours: 7:30 AM to 1 PM, 2 PM to 4 PM Monday to Friday. Many offices hold staff meetings on Monday and Friday mornings and are often not available for visitors. In the Muslim north, all establishments close at 1 PM on Friday. *Business dress code:* Conservative.

Climate and terrain: Consists of 4 regions. A hot, humid coastal belt of mangrove swamp leads north to tropical rain forest and oil-palm bush. The greater part of the north is a dry, central plateau of open woodland and savanna. Semidesert characterizes the extreme north. Nigeria has several navigable rivers, and the extensive lagoons of the southern coast play an important role in transportation and economic activity. The tropical climate varies considerably from north to south. In the north, it is humid from May to October, with a rainy season from April to October. The dry season is made dusty by Saharan harmattan winds. In the south, it is humid throughout the year, with two rainy seasons, from March to July and September to November. *Temperature ranges* (Lagos): January: 74° to 88°F; April: 77° to 89°F; July: 74° to 83°F; October: 74° to 85°F.

Visas: Photographers need a special visa; contact the consulate or embassy. It requires passport, photographer letter, client letter, 1 application, 1 photo, equipment list; allow at least 2 weeks for processing. *Tourists:* Tourist visa, valid for 1 entry within 3 months. Carry passport and return ticket with you at all times. *Health requirements:* Yellow fever vaccination is required if coming from an infected area and is recommended by CDC for travel outside urban areas. *Equipment importation:* Arrange for with visa.

Electricity: 230/50. *Plug types:* D and G.

Currency: Naira (NGN); Kobo. *Credit cards are not widely accepted.*

U.S. embassy in the country: 2 Eleke Crescent, P.O. Box 554, Lagos; *tel.* 610097; *telex:* 23616 EMLA NG or 21670 USATO NG. *Consulates:* Kaduna: (1) 201070/2.

Embassy in U.S.: 2201 M Street NW, Washington, DC 20037; *tel.* 202–822–1522. *Consulates:* California: 415–552–0334; Georgia: 404–577–4800; New York: 212–715–7200.

Central tourism office in country: Federal Ministry of Information and Culture, 15 Awolowo Ikoyi Road, Lagos.

Health suggestions: Water is not potable. Yellow fever vaccination is advisable. Regular use of malaria suppressants is strongly recommended. Vaccinations for typhoid and tetanus and gamma globulin shots for hepatitis should also be considered. Cholera infection is present. Medical care is available in major cities but is below U.S. standards.

Cultural mores and taboos: Lagos airport is quite congested and subject to considerable delays. Domestic airline schedules are unreliable, and flights may be canceled at a moment's notice or may be seriously overbooked. Reservations for travel arrangements and hotels often fail to materialize—be prepared to persist on your arrival and consider monetary inducements (*dash*, given before services are rendered), which are commonplace. Expect delays in almost all matters. Negotiations will require patience.

Complicated bureaucracy. Sensitivity about colonial past. Use honorary titles if possible. Important business is conducted face to face; personal space is very close, do not back away. Refer to "ethnic groups," rather than "tribes." Polygamy is not uncommon. **Gratuity guidelines:** 10% for service is often included in the bill; another 5% to 10% is appreciated.

NORWAY
Kingdom of Norway
Kongeriket Norge

Location: In northwestern Europe, bounded on the north by the Arctic Ocean, the northeast by the USSR and Finland, the east by Sweden, the south by the Skagerrak, and the west by the Atlantic Ocean and North Sea. *Size:* 125,049 square miles, slightly larger than New Mexico. **Major cities:** *Oslo* (lat. +59.56), Bergen (lat. +60.24). *Airports:* Fornebu (FBU), 5 miles outside of Oslo; Gardermoen (GEN), 29 miles outside of Oslo; Flesland (BGO), 12 miles outside of Bergen. **General transportation:** Many international flights, with direct links to U.S. Excellent public transport. *U.S. license:* Yes. *IDP:* Yes. *Rule of the road:* Right. *Motor clubs:* Norges Automobil-Forbund (NAF), Storgaten 2, Oslo; *tel.* 42–94–00; full AAA reciprocity. *Taxi markings:* All colors, marked TAXI; metered; taxi stands are common. **Population:** 4,200,000. *Type of government:* Constitutional monarchy; parliamentary democracy. Long tradition of friendly relations with the U.S. **Languages:** Norwegian. English is widely understood. *Ethnic groups:* Germanic (Nordic, Alpine, Baltic), with a 20,000 Lapp minority. *Religion:* 94% Evangelical Lutheran (state church), 4% other Protestant and Roman Catholic, 2% other. **Time:** EST +6; GMT +1. *Telephone codes:* Country: 47. Arendal 41, Bergen 5, Drammen 3, Fredrikstad 32, Haugesund 47, Kongsvinger 66, Kristiansund N. 73, Larvik 34, Moss 32, Narvik 82, Oslo 2, Sarpsborg 31, Skien 35, Stavanger 4, Svalbard 80, Tønsberg 33, Trondheim 7. Excellent domestic and international service. *Pay phone system:* Coins.

Holidays: January 1; Easter holiday from noon Wednesday through Easter Monday; May 1, 17; Whit Monday (varies—early June); December 25, 26. Many Norwegians vacation in July and August, particularly during the last three weeks in July. *Date/month system:* D/M.

Business hours: 9 AM to 4 PM Monday to Friday. *Business dress code:* Same as that of the U.S.

Climate and terrain: Glaciated; mostly high plateaus and rugged mountains broken by verdant valleys and many lakes; the coastline is deeply indented by magnificent fjords; arctic tundra in the north. Temperate climate along the coast, moderated by the North Atlantic Current; colder inland; rainy year-round on the west coast. *Temperature ranges* (Oslo): January: 20° to 30°F; April: 34° to 50°F; July: 56° to 73°F; October: 37° to 49°F; (Bergen): January: 27° to 43°F; April: 34° to 55°F; July: 51° to 72°F; October: 38° to 57°F.

Visas: Standard tourist entry, requiring passport; no visa is needed for stays of up to 3 months (period starts after entering any Scandinavian country—Norway, Finland, Iceland, Denmark, and Sweden). **Health requirements:** No vaccinations required. *Equipment importation:* Carnet. **Electricity:** 230/50. *Plug types:* C and F. **Currency:** Krone (NOK); Øre.

U.S. embassy in the country: Drammensveien 18, Oslo 2; *tel.* 44–85–50; *telex:* 78470.

Embassy in U.S.: 2720 Thirty-fourth

Street NW, Washington, DC 20008; *tel.* 202–333–6000. *Consulates:* California: 415–986–0766, 213–626–0338; Minnesota: 314–997–6810; New York: 212–421–7333; Texas: 713–521–2900.

Tourism office in U.S.: Norwegian Tourist Board, 655 Third Avenue, New York, NY 10017; *tel.* 212–949–2333.

Central tourism office in country: NORTRA, Havnelageret, Langkaia #1, 0150 Oslo 1; *tel.* 42–70–44.

Health suggestions: Excellent health standards. Water is potable.

Cultural mores and taboos: Business meetings are formal and punctual, but the Norwegians are a generally warm and tolerant people. First names are reserved for close friends.

Color labs: *Kodak* Norge A/S, Fotolaboratoriet, Trollasveien 6, 1410 Kolbotn. *Fuji* Color Service, Postboks 113, 3191 Horten.

Equipment rental/sales: *Balcar:* Til Mediahuset, Trondheim, *tel.* 888–200. *Broncolor:* Lars Farnes A/S, Oslo; *tel.* 0–04–72, 16–29–30. *Profoto:* Interphoto A/S, Hovik, *tel.* (2) 534–990.

Gratuity guidelines: Service is included in the bill; leaving a bit extra is customary.

OMAN
Sultanate of Oman
Saltanat 'Uman

Location: In southwestern Asia, bounded on the north by the Gulf of Oman, the east and south by the Arabian Sea, the southwest by South Yemen, the west by Saudi Arabia, and the northwest by the United Arab Emirates. *Size:* 82,000 square miles, slightly smaller than Kansas.

Major cities: *Masqat* (lat. +23.37). *Airports:* Seeb (MCT), 25 miles outside of Masqat.

General transportation: Many international flights, with direct links to the U.S. Daily flights to Salalah; bookings are sometimes available on charter flights for the Petroleum Development Oman to Fahud and Marmul. Hotels are heavily booked—reserve well in advance. Rental cars are available. *U.S. license:* No. *IDP:* Yes. *Rule of the road:* Right. *Motor clubs:* Oman Automobile Association, Royal Oman Police Pensions Trust LLC, Matrah; *tel.* 70–63–22, 70–20–24; partial AAA reciprocity. *Taxi markings:* Usually orange and beige; set price; commonly shared.

Population: 1,270,000. *Type of government:* Absolute monarchy, ruled by a sultan; independent with residual British influence. Friendly relations with the U.S. date back to the early years of American independence.

Languages: Arabic. English is used in business, and a fair number of Omanis understand some English. *Ethnic groups:* Almost entirely Arab, with small Baluchi, Zanzibari, and Indian groups. *Religion:* 75% Ibadhi Muslim; remainder Sunni Muslim, Shi'a Muslim, and Hindu.

Time: EST +9; GMT +4. *Telephone codes:* Country: 968. No city codes. New system provides good domestic and international service. *Pay phone system:* Coins.

Holidays: November 18, 19; plus several Muslim holidays—contact the consulate for dates. Hours are curtailed during Ramadan, and businesspeople may be hard to reach during the hot summer months. *Date/month system:* D/M.

Government hours: 7:30 AM to between 2 PM and 4 PM, Saturday to Thursday. *Business dress code:* Short-sleeved shirt and tie in summer; regular shirt in cooler weather. Conservative dress for women.

Climate and terrain: Vast central desert plain; rugged mountains in north and south. Hot and humid along the coast, with a hot, dry interior; a strong southwest summer monsoon affects the far south from May to September. *Temperature ranges* (Masqat): January: 66° to 77°F; April: 78° to 90°F;

July: 87° to 97°F; October: 80° to 93°F.

Visas: Business visa or nonobjection certificate, requiring letter of invitation from sponsor in Oman, passport, photographer or client letter, 2 photos, equipment list; valid for 3 months, for single entry. *Tourists:* No visas are issued. *Health requirements:* Yellow fever vaccination is required if coming from an infected area. *Equipment importation:* Arrange for with visa. **Electricity:** 240/50. *Plug types:* D and G. **Currency:** Rial (RIO); 1,000 Baizas. **U.S. embassy in the country:** P.O. Box 966, Masqat; *tel.* 738–231, 738–006; *telex:* 3785 AMEMBMUS ON. **Embassy in U.S.:** 2342 Massachusetts Avenue NW, Washington, DC 20008; *tel.* 202–387–1980/2.

Central tourism office in country: Ministry of Information, P.O. Box 600, Masqat; *tel.* 603–888.

Health suggestions: Modern medical care is available. Malaria suppressants, typhoid, polio, and gamma globulin treatments are recommended. Water is not potable.

Cultural mores and taboos: Times of business appointments are not precise; be flexible about your schedule. Expect your meetings to be interrupted by others frequently. This does not reflect a lack of interest on the part of your host, simply the unstructured style of transacting business. Politeness is highly prized. Handshakes are the standard greeting. Look people in the eye when addressing them. Muslim injunctions against alcohol and pork prevail. Do not cross legs, point or gesture at someone with the hand, show the soles of the feet, or pass or accept items with the left hand. If invited to a mosque, dress to cover the entire body, remove shoes (tip the attendant who gives you slippers), and do not walk in front of others praying. Discussions may be interrupted several times a day for prayer.

Gratuity guidelines: Service is usually included in the bill.

PAKISTAN
Islamic Republic of Pakistan

The State Department cautions about hazards when traveling to some areas in Pakistan—check with the U.S. embassy upon arrival.

Location: In southern Asia, bounded on the west and north by Afghanistan, the northeast by China, the east and southeast by India, the south by the Arabian Sea, and the southwest by Iran. *Size:* 310,403 square miles, about twice the size of California.

Major cities: *Islamabad* (lat. +33.40), Karachi (lat. +24.48), Lahore (lat. +31.34). *Airports:* Islamabad International Airport (ISB), 5 miles outside of Islamabad; Karachi (KHI), 10 miles outside of Karachi; Lahore (LHE), 2 miles outside of Lahore.

General transportation: Air service is excellent, including many international flights, with direct links to the U.S. Railroads are adequate; bus system is poor. Pakistan International Airlines (PK) is the sole domestic carrier. Highways are generally crowded, and driving, particularly at night, can be dangerous; north–south roads are primitive. Visa arrangements for entering by land can be complicated—check with the consulate. Buses, minibuses, motorized rickshaws, taxis, and even horse-drawn carriages provide local transportation. *U.S. license:* No. *IDP:* No. *Rule of the road:* Left. *Motor clubs:* Automobile Association of Pakistan, 62 Shadman Market, Lahore; *tel.* 414854. Karachi Automobile Association, Standard Insurance House I, 1 Chundriger Road, Karachi; *tel.* 23 21 73. Partial AAA reciprocity. *Taxi markings:* Yellow top, black body; metered.

Population: 107,500,000. *Type of government:* Federal republic; parliamentary with strong executive. The first Muslim country to elect a female leader. Good relations with the U.S. after strains in the late 1970s.

Languages: Urdu is the national language but is the first language of less than 10% of the population. English is widely understood throughout the country. *Ethnic groups:* Punjabi, Sindhi, Pushtan (Pathan), Baluch, Muhajir (immigrants from India and their descendants). *Religion:* 97% Muslim (77% Sunni, 20% Shi'a), 3% Christian, Hindu, and other. **Time:** EST + 10; GMT + 5. *Telephone codes:* Country: 92. Abbottabad 5921, Bahawalpur 621, Faisalabad 411, Gujranwala 431, Hyderabad 221, Islamabad 51, Karachi 21, Lahore 42, Multan 61, Okara 442, Peshawar 521, Quetta 81, Sahiwal 441, Sargodha 451, Sialkot 432, Sukkur 71. Local telephone service can be unreliable; overseas calls are sometimes difficult. *Pay phone system:* Not available on the streets, but good phones are available in hotels, shops, and restaurants. Calls are not free, so if you are not a customer, you should expect to pay for them.

Holidays: March 23; May 1; August 14; September 6, 11; November 9; December 25; plus several Muslim holidays—check with the consulate for exact dates. *Date/month system:* D/M.

Business and government hours: 8 AM to 4:40 PM Sunday to Thursday; to 4 PM in winter. *Business dress code:* Ties are not commonly worn, and a jacket is not expected in hot weather. Avoid jeans. Women are expected to dress conservatively.

Climate and terrain: Borders with India and Afghanistan are disputed. Most of the population live in Karachi, in the fertile and intensely cultivated Indus River Valley, and along an arc formed by Faisalabad, Lahore, Rawalpindi/Islamabad, and Peshawar. Flat Indus plain in the east; mountains (Himalayas, including the second- and third-highest mountains in the world) in the north and northwest; Baluchistan plateau in west. Hot climate near the coast; hot and dry in the desert areas; temperate in the northwest uplands; arctic in the higher regions of the north. Monsoon rains from July to August. *Temperature ranges* (Karachi): January: 55°

to 77°F; April: 73° to 90°F; July: 81° to 91°F; October: 72° to 91°F.

Visas: *Photojournalists and commercial photographers:* Contact the press attaché in Washington or New York with passport, complete application. Approval must be granted by ministry in Pakistan; allow 3 to 7 days for processing. Bring equipment list as well. *Tourists:* Tourist visa, obtained before arrival, requiring passport, photo, no fee; valid for 3 months, for multiple entries. *Health requirements:* Cholera vaccination is required if coming from an infected area. Yellow fever vaccination is required if coming from a country that has any infected areas and from countries in the endemic zone. *Equipment importation:* Arrange for with visa.

Electricity: 230/50 (220 in Karachi). *Plug types:* C and D.

Currency: Rupee (PAR); Paisa.

U.S. embassy in the country: Diplomatic Enclave, Ramna, Islamabad; *tel.* 8261–61/79; *telex:* 82–5–864. *Consulates:* Karachi: 515081/8; Lahore: 870221/5; Peshawar: 79801/3.

Embassy in U.S.: 2315 Massachusetts Avenue NW, Washington, DC 20008; *tel.* 202–939–6200. *Consulates:* California: 415–788–0677; Illinois: 312–853–7630; Kentucky: 502–425–6053; Massachusetts: 617–267–5555; New York: 212–879–5800; Texas: 713–960–8019.

Tourism office in U.S.: Care of Pakistan International Airlines, 545 Fifth Avenue, New York, NY 10017; *tel.* 212–370–9150.

Central tourism office in country: The Pakistan Tourism Development Corporation has offices throughout the country. In Karachi, at the Hotel Inter-Continental and at Karachi Airport; in Islamabad, at the Islamabad Hotel, *tel.* 824–702, 853–874; in Lahore, at 5 Transport House.

Health suggestions: Medical care is limited and facilities are crowded in the cities, although almost all doctors speak English. Facilities can be scarce in rural areas. Typhoid, paratyphoid, and tetanus inoculations are recommended. Malaria suppressants are

recommended throughout the country. Water is not potable.

Cultural mores and taboos: Islamic beliefs unify the country and pervade all aspects of life. Muslim injunctions against alcohol and pork prevail. Do not cross legs, point or gesture at someone with the hand, show the soles of the feet, or pass or accept items with the left hand. If invited to a mosque, dress to cover the entire body, remove shoes (tip the attendant who gives you slippers), and do not walk in front of others

praying. Hospitality is extremely important and should not be refused lightly. Westerners are expected to be punctual.

Photographic restrictions: Some areas are off limits. Contact Pakistan Tourism Development Corporation for specific information. Traditional women may resist photographs.

Gratuity guidelines: Service is usually included in hotel bills, although an additional 5% to 10% is expected. Otherwise, tip as you would in the U.S.

PANAMA
Republic of Panama
República de Panamá

The State Department cautions that travel in Panama can be hazardous because of unsettled political conditions.

Location: In southern Central America, bounded on the north by the Caribbean Sea, the east by Colombia, the south by the Pacific Ocean, and the west by Costa Rica. **Size:** 33,659 square miles, slightly smaller than South Carolina. **Major cities:** *Panama City* (lat. +9.00). **Airports:** Omar Torrijos (PTY), 18 miles outside of Panama City; Paitilla (PAC).

General transportation: Many international flights, with direct links to the U.S. The Inter-American Highway extends to Panama City but not through the thick jungle of the Darién Gap to the Colombian border. The capital and Colón are connected by rail and road (Trans-Isthmian Highway). Buses (and minibuses called *chibas*) in Panama City are crowded and of only fair quality; taxis are plentiful. *U.S. license:* Yes. *IDP:* Yes. *Rule of the road:* Right. *Motor clubs:* Automóvil Club of Panama, Via Brasil y Calle General Alvan, Apartado 6-8410 El Dorado, Panama City; *tel.* 23–6241/2, 64–3509; partial AAA reciprocity. *Taxi markings:* All colors; marked TAXI; set price by zone. **Population:** 2,300,000. *Type of government:* Centralized republic. Traditionally good relations with the U.S. but strained at the time of this writing.

Languages: Spanish. English is widely understood in major cities, particularly in business and official circles, and it is the first language of the West Indian community. *Ethnic groups:* 70% mestizo, 14% West Indian, 10% white, 6% Indian. *Religion:* 93% Roman Catholic, 6% Protestant. **Time:** EST; GMT −5. *Telephone codes:* Country: 507. No city codes. Modern domestic and international service. *Pay phone system:* Coins. **Holidays:** January 1, 9; Carnaval Days (Monday and Tuesday before Ash Wednesday); Good Friday; May 1; August 15 (Panama City); October 11; November 3, 4, 10, 28; December 8, 25. *Date/month system:* D/M.

Business hours: 9 AM to 5 PM Monday to Friday. *Business dress code:* Same as that of the U.S. for high-level meetings; otherwise, just a tie for standard business meetings.

Climate and terrain: Mostly mountainous and hilly; the eastern region is almost entirely covered by dense tropical forests. Tropical climate that is hot, humid, cloudy, with a prolonged rainy season from May to January and a short dry season from January to May. The Atlantic side has much higher precipitation and a less clearly defined dry season than the Pacific side. *Temperature ranges* (Balboa Heights, near Panama City): January: 71° to 88°F; April: 74° to 90°F; July: 74° to 87°F; October: 73° to 85°F.

Visas: Professionals may need business visas or special permits, but as of this writing, the government is issuing only tourist documents. Upon arrival, go to the Department of Immigration, Avenida Cuba between Twenty-eighth and Twenty-ninth Streets, Panama City, *tel.* 27–15–39, to arrange for a change of status. Tourist visa or card requires passport, proof of return ticket, $10 fee; valid for 30 days. Visa is available from consulate; tourist card, from airlines and is, in fact, recommended as more readily accepted upon arrival than the visa. *Health requirements, equipment importation:* Data unavailable.
Electricity: 110/60 (115–26 in Panama City). *Plug types:* A and B.
Currency: U.S. Dollar and Balboa (BAL); Cents.
U.S. embassy in the country: Apartado 6959, Panama City 5; *tel.* 27–1777.
Embassy in U.S.: 2862 McGill Terrace NW, Washington, DC 20008; *tel.* 202–483–1407, 265–0330. *Consulates:* California: 415–989–0934; Florida: 305–379–7280; Illinois: 312–944–5759; Louisiana: 504–525–3458; Massachusetts: 617–426–8106; New York: 212–246–3771; Pennsylvania: 215–568–0767; Texas: 713–521–9701.
Central tourism office in country: Instituto Panamania de Turismo (IPAT), Via Israel (in front of the Marriott Hotel at the Atlata Convention Center); *tel.* 267–000.
Health suggestions: Medical care and sanitary conditions in Panama City are good but are less adequate elsewhere. Water is not always potable. For travel outside the capital, typhoid, tetanus, polio, yellow fever, and hepatitis treatments are recommended. Malaria suppressants are recommended for some rural areas in the eastern and northwestern provinces.
Cultural mores and taboos: Avoid all discussions of the Canal Zone. Although the capital is cosmopolitan, traditional ideas about machismo remain.
Color labs: Laboratorios *Kodak* Limitada: Apartado 4591, Panama City 5; Via Israel #96, Paitilla, Panama City 5.
Gratuity guidelines: Service is not usually included in the bill; leave at least 10%.

PAPUA NEW GUINEA

The State Department advises that street crime is a serious problem, especially in urban areas, and extreme caution must be exercised, particularly at night.
Location: In the western Pacific Ocean, north of Australia and east of Indonesia; Indonesia shares the island of New Guinea.
Size: 182,700 square miles, slightly larger than California.
Major cities: *Port Moresby* (lat. −9.29).
Airports: Jackson (POM), 5 miles outside of Port Moresby.
General transportation: International flights to Australia, Solomon Islands, and other points in Asia. Air Niugini (PX) and several smaller carriers provide internal service, and charters are easily arranged (over 400 airports or airstrips). Bus service exists in the few areas where there are connecting roads. The longest road is the Highlands Highway from Lae to Wabong and beyond. No railroads. Taxis and rental cars are available. *U.S. license:* Yes. *IDP:* Yes. *Rule of the road:* Left. *Motor clubs:* Automobile Association of Papua New Guinea, G.P.O. Box 5999, Boroko; *tel.* 25 77 17; partial AAA reciprocity.
Population: 3,600,000. *Type of government:* Independent parliamentary state within the British Commonwealth, recognizing Elizabeth II as head of state; vigorous democracy with strong traditions of personal freedom and human rights guarantees. Enjoys friendly relations with the U.S.
Languages: Over 700 indigenous and often unrelated languages, usually spoken by no more than a few hundred or few thousand people. About 1% to 2% of the educated classes speak English; pidgin English and Police Motu are more widespread. *Ethnic groups:* One of the most heterogeneous nations in the world; isolation by the moun-

tainous terrain has been so great that some groups only recently discovered neighboring groups just a few miles away! The situation is reflected in the local saying, "each village, a different culture." Ritualized tribal warfare between villages has existed, in some cases, for centuries. Predominantly Melanesian and Papuan; some Negrito, Micronesian, and Polynesian. *Religion:* Over 50% nominally Christian, remainder indigenous beliefs.
Time: EST +15; GMT +10. *Telephone codes:* Country: 675. No city codes. No credit card calls to U.S. Adequate and improving domestic and international service, limited by extreme inaccessibility of the interior. *Pay phone system:* Coins.

Holidays: January 1; Good Friday; Easter Monday; June 13; July 23; September 16; December 25, 26. *Date/month system:* D/M.

Business hours: 8 AM to 4:30 PM Monday to Friday; 8 AM to 12 noon Saturday. *Government hours:* 7:45 AM to 1 PM, 2 PM to 4:15 PM Monday to Friday. *Business dress code:* Informal unless the meeting is very high level. Short-sleeved shirt and slacks are acceptable.

Climate and terrain: The main island constitutes 85% of the land; it has a complex system of mountains (to 15,000 feet) with precipitous slopes, knife-edge ridges, great outcroppings, and broad upland valleys from the eastern end to the western border. Large rivers, but few are navigable. Central depression between two of the mountain ranges. Smaller islands are also mountainous, with many volcanoes and peaks to 8500 feet. Coasts are lowlands and rolling foothills. Swamps are extensive throughout the country. Climate is tropical, with a northwest monsoon from December to March, a

southeast monsoon from May to October, and little seasonal temperature variation. Much less rain in Port Moresby. *Temperature ranges* (Port Moresby): January: 76° to 89°F; April: 75° to 87°F; July: 73° to 83°F; October: 75° to 86°F.

Visas: Photographers must contact the embassy to arrange permission; allow 2 to 4 weeks for approval. Include equipment list. *Tourists:* Passport, proof of return ticket; no visa is required for stays of up to 30 days if arriving at Jackson Airport, Port Moresby. No extensions—for longer stays, contact the consulate in advance of the trip. *Health requirements:* Yellow fever vaccination is required if coming from an infected area. *Equipment importation:* Arrange for when obtaining visa permission.
Electricity: 240/50. *Plug types:* H and I.
Currency: Kina (NGK); Toea.
U.S. embassy in the country: Armit Street, P.O. Box 1492, Port Moresby; *tel.* 211–455, 211–594, 211–654; *telex:* 22189 USAEM.
Embassy in U.S.: 1330 Connecticut Avenue NW, Suite 350, Washington, DC 20036; *tel.* 202–689–0856.
Tourism office in U.S.: Care of Air Niugini, Suite 3000, West Tower, 5000 Birch Street, Newport Beach, CA 92660; *tel.* 714–752–5440.
Central tourism office in country: Department of Tourism, P.O. 5644, Boroko; *tel.* 272–064.
Health suggestions: Medical facilities are small and limited to urban areas. Health conditions are adequate, with many tropical diseases less common than in other areas of the tropics. Malaria suppressants are recommended throughout the country.
Gratuity guidelines: Tips are not accepted and should not be offered.

PARAGUAY
Republic of Paraguay
República del Paraguay

Location: In central South America, bounded on the north and northwest by Bolivia, the northeast and east by Brazil, and

the southeast, south, and west by Argentina. *Size:* 157,043 square miles, slightly smaller than California.

Major cities: *Asunción* (lat. −25.17). *Airports:* Presidente General Stroessner (ASU), 8 miles outside of Asunción.

General transportation: Ample international flights, with direct links to the U.S. Internal flights and air charters are available. Railways are not recommended; intercity buses are a bit better. Ferry and boat service from Asunción—Paraguay's rivers are used as commercial highways. Some good roads between major cities, but many secondary roads are unpaved and often impassable in the rainy season. Streetcars, buses, minibuses, and taxis provide public transport. *U.S. license:* Yes. *IDP:* Yes. *Rule of the road:* Right. *Motor clubs:* Touring y Automóvil Club Paraguayo, 25 de Mayo y Brasil, Asunción; *tel.* 97 801; partial AAA reciprocity. *Taxi markings:* Yellow, marked TAXI; metered; can be scarce at night.

Population: 4,300,000. *Type of government:* Republic, under authoritarian rule, which has brought stability and economic growth but limitations on political rights and individual freedoms. Friendly relations with the U.S.

Languages: Spanish and Guarani, an Indian tongue. Spanish is the language of commerce and government. Guarani is used almost exclusively in rural areas and is also widely heard in the cities. About 70% of the country is bilingual. *Ethnic groups:* 95% mestizo, 5% white and Indian. *Religion:* 90% Roman Catholic; Mennonite and other Protestant denominations.

Time: EST +2; GMT −3. *Telephone codes:* Country: 595. Asunción 21, Ayolas 72, Capiatá 28, Ciudad Presidente Stroessner 61, Concepción 31, Coronel Bogado 74, Coronel Oviedo 521, Encarnación 71, Hernandarias 63, Itá 24, Pedro Juan Caballero 36, Pilar 86, San Antonio 27, San Ignacio 82, Villarrica 541, Villeta 25. Adequate to good domestic and international service. *Pay phone system:* Tokens, available from newsstands and shops.

Holidays: January 1; February 3; March 1; Holy Thursday; Good Friday; May 1, 14, 15; Corpus Christi (June); June 12; August 15, 25; September 29; October 12; November 1; December 8, 25; plus several local and regional feast days. The weeks before Ash Wednesday, Easter, and Christmas and the week after Christmas are also not ideal for conducting business. *Date/month system:* D/M.

Business hours: 7 AM to 12 noon, 3 PM to 6 PM Monday to Friday. From 12 noon to 3 PM is *siesta* time, and business is not normally conducted. Business often gets a very early start. *Government hours:* 7 AM to 12 PM. *Business dress code:* Conservative.

Climate and terrain: Grassy plains, wooded hills, tropical forests; generally temperate climate east of the Paraguay River. Low, flat, marshy plain in the Chaco region, west of Paraguay River, with a semiarid climate. *Temperature ranges* (Asunción): January: 71° to 95°F; April: 65° to 84°F; July: 53° to 74°F; October: 62° to 86°F.

Visas: Standard tourist entry, requiring passport; no visa is needed for stays of up to 90 days. Photojournalists may register with the government for assistance, but this is not compulsory; contact the Sub Secretaría de Informaciónes y Cultura de la Presidencia de la República, Benjamin Constand 893, 5th Floor, Office 2, Asunción; *tel.* 95484, 93933; *telex:* 411. *Health requirements:* Yellow fever vaccination is required if coming from an infected area and is recommended by CDC for travel outside urban areas. *Equipment importation:* Bring equipment list; no bond is required.

Electricity: 220/50. *Plug types:* C.

Currency: Guarani (GUA); Centimos.

U.S. embassy in the country: 1776 Avenida Mariscal Lopez, Casilla Postal 402, Asunción; *tel.* 201–041/9.

Embassy in U.S.: 2400 Massachusetts Avenue NW, Washington, DC 20008; *tel.* 202–483–6960/2.

Tourism office in U.S.: Contact the embassy; see **Embassy in U.S.,** above.

Central tourism office in country: Dirección General de Turismo, Oliva y Alverdi, Asunción; *tel.* 91230.

Health suggestions: Medical services are good in Asunción but inadequate in the interior. Generally, malaria suppressants are rec-

ommended only for rural areas bordering Brazil. Water may be potable in Asunción, but take full precautions elsewhere.

Cultural mores and taboos: Be punctual for business appointments, but be patient if they do not always begin exactly on time. Reserve first names for friendship.

Gratuity guidelines: Service is not included in the bill; tips are appreciated and customary.

PERU
Republic of Peru
República del Peru

The State Department cautions that terrorist activity has become a serious problem throughout Peru and is unpredictable. Exercise caution.

Location: In western South America, bounded on the north by Ecuador and Colombia, the east by Brazil and Bolivia, the south by Chile, and the west by the Pacific Ocean. *Size:* 496,222 square miles, slightly smaller than Alaska.

Major cities: *Lima* (lat. −12.05). *Airports:* Jorge Chávez International Airport (LIM), 7 miles outside of Lima.

General transportation: Many international flights, with direct links to the U.S. Domestic air service is available. Scenic central railway connecting Lima with the central highlands of the Peruvian Andes is the world's highest standard-gauge railway, reaching 15,000 feet. The more extensive southern railway links Mollendo on the coast with Arequipa, Cusco, and Puno. Taxis and rental cars are available in Lima. Traffic jams are common. *U.S. license:* Yes, for 180 days, for private vehicles only. *IDP:* Yes. *Rule of the road:* Right. *Motor clubs:* Touring Automóvil Club del Peru, Avenida César Vallejo, 699 Lince, Lima; *tel.* 403 270; partial AAA reciprocity. *Taxi markings:* All colors, marked TAXI; set price by zone, be sure to agree on price first. Shared taxis, called *colectivos*, are also available on fixed routes.

Population: 21,300,000. *Type of government:* Republic; generally good relations with the U.S., with some strains since the APRA came to power in 1985.

Languages: Spanish and Quechua. Many businesspeople understand some English but welcome your attempts to speak Spanish. *Ethnic groups:* 45% Indian, 37% mestizo, 15% white, 3% black, Asian, and other. *Religion:* Predominantly Roman Catholic.

Time: EST; GMT −3. *Telephone codes:* Country: 51. Arequipa 54, Ayacucho 6491, Callao 14, Chiclayo 74, Chimbote 44, Cuzco 84, Huancavelica 6495, Huancayo 64, Ica 34, Iquitos 94, Lima 14, Piura 74, Tacna 54, Trujillo 44. Adequate domestic and international service, but expect some delays. *Pay phone system:* Tokens, available from newsstands and shops.

Holidays: January 1; Holy Thursday; Good Friday; May 1; June 24, 29; July 28, 29; August 30; October 8; November 1; Immaculate Conception (varies); December 25. *Date/month system:* D/M.

Business and government hours: In April to December, winter, 8-hour days begin at 8 or 9 AM; factories may start as early as 6 AM. In January to March, summer, 8-hour days start at 7:45 to 8:15 AM; however, some ministries and public offices close at 1 PM, although important executives will often accept appointments after hours. *Business dress code:* Conservative, but tie and jacket may be omitted in very hot weather.

Climate and terrain: Has 3 regions and climates. The coastal area *(costa)* is 10 to 100 miles wide and consists of arid plains and foothills, with mild temperatures year-round. Industrial, commercial, and political centers are here. The contrast between the desert and verdant river valley along the coast is abrupt and striking. The Andes *(sierra)*, about 200 miles wide and occupying 27% of the land, forms a natural barrier to

the interior, climbing to 22,071 feet at its zenith. Climate varies from temperate to frigid, depending on the altitude. The eastern jungle *(selva)* accounts for more than half the land. Many rivers descend from the high jungle on the Andes's eastern slopes *(montana)* and feed the Amazon. The climate is warm and humid with abundant rainfall throughout the year. The climate of Lima has been compared to that of San Francisco, except annual rainfall on the desert coast is extremely slight. In winter (May to November), the city is almost constantly covered with low-hanging mist. *Temperature ranges* (Lima): January: 66° to 82°F; April: 63° to 80°F; July: 57° to 67°F; October: 58° to 71°F.

Visas: Standard tourist entry, requiring passport, proof of return ticket; no visa is needed for stays of up to 90 days, extendable after arrival. *Health requirements:* Yellow fever vaccination is required if coming from an infected area or any country in the endemic zone, as well as for those intending to visit rural areas; it is recommended for travel in rural areas by the CDC. *Equipment importation:* Bring equipment list; no bond is required.

Electricity: 220/60 (50 cycles in Arequipa). *Plug types:* A.
Currency: Inti (PEI); Centavos.
U.S. embassy in the country: Consular section: Grimaldo del Solar 346, Miraflores Lima 18; *tel.* 44–3621.
Embassy in U.S.: 1700 Massachusetts Avenue NW, Washington, DC 20036; *tel.* 202–833–9860/9. *Consulates:* California:

415–362–7136; Florida: 305–374–1407; Illinois: 312–853–6173; New York: 212–644–2850; Texas: 713–781–5000.
Tourism office in U.S.: Peru Tourist Office (FOPTUR), 999 South Bayshore Drive, Suite 201, Miami, FL 33131; *tel.* 305–374–0023.
Central tourism office in country: FOPTUR, Avenida Angamos 355, Miraflores Lima 18; *tel.* 453–394, 461–408.
Health suggestions: Sanitation is decent, but water is treated, and it is best to rely on boiled or bottled water, particularly outside of Lima. Yellow fever and hepatitis treatments are advisable. Malaria suppressants are recommended for rural areas. Altitude precautions are necessary in the Andes (Lima is along the coast).
Cultural mores and taboos: First names should be reserved for friendship. Be punctual, although appointments may not start on time.
Photographic restrictions: Military and security sites.
Color labs: Centro *Kodak:* Plaza San Martin: Nicolas de Pierola 978, Lima 1; Miraflores: Avenida Larco 1005, Lima 18; Arequipa: Calle Juan de Dios Salazar 251, La Perla, Arequipa; Cuzco: Portal de Carnes 218, Cuzco; Iquitos: Calle Morona, Casa 34, Urbanización Jardin, Iquitos.
Film commissions: Instituto Nacional de Cultura del Peru, P.O. Box 1787, Hollywood, CA 90028; *tel.* 213–465–8900.
Gratuity guidelines: Service is sometimes included in the bill; leaving a bit more is customary. If not included, tips are expected.

PHILIPPINES
Republic of the Philippines
Republika ng Pilipinas

The State Department cautions that insurgency and civil unrest are problems, particularly in the south—be sure to consult with the U.S. embassy about travel safety and security issues.

Location: In the southwestern Pacific Ocean, southeast of China and north of In-

donesia. *Size:* 115,651 square miles, slightly larger than Arizona.
Major cities: *Manila* (lat. +14.31). *Airports:* Manila International Airport (MNL), 5 miles outside of Manila.
General transportation: Many international flights, with direct links to the U.S.

Philippine Airlines (PR) makes scheduled flights to most cities and major towns, and several charter services operate out of a domestic airport in Manila. Jeepneys (6- to 11-passenger minibuses built on Jeep frames), buses, and taxis provide public transport in major cities, with pedicabs also common in smaller towns. Long-distance buses of varying quality provide service between cities, and all populated areas of the Philippines can be reached by automobile, but roads are often overcrowded and poorly maintained. *U.S. license:* No. *IDP:* Yes, for 90 days. *Rule of the road:* Right. *Motor clubs:* Philippine Motor Association, 683 Aurora Boulevard, Quezon City; *tel.* 721 5761, 78 01 91; partial AAA reciprocity. *Taxi markings:* All colors, marked TAXI or with name of taxi company; metered.

Population: 63,200,000. *Type of government:* Republic; new constitution framed with the Aquino government; many individual freedoms have been restored. Enjoys close relations with the U.S.

Languages: English and Tagalog. English is fully understood in business and government. The use of Spanish, spoken by few, is decreasing rapidly. *Ethnic groups:* 91.5% Christian Malay, 4% Muslim Malay, 1.5% Chinese, 3% other. *Religion:* 83% Roman Catholic, 9% Protestant, 5% Muslim, 3% Buddhist and other.

Time: EST +13; GMT +8. *Telephone codes:* Country: 63. Angeles 55, Bacolod 34, Baguio City 442, Cebu City 32, Clarkfield (military) 52, Dagupan 48, Davao 35, Iloilo City 33, Lucena 42, Manila 2, San Fernando (La Union) 46, San Fernando (Pampanga) 45, San Pablo 43, Subic Bay Military Base and Subic Bay Residential Housing 89, Tarlac City 47. Adequate domestic service; good to excellent international services. *Pay phone system:* Coins.

Holidays: January 1; Holy Thursday; Good Friday; May 1, 6; June 12; July 4; November 1, 30; December 25, 30. *Date/month system:* Varies.

Business hours: 8 or 9 AM to 12 or 1 PM, 2 PM to 5 PM Monday to Friday; 8:30 AM to 12 noon Saturday. *Government hours:* 9 AM to 12 noon, 1 PM to 6 PM Monday to Friday. *Business dress code:* Tie and jacket or the traditional shirt called *barong* is acceptable.

Climate and terrain: Some 7,100 islands, only 154 of which exceed 5 square miles; the 11 major ones compose 95% of the land. Luzon island in the north and Mindanao island in the south are separated by the Visayas group. Irregular coastlines marked by bays, straits, and inland seas. The larger islands are mountainous with narrow coastal lowlands, but some, like Luzon, have a large central plain, or larger lowlands regions. The climate is tropical, warm and humid (except for some mountainous areas) with only slight annual variation. Rainfall is generally adequate but varies from place to place. The wet season in Manila is caused by the southwest monsoon and lasts from June to November. The Philippines are subject to many destructive typhoons, volcanic activity, and earthquakes. *Temperature ranges* (Manila): January: 69° to 86°F; April: 73° to 93°F; July: 75° to 88°F; October: 74° to 88°F.

Visas: Photojournalists must apply for permission to enter the country from Manila. Contact the nearest consulate. Expect 1 to 4 weeks for processing. Commercial photographers may use a business visa; apply to the consulate; does not require approval from Manila; send client letter, 1 photo, application, passport. *Tourists:* Passport valid for 6 months beyond stay, proof of return ticket; no visa is needed for stays of up to 21 days if entering at Manila International Airport. Tourist visa, for stays of 21 to 59 days, requires passport, 1 photo, no fee. *Health requirements:* Yellow fever vaccination is required if coming from an infected area. *Equipment importation:* Contact Bureau of Customs, Manila International Airport, *tel.* (632) 265888, in advance to declare equipment. Bond may be required.

Electricity: 110/60. *Plug types:* A, B, C, D, and J.

Currency: Peso (PHP); Centavos.

U.S. embassy in the country: 1201 Roxas Boulevard, Manila; *tel.* 521–7116; *telex:* 722-27366 AME PH. *Consulates:* Cebu: 52044, 52984. **Embassy in U.S.:** 1617 Massachusetts Avenue NW, Washington, DC 20036; *tel.* 202–483–1414. *Consulates:* California: 213–387–5321; Hawaii: 808–595–6316; Illinois: 312–332–6458; New York: 212–764–1330; Texas: 713–524–0234; Washington: 206–441–1640. **Tourism office in U.S.:** Philippine Tourist Office, 556 Fifth Avenue, New York, NY 10036; *tel.* 212–575–7915. **Central tourism office in country:** Department of Tourism, Agrifina Circle, Rizal Park, Ermita, Manila; *tel.* (632) 501928, 599031. **Health suggestions:** Adequate medical facilities in Manila, with many English-speaking doctors. Water is potable in Manila but not outside the capital. Dysentery is endemic. Malaria suppressants are recommended for rural areas, with the exception of Bohol, Catanduanes, Cebu, and Leyte provinces.

Cultural mores and taboos: Filipinos generally expect a more personal relationship be established before some matters (such as salary, certain personal beliefs) are discussed. Great sensitivity to criticism and embarrassment. Be punctual, but be patient if appointments do not begin on time. Filipinos have had a great deal of exposure to Americans over the years and are very familiar with American customs. **Photographic restrictions:** Contact with New Peoples Army or other groups considered subversive by the government is forbidden. **Color labs:** *Kodak* Philippines, Ltd.: 2247 Pasong Tamo, Makati, Metro Manila 3117; Dumoy, Toril, Davao Coty 9501; P.O. Box 450, Cedu City 6401. **Gratuity guidelines:** Service is sometimes included in the bill; leaving an additional 5% to 10% is customary. If not included, leave 10% to 15%.

POLAND
Polish People's Republic
Polska Rzeczpospolita Ludowa

Location: In central Europe, bounded on the north by the Baltic Sea and the USSR, the east by the USSR, the south and southwest by Czechoslovakia, and the west by East Germany. *Size:* 120,756 square miles, slightly smaller than New Mexico. **Major cities:** *Warsaw* (lat. +52.13). *Airports:* Okecie (WAW), 6 miles outside of Warsaw. **General transportation:** Many international flights, with direct links to the U.S., as well as domestic service to major cities. Good intercity bus and rail service; good urban transport, including streetcars. *U.S. license:* Yes, for 3 months. *IDP:* Yes, for 12 months. *Rule of the road:* Right. *Motor clubs:* Polskie Towarzystwo Turystyczno-Krajoznawcze (Polish Tourism Society), ul. Senatorska 11, Warsaw; *tel.* 26 57 35, 26 01 56; partial AAA reciprocity. *Taxi markings:* All colors, marked TAXI, metered; fares increase at night. **Population:** 38,000,000. *Type of government:* Communist state with strict controls. Relations with the U.S. are improving, moving toward renewal of an ambassadorial exchange. **Languages:** Polish. *Ethnic groups:* 98.7% Polish, 0.6% Ukranian, 0.5% Byelorussian, less than 0.05% Jewish. *Religion:* 95% Roman Catholic (about 75% practicing), 5% Uniate, Russian Orthodox, Protestant, and other. **Time:** EST +6; GMT +1. *Telephone codes:* Country: 48. Białystok 85, Bydgoszcz 52, Kraków 12, Gdańsk 58, Gdynia 58, Katowice 32, Łódź 42, Lublin 42, Olsztyn 89, Poznán 61, Radom 48, Sopot 58, Toruń 56, Warsaw 22. *Pay phone system:* Coins. **Holidays:** January 1; Easter Monday;

May 1, 9; Corpus Christi (June); July 22; November 1; December 25, 26. *Date/month system:* D/M.
Business hours: 8 or 9 AM to 3 PM Monday to Friday. *Business dress code:* jacket is customary, often acceptable without a tie.
Climate and terrain: Bordering the Baltic Sea on the north and the Carpathian mountains on the south, most of the country is a continuous east–west plain. The climate is temperate, with moderately severe winters and mild, frequently rainy summers. *Temperature ranges* (Warsaw): January: 21° to 30°F; April: 38° to 54°F; July: 56° to 75°F; October: 41° to 54°F.

Visas: *Photojournalists and commercial photographers:* business visa, requiring passport, 2 photos, 1 application, $15 for cable to Poland for approval; if approved, $18 fee; valid for stays of up to 90 days, single entry. Usually takes as long as 3 weeks. *Tourists:* same requirements. *Health requirements:* No vaccinations required. *Equipment importation:* Carnet.
Electricity: 220/50. *Plug types:* C, E, and F.
Currency: Zloty (ZLO); Groszy. $15 per day must be exchanged.
U.S. embassy in the country: Aleje Ujaz-

dowskle 29/31, Warsaw; *tel.* 283041/9; *telex:* 813304 AMEMB PL. *Consulates:* Kraków: 229764, 221400, 226040, 227793; Poznań: 59586/7, 59874.
Embassy in U.S.: 2640 Sixteenth Street NW, Washington, DC 20008; *tel.* 202–232–4517. *Consulates:* Illinois: 312–337–8166; New York: 212–889–8360.
Tourism office in U.S.: ORDIS, 500 Fifth Avenue, New York, NY 10110; *tel.* 212–391–0844.
Central tourism office in country: National Tourist Office–Orbis, 16 Bracka Street, Warsaw 00028; *tel.* 260271.
Health suggestions: Water is potable in major cities and resorts.
Cultural mores and taboos: Use professional titles; first names are reserved for close friendships. Be patient, as official decisions take time. Avoid discussions of the current political turmoil.
Photographic restrictions: Be cautious; restrictions may be in effect at strategic, industrial, or border areas and the like.
Film commissions: Polish TV and Film Industry, 17 Woronicza, Warsaw.
Gratuity guidelines: Tips are legal and appreciated. Service is sometimes included in the bill.

PORTUGAL
Republic of Portugal
República Portuguesa

Location: In southwestern Europe, bounded on the north and east by Spain and the south and west by the Atlantic Ocean.
Size: 35,383 square miles, slightly smaller than Indiana.
Major cities: *Lisbon* (lat. +38.43). *Airports:* Lisboa (LIS), 5 miles outside of Lisbon.
General transportation: Many international flights, with direct links to the U.S. Domestic flights to Oporto, Porto Santo, Faro. Railroads and buses serve the entire country. Lisbon has good urban transport, including a subway. *U.S. license:* Yes.

IDP: Yes. *Rule of the road:* Right. *Motor clubs:* Automóvil Club de Portugal, Rua Rosa Arujo 24, Lisbon; *tel.* 563931, 553711, 553593; partial AAA reciprocity. *Taxi markings:* Green top and black body, marked TAXI; meter; can be scarce at peak hours.
Population: 10,400,000. *Type of government:* Republic; 1987 elections provided first absolute majority for a single party. Long tradition of close ties to the U.S.
Languages: Portuguese. *Ethnic groups:* Homogeneous Mediterranean stock, with a minority of black African descent (100,000)

who immigrated during decolonization. *Religion:* 97% Roman Catholic, 1% Protestant, 2% other.

Time: EST +5; GMT 0 (Azores +4). *Telephone codes:* Country: 351. Almada 1, Angra do Heroísmo 95, Barreiro 1, Beja 84, Braga 53, Caldas da Rainha 62, Coimbra 39, Estoril 1, Évora 66, Faro 89, Horta 92, Lajes AFB 95, Lisbon 1, Madalena 92, Madeira Islands 91, Montijo 1, Oporto 2, Ponta Delgada 96, Santa Cruz (Flores) 92, Santarém 43, Setúbal 65, Velas 95, Vila do Porto 96, Viseu 32. Adequate to good domestic and international service. *Pay phone system:* Coins.

Holidays: January 1; Carnaval; Good Friday; April 25; May 1; Corpus Christi (June); June 10; August 15; October 5; November 1; December 1, 8, 25. *Date/month system:* D/M.

Business hours: 9 AM to 5 PM Monday to Friday. *Government hours:* 9 AM to 12 noon, 2 PM to 5 PM Monday to Friday. *Business dress code:* Conservative.

Climate and terrain: The Tagus River, which flows into the Atlantic at Lisbon, divides the mainland into two regions. North of the river, the land is mountainous, with a rainy, moderately cool climate. The south has rolling plains, less rainfall, and a warmer climate, particularly in the interior. The Azores are 9 rugged, mountainous islands about 800 miles off the western coast, with a moist and moderate climate; they are subject to severe earthquakes. The Madeira Islands, off the coast of Morocco, southeast of the Azores, are more rugged, with 2 main, inhabited islands, and a mild climate that attracts many tourists. *Temperature ranges* (Lisbon): January: 46° to 56°F; April: 52° to 64°F; July: 63° to 79°F; October: 57° to 69°F.

Visas: Standard tourist entry, requiring passport; no visa is needed for stays of up to 60 days, with 2 extensions permitted. *Health requirements:* Yellow fever vaccination is required if coming from an infected area *and* destination is the Azores or Madeira Islands. *Equipment importation:* Carnet. **Electricity:** 220/50. *Plug types:* C and D. **Currency:** Escudo (ESP); Centavos. **U.S. embassy in the country:** Ave. das Forcas Armadas, 1600 Lisbon; *tel.* 726-6600, 726-6659, 726-8670, 726-8880; *telex:* 12528 AMEMB. *Consulates:* Oporto: 63094, 690008; Ponta Delgada, São Miguel, Azores: 22216/7. **Embassy in U.S.:** 2310 Tracey Place NW, Washington, DC 20008; *tel.* 202-332-3007. *Consulates:* California: 415-346-3400; Massachusetts: 617-536-8740; New York: 212-246-4580.

Tourism office in U.S.: Portuguese National Tourist Office, 548 Fifth Avenue, New York, NY 10036; *tel.* 212-354-4403. **Central tourism office in country:** State Tourist Office, Praca dos Restauradores (Palacio foz); *tel.* 363314. **Health suggestions:** Good health and medical standards. Water is potable in the large cities year-round and in much of the rest of the country, at least during the rainy season. **Color labs:** *Kodak* Portuguesa Ltd., Apartado 12, 2796 Linda-a-Velha, Codex. **Gratuity guidelines:** Service is sometimes included; leaving a bit more is customary. If not included, leave 10% to 15%. Tips are also given to people performing a wide range of services, including ushers and gas station attendants.

QATAR
State of Qatar
Dawlet al-Qatar

Location: In southwestern Asia, bounded on the west, north, and east by the Persian Gulf, the southeast by the United Arab Emirates, and the southwest by Saudi Arabia. *Size:* 4,400 square miles, slightly smaller than Connecticut.

Major cities: *Doha* (lat. +25.05). *Airports:* Doha (DOH), 4 miles outside of Doha.
General transportation: Ample international flights, with a number of direct links to the U.S. Good roads and infrastructure. Rental cars are available. Taxis are the basic form of urban transport and can be hired by the hour. *U.S. license:* Yes, with formalities on arrival. *IDP:* Yes, for vehicles registered abroad. *Rule of the road:* Right. *Motor clubs:* Qatar Automobile and Touring Club, 07 Jabber Bin Mohammed Street, Doha; *tel.* 413265, 414481; partial AAA reciprocity. *Taxi markings:* Orange and white with yellow and black plates, marked TAXI; metered, with rates varying at different times of day.

Population: 330,000. *Type of government:* Traditional monarchy. The amir is passed on within the ruling Al-Thani family. Qatar is evolving from a traditional society to a modern state, with most social services provided by the government. Islamic law prevails. Relations with the U.S. are cordial and becoming closer.

Languages: Arabic. English is widely understood in business and government. *Ethnic groups:* 40% Arab, 18% Pakistani, 18% Indian, 10% Iranian, 14% other. *Religion:* 95% Muslim (predominantly Sunni).

Time: EST +8; GMT +3. *Telephone codes:* Country: 974. No city codes. No credit card or collect calls to U.S. Modern domestic and international service. *Pay phone system:* Coins.

Holidays: January 1; February 22; September 3; plus Muslim holidays—check with consulate. *Date/month system:* D/M.

Business hours: 7:30 AM to 12:30 PM, 2 PM to 6 PM Saturday to Thursday. *Government hours:* 6 AM to 1 PM Saturday to Thursday. *Business dress code:* Conservative for men and women.

Climate and terrain: Generally flat and low, except for some hills and higher ground in the northwest. The north has some vegetation, while the south is arid, with stretches of salt flats. Desert climate with a long, hot summer and high humidity along the coast. Winter is mild with little rain. June to September can see 120°F temperatures. *Temperature ranges* (Doha): January 63°F; April 79°F; July 95°F; October 84°F.

Visas: All visitors must contact the embassy or the Ministry of Information (see **Central tourism office in country,** below) to arrange for a visa. *Tourists:* No visas issued. *Health requirements:* Yellow fever vaccination is required if coming from an infected area. *Equipment importation:* Arrange for with visa.

Electricity: 240/50. *Plug types:* D and G.
Currency: Riyal (QRI); Dirhams.

U.S. embassy in the country: Fariq Bin Omran (opposite the TV station), P.O. Box 2399, Doha; *tel.* 864701/3; *telex:* 4847.

Embassy in U.S.: 600 New Hampshire Avenue NW, Suite 1180, Washington, DC 20037; *tel.* 202-338-0111.

Central tourism office in country: Ministry of Information, P.O. Box 1836, Doha; *tel.* 831333, 322800; *telex:* 4229 INFORDH.

Health suggestions: Good, free medical care is available to visitors. Limited fresh water; reliance on desalinization plants; bottled water is available. Tetanus and polio shots are recommended.

Cultural mores and taboos: Muslim injunctions against alcohol and pork prevail. Do not cross legs, point or gesture at someone with the hand, show the soles of the feet, or pass or accept items with the left hand. If invited to a mosque, dress to cover the entire body, remove shoes (tip the attendant who gives you slippers), and do not walk in front of others praying. Be careful about admiring possessions—you may receive them as gifts.

Gratuity guidelines: Service charge of 10% is usually included.

ROMANIA
Socialist Republic of Romania
Republica Socialistă România

Location: In southeastern Europe, bounded on the north by the USSR, the east by the USSR and the Black Sea, the south by Bulgaria, and the west by Yugoslavia and Hungary. **Size:** 91,699 square miles, about the size of New York State and Pennsylvania combined. **Major cities:** Bucharest (lat. +44.25). **Airports:** Otopeni (OTP), 11 miles outside of Bucharest; Baneasa (BBU), 5 miles outside of Bucharest. *Note: Hand inspections of film are not normally granted but can usually be arranged in advance by contacting tourist or government authorities.*

General transportation: Ample international flights, with direct links to the U.S. Domestic air and rail links are recommended. Wintertime driving can be hazardous, although roads are good. Buses and streetcars in Bucharest can be crowded, taxis scarce. A limited subway opened in 1979. *U.S. license:* Yes, for 30 days or length of visa. *IDP:* For 30 days or length of visa. *Rule of the road:* Right. *Motor clubs:* Federatia Automobil Clubul Roman, Str. Nikos Beloinis 27, Bucharest; *tel.* 15 55 10, 14 67 65; partial AAA reciprocity. *Taxi markings:* Checkered stripes, marked TAXI; metered. **Population:** 23,000,000. *Type of government:* Communist state; strict controls but political stability. Diplomatic relations with the U.S. continue to expand despite political differences. **Languages:** Romanian, Hungarian, German. *Ethnic groups:* 89.1% Romanian, 7.8% Hungarian, 1.5% German, 1.6% Ukrainian, Serb, Croat, Russian, Turk, and gypsy. *Religion:* 80% Romanian Orthodox, 45% Calvinist, Lutheran, Jewish, Baptist, 6% Roman Catholic.

Time: EST +7; GMT +2. *Telephone codes:* Country: 40. Arad 66, Bicău 31, Braşov 21, Bucharest 0, Cluj-Napoca 51, Constanţa 16, Craiova 41, Galaţi 34, Iaşi 81, Oradea 91, Piteşti 76, Ploieşti 71, Satu-Mare 97, Sibiu 24, Timişoara 61, Tîrgu Mureş 54. Domestic service is automated; international service is generally good but may be subject to some delays. *Pay phone system:* Coins.

Holidays: January 1; May 1; August 23; plus the day after each of the above (unless it falls on a weekend, in which case an extra holiday is taken the day before). *Date/month system:* D/M.

Business and government hours: 8 AM to 4 PM Monday to Friday; 8 AM to 1 PM three Saturdays per month. *Business dress code:* Conservative.

Climate and terrain: Halfway across the Balkin peninsula, Romania occupies the greater part of the lower basin of the Danube and includes the Carpathian and Transylvanian Alps. In the Old Kingdom (east of the Carpathians and south of the Transylvanian Alps), temperatures approximate the extremes of the Russian climate; Transylvania is more moderate. Long and at times severe winters from December to March, hot summers from April to July, and prolonged autumns from August to November are the principal seasons; the change from winter to summer is so rapid that there is very little spring. *Temperature ranges* (Bucharest): January: 20° to 33°F; April: 41° to 63°F; July: 61° to 86°F; October: 44° to 65°F.

Visas: *Business visa:* Passport, client letter (include information about contacts in Romania if possible), photographer letter; single entry, valid 6 months, $25 fee; multiple entry, $63 fee; $10 per day currency exchange or prepaid travel vouchers indicating hotel reservations and the like; allow 2 to 3 weeks for processing. *Tourists:* Tourist visa for stays of up to 60 days with similar requirements, except no client letter and only $16 fee. *Transit visa:* Single entry $16 fee, double entry $20 fee, for stays of up to 72 hours; available at border or at embassy. *Health requirements:* No vaccinations required. *Equipment importation:* Carnet.

Electricity: 220/50. *Plug types:* C and F.
Currency: Leu (LEI); Bani.
U.S. embassy in the country: Strada Tudor Arhezi 7–9, Bucharest; *tel.* 10–40–40; *telex:* 11416.
Embassy in U.S.: 1607 Twenty-third Street NW, Washington, DC 20008; *tel.* 202–232–4747/9.
Tourism office in U.S.: Romanian National Tourist Office, 573 Third Avenue, New York, NY 10016; *tel.* 212–697–6971.
Central tourism office in country: National Tourist Office Carpati, 7 Boulevard Magherru, Bucharest; *tel.* 14–51–60.
Health suggestions: Water is potable. Polio and hepatitis vaccinations are recommended for rural areas.
Photographic restrictions: Restrictions can be very strict. Exercise caution at all strategic, industrial, border, and official sites; prohibitions will be posted. Contact the tourist office or embassy for permits.
Gratuity guidelines: Service charge of 10% is usually included in the bill; giving a bit extra is customary.

RWANDA
Republic of Rwanda
Republika y'u Rwanda

Location: In east-central Africa, bounded on the north by Uganda, the east by Tanzania, the south by Burundi, and the west by Zaire. *Size:* 10,169 square miles, slightly smaller than Maryland.
Major cities: *Kigali* (lat. −1.56). *Airports:* Gregoire Kayibanda (KGL), 8 miles outside of Kigali.
General transportation: Direct flights to Kamembe, other African capitals, and Europe (with connections to the U.S.), but schedules are subject to change. No railways. Only 10% of the roads are paved. Minibuses and taxis are available. *U.S. license:* No. *IDP:* Yes. *Rule of the road:* Right. *Taxi markings:* Black and white; set price, meters may soon be introduced; telephone-dispatched cabs are available.
Population: 7,050,000. *Type of government:* Republic; presidential system in which military leaders hold key offices. Political moderation, with focus on economic problems and ethnic harmony between Hutu and Tutsi; good human rights record. Friendly and cooperative relations with the U.S.
Languages: Kinyarwanda, French (official); Kiswahili used in commercial centers.
Ethnic groups: 90% Hutu, 9% Tutsi, 1% Twa (pygmoid). *Religion:* 65% Roman Catholic, 9% Protestant, 9% Muslim; indigenous beliefs.
Time: EST +7; GMT +2. *Telephone codes:* No direct-dial from U.S.—operator-assisted calls only. No credit card or collect calls to U.S. Fair domestic and international service. *Pay phone system:* In the stands that sell soft drinks; pay the proprietor.
Holidays: January 1, 28; Easter Monday; May 1; Ascension Day (40 days after Easter); Whit Monday; July 1, 5; August 1, 15; September 8, 25; October 26; November 1; December 25. *Date/month system:* D/M.
Business and government hours: 8 AM to 12 noon, 2 PM to 5 PM Monday to Friday.
Business dress code: Unless meeting is very high level, informal.
Climate and terrain: Mainly grassy uplands and hills that extend southeast from a chain of volcanoes in the northwest. It is divided by the Congo and Nile drainage systems and has many lakes. Rwanda has the densest population in sub-Saharan Africa. A country almost without villages, nearly every family in Rwanda lives in a self-contained compound. The few urban concentrations are grouped around administrative centers. Although close to the equator, the high elevation (14,700 feet at its zenith) makes the

climate temperate. During the major rainy seasons, from February to May and November to December, heavy downpours occur almost daily, alternating with periods of sunny weather. *Temperature ranges:* 65°F to 85°F year-round.

Visas: Contact the embassy for permission from Rwanda: 2 applications, passport, 2 photos, $15 fee, photographer's letter; permission can take several months. *Tourists:* Tourist visa, requiring passport, 2 applications, 2 photos, $15 fee, exact date of entry; valid for 3 months, for multiple entries. *Health requirements:* Yellow fever and cholera vaccinations. *Equipment importation:* Regulations are strict; bond may well be required.

Electricity: 220/50. *Plug types:* C and J.

Currency: Franc; Centimes.

U.S. embassy in the country: Boulevard de la Revolution, B.P. 28, Kigali; *tel.* 75601/3, 72126/8.

Embassy in U.S.: 1714 New Hampshire Avenue NW, Washington, DC 20009; *tel.* 202-232-2882.

Central tourism office in country: National Office of Tourism and National Parks, B.P. 905, Kigali; *tel.* 76512/5, 76607.

Health suggestions: Some qualified doctors and medications are available in Kigali. Water is not potable. Typhoid, tetanus, polio, and hepatitis treatments are recommended. Malaria suppressants are recommended throughout the country. Cholera infection is present.

Photographic restrictions: Military; intelligence agency building (very strict).

Gratuity guidelines: Service is usually included in the bill; leave small change as well.

SAINT LUCIA

Location: In the West Indies, north of St. Vincent and south of Martinique. *Size:* 238 square miles, slightly larger than Chicago. **Major cities:** *Castries* (lat. +14.01). *Airports:* Hewanorra (UVH), 45 miles outside of Castries; Vigie Field (SLU), 2 miles outside of Castries, for smaller-craft flights to other islands.

General transportation: Interisland and small charter flights out of Vigie Field near Castries; international flights land in Hewanorra, near Vieux Fort, an hour and a half from Castries. Car rentals are available both with and without drivers. *U.S. license:* Yes, if presented at main police stations, to obtain local license for a fee. *IDP:* Yes, if presented at main police stations, to obtain local license for a fee. *Rule of the road:* Left. *Taxi markings:* All colors, license plate has the letter *H;* usually cabs are telephone-dispatched; set price.

Population: 136,000. *Type of government:* Independent state within the British Commonwealth recognizing Elizabeth II as head of state; parliamentary democracy. Enjoys excellent relations with the U.S.

Languages: English (official), French patois. *Ethnic groups:* 90.3% black of African descent, 5.5% mixed, 3.2% East Indian, 0.8% white. *Religion:* 90% Roman Catholic, 7% Protestant, 3% Church of England.

Time: EST +1; GMT −4. *Telephone codes:* Direct-dialed from the U.S. using 809 area code. Modern domestic and international service. *Pay phone system:* Coins.

Holidays: January 1; February 22; Good Friday; May 1; August 1; October 3; December 13, 25, 26. *Date/month system:* D/M.

Business and government hours: 8:30 AM to 12:30 PM, 1:30 PM to 4 PM Monday to Friday. *Business dress code:* Tie and jacket are fine, but so is the "shirt-jac," a kind of shirt-suit that is commonly worn.

Climate and terrain: Striking, mountainous landscape of volcanic origin. Spiny mountain ridges and tropical forests in the interior radiate into rivers and broad fertile valleys. Tropical climate is moderated by

northeast trade winds, with a dry season from January to April and a rainy season from May to August. *Temperature ranges* (Soufrière): January: 63° to 85°F; April: 66° to 91°F; July: 71° to 91°F; October: 69° to 90°F.

Visas: Standard tourist entry, requiring proof of citizenship, proof of return ticket and sufficient funds; no visa is needed for stays of up to 6 months. *Health requirements:* Yellow fever vaccination is required if coming from an infected area. *Equipment importation:* Contact the mission in New York to make arrangements in advance; a bond is required for about 40% of value. **Electricity:** 240/50. *Plug types:* G.

Currency: East Caribbean Dollar (EC$), Cents.

U.S. embassy in the country: None; affairs are handled at the Barbados embassy, Canadian Imperial Bank of Commerce, Broad Street, Bridgetown; *tel.* 809–426–3574.

Embassy in U.S.: 2100 M Street NW, Washington, DC 20037; *tel.* 202–463–7378/9. *Consulates:* New York: 212–697–9360.

Tourism office in U.S.: St. Lucia Tourist Board, 41 East Forty-second Street, New York, NY 10017; *tel.* 212–867–2950.

Central tourism office in country: Point Seraphim Complex, Castries; *tel.* 24094.

Health suggestions: Water is considered potable (chlorinated), but bottled water is recommended. Avoid swimming in freshwater ponds.

Gratuity guidelines: Service is usually included in the bill (10%); a bit more is appreciated but not expected.

SAO TOME AND PRINCIPE
Democratic Republic of Sao Tome and Principe
República Democrática de São Tomé e Príncipe

Location: In the Gulf of Guinea, west of Equatorial Guinea and Gabon, south of Nigeria. *Size:* 372 square miles, slightly larger than New York City.

Major cities: *São Tomé* (lat. +0.20). *Airports:* São Tomé (TMS), 3 miles outside of São Tomé.

General transportation: Twice-a-week service from Libreville, Gabon, by Equatorial Airlines. Charter service is also available. The Angolan national airline, TAAG, has 2 flights a week from Luanda; once-a-month flights from Lisbon via TAP. Transportation between islands is by boat. Two-thirds of the roads on São Tomé are paved; on Príncipe, the roads are mostly unpaved and in poor repair. *U.S. license:* No. *IDP:* Yes. *Rule of the road:* Right. *Taxi markings:* Green and black, marked TAXI; set price.

Population: 117,000. *Type of government:* Republic; one party, MLSTP, dominates. Good relations with the U.S.

Languages: Portuguese (official). *Ethnic groups:* Mestizo (descendants of African slaves, also known as *filhos de terra*, or sons of the land); Angolares (reputed descendants of Angolan slaves who survived a 1540 shipwreck); Forros (descendants of slaves freed when slavery was abolished); Servicais (temporary-contract laborers from Angola, Mozambique, and Cape Verde); Tongas (children of Servicais born on the island; Europeans (primarily Portuguese). *Religion:* Roman Catholic, Evangelical Protestant, Seventh-Day Adventist.

Time: EST +5; GMT 0. *Telephone codes:* No direct-dial from U.S.—operator-assisted calls only. No credit card or collect calls to U.S. Minimal domestic and international service. *Pay phone system:* Coins; in hotels and restaurants.

Holidays: January 1; February 3; May 1; July 12; September 6, 30; December 21, 25. *Date/month system:* D/M.

Business and government hours: 8 AM to 11:30 AM, 2:30 PM to 6:30 PM Monday to Friday. *Business dress code:* Suit only for high-level meetings; otherwise, informal.

Climate and terrain: Both islands are part of an extinct volcanic mountain range. Swift streams radiate down from the peaks through lush forest and cropland to the sea. The climate is tropical at sea level—hot and humid—but cooler at the higher altitudes of the interior; rainy season extends from October to May. *Temperature ranges* (São Tomé): January: 73° to 86°F; April: 73° to 86°F; July: 69° to 82°F; October: 71° to 84°F.

Visas: Passport, photographer letter, 2 photos, client letter; processing takes less than a week. *Tourists:* Tourist visa with similar requirements. *Health requirements:* Yellow fever vaccination, unless arriving from a noninfected area and staying for less than two weeks. *Equipment importation:* Arrange for with visa.

Electricity: Data unavailable. *Plug types:* Data unavailable.

Currency: Dobra (STD); Centavos.

U.S. embassy in the country: None; affairs are handled through the Gabon embassy, Boulevard de la Mer, B.P. 400, Libreville; *tel.* (241) 762003.

Embassy in U.S.: 801 Second Avenue, Suite 1504, New York, NY 10017; *tel.* 212-697-4211.

Central tourism office in country: Direccao Turismo and Hotelaria, 2 Avenue 12 July, São Tomé; *tel.* 21542.

Health suggestions: Some basic medical care is available. Water is not potable. Malaria suppressants are recommended throughout the country.

Gratuity guidelines: Tips are appreciated but not expected.

SAUDI ARABIA
Kingdom of Saudi Arabia
Al-Mamlakah al-'Arabīyah as-Su'ūdīyah

Location: In southwestern Asia, bounded on the north by Jordan, Iraq, and Kuwait, on the east by the Persian Gulf, Qatar, and the United Arab Emirates, on the southeast by Oman, on the south by North and South Yemen, and on the east by the Red Sea. *Size:* 873,972 square miles, one-third the size of the U.S.

Major cities: *Riyadh* (lat. +24.39), Jidda (lat. 21.28), Dhahran (lat. +26.16). *Airports:* King Khaled (RUH), 22 miles outside of Riyadh; King Abdul Aziz (JED), 11 miles outside of Jidda; Dhahren (DHA), 5 miles outside of Dhahren.

General transportation: Many international flights, with direct links to U.S., and ample domestic flights, with over 24 airports. Road network and infrastructure are rapidly expanding. Intercity buses are available; railways are expanding but still slow. Car rentals and taxis are available. *U.S. license:* Yes, IDP recommended. *IDP:* Yes. *Rule of the road:* Right. *Note: Women are not allowed to drive. Motor clubs:* Saudi Automobile and Touring Association, P.O. Box 276, Dammam; *tel.* 83 24 441, 83 29 080; 83 42 053, 83 41 669; partial AAA reciprocity. *Taxi markings:* Orange; metered; tips are not customary. Travel to the Jidda/Mecca area during the pilgrimage (hajj) is difficult, with hotel rooms hard to get and flights overbooked.

Population: 15,500,000. *Type of government:* Monarchy; the birthplace of Islam; no formal constitution, elections, or political parties; king must rule by a consensus of the royal family, religious leaders *(ulema)*, and other important elements in Saudi society within the context of Islamic law. Enjoys close and friendly relations with the U.S.

Languages: Arabic. English is widely understood in business and government. *Ethnic groups:* 90% Arab, 10% Afro-Asian; significant population of resident foreigners. *Religion:* 100% Muslim.

Time: EST +8; GMT +3. *Telephone codes:* Country: 966. Abha 7, Abqaiq 3, Al-Khobar 3, Al-Markazi 2, Al-Ulaya 1, Dammam 3, Dhahran (Aramco) 3, Jidda 2, Khamis Mushait 7, Mecca 2, Medina 4, Naj-

ran 7, Qatif 3, Riyadh 1, Taif 2, Yenbo' 4. No credit card calls to U.S. Good domestic and international service, rapidly expanding. **Pay phone system:** Coins.

Holidays: Check with consulate for dates of Muslim holidays. **Date/month system:** D/M.

Business hours: 8 AM to 2 PM, 4:30 PM to 7:30 PM Saturday to Wednesday; 8 AM to 12 noon on Thursday. **Government hours:** 8 AM to 2 PM Saturday to Wednesday; 9 AM to 12 noon during Ramadan. Senior officials tend to arrive and stay later than the official hours. Business is curtailed during the day for Ramadan but may well be conducted late in the evening. **Business dress code:** Ties are expected of American visitors. Women should dress modestly, avoiding sleeveless dress and low necklines.

Climate and terrain: Occupies about four-fifths of the Arabian Peninsula. Mostly desert, including the Rub 'al Khali (Empty Quarter), a vast uninhabited expanse of sand. No permanent rivers or bodies of water. Major regions: the Hejaz, paralleling the Red Sea coast, where the two principal holy cities of Islam (Mecca and Medina), the commercial center (Jidda), and the summer capital (Taif) are located; the Asir, a mountainous region along the southern Red Sea coast; Nejd, the heartland and site of Riyadh, the capital city and new diplomatic center (was previously Jidda); the eastern province (al-Hasa), bordering the Persian Gulf (called the Arabian Gulf in Saudi Arabia) and containing the largest concentration of proven oil reserves in the world; the northern region, largely nomadic. Rainfall is erratic. In summer, heat is intense (as high as 120°F in the shade), and it is very humid along the coast. In winter, temperatures can go below freezing in the central and northern areas. **Temperature ranges** (Riyadh): January: 46° to 70°F; April: 64° to 89°F; July: 78° to 107°F; October: 61° to 94°F. Dhahran has similar temperatures.

Visas: Ministry of Foreign Affairs must be contacted by a sponsor in Saudi Arabia for photographer visits; requires passport, 1 photo, $15 fee. *Tourists:* No tourists visas are issued. **Health requirements:** Yellow fever vaccination is required if coming from a country with any infected areas. **Equipment importation:** Arrange for with visa.

Electricity: Riyadh, Medina, Jidda, Dammam, Al Khobar, 127/60; Buraida, Hofuf, Mecca, Taif, 220–230/50. **Plug types:** A, B, C, D, E, F, G, H, I, and J.

Currency: Riyal (ARI); Halala.

U.S. embassy in the country: Collector Road M, Riyadh Diplomatic Quarter, P.O. Box 9041, Riyadh 11143; *tel.* 488–3800; *telex:* 406866 AMEMB SJ. **Consulates:** Dhahran: 891–3200; Jidda: 667–0040.

Embassy in U.S.: 601 New Hampshire Avenue NW, Washington, DC 20037; *tel.* 202–333–4595/6. **Consulates:** California: 213–208–6566; New York: 212–752–2740; Texas: 713–785–5577.

Tourism office in U.S.: Same address as embassy but the information office has its own telephone number: 202–342–3800.

Health suggestions: Hospital and emergency medical care approaches U.S. standards, but practice food and water precautions outside of major hotels and restaurants. Malaria suppressants are recommended for urban areas of Jidda, Mecca, Medina, and Taif and for all areas in the western provinces except the high-altitude areas of Asir province, along the Yemen border.

Cultural mores and taboos: Saudis regard themselves as guardians of Muslim morals as well as its holy cities. *Women are forbidden to drive and are supposed to be accompanied by a male relative when taking a taxi, flying, or renting a hotel room.* Be punctual for appointments, but be prepared to wait. Business discussions are often prefaced by long conversations on unrelated topics. Handshakes are an accepted greeting. Look a man straight in the eye when talking to him. It is offensive to show the soles of your shoes. Business will be interrupted for prayer 5 times a day, the first at around 12:45 PM. Allow the worshipers plenty of room and be as silent as possible. Do not eat or smoke in public during the day on Rama-

dan. It is sometimes ill-mannered to say "no" directly.
Photographic restrictions: Photographing in public requires great caution. Observe local customs and check with local authorities.

Equipment rental/sales: *Balcar:* Mepps —Middle East Printing and Photographic System—Riyadh; *tel.* 463–2250.
Gratuity guidelines: A 15% service charge is usually included in the bill.

SENEGAL
Republic of Senegal
République du Sénégal

Location: In western Africa, bounded on the north and northeast by Mauritania, the east by Mali, the south by Guinea and Guinea-Bissau, and the west by the Atlantic Ocean. *Size:* 76,124 square miles, slightly smaller than South Dakota.
Major cities: *Dakar* (lat. +14.42). *Airports:* Yoff (DKR), 9 miles outside of Dakar.
General transportation: Ample international flights, with direct links to U.S.; domestic flights via Air Senegal. Car rentals are available both with and without drivers.
U.S. license: Yes. *IDP:* Yes. *Rule of the road:* Right. *Motor clubs:* Automobile Club du Sénégal, Immeuble Chambre de Commerce, place de l'Indépendance, Dakar; *tel.* 226 04; partial AAA reciprocity. *Taxi markings:* Yellow and black, marked TAXI; metered.
Population: 7,300,000. *Type of government:* Republic under multiparty democratic rule; on February 1, 1982, Senegal and Gambia formed a loose confederation named Senegambia that calls for the eventual integration of their armed forces and economic cooperation. Friendly relations with the U.S.
Languages: French (official), indigenous tongues. English is not understood by most businesspeople and officials. *Ethnic groups:* 36% Wolof, 17% Fulani, 17% Serer, 9% Toucouleur, 9% Diola, 9% Mandingo, 1% European and Lebanese. *Religion:* 92% Muslim, 6% indigenous beliefs, 2% Christian (mostly Roman Catholic).
Time: EST +5; GMT 0. *Telephone codes:* Country: 221. No city codes. Above-

average domestic service, with excellent international links. *Pay phone system:* Coins.
Holidays: January 1; Mawloud (varies); Easter Monday; April 4; May 1; Ascension Day (40 days after Easter); Whit Monday (varies—early June); August 15; Tabaski (varies); Korite (varies); Tamkharit (varies); November 1; Maulid-al-Nabi (varies); December 25. *Date/month system:* D/M.
Business and government hours: 8 AM to 12 noon, 2:30 PM to 6 PM Monday to Friday, plus Saturday mornings. *Business dress code:* Same as that of the U.S.
Climate and terrain: Mostly low, rolling savanna. In the southeast, plateaus rise to 1,600 feet, forming the foothills of the Fouta-Djallon Mountains. In the southwest, marshy swamps interspersed with tropical rain forests are common. Four major rivers—the Senegal, Saloum, Casamance, and Gambia—are navigable for substantial distances by large vessels. Dakar is the major port of entry into western Africa. June to October is the humid, rainy season; December to February is the dry season. *Temperature ranges* (Dakar): January: 64° to 79°F; April: 65° to 81°F; July: 76° to 88°F; October: 76° to 89°F.
Visas: Photojournalists require authorization from Senegal; contact the consulate. Commercial photographers need only a tourist visa, requiring passport, 3 photos, $5.10 fee (no personal checks); valid for 3 months. *Health requirements:* Yellow fever vaccination. *Equipment importation:* Carnet; or bring list to consulate; might still need bond upon arrival.
Electricity: 127/50. *Plug types:* C and F.

Currency: Franc (CFA); Centimes.
U.S. embassy in the country: B.P. 49, avenue Jean XXIII, Dakar; *tel.* 21–42–96; *telex:* 517 AMEMB SG.
Embassy in U.S.: 2112 Wyoming Avenue NW, Washington, DC 20008; *tel.* 202–234–0540/1.
Central tourism office in country: Ministry of Tourism, 5 place de l'Indépendance, Dakar.
Health suggestions: General level of health is good, but water is not potable.

Malaria suppressants are recommended throughout the country. Hepatitis, tetanus, polio, and typhoid treatments are also advisable.
Cultural mores and taboos: Visitors can expect a warm welcome.
Photographic restrictions: Use caution around military sites.
Gratuity guidelines: Service is often included in the bill; additional tips are acceptable.

SEYCHELLES
Republic of Seychelles

Location: In the Indian Ocean, northeast of Madagascar. *Size:* 107 square miles, about the size of Denver.
Major cities: *Victoria* (lat. −4.37). *Airports:* Seychelles (SEZ), 6 miles outside of Victoria.
General transportation: A number of international flights, with direct links from U.S. through Europe, to Mahé, the largest island. Air Seychelles (HM), ferries, and private launches provide interisland connections (but very little baggage is allowed on domestic flights). Buses, taxis, and car rentals are available. *U.S. license:* Yes. *IDP:* Yes. *Rule of the road:* Left. *Taxi markings:* All colors; set price. They do not cruise (although there is a taxi stand in downtown Victoria) but are telephone-dispatched.
Population: 69,000. *Type of government:* Republic; member of the British Commonwealth. Good relations with the U.S.
Languages: English and French (official), Creole. English is the language of government and business. *Ethnic groups:* Seychellois (mixture of Asians, Africans, and Europeans); 1,500 foreigners, including 100 Americans employed at the air force tracking base. *Religion:* 90% Roman Catholic, 8% Anglican, 2% other.
Time: EST +9; GMT +4. *Telephone codes:* No direct-dial from U.S.—operator-assisted calls only. Good domestic and international service. *Pay phone system:* Coins.

Holidays: January 1, 2; Good Friday; Easter Saturday; May 1; June 5, 29; Corpus Christi (June); August 15; November 1; December 8, 25. *Date/month system:* D/M.
Business hours: 8 AM to 12 noon, 1 PM to 4 PM Monday to Friday; 8 AM to 12 noon Saturday. *Business dress code:* Short-sleeved, open-necked conservative shirt, but no tie.
Climate and terrain: Archipelago of 92 scenic tropical islands. The granite Mahé group is rocky, and most have a narrow coastal strip and central range of hills rising as high as 3,000 feet. About 90% of the population lives on Mahé, site of the capital, Victoria. The coral islands are flat with elevated coral reefs at different stages of formation. They have no fresh water, and habitation is difficult. The climate is equable and healthy but humid. May to September is the cooler season. The Seychelles lie outside the cyclone belt. *Temperature ranges* (Victoria): January: 76° to 83°F; April: 77° to 86°F; July: 75° to 81°F; October: 75° to 83°F.
Visas: Standard tourist entry, requiring passport, proof of return ticket/sufficient funds; visa is issued upon arrival for stays of up to 1 month, can be extended for up to 1 year. *Health requirements:* No vaccinations required. *Equipment importation:* Still photographers usually pass without a bond or extensive paperwork, but it is a good idea to inform the Ministry of Education, Information and Youth, P.O. Box 48, Victoria,

Republic of Seychelles, *tel.* 21330, *telex* 997–2305, *answer-back* MINED SZ, before you arrive, to arrange for a press pass, which you may be asked for on the street. **Electricity:** 240/50. *Plug types:* D and G. **Currency:** Rupee (SER); Cents. **U.S. embassy in the country:** Box 148, Victoria; *tel.* 23921/2. **Embassy in U.S.:** 820 Second Avenue, Suite 203, New York, NY 10017; *tel.* 212–687–9766 (U.N. mission). **Tourism office in U.S.:** Seychelles Tourist Office, P.O. Box 33018, St. Petersburg, FL 33733; *tel.* 813–864–3013.

Central tourism office in country: Seychelles Tourist Office, Independence House, Victoria; *tel.* 22881.

Health suggestions: Public health standards are good but not up to U.S. standards. The islands' isolation has made them less subject to the common tropical diseases.

Gratuity guidelines: Service is usually included in the bill; otherwise, tips are accepted but not expected.

SIERRA LEONE
Republic of Sierra Leone

Location: In western Africa, bounded on the north and east by Guinea, the southeast by Liberia, and the south and west by the Atlantic Ocean. *Size:* 27,699 square miles, slightly smaller than South Carolina. **Major cities:** *Freetown* (lat. +8.37). *Airports:* Lungi International Airport (FNA), 13 miles outside of Freetown; Hastings (HGS), 15 miles outside of Freetown. **General transportation:** Flights to Europe (with connections to the U.S.), Africa, and several other international destinations. Most Freetown streets are narrow, without sidewalks, and congested with pedestrians. **U.S. license:** No. *IDP:* Yes. *Rule of the road:* Right. *Taxi markings:* Usually Nissans, some marked TAXI, yellow license plate; set price (be sure to agree in advance). Taxis cannot be dispatched by telephone. **Population:** 3,960,000. *Type of government:* Republic under presidential regimes since 1971. Relations with the U.S. are cordial. **Languages:** English (official), but use is limited to literate minority. Mende is spoken in the south and Temne in the north; Kiro is the language of the resettled ex-slave population of the Freetown area and is the lingua franca. *Ethnic groups:* 30% Temne, 30% Mende, 2% Creole, the rest European and Asian. *Religion:* 30% Muslim, 30% indigenous beliefs, 10% Christian, 30% other or none. **Time:** EST +5; GMT 0. *Telephone codes:* No direct-dial from U.S.—operator-assisted calls only. Fair domestic and international service. Overseas calls must be arranged in advance. *Pay phone system:* None.

Holidays: January 1; Good Friday; Easter Monday; April 27; December 25, 26; plus several Muslim holidays. *Date/month system:* D/M.

Business and government hours: 8 AM to 12 noon, 1:30 PM to 3:45 PM Monday to Friday; 8 AM to 12 noon Saturday. *Business dress code:* Conservative.

Climate and terrain: Three regions: a coastal belt (60 miles wide) of mangrove swamp making access to the sea difficult; an upland plateau; and mountains near the eastern frontier, including Bintimane, the highest peak in western Africa at 6,390 feet. Climate is tropical, with rainfall heaviest along the coast. The dry season is from November to April; the rainy season runs for the remainder of the year, with the heaviest rain from July to September. Early in the rainy season, rain builds through the day and breaks in late afternoon or evening; later in the season light rain falls all day. *Temperature ranges* (Freetown): January: 73° to 87°F; April: 76° to 88°F; July: 73° to 82°F; October: 72° to 85°F.

Visas: Business visa, requiring passport, photographer letter and client letter, proof of financial status, 2 application forms, $20.50 fee; allow 3 working days for processing.

Health requirements: Yellow fever and cholera vaccinations. *Equipment importation:* Get letter from consulate to assist with customs.
Electricity: 230/50. *Plug types:* D and G.
Currency: Leone (SLE); Cents. Sierra Leone has extensive currency requirements, involving documenting daily minimum exchanges, and rules concerning the use of hard currency for many transactions. All currency must be declared upon arrival on Form M and certified and stamped at port of entry; $100 minimum must be exchanged. Be sure to check with the consulate.
U.S. embassy in the country: Corner of Walpole and Siaka Stevens Streets, Freetown; *tel.* 26481; *telex:* (989)3509 USEMBSL.
Embassy in U.S.: 1701 Nineteenth Street NW, Washington, DC 20009; *tel.* 202-939-9261.
Central tourism office in country: Ministry of Tourism and Cultural Affairs, Wallace Johnson Street, Freetown.
Health suggestions: Some basic medical services are available in Freetown. Water is not potable. Insects are a problem. Avoid contact with freshwater streams and ponds. Malaria suppressants are recommended throughout the country, as are typhoid, tetanus, polio, and hepatitis treatments.
Cultural mores and taboos: Social relations are more formal at first. Personal matters should not be discussed until a friendship is established.
Gratuity guidelines: Service is not usually included in the bill; tips are accepted.

SINGAPORE
Republic of Singapore

Location: In southeastern Asia, south of the Malay Peninsula, east of Sumatra, Indonesia. *Size:* 225 square miles, about the size of Chicago.
Major cities: Singapore (lat. +1.18). *Airports:* Changi International Airport (SIN), 11 miles outside of Singapore (city); Seletar (XSP).
General transportation: Many international flights, with direct links to U.S. Rail links to Malaysia and Thailand. Excellent roads and urban transport. Subway (MRT) scheduled for 1990 completion. *U.S. license:* Yes. *IDP:* Yes, for 3 months. *Rule of the road:* Left. *Motor clubs:* Automobile Association of Singapore, AA Centre, 336 River Valley Road; *tel.* 737 2444; partial AAA reciprocity. *Taxi markings:* Light blue, green and white, or new white and red, marked TAXI; metered; tips are not encouraged. There is a surcharge from the airport.
Population: 2,650,000. *Type of government:* Republic within the British Commonwealth; ruling party, PAP, has been in power continuously since 1959. Friendly relations with the U.S.
Languages: Malay, Tamil, English (the language of government) and Chinese (Mandarin) are official. Mandarin is increasingly replacing the dialects of Hokkien, Teochew, Cantonese, Hainanese, Hakka, and Foochow. Telegu, Malayalam, Punjabi, and Bengali are spoken by ethnic Indians. *Ethnic groups:* 76.4% Chinese, 14.9% Malay, 6.4% Indian, 2.3% other. *Religion:* Chinese, predominantly Buddhists or atheists; Malays, nearly all Muslim; minorities include Christian, Hindu, Sikh, Taoist, Confucianist.
Time: EST +13; GMT +8. *Telephone codes:* Country: 65. No city codes. Excellent domestic and international service. *Pay phone system:* Coins.
Holidays: January 1; Chinese New Year (varies); Good Friday; May 1; Vesak Day (varies); August 9; Hari Raya Puasa (varies); Deepavali (varies); Hari Raya Haji (varies); December 25. *Date/month system:* D/M.
Business hours: 8:30 or 9 AM to 1 PM, 2:30 PM to 4:30 or 5 PM Monday to Friday; many firms open Saturday mornings. *Government hours:* 9 AM to 4:30 PM Monday to

Friday; 9 AM to 1 PM Saturday. *Business dress code:* Same as that of the U.S., but in hot weather, a jacket is not necessary.

Climate and terrain: One of the world's great ports, and until recently its busiest. Consists of 1 large island and 55 nearby islets. Mostly lowlands, much of it formerly swamp, now reclaimed. Warm climate, with high humidity and copious rainfall. Virtually no seasonal temperature variation and no pronounced wet and dry seasons. *Temperature ranges:* January: 73° to 86°F; April: 75° to 88°F; July: 75° to 88°F; October: 74° to 87°F.

Visas: Standard tourist entry, requiring passport; no visa is needed for stays of up to 90 days. *Health requirements:* Yellow fever vaccination is required if coming from a country with any infected areas or from countries in the endemic zone. *Equipment importation:* Carnet.

Electricity: 230/50. *Plug types:* C and G.

Currency: Dollar (SI$); Cents.

U.S. embassy in the country: 30 Hill Street, Singapore 0617; *tel.* 338–0251.

Embassy in U.S.: 1824 R Street NW, Washington, DC 20009; *tel.* 202–667–7555.

Tourism office in U.S.: Singapore Tourist Promotion Board, 342 Madison Avenue, Suite 1008, New York, NY 10173; *tel.* 212–687–0385.

Central tourism office in country: Singapore Tourist Promotion Board, Raffles City Tower, 250 North Bridge Road, Suite 3604, Singapore 0617; *tel.* 339–6622.

Health suggestions: Health standards are excellent, with many English-speaking doctors. Rely on bottled water.

Cultural mores and taboos: "Face" is all-important. Be punctual. Avoid gesturing with the fingers. Get business cards in English and Chinese. Rules concerning littering, jaywalking, and "antisocial" behavior such as long hair are strictly enforced, with stiff fines.

Photographic restrictions: List can be obtained locally from Ministry of Information and Communications, *tel.* 270–7988.

Color labs: *Kodak* (Singapore) Pte. Ltd.: 305 Alexandra Road, Singapore 0315.

Equipment rental/sales: *Comet:* Rovin Photo Pte. Ltd.; *tel.* 296–2177.

Gratuity guidelines: Service is usually included in the bill, and tips are not encouraged.

SOLOMON ISLANDS

Location: In the western Pacific Ocean, east of Papua New Guinea, northeast of Australia. *Size:* 15,220 square miles, slightly larger than Maryland.

Major cities: *Honiara* (lat. −9.28). *Airports:* Henderson (HIR), 8 miles outside of Honiara.

General transportation: Good air links to Papua New Guinea and Australia. Solair (Solomon Islands Airways—IE) serves several South Pacific destinations and provides service to all provincial centers in the Solomon Islands. Honiara has buses, taxis, and rental cars. *U.S. license:* Yes. *IDP:* Yes. *Rule of the road:* Left. *Taxi markings:* All colors, marked TAXI; set price, agree in advance.

Population: 310,000. *Type of government:* Independent parliamentary democracy within the British Commonwealth. Diplomatic relations with the U.S.

Languages: 120 indigenous languages. Melanesian pidgin is lingua franca in much of the country. English is spoken by 1% to 2% of the population. *Ethnic groups:* 93% Melanesian, 4% Polynesian, 1.5% Micronesian, 0.8% European, 0.3% Chinese, 0.4% other. *Religion:* Almost all nominally Christian; Anglican, Seventh-Day Adventist, and Roman Catholic churches dominate.

Time: EST +16; GMT −11. *Telephone codes:* No direct-dial from U.S.—operator-assisted calls only. Adequate domestic and international service. *Pay phone system:* None.

Holidays: January 1; Good Friday; Holy

Saturday; Easter Monday; Whit Monday (varies—early June); Queen's Birthday (June); July 7; December 25, 26. *Date/ month system:* D/M.

Business hours: 8 AM to 12 noon, 1 PM to 5 PM Monday to Friday. *Government hours:* Same as business hours but close at 4:30 PM. *Business dress code:* Very informal.

Climate and terrain: A 900-mile chain of islands, ranging from ruggedly mountainous to smaller low-lying coral atolls. The main islands have rain-forested mountain ranges of mainly volcanic origin, deep narrow valleys, and coastal belts lined with coconut palms and ringed by reefs. Earth tremors are frequent. Most people live in small, widely dispersed settlements along the coasts. The maritime, equatorial climate is humid, with little annual variation of temperature or weather. From June to August, it is a bit cooler, and rain is slightly more frequent from November to April. *Temperature ranges:* About 76°F to 87°F year-round.

Visas: *Special permit:* Apply to Permanent Secretary, Ministry of Education and Training, Honiara. *Tourists:* Tourist permit upon arrival for stays of up to 2 months, valid for a 1-year period, show proof of return ticket/ sufficient funds. *Health requirements:* Yellow fever vaccination is required if coming from an infected area. *Equipment importation:* Arrange for with visa.

Electricity: 240/50. *Plug types:* Data unavailable.

Currency: Dollar (SB$); Cents.

U.S. embassy in the country: None; affairs are handled at the Papua New Guinea embassy, Armit Street, P.O. Box 1492, Port Moresby; *tel.* (675) 211–455, 211–594, 211–654. *Consulates:* P.O. Box 561, Honiara; *tel.* (677) 30250.

Embassy in U.S.: 820 Second Avenue, New York, NY 10017; *tel.* 212–599–6194 (U.N. mission).

Central tourism office in country: Solomon Islands Tourist Authority, P.O. 321, Honiara; *tel.* 22442.

Health suggestions: Hospitals and pharmacies are limited to population centers and missions. Health conditions are generally adequate; the country is free of most serious endemic diseases except malaria, which is endemic throughout.

Cultural mores and taboos: Strong bonds of kinship, with important obligations extending beyond the immediate family; generally egalitarian relationships, emphasizing acquired rather than inherited status; and strong attachment to the land are all characteristic of Melanesian society.

Gratuity guidelines: Tipping is not customary and not recommended.

SOMALIA
Somali Democratic Republic
Jamhuriyadda Dimugradiga Somaliya

The State Department advises that travel to the northern and central provinces can be hazardous because of dissident activity.

Location: In eastern Africa, bounded on the north by the Gulf of Aden, the east and south by the Indian Ocean, and the west by Kenya, Ethiopia, and Djibouti. *Size:* 246,154 square miles, slightly smaller than Texas.

Major cities: *Mogadishu* (lat. +2.02). *Airports:* Mogadishu (MGQ), 3 miles outside of Mogadishu.

General transportation: International air links to Europe (with connections to the U.S.), Africa, and the Middle East. Somali Airlines (HH) provides domestic service. No railways; buses serve the interior. Car rentals are available. Accommodations and consumer goods are limited. *U.S. license:* No. *IDP:* Yes. *Rule of the road:* Left. *Taxi markings:* Red and yellow, marked TAXI; set price.

Population: 8,000,000. *Type of government:* Republic; president dominates political system; 1 political party; more moderate

policies and restoration of some civil rights since the late 1970s, but opposition is not tolerated. Excellent relations with the U.S. **Languages:** Somali (official), Arabic, Italian, English. *Ethnic groups:* 85% Somali, the rest mainly Bantu; 30,000 Arabs, 3,000 European, 800 Asians. *Religion:* Almost entirely Sunni Muslim. **Time:** EST +8; GMT +3. *Telephone codes:* No direct-dial from U.S.—operator-assisted calls only. No credit card or collect calls to U.S. Minimal domestic and international service, but there are links to Rome and London, and most towns and villages are linked to the capital. *Pay phone system:* Tokens; at banks, newsstands, shops. **Holidays:** May 1; June 26; July 1; October 21, 22; plus Muslim holidays. *Date/month system:* D/M.

Business hours: 8 AM to 12:30 PM, 4 PM to 7 PM Saturday to Thursday. *Government hours:* 8 AM to 2 PM Saturday to Thursday. *Business dress code:* Same as that of the U.S.

Climate and terrain: Often referred to as the Horn of Africa. Northern portion is hilly, with peaks to 7,000 feet. The central and southern areas are flat. The Juba and Shebelle rivers rise in Ethiopia and flow across the south toward the Indian Ocean. Year-round hot climate, seasonal monsoon winds, and irregular rainfall with recurring droughts are characteristic. The southwest monsoon, a cool sea breeze, makes May to October the most pleasant season in the capital. The northeast monsoon of December to February is also comfortable. The *tangambili* periods between are hot and humid. *Temperature ranges* (Mogadishu): January: 73° to 86°F; April: 78° to 90°F; July: 73° to 83°F; October: 76° to 86°F.

Visas: Standard tourist visa, requiring passport, 4 applications, 4 photos, $13 fee; allow 2 days for processing. *Health requirements:* Yellow fever vaccination is required if coming from an infected area. *Equipment importation:* Bring equipment list; no bond is required.

Electricity: 220–230/50. *Plug types:* C and D.

Currency: Shilling (SOM); Cents.

U.S. embassy in the country: Corso Primo Luglio, P.O. Box 574, Mogadishu; *tel.* 20811; *telex:* (999) 789 AMEMB MOG. **Embassy in U.S.:** 600 New Hampshire Avenue NW, Suite 710, Washington, DC 20037; *tel.* 202–333–5908. *Consulates:* New York: 212–687–9877.

Health suggestions: Only minimal health facilities. Malaria suppressants are recommended throughout the country.

Cultural mores and taboos: Respect Muslim customs.

Photographic restrictions: The U.S. consul in Somalia can advise on requirements.

Gratuity guidelines: Tips are accepted but not required.

SOUTH AFRICA
Republic of South Africa
Republiek van Suid-Afrika

The State Department cautions that, although travel to tourist areas is normally safe, the volatile political situation creates the potential for travel hazards.

Location: In southern Africa, bounded on the northwest by South-West Africa (Namibia), the north by Botswana and Zimbabwe, the northeast by Mozambique and Swaziland, and the east, south, and west by the Indian and Atlantic Oceans. *Size:* 471,455 square miles, slightly less than twice the size of Texas.

Major cities: *Pretoria* (lat. −25.45), Johannesburg (lat. −26.10), Cape Town (lat. −33.54). *Airports:* Jan Smuts (JNB), 14 miles outside of Johannesburg; Randburg (HCS); Randgermiston (QRA), 9 miles outside of Johannesburg; D.F. Malan (CPT), 14 miles outside of Cape Town. *It is policy to allow hand inspections only for ASA 400 or faster.*

General transportation: Many international flights, with direct links to the U.S. Modern domestic network includes many

domestic flights, good passenger railways, and excellent paved highways. *U.S. license:* Yes, with photo and signature. *IDP:* Yes. *Rule of the road:* Left. *Motor clubs:* Automobile Association of South Africa (AASA), 66 De Korte Street, Braamfontein; *tel.* 011–403–5700; full AAA reciprocity. *Taxi markings:* Rarely cruising; usually dispatched by phone. **Population:** 35,100,000. *Type of government:* Republic; administrative center in Pretoria, legislative in Cape Town, judicial in Bloemfontein; strong president; parliament has 3 separate chambers for whites, coloreds, and Indians. The U.S. is officially opposed to apartheid but has many ties to South Africa and recognizes its strategic importance. **Languages:** English and Afrikaans (both official), with English more common in business. *Ethnic groups:* South African law divides the population into 4 major categories. Africans are mainly descendants of Sotho and Nguni peoples who migrated centuries ago. They are subdivided into 10 groups, many of whom live in separate so-called tribal homelands such as at Transkei, Venda, and Bophuthatswana. Whites are primarily descended from Dutch, French, English, and German settlers. Coloreds are descended from indigenous peoples and the earliest European and Malay settlers. Asians are descendants of Indian workers brought to South Africa in the mid-nineteenth century. Blacks, comprising Africans, coloreds, and Indians, constitute about 82% of the population; whites, the remaining 18% or so. *Religion:* Most whites and coloreds and roughly 60% of the Africans are Christian (diverse sects); of the Indians, 60% are Hindu, 20% Muslim. **Time:** EST +7; GMT +2. *Telephone codes:* Country: 27. Bloemfontein 51, Cape Town 21, De Aar 571, Durban 31, East London 431, Gordons Bay 24, Johannesburg 11, La Lucia 31, Pietermaritzburg 331, Port Elizabeth 41, Pretoria 12, Sasolburg 16, Somerset West 24, Uitenhage 422, Welkom 171. Excellent domestic and international

service, the best in Africa. *Pay phone system:* Coins.

Holidays: January 1; Good Friday; Easter Monday; April 6; Ascension Day (40 days after Easter); May 31; October 10; December 16, 25, 26. When New Year's Day falls on a Sunday, it is observed on Monday. When Founders Day (April 6) falls on Good Friday, it is observed the following Saturday. December to February are vacation months, and business slows down considerably; travel reservations are difficult to obtain. Wildlife photos are best taken from April to October. *Date/month system:* D/M.

Business and government hours: 8 or 8:30 AM to 4:30 or 5 PM Monday to Friday. *Business dress code:* Conservative.

Climate and terrain: A narrow coastal zone leads to an extensive interior plateau, ranging from 3,000 to 6,000 feet. No important arterial rivers or lakes, so extensive water control and conservation are necessary. Moderate climate with sunny days and cool nights has been compared to that of southern and central California. Seasons are reversed from those of the U.S. *Temperature ranges* (Pretoria): January: 60° to 81°F; April: 50° to 75°F; July: 37° to 66°F; October: 55° to 80°F.

Visas: *Business visa:* Passport, 1 application, photographer letter, client letter, telex charge $14; allow 6 to 8 weeks for reply. The government does not encourage "loose-leaf" visas. If you plan to travel to countries rejecting visitors with South African visas, it is recommended that you get a second passport. Foreigners will need permits to visit black townships; contact the local police. *Tourists:* Similar requirements; allow about a month for processing. *Health requirements:* Yellow fever vaccination is required if coming from an infected area or a country in the endemic zone. *Equipment importation:* Carnet.

Electricity: 220–240/50. *Plug types:* D. **Currency:** Rand (SAR); Cents.

U.S. embassy in the country: Thibault House, 225 Pretorius Street, Pretoria; *tel.* 28–4266; *telex:* 3–751. *Consulates:* Cape

Town: 214–280/7; Durban: 304–4737/8; Johannesburg: 331–1681.
Embassy in U.S.: 3051 Massachusetts Avenue NW, Washington, DC 20008; *tel.* 202–337–3452/3. *Consulates:* California: 213–657–9200; Illinois: 312–939–7929; New York: 212–371–7997; Texas: 713–850–0150. **Tourism office in U.S.:** South African Tourism Board, 747 Third Avenue, New York, NY 10017; *tel.* 212–838–8841, or contact their public relations firm: Mr. Peter Celliers, Ellis Associates, 41 Union Square West, New York, NY 10003; *tel.* 212–645–4440.
Central tourism office in country: South Africa Tourism Board, Private Bag X164, Pretoria 0001; *tel.* 471131.
Health suggestions: Health standards and quality of medical care are high. Water is generally potable. Malaria suppressants are recommended in the rural areas (including game parks) in the north, east, and western low-altitude areas of the Transvaal and in the Natal coastal areas north of 28° south latitude. Bilharzia (schistosomiasis) is a problem in freshwater bodies of water.

Cultural mores and taboos: Punctuality is important. Ethnic tensions also exist within the white community between those of English descent and Afrikaaners. Try to avoid expressing your opinion on apartheid if you want to conduct business, although the topic is discussed and you will encounter a range of opinions on the issue. U.S. business dealings are often conducted under the guidelines of the Sullivan Code issued by the International Council for Equality of Opportunity Principles.
Photographic restrictions: The government restricts military subjects and civil disorders, as well as antiapartheid demonstrations. Photographing them could subject you to arrest.
Color labs: Kodak no longer operates in South Africa, and Kodak film is not available. *Fuji:* Photo Agencies Inc., P.O. Box 3916, Johannesburg 2000.
Gratuity guidelines: Service is not usually included in the bill; leaving 10% to 15% is recommended. It is customary to tip cab drivers.

SPAIN
España

Location: In southwestern Europe, bounded on the north by the Bay of Biscay, France, and Andorra, the east and southeast by the Mediterranean Sea, the southwest by the Atlantic Ocean, and the west by Portugal and the Atlantic Ocean. **Size:** 194,881 square miles, about twice the size of Oregon. **Major cities:** *Madrid* (lat. +40.25), Barcelona (lat. +41.24). **Airports:** Barajas (MAD), 10 miles outside of Madrid; Barcelona (BCN), 9 miles outside of Barcelona.
General transportation: Many international flights, with direct links to the U.S. Fine network of domestic air services. Good public transport, with rail connections to most major cities and good highways. Barcelona and Madrid have subways. **U.S. license:** No. **IDP:** Yes. **Rule of the road:**

Right. **Motor clubs:** Real Automóvil Club de España, José Abascal 10, Madrid; *tel.* 447–3200; partial AAA reciprocity. **Taxi markings:** Black in Madrid, marked TAXI; metered; small green light indicates availability.
Population: 39,200,000. **Type of government:** Constitutional monarchy; prime minister is responsible to the parliament *(cortes);* political liberalization with individual rights and freedoms came swiftly after the Franco years. Close relations with the U.S.
Languages: Castilian Spanish; second languages include Catalan (17%), Galician (7%), and Basque (2%). English is understood by quite a few in government and business. **Ethnic groups:** Composite of Mediterranean and Nordic groups. **Religion:** Over 90% at least nominally Roman Catholic (disestablished as the official religion in 1978).

Time: EST +6; GMT +1. *Telephone codes:* Country: 34. Barcelona 3, Bilbao 4, Cádiz 56, Ceuta 56, Granada 58, Igualada 3, Las Palmas de Gran Canaria 28, León 87, Madrid 1, Málaga 52, Melilla 52, Palma de Mallorca 71, Pamplona 48, Santa Cruz de Tenerife 22, Santander 42, Seville 54, Torremolinos 52, Valencia 6. Good domestic and international service. *Pay phone system:* Coins.

Holidays: January 1, 6; Holy Thursday; Good Friday; Easter Monday; May 1; Whit Monday (varies—end of May); Corpus Christi (early June); July 25; August 15; October 12; November 1; December 6, 8, 25; plus regional holidays. *Date/month system:* D/M.

Business hours: Later than most of Europe; 10 AM to 2 PM and 4 PM to 8 PM. Lunch, from 2 PM to 4 PM, and dinner, from 9 PM to 11 PM, are important parts of the day, and much business is conducted. *Government hours:* Officially 8 AM to 5 PM. *Business dress code:* Same as that of the U.S.

Climate and terrain: Most striking topological features are the high plateaus, which rise sharply from the sea, and the internal compartmentalization by mountain and river barriers, including the northern Pyrénées. Spain has few bays or natural harbors and almost no coastal islands. Nearly three-quarters of Spain is arid. The northwestern region resembles England in climate, with slight variations in temperature and plentiful rainfall. The eastern and southern coastal regions enjoy a typically Mediterranean climate, with warm temperatures and long dry spells. Madrid is located on the tableland in the center of the peninsula, is at the same latitude as New York, and is surrounded by mountains. *Temperature ranges* (Madrid): January: 33° to 47°F; April: 44° to 64°F; July: 62° to 87°F; October: 48° to 66°F; (Barcelona): January: 42° to 56°F; April: 51° to 64°F; July: 69° to 81°F; October: 58° to 71°F; (Seville): January: 41° to 59°F; April: 51° to 73°F; July: 67° to 96°F; October: 57° to 78°F.

Visas: Standard tourist entry, requiring passport; no visa is needed for stays of up to 6 months. Photographing may require permits in some cases. *Health requirements:* No vaccinations required. *Equipment importation:* Carnet.

Electricity: Mostly 220/50 (with some 127 volt). *Plug types:* C and E.

Currency: Peseta (PTS); Centimos.

U.S. embassy in the country: Serrano 75, Madrid; *tel.* 276–3400, 276–3600; *telex:* 27763. *Consulates:* Barcelona: 319–9550; Bilbao: 435–8300.

Embassy in U.S.: 2700 Fifteenth Street NW, Washington, DC 20009; *tel.* 202–265–0190/1. *Consulates:* California: 415–922–2995, 213–658–6050; Florida: 305–446–5511; Illinois: 312–782–4588; Louisiana: 504–525–4951; Massachusetts: 617–536–2506; New York: 212–355–4080; Texas: 713–783–6200.

Tourism office in U.S.: Spanish National Tourist Office, 665 Fifth Avenue, New York, NY 10022; *tel.* 212–759–8822.

Central tourism office in country: Oficina de Turismo, Señores de Luzon #10, Madrid; *tel.* 266–3900.

Health suggestions: Health standards are generally comparable to those in the rest of Europe. Typhoid, typhus, and hepatitis treatments may be advisable for travel to some areas. Water is potable in major cities but may not be in some rural areas; bottled mineral water is popular in any event.

Cultural mores and taboos: The Spanish are extremely proud and hospitable.

Color labs: *Kodak* S.A.: Apartado de Correos 130, Polígono Industrial "La Mina," Colmenar Viejo, Madrid; Calle del Pi, s/n, Polígono Industrial Manso Mateu, Apartado de Correos 92, El Prat de Llobregat, Barcelona. *Fujicolor* Service: Mampel Asens S.A.), Apartado 1900, Barcelona.

Equipment rental/sales: *Balcar:* Majestic Imp/Exp, Barcelona; *tel.* 202–0084. *Broncolor:* Master Rent Studio, Barcelona; *tel.* 240–1171.

Gratuity guidelines: Service is often included in the bill, although leaving a bit extra is customary.

SRI LANKA
Democratic Socialist Republic of Sri Lanka
Sri Lanka Prajathanthrika Samajavadi Janarajaya

Terrorist activity and civil unrest has made travel to some areas (particularly the northern and eastern provinces) dangerous—be sure to check with the U.S. embassy.
Location: In the Indian Ocean, southeast of India. *Size:* 25,332 square miles, slightly larger than West Virginia.
Major cities: *Colombo* (lat. +6.54). *Airports:* Katunayake (CMB), 20 miles outside of Colombo; Ratmalana (RML).
General transportation: Ample international flights, with direct links to the U.S. through Europe or Singapore. Domestic flights are available to several locations, and all parts of the island may be reached by rail or bus, although many foreign visitors hire a vehicle with a driver, which can actually be less expensive than a self-drive vehicle. *U.S. license:* Yes, must obtain visitor's license on arrival, valid for 3 months. *IDP:* Yes. *Rule of the road:* Left. *Motor clubs:* Automobile Association of Ceylon, 40 Sir M.M.M. Mawatha, Galle Face, Colombo; *tel.* 21528/9; partial AAA reciprocity. *Taxi markings:* All colors, particularly yellow-topped, marked TAXI; metered, although meters can be out of order or inaccurate—be sure to agree on price in advance. Larger, more expensive hotel taxis are also available.
Population: 16,600,000. *Type of government:* Republic; parliament with strong president; most difficult domestic problem is posed by the grievances and aspirations of Tamil separatists. Warm and cordial relations with the U.S.
Languages: Sinhala is official, but most public documents are published in English as well. Use of English has declined since independence in 1948 but is still widely spoken by businesspeople and senior civil servants.
Ethnic groups: 74% Sinhalese, 18% Tamil (two-thirds are "Ceylon Tamils" who have lived in Sri Lanka for centuries; the others are "Indian Tamils," whose forebears came in the late nineteenth century and are techni-

cally stateless persons, although the government has stated its intention to grant them citizenship), 7% Moor, 1% Burgher (descendants of Dutch, Portuguese, and British colonists), Malay, and Veddha (aborigines of the island). *Religion:* 69% Buddhist (mostly among the Sinhalese), 15% Hindu (mostly among the Tamil), 8% Christian (mostly Roman Catholic, found in both Sinhalese and Tamil communities), 8% Muslim (Moors and Malays).
Time: EST +10.5; GMT +5.5. *Telephone codes:* Country: 94. Ambalangoda 97, Colombo Central 1, Galle 9, Havelock Town 1, Kandy 8, Katugastota 8, Kotte 1, Maradana 1, Matara 41, Negombo 31, Panadura 46, Trincomalee 26. Fair domestic service, good international service. *Pay phone system:* Coins.
Holidays: January 1; February 4; May 22; December 25; plus many Buddhist, Muslim, Hindu, and Christian holidays—check with consulate. *Date/month system:* D/M/Y or Y/M/D.
Business hours: 8:30 AM to 12:30 PM, 1 PM to 4:30 PM Monday to Friday. *Government hours:* 8 AM to 12 noon, 1 PM to 4:15 PM Monday to Friday. *Business dress code:* Same as that of the U.S. for an American.
Climate and terrain: A plain only slightly above sea level makes up the entire northern half of the country and continues around the coast of the southern half. The south-central region is hilly and mountainous, ranging from 3,000 to 7,000 feet, and is where the country's famous teas are grown. About 50% of the population live in the southwest quarter. Generally hot, humid, tropical climate, with cooler temperatures in the south-central mountains. Two monsoon seasons, northeast, from December to March, and southwest, from June to October, with heaviest rainfall in the latter. The southwest region gets the most rainfall (200 inches per year). Occasional cyclones. *Temperature ranges* (Colombo): January: 72° to 86°F; April: 76°

to 88°F; July: 77° to 85°F; October: 75° to 85°F.

Visas: *Business visa:* Client letter, photographer letter, 1 application, 2 photos, passport, proof of return ticket, $2.52 fee; valid for up to 30 days; allow 3 days for processing. *Tourists:* Passport; no visa is needed for stays of up to 1 month. *Health requirements:* Yellow fever vaccination is required if coming from an infected area. *Equipment importation:* Bring equipment list upon entry; no bond is required. **Electricity:** 230/50. *Plug types:* D. **Currency:** Rupee (SLR); Cents. **U.S. embassy in the country:** 210 Galle Road, P.O. Box 106, Colombo 3; *tel.* 548007; *telex:* AMEMB CE. **Embassy in U.S.:** 2148 Wyoming Avenue NW, Washington, DC 20008; *tel.* 202-483-4025/8. *Consulates:* Hawaii: 808-941-4451; Illinois: 312-236-3306; Louisiana: 504-362-3232; New York: 212-986-7040.

Central tourism office in country: Ceylon Tourist Board, 228 Havelock Road, Colombo 5; *tel.* 581-801.

Health suggestions: Medical facilities are available in Colombo, with many English-speaking doctors, but can be poor in some areas, with medications scarce. Malaria is endemic except in Colombo. Water is not potable. Cholera infection is present.

Cultural mores and taboos: Business cards are a necessity. Politeness is highly prized; titles are important.

Photographic restrictions: Military and strategic installations such as bridges and airports.

Equipment rental/sales: *Comet;* Amila Photo Suppliers, Nugegoda; *tel.* 553-891.

Gratuity guidelines: Service is usually included in the bill (10%); additional tipping should be modest.

SUDAN
Republic of the Sudan
Jumhūrīyat as-Sūdān

The State Department warns that terrorism is a problem in many areas. Visitors must register with local police upon arrival and when changing locations. Registration with the U.S. embassy is recommended. Visitors arriving with alcoholic beverages are subject to immediate arrest.

Location: In northeastern Africa, bounded on the north by Egypt, the northeast by the Red Sea, the east by Ethiopia, the south by Kenya, Uganda, and Zaire, the west by the Central African Republic and Chad, and the northwest by Libya. *Size:* 967,500 square miles, over one-fourth the size of the U.S.

Major cities: *Khartoum* (lat. +15.37). *Airports:* Civil (KRT), 2 miles outside of Khartoum.

General transportation: Ample international flights, with direct links to the U.S. through Europe. Domestic flights are available via Sudan Airways (SD); travel by road or train outside Khartoum is limited (the only paved highway runs from Khartoum to Port Sudan, although there are plans for improvement). Taxis are available in Khartoum, Port Sudan, and Juba. *U.S. license:* Yes, but must be presented to local authorities upon arrival. *IDP:* Yes. *Rule of the road:* Right. *Taxi markings:* Yellow; set price; special airport taxis are available as well.

Population: 24,000,000. *Type of government:* Republic; political parties were reinstated after a 1985 coup; traditional tensions between Arab population of the north and black population of the south. Relations with the U.S. are now excellent after discord surrounding the events of 1973, when the American ambassador and deputy chief of mission were murdered by terrorists.

Languages: Arabic (official). English is widely understood in business and government. *Ethnic groups:* 52% black, 39% Arab, 6% Beja, 2% foreigner, 1% other. *Religion:* Predominantly Sunni Muslim in the north,

indigenous beliefs in the south, with some converts to Christianity.

Time: EST +7; GMT +2. *Telephone codes:* No direct-dial from U.S.—operator-assisted calls only. No credit card or collect calls to U.S. Barely adequate, poorly maintained domestic and international service. *Pay phone system:* None.

Holidays: January 1; March 3; May 1, 25; October 12, 21; December 25; plus Muslim holidays—check with consulate. *Date/month system:* D/M.

Business and government hours: 8:30 AM to 2 PM Saturday to Thursday in the summer; 7:30 AM to 2:30 PM Saturday to Thursday in the winter. *Business dress code:* Conservative for men and women.

Climate and terrain: The largest country in Africa, Sudan lies across the middle reaches of the Nile. Going from south to north, it has tropical forests and savanna; vast swamplands; open semitropical savanna and scrublands; and sandy, arid hills lying between the Red Sea and the Libyan and Saharan deserts. The extreme desert of the northwest gives way to sandy steppes north of Khartoum. The climate varies with the terrain and latitude. Khartoum has a hot desert climate, with low humidity and cooler nights. Subject to drought and famine. *Temperature ranges* (Khartoum): January: 59° to 90°F; April: 72° to 105°F; July: 77° to 101°F; October: 75° to 104°F.

Visas: All visitors need a visa with approval from the capital. *Tourists:* 1 photo, $9 fee, passport valid at least 6 months from date of entry, proof of return ticket/sufficient funds; good for single entry, for stays of up to 3 months. Business visits also require a client letter. *Transit visa:* 1 photo, $6 fee; valid for 3 months for stays of up to 7 days. *Health requirements:* Cholera vaccination is required if coming from an infected area.

Yellow fever vaccination is required if coming from infected area or a country in the endemic zone; also recommended by CDC for travel outside urban areas. *Equipment importation:* Bring equipment list; bond or deposit will most likely be required. Customs broker is recommended.

Electricity: 240/50. *Plug types:* C, F, and G.

Currency: Pound (SU£); Piasters. Strict declarations are enforced. Exchange only at official exchange centers; keep all receipts.

U.S. embassy in the country: Sharia Ali Abdul Latif, P.O. Box 699, Khartoum; *tel.* 74700, 75680, 74611; *telex:* 22619 AMEMB SD.

Embassy in U.S.: 2210 Massachusetts Avenue NW, Washington, DC 20008; *tel.* 202–338–8565. *Consulates:* New York: 212–421–2680.

Central tourism office in country: Tourist Information Office, Khartoum; *tel.* 70932.

Health suggestions: Facilities are extremely limited. Water is not potable. Malaria suppressants are recommended throughout the country. Typhoid, tetanus, polio, and hepatitis treatments are advisable.

Cultural mores and taboos: Muslim injunctions against alcohol and pork prevail. Do not cross legs, point or gesture at someone with the hand, show the soles of the feet, or pass or accept items with the left hand. If invited to a mosque, dress to cover the entire body, remove shoes (tip the attendant who gives you slippers), and do not walk in front of others praying. Strong streak of fatalism; appearance of disinterest can be misleading; Sudanese like to appraise a situation quietly before acting.

Photographic restrictions: Permits are required. Contact the Tourist Information Office.

SURINAME
Republic of Suriname

The State Department cautions of civil unrest, particularly in the eastern provinces.

Location: In northern South America, bounded on the north by the Atlantic Ocean, the east by French Guiana, the south by Bra-

zil, and the west by Guyana. *Size:* 63,251 square miles, slightly larger than Georgia. **Major cities:** *Paramaribo* (lat. +5.49). *Airports:* Zanderij (PBM), 30 miles outside of Paramaribo; Zorg en Hoop (ORG). **General transportation:** International flights to Miami, Amsterdam, Paris, the Caribbean, and Brazil. Overland travel is restricted because there are few roads and bridges, and large parts of the country outside the littoral are accessible only by light plane and canoe. Buses and taxis provide public transport in the capital. *U.S. license:* No. *IDP:* Yes. *Rule of the road:* Left. *Taxi markings:* All colors, some marked TAXI; set price. **Population:** 390,000. *Type of government:* In transition from military to civilian rule. Traditionally friendly relations with the U.S., but strained at the time of this writing. **Languages:** Dutch (official); English is widely spoken. Sranan Tongo (Surinamese, sometimes called Taki-Taki) is the native language of Creoles and much of the younger population and is the lingua franca among others. Also spoken are Hindi, Suriname Hindustani (a variation of Bhoqpuri), and Javanese. *Ethnic groups:* 37% Hindustani (East Indian), 31% Creole and mixed, 15.3% Javanese, 10.3% Bush blacks, 2.6% Amerindian (descendants of Arawak and Carib tribes), 1.7% Chinese, 1% European, 1.1% other. *Religion:* 27.4% Hindu, 19.6% Muslim, 22.8% Roman Catholic, 25.2% Protestant (predominantly Moravian), about 5% indigenous beliefs. **Time:** EST +2; GMT −3. *Telephone codes:* Country: 597. No city codes. No collect calls to U.S. Fair domestic service, good international service. *Pay phone system:* Tokens, available at stores, newsstands, and the like. **Holidays:** January 1; February 25; Good Friday; Easter Monday; May 1; July 1; November 25; December 25, 26; plus several Muslim holidays. *Date/month system:* D/M. **Business hours:** 7 AM to 3 PM Monday to Thursday; 7 AM to 2 PM Friday. *Business*

dress code: Same as that of the U.S. for high-level meetings; otherwise, an open shirt is acceptable. **Climate and terrain:** Consists of 3 zones. The northernmost is at sea level, where diking is necessary to save the land for agriculture. The central zone is a 30- to 40-mile belt of forest broken by scattered savanna. The southern zone is hilly, with savanna, gradually rising to about 4,120 feet in the Wilhelmina Mountains. This area constitutes about 75% of the land, and this thick jungle is inhabited by only a few Amerindians and Bush blacks. Climate is tropical, with high temperatures throughout the year and little seasonal change except for short dry seasons between 2 periods (December to January and March to September) of heavy rainfall. Outside both the hurricane and earthquake zones, however, sudden wind twisters have caused extensive damage in the jungles. *Temperature ranges* (Paramaribo): January: 72° to 85°F; April: 73° to 86°F; July: 73° to 87°F; October: 73° to 91°F.

Visas: All U.S. visitors need approval from Suriname, which enables multiple entries and is valid for 1 year, requiring 2 applications, 2 photos, $17 fee, passport, client letter; allow 1 to 2 weeks for a reply normally (but has taken as long as 6 weeks). Include equipment list. *Health requirements:* Yellow fever vaccination is required if coming from an infected area and is recommended by CDC for travel outside urban areas. *Equipment importation:* Arrange for with visa.

Electricity: 115/60. *Plug types:* C and F. **Currency:** Guilder/Florin; Cents. *Visitors must exchange 500 Suriname guilders* (about $283) *upon arrival.*

U.S. embassy in the country: Dr. Sophie Redmondstraat 129, P.O. Box 1821, Paramaribo; *tel.* 72900, 76459; *telex:* 373 AMEMSU SN.

Embassy in U.S.: 4301 Connecticut Avenue NW, Washington, DC 20008; *tel.* 202-244-7488 and 7490. *Consulates:* Florida: 305-871-2790; Georgia: 404-753-4753. **Central tourism office in country:** Dienft

voor het Torisme, Grote Combeweg #99, Paramaribo; *tel.* 72267.

Health suggestions: Some basic medical care is available, with English-speaking doctors, but medications are often in short supply. Malaria and other tropical diseases are endemic but are more of a problem in rural areas. Water in Paramaribo is considered potable.

Gratuity guidelines: Service is included in bills at restaurants but not usually in hotels. Tips are accepted.

SWAZILAND
Kingdom of Swaziland

Location: In southern Africa, bounded on the east by Mozambique and on the southeast, south, west, and north by South Africa. *Size:* 6,705 square miles, slightly smaller than New Jersey.

Major cities: *Mbabane* (lat. −26.20).

Airports: Matsapha (MTS), 5 miles outside of Manzini, southeast of Mbabane.

General transportation: Flights to Europe and Zambia (with connections to the U.S.), as well as other African capitals, including South Africa. Taxis and car rentals are available. *U.S. license:* Yes, if photo and signature are on license. *IDP:* Yes. *Rule of the road:* Left. *Taxi markings:* All colors, marked TAXI; set price.

Population: 740,000. *Type of government:* Monarchy; independent member of the British Commonwealth; no political parties. The parliament is partly elected indirectly and partly chosen by the crown, which must also approve all legislation. One of the more prosperous countries in Africa. Enjoys good relations with the U.S.

Languages: English and siSwati (a Nguni language related to Zulu) are both official. English is used in business and government.

Ethnic groups: 97% African, 3% European.

Religion: 57% Christian, 43% indigenous beliefs, often mixed together.

Time: EST +7; GMT +2. *Telephone codes:* Country: 268. No city codes. Basic domestic and international service. *Pay phone system:* Coins; few available.

Holidays: January 1; Good Friday; Easter Monday; April 19, 25; Ascension Day (40 days after Easter); July 22; Reed Dance Day (varies—August or September); September 6; December 25, 26, Incwala Day (varies—December or January). *Date/month system:* D/M.

Business hours: 8 AM to 5 PM Monday to Friday, 8:30 AM to 1 PM Saturday. *Government hours:* 8 AM to 5 PM Monday to Friday. *Business dress code:* Informal.

Climate and terrain: Consists of 3 regions of roughly equal breadth. The mountainous high veld in the west has a humid, near-temperate climate. The central middle veld and Lubombo Plateau of the extreme east are subtropical and drier than the high veld. The low veld, a broad area running north to south, is subtropical and drier still, with rainfall concentrated mainly in a few heavy storms.

Visas: Standard tourist entry, requiring passport; no visa is needed for stays of up to 60 days. Temporary residence permits are available from the immigration department for longer stays. Visitors entering from South Africa must report to immigration or a police station within 48 hours unless staying at a hotel. *Health requirements:* Yellow fever vaccination is required if coming from an infected area. *Equipment importation:* Contact the Customs and Excise Department, P.O. Box 720, Mbabane; *tel.* 45370.

Electricity: 220–230/50. *Plug types:* D.

Currency: Lilangeni (SZL); Cents.

U.S. embassy in the country: Central Bank Building, Warner Street, P.O. Box 199, Mbabane; *tel.* 22281/5; *telex:* 2016 WD.

Embassy in U.S.: 4301 Connecticut Avenue NW, Washington, DC 20008; *tel.* 202–362–6683.

Central tourism office in country: Ministry of Commerce, Industry, and Tourism, P.O. Box 451, Mbabane; *tel.* 43201.

Health suggestions: Basic medical care is available. Water is considered potable in the cities. Malaria suppressants are recommended for all lowland areas.

Gratuity guidelines: Tips are appreciated but not expected.

SWEDEN
Kingdom of Sweden
Kongungariket Sverige

Location: In northwestern Europe, bounded on the northeast by Finland, the east by the Gulf of Bothnia and the Baltic Sea, the south by the Baltic Sea, the southwest by the Kattegat, and the west by Norway. *Size:* 173,665 square miles, slightly larger than California.
Major cities: Stockholm (lat. +59.21).
Airports: Arlanda (ARN), 27 miles outside of Stockholm; Bromma (BMA),10 miles outside of Stockholm.
General transportation: Many international flights, with direct links to the U.S. Comprehensive modern transportation network, including good domestic air links. Small steamers and pleasure craft traverse the many waterways between Stockholm and Göteborg. *U.S. license:* Yes. *IDP:* Yes. *Rule of the road:* Right. *Motor clubs:* Motormannens Riksforbund, Sturegatan 32, Stockholm; *tel.* 782–3800; partial AAA reciprocity. *Taxi markings:* Usually dark, marked TAXI; metered.
Population: 8,400,000. *Type of government:* Constitutional monarchy; parliamentary democracy. Close, friendly relations with the U.S.
Languages: Swedish. English is widely understood. *Ethnic groups:* Homogeneous white population, with about 17,000 Lapps and 50,000 indigenous Finnish speakers in the north; about 12% of the population are immigrants and their children from the Nordic countries, Yugoslavia, Greece, and Turkey. *Religion:* 93.5% Evangelical Lutheran, 1% Roman Catholic, 5.5% other.
Time: EST +6; GMT +1. *Telephone codes:* Country: 46. Alingsås 322, Borås 33, Eskilstuna 16, Gamleby 493, Göteborg 31, Hälsingborg 42, Karlstad 54, Linköping 13, Lund 46, Malmö 40, Norrköping 11, Stock-

holm 8, Sundsvall 60, Trelleborg 410, Uppsala 18, Västerås 21. Excellent domestic and international service. *Pay phone system:* Coins; special phones take cards.
Holidays: January 1; Good Friday; Easter Monday; May 1; Ascension Day (40 days after Easter); Whit Monday (varies—early June); Mid-Summer Day (the Saturday between June 19 and 26); first Saturday in November; December 25, 26. Most organizations also close Mid-Summer, Christmas, and New Year's Eves, and many government and commercial institutions close at 1 PM before major holidays. July is the traditional vacation month. *Date/month system:* D/M.
Business hours: 8:30 or 9 AM to 5 PM Monday to Friday; to 3 PM or 4 PM in the summer. *Business dress code:* Same as that of the U.S.
Climate and terrain: Flat or gently rolling in southern and central Sweden and along the Gulf of Bothnia to the north. Mountains rising above 6,000 feet stretch along much of the frontier with Norway. Forests cover 50% of the land; lakes, 9%. Climate in the south is temperate, moderated by the North Atlantic Current, with long, cold winters of short days, and cool, partly cloudy summers with very long days. The north is subarctic. *Temperature ranges* (Stockholm): January: 23° to 31°F; April: 32° to 45°F; July: 55° to 70°F; October: 39° to 48°F.
Visas: Standard tourist entry, requiring passport; no visa is needed for stays of up to 3 months (period starts after entering any Scandinavian country—Sweden, Finland, Iceland, Norway, or Denmark). *Health requirements:* No vaccinations required. *Equipment importation:* Carnet.
Electricity: 220/50. *Plug types:* C and F.
Currency: Krona (SEK); Öre.

U.S. embassy in the country: Strandvagen 101, S-115 27 Stockholm; *tel.* 783–5300; *telex:* 12060 AMEMB S. *Consulates:* Göteborg: 100–590.
Embassy in U.S.: 600 New Hampshire Avenue NW, Suite 1200, Washington, DC 20037; *tel.* 202–944–5600. *Consulates:* California: 213–470–2555; Illinois: 312–781–6262; Minnesota: 612–332–6897; New York: 212–751–5900.
Tourism office in U.S.: Swedish Tourist Board, 655 Third Avenue, New York, NY 10017; *tel.* 212–949–2333.
Central tourism office in country: Stockholm Information Service, Swede House, Stockholm; *tel.* 789–2000.

Health suggestions: Standards are very high. Water is potable.
Cultural mores and taboos: Punctuality is important. Swedish manners are a bit more reserved than American.
Color labs: *Kodak* AB: S175 85 Jarfalla; Box 1004, S-436 00 Askim. *Fuji* Film Service, Box 40932, 100 28 Stockholm.
Equipment rental/sales: *Balcar:* Yrkesfoto, Göteborg, *tel.* 100–510; Yrkesfoto, Stockholm; *tel.* 541–595. *Profoto:* Molander & Son AB, Skarholmen; *tel.* (8) 710–0940.
Gratuity guidelines: Service is included in the bill; leaving a bit more is appreciated but not expected. Tip cab drivers 15%.

SWITZERLAND
Swiss Confederation
Schweizerische Eidgenossenschaft/Confédération Suisse/Confederazione Svizzera

Location: In central Europe, bounded on the north by West Germany, the east by Austria and Liechtenstein, the southeast and south by Italy, and the west by France. *Size:* 15,941 square miles, the size of Massachusetts, Connecticut, and Rhode Island combined.
Major cities: *Bern* (lat. +46.57), Zurich (lat. +47.23), Geneva (lat. +46.12).
Airports: Bdp (BRN), 6 miles outside of Bern; Zurich (ZRH), 7 miles outside of Zurich; Geneva (GVA), 12 miles outside of Geneva.
General transportation: Zurich and Geneva are international flight centers, with many direct flights to the U.S. Excellent electric railways connect all main cities and towns. Fine public transport. Although narrow and winding, roads are good. *U.S. license:* Yes. *IDP:* Yes, for 12 months. *Rule of the road:* Right. *Motor clubs:* Touring Club Suisse (TCS), Rue Pierre-Fatio 9, Geneva; *tel.* 37 12 12; full AAA reciprocity.
Taxi markings: All colors, marked TAXI; metered.
Population: 6,600,000. *Type of government:* Federal republic; 23 cantons; long tradition of armed neutrality and political sta-

bility. Long history of cooperative relations with the U.S.
Languages: 3 official languages: German, French, and Italian. Along with Romansch, a Latin language spoken by a tiny minority in Canton Graübunden, they are also the national languages. Spoken Swiss German differs substantially from regular spoken German and varies greatly from locality to locality. The standardized written language, High German, is used in broadcasting, on the stage, and at university. French is spoken in Fribourg, Vaud, parts of the Valais, Neuchâtel, Geneva, and Jura cantons. Italian is spoken in Ticino canton. English is widely understood, and many Swiss speak several languages. *Ethnic groups:* German, French, Italian, Romansch, with almost 15% resident foreigners. *Religion:* 49% Roman Catholic, 48% Protestant, 0.3% Jewish.
Time: EST +6; GMT +1. *Telephone codes:* Country: 41. Baden 56, Basel 61, Bern 31, Davos 83, Fribourg 37, Geneva 22, Interlaken 36, Lausanne 21, Lucerne 41, Lugano 91, Montreux 21, Neuchâtel 38, St. Gall 71, St. Moritz 82, Winterthur 42, Zurich 1. Excellent domestic and international service. *Pay phone system:* Coins.

Holidays: January 1, 2; Good Friday; Easter Monday; Ascension Day (40 days after Easter); Whit Monday (varies—early June); August 1; December 25, 26; plus regional holidays. *Date/month system:* D/M.
Business and government hours: 8 AM to 12 noon, 2 PM to 6 PM Monday to Friday. *Business dress code:* Conservative.

Climate and terrain: The Alps run roughly east to west through the southern part of the country and constitute 60% of the area. The Jura Mountains, an outspur of the Alps, stretch from the southwest to the northwest and occupy about 10% of the land. The highest point is Dufour Peak on Monte Rosa (15,217 feet). The remaining 30% of the land is lowlands—actually a plateau between the two ranges—home to the larger cities, industrial sections, and 75% of the people. Switzerland, where many rivers originate, forms the great European watershed. The Rhine flows to the North Sea; the Inn feeds the Danube; the Rhone empties into the Mediterranean; and the Ticino, which runs through Lake Maggiore, forms the source of the river Po. The climate is temperate but varies with altitude. *Temperature ranges* (Zurich): January: 28° to 38°F; April: 39° to 57°F; July: 55° to 76°F; October: 42° to 57°F. Geneva and Bern are similar to Zurich.

Visas: Standard tourist entry, requiring passport; no visa is needed for stays of up to 3 months. *Health requirements:* No vaccinations required. *Equipment importation:* Carnet.

Electricity: 220/50. *Plug types:* C and F.
Currency: Franc (SFR); Centimes.

U.S. embassy in the country: Jubilaeumstrasse 93, 3005 Bern; *tel.* 437–011; *telex:* (845) 912603. *Consulates:* Geneva: 335–537, 442–330; Zurich: 552–566.
Embassy in U.S.: 2900 Cathedral Avenue NW, Washington, DC 20008; *tel.* 202–745–7900. *Consulates:* California: 415–788–2272; Georgia: 404–872–7874; Illinois: 312–915–0061; New York: 212–758–2560; Texas: 713–650–0000.

Tourism office in U.S.: Swiss National Tourist Office, 608 Fifth Avenue, New York, NY 10020; *tel.* 212–757–5944.

Central tourism office in country: Swiss National Tourist Office, Bellariastrasse #38, 8027 Zurich; *tel.* 202–3737.

Health suggestions: Health standards are high. Water is potable.

Cultural mores and taboos: First names are reserved for friendship. Punctuality is crucial. The Swiss take great pride in their history and traditions.

Color labs: *Kodak* S.A. Processing Laboratories, Case Postale, CH-1001 Lausanne. *Fujicolor* Labor AG, Umkehrienst, Niederhaslistrasse 10, CH-8157 Dielsdorf.

Equipment rental/sales: *Balcar:* Modern Lights, Baar, *tel.* (42) 310–855; Tekno-Rent c/o Foto Gross AG, Basel, *tel.* 351–900; Tekno S.A., Geneva, *tel.* 314–740. *Broncolor:* Bron Elektronik AG, Allschwil, *tel.* (61) 634–400; Bron & Co., Basel, *tel.* 253–255; Bron Electronique S.A., Lausanne, *tel.* 205–466/7. *Profoto:* O. Schurch AG, Kriens, *tel.* (41) 410–526.

Gratuity guidelines: Service is included in the bill; it is not customary to leave extra.

SYRIA
Syrian Arab Republic
Al-Jumhūrīyah al-'Arabīyah as-Sūrīyah

The State Department advises that essential travel to Syria should not be precluded, but potential for terrorist activity exists, and it recommends consultation with the U.S. embassy upon arrival.

Location: In southwestern Asia, bounded on the north by Turkey, the east and southeast by Iraq, the south by Jordan, the southwest by Israel and Lebanon, and the west by Lebanon and the Mediterranean Sea. *Size:*

71,498 square miles, slightly larger than North Dakota. **Major cities:** Damascus (lat. +33.30). *Airports:* Damascus (DAM), 18 miles outside of Damascus. **General transportation:** Many international flights, with direct links to the U.S. Syrian Airlines (RB) serves most Arab capitals and the interior. Schedules can be erratic. Transport between cities and to neighboring countries can be arranged by private "service" taxis or air-conditioned buses. Rental cars are available; roads are good. *U.S. license:* No. *IDP:* Yes. *Rule of the road:* Right. *Motor clubs:* Automobile-Club de Syrie, Place Youssef El-Azme, Damascus; *tel.* 427–079; partial AAA reciprocity. *Taxi markings:* Red license plate, marked TAXI; metered. **Population:** 11,600,000. *Type of government:* Republic, under left-wing military regime since 1963. Baa'th Party rules; relative calm has prevailed since 1982. Has diplomatic relations with the U.S., but strong policy differences exist. **Languages:** Arabic (official); Kurdish, Armenian, Aramaic (the language of Jesus), Circassian. French and especially English are also widely understood among the educated. *Ethnic groups:* 90.3% Arab, 9.7% Kurds, Armenians, and others, including a tiny Jewish population. *Religion:* 74% Sunni Muslim; 16% Alawite, Druze, and other Muslim sects; 10% Christian (various sects). **Time:** EST +7; GMT +2. *Telephone codes:* No direct-dial from U.S.—operator-assisted calls only. Fair domestic and international service, currently undergoing improvement. Quality of international calls can vary, and delays can occur. *Pay phone system:* Coins. **Holidays:** January 1; February 27; March 8; April 17; May 1, 6; September 1; December 25; plus Muslim holidays. *Date/month system:* D/M. **Business hours:** 9 AM to 2 PM, 4 PM to 7 PM Saturday to Thursday. *Government*

hours: 8 AM to 2:30 PM Saturday to Thursday. *Business dress code:* Same as that of the U.S. for high-level meetings; otherwise, a tie and jacket are not always required.

Climate and terrain: The Anti-Lebanon and Ansariya mountains parallel the Mediterranean Sea from Israel to Turkey; the Euphrates River Valley traverses the country from the north to the southeast; the Jebal Druze mountains are in the south; and a semidesert plateau is in the southeast. The eastern side of the Anti-Lebanon Mountains is dotted with valley oases, the largest of which is the site of Damascus. The climate has been compared to that of Arizona. Summer days are dry and hot. December to March bring cold, but rarely freezing, weather. The rainy season generally lasts from November to April. *Temperature ranges* (Damascus): January: 36° to 53°F; April: 49° to 75°F; July: 64° to 96°F; October: 54° to 81°F.

Visas: Approval is necessary from Syria; apply to embassy with 1 application, 1 photo, client letter, photographer letter (samples of work are helpful), passport, $18 fee; reply usually takes around a month. *Transit visa:* $5 fee, valid for up to 3 days for entry and departure from Damascus Airport. *Health requirements:* Yellow fever vaccination is required if coming from an infected area. *Equipment importation:* Embassy will stamp list here. **Electricity:** 220/50. *Plug types:* C. **Currency:** Pound (SY£); Piasters.

U.S. embassy in the country: Abu Rumaneh, Al Mansur Street No. 2; P.O. Box 29, Damascus; *tel.* 333052, 332557, 330416, 332814, 332315; *telex:* 411919 USDAMA SY.

Embassy in U.S.: 2215 Wyoming Avenue NW, Washington, DC 20008; *tel.* 202–232–6313.

Central tourism office in country: Ministry of Tourism, Abu Firas Hamadani Street, Damascus; *tel.* 114918, 115916.

Health suggestions: Adequate basic medical and emergency service with Western-

trained doctors, but not well equipped for major surgery or long-term care. Sanitation can be poor. Water is not potable. Malaria suppressants are recommended for some rural areas.

Cultural mores and taboos: Muslim injunctions against alcohol and pork prevail. Do not cross legs, point or gesture at someone with the hand, show the soles of the feet, or pass or accept items with the left hand. If invited to a mosque, dress to cover the entire body, remove shoes (tip the attendant who gives you slippers), and do not walk in front of others praying. Do not refuse hospitality.

Gratuity guidelines: Service is sometimes included in the bill; otherwise same as those of the U.S.

TAIWAN
Republic of China
Chung-hua Min-kuo

Location: In eastern Asia, southeast of China, southwest of Japan, north of the Philippines. *Size:* 13,807 square miles, about half the size of West Virginia.

Major cities: *Taipei* (lat. +25.04). *Airports:* Chiang Kai Shek (TPE), 25 miles outside of Taipei; Sung Shan (TSA), 5 miles outside of Taipei.

General transportation: Many international flights, with direct links to the U.S. Domestic flights are available, as are comfortable express passenger trains. Extensive bus system and plentiful taxis. Car rentals are available. The north–south freeway provides excellent intercity connections. *U.S. license:* No. *IDP:* Yes. *Rule of the road:* Right. *Taxi markings:* All colors, marked TAXI; metered.

Population: 20,000,000. *Type of government:* One-party presidential regime, with new legislation to allow other parties expected. The U.S. changed its recognition from Taipei to Beijing on January 1, 1979, recognizing the government of the People's Republic of China as the sole legitimate government of China, and acknowledged that Taiwan is part of China. The joint communiqué also stated that "within this context, the people of the United States will maintain cultural, commercial, and other unofficial relations with the people of Taiwan."

Languages: Mandarin Chinese (official); Hakka and Taiwanese dialects also used. Many businesspeople speak English. *Ethnic groups:* 84% Taiwanese, 14% mainland Chinese, 2% aborigine. *Religion:* 93% mixture of Buddhist, Confucian, and Taoist; 4.5% Christian, 2.5% other.

Time: EST +13; GMT +8. *Telephone codes:* Country: 886. Changhua 47, Chunan 36, Chunghsing-Hsintsun 49, Chungli 34, Fengyuan 45, Hsiaying 6, Hualien 38, Kaohsiung 7, Keelung 32, Lotung 39, Pingtung 8, Taichung 4, Tainan 6, Taipei 2, Taitung 89, Taoyuan 33. Excellent domestic and international service. *Pay phone system:* Coins.

Holidays: January 1, 2; March 29; October 10, 25, 31; November 12; December 25; plus Chinese lunar holidays. *Date/month system:* D/M.

Business hours: 9 AM to 5 PM Monday to Friday; 9 AM to 12 noon Saturday. *Government hours:* 8:30 AM to 12 noon, 1:30 PM to 5:30 PM Monday to Friday; 8:30 AM to 12 noon Saturday. *Business dress code:* Same as that of the U.S.

Climate and terrain: A north–south mountain range forms the backbone of the island, with the highest peak, Yu Shan, rising to 13,110 feet. The eastern slope of this range is steep and craggy, but the western half of the island slopes gently to the sea and is fertile and highly cultivated. The climate is subtropical, with June to September being the wettest and hottest months. Chilly and damp in winter. Cloudiness is persistent and extensive all year. The island is in both earthquake and typhoon zones. *Temperature ranges* (Taipei): January: 53° to 66°F;

April: 64° to 77°F; July: 76° to 92°F; October: 68° to 80°F.

Visas: Standard tourist visa, allowing multiple entries, valid for 5 years; requires no fee, 2 photos, passport valid at least 6 months beyond issuance date. *Health requirements:* Yellow fever vaccination is required if coming from an infected area. *Equipment importation:* Bring equipment list; bond is probably not required.

Electricity: 110/60. *Plug types:* A, B, H, I, and J.

Currency: Dollar (NT$); Cents.

U.S. embassy in the country: None. Since the U.S. stopped recognizing Taiwan, commercial and cultural interaction is facilitated through the American Institute in Taiwan, a nongovernmental agency with headquarters in Washington, DC, and field offices at 7, Lane 134, Hsin Yi Road, Section 3, Taipei; *tel.* 709–2000; and 88 Wu Fu 3d Road, Kaohsiung; *tel.* 251–2444/7. It is authorized to provide assistance to U.S. citizens in Taiwan.

Embassy in U.S.: None. A counterpart organization of the American Institute in Taiwan, representing Taiwanese interests, is the Coordination Council for North American Affairs, headquartered in Taipei. It has field offices at 4201 Wisconsin Avenue NW, Washington, DC 20016–2137; *tel.* 202–895–1800 (Cultural Division: 202–686–1638); at 801 Second Avenue, 9th Floor, New York, NY 10017; *tel.*

212–289–8029; and in 9 other U.S. cities.

Tourism office in U.S.: See **Embassy in U.S.**, above.

Central tourism office in country: Tourism Bureau, 9th Floor, 280 Chung Hsiao East Road, Section 4, Taipei; *tel.* 721–8541.

Health suggestions: Epidemics and serious diseases are rare. High pollen and air pollution can cause discomfort to those who suffer from allergies or asthma. Water is not potable.

Cultural mores and taboos: Politeness, etiquette, and sensitivity to "face" are paramount in all dealings. Modesty and a reluctance to say "no" are common. Business cards with English on one side and Chinese on the other are recommended. Avoid discussions of the People's Republic of China. Dinner banquets to entertain foreign guests are common. The rice wine is to be drunk only when toasting, and the honored guest is expected to be the first to partake of every dish and the first to leave when dinner is concluded.

Color labs: *Kodak* Taiwan Ltd., 35 Chung Yang South Road, Section 2, Pei Tou, Taipei.

Equipment rental/sales: *Balcar:* Steelman Trading Co. Ltd., Taipei; *tel.* 561–8261. *Comet:* Shiu Hann Enterprise Co. Ltd., Taipei; *tel.* 594–3143. *Profoto:* Wing Zung Chong Co. Ltd., Taipei; *tel.* 364–411.

Gratuity guidelines: A 10% service charge is sometimes included in the bill; if not, leave a tip.

TANZANIA
United Republic of Tanzania
Jamhuri ya Mwungano wa Tanzania

The State Department cautions of a number of problems, including difficulties in notifying U.S. consular officials when detained or arrested, street crime, and difficulties when photographing (see Photographic restrictions, **below). Be sure to check with the U.S. embassy upon arrival.**

Location: In eastern Africa, bounded on the north by Uganda and Kenya, the east by the Indian Ocean, the south by Mozambique

and Malawi, the southwest by Zambia, the west by Zaire, and the northwest by Burundi and Rwanda. *Size:* 364,943 square miles, more than twice the size of California.

Major cities: *Dar es Salaam* (lat. −6.50).

Airports: Dar es Salaam (DAR), 8 miles outside of Dar es Salaam.

General transportation: Ample international flights, with direct links to the U.S. through Europe. Buses and trains in the cap-

ital are crowded. Rental cars are available. **U.S. license:** Yes, but must be endorsed at first licensing authority (revenue office) after crossing the frontier; valid for 21 days. **IDP:** Yes, if endorsed; valid for 1 year. **Rule of the road:** Left. **Motor clubs:** Automobile Association of Tanzania, 2309/50 Maktaba Street, Dar es Salaam; *tel.* 21965; partial AAA reciprocity. **Taxi markings** (Dar es Salaam): White; set price.

Population: 24,300,000. **Type of government:** Republic; single-party state with strong executive; formed from union of Tanganyika and Zanzibar in 1964; egalitarian framework. Friendly relations with the U.S.

Languages: Swahili is used as means of communication among ethnic groups, whose tongues are local languages, and it is generally the language of primary education. English is widely used in government, business, and higher education. **Ethnic groups:** 99% African of over 100 tribes, 1% Asian, European, and Arab. Zanzibar is almost all Arab. **Religion:** 33% Christian, 33% Muslim, 33% indigenous beliefs. Zanzibar is almost all Muslim.

Time: EST +8; GMT +3. **Telephone codes:** Country: 255. Dar es Salaam 51, Dodoma 61, Mwanza 68, Tanga 53. No credit card calls to U.S. Fair to poor domestic and international service. **Pay phone system:** Coins; few available.

Holidays: January 1, 12; February 5; Good Friday; Easter Monday; April 26; May 1; July 7; December 9, 25; plus several Muslim holidays—check with consulate. **Date/ month system:** D/M.

Business hours: 8:30 AM to 11:30 AM, 2 PM to 6 PM Monday to Friday; 8 AM to 12 noon Saturday. **Government hours:** 8:30 AM to 11:30 AM Monday to Friday. **Business dress code:** Open-collar, short-sleeved shirts are acceptable for the office. However, strict government regulations govern informal clothing for both men and women—dress accordingly.

Climate and terrain: Located among the great lakes of Africa: Victoria, Tanganyika, and Nyasa. Mainland has 4 climatic zones:

hot, humid coastal plains; hot, arid central plateau; high, moist lake regions; temperate highland areas. The highest point in Africa, Kilimanjaro, at 19,340 feet, lies near the Kenya border. Northeast monsoon from December to March brings hot temperatures; when the winds shift to the south from March to May, they bring heavy, intermittent rain. The southwest monsoon from June to September brings cooler weather. Light showers occur in November and December. **Temperature ranges** (Dar es Salaam): January: 77° to 83°F; April: 73° to 86°F; July: 66° to 83°F; October: 69° to 85°F.

Visas: Obtain permission from Dar es Salaam; apply at embassy or directly to the Director of Information Services (MAELEZO), P.O. Box 9142, Dar es Salaam; *tel.* 22771; *telex:* 41419. Allow at least 1 month for processing. **Health requirements:** Yellow fever vaccination is required if coming from an infected area or a country in the endemic zone and is recommended by CDC for travel in the northwestern forest areas. **Equipment importation:** Arrange for with visa.

Electricity: 230/50. **Plug types:** D and G. **Currency:** Shilling (TAS); Cents.

U.S. embassy in the country: 36 Laibon Road (off Bagamoyo Road), P.O. Box 9123, Dar es Salaam; *tel.* 37501; *telex:* 41250 AMEMB DAR.

Embassy in U.S.: 2139 R Street NW, Washington, DC 20008; *tel.* 202–939–6125.

Tourism office in U.S.: Tanzania Tourist Corporation, 205 East Forty-second Street, New York, NY 10017; *tel.* 212–972–9160.

Central tourism office in country: Tanzania Tourist Corporation, P.O. Box 2485, Azikiwe Street, Dar es Salaam; *tel.* 27671.

Health suggestions: Sanitation controls exist. Water is not potable. Malaria suppressants are recommended throughout country. Cholera infection is present.

Cultural mores and taboos: Avoid use of the left hand. Do not consider it rude if you do not hear "please" or "thank you"—these words are simply not part of the language; appreciation is shown in other ways.

Photographic restrictions: *The State Department cautions that strict enforcement of photographic restrictions is in effect. Photographing military installations is strictly forbidden; people have been detained and/or had cameras and film confiscated for photographing hospitals, schools, industrial sites, airports, harbors, railway stations, bridges, government buildings, and other facilities not always identified as off limits.* There are no restrictions on photographing in game parks.

Gratuity guidelines: A small service charge is usually included in the bill; otherwise, tips are officially discouraged but will be accepted.

THAILAND
Kingdom of Thailand
Muang Thai

The State Department advises that trekking in certain remote regions along the Thai-Burmese border can be hazardous.

Location: In southeastern Asia, bounded on the north by Burma and Laos, the east by Laos and Kampuchea, the south by the Gulf of Thailand and Malaysia, and the west by the Andaman Sea and Burma. *Size:* 198,455 square miles, about the size of Texas.

Major cities: *Bangkok* (lat. +13.44). *Airports:* Don Muang (BKK), 18 miles outside of Bangkok.

General transportation: Many international flights, with direct links to the U.S. Domestic flights to major cities and comfortable, dependable trains and buses to many cities and towns. Buses, taxis, rental cars, and *samlors* (three-wheeled motor vehicles) are available in Bangkok, which is very congested. Bangkok's canals *(klongs)* are also used for transportation. Pedicabs provide public transport in small towns. Roads vary from modern divided highways to unpaved, ungraded roads that may be impassable in the rainy season but are of generally good quality. *U.S. license:* No. *IDP:* Yes. *Rule of the road:* Left. *Motor clubs:* Royal Automobile Association of Thailand, 151 Rachadapisek Road, Bang Khen, Bangkok; *tel.* 511–2230/1; partial AAA reciprocity. *Taxi markings:* Marked TAXI; agree on fare before entering taxis or *samlors.*

Population: 54,600,000. *Type of government:* Constitutional monarchy; the only nation in southern and southeastern Asia never colonized by a European power. Close relations with the U.S.

Languages: Thai; ethnic and regional dialects. English is the second language of the elite. *Ethnic groups:* 75% Thai, 14% Chinese, about 4% Malay-speaking Muslims, 7% other. *Religion:* 95.5% Buddhist, 4% Muslim, 0.5% other.

Time: EST +12; GMT +7. *Telephone codes:* Country: 66. Bangkok 2, Buriram 44, Chanthaburi 39, Chiang Mai 53, Chiang Rai 54, Kamphaeng Phet 55, Lampang 54, Nakhon Sawan 56, Nong Khai 42, Pattani 73, Pattaya 38, Rat Buri 32, Sara Buri 36, Tak 55, Ubon Ratchathani 45. Adequate to good domestic and international service. *Pay phone system:* Coins.

Holidays: March 2; April 6, 13; May 5; August 12; October 23; December 5, 10; plus Buddhist lunar holidays. *Date/month system:* D/M.

Business and government hours: 8:30 AM to 12 noon, 1 PM to 4:30 PM Monday to Friday. *Business dress code:* For high-level meetings, same as that of the U.S.; a bit less formal otherwise.

Climate and terrain: Consists of 4 main regions. The central agricultural region is dominated by the most important river, the Chao Phraya, which supports an extensive network of canals and irrigation projects, long considered "the rice bowl" of Asia. It supports a concentrated rural population and includes Bangkok. The northeast is a poor, drought-ridden plateau. Northern Thailand is a region of forested mountains and steep,

fertile river valleys. The long, thin southern sliver is mostly rain forest. The tropical climate is dominated by the monsoons, with high humidity and temperatures. Most regions have 3 seasons: rainy from June to October, cool from November to February, and hot from March to May. Rainfall varies but is generally heaviest in the south and lightest in the northeast. *Temperature ranges* (Bangkok): January: 67° to 89°F; April: 78° to 95°F; July: 76° to 90°F; October: 76° to 88°F.

Visas: *Business visa:* Application, 3 photos, client letter, $20 fee; good for stays of up to 90 days. *Tourists:* Passport; no visa is needed for stays of up to 15 days if arriving and departing from Don Muang Airport. For tourist stays of up to 60 days, obtain visa with $15 fee and 3 photos. *Transit visa:* For stays of up to 30 days; $10 fee and 3 photos. *Health requirements:* Yellow fever vaccination is required if coming from an infected area. *Equipment importation:* Bring equipment list; no bond is required.

Electricity: 220/50. *Plug types:* A and C.

Currency: Baht (BHT); Satang.

U.S. embassy in the country: 95 Wireless Road, Bangkok; *tel.* 252–5040; *telex:* 20966 FCSBKK. *Consulates:* Chiang Mai: 252–629/31.

Embassy in U.S.: 2300 Kalorama Road NW, Washington, DC 20008; *tel.* 202–483–7200. *Consulates:* California 213–937–1894; Hawaii: 808–524–3888; Illinois: 312–236–2447; New York: 212–732–8166.

Tourism office in U.S.: Tourism Authority Thailand, 5 World Trade Center, Suite 2449, New York, NY 10048; *tel.* 212–432–0433. Los Angeles: 213–382–2353/5.

Central tourism office in country: T A

Thailand, #4 Ratchadamnoen Klang Avenue, Bangkok 10100; *tel.* 282–1143/7.

Health suggestions: Hospitals are available for routine treatment. Mosquitoes are plentiful, but malaria is not a problem in Bangkok. For rural areas, malaria suppressants and typhoid, tetanus, rabies, and hepatitis treatments are recommended. Cholera infection is present. Water is not potable.

Cultural mores and taboos: Thais have a complex system of courtesy that foreigners are not expected to master entirely. However: never show the soles of the feet or gesture with the foot. Never touch someone, even a child, on the head or upper part of the body. Remove shoes in temples and homes. The *wai*, in which both hands are placed together in a prayerlike position at the chest accompanied by a slight bow, is the traditional greeting and can mean "thank you" or "excuse me" as well; it should always be returned. Thais address each other by first names, leaving last names for formal occasions.

Photographic restrictions: Temples *(wats)*, if posted.

Color labs: *Kodak* (Thailand) Ltd., P.O. Box 2496, Bangkok 10501.

Equipment rental/sales: Vira Supplies Ltd., Bangkok, *tel.* 223–9122. *Comet* and *Profoto:* Kiti International Co. Ltd., Bangkok; *tel.* 235–0156. *Film commissions:* Thailand Film Promotion Centre, 599 Bumrung Muang Road, Bangkok 10100; *tel.* 223–4690.

Gratuity guidelines: Service is usually included in the bill; otherwise, tip only for special service. Cab drivers are not customarily tipped.

TOGO
Republic of Togo
République Togolaise

Location: In western Africa, bounded on the north by Burkina Faso, the east by Benin, the south by the Bight of Benin, and the west by Ghana. *Size:* 21,853 square miles, slightly smaller than West Virginia.

Major cities: *Lomé* (lat. +6.10). *Airports:* Lomé (LFW), 3 miles outside of Lomé.

General transportation: Flights to Europe (with connections to the U.S.) and sev-

eral African capitals. Uncertain road conditions and frontier difficulties can complicate automobile transport to Benin, other than the direct road to Cotonou. Accra is an easy 3-hour drive from Lomé, but the border can be closed. Rental cars are available. *U.S. license:* Yes. *IDP:* Yes. *Rule of the road:* Right. *Taxi markings:* All colors, marked TAXI; set price.

Population: 3,300,000. *Type of government:* Republic; one-party presidential regime. Enjoys excellent relations with the U.S.

Languages: French (official), the language of business; major African languages are Ewe and Mina in the south; Dagomba and Kabye in the north. Many in the south speak English. *Ethnic groups:* 37 tribes, Ewe, Mina, and Kabye being the largest and most important; under 1% European and Syrian-Lebanese. *Religion:* 70% indigenous beliefs, 20% Christian, 10% Muslim.

Time: EST +5; GMT 0. *Telephone codes:* Country: 228. No city codes. No credit card or collect calls to U.S. Fair domestic service, greatly improved international service, with direct-dial to Europe and the U.S. possible. *Pay phone system:* None.

Holidays: January 1, 13, 24; April 24; May 1; Ascension Day (40 days after Easter); June 21; August 15; November 1; plus several Muslim holidays. *Date/month system:* D/M.

Business and government hours: 7 AM to 12 noon, 2:30 PM to 5:30 PM Monday to Friday; 7:30 AM to 12 noon Saturday.

Climate and terrain: Consists of 2 savanna plains regions separated by a southwest–northwest range of hills (the Chaine du Togo); low coastal plain with lagoons and marshes. The south has a tropical climate, hot and humid; the north is semiarid with greater temperature fluctuations and is affected by dry harmattan winds that affect visibility. *Temperature ranges* (Lomé): January: 72° to 85°F; April: 74° to 86°F; July: 71° to 80°F; October: 72° to 83°F.

Visas: Standard tourist entry, requiring passport; no visa is needed for stays of up to 3 months. Travel to remote areas sometimes requires a visa. *Health requirements:* Yellow fever vaccination. *Equipment importation:* Bring equipment list; no bond is required.

Electricity: Mostly 220/50 (some 127 volt in Lomé). *Plug types:* C and E.

Currency: Franc (CFA); Centimes.

U.S. embassy in the country: Rue Pelletier Caventou et Rue Vauban, B.P. 852, Lomé; *tel.* 21–29–91/4, 21–36–09.

Embassy in U.S.: 2208 Massachusetts Avenue NW, Washington, DC 20008; *tel.* 202–234–4212/3.

Central tourism office in country: The High Commission for Tourism, Rue d'Aneho, B.P. 1289–1177, Lomé; *tel.* 21–43–13, 21–56–62; *telex:* 5007.

Health suggestions: Medical services are limited. Water is not potable. Malaria suppressants are recommended throughout the country.

Gratuity guidelines: Tips are appreciated but not expected.

TONGA
Kingdom of Tonga
Pule'anga Tonga

Location: In the western Pacific, west of the Cook Islands, northeast of New Zealand, east of Fiji, south of Western Samoa. *Size:* 270 square miles, slightly smaller than New York City.

Major cities: *Nuku'alofa* (lat. −21.09).

Airports: Tongatapu (TBU), 14 miles outside of Nuku'alofa.

General transportation: Air links to Fiji, New Zealand, and Western Samoa, with some connections to the U.S. A small national airline provides irregular service to airstrips on the 3 major island groups. Cars with drivers can be hired; rental cars are available. Buses and ferries connect the major islands. Taxis in larger towns and three-

wheeled vehicles provide urban transport. *U.S. license:* Yes. *IDP:* Yes. *Rule of the road:* Right. *Taxi markings:* Marked TAXI; set price. **Population:** 100,000. *Type of government:* Constitutional monarchy within the British Commonwealth; no political parties. Traditional society in 3 tiers (king, nobles, and commoners); somewhat isolated from developments in the rest of the world. The U.S. has no consular or diplomatic offices in Tonga. Officers from the embassy in Fiji make periodic visits.

Languages: Tongan, English. *Ethnic groups:* Polynesian; about 300 Europeans. *Religion:* Christian; Free Wesleyan church claims over 30,000 members.

Time: EST + 18; GMT + 13. *Telephone codes:* No direct-dial from U.S.—operator-assisted calls only. Minimal domestic and international service. *Pay phone system:* Coins.

Holidays: January 1; Good Friday; Easter Monday; April 25; May 5; June 4; July 4; November 4; December 4, 25, 26. *Date/month system:* D/M.

Business hours: 8 AM to 5 PM Monday to Friday; 8 AM to 12 noon Saturday. *Government hours:* 8 AM to 4 PM Monday to Friday. *Business dress code:* Informal, but men and women should dress modestly.

Climate and terrain: Consists of 3 main groups of islands; Vava'u, Ha'apai, and Tongatapu, which contains two-thirds of the population and the capital. Subtropical climate with a distinct warm period from December to April and a cooler period from May to November, with high humidity year-round. *Temperature ranges:* 70° to 80°F September to May; 60° June to August.

Visas: Standard tourist entry, requiring proof of return ticket, passport; no visa is needed for stays of up to 30 days. *Health requirements:* Yellow fever vaccination is required if coming from an infected area. *Equipment importation:* Bring equipment list; no bond is necessary.

Electricity: 240/50. *Plug types:* D and I. **Currency:** Pa'anga (T$); Seniti.

U.S. embassy in the country: None; affairs are handled at the Fiji embassy, 31 Loftus Street, P.O. Box 218, Suva, Fiji; *tel.* 314–466.

Embassy in U.S.: 360 Post Street, Suite 604, San Francisco, CA 94108; *tel.* 415–781–0365 (consulate general).

Tourism office in U.S.: Consulate in San Francisco (see **Embassy in U.S.,** above) has an information officer who will be glad to assist.

Central tourism office in country: Tonga Visitor's Bureau, P.O. Box 37, Nuku'alofa; *tel.* 21733.

Health suggestions: Free of most tropical diseases, including malaria. The capital has a modern hospital, but doctors can be in short supply. Water is considered potable in Nuku'alofa and in tourist resorts.

Cultural mores and taboos: Women in trousers and men with long hair are frowned upon. Sunglasses are considered jewelry. Raising the eyebrows is a gesture of agreement. Generosity is prized; excessive praise of another's belongings may prompt making it a gift. Very relaxed atmosphere.

Photographic restrictions: Request permission before photographing near the palace. It will be granted.

Gratuity guidelines: Tips are accepted but are neither customary nor expected.

TRINIDAD AND TOBAGO
Republic of Trinidad and Tobago

Location: In the West Indies, northeast of Venezuela, south of Grenada. *Size:* 1,980 square miles, about the size of Delaware. **Major cities:** Port-of-Spain (lat. + 10.38). *Airports:* Piarco (PAS), 19 miles outside of Port-of-Spain.

General transportation: Direct flights to the U.S. and Europe. Scheduled air and steamer service to Tobago from Trinidad. No railways; taxis and rental cars are available on both islands. *U.S. license:* No. *IDP:* Yes, for 90 days after registration with

local auto club. *Rule of the road:* Left. *Motor clubs:* Trinidad and Tobago Automobile Association, 41 Woodford Street, Newtown, Port-of-Spain; *tel.* 622–7194, 628–9047; partial AAA reciprocity. *Taxi markings:* All colors, *H* on the license plate; set price. **Population:** 1,280,000. *Type of government:* Parliamentary democracy. Maintains cordial relations with the U.S.

Languages: English (official), Hindi, French, Spanish. *Ethnic groups:* 43% black, 40% East Indian, 14% mixed, 1% white, 1% Chinese, 1% other. *Religion:* 36.2% Roman Catholic, 23% Hindu, 13.1% Protestant, 6% Muslim, 21.7% unknown.

Time: EST +1; GMT −4. *Telephone codes:* Direct-dial from the U.S. using 809 area code. Good domestic and excellent international service. *Pay phone system:* Coins.

Holidays: January 1; Carnaval (Monday and Tuesday before Ash Wednesday); Good Friday; Easter Monday; Whit Monday (varies—early June); Corpus Christi (June); June 19; August 1, 31; September 24; December 25, 26. *Date/month system:* D/M.

Business hours: 8 AM to 4 PM Monday to Friday; 8 AM to 12 noon Saturday. *Government hours:* 8 AM to 4 PM Monday to Friday. *Business dress code:* Same as that of the U.S.

Climate and terrain: Three relatively low mountain ranges cross Trinidad from east to west, reaching 3,085 feet in the heavily forested northern range. Between the northern and central ranges, the land is flat and well watered; between the central and southern ranges, it is rolling and dry in the dry season. Tropical forests cover half the island; swamps along the east and west coasts. The climate is tropical and pleasant, with a rainy season from June to December; out of the

hurricane belt. Tobago, known as "Robinson Crusoe Island," has long stretches of scenic, almost deserted beaches. A ridge of volcanic origin lies along the center, reaching 1,800 feet. Tobago is slightly cooler than Trinidad because of exposure to trade winds. *Temperature ranges:* January: 69° to 87°F; April: 69° to 90°F; July: 71° to 88°F; October: 71° to 89°F.

Visas: *Business visa:* Passport, 2 photos, photographer letter, client letter, $21 fee; allow 2 days for processing. *Tourists:* Proof of citizenship, photo ID, proof of return ticket; no visa is needed for stays of up to 2 months. *Health requirements:* Yellow fever vaccination is required if coming from an infected area and is recommended by CDC for travel outside urban areas. *Equipment importation:* Bond will probably be required at airport; customs broker is recommended.

Electricity: Both 115 and 230/60. *Plug types:* A, B, D, G, and I.

Currency: Dollar (TT$); Cents.

U.S. embassy in the country: 15 Queen's Park West, P.O. Box 752, Port-of-Spain; *tel.* 622–6372/6, 622–6176.

Embassy in U.S.: 1708 Massachusetts Avenue NW, Washington, DC 20036; *tel.* 202–467–6490. *Consulates:* Florida: 813–682–8922; New York: 212–682–7272.

Tourism office in U.S.: Trinidad and Tobago Tourist Board, 118–35 Queens Boulevard, Forest Hills, NY 11375; *tel.* 718–575–3909.

Central tourism office in country: Trinidad and Tobago Tourist Board, 122–124 Frederick Street, Port-of-Spain; *tel.* 623–7405.

Health suggestions: Tap water is considered potable.

Gratuity guidelines: Service is not included in the bill; tips are expected.

TUNISIA
Republic of Tunisia
Al-Jumhūrīyah at-Tunisīya

Location: In northern Africa, bounded on the north and east by the Mediterranean Sea, the southeast by Libya, and the south west and west by Algeria. *Size:* 63,378 square miles, about the size of Missouri.

Major cities: *Tunis* (lat. +36.47). *Air-*

ports: Carthage (TUN), 5 miles outside of Tunis.

General transportation: Ample flights to North Africa and Europe, with connections to the U.S. Car ferries across the Mediterranean to Italy and France. Roads are good, and long-distance taxis *(louages)* are available. Good public transport. *U.S. license:* Yes, for 3 months. *IDP:* Yes. *Rule of the road:* Right. *Motor clubs:* National Automobile Club de Tunisie, 29 Avenue Habib-Bourguiba, Tunis; *tel.* 241–176, 349–837; partial AAA reciprocity. *Taxi markings:* red and white *petit;* metered.

Population: 7,740,000. *Type of government:* Republic; leader in the Arab world in equal rights for women. Enjoys close and cordial relations with the U.S. despite some brief periods of strain.

Languages: Arabic is the national language, but French is commonly used in business. English is much less common. *Ethnic groups:* 98% Arab, 1% European, less than 1% Jewish. *Religion:* 98% Muslim, 1% Christian, less than 1% Jewish.

Time: EST +6; GMT +1. *Telephone codes:* Country: 216. Agareb 4, Béja 8, Bizerte 2, Carthage 1, Chebba 4, Gabès 5, Gafsa 6, Haffouz 7, Hamman-Sousse 3, Kairouan 7, Le Kef 8, Khenis 3, Médenine 5, Tabarca 8, Tozeur 6, Tunis 1. Good domestic and international service. *Pay phone system:* Coins.

Holidays: January 1, 18; March 20; April 9; May 1; June 1, 2; July 25; August 3, 13; September 3; October 15; plus Muslim holidays—check with consulate. *Date/month system:* D/M.

Business hours: 8 AM to 12 noon, 1 PM to 6 PM Monday to Thursday, 8 AM to 12 noon, 1 PM to 5 PM Friday in the winter; some businesses are open 8 AM to 7 PM Saturday. 7 AM to 1 PM Monday to Friday in the summer. *Government hours:* 8:30 AM to 1 PM, 3 PM to 5:45 PM Monday to Thursday, 8:30 AM to 1:30 PM Friday and Saturday in the winter (Note: some ministries are adopting 9 AM to 4 PM hours without lunch); 7:30 AM to 1:30 PM in summer. *Business dress code:* Conservative.

Climate and terrain: Most of the population live along the coastal areas. The northern portion of the country is well watered, fertile, and the main agricultural belt; a central coastal plain is noted for olives and pasture land; and a semiarid central steppe area leads to the Sahara. Several ranges of the Atlas Mountains extend into Tunisia from Algeria. Northern and central Tunisia has a Mediterranean climate, with mild, rainy winters and hot, dry summers. The greatest amount of rain falls from December to March. The south is hot and dry year-round. *Temperature ranges* (Tunis): January: 43° to 58°F; April: 51° to 70°F; July: 68° to 90°F; October: 59° to 77°F.

Visas: Standard tourist entry, requiring passport; no visa is needed for stays of up to 4 months. *Health requirements:* Yellow fever vaccination is required if coming from an infected area. *Equipment importation:* Normally a declaration without a bond is adequate, but making advance arrangements through the embassy is recommended, particularly if your gear is extensive and certainly if you are bringing motion picture equipment.

Electricity: Both 127/50 and 220/50. *Plug types:* C.

Currency: Dinar (TUD); 1,000 Millimes. Currency may not be imported or exported.

U.S. embassy in the country: 144 Avenue de la Liberté, 1002 Tunis-Belvedere; *tel.* 782–566; *telex:* 13379 AMTUN TN.

Embassy in U.S.: 1515 Massachusetts Avenue NW, Washington, DC 20005; *tel.* 202–862–1850. *Consulates:* California: 415–922–9222; New York: 212–742–6585.

Central tourism office in country: Office National du Tourisme Tunisien, 1 Avenue Mohamed V, Tunis; *tel.* 259–133, 341–077; *telex:* 12381.

Health suggestions: Adequate medical care is available in Tunis and other major cities. No particular health hazards, but water is not always potable, especially outside major cities.

Cultural mores and taboos: Business cards in English or French with Arabic on the reverse are common. Tunisians may

drink alcohol but do so discreetly and do usually consume pork. Muslim customs are not quite as strict as in other Islamic countries, particularly regarding rights of women.

Equipment rental/sales: *Balcar:* Foly Foto, Tunis; *tel.* 892–180.

Gratuity guidelines: Service is usually included in the bill; leaving a bit more is customary.

TURKEY
Republic of Turkey
Türkiye Cumhuriyeti

The State Department cautions of separatist attacks in the southeast and of other travel difficulties, particularly while driving at night, in some other remote areas. Be sure to consult with the U.S. embassy upon arrival. Turkey strictly enforces restrictions against illegal exportation of antiquities. Be sure to retain sales or museum receipts for all artifacts.

Location: In southeastern Europe and southwestern Asia, bounded on the north by the Black Sea, the northeast by the USSR, the east by Iran, the southeast by Iraq, the south by Syria and the Mediterranean Sea, the west by the Aegean Sea, and the northwest by Greece and Bulgaria. *Size:* 301,380 square miles, slightly larger than Texas.

Major cities: *Ankara* (lat. +39.57), İstanbul (lat. +40.58). *Airports:* Esenboga (ESB), 22 miles outside of Ankara; Ataturk (IST), 15 miles outside of İstanbul.

General transportation: Many international flights, with direct links to U.S. Air service and good railways connect most points within Turkey. Main roads are fairly good in the main centers; secondary roads, generally adequate. Steamships connect İstanbul with many major cities. Urban transport by buses, streetcars, and standard or shared taxis *(dolmus)*. *U.S. license:* Yes, for private vehicles registered abroad. *IDP:* Yes. *Rule of the road:* Right. *Motor clubs:* Türkiye Turing ve Otomobil Kurumu (Touring and Automobile Club of Turkey), Halaskargazi Cad. 364, İstanbul; *tel.* 131–4631/6; partial AAA reciprocity. *Taxi markings:* Checkered stripes, marked TAXI; metered.

Population: 54,200,000. *Type of government:* Republic; parliamentary democracy;

strong constitution. Close relations with the U.S., despite strains over Cyprus in the 1970s.

Languages: Turkish is the only language of about 90% of the population. Businesspeople usually speak some English, French, or German. *Ethnic groups:* 85% Turkish, 12% Kurd, 3% other. *Religion:* 98% Muslim (predominantly Sunni), 2% other (mostly Christian and Jewish).

Time: EST +7; GMT +2. *Telephone codes:* Country: 90. Adana 711, Ankara 41, Antalya 311, Bursa 241, Eskişehir 221, Gaziantep 851, İstanbul 1, İzmir 51, İzmit 211, Kayseri 351, Konya 331, Malatya 821, Mersin 741, Samsun 361. Fair domestic and international service. Some delays may occur during peak hours. *Pay phone system:* Tokens *(jetons)*, at post offices and newsstands.

Holidays: January 1; April 23; May 19; August 30; October 28, 29; December 31; plus religious holidays based on the lunar calendar—check with consulate. *Date/month system:* D/M.

Business hours: 9 AM to 5 PM Monday to Friday; some businesses are open on Saturday mornings. Businesses often close the day before and after important holidays. *Government hours:* 8:30 AM to 12 noon, 1:30 PM to 5 PM Monday to Friday. *Business dress code:* Same as that of the U.S.

Climate and terrain: Temperate climate with hot, dry summers. The coastal region, particularly in the south and west, enjoys mild but wet winters with sufficient rainfall for cultivation. Winters are colder in the western Anatolian Plateau, a rolling plain that becomes more mountainous toward the east. Eastern Turkey experiences some severe winter weather. The Tigris and Euphra-

tes both flow through Turkey; the Kizil Irmak is the largest river that is entirely on Turkish soil. Subject to severe earthquakes, particularly along the western river valleys. *Temperature ranges* (İstanbul): January: 36° to 45°F; April: 45° to 61°F; July: 65° to 81°F; October: 54° to 67°F; (Ankara): January: 24° to 39°F; April: 40° to 63°F; July: 59° to 86°F; October: 44° to 69°F.

Visas: Standard tourist entry, requiring passport; no visa is needed for stays of up to 3 months. *Health requirements:* No vaccinations required. *Equipment importation:* Carnet.

Electricity: 220/50 (sometimes 110 volts in İstanbul). *Plug types:* C, E, and F.

Currency: Lira (TUL); Kurus.

U.S. embassy in the country: 110 Ataturk Boulevard, Ankara; *tel.* 126–5470; *telex:* 43144 USIA TR. *Consulates:* Adana: 139–106, 142–145, 143–774; İstanbul: 151–3602; İzmir: 149–426, 131–369.

Embassy in U.S.: 1606 Twenty-third Street NW, Washington, DC 20008; *tel.* 202–387–3200. *Consulates:* California: 213–937–0118; Georgia: 404–399–5331; Illinois: 312–263–0644; New York: 212–949–0160; Texas: 713–622–5849.

Tourism office in U.S.: Turkish Cultural and Tourism Office, 2010 Massachusetts Avenue NW, Washington, DC 20036, *tel.* 202–429–9844; 821 United Nations Plaza, New York, NY 10017, *tel.* 212–687–2194.

Central tourism office in country: Ministry of Culture and Tourism, Gavi Mustafa Kemal Bulv. #33, Demirtepe, Ankara; *tel.* 231–7380.

Health suggestions: Public health standards in the larger cities approach U.S. standards, but some precautions are necessary in rural areas. Malaria suppressants are recommended for parts of southeast Anatolia. Water is generally potable in İstanbul. Turkish law requires that at least 1 pharmacy be open in a neighborhood at all times.

Cultural mores and taboos: Turks consider themselves Europeans. Avoid discussions of Cyprus or other tensions with Greece. Expect lots of Turkish coffee; hospitality and sumptuous meals are important.

Gratuity guidelines: Service is often included at hotels and restaurants; leaving another 5% is customary. If not included, leave at least 15%. Taxi drivers are rarely tipped, though the change is appreciated.

UGANDA
Republic of Uganda

Much of Uganda's infrastructure has been damaged or destroyed; insurgency remains in the eastern and northern portions of the country. The State Department cautions about a number of travel hazards outside of Kampala—be sure to check before traveling.

Location: In eastern Africa, bounded on the north by Sudan, the east by Kenya, the south by Tanzania, the southwest by Rwanda, and the west by Zaire. *Size:* 91,134 square miles, slightly smaller than Oregon.

Major cities: *Kampala* (lat. +0.20). *Airports:* Entebbe (EBB), 24 miles outside of Kampala.

General transportation: Flights to Europe (with connections to the U.S.), Africa, and several other international destinations. Rental cars are available. *U.S. license:* Yes, for 90 days. *IDP:* Yes. *Rule of the road:* Left. *Taxi markings:* All colors, some marked TAXI. There are taxi stands; inland private cars serving as taxis can be crowded and unreliable.

Population: 16,500,000. *Type of government:* Republic. The current government promises a return to constitutional rule and has seriously reduced the human rights violations that were the norm for decades, but its control of the country is not complete. Relations with the U.S. have greatly improved with these reforms.

Languages: English (official); Luganda

and Swahili are widely used; other Bantu and Nilotic languages. *Ethnic groups:* 99% African from 3 ethnic groupings: Bantu, Nilotic, and Nilo-Hamitic; the largest tribe is the million-member Baganda (Bantu); 1% European, Asian-Arab. *Religion:* 33% Roman Catholic, 33% Protestant, 18% indigenous beliefs, 16% Muslim. **Time:** EST +8; GMT +3. *Telephone codes:* Country: 256. Entebbe 42, Jinja 43, Kampala 41, Kyambogo 41. No credit card or collect calls to U.S. Fair domestic and international service. Links to U.S. and Europe are generally available. *Pay phone system:* Coins, few available.

Holidays: January 1; April 1; Good Friday; Holy Saturday; Easter Monday; May 1; October 9; December 25, 26; plus a few Muslim holidays. *Date/month system:* D/M.

Business hours: 8:30 AM to 12:45 PM, 2 PM to 4:30 PM Monday to Friday. *Business dress code:* Same as that of the U.S., but a safari suit is also acceptable.

Climate and terrain: About 18% of the land is water or swamp; the most important lake is Lake Victoria in the south. Most of the country is a plateau, 3,000 to 6,000 feet. The Ruwenzori Mountains (known as the Mountains of the Moon), on the border with Zaire, rise to 16,750 feet at Mount Margherita. Uganda has 3 large national game parks. Despite its location on the equator, the climate is pleasant most of the year. Generally, there are 2 dry seasons, from December to February and from June to July, though these are not well defined. The rest of the year is rainy, but most of the rain falls in the southwest and west; the northeast is semi-arid. *Temperature ranges* (Kampala): January: 65° to 83°F; April: 64° to 79°F; July: 62° to 77°F; October: 63° to 81°F.

Visas: *Business visa:* 2 applications, 2 photos, $10.50 fee; allow 2 days for processing. **Health requirements:** Yellow fever and cholera vaccinations. *Equipment importation:* A contact or sponsor in Uganda can probably make arrangements; otherwise, a bond might be required.

Electricity: 240/50. *Plug types:* G.

Currency: Shilling (UGS); Cents.

U.S. embassy in the country: British High Commission Building, Obote Avenue, P.O. Box 7007, Kampala; *tel.* 259–791/5.

Embassy in U.S.: 5909 Sixteenth Street NW, Washington, DC 20011; *tel.* 202–726–7100/2. *Consulates:* New York: 212–949–0110.

Central tourism office in country: Ministry of Tourism, P.O. 4241, Kampala; *tel.* 231–783, 232–971.

Health suggestions: Malaria suppressants are recommended throughout the country. Water is not potable.

Cultural mores and taboos: Be a bit more modest in your dress. Eating habits are somewhat formal—do not eat while walking in the street, for example.

Gratuity guidelines: Service is sometimes included in the bill; if not, leave a tip.

UNION OF SOVIET SOCIALIST REPUBLICS
Soyuz Sovetskykh Sotsialisticheskikh Respublic

The State Department cautions of strict enforcement of prohibitions against importation of any items deemed anti-Soviet, sexually oriented, or not for personal use, as well as religious propaganda. Any traveler with expected health problems should be aware that tour travel is strenuous and that visitors who become ill are sometimes left to fend for themselves within the Soviet health-care system. Theft is on the increase with the widening of tourist visits, and travel to Armenia and Azerbaijan is potentially hazardous because of political unrest and the massive earthquake of 1988.

Location: In eastern Europe and northern and central Asia, bounded on the north by the Barents Sea, Kara Sea, Arctic Ocean, Laptev Sea, and East Siberian Sea, the east by the Bering Straits and Sea, Sea of Okhotsk, Sea of Japan, and the Pacific

Ocean, the south by North Korea, China, Mongolia, Afghanistan, Iran, the Caspian Sea, Turkey, and the Black Sea, and the west by Romania, Hungary, Czechoslovakia, Poland, the Baltic Sea, and Finland. *Size:* 8,649,512, almost 2.5 times the size of the U.S.

Major cities: *Moscow* (lat. +55.46), Leningrad (lat. +59.56), Kiev (lat. +50.25).

Airports: Sheremetyevo (SVO), 18 miles outside of Moscow; Domodedovo (DME), 25 miles outside of Moscow; Vnukovo (VKO), 18 miles outside of Moscow; Pulkovo (LED), 11 miles outside of Leningrad; Borispol (KPP), 24 miles outside of Kiev; Zhulhany (IEV), 7 miles outside of Kiev.

General transportation: Many international flights, with direct links to the U.S. Intercity transport is usually by Aeroflot (SU) or train, most of which are clean and comfortable. The major cities have wide public transport networks, including subways. Some of the best maps of Moscow and Leningrad are available from the CIA. *U.S. license:* No. *IDP:* Yes. *Rule of the road:* Right. *Motor clubs:* INTOURIST (see **Central tourism office in country,** below); partial AAA reciprocity. *Taxi markings:* Checkered markings with green light indicating availability in upper right windshield; can be scarce at times.

Population: 286,500,000. *Type of government:* Communist state. The party rules; policy making is directed by the Politburo, day-to-day executive and administrative direction comes from the Secretariat. The General Secretary traditionally holds the top position. Theoretically, the Politburo and Secretariat report to the Central Committee of the party, and ultimately to the Party Congress, which meets every 5 years, but generally these organs have approved policies set out by the Politburo and Secretariat. The governmental apparatus has little independent authority. The KGB is empowered to function domestically as well as internationally. Relations with the U.S. have been improving in the Gorbachev era.

Languages: Russian (official); more than 200 languages and dialects are spoken, at least 18 of which have more than 1 million speakers. More and more young people are learning English but it is not, as of yet, commonly spoken or understood. *Ethnic groups:* 52% Russian, 16% Ukrainian, 32% divided among 100 other ethnic groups according to 1979 census. *Religion:* 70% atheist, 18% Russian Orthodox, 9% Muslim, 3% Jewish, Protestant, Roman Catholic, other.

Time: EST +8 (Moscow); GMT +3 to +13. *Telephone codes:* No direct-dial from U.S.—operator-assisted calls only. No credit card or collect calls to U.S. International service theoretically exists but difficulties placing calls may ensue. Direct-dial service to many countries was suspended in 1982 and has been only partially reinstated. *Pay phone system:* Coins.

Holidays: January 1; March 8; May 1, 2, 9; October 7; November 7, 8; December 5. *Date/month system:* D/M.

Business hours: 9 AM to 5 PM Monday to Friday, with an hour for lunch between 12 noon and 2 PM. *Business dress code:* Conservative.

Climate and terrain: Largest country in the world, with most of the land above 50° north latitude; Moscow is on the same latitude as southern Alaska. In the west, from the Pripet Marches near the Polish border to the Ural Mountains, is a broad plain, broken only by occasional low hills. Crossing this plain to the south are a number of rivers, the most important being the Dnieper and the Volga. Between the Black and Caspian seas lie the scenic Caucasus Mountains. The Urals mark the traditional division between European and Asiatic Russia. To the east are the vast Siberian lowlands and deserts of central Asia. Beyond are the barren Siberian highlands and mountain ranges of the Soviet far east. The farther higher ranges include the Pamirs, Altai, and Tien Shan. In Siberia, the frozen tundra leads south to a large forest belt covering half the country. South of the forests are the steppes, among the richest soil

in the world but hampered in agriculture by the rainless climate and the *sokhovey*, drying flows of hot air. The overall climate, though varied, tends to be characterized by long, severe winters and brief summers. Spring and fall weather can be unpredictable. A small subtropical zone lies south of the steppes, along the shores of the Black and Caspian seas. *Temperature ranges* (Moscow): January: 9° to 21°F; April: 31° to 47°F; July: 55° to 76°F; October: 34° to 46°F. Leningrad's temperatures are similar.

Visas: Standard tourist visa, valid for 1 entry, requiring no fee, 3 photos, passport or photocopy of passport. *Health requirements:* No vaccinations required. *Equipment importation:* Arranged with visa.

Electricity: 220/50. *Plug types:* C and I.

Currency: Ruble (RUB), Kopecks. No Soviet currency can be imported or exported. Declare all items of value upon entry, including commonplace items such as rings, and carry the declaration with you at all times. Do not exchange money at unofficial sources, and keep all exchange receipts.

U.S. embassy in the country: Ulitsa Chaykovskogo 19/21/23, Moscow; *tel.* 252–24–51/9; *telex:* 413160 USGSO SU. *Consulates:* Leningrad: 274–8235.

Embassy in U.S.: 1825 Phelps Place NW, Washington, DC 20008; *tel.* 202–332–1513. *Consulates:* California: 415–922–6642.

Tourism office in U.S.: INTOURIST, 630 Fifth Avenue, New York, NY 10111; *tel.* 212–757–3884.

Central tourism office in country: INTURIST, 16 Marx, Moscow, 103009; *tel.* 203–6962.

Health suggestions: Adequate medical care is available in the larger cities, although the methods of treatment may vary from those common in the U.S. Treatment is generally provided free of charge. No immunizations are generally required beyond those normally kept current in the U.S. There have been reports in recent years of an intestinal parasite, *Giardia lamblia*, suspected of being transmitted from tap water, or perhaps some cold foods such as salads, particularly in Leningrad. Rely on bottled water.

Cultural mores and taboos: Enormous patience is required when dealing with the bureaucracy. Refer to the "Soviet Union," not "Russia."

Photographic restrictions: Military sites, border areas, airports, bridges, some industrial and utility installations. Photography from airplanes is forbidden.

Gratuity guidelines: Tipping is officially forbidden. Rely on a small gift if you want to show appreciation. American cigarettes, cassette tapes, and pens are popular. Sometimes waiters and cab drivers keep the change as a form of tip unless asked for it.

UNITED ARAB EMIRATES
Ittihād al-Imarat al-Arabiyah

Location: In southwestern Asia, bounded on the north by Qatar and the Persian Gulf, the east by the Gulf of Oman and Oman, and the south and west by Saudi Arabia. *Size:* 32,000 square miles, slightly smaller than Maine.

Major cities: *Abu Dhabi* (lat. +24.28), Dubai (lat. +25.14). *Airports:* Abu Dhabi (AUH), 27 miles outside of Abu Dhabi; Dubai (DXB), 3 miles outside of Dubai.

General transportation: Many international flights, with direct links to the U.S.

Four international airports, all within 100+ miles of each other; rapidly expanding infrastructure. The 7 emirates are connected by excellent paved roads. Rental cars are available. *U.S. license:* Temporary local license will be issued upon presentation of national license and letter from visitor's sponsor in the U.A.E. *IDP:* Yes, for visitors driving their own cars registered in their country of residence. *Rule of the road:* Right. *Motor clubs:* Automobile and Touring Club for United Arab Emirates, P.O. Box 1183,

Sharjah; *tel.* 523183; partial AAA reciprocity. *Taxi markings:* Marked TAXI; set price, some metered; tipping is not customary.

Population: 2,000,000. *Type of government:* Federation, with specified powers delegated to the central government and other powers reserved by the member sheikhdoms. Arrival of U.S. ambassador in 1974 formalized years of friendly informal relations.

Languages: Arabic. English is widely understood in business and government. Farsi is spoken among the large Persian community. *Ethnic groups:* 19% Emirian, 23% other Arab, 50% South Asian (fluctuating), 8% other expatriates (including Westerners and East Asians); fewer than 20% of the population are citizens. *Religion:* 96% Muslim (80% Sunni, 16% Shi'a), 4% Christian, Hindu, and other.

Time: EST +9; GMT +4. *Telephone codes:* Country: 971. Abu Dhabi 2, Ajman 6, Al-Ain 3, Aweer 58, Dhayd 6, Dibba 70, Dubai 4, Falaj al-Moalla 6, Fujairah 70, Jebel Ali 84, Jebel Dhanna 52, Khawanji 58, Ras al-Khaimah 77, Sharjah 6, Tarif 53, Umm al-Quawain 6. Good, modern domestic and international service. *Pay phone system:* Coins.

Holidays: January 1; August 6; December 2; plus Muslim holidays—check with consulate. *Date/month system:* D/M.

Business hours: Generally 7:30 AM to 1 PM, 4 PM to 7 PM Saturday to Thursday, although many firms close a half or whole day on Thursday. *Government hours:* 8 AM to 2 PM Saturday to Wednesday, 8 AM to 12 noon Thursday; offices close an hour earlier in summer. *Business dress code:* Same as that of the U.S., perhaps a bit more formal.

Climate and terrain: Fast growth from village life to modern city-states. A barren, flat, island-dotted coastal plain gives way to rolling sand dunes that extend southward to merge with the vast wasteland of Saudi Arabia's Rub 'al Khali (Empty Quarter). Frequent dust and sand storms. The eastern end of the country includes part of the Hajar Mountains. Most of the emirates have a hot, dry desert climate (up to 120°F in the shade in summer), with slightly cooler temperatures and enough rainfall to allow some cultivation in the eastern mountains. Mid-October to April are generally slightly cooler months. *Temperature ranges* (Sharjah): January: 54° to 74°F; April: 65° to 86°F; July: 82° to 100°F; October: 71° to 92°F.

Visas: *Business visa:* Requires sponsor in the United Arab Emirates to arrange visa or meet you at the airport. *Photojournalists:* Must contact embassy, which will telex United Arab Emirates; allow at least 2 weeks for reply. *Health requirements:* Yellow fever vaccination is required if coming from an infected area. *Equipment importation:* Visa sponsor will arrange for equipment.

Electricity: Mostly 240/50 (220 in Dubai, 230 in Ajman). *Plug types:* D and G.

Currency: Dirham (ADH); Fils.

U.S. embassy in the country: Al-Sudan Street, P.O. Box 4009, Abu Dhabi; *tel.* 336–691; *telex:* 23513 AMEMBY EM. *Consulates:* Dubai: 371–115.

Embassy in U.S.: 600 New Hampshire Avenue NW, Suite 740, Washington, DC 20037; *tel.* 202–338–6500.

Central tourism office in country: DNATA, Dubai Airlines Center, P.O. Box 1515, Dubai; *tel.* 228–151.

Health suggestions: No unusual precautions are necessary. Water is potable. Adequate medical care is available. Malaria suppressants are recommended for some portions of northern emirates.

Cultural mores and taboos: Muslim injunctions against alcohol and pork prevail. Do not cross legs, point or gesture at someone with the hand, show the soles of the feet, or pass or accept items with the left hand. If invited to a mosque, dress to cover the entire body, remove shoes (tip the attendant who gives you slippers), and do not walk in front of others praying. Appointments may not start on time. It is rude to accept anything less than 3 small cups of coffee.

Photographic restrictions: Oil facilities, airports, military sites; exercise caution about photographing women.

Gratuity guidelines: Service is usually included in the bill; leaving a bit extra is not necessary.

UNITED KINGDOM OF GREAT BRITAIN AND NORTHERN IRELAND

Security is tight in Northern Ireland, particularly in "Control Zones." Expect to be searched frequently (you may be searched before entering some buildings throughout the UK).
Location: In northwestern Europe, north of France, east of Ireland. *Size:* 94,226 square miles, slightly smaller than Oregon.
Major cities: *London* (lat. +51.29), Glasgow (lat. +55.53). *Airports:* Heathrow (LHR), 15 miles outside of London; Gatwick (LGW), 27 miles outside of London; London City (LCY), 6 miles outside of London; Glasgow (GLA), 9 miles outside of Glasgow; Prestwick (PIK), 32 miles outside of Glasgow.
General transportation: Excellent and complete network of domestic and international service and ground transport of every kind. *U.S. license:* Yes. *IDP:* Yes. *Rule of the road:* Left. *Motor clubs:* The Automobile Association (AA), Fanum House, Basingstoke, Hants, England; *tel.* (256) 20123; full AAA reciprocity. *Taxi markings:* Usually black Austins, marked TAXI; metered.
Population: 57,000,000. *Type of government:* Constitutional monarchy. Extremely close relations with the U.S.
Languages: English; Welsh is spoken by about 26% of the population in Wales; about 60,000 in Scotland speak a Scottish form of Gaelic. *Ethnic groups:* 81.5% British, 9.6% Scottish, 2.4% Irish, 1.9% Welsh, 1.8% Ulster, 2.8% West Indian, Indian, Pakistani, other. *Religion:* 27 million Anglican, 5.3 million Roman Catholic, 2 million Presbyterian, 760,000 Methodist, 450,000 Jewish.
Time: EST +5; GMT 0. *Telephone codes:* Country: 44. Belfast 232, Birmingham 21, Bournemouth 202, Cardiff 222, Durham 385, Edinburgh 31, Glasgow 41, Gloucester 452, Ipswich 473, Liverpool 51, London 1, Manchester 61, Nottingham 602, Prestwick 292, Sheffield 742, Southampton 703. Excellent domestic and international service. *Pay phone system:* Coins and cards (available at newsstands).
Holidays: *England and Wales:* January 1; Good Friday; Easter Monday; first Monday in May; last Monday in May; last Monday in August; December 25, 26. *Scotland:* January 1, 2; Good Friday; first Monday in May; first Monday in August; December 25. *Northern Ireland:* January 1; March 17; Good Friday; Easter Monday; last Monday in May; July 12 (Orangeman's Day); last Monday in August; December 25, 26. *Date/month system:* D/M.
Business hours: 9 AM to 5 PM Monday to Friday. *Government hours:* 9 AM to 1 PM, 2 PM to 5:30 PM Monday to Friday. *Business dress code:* Conservative.
Climate and terrain: Level to rolling plains in the east and southeast. The farming region of the southern uplands in Scotland extend north to the Scottish lowlands and eventually the famous Scottish granite highlands. Wales is almost all hilly and mountainous. Because of the prevailing southwesterly winds over the North Atlantic Current, the climate is temperate and equable, with even distributions of rainfall; more than half the days are overcast. *Temperature ranges* (London): January: 35° to 44°F; April: 40° to 56°F; July: 55° to 73°F; October: 44° to 58°F; (Belfast): January: 34° to 42°F; April: 38° to 53°F; July: 52° to 65°F; October: 44° to 55°F; (Edinburgh): January: 35° to 43°F; April: 39° to 50°F; July: 52° to 65°F; October: 44° to 53°F.
Visas: Standard tourist entry, requiring passport; no visa is needed for stays of up to 6 months. *Health requirements:* No vacci-

nations required. *Equipment importation:* Carnet.
Electricity: 240/50. *Plug types:* C and G.
Currency: Pound (UK£); Pence.
U.S. embassy in the country: 24/31 Grosvenor Square, London W1A 1AE; *tel.* 499–9000; *telex:* 266777. *Consulates:* Belfast: 228–239; Edinburgh: 556–8315.
Embassy in U.S.: 3100 Massachusetts Avenue NW, Washington, DC 20008; *tel.* 202–462–1340. *Consulates:* California: 213–385–7381, 415–981–3030; Georgia: 404–524–5856; Illinois: 312–346–1810; Massachusetts: 617–437–7160; New York: 212–752–8400; Ohio: 216–621–7674; Texas: 214–637–3600.
Tourism office in U.S.: British Tourist Authority, 40 West Fifth-seventh Street, New York, NY; *tel.* 212–581–4700. British Information Services, 845 Third Avenue, New York, NY 10022; *tel.* 212–752–8400.
Central tourism office in country: Press and Public Relations of the British Tourist Authority, 24 Grosvenor Gardens, London SW IW OET; *tel.* 846–9000.
Health suggestions: Health standards are high; good medical care is available throughout.
Cultural mores and taboos: Traditionally, first names are reserved for friendship, but more informality is developing in this area. The people of Scotland are Scots; their traditions are Scottish. Scotch is a beverage. The Scots, Irish, and Welsh live in the United Kingdom but are not English, though the Scots and Welsh are British.
Photographic restrictions: Only where posted.
Color labs: *Kodak* Ltd., Subsidiary Photofinishing Companies, P.O. Box 66, Station Road, Hemel Hempstead, Hertfordshire HP2 7EJ. *Fuji* Processing Lab, Faraday Road, Dorcan Swindon, Wilshire SN3 5HW.
Equipment rental/sales: *Balcar:* South Bank Studio Centre, London; *tel.* 237–2452.
Film commissions: Film and Television Unit of the Central Office of Information, Hercules Road, London SEI 7OU; *tel.* 928–2345.
Gratuity guidelines: Tip from 10% to 15% routinely, more for special service. Give taxi drivers as much as 25%.

URUGUAY
Oriental Republic of Uruguay
República Oriental del Uruguay

Location: In southeastern South America, bounded on the north by Brazil, the east by Brazil and the Atlantic Ocean, the south by the Atlantic Ocean, and the west by Argentina. *Size:* 68,536 square miles, slightly smaller than Oklahoma.
Major cities: *Montevideo* (lat. −34.52).
Airports: Carrasco (MVD), 10 miles outside of Montevideo.
General transportation: Many international flights, with direct links to the U.S. No railways; internal travel is largely by bus and car. Main roads are good; secondary roads, adequate. Taxis are readily available.
U.S. license: Yes, for 90 days if presented to authorities. *IDP:* Yes. *Rule of the road:* Right. *Motor clubs:* Automóvil Club del Uruguay, Avenida del Libertador Brig Lavelleja y Uruguay, Montevideo; *tel.* 42091/2, 45016, 46131, 412528/9; partial AAA reciprocity. *Taxi markings:* Black, purple, marked TAXI, light on top; metered.
Population: 3,000,000. *Type of government:* Republic; returning to civilian rule. Friendly relations with the U.S.
Languages: Spanish. Use of English among businesspeople is increasing. *Ethnic groups:* 88% white (mostly of Spanish origin, but 25% of the population is of Italian descent), 8% mestizo, 4% black. *Religion:* 66% Roman Catholic (less than half the population attends church regularly), 2% Protestant, 2% Jewish, 30% nonprofessing or other.

Time: EST +2; GMT −3. *Telephone codes:* Country: 598. Atlántida 372, Colonia 522, Florida 352, La Paz 322, Las Piedras 322, Las Toscas 372, Maldonado 42, Mercedes 532, Minas 442, Montevideo 2, Parque del Plata 372, Paysandú 722, Punta del Este 42, Salinas 372, San José 342, San José de Carrasco 382. International service is good, but some delays may be encountered. Domestic system is overburdened. *Pay phone system:* Tokens, available at newsstands and shops.

Holidays: January 1, 6; 2 days of Carnaval (before Ash Wednesday); 2 days that fall 6 weeks after Carnaval (Tourism Week); April 23; May 1, 18; June 19; July 18; August 25; October 12; November 2; December 25. *Date/month system:* D/M.
Business hours: 9 AM to 7 PM Monday to Friday. *Government hours:* 7 AM to 1 PM Monday to Friday in summer; 12 noon to 6 PM Monday to Friday in winter. *Business dress code:* Conservative.

Climate and terrain: Attractive coastline features fine beaches and resorts, including Punta del Este; mostly rolling grassy plains and low hills; abundant pasture land is famous for stock breeding. Montevideo is the only large city; the rest of the population lives in about 20 towns. Climate is temperate with cool winters, but freezing temperatures are almost unknown. *Temperature ranges* (Montevideo): January: 62° to 83°F; April: 53° to 71°F; July: 43° to 58°F; October; 49° to 68°F.

Visas: Standard tourist entry, requiring passport; no visa is needed for stays of up to 3 months. *Health requirements:* No vaccinations required. *Equipment importation:* Bring equipment list; a bond will probably be necessary.
Electricity: 220/50. *Plug types:* C and I.
Currency: Peso (NUP); Centimos.
U.S. embassy in the country: Lauro Muller 1776, Montevideo; *tel.* 40–90–51 (40–91–26 after hours).
Embassy in U.S.: 1918 F Street NW, Washington, DC 20006; *tel.* 202–331–1313.
Consulates: California: 213–394–5777; Illinois: 312–236–3366; Louisiana: 504–525–8354; New York: 212–753–8193.
Central tourism office in country: Dirección de Turismo, Brigadier General Lavalleja 1409, Montevideo; *tel.* 983–165.
Health suggestions: Water is generally potable. Health standards are high. No special immunizations are necessary. Good medical care is available in Montevideo.
Cultural mores and taboos: Business manners are conservative. Refrain from personal discussions except with close friends. Cosmopolitan, European, and modern atmosphere in the capital.
Color labs: *Kodak* Uruguaya Ltd., P.O. Box 806, Montevideo.
Gratuity guidelines: Service charge of 10% is sometimes included, but give an additional 10%. Otherwise, same as those of the U.S.

VENEZUELA
Republic of Venezuela
República de Venezuela

Location: In northern South America, bounded on the north by the Caribbean Sea, the east by Guyana, the south by Brazil, and the west by Colombia. *Size:* 352,143 square miles, about twice the size of California.
Major cities: *Caracas* (lat. +10.30). *Airports:* Simon Bolívar (CCS), 12 miles outside of Caracas.
General transportation: Many interna-

tional flights, with direct links to the U.S. Interior cities are linked to the capital by air, rail, and highway. Caracas is completing a new subway. *U.S. license:* No. *IDP:* Yes.
Rule of the road: Right. *Motor clubs:* Touring y Automóvil Club de Venezuela (TACV), Centro Integral "Santa Rosa de Lima," Locales 11, 12, 13, y 14, Caracas; *tel.* 915–571; full AAA reciprocity. *Taxi mark-*

ings: All colors, marked TAXI; metered; standard and fixed-route taxis available. **Population:** 18,800,000. *Type of government:* Republic; South America's oldest democracy. Good, cooperative relations with the U.S. **Languages:** Spanish. Many people in business and government understand English. *Ethnic groups:* 67% mestizo, 21% white, 10% black, 2% Indian. *Religion:* 96% nominally Roman Catholic, 2% Protestant. **Time:** EST + 1; GMT − 5. *Telephone codes:* Country: 58. Barcelona 81, Barquisimeto 51, Cabimas 64, Caracas 2, Ciudad Bolívar 85, Coro 68, Cumaná 93, Los Teques 32, Maiquetía 31, Maracaibo 61, Maracay 43, Maturín 91, Mérida 74, Puerto Cabello 42, San Cristóbal 76, Valencia 41. Modern and expanding domestic and international service. *Pay phone system:* Coins.

Holidays: January 1; Carnaval; Holy Thursday; Good Friday; April 19; May 1; Ascension Day (40 days after Easter); Corpus Christi (June); June 24, 29; July 5, 24; August 15; September 4; October 12; November 1; December 25; plus several local holidays. *Date/month system:* D/M. **Business hours:** 8 AM to 6 PM Monday to Friday, with midday break. *Government hours:* 7:30–9 AM to 3:30–5:30 PM Monday to Friday. *Business dress code:* Same as that of the U.S.; a bit more informal in tropical cities such as Maracaibo.

Climate and terrain: Consists of 4 regions: the Andes Mountains and adjacent hill country in the northwest; the coastal zone north of the mountains bordering Lake Maracaibo and the Caribbean, including the Orinoco delta; the plain *(llanos),* extending from the mountains south and east to the Orinoco River; the Guyana highlands, a vast area of high plateaus and rolling plains south and east of the Orinoco. Angel Falls, the world's highest waterfall, is in this area. Although in the tropics, the temperature varies with the altitude. The lowland coastal area is hot and humid, as are the inland river valleys. The highlands are generally warm during the day and cool at night. For most of the country, the rainy season is from May to November; the rest of the year is dry. *Temperature ranges* (Caracas): January: 56° to 75°F; April: 60° to 81°F; July: 61° to 78°F; October: 61° to 79°F.

Visas: Standard tourist entry, requiring passport, tourist card/visa. Tourist card can be obtained from airlines, no fee, valid for 60 days, not extendable; tourist visas are available from the consulate, valid for 60 days, extendable, $2 fee, multiple entries. Also need proof of return ticket/sufficient funds, proof of employment. *Health requirements:* No vaccinations required. *Equipment importation:* Bring equipment list; no bond is necessary. **Electricity:** 120/60. *Plug types:* I and J. **Currency:** Bolívar (VBO); Centimos.

U.S. embassy in the country: Avenida Francisco de Miranda and Avenida Principal de la Floresta, P.O. Box 62291, Caracas 1060-A; *tel.* 284–7111, 284–6111; *telex:* 25501 AMEMB VE. *Consulates:* Maracaibo: 84–253/4, 52–54–55, 83–504/5. **Embassy in U.S.:** 2445 Massachusetts Avenue NW, Washington, DC 20008; *tel.* 202–797–3800. *Consulates:* California: 415–421–5172; Florida: 305–446–2851; Illinois: 312–236–9655; Louisiana: 504–522–3284; Maryland: 301–962–0362/3; Massachusetts: 617–266–9355; New York: 212–826–1660; Pennsylvania: 215–923–2905; Texas: 713–961–5141.

Central tourism office in country: Corpo Turismo, Torre Capriles, Plaza Venezuela, Caracas.

Health suggestions: Good medical services are available. Water is not always potable; rely on bottled. Yellow fever vaccination is recommended by CDC for travel outside urban areas. Malaria suppressants are recommended for rural areas of border states and some of the southeastern states.

Cultural mores and taboos: Modern, cosmopolitan atmosphere. The pace is a bit slower than that of the U.S.; be punctual,

but appointments may not start on time. People stand close in conversation—do not back away. Maintain eye contact when conversing. Do not refuse coffee lightly.
Color labs: *Kodak:* Foto Interamericana de Venezuela, S.A., Apartado 80658, Caracas 1080-A.

Equipment rental/sales: *Profoto:* Foto Lido SRL, Valencia; *tel.* 212–459.
Gratuity guidelines: If service is included in the bill, leave an additional 10%; otherwise, same as those of the U.S. Taxi drivers do not expect tips.

VIETNAM
Socialist Republic of Vietnam
Cong Hoa Xa Hoi Chu Nghia Viet Nam

The State Department discourages visits to Vietnam because of lack of American representation there. Americans have been detained incommunicado for months. Credit cards may not be used, but media representatives and researchers may purchase and bring back any materials directly related to their work.
Location: In southeastern Asia, bounded on the north by China, the east by the Gulf of Tonkin and the South China Sea, the southwest by the Gulf of Siam, and the west by Kampuchea and Laos. *Size:* 128,401 square miles, slightly larger than New Mexico.
Major cities: *Hanoi* (lat. +21.03), Ho Chi Minh City (Lat. +10.49). *Airports:* Gia Lam (HAN), 10 miles outside of Hanoi; Tan Son Nhut (SGN), 5 miles outside of Ho Chi Minh City.
General transportation: Hanoi is linked to eastern Europe, Moscow, and a few Communist states in Asia. Ho Chi Minh City has more international flights, with connections to the U.S. through Manila. There are no taxis, but most travel is escorted. *U.S. license:* No. *IDP:* Yes. *Rule of the road:* Right.
Population: 65,200,000. *Type of government:* Communist state. No relations with the U.S.
Languages: Vietnamese (official), French, Chinese, English, Khmer, tribal languages (mon-Khmer and Malayo-Polynesian). *Ethnic groups:* 85% to 90% predominantly Vietnamese, 3% Chinese; ethnic minorities include Muong, Thai, Meo, Khmer, Man,

Cham. *Religion:* Buddhist, Confucian, Taoist, Roman Catholic, indigenous beliefs, Islamic, Protestant.
Time: EST +12; GMT +7. *Telephone codes:* No service to the U.S. Minimal domestic and international service. *Pay phone system:* None.
Climate and terrain: Southern part dominated by Mekong delta, making the country low, flat, fertile, and marshy. Immediately north and east of Ho Chi Minh City (formerly Saigon), the topography is more varied: low-lying tropical rain forest, upland forest, and the rugged terrain of the Annamite Mountain chain. Ho Chi Minh City and the Mekong delta to the south experience a year-round tropical climate; the central lowlands and mountainous regions are cool from October to March. Rainfall is heavy in the delta and highlands in summer and in the central lowlands in winter. Most of northern Vietnam is mountainous or hilly. About half of the rugged highland areas are covered with a thick canopy of jungle. The lowlands consist principally of the Red River delta and coastal plains, which extend northeast and southeast from the delta. This area is densely populated and seasonally flooded. The north has a monsoon climate—a hot, humid wet season from mid-May to mid-September (southwest monsoon), a relatively warm, humid dry season from mid-October to mid-March (northeast monsoon), and 2 short transitional periods. *Temperature ranges* (Hanoi): January: 58° to 68°F; April: 70° to 80°F; July: 79° to 92°F; October: 72° to 84°F; (Ho Chi Minh City): January: 70°

to 89°F; April: 76° to 95°F; July: 75° to 88°F; October: 74° to 88°F. **Visas:** No U.S. diplomatic or consular relations or third-party representation. Visa must be obtained from a country with diplomatic relations with Vietnam. *Health requirements:* Yellow fever vaccination is required if coming from an infected area. *Equipment importation:* Arrange for with visa. **Electricity:** Both 127/50 and 220/50. *Plug types:* Data unavailable.

Currency: Dong; Xu. **U.S. embassy in the country:** None. **Embassy in U.S.:** None. **Health suggestions:** Malaria suppressants are recommended for rural areas except in the Red and Mekong deltas. Cholera infection is present. **Photographic restrictions:** Military, some industrial complexes. You will be accompanied in any event. **Gratuity guidelines:** Tips are not expected but will be accepted.

WESTERN SAMOA
Independent State of Western Samoa
Malotuto'atasi o Samoa i Sisifo

Location: In the southwestern Pacific, north of Tonga, northeast of Fiji. *Size:* 1,133 square miles, slightly smaller than Rhode Island. **Major cities:** *Apia* (lat. −13.48). *Airports:* Faleolo (APW), 23 miles outside of Apia. **General transportation:** Regular flights to several Pacific and Australian points. Flights and ferry service from Pago Pago, American Samoa. Daily air and ferry service is available to and from Upolo and Savai'i islands. Buses, car rentals, and taxis are available. *U.S. license:* No. *IDP:* Yes. *Rule of the road:* Right. *Taxi markings:* All colors, marked TAXI; set price. **Population:** 180,000. *Type of government:* Constitutional monarchy under a native chief; legal system based on British system and local custom. Relations with the U.S. have expanded with a consular office in Apia. **Languages:** Samoan (Polynesian), English. *Ethnic groups:* Samoan, about 7% Euronesians, 0.4% European. *Religion:* 99.7% Christian (about 50% associated with the London Missionary Society; includes Congregational, Roman Catholic, Methodist, Latter-Day Saints, Seventh-Day Adventist). **Time:** EST −6; GMT −11. *Telephone codes:* No direct-dial from U.S.—operator-assisted calls only. No credit card calls to

U.S. Domestic and international services are limited but available. *Pay phone system:* None. **Holidays:** January 1, 2; Good Friday; Holy Saturday; Easter Monday; April 25; June 1, 2, 3; October 12; November 2; December 25, 26. *Date/month system:* D/M. **Business hours:** 8 AM to 12 PM, 1 PM to 4:30 PM Monday to Friday. *Business dress code:* Informal; open shirt is acceptable. **Climate and terrain:** Formed from volcanic ranges, last active in 1911; consists of 2 main islands and 2 small islands. Narrow coastal plain and rocky, rugged interior. Climate is tropical, with rainy season from October to March and dry season from May to October. High humidity and average daily temperatures of 80°F year-round. **Visas:** Standard tourist entry, requiring proof of return ticket, passport; no visa is needed for stays of up to 30 days. *Health requirements:* Yellow fever vaccination if coming from infected area. *Equipment importation:* Bring equipment list; no bond is necessary. **Electricity:** 230/50. *Plug types:* Data unavailable. **Currency:** Tala (SAT); Sene. **U.S. embassy in the country:** None; affairs are handled through the U.S. consular agency, P.O. Box 4463 Matautu, Apia; *tel.* 34336.

Embassy in U.S.: None; affairs are handled through the New Zealand embassy, 37 Observatory Circle NW, Washington, DC 20008, *tel.* 202-328-4800; or through the U.N. mission, 820 Second Avenue, New York, NY 10017, *tel.* 212-599-6196. **Central tourism office in country:** Western Samoa Visitors Bureau, P.O. Box 882, Apia; *tel.* 20471.

Health suggestions: Basic medical services are available in Apia. Free of malaria. Water is not potable. **Cultural mores and taboos:** Don't point with the feet or legs. Respect the authority of local chiefs. **Gratuity guidelines:** Tipping is thought insulting; consider a small gift instead.

YEMEN, NORTH
Yemen Arab Republic
Al-Jumhuriyat al-Arabiyah al-Yamaniyah

Location: In southwestern Asia, bounded on the north by Saudi Arabia, the east and south by South Yemen, and the west by the Red Sea. *Size:* 75,290 square miles, about the size of Nebraska. **Major cities:** *San'a* (lat. +15.24). *Airports:* San'a (SAH), 15 miles outside of San'a. **General transportation:** Ample international flights, with direct links to the U.S. through Europe. No railroads; limited bus service. Taxis can be rented by the day for regional travel, and all major roads are paved. *U.S. license:* No. *IDP:* Yes. *Rule of the road:* Right. *Taxi markings:* White body with black stripe, marked TAXI; both metered and set price. **Population:** 6,730,000. *Type of government:* Republic; military regime since 1974; essentially a tribal society. Good relations with the U.S. **Languages:** Arabic. *Ethnic groups:* 90% Arab, 10% Afro-Arab; population about equally divided between the Shi'a Zaidi community in the north, central, and eastern portions and the Sunni Shafa'i in the south and southwest. *Religion:* 100% Muslim. **Time:** EST +8; GMT +3. *Telephone codes:* Country: 967. Al-Marawyah 3, Al-Qaidah 4, Amran 2, Bajil 3, Bait al-Faqih 3, Dhamar 2, Hodeida 3, Ibb 4, Mabar 2, Rada 2, Rawda 2, San'a 2, Ta'izz 4, Yarim 4, Zabid 3. Poor but improving domestic and international service. *Pay phone system:* Coins; few available.

Holidays: March 1; May 1; June 13; September 26; October 14; plus Muslim holidays—check with consulate. *Date/month system:* D/M. **Business hours:** 8 AM to 1 PM, 4 PM to 7:30 PM Saturday to Thursday; many firms close at 12 noon on Thursday. *Government hours:* 8 AM to 1:30 PM Saturday to Thursday. *Business dress code:* Conservative. **Climate and terrain:** The narrow coastal plain of Tihama, a hot, humid, sandy, semidesert strip about 40 miles wide, separates the Red Sea from the generally less arid mountainous interior. The mountains, terraced for agriculture, reach 12,000 feet. The interior normally has an agreeable climate and sufficient rainfall but has endured drought in recent years. Farther to the east is harsh desert. Centrally located San'a is 7,120 feet above sea level. **Visas:** Obtain permission from Ministry of Foreign Affairs, Alollfi Square, San'a, Yemen Arab Republic, *tel.* 73534, 72282, 73430; *telex:* 2216. The press has recently reported that applicants indicating Jewish as their religion have been unsuccessful in obtaining visas. *Health requirements:* Yellow fever vaccination is required if coming from an infected area. *Equipment importation:* Arrange for with visa. **Electricity:** 220/50. *Plug types:* C and D. **Currency:** Rial (YEM); Fils. **U.S. embassy in the country:** P.O. Box 1088, San'a; *tel.* 271-950/8; *telex:* 2697 EMBSAN YE.

Embassy in U.S.: 600 New Hampshire Avenue NW, Suite 840, Washington, DC 20037; *tel.* 202-965-4760. *Consulates:* New York: 212-355-1730.
Tourism office in U.S.: Contact Yemen Airlines, *tel.* 718-625-4814, for a booklet of information.
Central tourism office in country: Yemen Tourism Company, P.O. Box 1526, Qaal Ulfi, San'a; *tel.* 200-172; *telex:* 2824.
Health suggestions: Typhoid, tetanus, yellow fever, and hepatitis treatments are recommended. Malaria suppressants are recommended throughout, except for north-western provinces of Sa'ada and Hajja.
Cultural mores and taboos: Family and clan loyalties are still paramount. A peculiar habit of the Yemenis is the chewing of a mildly narcotic leaf called *qat* through the afternoon. If invited to partake, try to accept despite the taste.
Photographic restrictions: Be cautious at night on the street, as there are security patrols that might misunderstand your actions. Don't photograph veiled women.
Gratuity guidelines: Service is often included in the bill; leaving a bit more is customary.

YEMEN, SOUTH
People's Democratic Republic of Yemen
Jumhuriyat al-Yaman ad-Dimuqratiyah ash-Sha'biyan

Location: In southwestern Asia, bounded on the north by Saudi Arabia, the east by Oman, the south by the Indian Ocean and the Gulf of Aden, and the west by North Yemen. *Size:* 112,075 square miles, slightly larger than New Mexico.
Major cities: *Aden* (lat. +12.47). *Airports:* Aden (ADE), 6 miles outside of Aden.
General transportation: Flights to the Middle East and Europe, with a direct connection to New York through Kuwait. *U.S. license:* Yes, if accompanied by local temporary license, good for 3 months. *IDP:* Yes, but must be stamped by the traffic department. *Rule of the road:* Right. *Taxi markings:* White with yellow line, "TAXI" on door, set price on fixed route, shared.
Population: 2,400,000. *Type of government:* Republic; politically unstable over the years. No relations with the U.S.
Languages: Arabic; English is widely understood. *Ethnic groups:* Almost 100% Arab; a few Indians, Somalis, and Europeans. *Religion:* Sunni Muslim; a few Christians and Hindus.
Time: EST +8; GMT +3. *Telephone codes:* No direct-dial from U.S.—operator-assisted calls only. No credit card or collect calls to U.S. Small domestic and international system. *Pay phone system:* Very, very few.
Holidays: October 14; November 30 and Muslim religious holidays. *Date/month system:* D/M.
Business hours: 8 AM to 2 PM, 5 PM to 8 PM Saturday to Thursday. *Government hours:* 7 AM to 2 PM Saturday to Thursday. *Business dress code:* Informal.
Climate and terrain: Coastal areas are sandy and flat; the interior, mountainous. Mostly subsistence farmers and nomadic herders. Extraordinarily hot, with temperatures exceeding 130°F in summer and very little rainfall. Very humid.
Visas: No U.S. diplomatic or consular relations or third-party representation. Visa must be obtained from country with diplomatic relations. *Health requirements:* Yellow fever vaccination is required if coming from an infected area. *Equipment importation:* Arrange for with visa.
Electricity: 230/50. *Plug types:* A and D.
Currency: Dinar (DYD); 1,000 Fils.
U.S. embassy in the country: None. The United Kingdom now acts as protecting power for the U.S.
Embassy in U.S.: None.
Central tourism office in country: Public Corporation for Tourism (TAWAHI), Aden.
Health suggestions: Malaria suppressants are recommended throughout the country,

except for the city of Aden and the airport perimeter.

Cultural mores and taboos: Respect Muslim customs. But South Yemen is less strict than other Middle Eastern countries.

Photographic restrictions: Military and strategic. Don't take photos surreptitiously. **Gratuity guidelines:** Tipping is not the custom and may be offensive.

YUGOSLAVIA
Socialist Federal Republic of Yugoslovia
Socijalistička Federativna Republika Jugoslavija

Location: In southeastern Europe, bounded on the north by Austria and Hungary, the east by Romania and Bulgaria, the south by Greece and Albania, the west by the Adriatic Sea, and the northwest by Italy. **Size:** 98,766 square miles, slightly larger than Wyoming. **Major cities:** Belgrade (lat. +44.48), Zagreb (lat. +45.48). **Airports:** Beograde (BEG), 12 miles outside of Belgrade; Pleso (ZAG), 11 miles outside of Zagreb.

General transportation: Many international flights, with direct links to the U.S. Domestic flights are available; all republics and provinces have modern airports except Vojvodina. Trains make intercity connections. The road network has not kept pace with demand. Public transport is provided by buses and taxis. **U.S. license:** Yes. **IDP:** Yes. **Rule of the road:** Right. **Motor clubs:** Auot-Moto Savez Jugoslavije, Ruzveltova 18, Belgrade; tel. 401–699; partial AAA reciprocity. **Taxi markings:** Marked TAXI; metered.

Population: 23,600,000. **Type of government:** Communist state, federal republic in form. Each of the 6 republics—Serbia, Croatia, Slovenia, Bosnia and Herzegovina, Macedonia, and Montenegro—and two provinces within Serbia—Kosovo and Vojvodina—have considerable autonomy, and their aspirations have been the cause of political tensions in recent years. Social controls and restrictions on individual freedoms are less severe than in other Communist countries. Maintains cooperative relations with the U.S.

Languages: Serbo-Croatian is the principal language, spoken by about two-thirds of the population. English is the most com-

monly studied foreign language but is by no means universally spoken. **Ethnic groups:** 36.3% Serb, 19.7% Croat, 8.9% Muslim, 7.8% Slovene, 7.7% Albanian, 5.9% Macedonian, 5.4% Yugoslav, 2.5% Montenegrin, 1.9% Hungarian, 3.9% other. **Religion:** 50% Eastern Orthodox, 30% Roman Catholic, 10% Muslim, 1% Protestant, 9% other.

Time: EST +6; GMT +1. **Telephone codes:** Country: 38. Belgrade 11, Dubrovnik 50, Leskovac 16, Ljubljana 61, Maribor 62, Mostar 88, Novi Sad 21, Pirot 10, Rijeka 51, Sarajevo 71, Skopje 91, Split 58, Titograd 81, Titovo Užice, Zagreb 41. Satisfactory domestic and international service. **Pay phone system:** Coins.

Holidays: January 1, 2; May 1, 2; July 4; November 29, 30; plus regional liberation days: July 7 (Serbia); July 13 (Montenegro); July 22 (Slovenia); July 27 (Croatia; Bosnia and Herzegovina); and October 11 (Macedonia). November 1 is also a holiday in Slovenia; August 2 in Macedonia. **Date/month system:** D/M.

Business hours: 6 or 7 AM to 2 or 3 PM Monday to Friday, with 2 extra hours one day each week (usually Monday or Wednesday). **Government hours:** 8 AM to 4 PM Monday to Friday, until 5 PM on Wednesdays. **Business dress code:** Same as that of the U.S.

Climate and terrain: About a third of the total area (an oval from Zagreb in the northwest to Niš in the east) consists of agricultural lowland hills and plains, interrupted by a few minor mountain ranges. Most of the rest of the country is mountainous. The chief range is the Dinaric Alps, running parallel to the Adriatic coast. Subject to frequent and destructive earthquakes. The climate along

the coast is hot in summer and mild and rainy in winter. In the interior the climate varies but is generally more temperate, like that of the U.S. mid-Atlantic coast. *Temperature ranges* (Belgrade): January: 27° to 37°F; April: 45° to 64°F; July: 61° to 84°F; October: 47° to 65°F.

Visas: Standard tourist visa, requiring passport, allowing multiple entries, for stays of up to 90 days, valid for 1 year, no fee. *Health requirements:* No vaccinations required. *Equipment importation:* Carnet. **Electricity:** 220/50. *Plug types:* C and F. **Currency:** Dinar (YUD); Para. **U.S. embassy in the country:** Kneza Milosa 50, Belgrade; *tel.* 645–655; *telex:* 11529 AMEMBA YU. *Consulates:* Zagreb: 444–800. **Embassy in U.S.:** 2410 California Street NW, Washington, DC 20008; *tel.* 202–

462–6566. *Consulates:* California: 415–776–4941; Illinois: 312–332–0169; New York: 212–838–2300; Ohio: 216–621–2093; Pennsylvania: 412–471–6191.

Tourism office in U.S.: Yugoslav Tourist Office, 630 Fifth Avenue, New York, NY 10022; *tel.* 212–757–2801.

Central tourism office in country: Dial 988 for information in Zagreb, ask for tourist bureau.

Cultural mores and taboos: Atmosphere is more like that of Western Europe than Eastern Europe. Avoid discussions of regional tensions.

Photographic restrictions: Military sites. **Equipment rental/sales:** *Profoto:* Jugolaboratorija, Belgrade; *tel.* 622–650.

Gratuity guidelines: Service is often included in the bill, but giving a bit extra is customary.

ZAIRE
Republic of Zaire
République du Zaïre

Location: In central Africa, bounded on the northwest and north by the Central African Republic, the northeast by Sudan and Uganda, the east by Rwanda, Burundi, and Tanzania, the south by Zambia and Angola, and the west by the Atlantic Ocean and Congo. *Size:* 905,063 square miles, one-fourth the size of the U.S.

Major cities: *Kinshasa* (lat. −4.20). *Airports:* N'Djili (FIH), 14 miles outside of Kinshasa; N'Dolo (NLO).

General transportation: Flights to Europe (with connections to the U.S.), Africa, and several other international destinations. Local transport is crowded, and the system is in need of an overhaul. Main streets in cities are paved, as are the main roads from the capital to Boma and Kikwit and the road from Kolwezi to Lubumbashi. Otherwise, intercity roads are not good and may be impassable in the rainy season. Rental cars are available. *U.S. license:* No. *IDP:* Yes. *Rule of the road:* Right. *Motor clubs:* Fédération Automobile du Zaïre, Avenue des Citron-

niers No. 1, Kinshasa; partial AAA reciprocity. *Taxi markings:* Yellow, marked TAXI; both metered and set price, often shared; be sure to agree on price in advance. Taxis can be hired by the hour.

Population: 33,300,000. *Type of government:* Republic with strong presidential system; has suffered from long periods of instability, particularly in the 1960s. Excellent relations with the U.S.

Languages: French (official), English, Lingala, Swahili, Kingwana, Kikongo, Tshiluba. *Ethnic groups:* Over 200 ethnic groups, the majority are Bantu; 4 largest tribes—Mongo, Luba, Kongo (all Bantu), and the Mangbetu-Azande (Hamitic)—constitute 45% of the population. *Religion:* 50% Roman Catholic, 20% Protestant, 10% Kimbanguist, 10% Muslim, 10% other indigenous beliefs and mixtures with Christianity.

Time: EST + 6 (Kinshasa); GMT + .5. *Telephone codes:* Country: 243. Kinshasa 12, Lubumbashi 222. Barely adequate and

often unreliable domestic and international service. *Pay phone system:* None.

Holidays: January 1, 4; May 1, 20; June 24, 30; August 1; October 14, 27; November 17, 24; December 25. *Date/month system:* D/M.

Business hours: 7–9 AM to 4–5 PM Monday to Friday. *Government hours:* 7 AM to 4 PM, approximately. *Business dress code:* Informal.

Climate and terrain: Includes the greater part of the Zaire (formerly Congo) River basin. The vast low-lying area is a basin-shaped plateau sloping toward the west, covered by tropical rain forest. This area is surrounded by mountainous terraces in the west, plateaus merging into savannas in the south and southwest, and dense grasslands extending beyond the Zaire River in the north. High mountains are found in the extreme east. Hot and humid equatorial climate in the river basin; cool and dry in the southern highlands. South of the equator, the rainy season is from October to May; north of the equator, from April to November; along the equator, rain is regular throughout the year. Thunderstorms in the rainy seasons are violent but rarely last more than a few hours. *Temperature ranges* (Kinshasa): January: 70° to 87°F; April: 71° to 89°F; July: 64° to 81°F; October: 70° to 88°F.

Visas: Business visa: 3 applications, 3 photos, client letter assuming responsibility for traveler, passport, proof of return ticket, $60 fee; allow 2 days for processing. *Tourists:* Similar requirements without client letter, with $20 fee for 1 month, $40 fee for 2

months, $50 fee for 3 months. *Transit visa:* For stays of up to 8 days, $8 single entry, $16 multiple entry. *Health requirements:* Yellow fever vaccination. *Equipment importation:* Bring equipment list; no bond is required. *Electricity:* 220/50. *Plug types:* E. *Currency:* Zaire (ZAI); Makutas.

U.S. embassy in the country: 310 Avenue des Aviateurs, Kinshasa; *tel.* 25881/6; *telex:* 21405 US EMB ZR. *Consulates:* Lubumbashi: 222–324.

Embassy in U.S.: 1800 New Hampshire Avenue NW, Washington, DC 20009; *tel.* 202–234–7690/1. *Consulates:* New York: 212–754–1966.

Tourism office in U.S.: Contact Air Zaire, *tel.* 800–442–5114.

Health suggestions: Only basic medical care is available in the capital. Malaria suppressants are recommended throughout the country. AIDS is a major health problem. Zambia recommends a typhoid vaccination. Cholera infection is present. Water is not potable.

Cultural mores and taboos: Politeness and hospitality are of utmost importance—do not refuse a meal. Do not confuse shyness with reticence. "Please" and "thank you" are not part of the language; their absence does not imply rudeness.

Photographic restrictions: Strategic locations.

Gratuity guidelines: Service is usually included in the bill; giving a bit extra is customary.

ZAMBIA
Republic of Zambia

The State Department cautions of travel difficulties for foreigners as a result of harassment by security officials and crime.

Location: In south-central Africa, bounded on the north by Zaire and Tanzania, the east by Malawi, the southeast by Mozambique, the south by Zimbabwe and southwest Africa (Namibia), and the west by An-

gola. *Size:* 290,585 square miles, slightly larger than Texas.

Major cities: *Lusaka* (lat. −15.25). *Airports:* Lusaka (LUN), 16 miles outside of Lusaka.

General transportation: Ample international flights, with direct links to the U.S. Zambia Airways (QZ) provides connections

to larger provincial towns. Zambia Railways also makes these connections (and to Dar es Salaam, Tanzania, as well), but service is slow. Rivers are navigable for some distances but are broken by waterfalls. Paved roads lead from Lusaka to the Tanzanian and Malawian borders. Rental cars are available. An intercity "luxury" bus service is available. Urban buses are crowded and erratic. Taxis are also in demand. *U.S. license:* No. *IDP:* Yes. *Rule of the road:* Left. *Taxi markings:* Usually yellow, marked TAXI; set price. **Population:** 7,500,000. *Type of government:* One-party state, although political life is vigorous; politically stable. Good relations with the U.S., despite some differences on international issues.

Languages: English is the language of business, government, and social exchange. There are 70 indigenous languages. *Ethnic groups:* 98.7% African, 1.1% European, 0.2% other. *Religion:* 50% to 75% Christian, 1% Muslim, remainder indigenous beliefs.

Time: EST +7; GMT +2. *Telephone codes:* Country: 260. Chingola 2, Kitwe 2, Luanshya 2, Lusaka 1, Ndola 26. Domestic service is barely adequate but improving; international service is adequate but expensive. *Pay phone system:* None.

Holidays: January 1; Youth Day (March); Good Friday; Holy Saturday; May 1, 25; Heroes Day (July); Unity Day (July); Farmers Day (August); October 24; December 25. *Date/month system:* D/M.

Business hours: 8 AM to 5 PM Monday to Friday, with half-days observed on Tuesday, Wednesday, or Saturday, depending on the city. *Business dress code:* Safari suits are acceptable, but a suit and tie are better. *Avoid wearing military-style clothing.*

Climate and terrain: High plateau savanna (3,000 to 5,000 feet) with northern watershed containing 2 great rivers, the Zambezi and the Zaire (formerly Congo) and including the famous Victoria Falls. Generally dry, subtropical climate, modified by the altitude. Rains are concentrated from October to April. *Temperature ranges* (Lusaka): January: 63° to 78°F; April: 59° to

79°F; July: 49° to 73°F; October: 64° to 88°F.

Visas: Standard tourist visa: 2 applications, 2 photos, passport, $15.00; allow 3 weeks for processing; valid for 6 months. *Health requirements:* Yellow fever vaccination is required if coming from an infected area and is recommended by CDC for travel to northwestern forest areas. *Equipment importation:* Bring equipment list; no bond is necessary.

Electricity: 220/50. *Plug types:* G.

Currency: Kwacha (ZMK); Ngwee.

U.S. embassy in the country: Corner of Independence and United Nations avenues, P.O. Box 31617, Lusaka; *tel.* 214911; *telex:* AMEMB ZA 41970.

Embassy in U.S.: 2419 Massachusetts Avenue NW, Washington, DC 20008; *tel.* 202–265–9717/21.

Tourism office in U.S.: Zambian National Tourist Board, 237 East Fifty-second Street, New York, NY 10022; *tel.* 212–308–2155.

Central tourism office in country: Zambian National Tourist Board, P.O. Box 30017, Lusaka; *tel.* 217761; *telex:* 41780.

Health suggestions: Medical treatment and medicines are in short supply. Health standards in Lusaka and other urban areas are fair. Water is considered potable, but boiling is recommended. Malaria suppressants are recommended throughout the country. Avoid bathing in streams, lakes, and ponds. Yellow fever vaccination is required; typhoid and paratyphoid, recommended. AIDS is a major health problem.

Cultural mores and taboos: Handshakes are common. Use titles. Be flexible if appointments do not materialize.

Photographic restrictions: Military sites, government buildings, and many civil facilities (airports, railways, utilities) require permission, and the State Department recommends caution in using cameras outside tourist and approved areas. Ask permission before photographing people on the street, although they are understanding.

Gratuity guidelines: Service is sometimes included in the bill, but always give more.

ZIMBABWE
Republic of Zimbabwe

Despite relative calm since independence in 1980, sporadic outbursts of violence occur. Also difficulties have been experienced near the border with Mozambique. Be sure to check conditions with the U.S. embassy.

Location: In south-central Africa, bounded on the northwest by Zambia, the north by Zambia and Mozambique, the east by Mozambique, the south by South Africa, and the southwest by Botswana. *Size:* 150,820 square miles, slightly larger than Montana.

Major cities: *Harare* (lat. −17.50). *Airports:* Harare (HRE), 8 miles outside of Harare.

General transportation: Flights to Europe (with connections to the U.S.), Africa, and several other international destinations. The railway hub of southern Africa, but passenger service is limited. Car rentals and taxis are available. The road system is excellent. *U.S. license:* Yes. *IDP:* Yes. *Rule of the road:* Left. *Motor clubs:* Automobile Association of Zimbabwe, 57 Samora Machel Avenue, Harare; *tel.* 70 70 21; partial AAA reciprocity. *Taxi markings:* All colors; metered. Private cars are used as "pirate" taxis.

Population: 9,700,000. *Type of government:* Presidential system with bicameral legislature. Relations with the U.S. are improving after periods of serious discord, particularly in the mid-1980s.

Languages: English (official), Chi Shona and Si Ndebele. *Ethnic groups:* 98% African (71% Shona, 16% Ndebele), 1% white, 1% mixed and Asian. *Religion:* 50% syncretic (mixture of Christianity and indigenous beliefs), 25% Christian, 24% indigenous beliefs, approximately 1% Muslim.

Time: EST +7; GMT +2. *Telephone codes:* Country: 263. Bulawayo 9, Harare 0, Mutare 20. Phone service was once one of the best in Africa but now suffers from poor maintenance. International service is available. *Pay phone system:* Coins.

Holidays: January 1; Good Friday; Easter Monday; April 18; May 1, 25; August 11, 12; December 25, 26. *Date/month system:* D/M.

Business hours: 8 AM to 5 PM Monday to Friday; 8 AM to 12 noon Saturday. *Government hours:* 8:30 AM to 5 PM Monday to Friday. *Business dress code:* Conservative.

Climate and terrain: Mostly high plateau country at 3,000 to 4,000 feet. Still higher plateau, called the high veld, crosses from southwest to northeast at 4,000 to 5,000 feet. From the central plateau, the land slopes north to the Zambezi River at the border with Zambia and south to the Limpopo River at the border with South Africa. In the eastern districts along the border with Mozambique is a mountain range that rises to 6,000 to 8,000 feet. Although the country is in the tropics, the climate is subtropical, varying with altitude. Most of the rain falls from October to April. Floods and severe storms are rare. The climate of the high veld has been compared to that of southern California. *Temperature ranges* (Harare): January: 60° to 78°F; April: 55° to 78°F; July: 44° to 70°F; October: 58° to 83°F.

Visas: Contact consulate to obtain permission from the Ministry of Information in Harare, requiring photographer letter, client letter, passport, proof of return ticket/sufficient funds, 2 photos; bring equipment list. *Health requirements:* Yellow fever vaccination is required if coming from an infected area. *Equipment importation:* Data unavailable.

Electricity: 220/50. *Plug types:* D and G.

Currency: Dollar (ZW$); Cents. Currency transactions are strictly regulated.

U.S. embassy in the country: 172 Rhodes Avenue, P.O. Box 3340, Harare; *tel.* 794–521; *telex:* 4591 USFCS ZW.

Embassy in U.S.: 2852 McGill Terrace NW, Washington, DC 20008; *tel.* 202–332–7100.

Tourism office in U.S.: Zimbabwean Tourist Development Corporation, 1270 Avenue of the Americas, New York, NY 10020; *tel.* 212–307–6565, 800–621–2381.

Central tourism office in country: Fourth Street and Stanley Avenue, P.O. Box 8052 Causeway, Harare; *tel.* 793–666.

Health suggestions: Water is considered potable in urban areas but not rural regions. Medical facilities are good to excellent in the cities, adequate in the rural areas. Malaria suppressants are recommended for all areas outside of Harare.

Cultural mores and taboos: Direct eye contact during conversation is considered rude, especially in rural areas. Humility is prized. Great sensitivity to British colonial past, when the country was known as Rhodesia.

Photographic restrictions: Authorities are extremely sensitive about the photographing of government buildings, official residences, embassies, and the like.

APPENDIXES

Appendix 1
BOUNDARY MAPS BY REGION

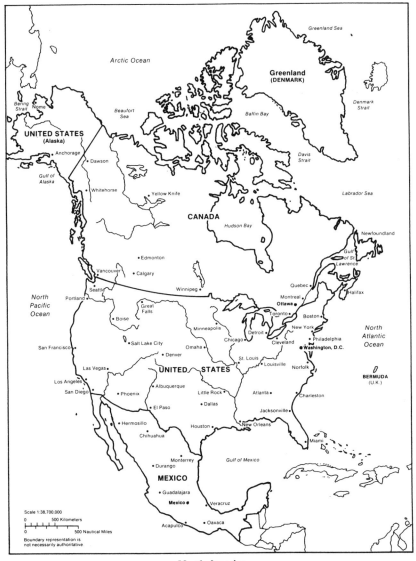

North America

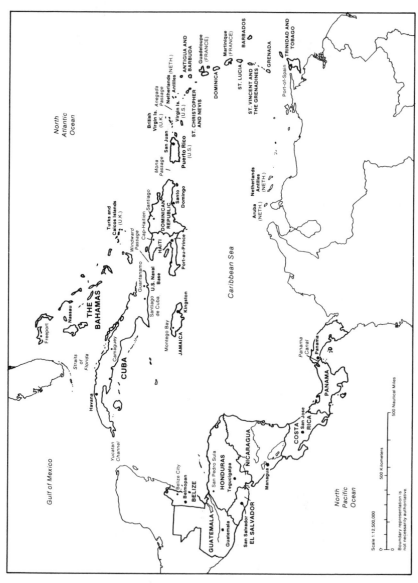

Central America and the Caribbean

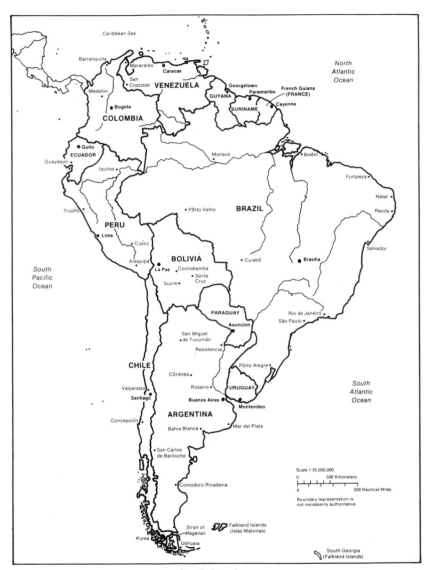

South America

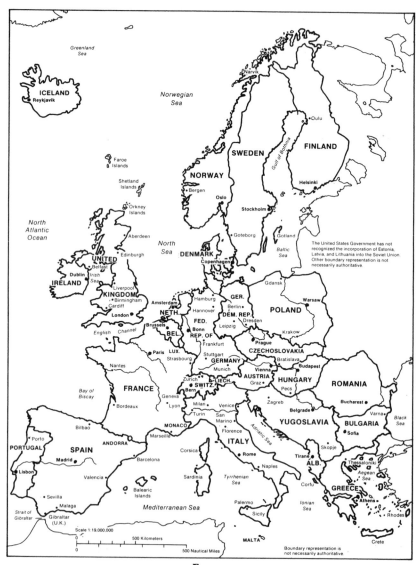

The United States Government has not recognized the incorporation of Estonia, Latvia, and Lithuania into the Soviet Union. Other boundary representation is not necessarily authoritative.

Scale 1:19,000,000

500 Kilometers

500 Nautical Miles

Boundary representation is not necessarily authoritative.

Europe

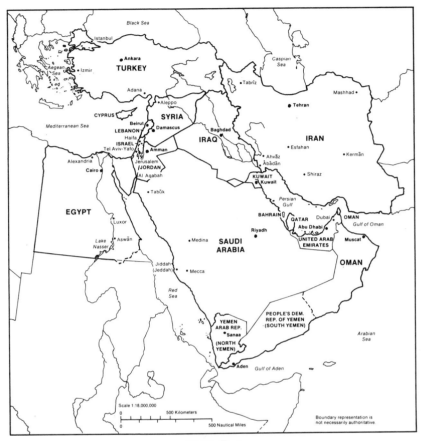

Middle East

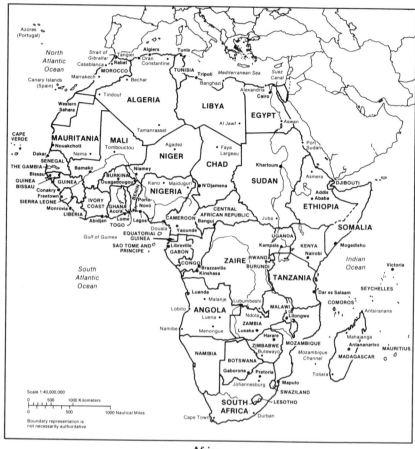

Africa

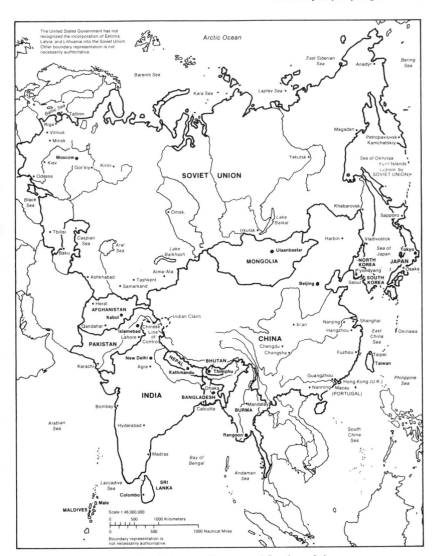

The United States Government has not
recognized the incorporation of Estonia,
Latvia, and Lithuania into the Soviet Union.
Other boundary representation is not
necessarily authoritative.

The Soviet Union and Eastern and Southern Asia

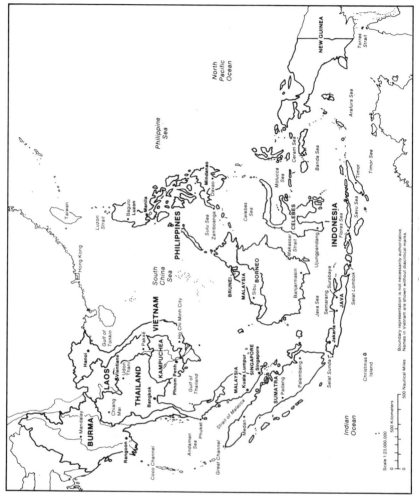

Southeast Asia

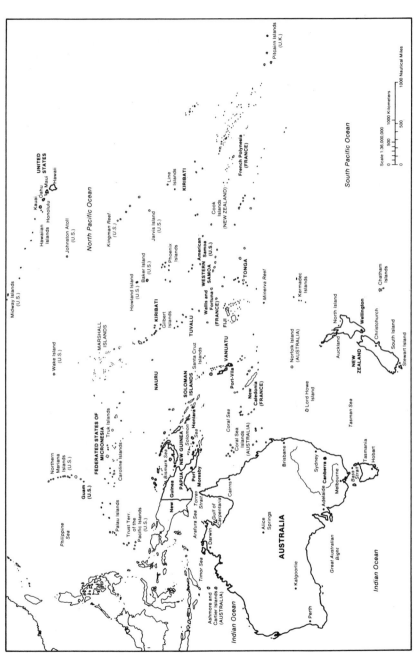

Oceania

Appendix 2
U.S. FILM COMMISSIONS BY STATE

This appendix lists the latest membership of the Association of Film Commissions, whose roster is updated biannually. (Courtesy of the Association of Film Commissions)

ALABAMA

Alabama Film Office
800–633–5898

ALASKA

Alaska Motion Picture and
Television Production
907–563–2167

ARIZONA

Arizona Film Commission
602–255–5011

Havasu Area Film
Commission
602–453–3456

Page/Lake Powell Film
Commission
602–645–2741

Parker Area Chamber of
Commerce
602–669–2174

City of Phoenix Motion
Picture Office
602–262–4850

Prescott Chamber of
Commerce
602–445–2000

City of Scottsdale
602–994–7809

Sedona–Oak Creek
Chamber of Commerce
602–282–7333

Tucson Film Office
602–791–4000

Verde Valley Film
Commission
602–634–9536

Yuma Film Commission
602–726–4027

ARKANSAS

Northwest Arkansas Motion
Picture Commission
501–442–6554

CALIFORNIA

California Film Commission
213–736–2465

County of Los Angeles
213–738–3456

Madera County Film
Commission
209–642–3676

Merced Chamber of
Commerce
209–384–3333

Modesto Film Commission
209–577–5757

Monterey County Film
Commission
408–646–0910

Nevada County Chamber of
Commerce
916–273–4667

Riverside Economic and
Commission
Development
714–788–9770

Sacramento Metropolitan
Chamber of Commerce
916–443–3771

San Diego Motion Picture
and Television
619–234–3456

San Francisco Mayor's
Office
415–554–6144

San Jose Film and Video
Commission
408–295–9600

San Mateo County Film
Commission
415–952–7600

Santa Cruz Convention and
Visitor's Council
408–425–1234

Sonoma County Film/Video
Commission
707–575–1191

COLORADO

Colorado Motion Picture
and Television
303–866–2778

Boulder County Film
Commission
303–442–1044

Canon City Chamber of
Commerce
719–275–2331

City of Colorado Springs
719–578–6600

Greater Denver Chamber of
Commerce
303–894–8500

Durango Film Commission
303–247–0312

**DISTRICT OF
COLUMBIA**

Mayor's Office of Motion
Picture/Television
202–727–6600

FLORIDA

Florida Film Bureau
904–487–1100

Motion Picture and
Television Development
813–223–8419

Office of Film, Video and
Recording
305–579–3366

Brevard County Tourist
Development Council
800–872–1969

Broward Economic
Development Board
305–524–3113

Collier County Economic
Development Council
813–263–8989

Jacksonville Film and
Television Liaison Office
904–630–1073

Miami/Dade County Office
of Film Television
305–375–3456

Ocala/Marion County Film
Commission
904–629–2757

Industrial Development
Commission—Orlando
305–422–7159

Economic Development
Council of Polk County
813–533–1755

GEORGIA

Georgia Film and Videotape
Office
404–656–3591

HAWAII

Film Industry Branch
808–548–4535

Maui Motion Picture
Coordinating Committee
808–871–8691

IDAHO

Idaho Film Bureau
208–334–2470

ILLINOIS

Illinois Film Office
312–917–3600

Chicago Office of Film and
Entertainment
312–744–6415

INDIANA

Indiana Film Commission
317-232-8829

IOWA

Iowa Film Office
515-281-8319

Cedar Rapids Area
Convention and Visitor's
Bureau
319-398-5009

KANSAS

Kansas Film Commission
913-296-4927

Southeast Kansas Film
Commission
316-625-3559

Lawrence Convention and
Visitor's Bureau
913-843-4411

Topeka Convention and
Visitor's Bureau
913-234-2644

KENTUCKY

Kentucky Film Office
502-564-3456

LOUISIANA

Louisiana Film Commission
504-342-8150

City of Kenner
504-468-7221

Monroe–West Monroe
Convention and Visitor's
Bureau
318-387-5691

New Orleans Association of
Film/Tape Professionals
504-486-5556

Winnfield Chamber of
Commerce/Film
318-628-4461

MAINE

Maine Film Commission
207-289-5710

MARYLAND

Maryland Film Commission
301-333-6633

Prince Georges County
301-952-4136

MASSACHUSETTS

Massachusetts Film Office
617-973-8800

MICHIGAN

Michigan Film Office
313-256-2000

Detroit Film Commission
313-224-4733

MINNESOTA

Minnesota Motion Picture
and Television Board
612-332-6493

MISSISSIPPI

Mississippi Film Office
601-359-3449

Columbus Film
Commission
601-329-1191

Natchez Film Commission
601-446-6345

Vicksburg Film
Commission
800-221-3536

MISSOURI

Missouri Film Commission
314-751-9050

St. Louis Film Partnership
314-231-5555

MONTANA

Montana Film Commission
800-548-3390

Billings, Montana, Film
Commission
406-656-0645

NEBRASKA

Nebraska Film Office
402-471-2593

Lincoln Film and Television
Office
402-471-7375

NEVADA

Motion Picture and
Television Division/
Nevada Commission of
Economic Development
702-486-7150

NEW JERSEY

New Jersey Motion Picture
and Television
Commission
201-648-6279

NEW MEXICO

New Mexico Film
Commission
800-545-9871

Albuquerque Film
Commission
505-768-4512

NEW YORK

New York State
Government Office for
Motion Picture/Television
Development
212-575-6570

Nassau County Film Office
516–535–3168

Suffolk County Film
Commission
516–360–4800

NORTH CAROLINA

North Carolina Film Office
919–733–9900

NORTH DAKOTA

EDC-Tourism Promotion
Division
701–224–2525

OHIO

Ohio Film Bureau
614–446–2284

Cincinnati Chamber of
Commerce
513–579–3180

OKLAHOMA

Oklahoma Film Office
405–841–5135

OREGON

Economic Development
Department
503–373–1232

Portland Film and Video
Office
503–248–4739

PENNSYLVANIA

Pennsylvania Film Bureau
717–783–3456

Philadelphia Film Office
215–686–2668

PUERTO RICO

Puerto Rico Film
Commission
809–758–4747

RHODE ISLAND

Rhode Island Film
Commission
401–277–3456

SOUTH CAROLINA

South Carolina State Film
Office
803–737–0400

Myrtle Beach Area Film
Office
803–626–7444

SOUTH DAKOTA

South Dakota Tourism
800–843–8000

TENNESSEE

Tennessee Film/
Entertainment/Music
Commission
615–741–3456

Memphis/Shelby Film-
Tape-Music
901–576–4284

TEXAS

Texas Film/Music Office
512–469–9111

Alpine Chamber of
Commerce
915–837–2326

Amarillo Convention and
Visitor's Council
806–374–1497

Austin Convention/Visitor's
Bureau
512–474–5171

City of Austin
512–322–3661

Film Commission of North
Texas/Dallas
214–869–7657

El Paso Film Commission
915–534–0698

Houston Film Commission
713–620–6614

Irving Texas Film
Commission
214–252–7476

Kerrville Convention and
Visitor's Bureau
512–896–1155

San Antonio Convention
and Visitor's Bureau
512–270–8700

UTAH

Utah Film Commission
801–538–3039

Southwest Utah Film
Commission
801–673–8824

Moab Film Commission
801–259–6388

Park City Chamber of
Commerce
800–453–1360

VERMONT

Vermont Film Bureau
802–828–3226

VIRGINIA

Virginia Film Office
804–786–5832

Fairfax County Film Office
703–790–0600

VIRGIN ISLANDS

United States Virgin Islands
Film Production Office
809-775-1444

WASHINGTON

Washington State Film and
Video
206-464-7148

Community Development
Department
206-591-5209

WISCONSIN

Wisconsin Film Office/
Tourism Development
608-267-3456

Department of City
Development
414-223-5818

WYOMING

Wyoming Film Office
800-458-6657

Jackson Hole Film
Commission
307-733-3316

Lander Film Commission
307-332-3892

Sheridan County Chamber
Film Promotion
307-672-2481

Appendix 3
U.S. PHONE NUMBERS AND STANDARD ABBREVIATIONS OF MAJOR AIRLINES

Aer Lingus (EI)
800–223–6537

Aerolineas Argentinas (AR)
800–333–0276

Aeromexico (AM)
800–237–6639

Aeroperu (PL)
800–327–7080;
 in Miami 305–594–0022

Air Afrique (RK)
212–247–0100

Air Canada (AC)
800–422–6232;
 in Canada 514–393–3333

Air France (AF)
800–AF–PARIS

Air-India (AI)
800–223–7776

Air Jamaica, Ltd. (JM)
800–523–5585

Air Lanka (UL)
800–421–9898

Air New Zealand (TE)
800–262–1234

Alaska Airlines (AS)
800–426–0333

Alitalia (AZ)
800–442–5860

All Nippon Airways (ANA)
800–2–FLY–ANA

Alm-Antillean Airlines
 (LM)
800–327–7230/3

Aloha Airlines, Inc. (AQ)
800–367–5250

American Airlines (AA)
800–433–7300

America West Airlines (HP)
800–247–5692

Ansett Airlines of Australia
 (AN)
800–366–1300

Arkia-Israel Inland Airlines
 (IZ)
212–687–0615

Austrian Airlines (OS)
800–843–0002

Avianca Airlines (CE)
800–AVIANCA

Aviateca (Aerolineas de
 Guatemala) (GU)
504–522–1010

Bahamasair (UP)
800–222–4262

Balair Ltd. Air Charter of
Switzerland
212–581–3411

Bangladesh Biman (BG)
212–967–7930

Braniff (BN)
800–BRANIFF

British Airways (BA)
800–AIRWAYS

BWIA International (BW)
800–327–7401

CAAC, National Airline of
the People's Republic of
China (CA) (contact Pan
Am and Northwest)

Canadian Pacific Air Lines
(CP AIR) (CP)
800–426–7000;
in Washington
800–552–7576

Cathay Pacific Airways (CX)
800–233–2742

Cayman Airways (KX)
800–422–9626

China Airlines (CI)
800–227–5118

Continental Airlines (CO)
800–525–0280

CSA—Czechoslovak
Airlines (OK)
800–223–2365 (except in
NY)

Cyprus Airways, Ltd. (CY)
212–714–2190

Delta Air Lines (DL)
800–221–1212

Dominicana Airlines (DO)
800–327–7240

Eastern Airlines (EA)
800–EASTERN

Ecuatoriana Airlines (EU)
800–328–2367

Egyptair (MS)
800–33–HORUS

El Al Israel Airlines (LY)
800–223–6700

Ethiopian Airlines (ET)
212–867–0095

Faucett First Airlines of
Peru (CF)
800–334–3356

Finnair (AY)
800–950–5000

Garuda Indonesia (GA)
800–342–7832

Gulf Air (GF)
800–223–1740

Guyana Airways Corp. (GY)
800–242–4210;
in NY: 718–693–8000

Hawaiian Airlines (HA)
800–367–5320

Iberia Air Lines Of Spain
(IB)
800–772–4642

Icelandair (FI)
800–223–5500

Iraqi Airways (IA)
212–921–8990

Japan Air Lines (JL)
800–525–3663

Kenya Airways (KQ)
212–832–8810

KLM Royal Dutch Airlines
(KL)
800–777–5553

Korean Air (KE)
800–223–1155;
on the West Coast
800–421–8200

Lacsa Airlines (LR)
800–225–2272

Lan-Chile International
Airlines
800–735–5526;
in Miami
800–591–3700

Liat (1974) Ltd. (LI)
809–462–0700

Lineas Areas Paraguayas
in Florida
(305) 591–1900

Lloyd Aero Boliviano (LB)
800–327–7407

Lot-Polish Airlines (LO)
800–223–0593

Lufthansa German Airlines
(LH)
800–645–3880

Malaysia Airlines (MH)
800–421–8641

Malev Hungarian Airline
(MA)
800–223–6884;
in NY: 212–757–6446

Mexicana Airlines (MX)
800–531–7921

Middle East Airlines (ME)
212–664–7310

Midway Airlines, Inc. (ML)
800–621–5700

Nigeria Airways (WT)
212–935–2700

Northwest Airlines (NW)
800–225–2525

Olympic Airways (OA)
800–223–1226

Pakistan International
Airlines (PK)
800–221–2552

Pan American World
Airways (PA)
800–221–1111

Philippine Airlines (PR)
800–435–9725

Piedmont Airlines (PI)
800–251–5720;
in North Carolina
800–672–0191

Qantas Airways (QF)
800–227–4500

Royal Air Maroc (AT)
800–344–6726

Royal Jordanian (RJ)
800–233–0470

Sabena Belgian World
Airlines (SN)
800–632–8050

Saudi Arabian Airlines (SV)
800–4–SAUDIA;
in NY: 212–758–4727

Scandinavian Airlines
System (SK)
800–221–2350

Singapore Airlines (SQ)
800–SIA–3333

Skywest Western Express
(OO)
800–453–9417;
in Utah
800–662–4237

Suriname Airways (PY)
800–327–6864

Swissair (SR)
800–221–4750

Taca International Airlines
800–535–8780

Tap Air Portugal (TP)
800–221–7370

Tarom-Romanian Air
Transport (RO)
212–687–6013/4

Thai Airways International
(TG)
800–426–5204

Trans World Airlines (TW)
800–221–2000

United Airlines (UA)
800–241–6522

USAIR (AL)
800–428–4322

UTA-French Airlines (UT)
800–282–4484

Varig Brazilian Airlines
(RG)
800–GOVARIG

Viasa-Venezuelan
International Airways
(VA)
800–221–2150;
in Florida
800–327–5454

Virgin Air, Inc. (ZP)
809–776–2722

Virgin Atlantic Airways,
Ltd. (VS)
800–862–8621

Yemen Airways (IY)
800–257–1133;
in NY: 212–286–0660

Yugoslav Airlines–Jat (JU)
800–752–6528

Zambia Airways (QZ)
212–685–1112/3/4

Appendix 4
Nationwide Toll-free Numbers for Hotel Representatives

Atlantic City Hotel Resort
Center
800–524–1351

Atlas Hotels
800–854–2608

Bermuda Hotel
Representatives
800–343–4155

Best Western
800–334–7234

Beverly Heritage Hotels
800–443–4455

British Transport Hotels
(BTH)
800–221–1074

Budgetel Inns
800–4–BUDGET

California Innkeepers
800–245–6907

CHUSA International
800–526–2915

CIGAHOTELS
800–221–2340

Club Med
800–CLUB–MED

Comfort Inns
800–228–5150

Condo Network, Inc.
800–321–2525

CP Hotels
800–828–7447

Creative Leisure
800–4–CONDOS

Cunard Hotels and Resorts
800–222–0939

Days Inns of America
800–633–1414

Divi Hotels
800–367–DIVI

Doubletree Hotels
800–528–0444

Embassy Suites
800–EMBASSY

Fairmont Hotels
800–527–4727

Forum Hotels
800–327–0200

Four Seasons Hotels
800–332–3442

Golden Tulip
800–344–1212

Guest Quarters
800–424–2900

Harley Hotels
800–321–2323

Helmsley Hotels
800–321–2323

Hilton Hotels
800–HILTONS

Holiday Inns
800–HOLIDAY

Howard Johnson's
800–654–2000

Hungarian Hotels
800–448–4321

Hyatt Hotels
800–228–9000

Inn Suites International
800–842–4242

Inter-Continental Hotels
800–327–0200

International Travel
Industries (ITI)
800–458–6888

Krystal Hotels
800–231–9860

Loew's (LRI)
800–223–0888

Marquis Hotels
800–237–8906

Marriott
800–228–9290

Meridien International
Hotels
800–543–4300

New Otani
800–421–8795

Nikko Hotels International
800–NIKKO–US

Novotel
800–221–4542

Omni/Dunfey Hotels
800–THE–OMNI

Preferred Hotels
800–323–7500

Prince Hotels
800–542–8686

Quality International
800–228–5151

Quality Royales
800–228–5152

Radisson
800–333–3333

Ramada Hotels
800–2–RAMADA

Rank Hotels
800–223–5560

Red Lion Inns
800–547–8010

Regent International
800–545–4000

Resorts International
800–321–3000

Rock Resorts
800–223–7637

Rodeway Inns International
800–228–2000

SAS International Hotels
800–221–2350

Shangri-La International
800–457–5050

Sheraton
800–334–8484

Shilo Inns
800–222–2244

Sonesta
800–343–7170

Stouffer
800–HOTELS–1

Tokyu Hotel Chain
800–624–5068

Trusthouse Forte (THF)
800–225–5843

Vacation Time Condos
800–882–6636

Vagabond Inns
800–522–1555

Westin Hotels
800–228–3000

Wyndham Hotels
800–822–4200

Appendix 5
Electric Plug Types

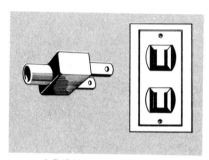

A: FLAT-BLADE ATTACHMENT PLUG

B: FLAT BLADES WITH ROUND GROUNDING PIN

C: ROUND-PIN ATTACHMENT PLUG

D: ROUND PINS WITH GROUND

E: ROUND-PIN PLUG AND RECEPTACLE WITH MALE
GROUNDING PIN

F: "SCHUKO" PLUG AND RECEPTACLE WITH SIDE
GROUNDING CONTACTS

G: RECTANGULAR-BLADE PLUG

H: OBLIQUE FLAT BLADES

I: OBLIQUE FLAT BLADES WITH GROUND

J: OBLIQUE FLAT BLADES WITH GROUND

Appendix 6
Weights and Measures

U.S. WEIGHTS AND MEASURES

Unit	Equivalents	Metric Equivalent
Weight		
ton		
short ton	2,000 pounds	0.907 metric ton
long ton	2,240 pounds	1.016 metric tons
pound	16 ounces	0.453 kilogram
ounce	—	28.349 grams
Liquid measure		
gallon	4 quarts, 231 cubic inches	3.785 liters
quart	2 pints, 57.75 cubic inches	0.946 liter
pint	2 cups, 28.875 cubic inches	0.473 liter
cup	8 fluid ounces, 14.436 cubic inches	236.6 milliliters
fluid ounce	1.804 cubic inches	29.573 milliliters
Length		
mile	5,280 feet, 1,760 yards	1.609 kilometers
yard	3 feet, 36 inches	0.9144 meter
foot	12 inches	30.48 centimeters
inch	—	2.54 centimeters
Area		
square mile	640 acres	2.590 square kilometers
acre	4,840 square yards, 43,560 square feet	0.405 hectare, 4,047 square meter
square yard	9 square feet, 1,296 square inches	0.836 square meter
square foot	144 square inches	0.093 square meter
square inch	—	6.451 square centimeters
Volume		
cubic yard	27 cubic feet, 46,656 cubic inches	0.765 cubic meter
cubic foot	1,728 cubic inches	0.028 cubic meter
cubic inch	—	16.387 cubic centimeters

METRIC WEIGHTS AND MEASURES

Unit	Equivalent	U.S. Equivalent (approx.)
Weight		
metric ton	1,000,000 grams	1.1 tons
quintal	100,000 grams	220.46 pounds
kilogram	1,000 grams	2.2046 pounds
hectogram	100 grams	3.527 ounces
dekagram	10 grams	0.353 ounce
gram	—	0.035 ounce
Liquid measure		
kiloliter	1,000 liters	264.172 gallons
hectoliter	100 liters	26.417 gallons
dekaliter	10 liters	2.64 gallons
liter	—	1.057 quarts
deciliter	0.10 liter	0.21 pint
centiliter	0.01 liter	0.338 fluid ounce
milliliter	0.001 liter	0.034 fluid ounce
Length		
myriameter	10,000 meters	6.2 miles
kilometer	1,000 meters	0.62 mile
hectometer	100 meters	109.36 yards
dekameter	10 meters	32.81 feet
meter	—	39.37 inches
decimeter	0.1 meter	3.94 inches
centimeter	0.01 meter	0.39 inch
millimeter	0.001 meter	0.04 inch
Area		
square kilometer	1,000,000 square meters	0.3861 square mile
hectare	10,000 square meters	2.47 acres
are	100 square meters	119.60 square yards
centare	1 square meter	10.76 square feet
square centimeter	0.0001 square meter	0.155 square inch
Volume		
dekastere	10 cubic meters	13.10 cubic yards
stere	1 cubic meter	1.31 cubic yards
decistere	0.10 cubic meter	3.53 cubic feet
cubic centimeter	0.000001 cubic meter	0.061 cubic inch

TEMPERATURE

To convert Fahrenheit to Celsius, subtract 32, multiply by 5, and divide by 9. For example, 97°F equals 36.1°C (97 − 32 = 65; 65 × 5 = 325; 325/9 = 36.1).

To convert Celsius to Fahrenheit, multiply by 9, divide by 5, and add 32. For example, 97°C = 206.6°F (97 × 9 = 873; 873/5 = 174.6; 174.6 + 32 = 206.6).

In the Fahrenheit system, the freezing point is about 32°F and the boiling point is about 212°F. In the Celsius system, the freezing point is 0°C and the boiling point is 100°C.

Appendix 7
Model Releases

The Adult Release, Minor Release, and Property Release that follow are courtesy of ASMP, from *Professional Business Practices in Photography*, 4th ed. (New York: American Society of Magazine Photographers, Inc., 1986), pages 69, 70, and 72. The other releases were provided courtesy of the APA, from the revised edition of the *APA Buyer's Guide*.

ADULT RELEASE

In consideration of my engagement as a model, and for other good and valuable consideration herein acknowledged as received, I hereby grant to [PHOTOGRAPHER], his/her heirs, legal representatives and assigns, those for whom [PHOTOGRAPHER] is acting, and those acting with his/her authority and permission, the absolute right and permission to copyright, in his/her own name or otherwise, and use, reuse, publish, and republish photographic portraits or pictures of me or in which I may be included, in whole or in part, or composite or distorted in character or form, without restriction as to changes or alterations, in conjunction with my own or a fictitious name, or reproductions thereof in color or otherwise, made through any medium at his/her studios or elsewhere, and in any and all media now or hereafter known for illustration, promotion, art, advertising, trade, or any other purpose whatsoever. I also consent to the use of any printed matter in conjunction therewith.

I hereby waive any right that I may have to inspect or approve the finished product heirs, or products and the advertising copy or other matter that may be used in connection therewith or the use to which it may be applied.

I hereby release, discharge, and agree to save harmless [PHO-TOGRAPHER], his/her heirs, legal representatives and assigns, and all persons acting under his/her permission or authority or those for whom he/she is acting, from any liability by virtue of any blurring, distortion, alteration, optical illusion, or use in composite form, whether intentional or otherwise, that may occur or be produced in the taking of said picture or in any subsequent processing thereof, as well as any publication thereof, including without limitation any claims for libel or invasion of privacy.

I hereby warrant that I am of full age and have the right to contract in my own name. I have read the above authorization, release, and agreement, prior to its execution, and I am fully familiar with the contents thereof. This release shall be binding upon me and my heirs, legal representatives, and assigns.

DATE: _____ _____
 (NAME)

_____ _____
 (WITNESS) (ADDRESS)

MINOR RELEASE

In consideration of the engagement as a model of the minor named below, and for other good and valuable consideration herein acknowledged as received, upon the terms hereinafter stated, I hereby grant to [PHOTOGRAPHER], his/her legal representatives and assigns, those for whom [PHOTOGRAPHER] is acting, and those acting with his/her authority and permission, the absolute right and permission to copyright and use, reuse, publish, and republish photographic portraits or pictures of the minor or in which the minor may be included, in whole or in part, or composite or distorted in character or form, without restriction as to changes or alterations from time to time, in conjunction with the minor's own or a fictitious name, or reproductions thereof in color or otherwise, made through any medium at his/her studios or elsewhere, and in any and all media now or hereafter known, for art, advertising, trade, or any other purpose what-

soever. I also consent to the use of any printed matter in conjunction therewith.

I hereby waive any right that I or the minor may have to inspect or approve the finished product or products or the advertising copy or printed matter that may be used in connection therewith or the use to which it may be applied.

I hereby release, discharge, and agree to save harmless [PHOTOGRAPHER], his/her legal representatives or assigns, and all persons acting under his/her permission or authority or those for whom he/she is acting, from any liability by virtue of any blurring, distortion, alteration, optical illusion, or use in composite form, whether intentional or otherwise, that may occur or be produced in the taking of said picture or in any subsequent processing thereof, as well as any publication thereof, including without limitation any claims for libel or invasion of privacy.

I hereby warrant that I am of full age and have every right to contract for the minor in the above regard. I state further that I have read the above authorization, release, and agreement, prior to its execution, and that I am fully familiar with the contents thereof. This release shall be binding upon me and my heirs, legal representatives, and assigns.

DATE: _____

_____	_____
(MINOR'S NAME)	(FATHER) (MOTHER) (GUARDIAN)
_____	_____
(MINOR'S ADDRESS)	(ADDRESS)

(WITNESS)

MODEL RELEASE AND CONSENT AGREEMENT

Date: _____

Studio Job #: _____

For the payment indicated, I consent to the use described below of the photographs made of me today by photographer: _____

Description and usage: _____

I am providing modeling services as independent contractor.

Hours worked: _____ Payment: _____

_____ _____
(Model's Name) (Photographer's signature)

_____ _____
(Address) (Date)

(___)_____
(Telephone)

_____/_____/_____
(Social Security #)

(Model's signature)

(Date)

If Model Is a Minor, Parent or Guardian Must Sign Below

I am the parent or guardian of the minor whose name appears above. I consent to the above terms on his/her behalf and warrant that I have the authority to give such consent.

_____ _____
(Parent's name) (Address)

_____ _____
(Signature) (Date)

This form has been approved by the Advertising Photographers of America, New York Chapter

STOCK PHOTOGRAPHY MODEL RELEASE

For valuable consideration, receipt of which I acknowledge as payment in full for my services as model and for permission herein granted, I hereby irrevocably consent to and authorize the reproduction, publication, and/or sale by _____ , its agents, licensees, and assigns, of the photographs identified below, in whole or part or in conjunction with other photographs, in any medium and for any lawful purpose, including illustration, promotion, or advertising, without any further compensation to me.

I waive any right to notice or approval of any use of the photographs which _____ may make or authorize and I release, discharge, and agree to save harmless _____, and its agents, licensees, and assigns, from any claim or liability in connection with the use of the photographs as aforesaid or by virtue of any alteration, processing, or use thereof in composite form, whether intentional or otherwise.

PHOTOGRAPHS:

Description(:) _____

Date(s) taken: _____

Photographer: _____

MODEL: I am over twenty-one years of age.

Signature: _____

Print name and address: _____

FOR MINOR: I am the father/mother/guardian of _____ .

For value received, I consent to the foregoing on his/her behalf.

Signature: _____

Print name and address: _____

WITNESS:

Dated: _____

Signature: _____

PROPERTY RELEASE

For good and valuable consideration herein acknowledged as received, the undersigned, being the legal owner of, or having the right to permit the taking and use of photographs of, certain property designated as _____, does grant to [PHOTOGRAPHER], his/her heirs, legal representatives, agents, and assigns the full rights to use such photographs and copyright same, in advertising, trade, or for any purpose.

The undersigned also consents to the use of any printed matter in conjunction therewith.

The undersigned hereby waives any right that he/she/it may have to inspect or approve the finished product or products, or the advertising copy or printed matter that may be used in connection therewith, or the use to which it may be applied.

The undersigned hereby releases, discharges, and agrees to save harmless [PHOTOGRAPHER], his/her heirs, legal representatives, and assigns, and all persons acting under his/her permission or authority, or those for whom he/she is acting, from any liability by virtue of any blurring, distortion, alteration, optical illusion, or use in composite form, whether intentional or otherwise, that may occur or be produced in the taking of said picture or in any subsequent processing thereof, as well as any publication thereof, even though it may subject me to ridicule, scandal, reproach, scorn, and indignity.

The undersigned hereby warrants that he/she is of full age and has every right to contract in his/her own name in the above regard. The undersigned states further that he/she has read the above authorization, release, and agreement, prior to its execution, and that he/she is fully familiar with the contents thereof. If the undersigned is signing as an agent or employee of a firm or corporation, the undersigned warrants that he/she is fully authorized to do so. This release shall be binding upon

the undersigned and his/her/its heirs, legal representatives, successors, and assigns.

DATE: _____ _____

 (NAME)

_____ _____

 (WITNESS) _____

 (ADDRESS)

LOCATION RELEASE

 Date: _____
 Studio Job # _____

The owner/agent of the building/property located at:

hereby grants permission to photographer:

to make photographs including any furnishings, signs, displays, etc., for the purpose of commercial sale or publication including advertising.

The photographer agrees to indemnify the owner/agent from and against any liability that may arise from the use of the building/property or photographs.

_____ _____

(Owner–Agent) (Signature of Photographer)

_____ _____

(Address) (Date)

(Signature)

(Date)

(Notes) _____

This form has been approved by the Advertising Photographers of
America, New York Chapter

Appendix 8
Translations of Short-form Releases

ENGLISH SHORT-FORM RELEASE

I hereby freely grant _____ and _____ permission to publish the photographs taken of me on _____ 199_, in _____ for editorial, advertising, or commercial purposes.

Your signature

FRENCH SHORT-FORM RELEASE

Je soussigné _____ dûment autorise _____ a publier en toutes bonnes considération les photographies de moi même du _____ 199_, dans _____, pour des raisons, de rédaction, de publicité ou à des fins purement commerciales.

lu et approuvé

GERMAN SHORT-FORM RELEASE

Durch meine unten angegebene Unterschrift gestatte ich die
Veröffentlichung in Redaktion, Reklame, und kommerziellem Interesse
der am ——————————————— von ———————————————
 Tag/Monat/Jahr Fotograf
der Firma ——————————————— in ———————————————
 Firmenname Ort
Selbstfotoaufnahmen.

——————————————— ———————————————
 Unterschrift Datum

SPANISH SHORT-FORM RELEASE

La presente sirve como constancia que he otorgado permiso
al ——————— para publicar mis fotografias tomadas el ——— 199 ,
en ——————— para fines editoriales, de publicidad, or
comerciales.

——————————————
 Firmado

ITALIAN SHORT-FORM RELEASE

Per buon considerazione, lo concedo permesso a ——————— a
publicare le fotografle preso di me il ——— 199 , in ———————
per uso editoriale, avverdimento, or commerciale.

——————————————
 sua firma

CHINESE SHORT-FORM RELEASE

本人同意允許——————與——————

刊登本人於——————在——————

拍攝的照片用於社論，廣告或商業用途。

簽署：——————————

ARABIC SHORT-FORM RELEASE

انني اسمـح بكـل حرّيتـي لـ ـــــــ و ـــــــ بنشـر الـصو ر الفوتوغرافية
التـي أُخذت عـى بتـاريـخ ـــــ ١٩٩ـــ فـي ـــــ لـلتعليـق الصحفى
والدعـايـة والتجـارة .

ـــــــــــ
تـوقـيـعـك

JAPANESE SHORT-FORM RELEASE

私は、＿＿＿＿＿＿＿氏が撮影した今回(＿＿年＿＿月＿＿日)の写真について、同氏がその記事、
広告、出版、その他いかなる商業活動に使用することを承認します。

ーーーーーー
(署名)

RUSSIAN SHORT-FORM RELEASE

Я даю своё добровольное согласие на то, чтобы фотографии взятые у
меня ＿＿＿＿＿＿ ＿＿＿＿ ＿＿＿＿199＿＿г. (для книги) ＿＿＿＿＿
были использованы редакцией для рекламы или в коммерческих целях.

ーーーーーー
подпись

Appendix 9

Sunrise and Sunset Times by Latitude

SUNRISE

Lat.	−55°	−50°	−45°	−40°	−35°	−30°	−20°	−10°	0°	+10°	+20°	+30°	+35°	+40°
	h m	h m	h m	h m	h m	h m	h m	h m	h m	h m	h m	h m	h m	h m
Jan. −2	3 23	3 52	4 15	4 33	4 47	5 00	5 22	5 41	5 58	6 16	6 34	6 55	7 07	7 21
2	3 27	3 56	4 18	4 36	4 50	5 03	5 25	5 43	6 00	6 17	6 36	6 56	7 08	7 22
6	3 33	4 01	4 22	4 39	4 54	5 06	5 27	5 45	6 02	6 19	6 37	6 57	7 09	7 22
10	3 39	4 06	4 27	4 43	4 57	5 09	5 30	5 48	6 04	6 20	6 37	6 57	7 09	7 22
14	3 46	4 12	4 32	4 48	5 01	5 13	5 33	5 50	6 05	6 21	6 38	6 57	7 08	7 20
18	3 53	4 18	4 37	4 52	5 05	5 16	5 35	5 52	6 07	6 22	6 38	6 56	7 07	7 19
22	4 01	4 24	4 42	4 57	5 09	5 20	5 38	5 54	6 08	6 22	6 38	6 55	7 05	7 17
26	4 10	4 31	4 48	5 02	5 13	5 23	5 40	5 55	6 09	6 23	6 37	6 53	7 03	7 14
30	4 18	4 38	4 54	5 07	5 17	5 27	5 43	5 57	6 10	6 23	6 36	6 52	7 00	7 10
Feb. 3	4 27	4 45	5 00	5 11	5 22	5 30	5 45	5 58	6 10	6 22	6 35	6 49	6 57	7 07
7	4 35	4 52	5 05	5 16	5 26	5 34	5 48	6 00	6 11	6 22	6 33	6 46	6 54	7 03
11	4 44	4 59	5 11	5 21	5 30	5 37	5 50	6 01	6 11	6 21	6 31	6 43	6 50	6 58
15	4 53	5 06	5 17	5 26	5 34	5 40	5 52	6 02	6 11	6 20	6 29	6 40	6 46	6 53
19	5 01	5 13	5 23	5 31	5 38	5 43	5 54	6 02	6 10	6 18	6 27	6 36	6 42	6 48
23	5 10	5 20	5 29	5 35	5 41	5 47	5 55	6 03	6 10	6 17	6 24	6 32	6 37	6 42
27	5 18	5 27	5 34	5 40	5 45	5 49	5 57	6 03	6 09	6 15	6 21	6 28	6 32	6 37
Mar. 3	5 27	5 34	5 40	5 45	5 49	5 52	5 58	6 04	6 09	6 13	6 18	6 24	6 27	6 31
7	5 35	5 41	5 45	5 49	5 52	5 55	6 00	6 04	6 08	6 11	6 15	6 19	6 22	6 24
11	5 43	5 47	5 50	5 53	5 56	5 58	6 01	6 04	6 07	6 09	6 12	6 15	6 16	6 18
15	5 51	5 54	5 56	5 57	5 59	6 00	6 02	6 04	6 06	6 07	6 09	6 10	6 11	6 12
19	5 59	6 00	6 01	6 02	6 02	6 03	6 04	6 04	6 05	6 05	6 05	6 05	6 05	6 05
23	6 07	6 06	6 06	6 06	6 05	6 05	6 05	6 04	6 03	6 03	6 02	6 00	6 00	5 59
27	6 15	6 13	6 11	6 10	6 09	6 08	6 06	6 04	6 02	6 00	5 58	5 56	5 54	5 52
31	6 22	6 19	6 16	6 14	6 12	6 10	6 07	6 04	6 01	5 58	5 55	5 51	5 48	5 46
Apr. 4	6 30	6 25	6 21	6 18	6 15	6 12	6 08	6 04	6 00	5 56	5 51	5 46	5 43	5 39

SUNSET

Lat.	−55°	−50°	−45°	−40°	−35°	−30°	−20°	−10°	0°	+10°	+20°	+30°	+35°	+40°
	h m	h m	h m	h m	h m	h m	h m	h m	h m	h m	h m	h m	h m	h m
Jan. −2	20 41	20 12	19 49	19 32	19 17	19 04	18 42	18 23	18 06	17 49	17 30	17 09	16 57	16 43
2	20 40	20 11	19 50	19 32	19 18	19 05	18 43	18 25	18 08	17 51	17 33	17 12	17 00	16 46
6	20 38	20 10	19 49	19 32	19 18	19 05	18 44	18 26	18 10	17 53	17 35	17 15	17 03	16 50
10	20 35	20 08	19 48	19 31	19 18	19 06	18 45	18 28	18 11	17 55	17 38	17 18	17 07	16 54
14	20 31	20 06	19 46	19 30	19 17	19 05	18 46	18 29	18 13	17 57	17 41	17 22	17 11	16 58
18	20 26	20 02	19 43	19 28	19 16	19 04	18 46	18 29	18 14	17 59	17 43	17 25	17 15	17 03
22	20 21	19 58	19 40	19 26	19 14	19 03	18 45	18 30	18 15	18 01	17 46	17 29	17 19	17 07
26	20 14	19 53	19 36	19 23	19 12	19 02	18 45	18 30	18 16	18 03	17 48	17 32	17 23	17 12
30	20 07	19 48	19 32	19 20	19 09	18 59	18 44	18 30	18 17	18 04	17 51	17 35	17 27	17 17
Feb. 3	20 00	19 42	19 27	19 16	19 06	18 57	18 42	18 29	18 17	18 06	17 53	17 39	17 31	17 21
7	19 52	19 35	19 22	19 11	19 02	18 54	18 40	18 29	18 18	18 07	17 55	17 42	17 35	17 26
11	19 43	19 28	19 16	19 07	18 58	18 51	18 39	18 28	18 18	18 08	17 57	17 46	17 39	17 31
15	19 34	19 21	19 10	19 02	18 54	18 48	18 36	18 27	18 18	18 09	17 59	17 49	17 43	17 36
19	19 25	19 13	19 04	18 56	18 50	18 44	18 34	18 25	18 17	18 09	18 01	17 52	17 46	17 40
23	19 15	19 05	18 57	18 51	18 45	18 40	18 31	18 24	18 17	18 10	18 03	17 55	17 50	17 45
27	19 06	18 57	18 50	18 45	18 40	18 36	18 28	18 22	18 16	18 10	18 04	17 58	17 54	17 49
Mar. 3	18 56	18 49	18 43	18 39	18 35	18 31	18 25	18 20	18 15	18 11	18 06	18 00	17 57	17 54
7	18 46	18 40	18 36	18 32	18 29	18 27	18 22	18 18	18 14	18 11	18 07	18 03	18 01	17 58
11	18 36	18 32	18 29	18 26	18 24	18 22	18 19	18 16	18 13	18 11	18 08	18 06	18 04	18 03
15	18 26	18 23	18 21	18 20	18 18	18 17	18 15	18 14	18 12	18 11	18 10	18 08	18 08	18 07
19	18 16	18 15	18 14	18 13	18 13	18 12	18 12	18 11	18 11	18 11	18 11	18 11	18 11	18 11
23	18 05	18 06	18 06	18 07	18 07	18 08	18 08	18 09	18 10	18 10	18 11	18 12	18 13	18 14
27	17 55	17 57	17 59	18 00	18 02	18 03	18 05	18 07	18 09	18 11	18 13	18 16	18 17	18 19
31	17 45	17 49	17 51	17 54	17 56	17 58	18 01	18 04	18 07	18 11	18 14	18 18	18 20	18 23
Apr. 4	17 35	17 40	17 44	17 47	17 50	17 53	17 58	18 02	18 06	18 10	18 15	18 20	18 24	18 27

SUNRISE

Lat.	+40°	+42°	+44°	+46°	+48°	+50°	+52°	+54°	+56°	+58°	+60°	+62°	+64°	+66°
	h m	h m	h m	h m	h m	h m	h m	h m	h m	h m	h m	h m	h m	h m
Jan. −2	7 21	7 28	7 34	7 42	7 50	7 59	8 08	8 19	8 32	8 46	9 03	9 25	9 52	10 32
2	7 22	7 28	7 35	7 42	7 50	7 59	8 08	8 19	8 31	8 45	9 02	9 22	9 49	10 26
6	7 22	7 28	7 35	7 42	7 49	7 58	8 07	8 17	8 29	8 43	8 59	9 18	9 43	10 18
10	7 22	7 27	7 34	7 41	7 48	7 56	8 05	8 15	8 26	8 39	8 55	9 13	9 36	10 07
14	7 20	7 26	7 32	7 39	7 46	7 54	8 02	8 12	8 22	8 35	8 49	9 07	9 28	9 56
18	7 19	7 24	7 30	7 36	7 43	7 50	7 58	8 07	8 18	8 29	8 43	8 59	9 19	9 44
22	7 17	7 22	7 27	7 33	7 39	7 46	7 54	8 03	8 12	8 23	8 36	8 50	9 08	9 31
26	7 14	7 19	7 24	7 29	7 35	7 42	7 49	7 57	8 06	8 16	8 27	8 41	8 57	9 17
30	7 10	7 15	7 20	7 25	7 30	7 37	7 43	7 51	7 59	8 08	8 19	8 31	8 46	9 03
Feb. 3	7 07	7 11	7 15	7 20	7 25	7 31	7 37	7 44	7 51	8 00	8 09	8 20	8 33	8 49
7	7 03	7 06	7 10	7 15	7 19	7 25	7 30	7 36	7 43	7 51	7 59	8 09	8 21	8 35
11	6 58	7 01	7 05	7 09	7 13	7 18	7 23	7 28	7 34	7 41	7 49	7 58	8 08	8 20
15	6 53	6 56	6 59	7 03	7 07	7 11	7 15	7 20	7 25	7 31	7 38	7 46	7 55	8 06
19	6 48	6 51	6 53	6 56	7 00	7 03	7 07	7 11	7 16	7 21	7 27	7 34	7 42	7 51
23	6 42	6 45	6 47	6 50	6 53	6 56	6 59	7 03	7 07	7 11	7 16	7 22	7 28	7 36
27	6 37	6 38	6 41	6 43	6 45	6 48	6 50	6 53	6 57	7 00	7 05	7 09	7 15	7 21
Mar. 3	6 31	6 32	6 34	6 36	6 37	6 39	6 42	6 44	6 47	6 50	6 53	6 57	7 01	7 06
7	6 24	6 26	6 27	6 28	6 30	6 31	6 33	6 34	6 36	6 39	6 41	6 44	6 47	6 50
11	6 18	6 19	6 20	6 21	6 22	6 23	6 24	6 25	6 26	6 28	6 29	6 31	6 33	6 35
15	6 12	6 12	6 13	6 13	6 13	6 14	6 14	6 15	6 16	6 16	6 17	6 18	6 19	6 20
19	6 05	6 05	6 05	6 05	6 05	6 05	6 05	6 05	6 05	6 05	6 05	6 05	6 05	6 05
23	5 59	5 58	5 58	5 58	5 57	5 57	5 56	5 55	5 55	5 54	5 53	5 52	5 51	5 49
27	5 52	5 52	5 51	5 50	5 49	5 48	5 47	5 45	5 44	5 42	5 41	5 39	5 36	5 34
31	5 46	5 45	5 43	5 42	5 41	5 39	5 37	5 36	5 34	5 31	5 29	5 26	5 22	5 18
Apr. 4	5 39	5 38	5 36	5 35	5 33	5 31	5 28	5 26	5 23	5 20	5 17	5 13	5 08	5 03

SUNSET

	+40°	+42°	+44°	+46°	+48°	+50°	+52°	+54°	+56°	+58°	+60°	+62°	+64°	+66°
	h m	h m	h m	h m	h m	h m	h m	h m	h m	h m	h m	h m	h m	h m
Jan. −2	16 43	16 37	16 30	16 23	16 15	16 06	15 56	15 45	15 33	15 18	15 01	14 40	14 13	13 32
2	16 46	16 40	16 33	16 26	16 18	16 10	16 00	15 50	15 37	15 23	15 07	14 46	14 20	13 42
6	16 50	16 44	16 37	16 30	16 23	16 14	16 05	15 55	15 43	15 29	15 13	14 54	14 39	13 55
10	16 54	16 48	16 42	16 35	16 28	16 20	16 11	16 01	15 49	15 36	15 21	15 03	14 39	14 08
14	16 58	16 52	16 46	16 40	16 33	16 25	16 17	16 07	15 56	15 44	15 30	15 12	14 51	14 23
18	17 03	16 57	16 51	16 45	16 39	16 31	16 23	16 14	16 04	15 52	15 39	15 23	15 03	14 38
22	17 07	17 02	16 57	16 51	16 44	16 37	16 30	16 21	16 12	16 01	15 48	15 34	15 16	14 53
26	17 12	17 07	17 02	16 56	16 51	16 44	16 37	16 29	16 20	16 10	15 59	15 45	15 29	15 09
30	17 17	17 12	17 07	17 02	16 57	16 51	16 44	16 37	16 29	16 19	16 09	15 57	15 42	15 24
Feb. 3	17 21	17 17	17 13	17 08	17 03	16 58	16 52	16 45	16 37	16 29	16 19	16 08	15 55	15 40
7	17 26	17 23	17 18	17 14	17 10	17 05	16 59	16 53	16 46	16 39	16 30	16 20	16 08	15 55
11	17 31	17 28	17 24	17 20	17 16	17 11	17 06	17 01	16 55	16 48	16 41	16 32	16 22	16 09
15	17 36	17 33	17 30	17 26	17 22	17 18	17 14	17 09	17 04	16 58	16 51	16 43	16 34	16 24
19	17 40	17 38	17 35	17 32	17 29	17 25	17 21	17 17	17 12	17 07	17 02	16 55	16 47	16 38
23	17 45	17 43	17 40	17 38	17 35	17 32	17 29	17 25	17 21	17 17	17 12	17 06	17 00	16 52
27	17 49	17 48	17 46	17 43	17 41	17 39	17 36	17 33	17 30	17 26	17 22	17 18	17 12	17 06
Mar. 3	17 54	17 52	17 51	17 49	17 47	17 45	17 43	17 41	17 38	17 35	17 32	17 29	17 25	17 20
7	17 58	17 57	17 56	17 55	17 53	17 52	17 50	17 49	17 47	17 45	17 42	17 40	17 37	17 33
11	18 03	18 02	18 01	18 00	17 59	17 58	17 57	17 56	17 55	17 54	17 52	17 51	17 49	17 47
15	18 07	18 06	18 06	18 06	18 05	18 05	18 04	18 04	18 03	18 03	18 02	18 01	18 01	18 00
19	18 11	18 11	18 11	18 11	18 11	18 11	18 11	18 11	18 12	18 12	18 12	18 12	18 12	18 13
23	18 15	18 15	18 16	18 16	18 17	18 18	18 18	18 19	18 20	18 21	18 22	18 23	18 24	18 26
27	18 19	18 20	18 21	18 22	18 23	18 24	18 25	18 26	18 28	18 30	18 31	18 34	18 36	18 39
31	18 23	18 24	18 26	18 27	18 29	18 30	18 32	18 34	18 36	18 38	18 41	18 44	18 48	18 52
Apr. 4	18 27	18 29	18 30	18 32	18 34	18 36	18 39	18 41	18 44	18 47	18 51	18 55	19 00	19 05

SUNRISE

Lat.	−55°	−50°	−45°	−40°	−35°	−30°	−20°	−10°	0°	+10°	+20°	+30°	+35°	+40°
	h m	h m	h m	h m	h m	h m	h m	h m	h m	h m	h m	h m	h m	h m
Mar. 31	6 22	6 19	6 16	6 14	6 12	6 10	6 07	6 04	6 01	5 58	5 55	5 51	5 48	5 46
Apr. 4	6 30	6 25	6 21	6 18	6 15	6 12	6 08	6 04	6 00	5 56	5 51	5 46	5 43	5 39
8	6 38	6 31	6 26	6 22	6 18	6 15	6 09	6 04	5 59	5 53	5 48	5 41	5 37	5 33
12	6 45	6 38	6 31	6 26	6 21	6 17	6 10	6 04	5 57	5 51	5 44	5 37	5 32	5 27
16	6 53	6 44	6 36	6 30	6 24	6 20	6 11	6 04	5 56	5 49	5 41	5 32	5 27	5 21
20	7 01	6 50	6 41	6 34	6 28	6 22	6 12	6 04	5 56	5 47	5 38	5 28	5 22	5 15
24	7 08	6 56	6 46	6 38	6 31	6 24	6 14	6 04	5 55	5 45	5 35	5 24	5 17	5 09
28	7 16	7 02	6 51	6 42	6 34	6 27	6 15	6 04	5 54	5 44	5 33	5 20	5 13	5 04
May 2	7 23	7 08	6 56	6 46	6 37	6 29	6 16	6 05	5 54	5 42	5 30	5 16	5 08	4 59
6	7 30	7 14	7 01	6 50	6 40	6 32	6 18	6 05	5 53	5 41	5 28	5 13	5 04	4 54
10	7 38	7 20	7 05	6 54	6 43	6 35	6 19	6 06	5 53	5 40	5 26	5 10	5 01	4 50
14	7 45	7 25	7 10	6 57	6 47	6 37	6 21	6 06	5 53	5 39	5 24	5 07	4 57	4 46
18	7 51	7 31	7 14	7 01	6 50	6 40	6 22	6 07	5 53	5 38	5 23	5 05	4 54	4 42
22	7 58	7 36	7 19	7 04	6 52	6 42	6 24	6 08	5 53	5 38	5 22	5 03	4 52	4 39
26	8 04	7 40	7 22	7 08	6 55	6 44	6 25	6 09	5 53	5 38	5 21	5 01	4 50	4 36
30	8 09	7 45	7 26	7 11	6 58	6 47	6 27	6 10	5 54	5 38	5 20	5 00	4 48	4 34
June 3	8 14	7 49	7 29	7 14	7 00	6 49	6 29	6 11	5 54	5 38	5 20	4 59	4 47	4 32
7	8 18	7 52	7 32	7 16	7 02	6 51	6 30	6 12	5 55	5 38	5 20	4 58	4 46	4 31
11	8 22	7 55	7 35	7 18	7 04	6 52	6 31	6 13	5 56	5 39	5 20	4 58	4 45	4 31
15	8 24	7 57	7 37	7 20	7 06	6 54	6 33	6 14	5 57	5 39	5 20	4 58	4 45	4 30
19	8 26	7 59	7 38	7 21	7 07	6 55	6 34	6 15	5 58	5 40	5 21	4 59	4 46	4 31
23	8 27	8 00	7 39	7 22	7 08	6 56	6 34	6 16	5 58	5 41	5 22	5 00	4 47	4 32
27	8 27	8 00	7 39	7 23	7 09	6 56	6 35	6 17	5 59	5 42	5 23	5 01	4 48	4 33
July 1	8 26	8 00	7 39	7 23	7 09	6 56	6 36	6 17	6 00	5 43	5 24	5 02	4 50	4 35
5	8 24	7 58	7 38	7 22	7 08	6 56	6 36	6 18	6 01	5 44	5 25	5 04	4 51	4 37

SUNSET

	h m	h m	h m	h m	h m	h m	h m	h m	h m	h m	h m	h m	h m	h m
Mar. 31	17 45	17 49	17 51	17 54	17 56	17 58	18 01	18 04	18 07	18 11	18 14	18 18	18 20	18 23
Apr. 4	17 35	17 40	17 44	17 47	17 50	17 53	17 58	18 02	18 06	18 10	18 15	18 20	18 24	18 27
8	17 25	17 32	17 37	17 41	17 45	17 48	17 55	18 00	18 05	18 10	18 16	18 23	18 27	18 31
12	17 15	17 23	17 30	17 35	17 40	17 44	17 51	17 58	18 04	18 10	18 17	18 25	18 30	18 35
16	17 06	17 15	17 23	17 29	17 35	17 40	17 48	17 56	18 03	18 11	18 19	18 28	18 33	18 39
20	16 56	17 07	17 16	17 23	17 30	17 35	17 45	17 54	18 02	18 11	18 20	18 30	18 36	18 43
24	16 47	17 00	17 10	17 18	17 25	17 31	17 42	17 52	18 01	18 11	18 21	18 33	18 40	18 47
28	16 38	16 52	17 03	17 13	17 21	17 28	17 40	17 51	18 01	18 11	18 22	18 35	18 43	18 51
May 2	16 30	16 45	16 58	17 08	17 16	17 24	17 37	17 49	18 00	18 12	18 24	18 38	18 46	18 56
6	16 22	16 39	16 52	17 03	17 12	17 21	17 35	17 48	18 00	18 12	18 25	18 41	18 49	19 00
10	16 14	16 33	16 47	16 59	17 09	17 18	17 33	17 47	18 00	18 13	18 27	18 43	18 53	19 03
14	16 07	16 27	16 42	16 55	17 06	17 15	17 32	17 46	18 00	18 14	18 28	18 46	18 56	19 07
18	16 01	16 22	16 38	16 51	17 03	17 13	17 30	17 46	18 00	18 14	18 30	18 48	18 59	19 11
22	15 55	16 17	16 34	16 48	17 00	17 11	17 29	17 45	18 00	18 15	18 32	18 51	19 02	19 15
26	15 50	16 13	16 31	16 46	16 58	17 09	17 28	17 45	18 01	18 16	18 33	18 53	19 05	19 18
30	15 45	16 10	16 29	16 44	16 57	17 08	17 28	17 45	18 01	18 17	18 35	18 55	19 07	19 21
June 3	15 42	16 07	16 26	16 42	16 56	17 07	17 28	17 45	18 02	18 18	18 36	18 57	19 10	19 24
7	15 39	16 05	16 25	16 41	16 55	17 07	17 28	17 46	18 02	18 20	18 38	18 59	19 12	19 27
11	15 37	16 04	16 24	16 41	16 55	17 07	17 28	17 46	18 03	18 21	18 39	19 01	19 14	19 29
15	15 36	16 03	16 24	16 41	16 55	17 07	17 28	17 47	18 04	18 22	18 41	19 03	19 15	19 30
19	15 36	16 03	16 24	16 41	16 55	17 08	17 29	17 47	18 05	18 23	18 42	19 04	19 17	19 32
23	15 37	16 04	16 25	16 42	16 56	17 09	17 30	17 48	18 06	18 23	18 42	19 04	19 18	19 33
27	15 39	16 06	16 27	16 43	16 57	17 10	17 31	17 49	18 07	18 24	18 43	19 05	19 18	19 33
July 1	15 42	16 08	16 29	16 45	16 59	17 11	17 32	17 50	18 07	18 25	18 43	19 05	19 18	19 33
5	15 45	16 11	16 31	16 47	17 01	17 13	17 33	17 51	18 08	18 25	18 44	19 05	19 17	19 32

SUNRISE

Lat.	+40°	+42°	+44°	+46°	+48°	+50°	+52°	+54°	+56°	+58°	+60°	+62°	+64°	+66°
	h m	h m	h m	h m	h m	h m	h m	h m	h m	h m	h m	h m	h m	h m
Mar. 31	5 46	5 45	5 43	5 42	5 41	5 39	5 37	5 36	5 34	5 31	5 29	5 26	5 22	5 18
Apr. 4	5 39	5 38	5 36	5 35	5 33	5 31	5 28	5 26	5 23	5 20	5 17	5 13	5 08	5 03
8	5 33	5 31	5 29	5 27	5 25	5 22	5 19	5 16	5 13	5 09	5 05	5 00	4 54	4 47
12	5 27	5 25	5 22	5 20	5 17	5 14	5 10	5 06	5 02	4 58	4 53	4 47	4 40	4 32
16	5 21	5 18	5 15	5 12	5 09	5 05	5 01	4 57	4 52	4 47	4 41	4 34	4 26	4 16
20	5 15	5 12	5 09	5 05	5 01	4 57	4 53	4 48	4 42	4 36	4 29	4 21	4 12	4 01
24	5 09	5 06	5 02	4 58	4 54	4 50	4 44	4 39	4 33	4 26	4 18	4 08	3 58	3 45
28	5 04	5 00	4 56	4 52	4 47	4 42	4 36	4 30	4 23	4 15	4 06	3 56	3 44	3 29
May 2	4 59	4 55	4 50	4 46	4 40	4 35	4 29	4 22	4 14	4 05	3 55	3 44	3 30	3 14
6	4 54	4 50	4 45	4 40	4 34	4 28	4 21	4 14	4 05	3 56	3 45	3 32	3 17	2 58
10	4 50	4 45	4 40	4 34	4 28	4 22	4 14	4 06	3 57	3 47	3 35	3 20	3 03	2 42
14	4 46	4 41	4 35	4 29	4 23	4 16	4 08	3 59	3 49	3 38	3 25	3 09	2 50	2 26
18	4 42	4 37	4 31	4 25	4 18	4 10	4 02	3 52	3 42	3 30	3 16	2 59	2 38	2 10
22	4 39	4 33	4 27	4 21	4 13	4 05	3 56	3 47	3 35	3 22	3 07	2 49	2 25	1 54
26	4 36	4 30	4 24	4 17	4 09	4 01	3 52	3 41	3 29	3 16	2 59	2 39	2 14	1 38
30	4 34	4 28	4 21	4 14	4 06	3 57	3 48	3 37	3 24	3 10	2 52	2 31	2 03	1 21
June 3	4 32	4 26	4 19	4 12	4 04	3 54	3 44	3 33	3 20	3 05	2 46	2 24	1 53	1 04
7	4 31	4 25	4 18	4 10	4 02	3 52	3 42	3 30	3 17	3 01	2 42	2 18	1 45	0 45
11	4 31	4 24	4 17	4 09	4 00	3 51	3 40	3 28	3 14	2 58	2 38	2 13	1 38	0 21
15	4 30	4 24	4 16	4 08	4 00	3 50	3 39	3 27	3 13	2 56	2 36	2 10	1 33	** **
19	4 31	4 24	4 17	4 09	4 00	3 50	3 39	3 27	3 13	2 56	2 35	2 09	1 31	** **
23	4 32	4 25	4 18	4 10	4 01	3 51	3 40	3 28	3 14	2 57	2 36	2 10	1 31	** **
27	4 33	4 26	4 19	4 11	4 02	3 53	3 42	3 29	3 15	2 59	2 38	2 12	1 35	** **
July 1	4 35	4 28	4 21	4 13	4 04	3 55	3 44	3 32	3 18	3 02	2 42	2 17	1 41	0 18
5	4 37	4 30	4 23	4 15	4 07	3 58	3 47	3 35	3 22	3 06	2 47	2 22	1 49	0 46

SUNSET

Lat.	+40°	+42°	+44°	+46°	+48°	+50°	+52°	+54°	+56°	+58°	+60°	+62°	+64°	+66°
	h m	h m	h m	h m	h m	h m	h m	h m	h m	h m	h m	h m	h m	h m
Mar. 31	18 23	18 24	18 26	18 27	18 29	18 30	18 32	18 34	18 36	18 38	18 41	18 44	18 48	18 52
Apr. 4	18 27	18 29	18 30	18 32	18 34	18 36	18 39	18 41	18 44	18 47	18 51	18 55	19 00	19 05
8	18 31	18 33	18 35	18 38	18 40	18 43	18 46	18 49	18 52	18 56	19 01	19 06	19 12	19 18
12	18 35	18 38	18 40	18 43	18 46	18 49	18 52	18 56	19 01	19 05	19 11	19 17	19 24	19 32
16	18 39	18 42	18 45	18 48	18 52	18 55	18 59	19 04	19 09	19 14	19 20	19 28	19 36	19 46
20	18 43	18 46	18 50	18 53	18 57	19 01	19 06	19 11	19 17	19 23	19 30	19 39	19 48	19 59
24	18 47	18 51	18 55	18 59	19 03	19 08	19 13	19 19	19 25	19 32	19 40	19 50	20 01	20 14
28	18 51	18 55	18 59	19 04	19 09	19 14	19 20	19 26	19 33	19 41	19 50	20 01	20 13	20 28
May 2	18 56	19 00	19 04	19 09	19 14	19 20	19 26	19 33	19 41	19 50	20 00	20 12	20 26	20 43
6	19 00	19 04	19 09	19 14	19 20	19 26	19 33	19 41	19 49	19 59	20 10	20 23	20 39	20 58
10	19 03	19 08	19 14	19 19	19 25	19 32	19 40	19 48	19 57	20 08	20 20	20 34	20 52	21 14
14	19 07	19 13	19 18	19 24	19 31	19 38	19 46	19 55	20 05	20 16	20 29	20 45	21 05	21 29
18	19 11	19 17	19 22	19 29	19 36	19 43	19 52	20 01	20 12	20 24	20 39	20 56	21 17	21 46
22	19 15	19 20	19 27	19 33	19 41	19 49	19 58	20 08	20 19	20 32	20 48	21 06	21 30	22 03
26	19 18	19 24	19 31	19 38	19 45	19 54	20 03	20 14	20 26	20 40	20 56	21 16	21 42	22 20
30	19 21	19 27	19 34	19 41	19 49	19 58	20 08	20 19	20 32	20 46	21 04	21 26	21 54	22 38
June 3	19 24	19 30	19 37	19 45	19 53	20 02	20 12	20 24	20 37	20 52	21 11	21 34	22 05	22 57
7	19 27	19 33	19 40	19 48	19 56	20 06	20 16	20 28	20 42	20 58	21 17	21 41	22 15	23 18
11	19 29	19 35	19 43	19 51	19 59	20 09	20 19	20 31	20 45	21 02	21 22	21 47	22 23	23 48
15	19 30	19 37	19 45	19 53	20 01	20 11	20 22	20 34	20 48	21 05	21 25	21 51	22 29	** **
19	19 32	19 39	19 46	19 54	20 03	20 12	20 23	20 36	20 50	21 07	21 27	21 54	22 32	** **
23	19 33	19 39	19 47	19 55	20 03	20 13	20 24	20 36	20 51	21 07	21 28	21 54	22 32	** **
27	19 33	19 40	19 47	19 55	20 04	20 13	20 24	20 36	20 50	21 07	21 27	21 53	22 30	** **
July 1	19 33	19 39	19 47	19 54	20 03	20 12	20 23	20 35	20 49	21 05	21 25	21 50	22 25	23 41
5	19 32	19 39	19 46	19 53	20 02	20 11	20 21	20 33	20 47	21 02	21 21	21 45	22 18	23 18

(** **) indicates Sun continuously above horizon.

SUNRISE

Lat.	−55°	−50°	−45°	−40°	−35°	−30°	−20°	−10°	0°	+10°	+20°	+30°	+35°	+40°
	h m	h m	h m	h m	h m	h m	h m	h m	h m	h m	h m	h m	h m	h m
July 1	8 26	8 00	7 39	7 23	7 09	6 56	6 36	6 17	6 00	5 43	5 24	5 02	4 50	4 35
5	8 24	7 58	7 38	7 22	7 08	6 56	6 36	6 18	6 01	5 44	5 25	5 04	4 51	4 37
9	8 21	7 56	7 37	7 21	7 08	6 56	6 36	6 18	6 02	5 45	5 27	5 06	4 54	4 39
13	8 18	7 53	7 35	7 19	7 06	6 55	6 35	6 18	6 02	5 46	5 28	5 08	4 56	4 42
17	8 13	7 50	7 32	7 17	7 05	6 54	6 35	6 18	6 03	5 47	5 30	5 10	4 58	4 45
21	8 08	7 46	7 29	7 14	7 02	6 52	6 34	6 18	6 03	5 48	5 31	5 12	5 01	4 48
25	8 02	7 41	7 25	7 11	7 00	6 50	6 33	6 17	6 03	5 48	5 33	5 15	5 04	4 52
29	7 55	7 36	7 20	7 08	6 57	6 47	6 31	6 17	6 03	5 49	5 34	5 17	5 07	4 55
Aug. 2	7 48	7 30	7 16	7 04	6 54	6 45	6 29	6 16	6 03	5 50	5 36	5 19	5 10	4 59
6	7 41	7 24	7 10	6 59	6 50	6 42	6 27	6 14	6 02	5 50	5 37	5 22	5 13	5 03
10	7 32	7 17	7 05	6 55	6 46	6 38	6 25	6 13	6 02	5 51	5 38	5 24	5 16	5 07
14	7 24	7 10	6 59	6 50	6 42	6 35	6 22	6 12	6 01	5 51	5 40	5 27	5 19	5 10
18	7 15	7 03	6 53	6 44	6 37	6 31	6 20	6 10	6 00	5 51	5 41	5 29	5 22	5 14
22	7 06	6 55	6 46	6 39	6 32	6 27	6 17	6 08	6 00	5 51	5 42	5 31	5 25	5 18
26	6 56	6 47	6 39	6 33	6 27	6 22	6 14	6 06	5 58	5 51	5 43	5 34	5 28	5 22
30	6 47	6 39	6 32	6 27	6 22	6 18	6 10	6 04	5 57	5 51	5 44	5 36	5 31	5 26
Sept. 3	6 37	6 30	6 25	6 21	6 17	6 13	6 07	6 01	5 56	5 51	5 45	5 38	5 34	5 29
7	6 27	6 22	6 18	6 14	6 11	6 08	6 03	5 59	5 55	5 50	5 46	5 40	5 37	5 33
11	6 17	6 13	6 10	6 08	6 05	6 03	6 00	5 57	5 53	5 50	5 46	5 42	5 40	5 37
15	6 07	6 05	6 03	6 01	6 00	5 58	5 56	5 54	5 52	5 50	5 47	5 44	5 43	5 41
19	5 56	5 56	5 55	5 54	5 54	5 53	5 52	5 52	5 51	5 49	5 48	5 47	5 46	5 45
23	5 46	5 47	5 47	5 48	5 48	5 48	5 49	5 49	5 49	5 49	5 49	5 49	5 49	5 48
27	5 36	5 38	5 40	5 41	5 42	5 43	5 45	5 47	5 48	5 49	5 50	5 51	5 52	5 52
Oct. 1	5 26	5 29	5 32	5 35	5 37	5 39	5 42	5 44	5 46	5 49	5 51	5 53	5 55	5 56
5	5 15	5 21	5 25	5 28	5 31	5 34	5 38	5 42	5 45	5 48	5 52	5 56	5 58	6 00

SUNSET

	h m	h m	h m	h m	h m	h m	h m	h m	h m	h m	h m	h m	h m	h m
July 1	15 42	16 08	16 29	16 45	16 59	17 11	17 32	17 50	18 07	18 25	18 43	19 05	19 18	19 33
5	15 45	16 11	16 31	16 47	17 01	17 13	17 33	17 51	18 08	18 25	18 44	19 05	19 17	19 32
9	15 49	16 14	16 34	16 50	17 03	17 15	17 35	17 52	18 09	18 25	18 43	19 04	19 17	19 31
13	15 54	16 18	16 37	16 52	17 05	17 17	17 36	17 53	18 09	18 26	18 43	19 03	19 15	19 29
17	16 00	16 23	16 41	16 55	17 08	17 19	17 38	17 54	18 10	18 25	18 42	19 02	19 13	19 27
21	16 05	16 27	16 45	16 59	17 11	17 21	17 39	17 55	18 10	18 25	18 41	19 00	19 11	19 24
25	16 12	16 32	16 49	17 02	17 13	17 23	17 41	17 56	18 10	18 24	18 40	18 58	19 08	19 21
29	16 18	16 38	16 53	17 05	17 16	17 26	17 42	17 56	18 10	18 24	18 38	18 55	19 05	19 17
Aug. 2	16 25	16 43	16 57	17 09	17 19	17 28	17 43	17 57	18 10	18 23	18 37	18 53	19 02	19 13
6	16 32	16 48	17 02	17 13	17 22	17 30	17 45	17 57	18 09	18 21	18 34	18 49	18 58	19 08
10	16 39	16 54	17 06	17 16	17 25	17 33	17 46	17 58	18 09	18 20	18 32	18 46	18 54	19 03
14	16 46	17 00	17 11	17 20	17 28	17 35	17 47	17 58	18 08	18 18	18 29	18 42	18 50	18 58
18	16 53	17 06	17 16	17 24	17 31	17 37	17 48	17 58	18 07	18 17	18 27	18 38	18 45	18 53
22	17 01	17 11	17 20	17 28	17 34	17 39	17 49	17 58	18 06	18 15	18 24	18 34	18 40	18 47
26	17 08	17 17	17 25	17 31	17 37	17 42	17 50	17 58	18 05	18 12	18 20	18 30	18 35	18 41
30	17 15	17 23	17 30	17 35	17 40	17 44	17 51	17 58	18 04	18 10	18 17	18 25	18 30	18 35
Sept. 3	17 23	17 29	17 34	17 39	17 43	17 46	17 52	17 57	18 03	18 08	18 14	18 20	18 24	18 29
7	17 30	17 35	17 39	17 42	17 45	17 48	17 53	17 57	18 01	18 05	18 10	18 15	18 19	18 22
11	17 37	17 41	17 44	17 46	17 48	17 50	17 54	17 57	18 00	18 03	18 06	18 10	18 13	18 16
15	17 45	17 47	17 48	17 50	17 51	17 52	17 55	17 56	17 58	18 00	18 03	18 05	18 07	18 09
19	17 52	17 53	17 53	17 54	17 54	17 55	17 55	17 56	17 57	17 58	17 59	18 00	18 01	18 02
23	18 00	17 59	17 58	17 58	17 57	17 57	17 56	17 56	17 56	17 55	17 55	17 55	17 56	17 56
27	18 07	18 05	18 03	18 01	18 00	17 59	17 57	17 56	17 54	17 53	17 52	17 51	17 50	17 49
Oct. 1	18 15	18 11	18 08	18 05	18 03	18 01	17 58	17 55	17 53	17 51	17 48	17 46	17 44	17 43
5	18 23	18 17	18 13	18 09	18 06	18 04	17 59	17 55	17 52	17 48	17 45	17 41	17 39	17 36

SUNRISE

Lat.	+40°	+42°	+44°	+46°	+48°	+50°	+52°	+54°	+56°	+58°	+60°	+62°	+64°	+66°
	h m	h m	h m	h m	h m	h m	h m	h m	h m	h m	h m	h m	h m	h m
July 1	4 35	4 28	4 21	4 13	4 04	3 55	3 44	3 32	3 18	3 02	2 42	2 17	1 41	0 18
5	4 37	4 30	4 23	4 15	4 07	3 58	3 47	3 35	3 22	3 06	2 47	2 22	1 49	0 46
9	4 39	4 33	4 26	4 18	4 10	4 01	3 51	3 40	3 26	3 11	2 53	2 30	1 59	1 07
13	4 42	4 36	4 29	4 22	4 14	4 05	3 55	3 44	3 32	3 17	3 00	2 38	2 09	1 26
17	4 45	4 39	4 33	4 26	4 18	4 10	4 00	3 50	3 38	3 24	3 07	2 47	2 21	1 44
21	4 48	4 43	4 36	4 30	4 22	4 14	4 05	3 55	3 44	3 31	3 15	2 57	2 33	2 01
25	4 52	4 46	4 40	4 34	4 27	4 19	4 11	4 02	3 51	3 39	3 24	3 07	2 46	2 17
29	4 55	4 50	4 45	4 39	4 32	4 25	4 17	4 08	3 58	3 47	3 33	3 18	2 58	2 33
Aug. 2	4 59	4 54	4 49	4 43	4 37	4 30	4 23	4 15	4 05	3 55	3 43	3 28	3 11	2 49
6	5 03	4 58	4 53	4 48	4 42	4 36	4 29	4 22	4 13	4 03	3 52	3 39	3 23	3 04
10	5 07	5 02	4 58	4 53	4 48	4 42	4 36	4 29	4 21	4 12	4 02	3 50	3 36	3 19
14	5 10	5 07	5 02	4 58	4 53	4 48	4 42	4 36	4 29	4 21	4 11	4 01	3 48	3 33
18	5 14	5 11	5 07	5 03	4 59	4 54	4 49	4 43	4 36	4 29	4 21	4 12	4 01	3 48
22	5 18	5 15	5 12	5 08	5 04	5 00	4 55	4 50	4 44	4 38	4 31	4 22	4 13	4 01
26	5 22	5 19	5 16	5 13	5 10	5 06	5 02	4 57	4 52	4 47	4 40	4 33	4 25	4 15
30	5 26	5 23	5 21	5 18	5 15	5 12	5 08	5 04	5 00	4 55	4 50	4 44	4 37	4 28
Sept. 3	5 29	5 27	5 25	5 23	5 20	5 18	5 15	5 11	5 08	5 04	4 59	4 54	4 48	4 41
7	5 33	5 32	5 30	5 28	5 26	5 24	5 21	5 19	5 16	5 12	5 09	5 05	5 00	4 54
11	5 37	5 36	5 34	5 33	5 31	5 30	5 28	5 26	5 23	5 21	5 18	5 15	5 11	5 07
15	5 41	5 40	5 39	5 38	5 37	5 36	5 34	5 33	5 31	5 29	5 28	5 25	5 23	5 20
19	5 45	5 44	5 43	5 43	5 42	5 42	5 41	5 40	5 39	5 38	5 37	5 36	5 34	5 32
23	5 48	5 48	5 48	5 48	5 48	5 48	5 47	5 47	5 47	5 47	5 46	5 46	5 45	5 45
27	5 52	5 52	5 53	5 53	5 53	5 54	5 54	5 54	5 55	5 55	5 56	5 56	5 57	5 58
Oct. 1	5 56	5 57	5 57	5 58	5 59	6 00	6 01	6 02	6 03	6 04	6 05	6 07	6 08	6 10
5	6 00	6 01	6 02	6 03	6 05	6 06	6 07	6 09	6 11	6 13	6 15	6 17	6 20	6 23

SUNSET

Lat.	+40°	+42°	+44°	+46°	+48°	+50°	+52°	+54°	+56°	+58°	+60°	+62°	+64°	+66°
	h m	h m	h m	h m	h m	h m	h m	h m	h m	h m	h m	h m	h m	h m
July 1	19 33	19 39	19 47	19 54	20 03	20 12	20 23	20 35	20 49	21 05	21 25	21 50	22 25	23 41
5	19 32	19 39	19 46	19 53	20 02	20 11	20 21	20 33	20 47	21 02	21 21	21 45	22 18	23 18
9	19 31	19 37	19 44	19 51	20 00	20 09	20 19	20 30	20 43	20 58	21 17	21 39	22 10	22 59
13	19 29	19 35	19 42	19 49	19 57	20 06	20 15	20 26	20 39	20 53	21 11	21 32	22 00	22 42
17	19 27	19 33	19 39	19 46	19 54	20 02	20 11	20 22	20 34	20 47	21 04	21 23	21 49	22 25
21	19 24	19 30	19 36	19 42	19 50	19 58	20 06	20 16	20 28	20 41	20 56	21 14	21 37	22 09
25	19 21	19 26	19 32	19 38	19 45	19 53	20 01	20 10	20 21	20 33	20 47	21 04	21 25	21 52
29	19 17	19 22	19 28	19 33	19 40	19 47	19 55	20 04	20 14	20 25	20 38	20 53	21 12	21 36
Aug. 2	19 13	19 18	19 23	19 28	19 34	19 41	19 48	19 56	20 06	20 16	20 28	20 42	20 59	21 21
6	19 08	19 13	19 18	19 23	19 28	19 35	19 41	19 49	19 57	20 07	20 18	20 31	20 46	21 05
10	19 03	19 08	19 12	19 17	19 22	19 28	19 34	19 41	19 48	19 57	20 07	20 19	20 32	20 49
14	18 58	19 02	19 06	19 10	19 15	19 20	19 26	19 32	19 39	19 47	19 56	20 06	20 19	20 33
18	18 53	18 56	19 00	19 04	19 08	19 13	19 18	19 24	19 30	19 37	19 45	19 54	20 05	20 18
22	18 47	18 50	18 53	18 57	19 01	19 05	19 09	19 14	19 20	19 26	19 33	19 41	19 51	20 02
26	18 41	18 44	18 47	18 50	18 53	18 57	19 01	19 05	19 10	19 15	19 22	19 29	19 37	19 46
30	18 35	18 37	18 40	18 42	18 45	18 48	18 52	18 56	19 00	19 04	19 10	19 16	19 23	19 31
Sept. 3	18 29	18 31	18 33	18 35	18 37	18 40	18 43	18 46	18 49	18 53	18 58	19 03	19 09	19 15
7	18 22	18 24	18 25	18 27	18 29	18 31	18 34	18 36	18 39	18 42	18 46	18 50	18 54	19 00
11	18 16	18 17	18 18	18 19	18 21	18 23	18 24	18 26	18 28	18 31	18 34	18 37	18 40	18 44
15	18 09	18 10	18 11	18 11	18 12	18 13	18 14	18 15	18 16	18 18	18 20	18 21	18 24	18 29
19	18 02	18 03	18 03	18 04	18 04	18 05	18 06	18 06	18 07	18 08	18 09	18 10	18 12	18 13
23	17 56	17 56	17 56	17 56	17 56	17 56	17 56	17 56	17 57	17 57	17 57	17 57	17 58	17 58
27	17 49	17 49	17 48	17 48	17 48	17 47	17 47	17 47	17 46	17 45	17 45	17 44	17 44	17 43
Oct. 1	17 43	17 42	17 41	17 40	17 40	17 39	17 38	17 37	17 35	17 34	17 33	17 31	17 29	17 27
5	17 36	17 35	17 34	17 33	17 31	17 30	17 28	17 27	17 25	17 23	17 21	17 18	17 15	17 12

SUNRISE

Lat.	−55°	−50°	−45°	−40°	−35°	−30°	−20°	−10°	0°	+10°	+20°	+30°	+35°	+40°
	h m	h m	h m	h m	h m	h m	h m	h m	h m	h m	h m	h m	h m	h m
Oct. 1	5 26	5 29	5 32	5 35	5 37	5 39	5 42	5 44	5 46	5 49	5 51	5 53	5 55	5 56
5	5 15	5 21	5 25	5 28	5 31	5 34	5 38	5 42	5 45	5 48	5 52	5 56	5 58	6 00
9	5 05	5 12	5 17	5 22	5 26	5 29	5 35	5 39	5 44	5 48	5 53	5 58	6 01	6 04
13	4 55	5 04	5 10	5 16	5 20	5 24	5 31	5 37	5 43	5 48	5 54	6 00	6 04	6 08
17	4 46	4 55	5 03	5 10	5 15	5 20	5 28	5 35	5 42	5 49	5 55	6 03	6 07	6 12
21	4 36	4 47	4 56	5 04	5 10	5 16	5 25	5 34	5 41	5 49	5 57	6 06	6 11	6 17
25	4 27	4 39	4 50	4 58	5 05	5 12	5 23	5 32	5 41	5 49	5 58	6 09	6 14	6 21
29	4 18	4 32	4 43	4 53	5 01	5 08	5 20	5 31	5 40	5 50	6 00	6 12	6 18	6 26
Nov. 2	4 09	4 25	4 38	4 48	4 57	5 05	5 18	5 29	5 40	5 51	6 02	6 15	6 22	6 30
6	4 01	4 18	4 32	4 43	4 53	5 02	5 16	5 29	5 40	5 52	6 04	6 18	6 26	6 35
10	3 53	4 12	4 27	4 39	4 50	4 59	5 14	5 28	5 40	5 53	6 06	6 21	6 29	6 39
14	3 45	4 06	4 22	4 36	4 47	4 56	5 13	5 28	5 41	5 54	6 08	6 24	6 33	6 44
18	3 39	4 01	4 18	4 32	4 44	4 55	5 12	5 27	5 42	5 56	6 11	6 27	6 37	6 48
22	3 33	3 56	4 15	4 30	4 42	4 53	5 12	5 28	5 43	5 57	6 13	6 31	6 41	6 53
26	3 27	3 52	4 12	4 27	4 41	4 52	5 11	5 28	5 44	5 59	6 15	6 34	6 45	6 57
30	3 23	3 49	4 10	4 26	4 40	4 51	5 12	5 29	5 45	6 01	6 18	6 37	6 49	7 02
Dec. 4	3 19	3 47	4 08	4 25	4 39	4 51	5 12	5 30	5 47	6 03	6 21	6 41	6 52	7 05
8	3 17	3 46	4 07	4 24	4 39	4 52	5 13	5 31	5 48	6 05	6 23	6 44	6 55	7 09
12	3 16	3 45	4 07	4 25	4 40	4 52	5 14	5 33	5 50	6 07	6 25	6 46	6 58	7 12
16	3 15	3 45	4 08	4 26	4 41	4 54	5 16	5 34	5 52	6 09	6 28	6 49	7 01	7 15
20	3 16	3 46	4 09	4 27	4 42	4 55	5 17	5 36	5 54	6 11	6 30	6 51	7 04	7 18
24	3 18	3 48	4 11	4 29	4 44	4 57	5 19	5 38	5 56	6 13	6 32	6 53	7 05	7 20
28	3 22	3 51	4 14	4 32	4 47	5 00	5 21	5 40	5 58	6 15	6 34	6 55	7 07	7 21
32	3 26	3 55	4 17	4 35	4 49	5 02	5 24	5 43	6 00	6 17	6 35	6 56	7 08	7 22
36	3 31	3 59	4 21	4 38	4 53	5 05	5 26	5 45	6 02	6 18	6 36	6 57	7 09	7 22

SUNSET

	h m	h m	h m	h m	h m	h m	h m	h m	h m	h m	h m	h m	h m	h m
Oct. 1	18 15	18 11	18 08	18 05	18 03	18 01	17 58	17 55	17 53	17 51	17 48	17 46	17 44	17 43
5	18 23	18 17	18 13	18 09	18 06	18 04	17 59	17 55	17 52	17 48	17 45	17 41	17 39	17 36
9	18 30	18 24	18 18	18 13	18 09	18 06	18 00	17 55	17 51	17 46	17 41	17 36	17 33	17 30
13	18 38	18 30	18 23	18 18	18 13	18 09	18 01	17 55	17 50	17 44	17 38	17 32	17 28	17 24
17	18 46	18 36	18 28	18 22	18 16	18 11	18 03	17 55	17 49	17 42	17 35	17 27	17 23	17 18
21	18 55	18 43	18 34	18 26	18 20	18 14	18 04	17 56	17 48	17 40	17 32	17 23	17 18	17 12
25	19 03	18 50	18 39	18 31	18 23	18 17	18 06	17 56	17 47	17 39	17 30	17 19	17 13	17 07
29	19 11	18 57	18 45	18 35	18 27	18 20	18 08	17 57	17 47	17 37	17 27	17 16	17 09	17 01
Nov. 2	19 20	19 03	18 50	18 40	18 31	18 23	18 10	17 58	17 47	17 36	17 25	17 12	17 05	16 57
6	19 28	19 10	18 56	18 45	18 35	18 26	18 12	17 59	17 47	17 36	17 23	17 09	17 01	16 52
10	19 37	19 17	19 02	18 49	18 39	18 29	18 14	18 00	17 47	17 35	17 22	17 07	16 58	16 48
14	19 45	19 24	19 07	18 54	18 43	18 33	18 16	18 01	17 48	17 35	17 21	17 04	16 55	16 45
18	19 53	19 30	19 13	18 59	18 47	18 36	18 18	18 03	17 49	17 35	17 20	17 03	16 53	16 42
22	20 01	19 37	19 18	19 03	18 51	18 40	18 21	18 05	17 50	17 35	17 19	17 01	16 51	16 39
26	20 08	19 43	19 23	19 08	18 54	18 43	18 23	18 07	17 51	17 35	17 19	17 00	16 49	16 37
30	20 15	19 49	19 28	19 12	18 58	18 46	18 26	18 09	17 52	17 36	17 19	17 00	16 49	16 36
Dec. 4	20 22	19 54	19 33	19 16	19 02	18 49	18 29	18 11	17 54	17 37	17 20	17 00	16 48	16 35
8	20 27	19 59	19 37	19 20	19 05	18 52	18 31	18 13	17 56	17 39	17 21	17 00	16 48	16 35
12	20 32	20 03	19 41	19 23	19 08	18 55	18 34	18 15	17 57	17 40	17 22	17 01	16 49	16 35
16	20 36	20 06	19 44	19 26	19 11	18 58	18 36	18 17	17 59	17 42	17 24	17 02	16 50	16 36
20	20 39	20 09	19 46	19 28	19 13	19 00	18 38	18 19	18 01	17 44	17 25	17 04	16 52	16 37
24	20 41	20 11	19 48	19 30	19 15	19 02	18 40	18 21	18 03	17 46	17 27	17 06	16 54	16 40
28	20 41	20 12	19 49	19 31	19 16	19 04	18 42	18 23	18 05	17 48	17 30	17 09	16 56	16 42
32	20 41	20 12	19 50	19 32	19 17	19 05	18 43	18 24	18 07	17 50	17 32	17 11	16 59	16 45
36	20 39	20 11	19 49	19 32	19 18	19 05	18 44	18 26	18 09	17 52	17 35	17 14	17 02	16 49

SUNRISE

Lat.	+40°	+42°	+44°	+46°	+48°	+50°	+52°	+54°	+56°	+58°	+60°	+62°	+64°	+66°
	h m	h m	h m	h m	h m	h m	h m	h m	h m	h m	h m	h m	h m	h m
Oct. 1	5 56	5 57	5 57	5 58	5 59	6 00	6 01	6 02	6 03	6 04	6 05	6 07	6 08	6 10
5	6 00	6 01	6 02	6 03	6 05	6 06	6 07	6 09	6 11	6 13	6 15	6 17	6 20	6 23
9	6 04	6 06	6 07	6 09	6 10	6 12	6 14	6 16	6 19	6 21	6 24	6 28	6 32	6 36
13	6 08	6 10	6 12	6 14	6 16	6 18	6 21	6 24	6 27	6 30	6 34	6 39	6 43	6 49
17	6 12	6 15	6 17	6 19	6 22	6 25	6 28	6 31	6 35	6 39	6 44	6 49	6 55	7 03
21	6 17	6 19	6 22	6 25	6 28	6 31	6 35	6 39	6 44	6 48	6 54	7 00	7 08	7 16
25	6 21	6 24	6 27	6 30	6 34	6 38	6 42	6 47	6 52	6 58	7 04	7 12	7 20	7 30
29	6 26	6 29	6 32	6 36	6 40	6 45	6 49	6 55	7 00	7 07	7 14	7 23	7 33	7 44
Nov. 2	6 30	6 34	6 38	6 42	6 46	6 51	6 57	7 02	7 09	7 16	7 25	7 34	7 45	7 59
6	6 35	6 39	6 43	6 48	6 52	6 58	7 04	7 10	7 17	7 26	7 35	7 46	7 58	8 13
10	6 39	6 44	6 48	6 53	6 59	7 04	7 11	7 18	7 26	7 35	7 45	7 57	8 11	8 28
14	6 44	6 49	6 54	6 59	7 05	7 11	7 18	7 26	7 34	7 44	7 55	8 08	8 24	8 43
18	6 48	6 53	6 59	7 04	7 11	7 17	7 25	7 33	7 43	7 53	8 05	8 20	8 37	8 58
22	6 53	6 58	7 04	7 10	7 16	7 24	7 32	7 40	7 50	8 02	8 15	8 31	8 49	9 14
26	6 57	7 03	7 09	7 15	7 22	7 30	7 38	7 47	7 58	8 10	8 24	8 41	9 02	9 29
30	7 02	7 07	7 13	7 20	7 27	7 35	7 44	7 54	8 05	8 18	8 33	8 51	9 13	9 43
Dec. 4	7 05	7 11	7 18	7 25	7 32	7 41	7 50	8 00	8 12	8 25	8 41	9 00	9 24	9 57
8	7 09	7 15	7 22	7 29	7 37	7 45	7 55	8 05	8 17	8 31	8 48	9 08	9 34	10 10
12	7 12	7 19	7 25	7 33	7 41	7 49	7 59	8 10	8 22	8 37	8 54	9 14	9 41	10 21
16	7 15	7 22	7 28	7 36	7 44	7 53	8 03	8 14	8 26	8 41	8 58	9 20	9 48	10 29
20	7 18	7 24	7 31	7 38	7 46	7 55	8 05	8 16	8 29	8 44	9 01	9 23	9 52	10 34
24	7 20	7 26	7 33	7 40	7 48	7 57	8 07	8 18	8 31	8 46	9 03	9 25	9 53	10 36
28	7 21	7 27	7 34	7 42	7 50	7 58	8 08	8 19	8 32	8 46	9 04	9 25	9 53	10 34
32	7 22	7 28	7 35	7 42	7 50	7 59	8 08	8 19	8 31	8 46	9 02	9 23	9 50	10 28
36	7 22	7 28	7 35	7 42	7 50	7 58	8 07	8 18	8 30	8 44	9 00	9 20	9 45	10 20

SUNSET

Lat.	+40°	+42°	+44°	+46°	+48°	+50°	+52°	+54°	+56°	+58°	+60°	+62°	+64°	+66°
	h m	h m	h m	h m	h m	h m	h m	h m	h m	h m	h m	h m	h m	h m
Oct. 1	17 43	17 42	17 41	17 40	17 40	17 39	17 38	17 37	17 35	17 34	17 33	17 31	17 29	17 27
5	17 36	17 35	17 34	17 33	17 31	17 30	17 28	17 27	17 25	17 23	17 21	17 18	17 15	17 12
9	17 30	17 28	17 27	17 25	17 23	17 22	17 19	17 17	17 15	17 12	17 09	17 05	17 02	16 57
13	17 24	17 22	17 20	17 18	17 16	17 13	17 11	17 08	17 05	17 01	16 57	16 53	16 48	16 42
17	17 18	17 16	17 13	17 11	17 08	17 05	17 02	16 58	16 55	16 50	16 46	16 40	16 34	16 27
21	17 12	17 09	17 07	17 04	17 01	16 57	16 53	16 49	16 45	16 40	16 34	16 28	16 20	16 12
25	17 07	17 04	17 00	16 57	16 53	16 50	16 45	16 41	16 35	16 30	16 23	16 16	16 07	15 57
29	17 01	16 58	16 55	16 51	16 47	16 42	16 37	16 32	16 26	16 20	16 12	16 04	15 54	15 42
Nov. 2	16 57	16 53	16 49	16 45	16 40	16 35	16 30	16 24	16 17	16 10	16 02	15 52	15 41	15 27
6	16 52	16 48	16 44	16 39	16 34	16 29	16 23	16 16	16 09	16 01	15 52	15 41	15 28	15 13
10	16 48	16 44	16 39	16 34	16 29	16 23	16 16	16 09	16 01	15 52	15 42	15 30	15 16	14 59
14	16 45	16 40	16 35	16 30	16 24	16 17	16 10	16 03	15 54	15 44	15 33	15 20	15 04	14 45
18	16 42	16 37	16 31	16 25	16 19	16 12	16 05	15 57	15 47	15 37	15 24	15 10	14 53	14 31
22	16 39	16 34	16 28	16 22	16 15	16 08	16 00	15 51	15 41	15 30	15 17	15 01	14 42	14 18
26	16 37	16 31	16 26	16 19	16 12	16 05	15 56	15 47	15 36	15 24	15 10	14 53	14 32	14 05
30	16 36	16 30	16 24	16 17	16 10	16 02	15 53	15 43	15 32	15 19	15 04	14 46	14 24	13 54
Dec. 4	16 35	16 29	16 22	16 15	16 08	16 00	15 50	15 40	15 29	15 15	14 59	14 40	14 16	13 43
8	16 35	16 28	16 22	16 15	16 07	15 58	15 49	15 38	15 26	15 12	14 56	14 36	14 10	13 34
12	16 35	16 29	16 22	16 15	16 07	15 58	15 48	15 37	15 25	15 11	14 54	14 33	14 06	13 27
16	16 36	16 30	16 23	16 15	16 07	15 59	15 49	15 38	15 25	15 10	14 53	14 32	14 04	13 22
20	16 37	16 31	16 24	16 17	16 09	16 00	15 50	15 39	15 26	15 11	14 54	14 32	14 04	13 21
24	16 40	16 33	16 26	16 19	16 11	16 02	15 52	15 41	15 28	15 14	14 56	14 34	14 06	13 24
28	16 42	16 36	16 29	16 22	16 14	16 05	15 55	15 44	15 32	15 17	15 00	14 38	14 11	13 30
32	16 45	16 39	16 32	16 25	16 17	16 09	15 59	15 48	15 36	15 22	15 05	14 44	14 18	13 39
36	16 49	16 43	16 36	16 29	16 21	16 13	16 04	15 53	15 41	15 27	15 11	14 51	14 26	13 51

Appendix 10
Kodak-approved European Labs

BELGIUM

Antwerp

Studio Pelegrie
Van Luppenstraat 83–87
Tel. (03) 230 45 93

Berchem

Cromo Labo
Weidestraat 5
Tel. (03) 230 80 92

Brussels

The street addresses
for Brussels labs appear
in both Dutch and
French.

American Color Laboratory
Eendrachtstraat 31
Rue de la Concorde 31
Tel. (02) 512 19 33

Diachrome
Emile Banningstraat 22
Rue Emile Banning 22
Tel. (02) 647 67 01

Dupli Media
Kroonlaan 153
Avenue de la Couronne 153
Tel. (02) 648 30 71

Euro Chemical
Elzas-Lotharingenstraat 52
Rue d'Alsace-Lorraine 52
Tel. (02) 513 13 14

Authentic
St. Bernardusstraat 9
Rue St. Bernard 9
Tel. (02) 537 54 95

Phogelab
Fontaine
 Vanderstraetenlaan 53
Avenue Fontaine
 Vanderstraeten 53
Tel. (02) 344 07 29

Kade Process
Erfprinslaan 149
Avenue du Prince Heritier
 149
Tel. (02) 736 38 38

Embourg

Photo Studio 9
Rue Joseph Dupont 75
Tel. (041) 65 39 10

Harelbeke

Foto Studio Eshof
Politieke Gevangenenstraat
 12
Tel. (056) 21 55 05

Hasselt

Foto Studio Truyens
Walenstraat 92
Tel. (011) 21 10 15

Kontich

Heidia International
Pronkenbergstraat 29
Tel. (03) 457 91 81

Liège

Forma
Rue Commandant
Marchand 5
Tel. (041) 27 12 48

Marcinelle

Graphocolor
Avenue Mascaux 124
Tel. (071) 43 43 92

FRANCE

Paris and environs

Dahinden
10–12 rue Française
75002 Paris
Tel. 42 33 61 35

Colortec
109, avenue de La
 Bourdonnais
75007 Paris
Tel. 45 55 91 44

Sipa Labo
14, rue Roquepine
75008 Paris
Tel. 42 66 63 06

Copy Color
21, rue Robert de Flers
75016 Paris
Tel. 45 78 81 12

Central Color
10, rue Pergolese
75016 Paris
Tel. 45 02 14 33

Image Industrielle
26, rue de Saussure
75097 Paris
Tel. 42 67 09 66

Prolab 91
Les Cochets
91290 St-Germain les
 Arpajons
Tel. 60 84 97 40

Nouveau Gorne
5, place du Pantheon
75005 Paris
Tel. 43 25 50 34

Epi
122, avenue des Champs-
 Elysées
75008 Paris
Tel. 42 25 29 29

Rush Labo.
9, place Falguiere
75015 Paris
Tel. 43 06 16 60

Opalix
6, rue Pierre Louys
75016 Paris
Tel. 45 27 13 34

Tricolor
64, rue Sauffroy
75017 Paris
Tel. 42 63 43 85

Publimod
18, rue du Roi de Sicile
75004 Paris
Tel. 42 71 65 10

Traphot
37–39, place J. Ferry
92120 Montrouge
Tel. 46 56 87 27

Phidap
119, rue J.-P. Timbaud
92400 Courbevoie
Tel. 47 89 24 24

Initial
69, rue Danjou
92100 Boulogne-Billancourt
Tel. 46 20 22 22

Labo 4
8, place du Marche
92220 Neuilly-sur-Seine
Tel. 47 22 66 88

Le Laboratoire Positif
33, Rue Cave
92300 Levallois
Tel. 47 37 04 00

Bordeaux

D.P.M.
13, place Stalingrad
33100 Bordeaux
Tel. 56 32 26 83

Caen

L.S.N.
rue de la Girafe
Z.I. Du Mont Coco
14007 Caen
Tel. 31 45 35 00

Cesson Sevigne

Rennes Color
rue des Landelles
35510 Cesson Sevigne
Tel. 99 50 66 95

Colmar

Top Color
9A, quai de la Fecht-
 Ingersheim
68000 Colmar
Tel. 89 27 31 27

Lille

Picto Lille
11, rue Nicolas Leblanc
59000 Lille
Tel. 20 54 23 02

Panchiro
29, boulevard J-B Lebas
59000 Lille
Tel. 20 52 98 08

Lab Color
88, rue d'Artois
59000 Lille
Tel. 20 57 62 02

Lourdes

Pyrénées Labo Photo
14, avenue Francis
Lagardere
65100 Lourdes
Tel. 62 94 74 25

Lyons

Intercolor
16, rue E. Rognon
69009 Lyons
Tel. 78 72 75 71

Marseilles

Nat' Color
37, boulevard National
13001 Marseilles
Tel. 91 62 08 30

Orvault

D.S.A.
10, avenue du Taillis
44700 Orvault
Tel. 40 76 06 12

Toulouse

Pictaphot
22–28, allée de Bellefontaine
31035 Toulouse
Tel. 61 41 11 01

Labo Bacou
55, avenue L. Breguet
31400 Toulouse
Tel. 61 54 02 67

IRELAND

Dublin

LSL Photo Lab Ltd.
25 Lennox Street
Dublin 8
Tel. 781078

Primary Colour
13 Upper Stephens Street
Dublin 8
Tel. 780177, 780078

Quirke Lynch Ltd.
Lower Rathmines Road
Rathmines
Dublin 6
Tel. 964666

ITALY

Alessandria

Colorphoto S.p.A.
Loc. Andasso Strada per
Giard 1
15040 Castelletto
Monferrato
Tel. (131) 33761

Ascoli Piceno

Adriatica Colorfoto S.p.A.
Via dell'Industria
63033 Cantobuchi
Tel. (735) 67289

Belluno

F.LLI Ghedina G.B.M.
Via C. Battiesi 23
32043 Cortina d'Ampezzo
Tel. (463) 60767

Bergamo

Color Service
S.r.l. Via Verdi 6
24020 Gorle
Tel. (035) 661456

Bologna

Arcobaleno S.n.C.
Via Ciro Menotti 3
C-40100 Bologna
Tel. (51) 500120

Brescia

Foto Color Medaina E
Beltrami
Via Damiano Chiesa 7
26100 Brescia
Tel. (30) 309366

Catania

HF Professional Anastasi
S.n.s.
Via Guido Gozzano 41
95100 Catania
Tel. (95) 552528

Cuneo

Fotocolor Ramero
Strade B.go.S. Dalmazzo
12012 Cuneo

Firenze

Nuova Universal Color
Via Paiaiello 21
60011 Calenzano
Tel. (56) 8879789–8879772

Forlì

Extracolor
Via Aldrovandi 7
47100 Forlì

Imperia

Fotocolor Tre Elle
Trav. Amoretti 16
18100 Imperia

La Spezia

Laborcolor S.p.A.
19037 S. Stefano Magra

Livorno

Professional Color
Via della Stazione 38
57020 Populonia

Matera

Color 3000 Service
Via Aldo Moro 100
75024 Montecaglioso

Milano

Color Center
Via Porpora 46
20131 Milan
Tel. (2) 2365150

Color Zenith
Via Fassinett 9
20154 Milan
Tel. (2) 4042745

Domus Color
Via Pellizzone 13
20133 Milan
Tel. (2) 717061

Gemini
Via Superga 13
20124 Milan
Tel. (2) 6703552

New Reversal Service
Via Osoppa 7
20148 Milan

Novakolor S.r.t.
Via F. Filzi 8
20110 Milan

Valerio Capelli
Via Alzala Nav. Pavese 62
20136 Milan
Tel. (2) 8373623

Modena

I.P.S. S.n.c.
Via Murazzo 96
A-41100 Modena
Tel. (69) 334134

Napoli

Technifoto S.p.A.
Viale Augusto 9
80125 Naples

Cosmo Film
Parco Grileo 30
80100 Naples

Padova

Color Color
Via Pisacane 33
36138 Padua

Safety Color
Via Zanbone Daull 14
35100 Padua

Palermo

Mediterranea Color Print
Via Regione Siciliana 2173
90100 Palermo

Reggio Emilia

Sternieri Fotolab
Via Bosco 39
42109 Scandiano

Rome

Professional Color
Via G.B. Soria 52
A00168 Rome

Fotoservice S.r.l.
Via della Pisana 419
Rome

Torino

Studio 44
C.ao Matteotti 10
10121 Torino

Fotocolor Tardivello
Via Piria 7
10144 Torino
Tel. (11) 748383

Venezia

Foto Ghuman
Via Castellana 96
30030 Martellago

Master Color
Via Torino, Venice

Verona

Lab. Ferrari Gianfranco
Via Marconi 21
25015 Deeanzano

NETHERLANDS

Almere-Haven

21:00 Vaklab Almere
Ambachtsmark 63–64
1355 EE
Tel. (3240) 17255

Amsterdam

Four Color B.V.
Plantage Middenlaan 46
1018 DH
Tel. (20) 249145

Peter Paul Huf
Rijnstraat 232
1079 HV
Tel. (20) 442838

Kleintje Kleur
Nieuwe Hemweg 4A
1013 BG
Tel. (020) 860011

Kleurgamma
Mauritskade 55
1092 AD
Tel. (20) 655301

Triplocolor B.V.
N.Z. Voorburgwal 61
1012 RE
Tel. (20) 240286

VB Fototechniek B.V.
Rooswijck 5
1081 AJ
Tel. (20) 464006

Arnhem

Maxicolor
Looierstraat 32
6811 AX
Tel. (85) 454272

Beek

Vaklab Beek
Labourestraat 1 A
6190 AG
Tel. (4490) 71061

Breda

Deltavision
Takkebijsters 7
4817 BL
Tel. (76) 712740

Buchten

Vakcolor B.V.
Spoorstraat 3 A
6121 EX
Tel. (4498) 56017

Ede

B.G. Color
Morsestraat 26
6710 EA
Tel. (8380) 22112

Eindhoven

Eindhoven Druk BV/Foto
Kanaaldijk Noord 15 C
5613 DH
Tel. (40) 433736

Emulta
Engelsbergenstraat 315
5616 JZ
Tel. (40) 550801

FFP Colour Lab
Vlokhovenseweg 38
5625 WP
Tel. (40) 420468

Images
Ukkelstraat 2 D
5600 CC
Tel. (40) 426821

Intercolor B.V.
Rooyakkerstraat 2 A
5605 JA
Tel. (40) 525525

Enschede

Procolor
Lipperkerkstraat 265
7533 AB
Tel. (53) 317675

Geleen

Perfect Color
Mauritslaan 132
6161 HZ
Tel. (4490) 53612

Gouda

HE Vaklab
Industriestraat 8–10
2802 AC
Tel. (1820) 17033

The Hague

Studio Lanza B.V.
Hanenburglaan 375
2565 GP
Tel. (70) 614141

Vaklab Guus Jautze
Prinses Beatrixlaan 14
2595 AL
Tel. (70) 476666

Laren

Eurocolor B.V.
Oudekerkweg 24
1251 NZ
Tel. (2153) 12529

Maarssen

Foto Koppelman
Kerkweg 10
3603 CM
Tel. (3465) 61347

Noordwijk

Studio Gallery B.V.
A. van Rooyenstraat 104 A
2202 EP
Tel. (1719) 10211

Rotterdam

Herbert Degens Studiolab
Zestienhovensekade 176
3004 AA
Tel. (10) 4620066

Kleurlab J. van Roggekamp
Aleidisstraat 3
3021 SB
Tel. (10) 4258551

Quality Color
Maaskade 154
3071 NP
Tel. (10) 4330600

Tilburg

PLM Photofinishing
Koningshoeven 67 A
5080 AA
Tel. (13) 368075

Veendam

Color Center
Ommelanderwijk 8
9644 TL

Veenendaal

Color Team
De Smalle Zijde 27
3903 LM
Tel. (8385) 14174

't Vaklab B.V.
Nieuweweg Noord 251
3905 LW
Tel. (8385) 99234

Veldhoven

Portegies B.V.
De Reek 3
5500 HX
Tel. (40) 537775

Weesp

Souverein
Eemmeerlaan 12
1382 KA
Tel. (2940) 17205

Zwolle

Art Production Wehkamp
Punterweg 18
8042 PB
Tel. (38) 279758

SWITZERLAND

Basel

Inter Colorfoto AG
St. Johann-Vorstadt 71
Tel. (61) 57 06 06

Spectracolor H. Schwyn AG
Augustinergasse 3
Tel. (61) 25 81 91

Stutz Foto Color Technik
AG
Riehenstrasse 60
Tel. (61) 681 11 22

Bern

Graficolor AG
Gewerbestrasse 22
Tel. (31) 24 03 24

Farbstudio E. Fisler
Indermühleweg 20 A
Tel. (31) 55 33 20

Zumstein AG Foto Color
Labor
Gesellschaftsstrasse 73
Tel. (31) 24 24 55

Fribourg

JM Diaprint SA
Chemin des Sources 1
Tel. (37) 46 51 15

Francis Marchon
Tel. (37) 33 10 39

Geneva

Laboratoire Authenticolor
SA
Avenue Industrielle 1
Tel. (22) 43 46 92

Teamcolor SA
Rue du Clos 1
Tel. (22) 36 19 07

Geneva/Chatelaine

Stutz Foto Color Technik
SA
Avenue de Chatelaine 87
Tel. (22) 97 08 23

Lausanne

Michel Meyer
Ch. Trabandan 45
Tel. (21) 28 85 24

Lausanne-Crissier

PPP Prof. Photo Processing
SA
Route de Morges 13
Tel. (21) 702 29 52

Locarno

Huwyler + Pünter Lab.
Foto Prof.
Via B. Luini 18
Tel. (93) 31 65 59

Lucerne-Reussbühl

Schenker Studio AG
Täschmattstrasse 18
Tel. (41) 55 74 80

Olten

Fotolabor Chromcolor
Leberngasse 1
Tel. (62) 32 33 72

Saint Gall

Martin Gubler
Farbfotolabor
Hintere Gilstrasse
Tel. (71) 28 10 10

Markus Ryser
Merkurstrasse 4
Tel. (71) 22 96 72

Zurich

Pro Cine Colorlabor AG
Holzmoosrütistrasse 48
Tel. (1) 783 71 11

Color Station Maur AG
Badanstaltstrasse 4
Tel. (1) 980 30 31

Photo Color Studio Max
Peter AG
Schöntalstrasse 5
Tel. (1) 2412 46 03

Hans Gabriel
Hohlstrasse 409
Tel. (1) 491 26 60

Studio Gwerder AG
Hafnerstrasse 61
Tel. (1) 44 66 22

Jan Kruszona
Moosstrasse 26
Tel. (1) 482 91 36

Photo Studio 13
Hafnerstrasse 24
Tel. (1) 271 13 66

PPL Photo Lab. Urs
Schmid
Volkmarstrasse 10
Tel. (1) 362 39 81

Stutz Foto Color Technik
AG
Bederstrasse 80
Tel. (1) 201 26 76

A. Weider AG Dialabor
Leonhardshalde 21
Tel. (1) 47 48 80

UNITED KINGDOM

London—East

ARC Colour
103 Hatton Square
16–16a Baldwin Gardens
EC1N 7RJ
Tel. (1) 242 2057

Ceta City Colour Labs Ltd.
45 St. John's Street
EC1M 4AN
Tel. (1) 490 0263

Colourstar Photo Ltd.
29–31 Greville Street
EC1N 8SU
Tel. (1) 404 3175

Forest Photographic Co.
128–130A Hoe Street
Walthamstow
E17 4QR
Tel. (1) 520 1370

Gene Nocon
12–16 Laystall Street
EC1R 4PA
Tel. (1) 833 2088, 837 9909

Gilchrist Studios Ltd.
6–10 Kirby Street
EC1N 8TH
Tel. (1) 405 0481

Hill's Colour Services
72–80 Leather Lane
EC1N 7TR
Tel. (1) 405 9965

Lancaster Laboratories Ltd.
Holborn Studio
10 Back Hill
EC1R 5EN
Tel. (1) 833 0872

Lancaster Laboratories Ltd.
23–25 Great Sutton Street
EC1V 0DX
Tel. (1) 250 1471

Metro Photographic
45–47 Clerkenwell Road
EC1M 5RS
Tel. (1) 253 1547

Optikos Labs Ltd.
3–7 Ray Street
EC1R 3DJ
Tel. (1) 278 2957

'PA' Colour Laboratory
85 Fleet Street
EC4P 4BE
Tel. (1) 353 7440

PH Colour Laboratory
728 Romford Park
Manor Park
E12 6BT
Tel. (1) 553 0928/0401

Photolab Techniques
20–24 Kirby Street
EC1N 8TS
Tel. (1) 405 1397

Protocol (East)
Perseverance Works
39 Kingsland Road
E2 8AA
Tel. (1) 729 5270

Rex Features
18 Vine Hill
EC1R 5DX
Tel. (1) 278 7294

Spencer Colour Laboratory
71–73 St. John Street
EC1M 4AN
Tel. (1) 608 0235

Studio 10 (Advertising
 Services) Ltd.
25–27 Farringdon Road
EC1M 3HB
Tel. (1) 404 4044

Tantrums
116 Old Street
EC1V 9BD
Tel. (1) 251 5242

Technical Colour
 Laboratories Ltd.
1–3 Berry Street
Clerkenwell Road
EC1V 0AA
Tel. (1) 253 1614

The Photo Source
Unit C1, Enterprise
 Business Estate
2 Millharbour
Mastmaker Road
E14 9TE
Tel. (1) 987 1212

U.P.P.A. Ltd. Commercial
 Photographers
30–34 New Bridge Street
EC4V 6BN
Tel. (1) 248 6730

London—North

Carlton T & S
16 St. Pancras Way
Camden Town
NW1 0QG
Tel. (1) 388 6671, 387 6822

C.I.S. Colour Service Ltd.
The Court Yard
44 Gloucester Avenue
Primrose Hill
NW1 8JD
Tel. (1) 586 7272

Colourbox
3 Melcombe Street
(off Baker Street)
NW1 6AE
Tel. (1) 935 6075/8020

Primary Colour Ltd.
11–13 Kings Terrace
NW1 0JP
Tel. (1) 388 2046

SCL Photographic Services
16 Bull Lane
Edmonton
N18 1SX
Tel. (1) 807 0725

Trucolour At Conran
 Studios
29–31 Brewery Road
N7 9QN
Tel. (1) 607 5585

W Photoprint Ltd.
85–87 Bayham Street
NW1 0AG
Tel. (1) 267 9591

London—South

Ceta Colour Laboratories
 Ltd.
65 Queensgate Mews
SW7 5QN
Tel. (1) 584 0064

Howard Thomas
 Photographic Services
 Ltd.
Chrisnic House, Chrisnic
 Court
Rear of 264–274 Kirkdale
SE26 4RS
Tel. (1) 659 2296

Lab One Ltd.
Brigade House, Brigade
 Street

Blackheath
SE3 0TW
Tel. (1) 318 4237

Professional Photographic
 Services
14–22 Ossory Road
SE1 5AN
Tel. (1) 237 4661

Push One
32 Old Church Street
Chelsea
SW3 5BY
Tel. (1) 351 4195, 352 2926

Russell Colour Laboratory
17 Elm Grove
SW19 4HE
Tel. (1) 947 6171

The Sanctuary
The South Bank Studio
 Centre Ltd.
Unit B1, Galleywall Road
SE16 3PB
Tel. (1) 237 8263/2452

Tony Othen & Associates
Neptune House
70 Royal Hill
Greenwich
SE10 8RT
Tel. (1) 692 6817

Triumph Processing Ltd.
13a Deodar Road
Putney
SW15 2NP
Tel. (1) 785 3011

Westwood Processing
E6 Specialist Laboratory
100 Liberty Street
SW9 0ED
Tel. (1) 587 1223

London—West

Acorn Studios
22 Chenies Street
WC1E 7EX
Tel. (1) 323 2794

Bruton Photography Ltd.
22 Bruton Street
W1X 7DA
Tel. (1) 629 9996

Cascade Colour Services
 Ltd.
50–54 Charlotte Street
W1P 1LW
Tel. (1) 636 3033

Ceta (West One) Colour
 Laboratories Ltd.
1–5 Poland Street
W1V 3DG
Tel. (1) 434 1235

Cleveland Photographic
 Ltd.
18 Cleveland Street
W1P 5FA
Tel. (1) 636 5165/5275

Colour Centre (London)
 Ltd.
41A North End Road
W14 8SZ
Tel. (1) 602 0167

Colour Fast Laboratories
 Ltd.
The Basement
24 Great Queen Street
Holborn
WC2B 5BB
Tel. (1) 404 4785

Colour Processing
 Laboratories Ltd.
Duchess House
18–19 Warren Street
W1P 5DB
Tel. (1) 388 7836

Colour Techniques Ltd.
17 Avon Trading Estate
Avonmore Road
W14 8TS
Tel. (1) 602 2936

Contour Colour Ltd.
7–8 Rathbone Place
W1P 1DE
Tel. (1) 323 1166

Cowbell Processing
1 Junction Mews
W2 1PN
Tel. (1) 402 3282

ETA Partners
216 Kensington Park Road
W11 1NR
Tel. (1) 727 2570/3570/3432

Flash Photographic Ltd.
9 Colville Mews
W11 2DA
Tel. (1) 727 9881

Graham Nash Ltd.
12 Stephens Mews, Gresse
 Street
P.O. Box 4WP
W1A 4WP
Tel. (1) 580 8585

Indusfoto
3A–7A Kinnoul Road
W6 8NG
Tel. (1) 385 7618

Joe's Basement
1st Floor, 89–91 Wardour
 Street
W1V 4AF
Tel. (1) 434 9313

Keishi Colour Ltd.
Unit 15, 21 Wren Street
WC1X 0HF
Tel. (1) 278 4537

Lynn Driscoll Colour
 Processing
1st Floor, Cubitts Yard
James Street
Covent Garden
WC2H 7HA
Tel. (1) 240 3765

Michael Dyer Associates
 Ltd.
81A Endell Street
WC2H 9HA
Tel. (1) 240 0165

Obscura
34A Bryanston Street
W1H 7AH
Tel. (1) 723 1487

One Stop Studio Ltd.
5 Sedley Place
Woodstock Place
W1R 1HH
Tel. (1) 629 5701

Photographic Techniques
Ltd.
14a Shouldham Street
W1H 5FG
Tel. (1) 723 1496

Profilm
Unit 2
26 Agnes Road
W3 7RE
Tel. (1) 743 6636

Promises Specialist Colour
Processing
Unit 9, Goldhawk Industrial
Estate
2a Brackenbury Road
W6 0BA
Tel. (1) 749 2136/7

Protocol (West)
15 Crawford Street
W1H 1PF
Tel. (1) 486 7606

Sky Photographic Services
Ltd.
Sky House, 111 High
Holborn
WC1V 6JS
Tel. (1) 242 2504

Sky Photographic Services
Ltd.
Ramillies House, Ramillies
Street
W1V 2EL
Tel. (1) 434 2266

Stoneapple Ltd.
33 Dover Street
W1X 3RA
Tel. (1) 629 1574

Superchrome
128–134 Cleveland Street
W1P 5DN
Tel. (1) 388 6303

Tapestry Colour
51–52 Frith Street
W1V 5TF
Tel. (1) 437 1406

Team 86
37 Endell Street
WC2H 9AG
Tel. (1) 240 2908

Transcolour Ltd.
Wells House (5th Floor)
Wells Street
W1P 3RE
Tel. (1) 636 8443/6649

TRP Slavin Ltd.
Slavin House
18 Chenies Street
WC1E 7EX
Tel. (1) 631 5151

Ultrachrome (CPL Ltd.)
12 Poland Street
W1V 3DE
Tel. (1) 437 6463

66 Wells Street Ltd.
66 Wells Street
W1P 3RB
Tel. (1) 636 0625

West 8 Colour Laboratories
Ltd.
Unit 4, Bard Road
W10 6TP
Tel. (1) 968 5606

Avon

Avoncolour Ltd.
131 Duckmoor Road
Ashton Gate
Bristol BS3 2BH
Tel. (272) 633456

Colour Processing
Laboratories Ltd.
Unit E, Central Trading
Estate
Bath Road, Arnos Vale
Bristol BS4 3DX
Tel. (272) 713431

Redcliffe Colour
Laboratories Ltd.
11–15 Wade Street
St. Judes
Bristol BS2 9DR
Tel. (272) 540159

Bedfordshire

Home Counties Colour
Services Ltd.
12–14 Leagrave Road
Luton LU4 8HZ
Tel. (582) 31899

Berkshire

Brian Tyer Associates Ltd.
1–2 Central Estate
Denmark Street
Maidenhead SL6 7BN
Tel. (628) 32222

Colorific Photo Labs
428 Bath Road
Cippenham
Slough SL1 6BB
Tel. (6286) 67911

Color Processing
Laboratories Ltd.
1 Arkwright Road
Reading RG2 0LU
Tel. (734) 863515

Plus 2
382 Sykes Road
Edinburgh Avenue
Slough SL1 4SP
Tel. (753) 38719

Birmingham

Colin Alford Photographic
Laboratories Ltd.
20–22 Pemberton Street
Hockley
B18 6NY
Tel. (21) 236 5767

Color Processing
Laboratories Ltd.
48 Upper Gough Street
B1 1JL
Tel. (21) 643 8984

ICL Individual Colour
Laboratories Ltd.
2 Ribblesdale Road
Stirchley
B30 2YP
Tel. (21) 472 6747

Kaminski Professional
Photographic
Laboratories Ltd.
112–116 Park Hill Road
Harborne
B17 9HD
Tel. (21) 427 1160

Leach Midlands Ltd.
25 Lordswood Road
Harborne
B17 9RP
Tel. (21) 427 5082

Palm Laboratory (Midlands)
Ltd.
69 Rea Street
B5 6BB
Tel. (21) 622 5504

W. Photoprint
23 Moat Lane
Digbeth
B5 5BD
Tel. (21) 427 4122

Buckinghamshire

Hamilton Colour Services
Ltd.
Unit 5, Lisle Road
High Wycombe HP13 5SH
Tel. (494) 20772

Photoservices
60 Edison Road
Rabans Lane
Aylesbury HP19 3RT
Tel. (296) 432731

Cambridgeshire

Saffron Photography Ltd.
24 High Street
Whittlesford
Cambridge CB2 4LT
Tel. (223) 835828

Cheshire

Cheshire Colour Labs
Dale Street
Broadheath
Altrincham WA14 5EH
Tel. (61) 928 4145

Ness Photographic
Laboratories
Kershaw Street
Widnes WA8 7JH
Tel. (51) 424 0514

Derbyshire

Derby Professional Colour
P.O. Box 17
Sandown Road
Derby DE2 8XW
Tel. (332) 363947

Devon

Alan Cooper Colour Labs
Unit 14
Swift Industrial Estate
Kingsteignton
Newton Abbot TQ12 3SG
Tel. (626) 62216

Colortone Photographic
Wynards Works
Old Rydom Lane
Exeter EX2 7JS
Tel. (392) 877650

South West Colour Labs
Northfields Industrial Estate
Northfield Lane
Brixham TQ5 8UA
Tel. (804) 57238

Nexus Colour Laboratory
Ltd.
87–89 Duke Street
Devonport PL1 4EE
Tel. (752) 558712

Dorset

Dave Blunden Ltd.
Cromwell House
68 Calvin Road
Winton
Bournemouth BH9 1LN
Tel. (202) 532366

Essex

Chelmsford Colour Labs
Unit CO4, Globe House
New Street
Chelmsford CM1 1TY
Tel. (245) 359702

Colour Processing
Laboratories Ltd.
53 Tallon Road
Hutton Industrial Estate
Brentwood CM13 1TG
Tel. (272) 713431

Photofen Processing Ltd.
Unit 16, Leighcliff Building
Maple Avenue
Leigh-on-Sea SS9 1PR
Tel. (702) 715410

Redwood Colour
Laboratories
Unit B2, Cowdray Centre
Cowdray Avenue
Colchester CO1 1BL
Tel. (206) 540333

Gloucestershire

Hamill Photo Services Ltd.
Unit 18, Landsdown
Industrial Estate
Gloucester Road
Cheltenham GL51 8PL
Tel. (242) 39031/2

Hampshire

Colour Processing
 Laboratories Ltd.
Speedwell Close
Chandler's Ford
Eastleigh S05 3NB
Tel. (703) 254752

Philip Dean Photo Prints
 Ltd.
The Lab, Old Lyndhurst
 Road
Cadnam
Southampton SO4 2NN
Tel. (703) 813722

Hertfordshire

Bushey Colour Labs
Melbourne Road
Bushey WD2 3LN
Tel. (1) 950 6664

Harbutt and Grier Ltd.
58 Bridge Road East
Welwyn Garden City
 AL7 1JU
Tel. (707) 335258

Lea Valley Colour Labs
48 Charlton Mead Lane
 South
Hoddesdon EN11 0DJ
Tel. (992) 443461

Photogenesis Ltd.
11 Finway Court
Whippindell Road
Watford WD1 7EN
Tel. (923) 249866

Humberside

Ivor Innes Ltd.
11–13 The Square
Hessle HU13 0AF
Tel. (482) 649271

Richmond & Rigg
 Photography
Kings Studios
South Church Side
Hull HU1 1RR
Tel. (482) 216914

Kent

Andrews Professional
 Colour Laboratories
Chart Road Industrial
 Estate
Godington Road
Ashford TN23 1ES
Tel. (233) 20764

Colour Processing
 Laboratories Ltd.
Fircroft Way
Edenbridge TN8 6ET
Tel. (732) 862555

Marlowe Photolab
45 St. Peter's Street
Canterbury CT1 2BG
Tel. (227) 472515

Mosaic Colour
Unit 7
Collingwood Industrial
 Estate
Maidstone Road
Sutton Valence
Maidstone ME17 3LS
Tel. (622) 843826

Photocare
Unit 3, Cannon Bridge
 Works
Cannon Lane
Tonbridge TN9 1PP
Tel. (732) 353999

Lancashire

Colourlabs Professional
2 Topping Street
Bury BL9 6DR
Tel. (61) 7974700

Leicestershire

K & S Commercial Photos
 Ltd.
90 Commercial Square
Freeman's Common
Leicester LE2 7SR
Tel. (533) 470270

One Stop Photographic Ltd.
19 Wharf Street South
Leicester LE1 2AA
Tel. (533) 516064

Studio Colophon Ltd.
4 Selbury Drive
Oadby Industrial Estate
Oadby
Leicestershire LE2 5NG
Tel. (533) 719147/8, 715827,
 720805

Lincolnshire

A Foster & Son
8 High Street
Horncastle LN9 5BL
Tel. (6582) 2334

Manchester

Casco 129 Ltd.
129 Barlow Moor Road
West Didsbury
M20 8PP
Tel. (61) 445 3145

Colour 061
Aldine House
New Bailey Street
Salford M60 9HP
Tel. (61) 834 9687

Colourpoint (M/cr) Ltd.
Unit 4, Olympia Trading
 Estate
Great Jackson Street
M15 4NP
Tel. (61) 228 0303/4/5

Professional Colour Labs
 Ltd.
101–115 Chapel Street
Salford M3 5DN
Tel. (61) 832–5663

R S Colour
65–69 Downing Street
M1 7JE
Tel. (61) 273 2271

Merseyside

C. E. S. Photographic Ltd.
Unit 5
Chalon Way Industrial
 Estate
St. Helens WA10 1AT
Tel. (744) 451014

John Mills (Photography)
 Ltd.
11 Hope Street
Liverpool L1 9BJ
Tel. (51) 709 9822

Middlesex

Coker Colour Processing
 Ltd.
Unit N4, Renshaw
 Industrial Estate
Mill Mead
Staines TW18 4UQ
Tel. (784) 63254

Harrow Photolabs Ltd.
35 Pinner Road
Harrow HA1 4ES
Tel. (1) 427 9022

Incolour Photographic
 Services
Unit 5, Teddington
 Business Park
Station Road
Teddington TW11 9BQ
Tel. (1) 943 2436

Kenton Photographic
 Colour Laboratories Ltd.
199 Streatfield Road
Kenton
Harrow HA3 9DA
Tel. (1) 206 0226

P & PF James
 (Photography) Ltd.
496 Great West Road
Hounslow TW5 0TE
Tel. (1) 570 3974/8951

Photoeye
Unit 2
Norcutt Road
Twickenham TW2 6SR
Tel. (1) 755 1333

Sharpe Studios Ltd.
Unit 14, Shield Drive
Westcross Centre
Great West Road
Brentford TW8 9EX
Tel. (1) 847 5669

Silver Images Ltd. (Studio
 Berkeley)
14 Hanworth Road
Hounslow TW3 1UA
Tel. (1) 570 3628

Norfolk

Magna Professional Photo
 Services
27 Yarmouth Road
Thorpe St. Andrews
Norwich NR7 0EE
Tel. (603) 701234

Reflections (Norwich)
Hi-Tech House
10 Blackfriars Street
Norwich NR3 1SF
Tel. (603) 630081

Northamptonshire

Beedle & Cooper
 Photography
13 St. Matthews Parade
Kettering Road
Northampton NN2 7HF
Tel. (604) 718013

Northampton Colour
 Processors Co. Ltd.
9 Scotia Close
Brackmills Industrial Estate
Northampton NN4 0HR
Tel. (604) 768886

Nottinghamshire

Colour Processing
 Laboratories Ltd.
92 Lower Parliament Street
Nottingham NG1 1EH
Tel. (602) 587379

Mallard Colour Labs
Graphic House
Noel Street
Kimberley NG16 2NE
Tel. (602) 382670

Marshalls
Photographic House,
 Northgate
New Basford
Nottingham NG7 7BE
Tel. (602) 784527

Oxfordshire

Monument Photo Labs Ltd.
Monument Industrial Park
Chalgrove
Oxford OX9 7RW
Tel. (865) 891199

Oxford Colour
Mill Street
Osney
Oxford OX2 0DJ
Tel. (865) 248615

Staffordshire

Moorland Photolabs Ltd.
123 Moorland Road
Burslem
Stoke-on-Trent ST6 1EG
Tel. (782) 85445

Suffolk

Colorlabs Professional
The Maltings
Fordham Road
Newmarket CB8 7AG
Tel. (638) 664444

408 Appendixes

Surrey

Academy Colour
Laboratories
Academy House
40–44 Stafford Road
Wallington SM6 9AA
Tel. (1) 669 7911

Allied Photographic
Services
The Creative Centre
Business Park 1
Kingston Road
Leatherhead KT22 7LA
Tel. (372) 379933

Chorley Hanford Visual
Aids Services
Stafford Studios
129A Stafford Road
Wallington SM6 9BN
Tel. (1) 6478181

CPCL
8 Seaforth Avenue
New Malden KT3 6JP
Tel. (1) 942 8155

The Darius Organisation
171 Brighton Road
Coulsdon CR3 2NH
Tel. (1) 668 3232

Dawson Strange
Photography Ltd.
15 Between Streets
Cobham KT11 1AA
Tel. (932) 67161

Industrial Photolabs
(Thames) Ltd.
Park Works, Park Road
Kingston upon Thames
KT2 6BJ
Tel. (1) 546 8899

Positive Images (UK) Ltd.
3 Dee Road
Richmond KT8 9HA
Tel. (1) 940 9344

Taurus Colour Laboratories
Mount Pleasant Road
Lingfield RH7 6BH
Tel. (342) 834052

Weycolour Ltd.
Moss Lane
Godalming GU7 1EF
Tel. (4868) 7670

Sussex

Chromatics
79–80 Western Road
Hove BN3 2JQ
Tel. (273) 722242

Colortech
31 Chatsworth Road
Worthing BN11 1LY
Tel. (903) 209911

Tyne and Wear

Colorlabs Professional
Western Approach
South Shields NE33 5QT
Tel. (91) 455 2236

Colorworld Ltd.
P.O. Box 2
Norham Road
North Shields NE29 0NX
Tel. (91) 259 6926

Image Photographic
Services
Samson Close
George Stephenson
Industrial Estate
Newcastle upon Tyne NE12
0DX
Tel. (91) 268 8000

Inter-Pro Laboratories
Pink Lane House
7–15 Pink Lane
Newcastle upon Tyne NE1
5HT
Tel. (91) 232 0634

M. P. S. Colour Lab
Carliol Square
Newcastle upon Tyne
NE1 2NB
Tel. (91) 232 3558, 261 7509

P2 Colourlab
14a West Blandford Square
Newcastle upon Tyne
NE1 4HZ
Tel. (91) 232 3277

Photo Mayo Ltd.
Neilson Road
Gateshead
Tyne and Wear NE10 0EW
Tel. (91) 477 5827

Pro-Lab
Pennine House
4 Osbourne Terrace
Newcastle upon Tyne
NE2 1NE
Tel. (91) 281 7804

Warwickshire

Stoneleigh Visual Services
Queensway
Leamington Spa CV31 3JT
Tel. (926) 27030

West Midlands

Dunns Photographic
Laboratories Ltd.
Chester Road
Cradley Heath
West Midlands B64 8AA
Tel. (384) 64770

Wiltshire

Hedges Wright Group Ltd.
Unit 8 ISIS Estate
Stratton Road
Swindon SN1 2PG
Tel. (793) 37631

Worcestershire

Kay & Co. Ltd.
13 Pierpoint Street
Worcester WR1 1TA
Tel. (905) 23411

Kolorkraft Photographic
Laboratory
20B Rowland Way
Hoo Farm Industrial Estate
Kidderminster DY11 7RA
Tel. (562) 742866

Yorkshire

A. H. Leach & Co. Ltd.
Photo Works
Brighouse HD6 2AD
Tel. (484) 715241

CC Processing
39 Belle Vue Road
Leeds LS3 1ES
Tel. (532) 443441

Chromagene
13 Abbey Road
Abbey Mills
Leeds LS5 3HP
Tel. (532) 742939

Greatrex Photographic
Services Ltd.
Rutland Street
Bradford BD4 7AE
Tel. (274) 308632

K. L. Photographic Services
39–41 Boroughbridge Road
York YO2 5SQ
Tel. (904) 792338, 781188

Propix Ltd.
Rockingham House
Broad Lane
Sheffield S1 3PP
Tel. (742) 737778

R. Elliff & Co. Ltd.
(Procolour Labs)
Doncaster Road
Denaby Doncaster DN12
4HX
Tel. (709) 82183

Warrens Professional
Photolab
361 Burley Road
Leeds LS4 2SL
Tel. (532) 783614

Woods Visual
Communications
Wood House
500 Leeds Road
Bradford BD3 9RU
Tel. (274) 732362

Wales

Davies Colour Ltd.
168 Sloper Road
Cardiff CF1 8AA
Tel. (222) 230565

Scotland

Photo-Technical Services
Ltd.
North Esplanade West
Aberdeen AB1 2RJ
Tel. (224) 580760

The Image Machine
P.O. Box 6
7–8 Simpson Court
Clydebank Business Park
Clydebank
Dumbarton G81 1RS
Tel. (41) 952 6447

Borowski Colour
Laboratories
Unit D19, Wellheads
Crescent
Wellheads Industrial Estate
Dyce AB2 0GA
Tel. (224) 770585

Eastern Photocolour Ltd.
14–16 Union Street
Edinburgh EH1 2LR
Tel. (31) 557 2364

J. S. Marr
40 Polwarth Crescent
Edinburgh EH11 1HN
Tel. (31) 228 1823

Tarquin Photographic
17 Great Stuart Street
Edinburgh EH3 7TP
Tel. (31) 220 2202

B & S Colour Labs Ltd.
57 Elliot Street
Glasgow G3 8AX
Tel. (41) 221 8283

Clyde Colour Laboratory
113 West Regent Street
Glasgow G2 2RU
Tel. (41) 221 5040, 204 2340

Swains (Glasgow) Ltd.
50–58 York Street
Glasgow G2 8JU
Tel. (41) 221 9061

Thos. Litster
P.O. Box 7
March Street
Peebles EH45 8DE
Tel. (721) 20685

Northern Ireland

Craigavon Photographic
Services
Unit 13, Annesborough
Industrial Estate
Lurgan
Craigavon
County Armagh BT67 9JD
Tel. (762) 326666

Irish Colour Laboratories
Unit 2a, Kilroot Park
Carrickfergus
County Antrim BT38 7PR
Tel. (9603) 65516

WEST GERMANY

Aachen

Audiophil
Annuntiatenbach 30
5100 Aachen

Colorfachlabor Weber
Komphausbadstrasse 38
5100 Aachen

Altena

Studio Karrasch
1, Fulbecker Strasse 36
5990 Altena

Augsburg

Fachlabor Bachschmid
Schroeckstrasse 6
Augsburg

Berlin

Albert Huber Farblabor
19, Suarezstrasse 59
1000 Berlin

Fototechnik
P. Gordt
30, Schwabische Strasse 12
1000 Berlin

Jacobs & Schultz
30, Keithstrasse 2
1000 Berlin

Niggemeyer
Professional-Farblabor
30, Genthiner Strasse 8
1000 Berlin

P.L. Ektachrome Labor
31, Ruhrstrasse 127
1000 Berlin

Schafer Fachlabor
31, Mecklenburgische
Strasse 85
1000 Berlin

Ektachrome Labor
Jacobs KG
41, Albestrasse 3
1000 Berlin

Beger & Tschink
Werbefoto GmbH
42, Friedrich-Wilhelm-
Strasse 60
1000 Berlin

Bielefeld

Delta-Color
Bleichstrasse 40
4800 Bielefeld

Fachcolor
Labor für Berufsfotografie
GmbH & Co. KG
1, Beckhausstrasse 171
4880 Bielefeld

Bochum

Niggemeyer
Fotofachlabor und
Mikrofilmtechnik
Prinz-Regent Strasse 64–68
4630 Bochum

Bonn

Color Service
Heerstrasse 167
5300 Bonn

Gortz und Partner
1, Von-Weichs Strasse 9
5300 Bonn

Braunschweig

Kollmorgen GmbH
Industrie und
Werbefotografie
Wachtelstieg 6A
3300 Braunschweig

Professional Labor Service
Ritterstrasse 23
3300 Braunschweig

Bremen

Fachlabor Reimerdes
Stresemannstrasse 54
2800 Bremen

Das Labor
Fachlabor Seekamp
GmbH
33, Universitätsallee 21
2800 Bremen

Geert Halifeldt
Fotofachlabor
Schwachhauser
Heerstrasse 345
2800 Bremen

Darmstadt

Die Dunkelkammer
Killian & Kern
Artilleriestrasse 3
6100 Darmstadt

Hogen Labor
Erbacher Strasse 11
6100 Darmstadt

Dauchingen

Foto Werbung
Schulte GmbH
Industriegebiet
7735 Dauchingen

Dortmund

Foto-Schlicht
12, Brackeler Hellweg
110/112
4600 Dortmund

Düsseldorf

Creative Colour
Dusseldorf GmbH
1, Huttenstrasse 41
4000 Düsseldorf

HSL
Fachlabor für professionelle
Fotografie
1, Scheurenstrasse 22
4000 Düsseldorf

Labor Grieger GmbH +
Co. KG
Farblabor für
Berufsfotografie
1 Farberstrasse 94
4000 Düsseldorf

Studio Leon van Noort
GmbH
1, Kirchfeldstrasse 116
4000 Düsseldorf

Print-in-Fachlabor
1, Hermannstrasse 18
4000 Düsseldorf

Farbfoto Harz GmbH
30, Vogelsanger Weg 39
4000 Düsseldorf

Essen

Der Fotoherr
Postfach 164105
4300 Essen

Foto Krappe
1, Rellinghauser Strasse 334
4300 Essen

Color Studio 27
Packmohr und Muller
1, Witteringstrasse 22
4300 Essen

Esslingen

Fachlabor Blum der Prolab
 GmbH
Ina Seidel Weg 26
7300 Esslingen

Fellbach

Kleiber Studio GmbH
Max-Planck Strasse 28–1
7012 Fellbach

Filderstadt

Intercolor Gewalt
Rohrl KG
1, Nurtinger Strasse 9
7024 Filderstadt

Florsheim

Color Labor für
 Professionale
Rudolf Riffel
Werner von Stemans
 Strasse 2
6093 Florsheim

Frankfurt

Graf-Color
1, Ludwigstrasse 37
6000 Frankfurt

Labor Facolor
2, Burgstrasse 70–74
6000 Frankfurt

Vekony Color
1, Baumweg 10
6000 Frankfurt

Fachlabor
Edith Zimmer
1, Raimundstrasse 147
6000 Frankfurt

CW MasterLab
70, Ziegelhuttnweg 27–31
6000 Frankfurt

Brieke das Fach-
 Fotozentrum GmbH &
 Co.
90, Tilsiter Strasse 10
6000 Frankfurt

Fürth

Wolf Labor Fürth
Coloranstalt der Wolf
 Werbung OHG
2, Frankenstrasse 16/18
8510 Fürth

Gross-Gerau

Studio Mienert
Sudetenstrasse 23a
6080 Gross-Gerau

Gütersloh

Borgmann GmbH
Foto-Fachlabor
Dieselstrasse 102
4830 Gütersloh

Hamburg

PPS—Professional Photo
 Service
4, Feldstrasse/Hochhaus 1
2000 Hamburg

Fachlabor Dormoolen
13, Kleiner Kielort 8
2000 Hamburg

City Color GmbH
26, Eiffestrasse 74
2000 Hamburg

Photo Center
54, Rutersberg 54a
2000 Hamburg

Tricolor Druckvorlagen
 Herstellung GmbH
54, Wehmerweg 26
2000 Hamburg

Ralph Kleinhempel GmbH
 & Co.
Fotofachlabore
60, Bussestrasse 11
2000 Hamburg

Alstercolor
76, Humboldtstrasse 67A
2000 Hamburg

Hamm

Foto Ebrecht
Fritz-Husemann Strasse 58
4700 Hamm

Hannover

Foto Schrader
1, Öltzenstrasse 13
3000 Hannover

Fotocentrum Zimmermann
1, Vahrenwalder Strasse 263
3000 Hannover

Peter Gauditz
Fachlabor für Fotografie
 GmbH
21, Alte Herrenhauser
 Strasse 22
3000 Hannover

Foto-Fiss Color GmbH
81 Grazer Strasse 30
3000 Hannover

Csw-Fachlabor
H. Boettger
91, Gottinger Hof 1
3000 Hannover

Hardhelm

Foto Bernhard GmbH
Wurzburger Strasse 41
6969 Hardhelm

Heidelberg

Dia-Print Service Richter
GmbH
Treitschkestrasse 3
6900 Heidelberg

Karlsdorf

Fotofachlabor Harenbrock
Industriestrasse 4
7521 Karlsdorf

Karlsruhe

Foto-Augustat
1, Bahngofsplatz 8
7500 Karlsruhe

Fotofachlabor
Skowronek
Kronenstrasse 7
7500 Karlsruhe

Foto Studio Bauer
31, Klammweg 1
7500 Karlsruhe

Kassel

PE Color-Studio
1 Friedrich-Ebert Strasse 55
1 Konigstor 45
3500 Kassel

Kirchheim unter Teck

Heudorfer GmbH & Co.
Fotokunstanstalt
Schulestrasse 13
7312 Kirchheim

Knittlingen

Gerd Schweizer
Fotografie und Konzeption
Kalkofenstrasse 6
7134 Knittlingen

Köln (Cologne)

Farblabor für
Berufsfotografie
1, Brusseler Strasse 100
5900 Köln

Labor Kreyenmeier
1, Sachsenning 73a
5900 Köln

Fachlabor Lillig
30, Widdersdorfer Strasse
188
5900 Köln

Foto-Fachlabor Neuhoff
1, Gentner Strasse 3–5
5900 Köln

Fachlabor Sander
30, Venloer Strasse 515
5900 Köln

Schloms und Schmitz
30, Sommering 24
5900 Köln

Fotofachlabor Bachor
41, Aachener Strasse 311
5900 Köln

Königslutter

Kollmorgen GmbH
Fachlabor für professionelle
Fotografie
Am Kleiberg 14
3308 Königslutter

Krefeld

Fachlabor für Industrie und
Werbung
Hagemann
Philadelphiastrasse 146
4150 Krefeld

Lage

Hesterbrinck Fotowerbung
Kameruner Strasse 27
4937 Lage

Kraft Color Labor
Am Umfluter 11
4937 Lage

Leinfelden-Echterdingen

Photo Studio 13
2, Heilbronner Strasse 1
7022 Leinfelden-
Echterdingen

Mainz

Prisma-Fachlabor
Friedlund Pabst
Mittlere Bleich 2
6500 Mainz

Mannheim

Dia-Print Service Richter
GmbH
Am Ullrichsberg 8
6800 Mannheim

Gerold Fotofachlabor
GmbH
Niederfelderstrasse 120
6800 Mannheim

Memmingen

Foto Fachlabor Engel
Zangmeisterstrasse 5
8940 Memmingen

Mörs

GeWa-Foto
Zum Schurmannsgraben 12
4130 Mörs

Mühlacker

Foto Frischkorn GmbH
Bahnhofstrasse 88
7130 Mühlacker

Munich

Rawe Fotofachlabor GmbH
2, Sandstrasse 31
8000 Munich

Fachlabor Reinhardt
Pfunder
22, Herrnstrasse 13
8000 Munich

Ektachrome Fachlabor
Flasch GmbH
40, Barerstrasse 68
8000 Munich

Foto Service Frister
40, Friedrichstrasse 31
8000 Munich

Fachlabor Bernhard Mayer
43, Hohenzollernstrasse 47
8000 Munich

Reger Studios
50, Hanauer Strasse 50
8000 Munich

3 F–Fachlabor
Dr. Frickhinger GmbH &
Co.
60, Zehenstadelweg 12
8000 Munich

Fachlabor für
Umkehrtechnik
Jurgen Freisler
70, Dankstrasse 2
8000 Munich

Fotolabor Treml
70, Halmstrasse 5
8000 Munich

High Color
70, Emil-Geis Strasse 17
8000 Munich

Dia Direkt Fotofachlabor
GmbH
80, Kirchenstrasse 42
8000 Munich

Ektachrome Service
S. Pfaffenbichler GmbH
80, Prinzregentenstrasse 78
8000 Munich

Weila-Profi Center
82, Stahlgruberring 32
8000 Munich

Foto Fach Labor
Knoblich GmbH
90, Senftlstrasse 1
8000 Munich

Entwicklungs Service
Fischer
90, Claude-Lorrain Strasse
37
8000 Munich

Seitz & Zobeley GmbH
90, Untere Weidenstrasse 26
8000 Munich

Neusass bei Augsburg

K & E Colorfachlabor
Benzstrasse 11
8902 Neusass bei Augsburg

Neustadt bei Coburg

Greiner Studios KG
Brunnenstrasse 9
8632 Neustadt bei Coburg

Neu-Ulm

Iraci Fachlabor und
Reproduktion
Schutzenstrasse 54
7910 Neu-Ulm

Offenbach

Color Studio Schiela
Schumannstrasse 14
6050 Offenbach

Ortenberg

Labotech
Labor für professionelle
Fotografie
Haupstrasse 53
7601 Ortenberg

Osnabrück

Strenger Color KG
Martinistrasse 86
4500 Osnabrück

Ostfildern

Labor Grieger GmbH +
Co. KG
Farblabor für
Berufsfotografie
2, Karlsbader Strasse 12
7302 Ostfildern

Pforzheim

Labor 6
Diaservice GmbH
Habermehlstrasse 17
7530 Pforzheim

Saarbrücken-Brebach

Foto-Fachlabor
Tom Knipper
Saarbrücker Strasse 29
6604 Saarbrücken-Brebach

Selb

M2 Fotolabor und Studio
Christoph-Krautheim
Strasse 15
8672 Selb

Stuttgart

Labor M. M. Miocevic
1, Rotebuhlstrasse 51a
7000 Stuttgart

Dia Service Fachlabor für
Ektachrome E-6
1, Olgastrasse 97c
7000 Stuttgart

Prolab GmbH
Fachlabor für
Berufsfotografie
1, Rotebuhlplatz 35a
7000 Stuttgart

R & P Professional Dia
Service
61, Rohracker Strasse 338
7000 Stuttgart

Fotofachlabor
Hermann Schnepf
70, Julius-Holder Strasse 14
7000 Stuttgart

Wolfsburg

Studio für Werbefotografie
S. B. Tautz
14, Haldensleber Strasse 8
3180 Wolfsburg

Technical Slide Art GmbH
Waldemar Schmidt
2, Ferdinand-Thun Strasse
44
5600 Wuppertal

Wiesbaden

Fischer-Labors
Albrechtstrasse 5
6200 Wiesbaden

Wuppertal

Color Fachlabor
Sigrid Kruger
1, Gesundheitsstrasse 91/93a
5600 Wuppertal

Würzburg

Werbestudio S-G GmbH
St. Liobastrasse 1
8700 Würzburg

ABOUT THE AUTHOR

New Yorker Ken Haas has been traveling around the world on photographic assignments for the last twenty years, including two years based exclusively in Asia.

His work has appeared in such publications as *Newsweek, Fortune, People,* and the *New York Times Magazine,* and he has been the subject of articles in *Print* and *How.* He is one of America's leading corporate photographers and the list of clients he has serviced includes such international companies as Citicorp, AT&T, Hong-kong Bank, Chase Manhattan Bank, General Electric, and Merrill Lynch.

Index

Notes